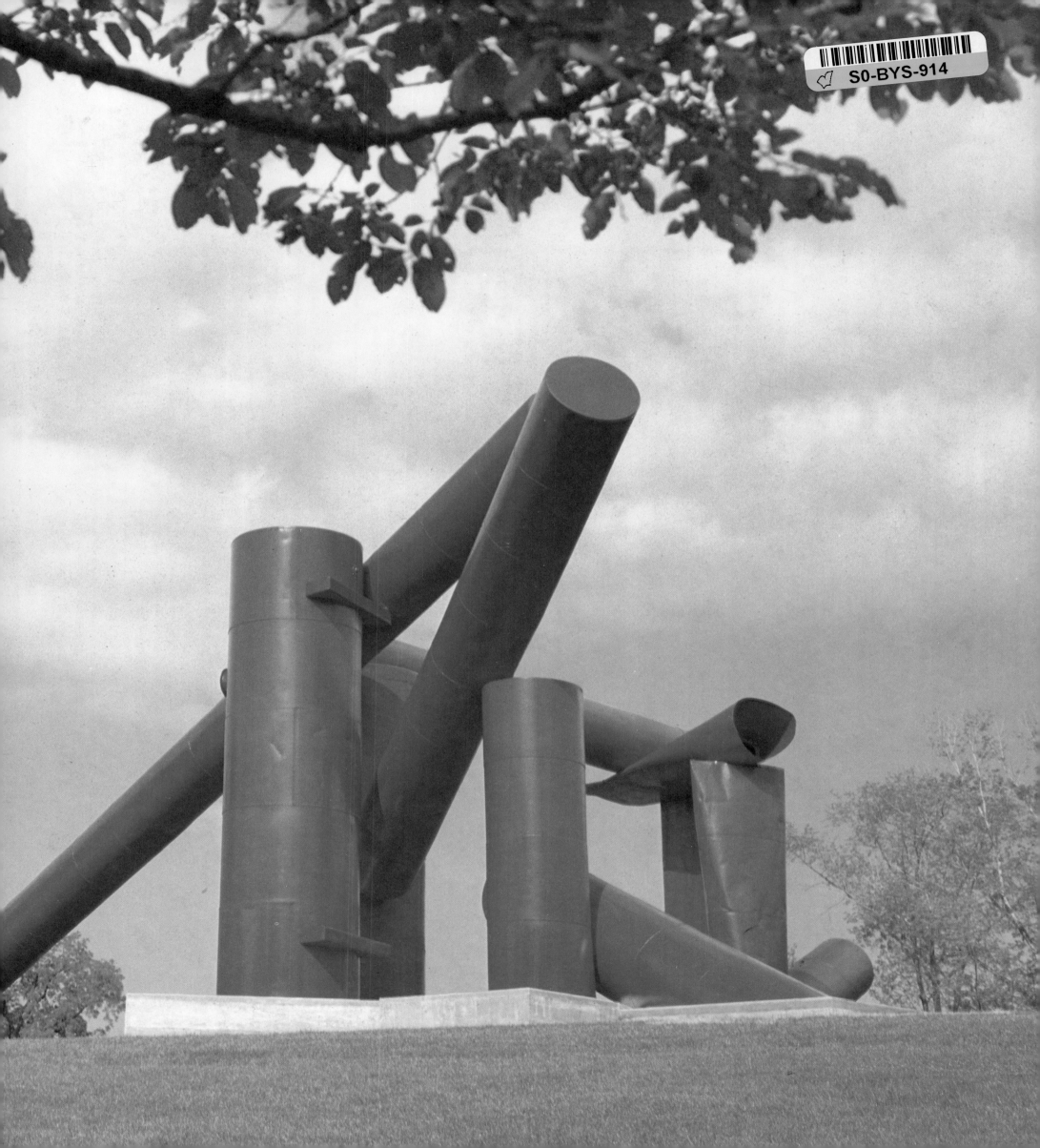

TO TATIANA

# ALEXANDER LIBERMAN

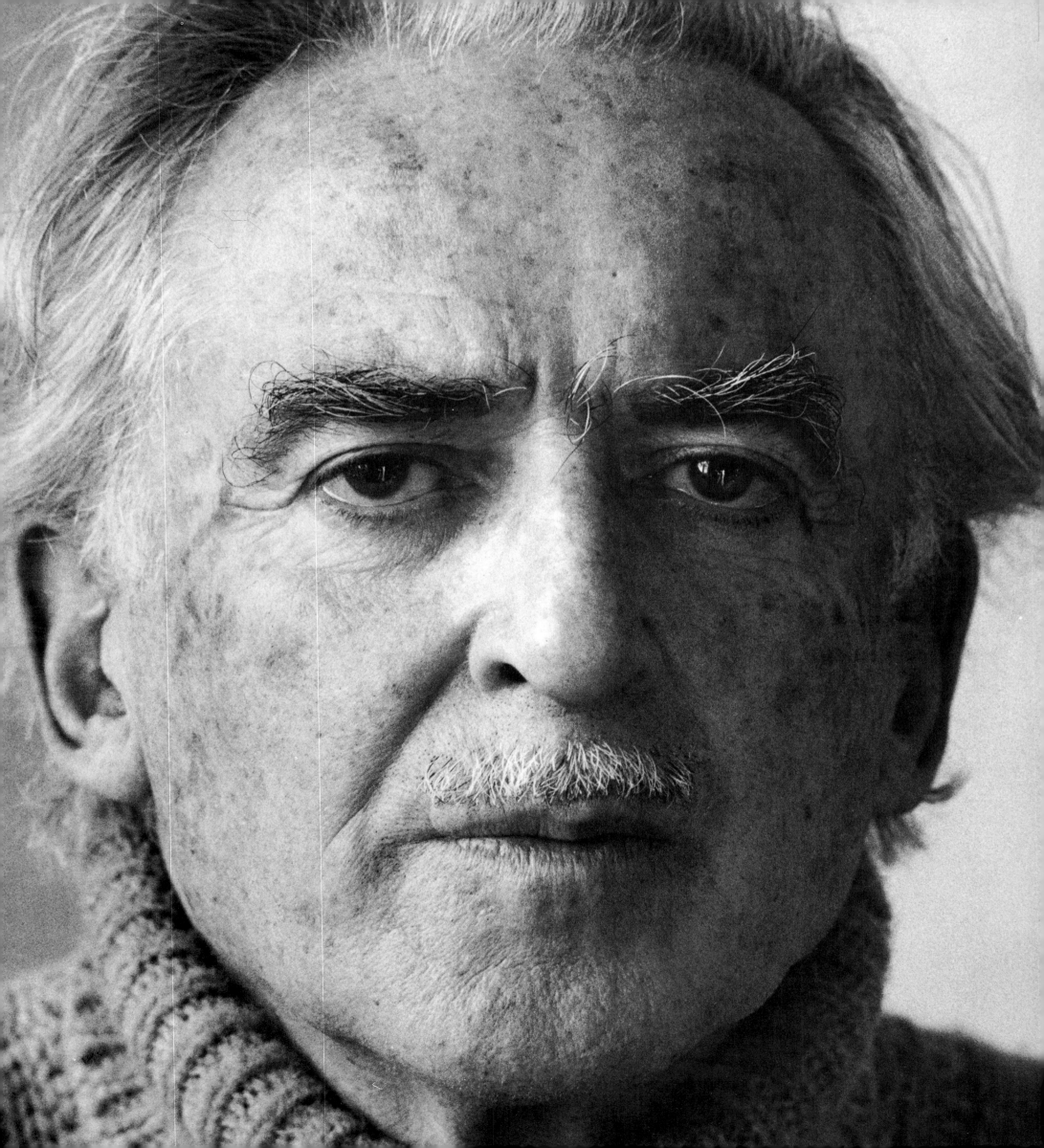

# ALEXANDER LIBERMAN

## BARBARA ROSE

ABBEVILLE PRESS, PUBLISHERS, NEW YORK

FRONT COVER

*Iliad*, 1974–77

BACK COVER

*Triad VIII*, 1973
Acrylic on canvas, 70 x 70 in.

FRONT ENDPAPER

*The Way*, 1972–80

BACK ENDPAPER

*Big Blue Circle*, 1963
Liquitex on canvas, 111½ x 202 in.
Collection Bennington College, Bennington, Vermont

OPPOSITE TITLE PAGE

1. Alexander Liberman, Warren, Connecticut. This photograph and
those that follow in the introductory material were taken by
Irving Penn in 1977

OPPOSITE CONTENTS

2. Closeup of Erg painting

ALL STATEMENTS IN ITALICS ARE QUOTATIONS FROM THE ARTIST.

Plate references in the text are italic numerals in parentheses.

In the captions to works illustrated,
the measurements are given in the following order:
for paintings, height and width;
for sculptures, height, width, and depth or length.

Unless otherwise indicated, all works are in the collection of the artist.

EDITORS: MARK GREENBERG AND SUSAN WOLF

DESIGN: RONALD KAJIWARA

ISBN: 0-89659-149-2

Library of Congress catalog card number: 80-66524

# ACKNOWLEDGMENTS

This book was Harry N. Abrams's idea. Although he did not live to see it completed, his inspiration gave it life and his enthusiasm kept us all going during the years required to produce this book. It is the last of the individual monographs on contemporary artists that Harry himself conceived and commissioned, the series he considered his own pride and joy.

After Harry was no longer with us, his son Robert Abrams assumed the role of goad and critic, contributing many suggestions we incorporated into the project. While working on this book, I often thought of my friend Milton Fox, who always stood for the highest standards of quality. Rarely does a writer feel that writing—especially writing about a living artist—is a pleasure. This book, however, has been a great pleasure for me. The opportunity to know Tatiana Iacovleva Liberman, an exceptional person in her own right, was a privilege. Many have spoken of turning life into art; she is among the few who have done it.

I also want to thank my editor, Mark Greenberg, for his patience, understanding, and support. Others who contributed are Gladys Pohl, who kept track of Liberman's work during the years she was his assistant, and also Edmund Winfield and Ronald Kajiwara, who helped in the demanding process of assembling and designing this book. Cynthia Goodman was also a great help, not only in preparing the chronology and bibliography, but also in discussions concerning content.

Finally, I want to thank Jerry Leiber for his kindess and continuing interest.

Barbara Rose
New York

# CONTENTS

# INTRODUCTION

Alexander Liberman is known as a prolific painter, sculptor, draftsman, printmaker, and photographer, but his art has never been looked at from a perspective that would permit an understanding of its essential wholeness, integrity, and interrelatedness. Liberman's contribution is hard to assess because he is difficult to pin down—a whirling dervish in perpetual motion, the state of those who fear the gods may catch up with them. But flight from the past into an unknown future has been the story of Liberman's life. Throughout his career as an artist, Liberman has been attracted to the epic and to the radical—a combination sometimes found in baroque art, but rarely, except perhaps in the art of Picasso, Matisse, Léger, and the greatest of the Abstract Expressionists, in modern art.

Liberman's impulse to create epic and monumental art, coupled with his urge to experiment with new media and techniques, are explicable if we know the facts of his life. Like his life, his art has often been based on violent rupture. Nevertheless, one discerns threads of continuity: a dedication to the goals of high art as well as to stretching the limits of the possible and the practical; a need to deny reality, the better to transcend it; an attraction to technical innovation coupled with a disdain for technique for its own sake; a preoccupation with the symbolic content of abstract art and the capacity of art to communicate.

The peculiar circumstances of Liberman's life as a refugee first from Lenin's Russia and then from Nazi-occupied France irrevocably affected the course of his art. His connections to Europe remain profound. He spends every summer in Italy and France, as he did in his youth before the War swept away the civilization and culture that formed him. Because both his parents were revolutionaries—his father in politics, his mother in aesthetics—Liberman was prepared for the radicalism of the New York School. However, his development as a major artist of that school was slowed by his experiences as a refugee who arrived at the same time as the Surrealists, but who chose a very different course for his art.

Because Liberman is both a modest and a guarded man who has created an impenetrable façade of courtesy and reserve, in many respects he has been as difficult to see through as the glossy, resistant surfaces of his early enamel paintings. Within the New York School, he is a unique character: his roots are most closely tied to the School of Paris, where he spent his formative years, but his emotional life remains tied to Russian culture. Throughout his life, the theme of the double dominates. His public persona as a man of the world, the sophisticated, urbane editorial director of all Condé Nast publications, whose name is synonymous with *Vogue*, sharply diverges from his private life with his wife, Tatiana; her daughter, Francine du Plessix; son-in-law, artist Cleve Gray; and grandsons, Thaddeus and Luke Gray. It is not so much that Liberman is a classic schizophrenic (Alex the Terrible and the adored Grandpa, for example), the point is rather that he is a Dostoevskian personality, a larger-than-life gambler, adventurer, and mystic haunted by a double who acts as conscience and often requires him to behave unpredictably.

In the past, artists like Velázquez and Rubens—two heroes high in Liberman's pantheon—have been both men of the world involved with power and international affairs as well as great painters. Today's conception of the artist as marginal to society, a raffish, irresponsible bohemian incapable of running anything, is too narrow for Liberman and too confining for his enormous energies. Betty Parsons attributes Liberman's capacity to lead two lives to the fact that "Russians have two of everything—two stomachs, two heads,

two hearts. And Alex is, above all, Russian." To his wife, the explanation is simpler:"Alex is Superman,"Tatiana says.

Like Superman, Liberman has two costumes, and changing from one to the other signifies a different persona. At work, he is dressed in the same charcoal gray suit (he has two, and a new one is ordered when one wears out). In his painting studio, now attached to his house in Warren, Connecticut, and his sculpture shop—a huge field filled with cranes and machinery not far away—he wears khakis. Either way, he is always in uniform, ready to do battle.

It is almost impossible to get Liberman to talk about his past. He has no sense of chronology; everything is happening synchronically in the present. He did, however, consent to taping hours and hours of interviews over a period of several years. This book is based on those interviews and on biographical material found in books by or about his family. Fortunately for the bewildered art historian trying to reconstruct Liberman's biography, both his parents wrote memoirs. *Building Lenin's Russia*, his father's account of the years he worked for the Soviet government as Lenin's advisor and the years he spent as manager of the North Timber Trust; and *Mon Théatre à Moscou*, his mother's story of how she got permission from Lunatcharski to start the first children's state theater to entertain her depressed and melancholy young son shortly after the Revolution, provide the background of Liberman's early life he has chosen to forget.

One of the consistent stylistic features of Liberman's art is the ways in which he contrives to leave himself out of the picture—either by working in anonymous geometric styles or with automatic techniques in recent years. Only in his latest paintings and sculpture do we actually see the mark of the artist's own hands, in the scratching and gouging of painting surfaces and in the monumental cut-out forms of the environmental sculptures drawn by the artist. According to Liberman's friend, the late Thomas B. Hess, Liberman learned from his Calvinist education in France to believe that Pascal was right when he said, "le moi est haissable"—the ego is hateful—and to strive for anonymity.

Unlike many contemporary artists, Liberman has never written about himself, but he has demonstrated unique respect and homage for other artists in his essays on the School of Paris masters, in *The Artist in His Studio*, and in his photographs of artists he admires. These essays give clues to Liberman's own concerns as an artist. Over and over, he describes those he respects most as "priests" or "monks" of art. The exception is Picasso, whom he sees as an eternal child, a gambler, and an adventurer.

Photography has been important to Liberman in many ways, not the least of which is to give him a fresh perception of form. Through photography, he has studied people, nature, structures and shapes as well as art. Despite the esteem experts have expressed for his photography, Liberman insists that for him photography is not an art but a way of taking notes. Restless, self-critical, enigmatic, complex, Liberman never wanted his art subjected to the pressures of the art market. His refusal to be part of the art world has earned him great hostility from so-called "revolutionaries" infuriated by an artist who decided to become a worldly success so he could afford to take the greatest risks in his art. But who is to say when the mild-mannered editor jumps out of his gray flannel suit into his khaki Superman action outfit that his regression is not as complete as that of any drunk or drugged bohemian? As to who is the greater radical—the artist who demonstrates art's impotence in ephemeral works or the artist who believes in the transcendent power of art to elevate, inspire, and redeem—only history can answer.

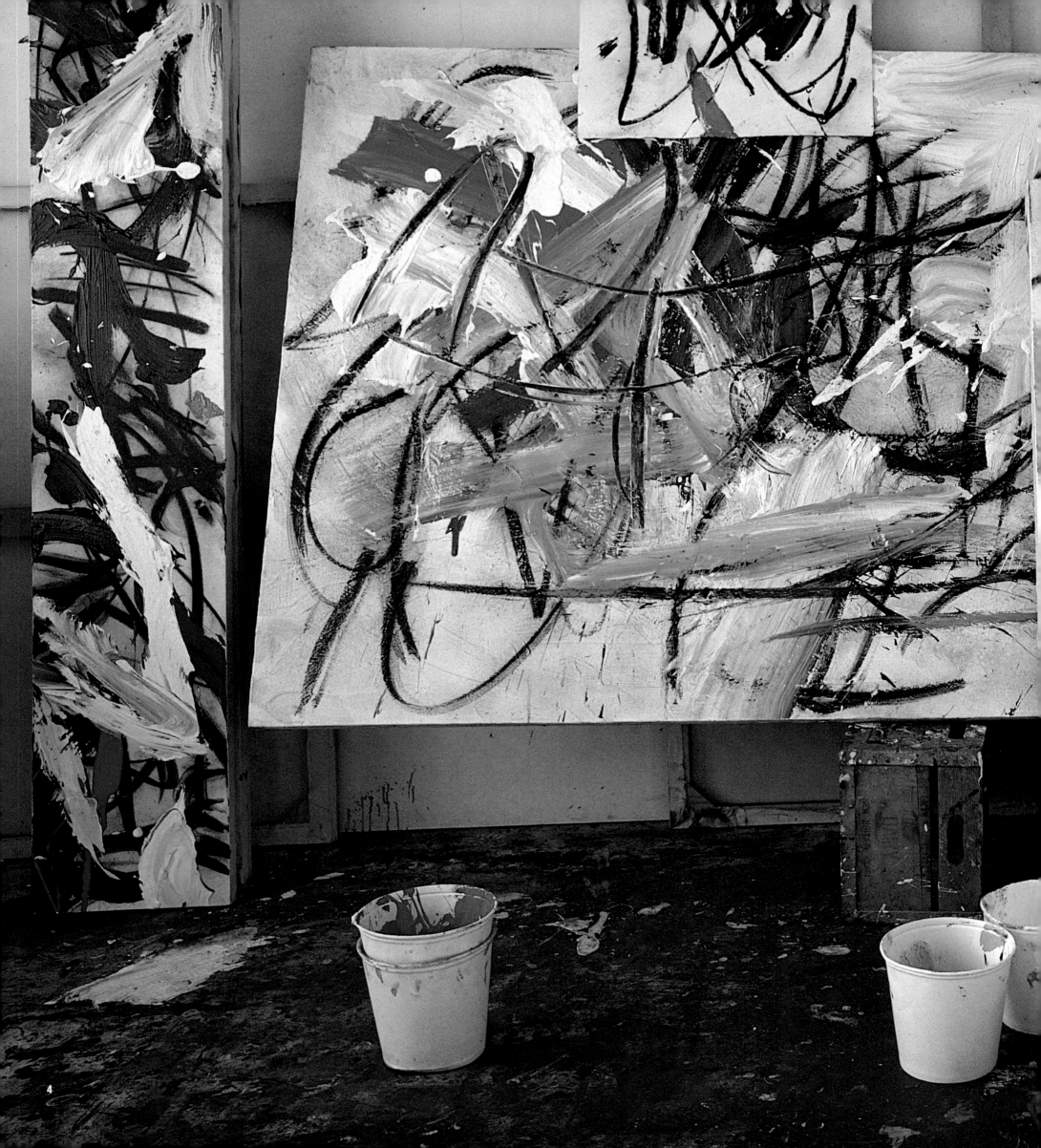

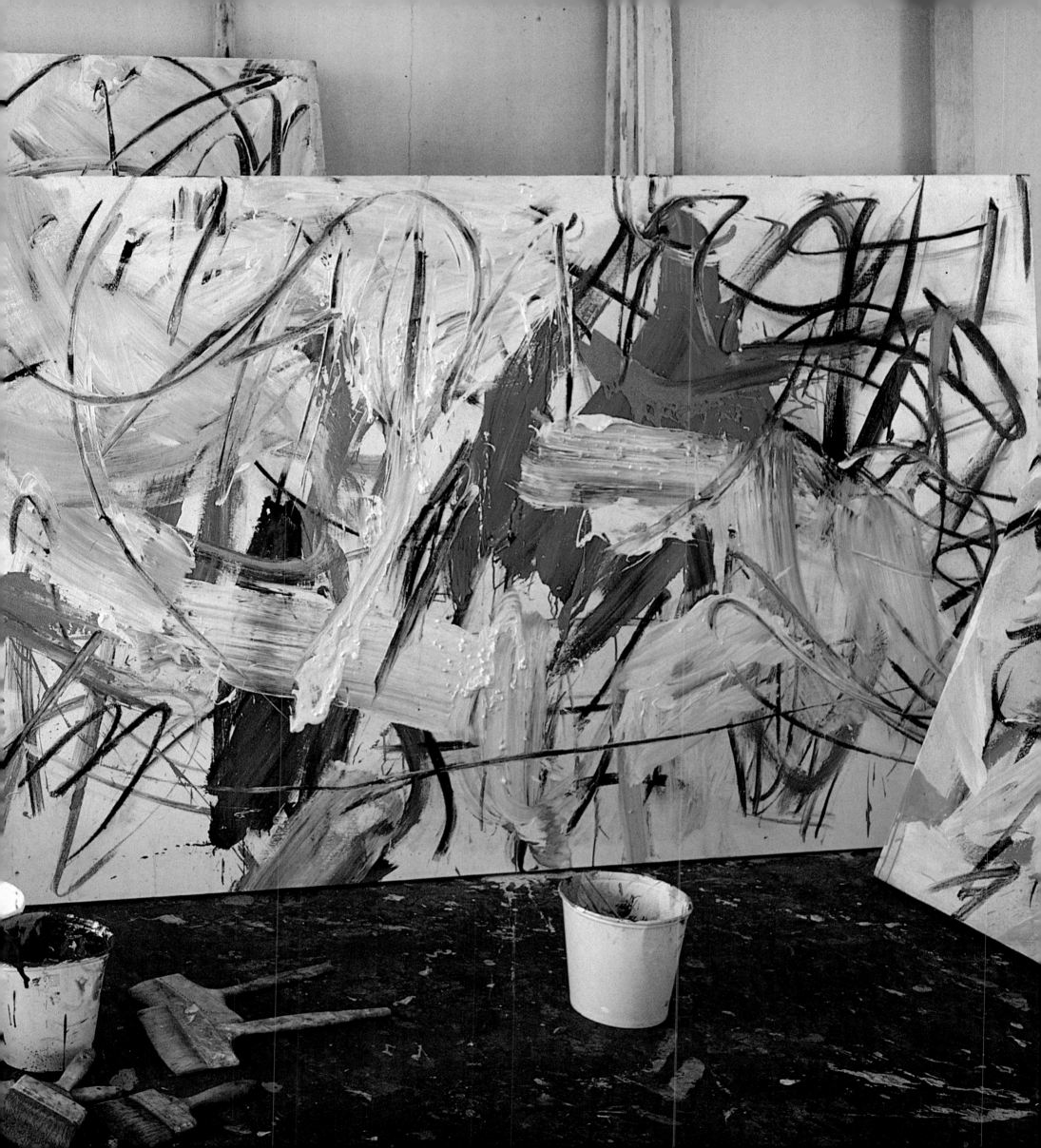

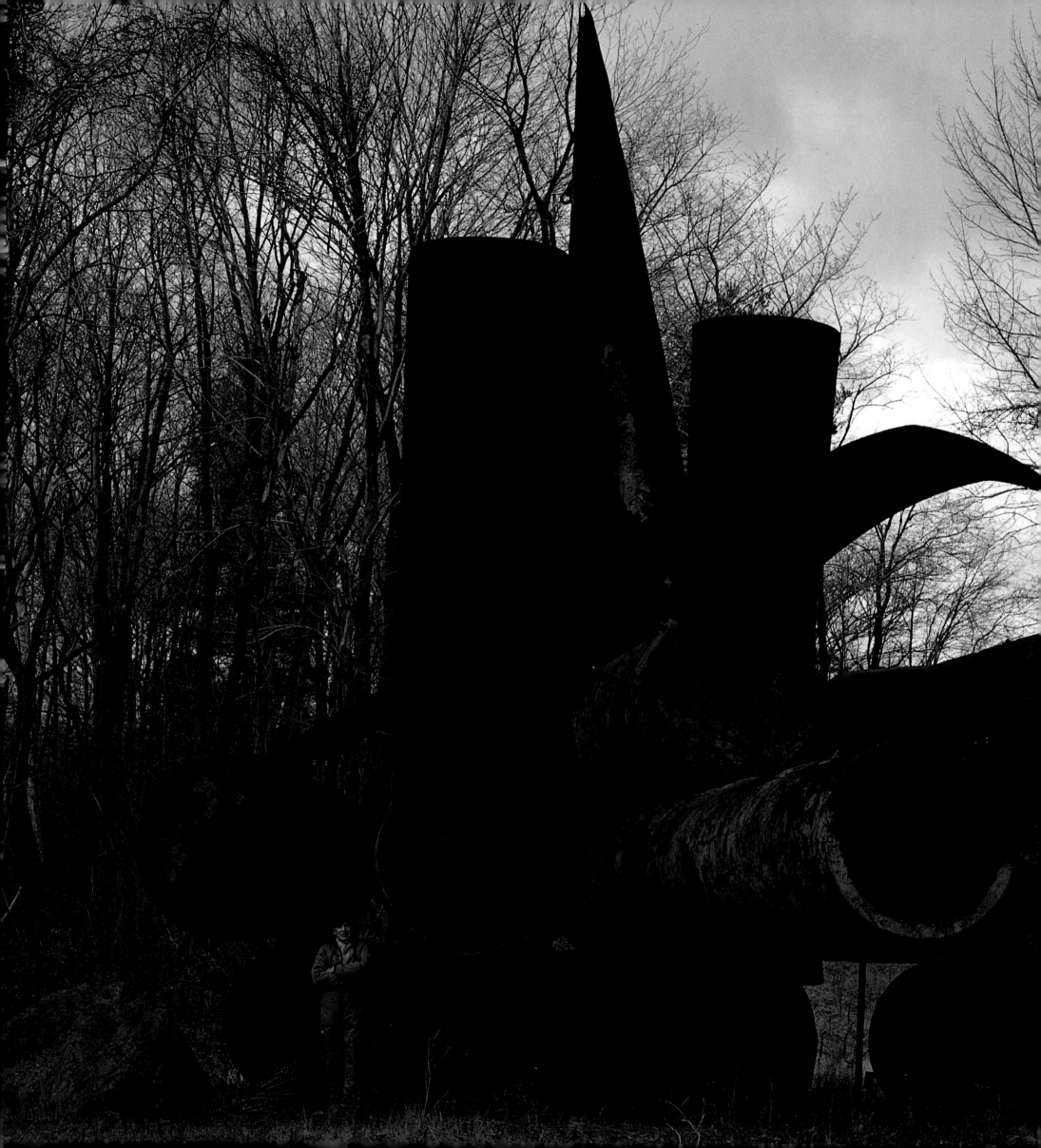

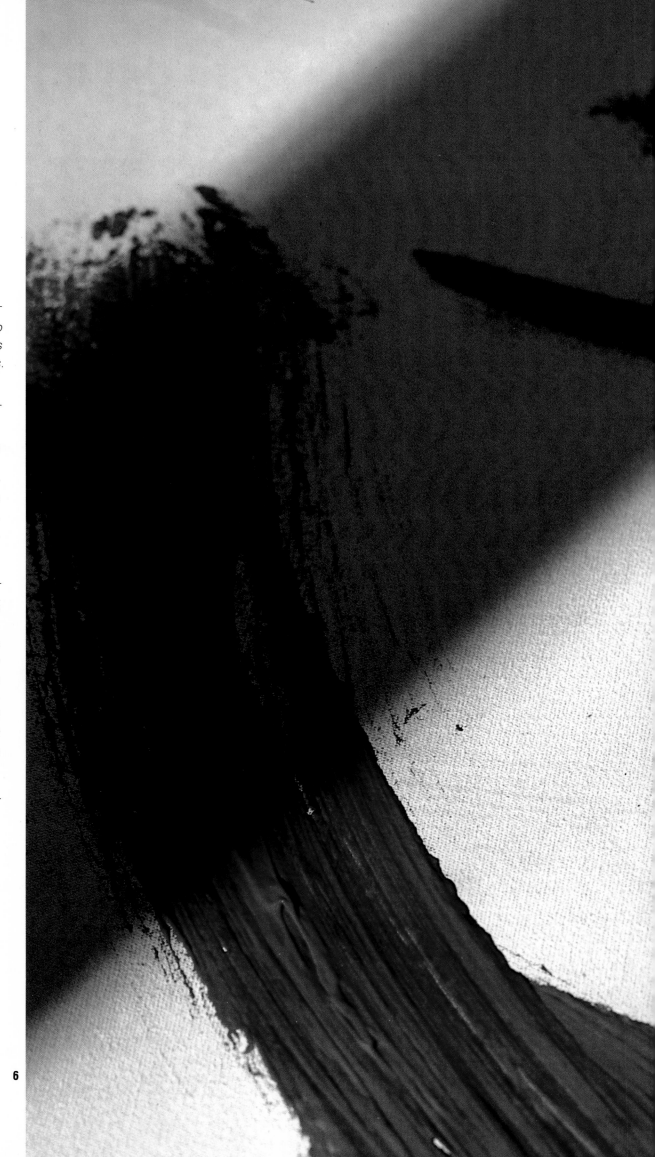

I believe the artist has a mission. The artist has to do what he has faith in. If it has real quality—if it touches some inner spring, if it communicates—that is success. Communication is the purpose of art.

I always imagined Cézanne suffering in a small studio, but he had an immense studio. What I thought was extraordinary was that, when he finished the Grandes Baigneuses, they couldn't get it out through the door or through the window, so he knocked a narrow panel in his studio wall to get it out. I was always fascinated by going beyond the limitations of one's surrounding, to do the impossible work.

I think art is an act of devotion. Cenino Cennini was right: you have to pray before you start a work of art. But praying in the modern sense may be meditation or may just be a withdrawal, which is helped by music. He says you must put on your finest robes and pray before you start a work of art. Art is a superior human activity, and it should not be defiled by money, lies, by anything menial. I still resent that Renaissance masters had to do jewel boxes for some prince. I resent this artisanal function of any talent.

6. The artist's hand at work

**6**

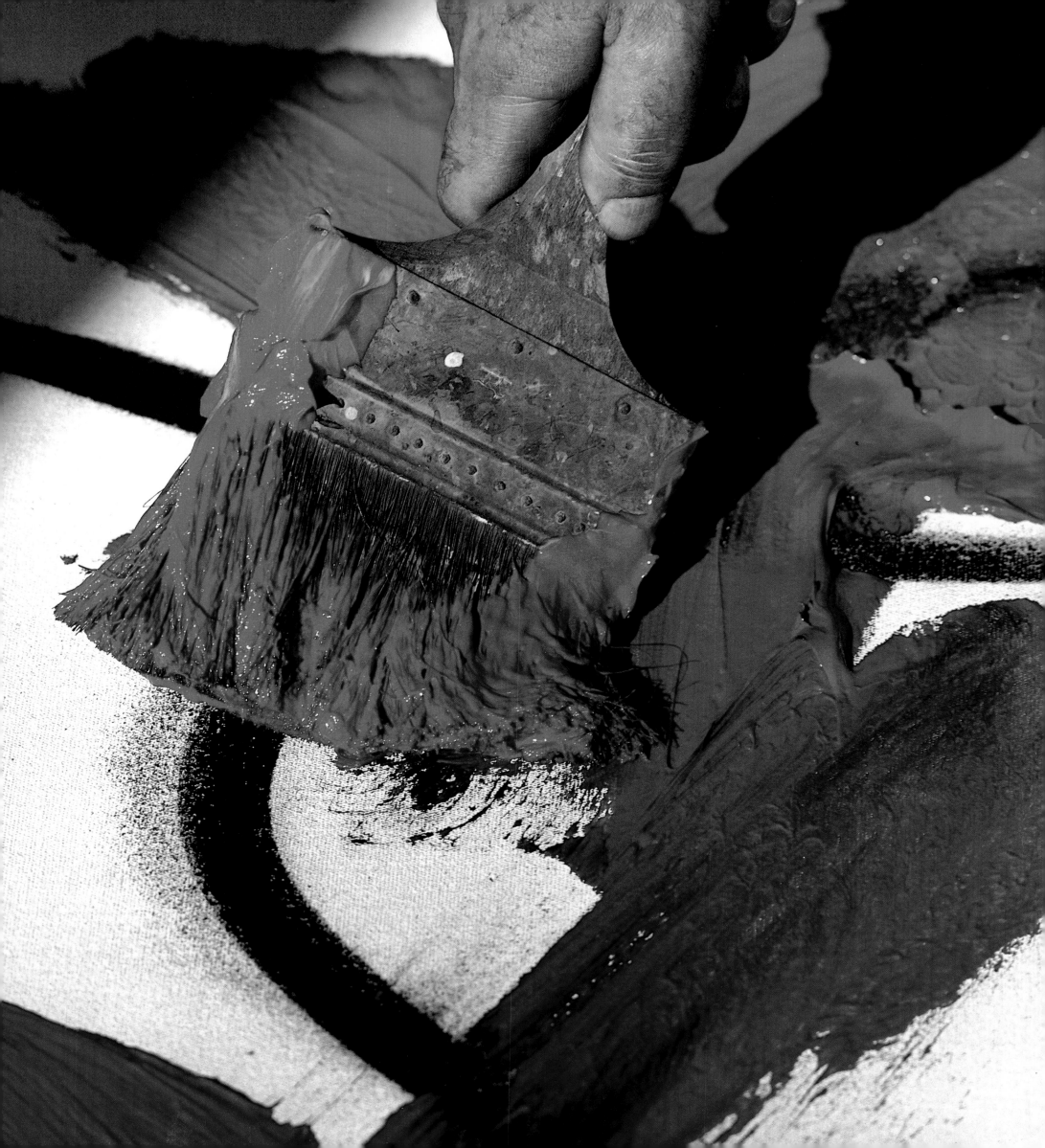

# CHAPTER

# I

## NEVER TAKE NO
## FOR
## AN ANSWER

*The Revolution occurred in 1917, and I remember vividly masses—dark, black masses like black rivers —going through the big avenues of St. Petersburg, with red flags, chanting revolutionary songs. I remember the Czar's portrait being burnt at night. But all of these things did not in any way frighten me. But I suppose I must have sensed, like any child of five, the nervousness and, perhaps, the terror of my parents. I even remember one incident that was quite terrifying perhaps, when, with my mother, we went to visit a friend. We entered the apartment. Behind the door was a Red Army soldier, and in the living room were seated twelve or fifteen people—we discovered that we had been caught in a trap. These were organized quite often so that all the people who could be in any way connected with a given suspect would be arrested. And I remember my mother being quite terrified. But, as I was only five years old, I was allowed to leave and I warned my father.*

*We then moved to Moscow and I still remember (being then about six) coming home, or looking down from upstairs, and seeing my mother and father dead drunk with their friends, lying sprawled on the floor. To this day, when I open a door, I always expect to see a figure lying on the floor. The other part of my strange childhood was relative abandon because my mother would go off to her theater, my father would go off to his Lumber Ministry, and, as I recall, I would be left completely alone. I lived in the street with groups of semiabandoned hooligans, or children. Behind our house in Moscow was a bombed-out building, completely reduced to rubble. A huge area, perhaps as wide as two whole blocks. This became our fighting fortress. We would split into two gangs and fight by throwing stones at each other. By then I must have been about seven—or maybe even eight—because I left Russia in September of 1921. We would build hideouts or fortresses out of abandoned bricks, masonry, cover our impregnable fortresses with whatever pieces of rusted roof or steel that we could find, and fight out whatever battles we could sustain. I remember boys being hit in the head by stones, and bleeding, and I also remember all sorts of impossible escapades that I was involved in. This violence, this fighting, I even brought to the school in which I had to work for a few hours a day.*

*I would give the sandwiches that my mother prepared for me to a truck driver, who would drive me to school in exchange for the food, and I would go without lunch. I was appallingly shy and timid. For instance, I was asked to do a school dance and after hours and hours of rehearsal with the top dancer of the Bolshoi, I froze when the curtain opened and ran away in tears. This shyness still more or less prevents me from appearing or speaking in public.*

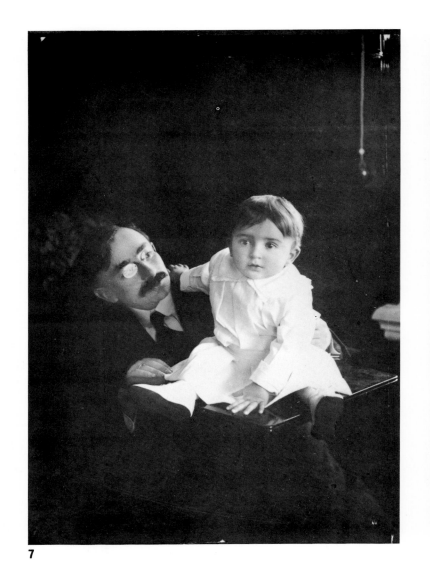

7

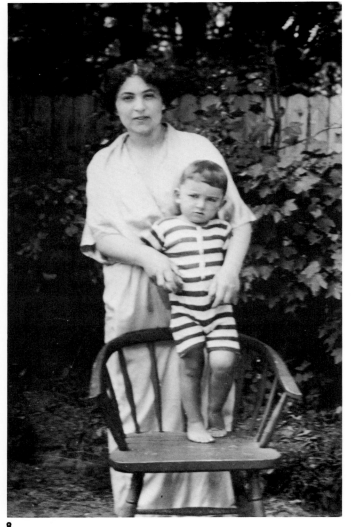

8

*My father represented the whole of Russian timber, so when he went to England he was selling or dealing with England regarding all the vastness of Russia. As a child, I remember that when he had to go inspect the czar's uncle's forests, seven cars were sent to Moscow to bring us down to the Caucasus. Later on, he had a private train—just one car with a private train—and we traveled across Russia inspecting the forests.*

7. Liberman with his father, St. Petersburg, c. 1914-15

8. With his mother, c. 1916

ALEXANDER SEMEONOVITCH LIBERMAN was born on September 4, 1912, in Kiev, Russia, on one of his family's trips back and forth from the forests in the Urals, the Caucasus, and Siberia. (7) His father, Simon Liberman, an economist and timber expert educated at the University of Vienna, managed the estates of many nobles, including the czar's uncle, Prince Oldenburg. His mother, Henriette Pascar, an actress who maintained her maiden name, was the first of twenty children born to an immensely wealthy Bessarabian timber heiress and a handsome gypsy. Before her marriage, she had escaped to Paris to study French literature at the Sorbonne. The founder of the first state children's theater, and in later years an internationally known mime, she was devoted to art. And she was determined that her only child, Alexander, should become an artist. (8)

Simon Liberman was a brilliant and powerful man. (27) The family enjoyed the patronage first of the Romanovs, and later of V. I. Lenin, who leaned heavily on Liberman's expertise in economics and international finance. While his father was still working for the Russian nobility, young Alex rode with his family in the private railroad car Prince Oldenburg provided. Later, he was taken to the Kremlin when his father went to see Lenin or others on official business. There he was awed by the giant cannon of Ivan the Terrible, an aggressive jutting form recalled later in his sculptures.

Although he had always been a socialist, Simon Liberman was not a Bolshevik. He remained sympathetic to the socialist cause to the end of his life. But when Lenin suggested he could be more secure as a bureaucrat if he would join the Party, Liberman refused with the response, "Comrade Lenin, Bolsheviks, like singers, are born, not made." As conditions became more difficult for non-Communist experts, he was warned he could survive only by publicly denouncing the Mensheviks in the press. He refused, aware that Lenin's good will alone protected him.

In his memoir of his service to the Soviets, *Building Lenin's Russia*, Simon Liberman explained that he was not guided by Marxist theory: "The basic and decisive factor was in my moral searches, my general idealistic strivings. What I daydreamed of was a kingdom of freedom, equality, and social justice; for, mark you, I had come out of that Jewish milieu where the old tradition of romantic mysticism was still alive, where the word 'miracle' was a true clarion call that woke men's hearts." The product of a mystical tradition that was both Russian and Old Testament, Simon Liberman had formed a close relationship with the Christian theologian and philosopher Nikolas Berdyaev. He had been convinced that the collapse of the empire was inevitable, and he was appalled by "the horrible width and depth of the chasm separating the masses of the Russian people from the handful of landlords, bankers, and court officials ruling the country and enjoying

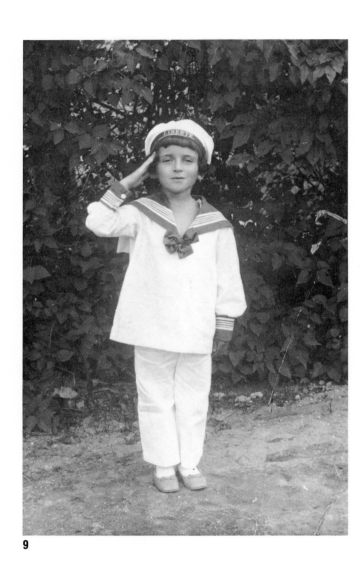

**9**

9. Liberman, Moscow, 1920

10. Fedotov
    Sketch for set for "Les Enfantines"
    by Moussorgsky
    State Children's Theater, 1920
    Watercolor
    Original now lost

all the rights and privileges on earth." Having decided to cast his lot with the people, he had been active as a Menshevik leader in the abortive 1905 Revolution.

During the upheaval that culminated in the 1917 Revolution, the Libermans were living in St. Petersburg; after the October Revolution, they followed the government to Moscow. As a boy, Alex roamed the Moscow streets with a gang of children who played games of mock warfare in the rubble, building fortresses from the ruins of destroyed buildings and throwing stones and glass at each other.

Liberman's early childhood was chaotic, which may explain why, in his first mature paintings, he imposed a rigid geometric order. Indeed, not until he had proved his ability to create order was he free enough to permit any eruption of chaos. As a child in St. Petersburg, he recalls seeing Nevski Prospekt filled with crowds carrying red flags and burning the czar's portrait. In Moscow, his family now shared their four-room apartment with two working-class families. Everywhere there was tension and fear. The Communist who shared their apartment would get drunk and beat his wife, often bursting in on the Libermans in a rage. Young Alexander was sent to school, but he was a violent and unruly child, difficult to discipline. His teachers informed his father that Alexander was a sick boy and should be taken abroad. (9)

Liberman's parents were too preoccupied with their duties and problems to notice their son's emotional difficulties and his potential for delinquency. During the early years of the Revolution, both his parents were deeply engaged with the utopian activities that terminated when the Bolsheviks completely consolidated their power. To distract the hungry children, Anatole Lunatcharski, the innovative commissar of education, directed Henriette Pascar to set up the first state children's theater in 1919. Her theater functioned as a workshop for the latest Russian constructivist experiments in costume and set design, but she showed a preference for plays by Kipling, Stevenson, and Mark Twain, which the Soviets found suspect. In addition to her other accomplishments, Henriette Pascar was an author. Her autobiographical novel of the life and loves of a Bohemian adventuress, *Le Coeur Vagabond*, was privately published in Paris; but her book *Mon Théâtre à Moscou* was translated and remains a classic in the literature on children's theater. Her apartment and theater were filled with designers, artists, playwrights, and actors, and her son was encouraged to take part in everything. He preferred the stage to school. He loved to climb over the sets, which seemed to him like strange cities. His mother believed children should be encouraged to dream rather than to be overly realistic. She encouraged the boy to draw sets for the theater. He imitated the bright geometric shapes he saw being created by designers like Fedotov, who worked for the children's theater. (10) In the streets he saw

posters and the monuments being erected to the Revolution; but he remembers even more clearly the constructivist designs for his mother's theater. These are recalled in sketches he made as a teenager (*11, 12, 13, 14*) and in the sets he himself designed for her productions in Paris. (*33*)

School being something of a disaster, Alex was taught at home by tutors who had worked for the czar's family before the Revolution. But he was more interested in squeezing paint for the artists who came to paint his mother's portrait, and in banging angrily on the piano, than he was in reading books. (He learned to multiply only because failure in mathematics meant he could not go to the Bolshoi or the other theaters.) Finally the tutors gave up, too, and the boy spent his time dreaming of the forts he would win in street battles.

In the meantime, Simon Liberman had been drawn into Lenin's inner circle. He was among the major architects of Lenin's New Economic Policy, a plan to reconstruct the Russian economy through the limited reintroduction of capitalist practices and trade with capitalist countries. In *Building Lenin's Russia*, he recalled a conversation about timber shipping and the "gigantic task of restoring and expanding shipping on the two great Russian rivers." He wrote of the vision of modern steamers transporting timber on the Volga and the Kama; they would be "like floating skyscrapers, with stores, libraries, fine dining rooms, and what not!" Possibly his son overheard conversations involving such visionary projects, which may be reflected in the drawings and woodcuts he made as a teenager in Paris. (*30, 31, 32*) Although Simon was a practical man, his discussions with international power-brokers and politicians about immense engineering and shipping projects always involved a new and improved world of transportation and communication, in which the wonders of modern industry would make anything possible. On her side, Henriette Pascar encouraged dreaming for its own sake. Imagination, for her, always ruled over reality. In Alexander Liberman's later life, his father's practicality would aid survival, and his utopian visions would be reflected in the gigantic public sculptures that he executed as an American artist. But the drive toward the new, the unimagined, and later toward the theatrical and the flamboyant was Henriette Pascar's legacy to her son.

In 1921, Simon Liberman was ordered by Lenin to leave for a second trip to England to negotiate trade contracts. He refused to go without his son. Lenin met with Trotsky and Dzerzhinsky, head of the dreaded Cheka, the secret police, to decide the issue. Lenin convinced Dzerzhinsky to permit Simon Liberman to take his son to London. Simon returned to Moscow with the signed contracts and an open line of credit at Lloyd's bank for the new revolutionary government. He left his nine-year-old son with the Leonid Krassin family in London. For three years, Alexander lived with the Krassins

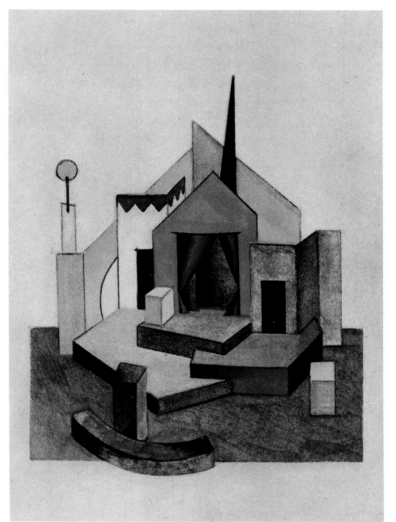

**10**

*Seeing sets in the theater from the inside impressed me. For a boy who's about, what, four feet tall, to see twenty- or thirty-foot high stage props must have created a sense of grand scale. And then, of course, Russia had monuments. I still remember going to the Kremlin, I remember the Cathedral of St. Basil with its extraordinary enrichment of turrets and towers and bulbs, and the great cannon in the Kremlin. I remember looking at this enormous cylinder, of iron, I suppose, and the gigantic cannon balls. These memories are indelible.*

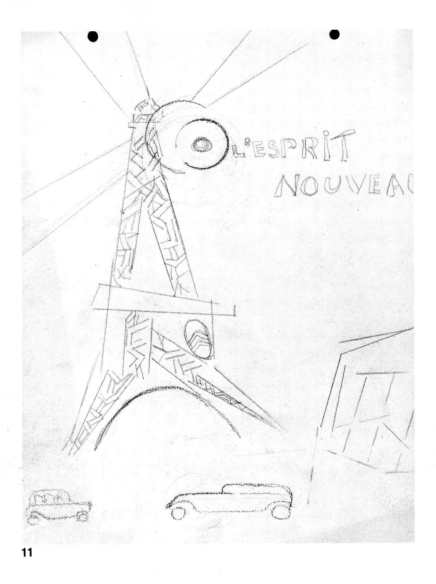

**11**

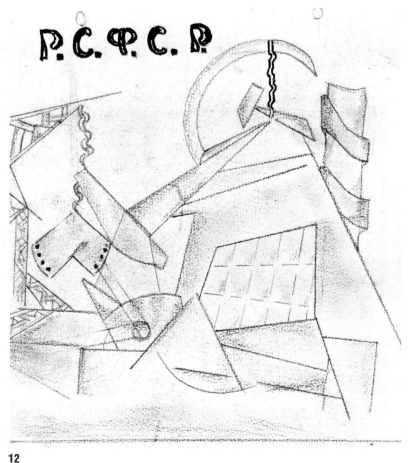

**12**

and their four daughters. He was sent to English schools, where he was soundly beaten until he learned the discipline and self-control he lacked. "They stop beating you," he recalls, "when you stop crying. If you cry, they beat you twice as hard." This experience gave him a stoical reserve that remains part of his character. When he was ten, he was sent to St. Pirans, an exclusive boarding school in Maidenhead, where a classmate was Anthony West, the son of Rebecca West and H. G. Wells.

Liberman describes the three years he was separated from his parents as "pure Dickens," a time when, by way of the beatings, he learned to read, write, and speak English properly. Although he is now completely fluent in English, French, and Russian, his handwriting has been a special problem; only recently has he felt free enough to write cursive script instead of the straight vertical calligraphy he was forced to acquire. This freedom is reflected in his most recent impastoed paintings and cut-out sculptures.

The Cheka had closed Henriette Pascar's theater because she refused to change a line in *Treasure Island* from "Hoist the Union Jack and God save the King" to "Long Live the Soviet Socialist Republic." In 1924, she and her husband left Russia on official business. In London, Liberman, now the director of the North Timber Trust, received a telegram commanding him to return to the Soviet Union. He was warned by friends that the plan was to liquidate him as a symbol that the Mensheviks had been purged. In his memoir, Simon Liberman described his decision to return to Moscow: "It was my duty to my family, to my son, to go back to the Soviet Union and defend myself against slander." During the winter of 1925-26, Liberman prepared a one-hundred-and-fifty-page dossier of his eight years of service to the Soviets. Lenin was dead. Every night he was interrogated and threatened. He slept with a razor under his pillow, sure that the Cheka would come for him. In January, 1926, he was told he could leave the Soviet Union. His nerves were shattered, and he spent the rest of the year in a Swiss sanitorium.

11. Poster project, Paris, 1925
Pencil

12. Study for poster, 1925
Pencil

13-15. Three abstractions, Paris, 1925
Gouache

I suppose one of the most important events in my life was the exhibition "Arts Décoratifs," in Paris in 1925. I had arrived in Paris in '24, so in 1925 this extraordinary exhibition in the center of Paris brought to me the first strong impact of modernism. The two special buildings were the Pavilion of the Soviet Union, designed by Melnikov. Its futuristic forms, structures, and shapes made an incredible impression on me, as I recall now. If you look at some of my drawings of that period, you will see that all the mannerisms of modern art came to me from that exhibition.

14

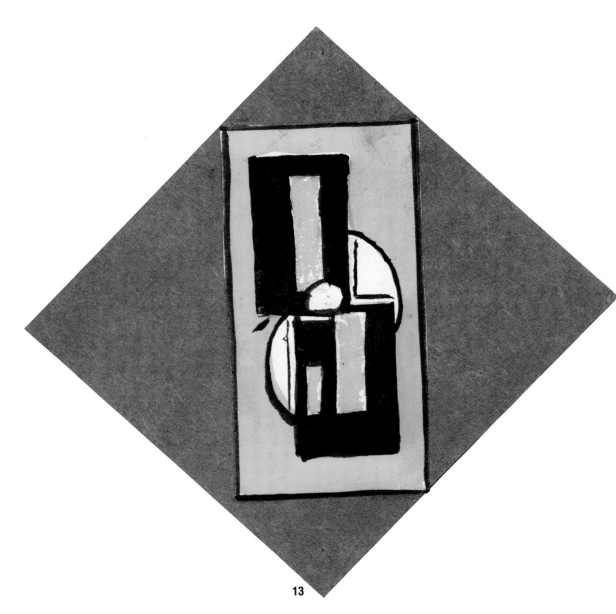

13

15

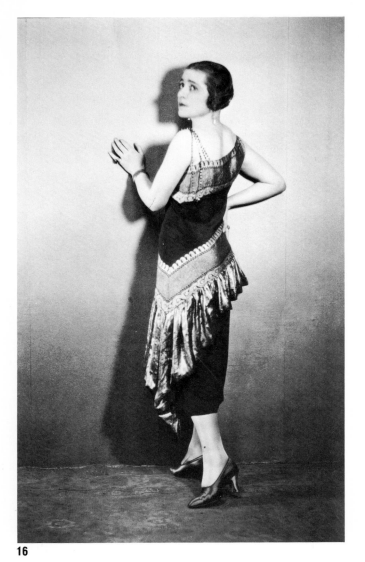

16

17

18

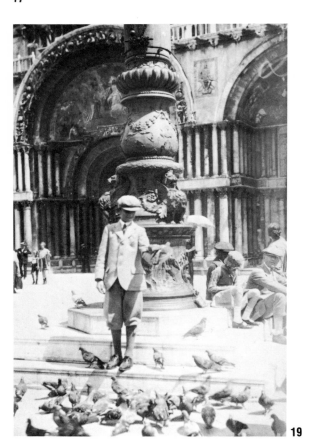

19

**20**

*My mother's tremendous striving to improve the conditions of children, to bring visual poetry to children, her belief in art, her belief in the beauty of decor, her belief in music impressed me. I remember especially* Don Quixote *was one of the first great books that she bought for me.*

**21**

By this time, Henriette Pascar had started a new theater in Paris. During the summer, she traveled to France and Italy with her son, who was taken on museum tours wherever they went. (*19*) She gave him books as presents and convinced him to read the classics. Simon Liberman had returned to London to join the great timber firm of Churchill and Sim. In Paris, his wife, who had never been political, entertained the Russian refugee artists in exile. Liberman recalls as a teenager meeting Exter, Gontcharova, and Larionov, as well as Léger and Chagall, among others. Once again, he was sent away to school, this time to the aristocratic Ecole des Roches, which had never before admitted a Jew.

Alexander had been raised with no formal religious training, although his mother often spoke of the identity of spiritual and aesthetic values, and of art as expressing the realm of the visionary. Thus when Liberman came to know Frank Kupka after World War II, the older artist's mysticism was familiar.

At the Ecole des Roches, Liberman studied Latin, history, ancient and modern literature, mathematics, philosophy, and art. One class that particularly interested him was industrial drafting, at which he excelled, learning basic engineering principles he would apply years later in constructing monumental sculptures. At Ecole des Roches he also worked at a foundry, which was part of the curriculum.

By now his mother had begun to perform herself. The apartment they shared, among the first modern studios built in Paris (*18*), on the rue Schoelcher, near the Cimetière Montparnasse, was full of Henriette Pascar's exotic costumes and masks. (*23*) Her wardrobe was designed by Poiret and Lanvin. (*16*) When she performed at the Théâtre des Champs-Elysées, she commissioned Bronislava Nijinska to stage her dances, Chagall to design her sets, and Milhaud to compose her music. Her son designed the posters. (*26*)

16. The artist's mother in a Poiret dress, Paris, 1925

17. Imaginary drawing, 1927
   Pencil and watercolor

18. Apartment-studio, rue Schoelcher, Paris, 1924
   Pencil

19. Liberman, first trip to Venice, 1924

20. With his mother, Baden-Baden, c. 1925

21. Imaginary architecture, 1926
   Pencil

22

23

24

25

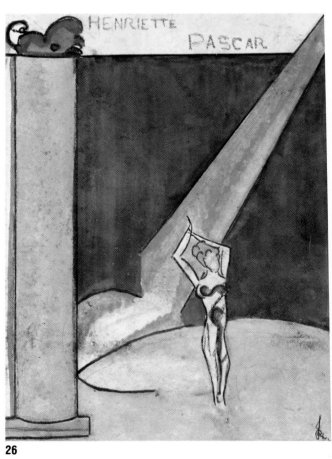

26

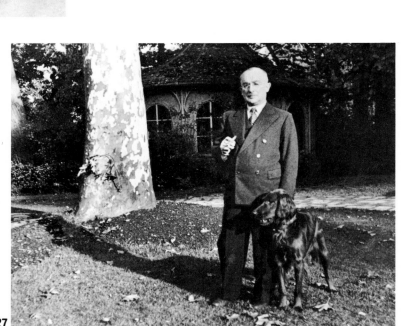

27

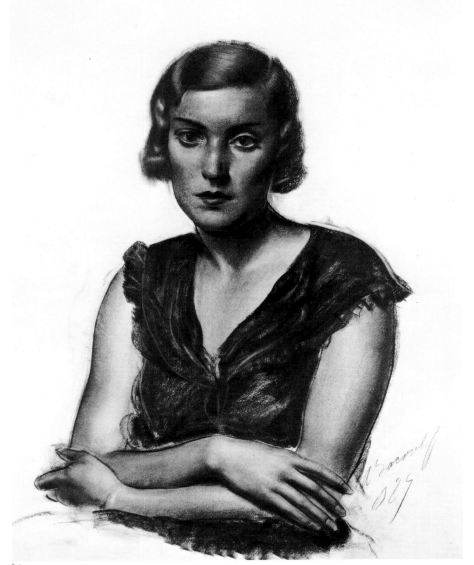

*I never finished my degree in architecture, but I think that through architecture, through geometry, which is very basic and primitive in my case, one acquires an instinctive structural logic. With modern means and modern engineering . . . everything that's impossible can be made possible.*

*Our training in Europe, especially in architecture schools, was involved with columns. You always had to study the antique. The antique was Greece or Rome, especially Rome. You were always given as a theme: build an entrance to a cemetery or build a temple for something or other, and you spent your time drawing columns. And, of course, all French education also has industrial drawing classes.*

**28**

22. Sketches demonstrating
   André Lhote's theory of *passage*, 1931
   Pencil

23. The artist's mother in Chagall costume, 1930

24. Nude, at André Lhote's, 1931
   Pencil

25. Study of Beaux-Arts architecture, 1931
   Pencil

26. Poster project for mother's theater, 1930
   Watercolor

27. The artist's father, Paris, 1936

28. Alexander Iacovleff
   *Tatiana Iacovleff*, 1929
   Sanguine

29. Alexander Iacovleff
   *Alexander Liberman*, 1929
   Sanguine

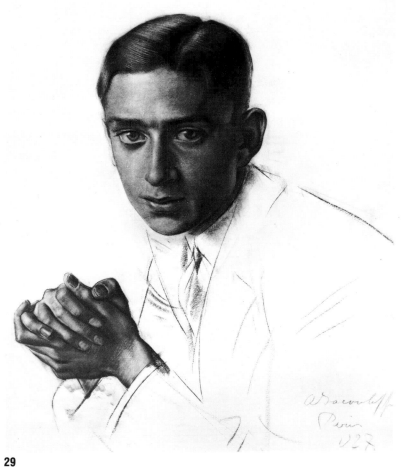

**29**

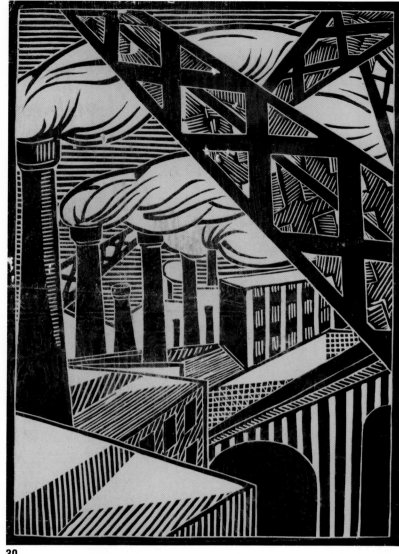

**30**

During his last year at the Ecole des Roches, Liberman had the first of many debilitating attacks of bleeding ulcers, which gave him time to reflect on his life. He was sure he wanted to be an artist but doubtful about art as a living. He was also doubtful of drawing well enough to rival the Russian expatriate Iacovleff, a friend of his mother's and famous for his sanguine chalk portraits. (*28, 29*) Alexander Iacovleff had escaped from Russia through China and had illustrated books on the classical Chinese and Japanese theater. The books were published by Lucien Vogel, who had created the fashionable *Gazette du Bon Ton*, a magazine bought in 1915 by the American publisher Condé Nast; it formed the basis of *Vogue*.

Henriette Pascar's son cared more for his books and for the notebooks he filled with drawings of ideal cities and factories than he did for his mother's fashionable friends. (*32*) Her involvement with artifice was especially repugnant to him, and ultimately it helped to bring about a thorough rejection of illusionism in art later in his life. During this period of the Twenties, he faithfully attended all the great modern art exhibitions in Paris, including the 1925 Exposition des Arts Décoratifs and the great constructivist exhibitions, which inspired a number of his student drawings. (*11, 12*)

In 1930, having passed his baccalaureate at the Sorbonne in philosophy and mathematics, Alexander enrolled in the art school of André Lhote. This painter, who had written a treatise on color based on the scientific theories of Chevreul and Delaunay, was then considered by many the finest teacher of cubism in Paris. Liberman was suspicious, however, of the superficial abstractions from the figure Lhote encouraged (*24*) in contrast to his own experience with the flat, simplified images of the Paris posters created in the Thirties.

*I suppose I have this fascination, from way back, about the industrial image—the excitement of the industrial vision. In some of the childhood drawings, I had a tendency to sketch smoke stacks or gas containers or bridges. Architecture interested me more than painting. The architecture that I was involved in was LeCorbusier's, the early Villa Savoye or seeing in Cahier d'Art reproductions of Le Doux.*

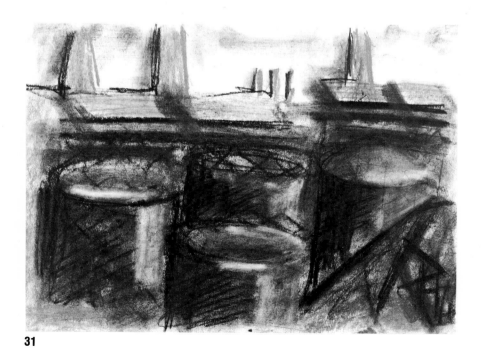

**31**

30. Industrial landscape, 1927
First woodcut

31. Industrial landscape, 1927
Sanguine and charcoal

32. Imaginary industrial landscape, France, 1928
Watercolor and pencil

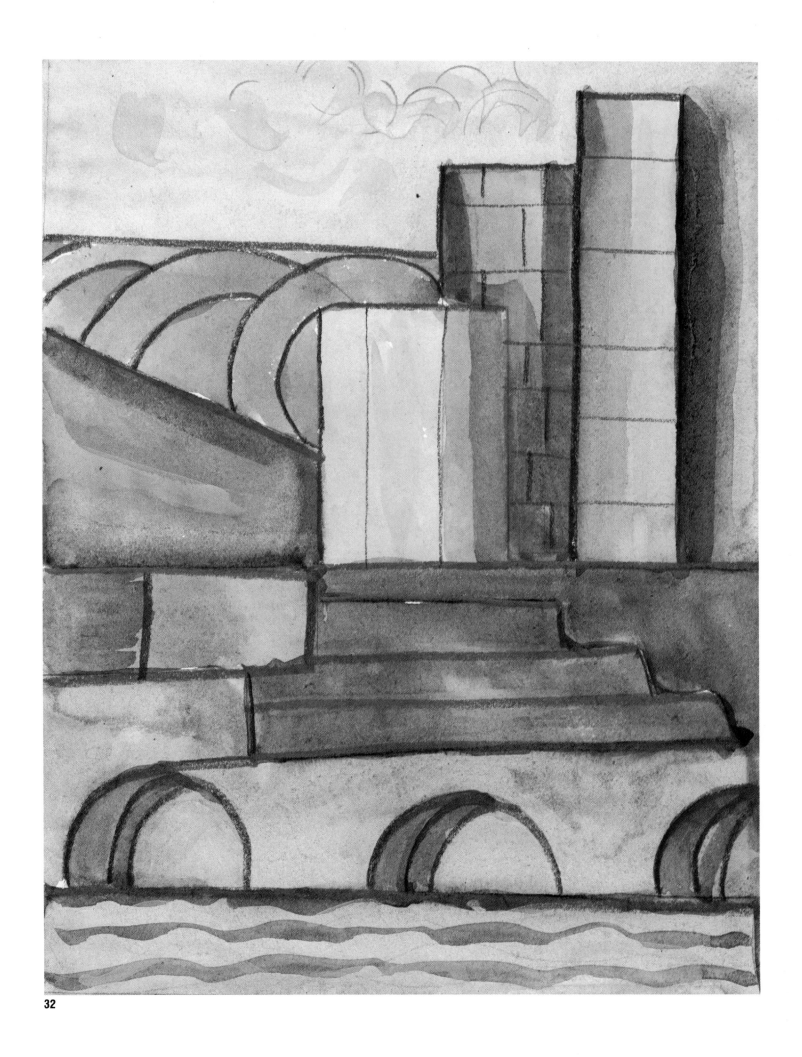

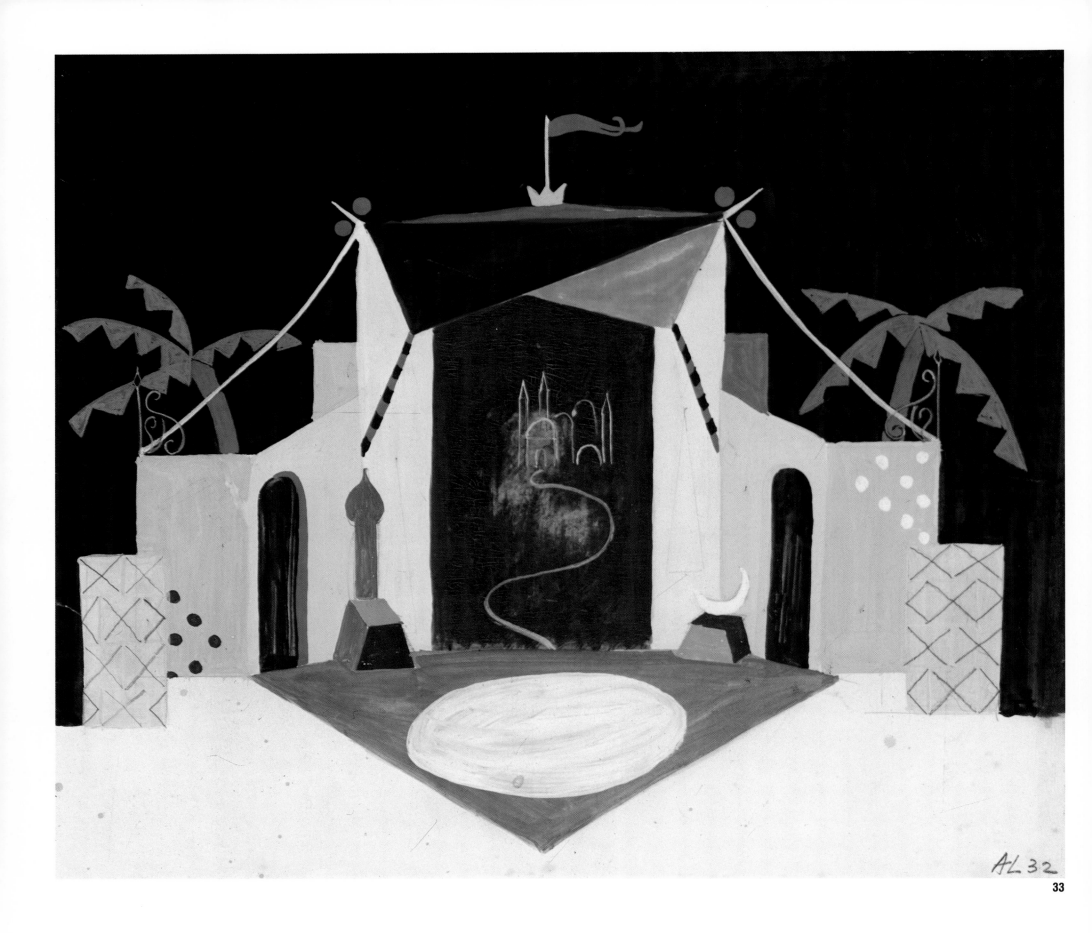

AL 32

33

In my mother's set that I did in '32, the floor is a triangle with a circle in the middle. And I was fascinated, looking at it later that even the door, which is sort of a mock door, has a phallic quality. I've always felt that Muslim or Arab doors were really basic phallic symbols.

These were, in fact, more stylistically advanced than Lhote's abstractions from reality, which were based on sculptural modeling and conventional chiaroscuro. (22)

In 1931, feeling that Lhote was not the answer, Liberman enrolled at the Ecole Spéciale d'Architecture to study with Auguste Perret, who had forecast the International Style and who pioneered poured-concrete construction. Liberman found Perret's ideas regarding a geometric modern style in architecture far more radical and congenial than Lhote's academic modernism, and he had already done a number of drawings of buildings in the *style moderne*. (21) Perret was particularly impressed with Liberman's design for a monumental park stairway project and encouraged him to continue in his studies. However, Simon Liberman had been hard hit by the Crash, and to support his mother, Alexander had to find a variety of jobs. He worked for the great poster designer Cassandre after morning classes at the Ecole Spéciale with Perret. His double life—as a serious artist and as a freelance designer who supported the artist—had begun.

After three months, Cassandre told Liberman he was too talented for the mechanical work he was doing, and that he should find something more suitable. Liberman now decided to pursue architecture in part as a preparation for painting. He passed the demanding examination for admission to the oldest and most academic branch of the Ecole des Beaux-Arts, the Atelier Defrasse. Soon he became *chef cochon*, the "head of the new kids," as he describes it. At the Beaux-Arts, students were required not only to design public projects (as they were at Perret's), but also to design them in a suitably neoclassical style. To prepare for this, they copied antique orders and architecture. (25)

To earn money to live, Liberman designed abstract ornaments for book bindings. At this time he also started to work for *Vu*, which Iacovleff's patron, Lucien Vogel, had founded in 1928. It was the first illustrated photo news magazine, the model for *Life*. He also designed books, newspapers, and window displays and by 1934 was writing film reviews under the pseudonym Jean Orbay. But while he created advanced photomontage covers for *Vu* in a style that recalls Rodchenko's constructivist posters, he continued to paint and draw realistic landscapes and portraits. (34, 35, 37)

When the Depression had receded, Simon Liberman prospered again, and once again he offered his son the possibility of painting full-time. In 1936 Alexander married a beautiful German ski champion, Hilda Sturm, and Simon bought him a villa in the south of France where he was to practice his art. Liberman was, he describes, "madly happy." His days were a delight: "I would go off at 7 a.m. like Cézanne—I adored Cézanne even then—and go through the woods with my portable easel as I imagined Cézanne

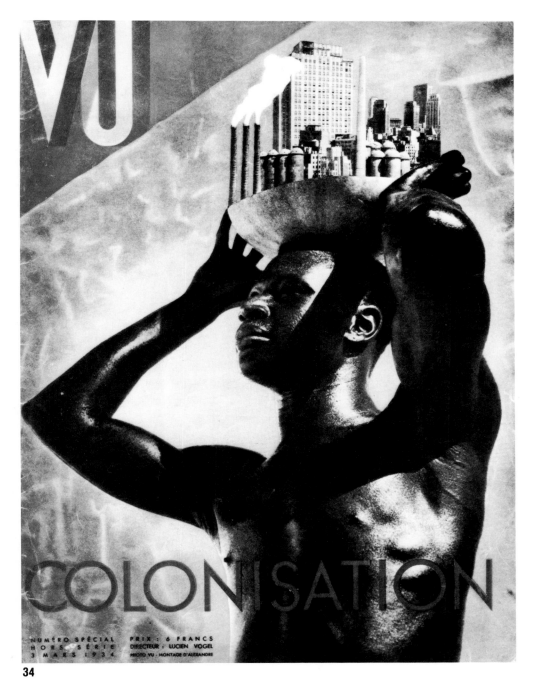

**34**

33. Set for "L'Ours et le Pacha" by Scribe, Paris, 1932
Gouache

34. Cover design for *Vu* magazine, 1934
Photomontage
Original now lost

35

36

had done." He painted his wife, his mother-in-law, anyone who would sit for him, as well as the countryside. His new wife eventually grew bored with his artist's life, however, and divorced him.

At about this time, his mother's friend Iacovleff died. Liberman had known Iacovleff's niece, Tatiana, as a child. She had been the inspiration of some of Mayakovsky's last poems. She wrote Liberman to ask if he wished to buy Iacovleff's art library. Tatiana, who was also the niece of Stanislavsky, was a tall, striking White Russian. She had survived the Revolution by reciting poetry to soldiers in exchange for bread. (28) After escaping to Paris, she had become part of the milieu of Diaghilev and Prokofiev, and married the dashing Comte Bertrand du Plessix.

Tatiana encouraged Liberman to paint. Her favorite artist was Vermeer, whom he now tried in vain to imitate in academic portraits. This effort was reinforced by a generally conservative tendency in French art at a time when painters like Derain were also looking back to the old masters.

In 1940 the Germans invaded France. The Comte du Plessix was killed flying to join De Gaulle in England. Liberman had wished to join the French Army but was turned down because of his history of ulcers. After the German invasion, everyone was mobilized. Liberman joined his unit at La Rochelle, only to be told there would be no battle; the French had already capitulated. His father had left for America, Tatiana's husband was lost in action, and Liberman felt responsible to get her and her ten-year-old daughter, Francine, to safety.

Escaping to the south with his mother, he was halted by the gendarmes, who said no one was permitted to leave. He circled around and drove back to the same guard, persuading him he had a legitimate destination. He describes the experience as an epiphany: "I learned that in life one has to push a little harder and not take no for an answer." This became a secret motto, enabling him to overcome many obstacles later in life.

35. *Yellow Boy*, 1937
    Oil on canvas, 25 x 21 in.

36. *View from Studio, Villa Montmorency*, 1938
    Oil on canvas, 25 x 21 in.

37. *Self-portrait*, 1936
    Oil on canvas, 24 x 19¾ in.

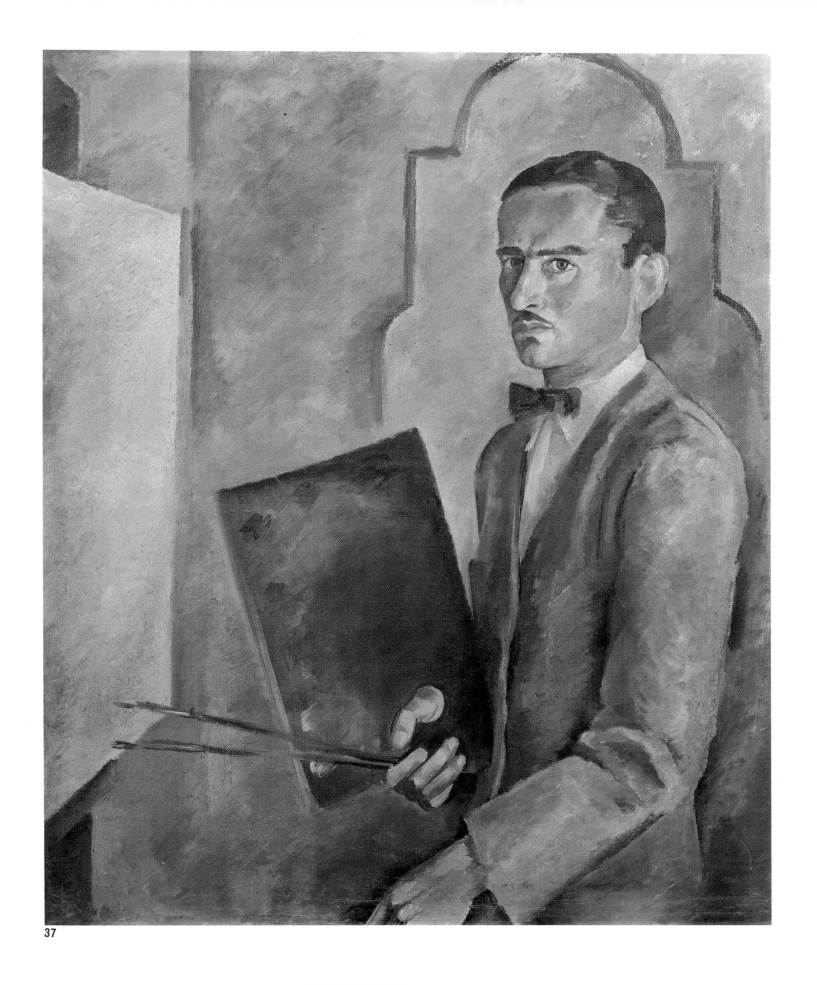

37

There's a Russian saying that chance is noble—perhaps I was brought up with this feeling. Somewhere all the romantic figures in literature have always been involved in chance—from Dostoevsky to Balzac. I think chance is the ultimate insecurity, because you're constantly groping. It's like relying on dice, hoping the dice will make you win.

# CHAPTER

# II

## EXILES ARRIVE

*The survival of human beings is astounding. Maybe artists are sent to be the living optimists, and maybe they have to do what they do just for that reason. In the long run, art is energy, and any art is communication of energy. The communication of energy is the great risk of the artist.*

*There's lots of time in 30 years. Actually no one can paint fulltime. You would go mad. It's the thinking about it that's important. The actual execution is quite rapid after you know what you want to do.*

*The French have this awful saying that you have to be stupid to be a good painter: "Il faut être bête pour être un bon peintre." To a certain extent it seems ridiculous and wrong for a contemporary creative life, but there's a grain of truth in it. Illnesses are the most constructive things in life because when you lie and you are close to death, you really evaluate things. What are purposes? What are functions? What is life about? Once you have decided, I think one just tries to carry on.*

*Serious art is against convention. I think convention is a rule to discipline people to live attractively together, and art has nothing to do with that. Art is a breaking of conventions, of barriers because it's a search to stimulate deeper yearnings that would upset society. Serious artists or thinkers or religious leaders have been persecuted for this reason.*

*One must be the prince of one's own art. The pope gave Michelangelo a whole ceiling, but that's over. Who was there to give us anything to execute on a grand scale? I remember Newman and Pollock talking about doing billboards—something that had scale and would involve an experience beyond the confines of the studio.*

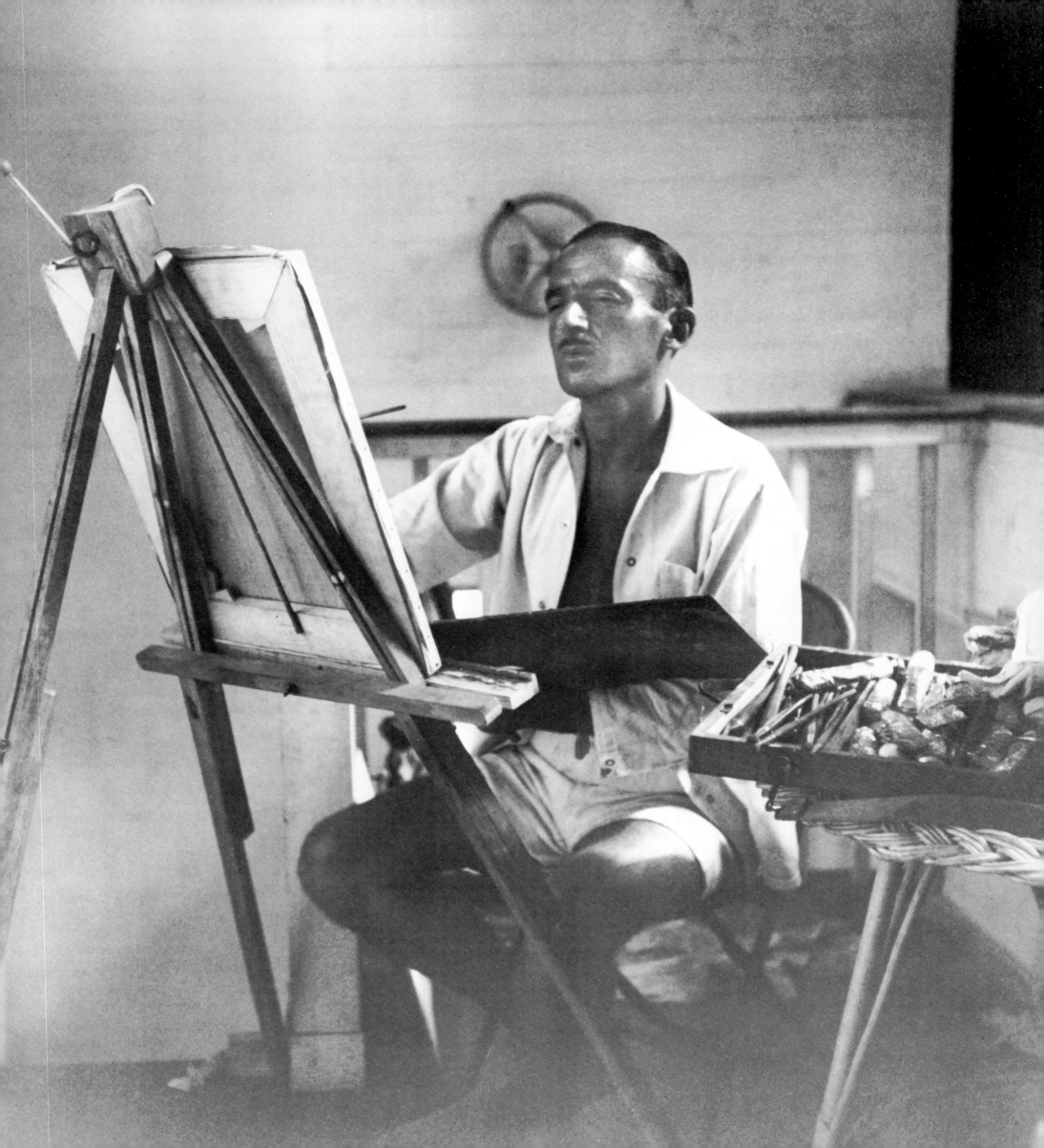

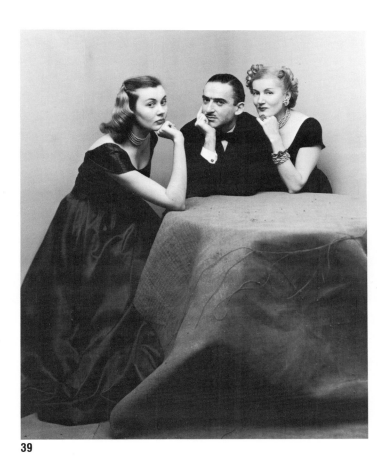

**39**

Escaping through Spain and Portugal, Liberman arrived with Tatiana and Francine in New York early in 1941. They had very little money. Fortunately, Lucien Vogel was now working for Condé Nast. Vogel spoke no English, so he was delighted to hear that the former *Vu* designer had arrived in New York and he convinced Condé Nast to hire Liberman at $50 a week. The art director, Dr. Agha, did not think Liberman was talented enough for *Vogue* and promptly fired him. Condé Nast rehired him, however, when he saw the gold medal for design Liberman won at the 1937 Exposition Internationale, one of the few possessions brought from Paris. In 1943 he became art director and in 1962 accepted the position of editorial director of all Condé Nast publications. (*45*)

Through his mother, who had already settled in New York, Liberman met the visionary architect, Frederick Kiesler, and he also saw Léger and Chagall once more. Quietly, he began commissioning artists he admired, like Marcel Duchamp and Joseph Cornell, to do illustrations for *Vogue*. In 1942 he and Tatiana, who supplemented their income by designing hats, were married and moved into the Manhattan townhouse where they still live. But art had to take a back seat while the war continued and until the chaos of life in a new country could be resolved. During the early Forties, Liberman stopped painting except for completing a few small family portraits. (*44*) However, he continued to read books on art and aesthetics and to see exhibitions, especially at Art of This Century, the avant-garde gallery Kiesler designed for heiress Peggy Guggenheim. He also visited the Betty Parsons and Sidney Janis galleries, as well as shows at The Museum of Modern Art and The Museum of Non-Objective Art, as the Guggenheim was then known. Liberman was very impressed by Kiesler's willingness to experiment and by the freewheeling daring of the artists Peggy Guggenheim showed. He particularly admired Jackson Pollock's audacity. In 1942 he bought a Pollock drawing at an auction for British War Relief for $150—to the laughter of the audience!

Once the war was over, and life began to take a steady course, there was time again for art. During the summer of 1946, the Libermans took a house in St. James, Long Island, and Liberman began to paint again. The following summer, he painted landscapes in a vigorous postimpressionist style quite unlike the academic portraits he had been doing earlier. (*46*) Experimenting with a freer, more expressionist style, he painted portraits of Francine (*51*) as well as a heavily impastoed Cézannesque self-portrait. (*48*) He also began to take regular trips to Venice during the summer. These inspired a series of high-color postimpressionist paintings beginning with canal scenes reminiscent of the landscapes of Nicolas de Staël, the leading postwar School of Paris painter. (*58*)

---

*Tatiana was enormously influential. With her Russian background and no formal education, she cuts through the conventions of European civilization. Her favorite artist has always been Douanier Rousseau. Her unconventional attitude helped me dare to build my primitive cathedrals. But you have to have a point of departure—all art has a point of departure in other art. Nothing starts in a vacuum. One just has to admit that the idea, "my genius created this strange thing," is false. It just doesn't work like that.*

---

38. Liberman at Stony Brook,
   Long Island studio, by Irving Penn, 1944

39. Liberman with Francine and Tatiana,
   photographed by Irving Penn, 1947

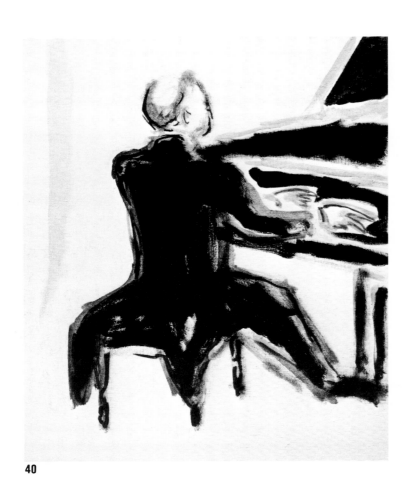

**40**

**41**

**42**

**43**

During the late Forties, Liberman experimented with a variety of different styles in attempts to break through to an original and personal statement. Series of paintings of the same subject in different postimpressionist styles show Liberman working through his "admiration" for the artists he considered the greatest masters: Cézanne, Braque, Monet, van Gogh, Seurat, Picasso, and Matisse. He was fond of quoting Matisse's saying that an artist had to be strong enough to imitate the great masters. In a series of paintings of the church of Santa Maria della Salute, painted in Venice during the summers of 1947-49, he paid homage to the founders of modernism. (54, 55, 56, 57) A series of paintings of floral arrangements refer to Seurat's allover patches of scintillating color, to Rouault's drawing in paint, and to Matisse's brilliant decorative patterning. (52, 53) Among the last of the floral series is a painting in which separate blobs of color, apparently squeezed directly from the tube onto the canvas, point forward to an abstract style based on flat balls or chips of color floating on a field. (52)

In 1947, working to find and secure his artistic identity, Liberman began a thirteen-year project that culminated in a series of celebrated photographs of artists in their studios. Returning to Europe, the source of modern art, he tracked down the great masters who were still alive, like Picasso, Kupka, Braque, and Matisse. And he visited the studios, for the most part still intact after the war, of dead titans like Cézanne, Monet, and Kandinsky. The procedure was so much like a religious pilgrimage that the photographs of the artists' studios appear as shrines documenting sacred arts. In the introduction to the book of these photographs, *The Artist in His Studio*, ultimately published in 1960, Liberman confessed his belief in the "religion of art." His dedication to a cult of art-for-art's-sake is not surprising, since this was the religion his mother preached all her life.

Photographing the modern masters, Liberman refined his conception of how the great artist works. Seeing how their

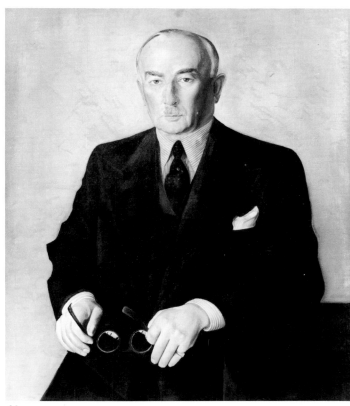

44

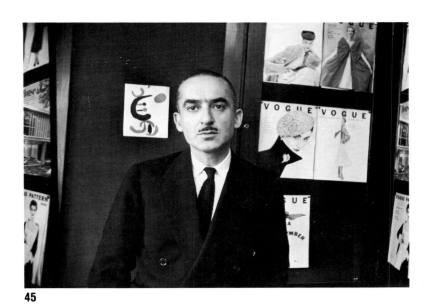

45

40. *Artur Rubinstein*, 1948
   Oil on canvas, 24 x 20 in.

41. *The Piano*, 1948
   Oil on canvas, 40 x 30 in.
   Collection Mr. and Mrs. Charles Zadok

42. *Horowitz, Carnegie Hall*, 1948
   Ink on paper

43. *The Piano*, 1948
   Oil on canvas, 20 x 24 in.

44. *My Father*, 1942
   Oil on canvas, 30 x 25 in.

45. Liberman in *Vogue* office
   at Condé Nast, New York, 1948

studios operated gave him insight into a world of serious art and the making of it. The experience of photographing the masters of the School of Paris at work provided him with the role models that his own background as the son of a powerful businessman and a dilettante Bohemian did not. In Tatiana, he had found both an aristocratic beauty and a forceful, spirited woman, more profoundly and genuinely cultured than his mother. Tatiana, who can still recite classic Russian poetry by heart, loved theater and ballet, but her real passions were music and literature. A voracious reader in Russian and French, she also introduced Liberman to classical music and opera. In their home, as pristine white as Liberman's nursery in Moscow had been, she created a beautiful and charming atmosphere of warmth and order. (50) Briefly, Liberman worked in a spare room in their house. As soon as it was financially feasible, he took a studio (in a former funeral parlor). There he would eventually express the unruly and undisciplined side of his nature, which needed freedom to experiment with the chaos and disorder necessary to innovation. (47)

Tatiana's beauty, courage, unconventional character, and *joie de vivre* inspired Liberman as they had Mayakovsky. She was the antidote to his own tendency to become introspective and withdrawn, and she was the center of a rich social life and a magnet for the Russian artists in exile. Through Prokofiev she knew Balanchine, and she also knew many musicians and writers. The Libermans regularly went to concerts, where Liberman sketched the musicians. (40, 43) A series of pianists, apparently based on sketches he had done of Vladimir Horowitz and Artur Rubinstein playing, are, like the Venice views and the floral still lifes, experiments with a variety of styles. Some imitate Matisse's transparent color planes (41), others are more Picassoid. (43) Some reflect the dark, brooding influence of Munch. (49) Later,

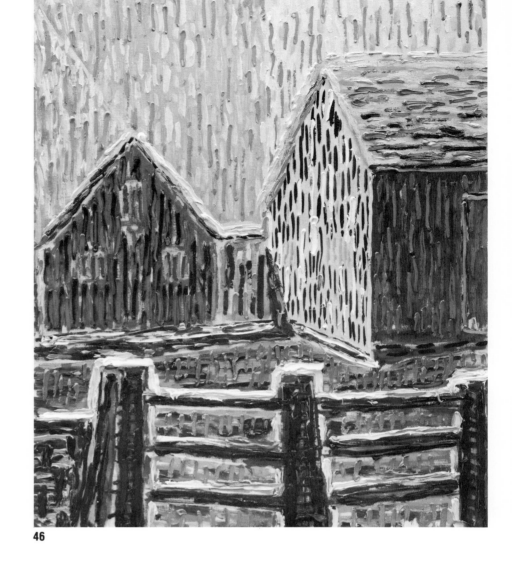

46

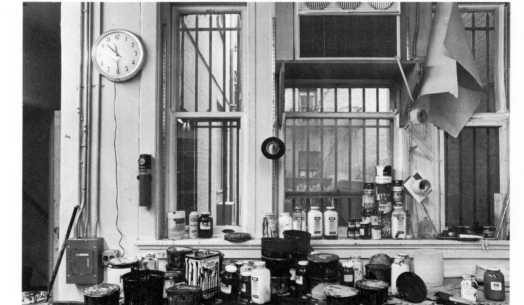

47

46. *Barns, Litchfield*, 1947
    Oil on canvas, 30 x 25 in.

47. Detail, studio at 132 East 70th Street, New York, 1959

48. *Self-portrait*, 1948
    Oil on canvas, 30 x 25 in.

49. *The Piano*, 1948
    Oil on canvas, 28 x 34 in.

50. Livingroom, 173 East 70th Street, New York, 1949

51. *Portrait of Francine*, 1948
    Oil on canvas, 16 x 12 in.

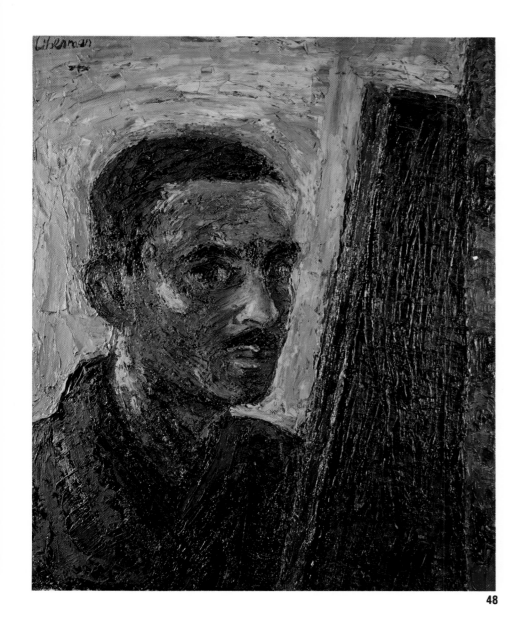

**48**

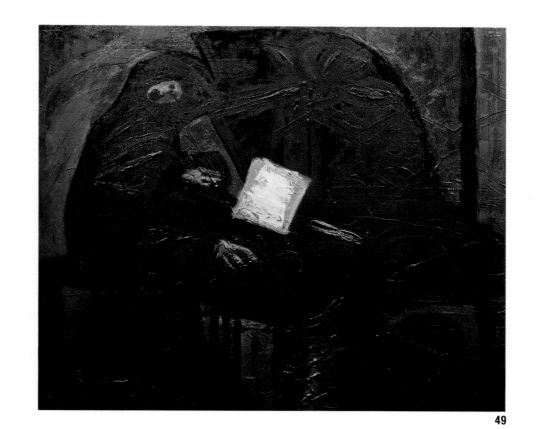

**49**

**51**

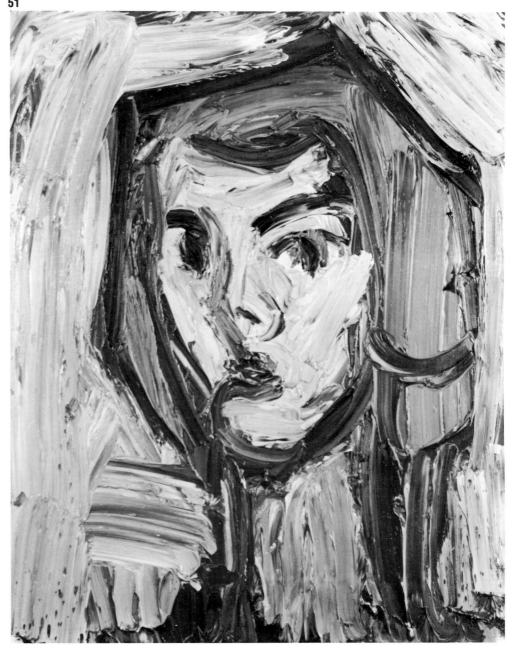

**50**

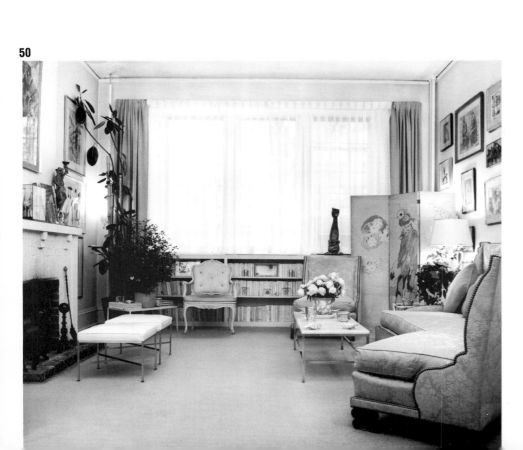

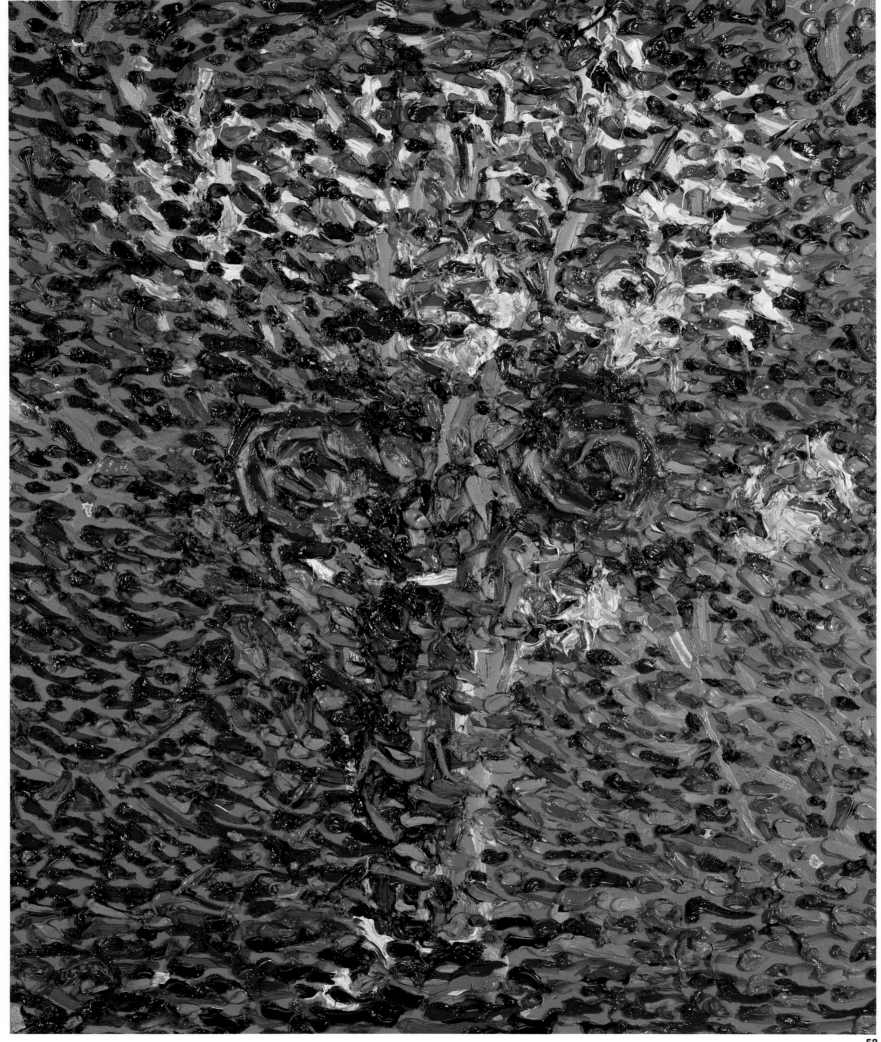

in his mature painting, Liberman would oscillate between the stylistic polarities of the brilliant color-field and the darkly expressionistic.

At this time, however, his primary concern was to free himself from the "admirations" he had worked through. His objective now was a *tabula rasa*. For the first time since his father spirited him out of Russia as a boy, he had a real passport. (He had become an American citizen in 1946.) He wanted a fresh start in his new country, which he thought of as a haven of freedom and of the kind of industrial productivity and progress his father had preached. To create art that was clean and clear of history, art with a new beginning, symbolized to him at the time the qualities of his new life in America. He admired the American Abstract Expressionists. Ironically, however, he thought their involvement with painterly painting was old-fashioned and European. They were antitheoretical, whereas he was concerned with a theoretical search for a style of antipainting that broke totally with the past, a style that was really *American*. He also disliked the autobiographical impulse of abstract expressionism, believing, at the time, that "the ego was hateful, the hand of the artist should not be seen." Later he would entirely reverse this opinion. He admired Mondrian, whose works were widely exhibited in the Forties. Yet he was critical of Mondrian's constant revisions. He felt they made the painting look relative, not absolute. He disliked the wavering edges of Mondrian's black bands and color planes. To Liberman, they looked too obviously handmade, too deliberately "sensitive" in a way he found—in his dedication to becoming a real American—too European. Mondrian looked old-fashioned to Liberman, who was searching for an identity as an American artist in a style that would always look "brand new."

The late Forties was a period of incubation for Liberman. He experimented in various styles and read books like Gyorgy Kepes's *Vision in Motion* and Charles Biederman's *Art as the Evolution of Visual Knowledge*. Both books lauded photography as the new art of the twentieth century and suggested that painting was in a terminal phase. He wrote and drew in notebooks. He mused on the possibility that painting could be like music or theater, a kind of repeatable performance. He continued his search for a means of transforming the visible world into abstract images that would be thoroughly modern, absolutely radical, and without obvious connections to European art or history.

Liberman was beginning to meet the Abstract Expressionists, such as Pollock, Rothko, and Newman, who showed at Betty Parsons's gallery. He often discussed art with her and respected her not only as a dealer but as an artist. In 1951, he bought his second Pollock drawing—this time from her. He thought the artists she exhibited were great, if unrecognized, modern masters, who should be treated as well as

*Russians always had a certain mystical urge, and also a certain barbaric quality of color. Barbarism expresses itself in violence, or it may express itself in desire for wonderment. I have always been involved in getting the canvas to sparkle—sparkle is a difficult word—to vibrate with light. In the Russian church, the iconostasis and the domes are gold. Russians love things that shine.*

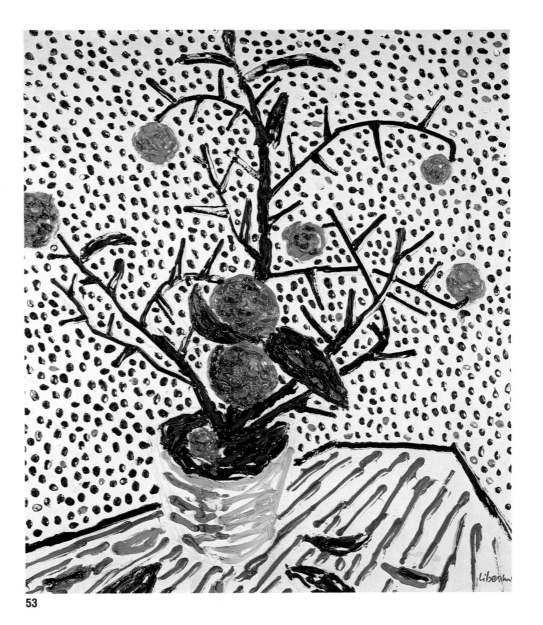

53

52. *Two Roses*, 1948
Oil on canvas, 20 x 24 in.

53. *Orange Tree*, 1948
Oil on canvas, 30 x 25 in.

45

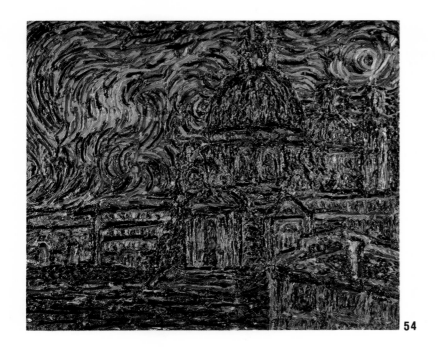

54

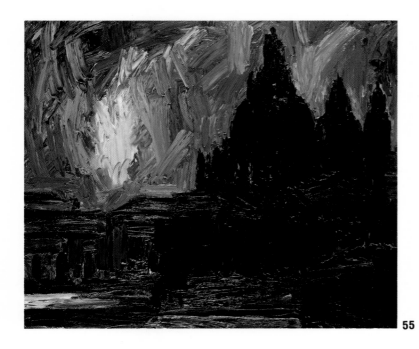

55

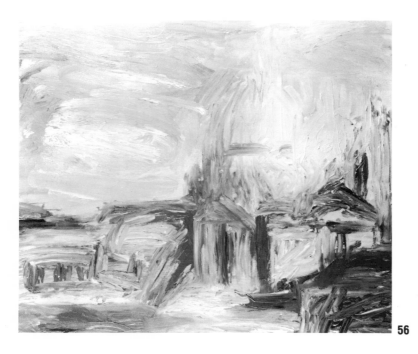

56

Picasso. In this spirit, he organized a lunch at the Café Chambord for the artists who showed with Parsons. He recalls that their conversation was about the possibility of making billboard-size paintings, and that large scale was the issue of the moment. Like the Abstract Expressionists, Liberman found the imagery of surrealism literary and superficial. His reaction was perhaps even more intensely antipathetic, since he spoke their language, shared their culture, and immediately recognized the Surrealists' social aspirations as belonging more to the world of fashion than to the world of art. On the other hand, he was fascinated by the personality and attitudes of Marcel Duchamp.

For Liberman, Duchamp was everything the Surrealists were not: a genuine rebel who preached that art and life were one, but who kept social life and studio life absolutely separate from each other. Liberman was particularly fascinated by Duchamp's idea that art was a form of research, like physics, and an intellectual pursuit like philosophy. In Duchamp, Liberman found the first artist since Cézanne who appeared to break with all the conventions of the past. Liberman felt a natural affinity with Duchamp for many reasons. A Frenchman who preferred New York, Duchamp was a model of disciplined, stoical detachment; he practiced his art privately and did not inflict it on his family and friends. In Duchamp's reticence, his philosophical objectivity, his peculiarly intense rebellion against the past, and his identification of taste and personal expression as the greatest enemies of art, Liberman found a kindred soul.

When Tatiana's daughter, Francine du Plessix, left to study at Black Mountain College in 1949, Liberman also came into contact indirectly with John Cage, Merce Cunningham, Robert Rauschenberg, and others teaching at the college who had been influenced by Duchamp's ideas regarding chance and the importance of reproduction in changing the perception of art in our time. The reproductive arts had been familiar to Liberman since early childhood, when his father brought him back a vest-pocket camera from England. He had always been a photographer. From the days he worked on *Vu* with photomontage, he was constantly handling photographs and involved with printing processes. In 1938, with the Louvre staff, he made one of the first color films on art, "La Femme Française dans l'Art," which traced the image of the French woman through the history of French art. Filming art works focused his attention on details rather than on the full canvas. And his work with photo-engravers taught him how images are transformed into a series of dots. One day he began to imagine enlarging, as one might a photograph, sections of a painting he had done in New York. He sectioned off a portion of the painting by framing it with strips of white paper. From this first abstract, pointilliste painting, Liberman isolated several small sections. For sub-

**57**

---

*I looked at my paintings where I had used dots to translate light on the lagunas of Venice. I thought, These dots are really circles. From this infinitely small dot to the infinity of the sun, to Cézanne's apples, there was a sort of amalgam in my mind of circular motifs.*

---

54. *Santa Maria della Salute, Venice*, 1948
    Oil on canvas, 25 x 30 in.

55. *Santa Maria della Salute, Venice*, 1948
    Oil on canvas, 25 x 30 in.

56. *Santa Maria della Salute, Venice*, 1948
    Oil on canvas, 25 x 30 in.

57. *Venice, ''Santa Maria della Salute,''* 1948
    Oil on canvas, 25 x 30 in.

58

sequent paintings, he enlarged these sections. This concept of auto-inspiration led Liberman to use this first abstraction as a matrix for further abstract work. (59)

Liberman's breakthrough to abstraction happened at the same moment that other New York School artists were moving toward the abstract. For example, there is a specific parallel between his blowing up a section of his own paintings and the way Franz Kline in 1950 projected his own drawings until they became so large that they appeared abstract. It is worth remarking that in both cases, the source of an abstract style was not the art of earlier artists, not reality itself, but an enlarged section of the artist's own work. As Liberman began to study the photographic reproduction process, he noticed an affinity between the dots constituting the photographic image and neoimpressionist compositions. Likewise, the "matrix" painting resembles Mondrian's plus-and-minus works. Some of the paintings made from these enlarged details also had oval formats similar to Mondrian's series.

For some time, Liberman had been searching for a way out of cubism. In the course of these experiments with "photographic" enlargement, he found it. Slowly, he began

simplifying the irregular shapes that emerged in the enlargements into ovoid shapes, which appeared to him the logical answer to the straight edge and right angle of cubism. (60, 62) The first of the circle paintings still had elements of impressionism and expressionism, which Liberman excised in his search for the absolute. Some resembled Monet's suns (64); others, deep craters with cosmic overtones that would reassert themselves later in Liberman's career. (65) He rejected these as not sufficiently absolute. His first objective was to rid himself of any historical allusion and any trace of personal expression.

The composition of these works based on the circle was, as later criticism would write of Barnett Newman's banded paintings of the same date, "nonrelational." Liberman did not know Newman at this time. When he saw his first exhibition at Betty Parsons Gallery in 1950, he realized they were waging a similar war on cubism, and that in Mondrian they had a common enemy. During the Fifties, Newman became a close friend and supporter. Both wished to eliminate the internal relationships of analogous forms. These relationships were the basis not only of cubism, which linked the right angle to that of the framing edge, but also of Mondrian's

**59**

58. *Venice, Rialto Bridge*, 1949
   Oil on canvas, 40 x 50 in.

59. *Untitled Abstraction*, 1949
   Oil on canvas, 50 x 40 in.

**60**

**61**

*What is called "original" is very often the tiny tiny drop that is added to something that has been done before. Every artist builds upon the art that has existed before. Originality is very often an accretion to the ongoing flow of art. That accretion can very often be of a different racial or cultural background that changes the direction of the mainstream of art. There is no such a thing as creation from nothing at all. Everything is a refinement, and a small contribution is enough to make originality. Cézanne said, "I'm one on a long road, others will come." I think every artist should feel that way.*

**62**

60. *Untitled*, 1949
    Oil on canvas, 40 x 50 in.

61. *Untitled Abstraction* (1949)
    (see plate 59)

62. *Untitled*, 1949
    Oil on canvas, 40 x 50 in.

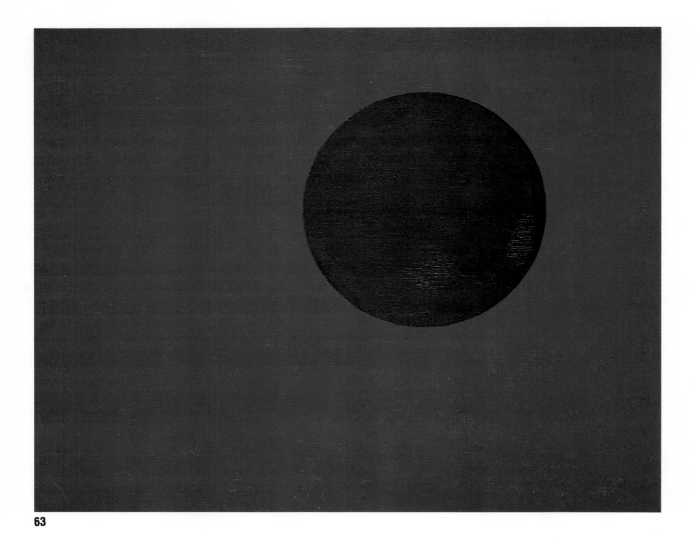

63. *Untitled*, 1949
   Oil on canvas, 30 x 40 in.

64. *Untitled*, 1949
   Mixed media on masonite,
   14¾ x 23¾ in.

65. *Untitled*, 1949
   Mixed media on masonite,
   14¾ x 23¾ in.

purer neoplastic version of cubism as well. Looking at American art around 1950, we note that Liberman and Newman were both seeking radical means to annihilate the relational composition on which cubist design was based. They did this by treating the surface as a field to be divided, rather than as a space to be filled up with many small forms.

Like Rothko and Still, whom Liberman also admired, Newman was a color-field painter interested in the resonance of color as light. At this stage, however, Liberman felt the need to reject color absolutely because he wanted to create images that had the directness and impact of posters, signs, and signals. Perhaps because he knew it so well, he reacted against the European tradition of the *petit frisson*—the delicate painterly passages of cubism, as well as against the sculptural modeling that he had detested since Lhote forced him to shade forms with cubist *passage*. He felt he had to reject the spectrum and use only primary colors. Liberman chose to begin his career as an abstract artist with a radical technique as well as with a radical new format of circles floating in a field. He did not paint on canvas anymore, but on masonite or aluminum; and he did not use oils, but commercial high-gloss enamel, which created a hard, reflective

sheen suggesting an industrial surface. His assistant applied paint not with a brush, but with a spray gun. His intention, he recalls, was to make paintings that would always look "brand new" because they could be repainted—an art that was not precious, either aesthetically or literally—since the cheap masonite panels were also a standard industrial material.

Some of the early geometric circle paintings were executed by Liberman himself, but others were done from maquettes he provided an assistant. The idea of long-distance art was suggested by Moholy-Nagy in his celebrated proposal for a painting that could be executed on the basis of the artist's telephoned instructions. Liberman's architectural training pointed to an art executed by others, and his familiarity with scores also focused his interest on work "performed" by others. At the time, Liberman was still suffering from the dreaded ulcer attacks that left him too weak to paint much. He may have felt motivated to find a style that could be executed by others, should he fall ill or even die—something he had reason to fear. In any event, his style changed radically after a stomach operation in 1959 restored his health. From that time on, he never made drawings or maquettes for his paintings, always executing them *alla prima*.

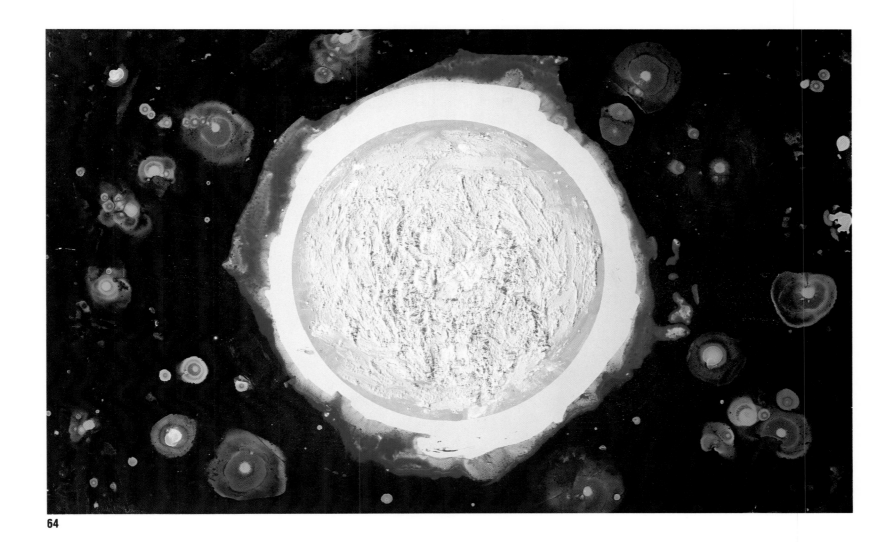

**64**

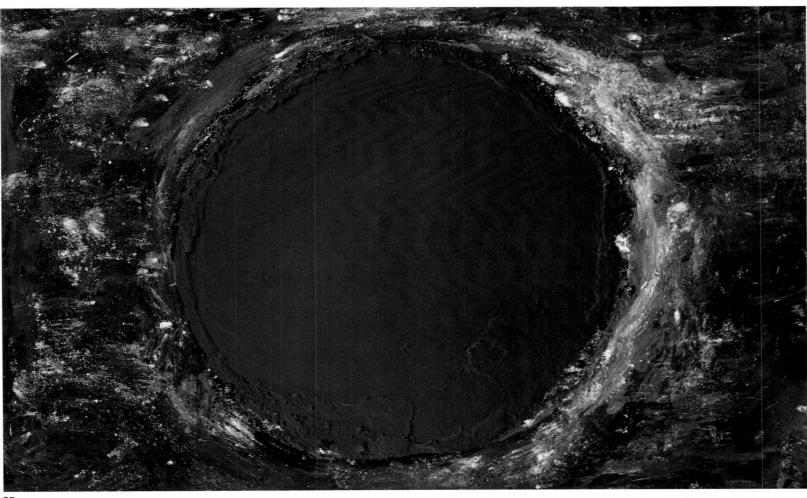

**65**

# CHAPTER

# THE EYE

# THE FIRST CIRCLE

Chronology is not linear. This is what nobody understands. Chronology connects in depth. You connect much later. Chronology also has bypasses that link with other moments.

From the beginning I was interested in the imprinting on the retina. I was trying to get away from the material question of painting—the paint and texture and weight—and get into the essence of the optical image. I believed that in the long run painting had to have its limitation. Painting was painting. It was a square surface. I thought one should work within the discipline and not try to break the discipline. It was my decision to maintain that discipline.

I thought that basically the circle had been overlooked by Western civilization (of course, the Tibetans and other Oriental civilizations had been involved with the mandalas), and it was time to use the circle for its eternal cosmic significance. So I plunged into the circle. To avoid composition, which I thought was really an old traditional drawback, one could throw the circle—use chance, but using the circular form practically as a tool and not as an absolute form in itself.

Arp abandoned his absolute hard edge because he found that many works that he did with his wife peeled and cracked. I was very preoccupied with the technical means of art destroying the work: oil paint cracking, surfaces getting destroyed. I tried to create a technical tabula rasa and to stop using canvas, to stop using oil paint, to get into what I thought would be 20th-century means. I thought like music, painting could be reproduced, once one could use a precise system, and that a work could be repeated.

We have to cleanse our mind of the accumulated deposits of art memories. There should be no visual art association. A Circlist painting should, by its apparent simplicity, act with such immediacy that the innermost centers of the mind can be reached without time for hesitation and time for reference to our memory or doubt centers. A Circlist painting should have no mark of personality, such as brushstrokes, so that at no time is the attention of the spectator distracted from the essential by minor accidental details. This essential is the communication of a visual truth. We can define a visual truth as the evocation within the spectator of his highest faculties as a human being by purely visual means.
—Statement for the Museum of Modern Art archives

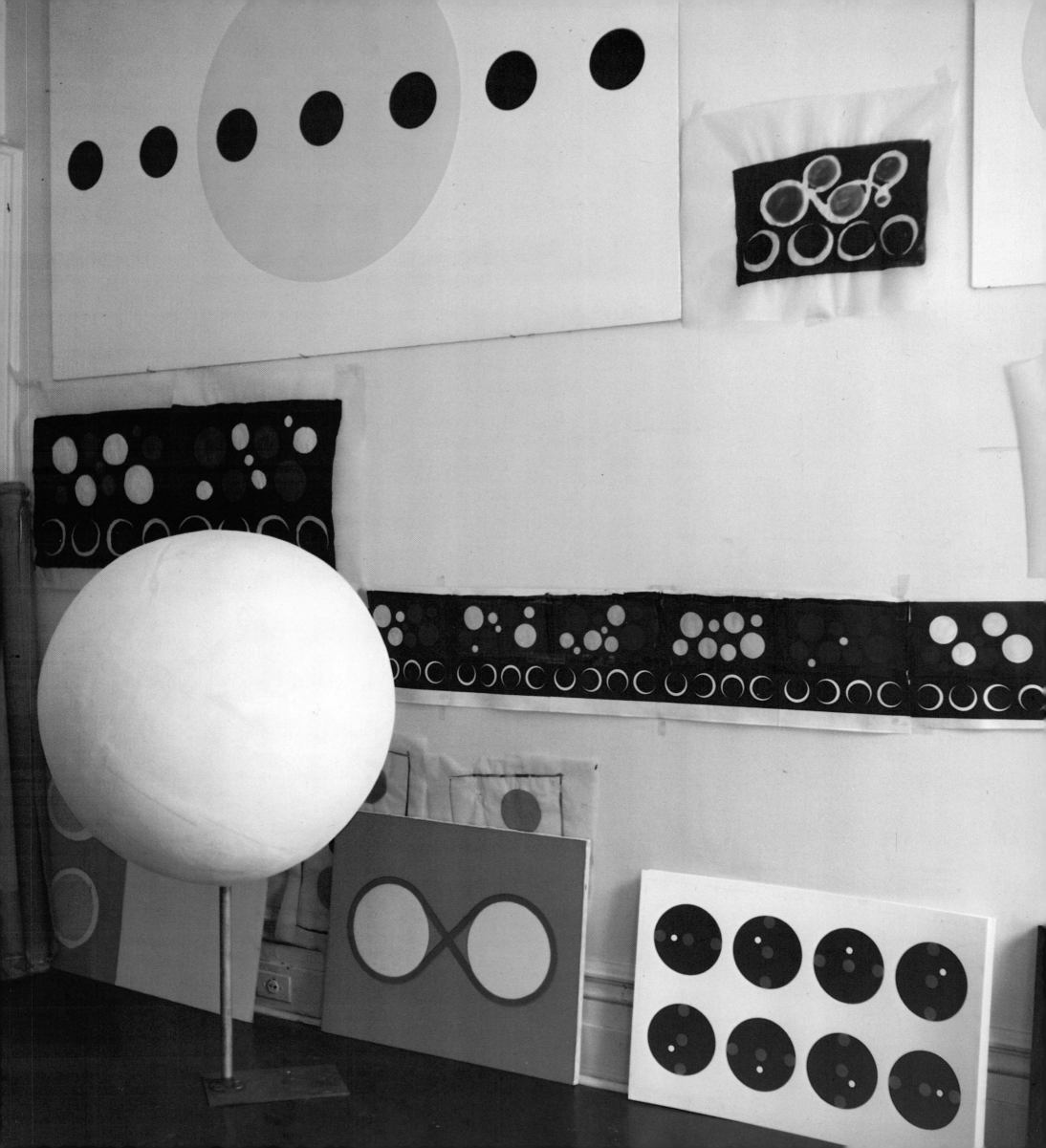

**67**

66. Studio at 173 East 70th Street,
New York, 1953

67. Liberman, 1958

THROUGHOUT THE FIFTIES, when "action painting" was at its height, Liberman was a hard-edge geometric painter. He continued to be interested in intellectual and theoretical matters: the relationship between time and space, music and art, painting and performance. A series of projects for very narrow, horizontally extended paintings was based on musical notation and resembled architectural friezes. The idea was that the clustered dots could be "read" like a score. (88) The image of punched-out circles was actually inspired by a perforated player piano score Liberman had found, and by the new digital tapes he saw reproduced in *Scientific American*, his favorite magazine.

The circle paintings of the early Fifties were painted on standard industrial panels. (69, 72, 73, 74) Many were inspired by ideas concerning performance. Liberman imagined that the individual panels, which together constituted a horizontal painting, could be interchanged to create different permutations. (72) The panels were like stylized Kabuki stage sets, which could be moved around. The title *Sixteen Ways*, for example, refers to the possible number of permutations. (69) Diptychs were supposed to suggest that one circle could cover the other, a physical operation the eye could imaginatively carry out. He liked to think the paintings could be repeated like performances.

Some of the panels were bought already enameled with white refrigerator enamel. Liberman liked the dazzle of the light reflected off the hard surface. He would merely paint circles on the prepainted ground. *Time* (78) was done this way. To make a painting as modern as a new refrigerator was a challenge for a European. In Europe, a refrigerator was the symbol of America. In the middle Fifties, Liberman painted with automobile lacquer for similar reasons. The idea was suggested to him by a passage in a book by Vladimir Nabokov, who ridiculed modern art by describing an artist so terrible he even thought of using automobile paint. Liberman decided automobile lacquer would create paintings that did not have to be protected as precious objects. At this time he also began to use tape to create the hard edge that for him was another way to defeat the precious and the sentimental.

Liberman felt that to have a really solid basis, painting had to be related to science—as a branch of research in optics—as well as to architecture and philosophy. The idea of a conceptual, anonymous style, executed by others, was further supported by his architectural training. The interaction between brain and eye was the point of departure for many of his paintings of the Fifties: in some an image was duplicated in different scales, causing a certain optical confusion (98); in others "tracks" for the eye to follow were created by twisting bands encircling forms. (77) Fascinated by the way the brain took information scanned by the eye and

processed it into intelligible patterns, Liberman thought of his art as "mental gymnastics"—exercises for the brain, or optical workouts. His still fragile physical condition permitted only intellectual excitement.

Liberman was acquainted with the story of how Giotto could draw a perfect "O" freehand. The first circle paintings were drawn freehand. (63) However, his search for the absolute led him back to the compass, a tool he knew well from his architectural studies at the Beaux-Arts. After he decided to pursue the circle motif, Liberman used a compass to draw a perfect circle with an architect's drafting pen, which he loaded with diluted enamel. At the time, he was reading a book on the occult symbolism of the Golden Section, Le Nombre d'Or by Matila Ghyka, which was illustrated with geometric diagrams. It convinced him to paint panels based on the proportions of the Golden Section in works like Sixteen Ways. This book also reinforced his conclusions regarding Cézanne's definition of the cylinder, the sphere, and the cone as the basis of a modern classicism. Cézanne, the precursor of the Cubists, suggested to Liberman that the way out of the cube was through the circle.

Answering a query from The Museum of Modern Art in 1960, Liberman described "Circlism"—his answer to cubism. He explained his challenge to the cubist grid, created by the straight edge of the ruler. He opposed the grid, which inevitably related the right-angled image within the painting to the right angle of the frame, with a system of curves and arcs derived from circles and their sections. (86) In these circle paintings, images do not echo the frame but are centered on a field, which they boldly occupy. The circles tend to be equidistant either from the top and the bottom, or be-tween the sides of the frame. Therefore, without echoing the structure of the frame, they express a stability that is iconic rather than architectonic. This is, as Liberman intended it to be, the opposite of cubist composition. (70)

It was as a philosophy student that Liberman first became acquainted with Pythagorean circle symbolism, and with the neo-Platonic conception of the circle as the sign of the Infinite—the image with neither beginning nor end. Minimum, a painting owned by The Museum of Modern Art, has a special significance in the evolution of Liberman's iconography. Based on the familiar humanistic diagram (illustrated in Le Nombre d'Or) through which the architect Vitruvius contained a man within a circle (68), Minimum conceptualizes infinity as a transparent ring. In Liberman's conception, not man but the cosmos itself is the center, like the circle symbolizing the godhead for neo-Platonists.

One reason Liberman rejected cubism was that its emphasis on the literal and the worldly lacked a cosmic or spiritual dimension. Cubism was typical of the French rationalist opposition to mystical ideas. Totally nonobjective abstract art was the invention, not of the French Cubists, who remained rooted to reality, but of mystical artists like Kandinsky, Malevich, and the Czech painter Frank Kupka, all of whom came from Liberman's native Eastern Europe. Kupka was hardly known in Paris, though he worked there for over forty years. Some of his paintings were shown in New York in the late Forties in a gallery run briefly by the French art dealer Louis Carré. When Liberman returned to Europe after the war to photograph the School of Paris masters, he sought out the aging Kupka. He bought a number of the artist's drawings and gouaches, which still hang in the Libermans'

*I consider the circle the purest, simplest element of visual research. The circle is the common property of the two infinites from the immense sun to the infinitesimal atom. It is no accident that our eyes see through the round iris. But, above all, the circle is the purest symbol because it is instantly visible in its totality.*

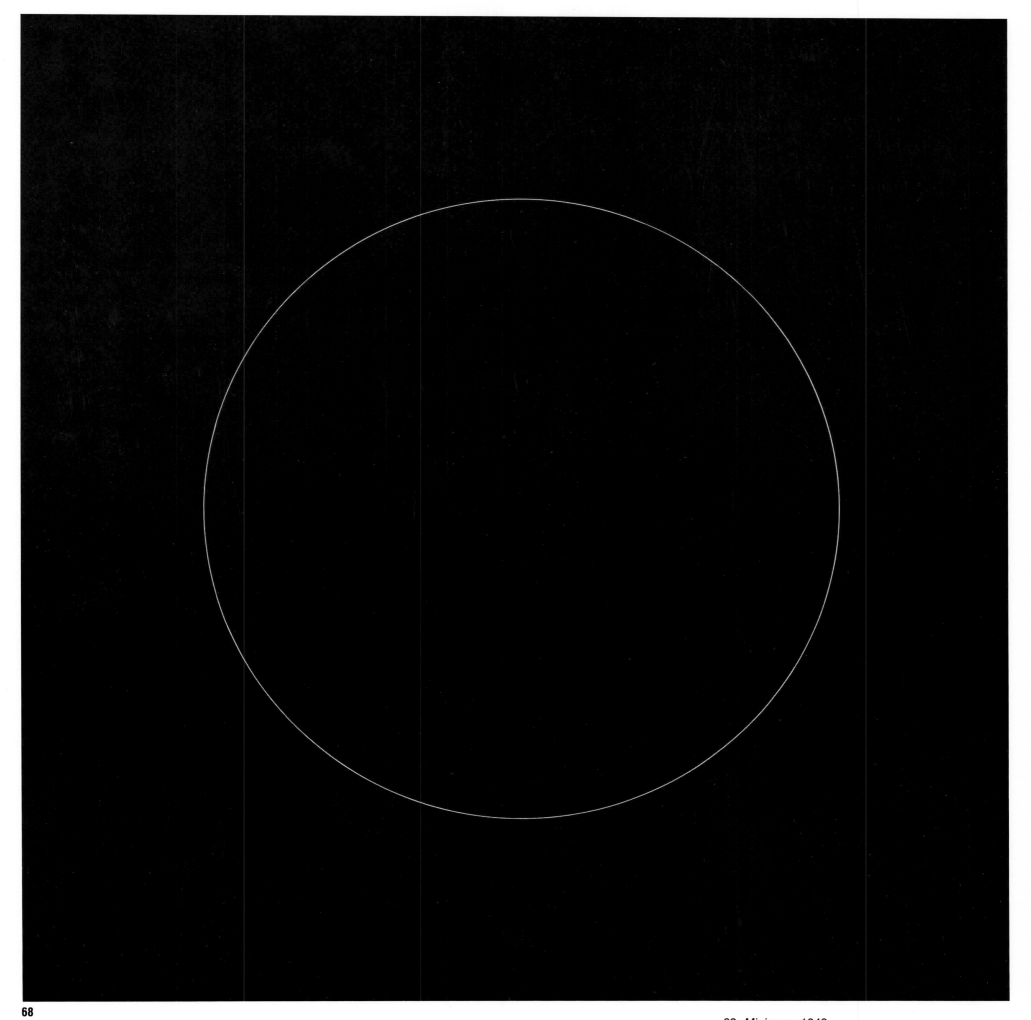

**68**

68. *Minimum*, 1949
Enamel on composition board, 48 x 48 in.
Collection The Museum of Modern Art, New York.
Gift of the Samuel I. Newhouse Foundation, Inc.

**69**

69. *Sixteen Ways*, 1951
    Oil and enamel on masonite;
    four panels, outside dimensions, 50 x 123 in.
    Collection Solomon R. Guggenheim Museum, New York.
    Gift of Francine and Cleve Gray

Sculpture had been on my mind in 1958–59, even in the paintings. I did them on aluminum and on plaster board and wood. I always wanted them standing out from the wall. Sixteen Ways *at the Guggenheim is a panel painting, the panels were originally conceived as separate. I wanted someone like a Kabuki actor to come and place them into the different positions they were supposed to occupy.*

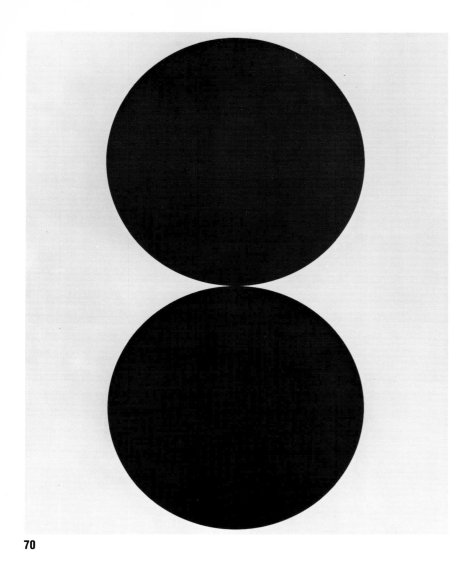

70

70. *Two Circles*, 1951
    Enamel on masonite, 50 x 40 in.

71. *Untitled*, 1950
    Enamel and oil on masonite,
    40-in. tondo

living room. He also published his photographs of Kupka in *Vogue* in 1951, in the first article on Kupka to appear in America. He discussed astronomy and Plato with the old man, who looked to him like a "Buddhist priest." In Kupka's mystical paintings, like the *Discs of Newton* (92), Liberman found a cosmic vision that reinforced his own quest for symbolic content. However, he was critical of Kupka's irregular surfaces for reasons similar to his rejection of Mondrian: he wanted painting that was flatter, less inflected—surfaces that were to his mind more "American."

The peculiar weightlessness of Liberman's discs derives from the lack of any tie of figure to frame, and from the lack of any allusion to an earthly horizon line. Liberman's circles are not pinned to the edge, but float freely through space, like the planets themselves. In some of Liberman's circle paintings, the shape is a ghostly antiform, a void with no material character, a pure disembodied line, which defines no solid shape because it is not filled in with color. (73, 90) Since he used no value contrasts, confining himself to contrasts of hue, the circle paintings remain extremely flat even when color is added to black and white. They appear to be all surface and no depth, an effect Liberman heightened by painting on rigid, thin masonite and aluminum supports. Both this extreme flatness, as well as the radically simplified hard-edge shapes of Liberman's paintings of the Fifties fore-shadowed the pop and minimal styles of the Sixties.

The decade of the Fifties was a period of optical experiments for Liberman. Among the first of them was a machine he constructed—a kind of electrical Rube Goldberg contraption—that rotated moving discs into various positions of superimposition and disengagement. The idea was to add a kinetic dimension to optical art. (94) These rotary movements later inspired a series of circular paintings and paintings of circles within circles. (71, 91) The machine itself appears to be based on Duchamp's experiments with kinetic art. (95) Liberman also owned a set of the discs Duchamp designed to create an illusion of three-dimensional forms projected into space when they are mechanically rotated. (96)

Duchamp's concern with the illusion of three-dimensional projection was the opposite of Liberman's anti-illusionist concerns as a painter. Liberman's objective was to make the flattest, most explicitly two-dimensional shapes possible. He wished to avoid illusion, either recession or projection, because he believed that spatial perception slowed the eye down in its communication of information to the brain. He searched for the most direct route of communication between eye and brain. He sought to emulate the instant impact of posters. He was also inspired by the clear legibility of road signs, especially the traffic signals that were becoming an international language of the highway.

To defeat composition and to communicate instantan-

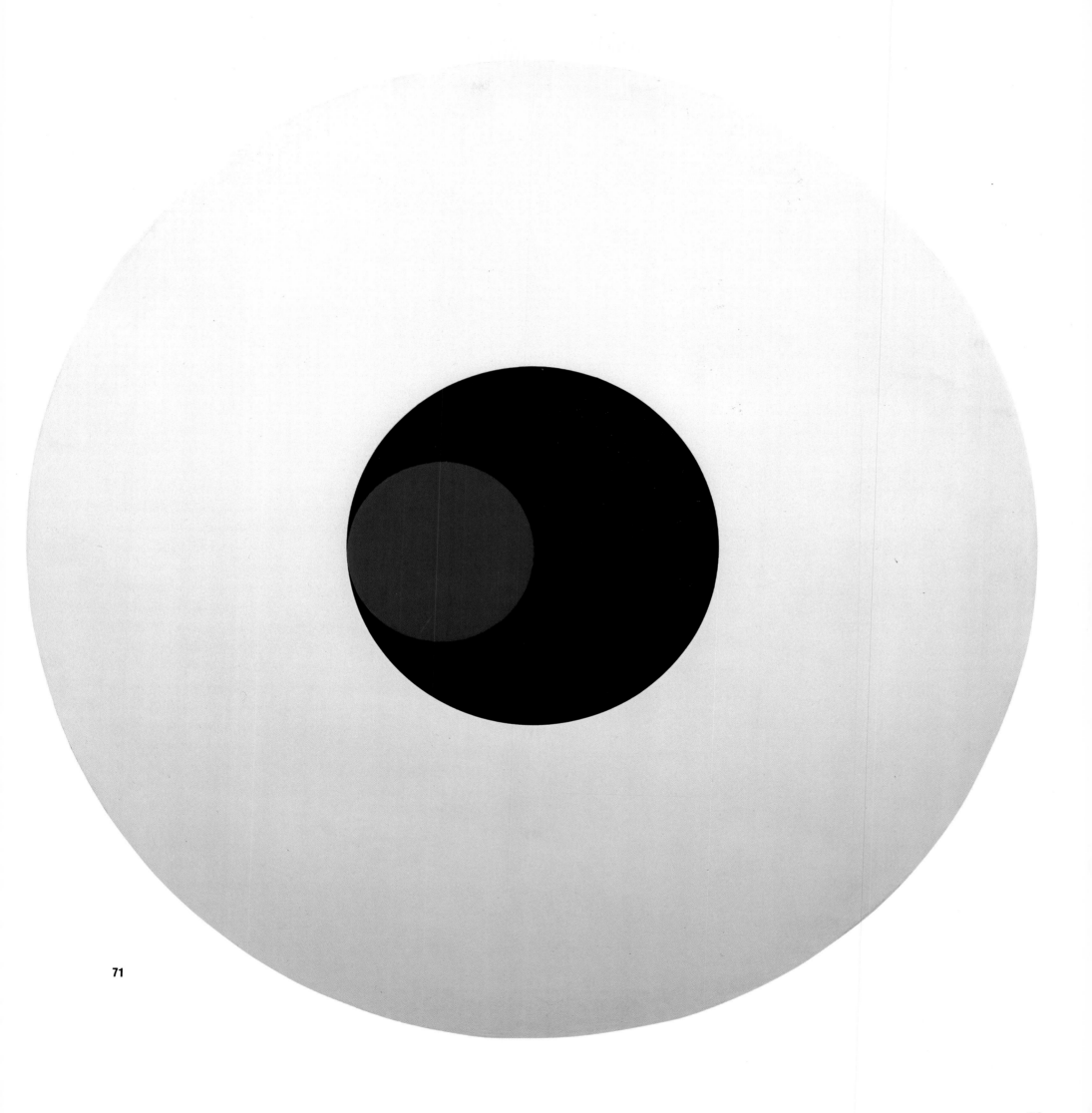

71

*I was terribly interested in after-images. I didn't think in terms of optical art. I was interested in optical printing on the brain, colors that are born of after-images—you know, complementary colors. I was trying to create nonexistent paintings with nonexistent means, subliminal image, immaterial image. I was very interested in finding basic human needs. I always thought the human brain demanded contradiction, so if you gave them a positive image—let's say a circle—that instinctive desire would be to demand the negative of that circle, the opposite of that circle. I thought you could short-circuit the brain by bringing physically a second panel which would negate the first panel. I was using the eye to penetrate the brain. That was the idea.*

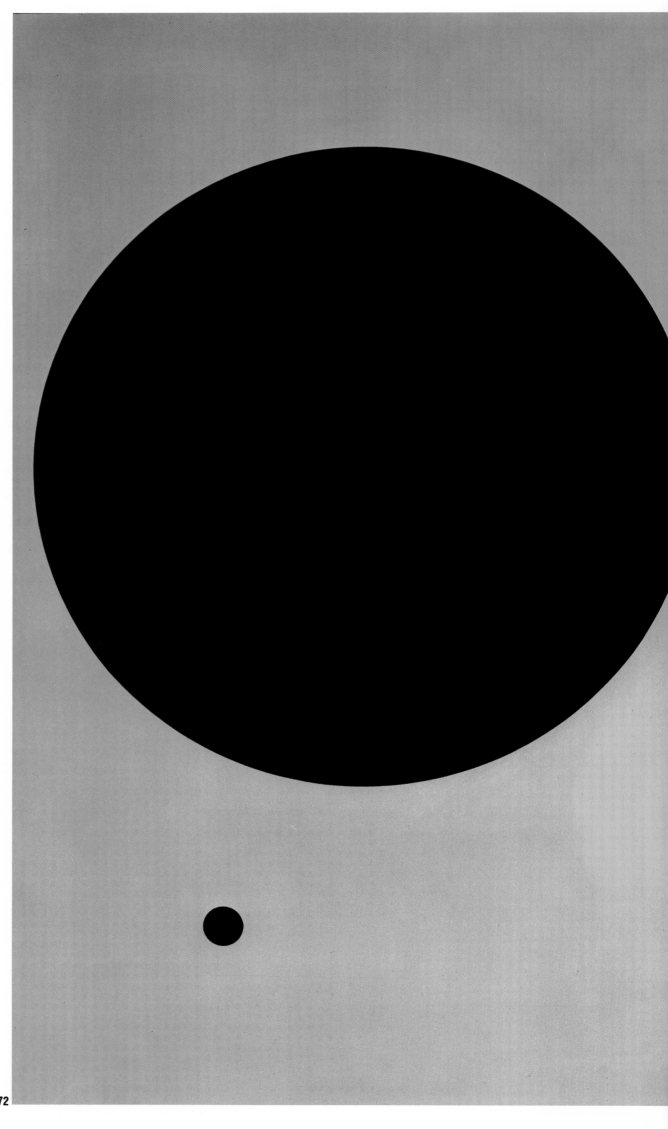

72. *Diptych—One Way*, 1950
Oil and enamel on masonite;
two panels,
outside dimensions, 60 x 74¼ in.

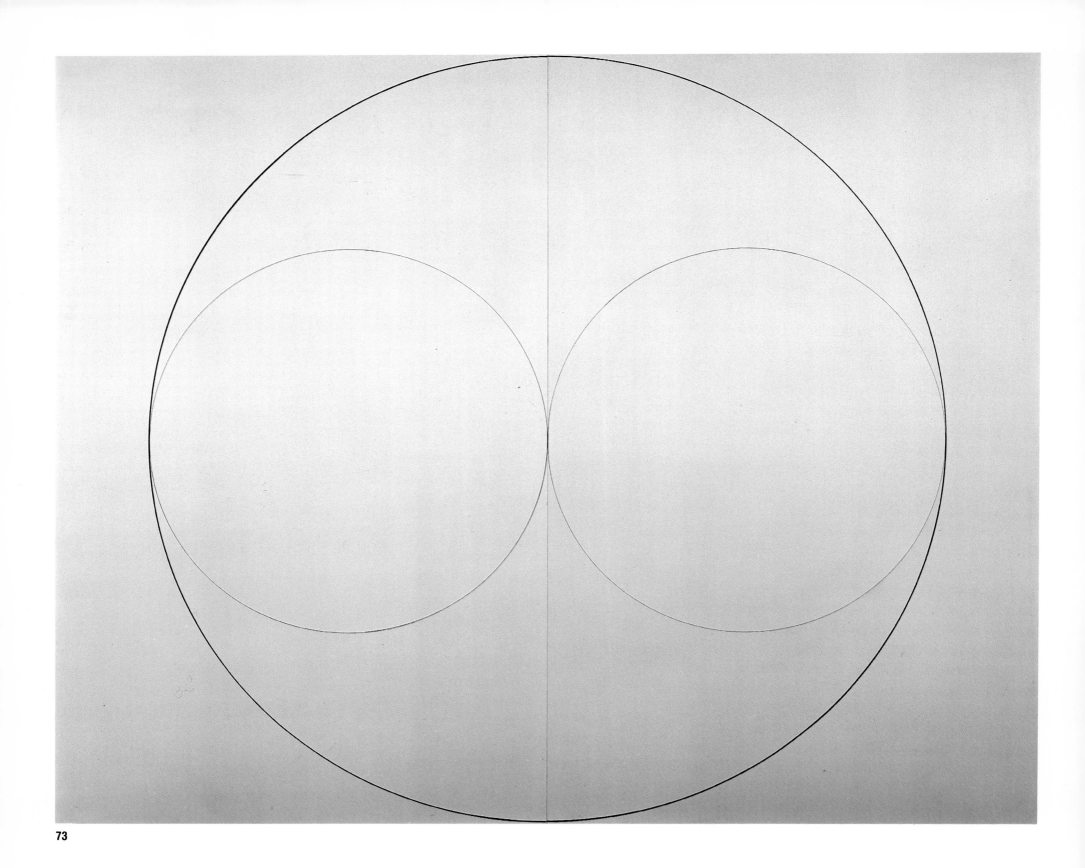

**73**

73. *Diptych—Complementary*, 1950
   Enamel on masonite, 60 x 74¼ in.

74. *Diptych—Two Ways*, 1950
   Enamel on masonite, 60 x 74¼ in.

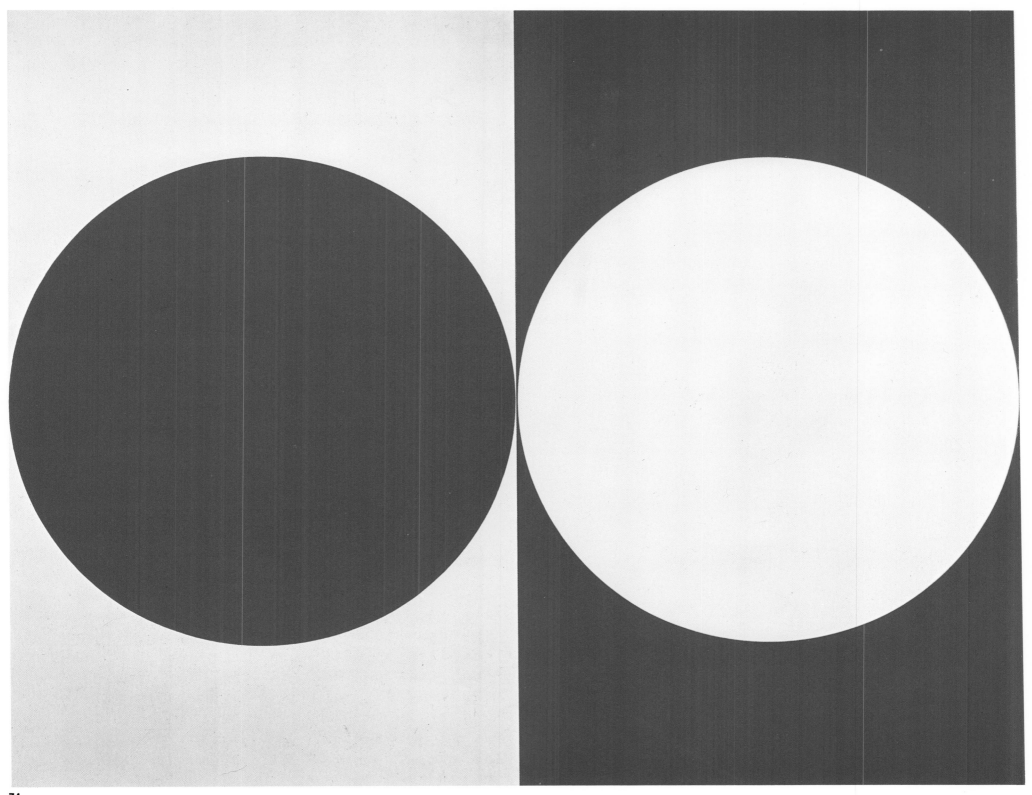

**74**

Mondrian based his theory of art on the vertical negating the horizontal. This contradiction, logical in its concept, creates a static equilibrium and acts like a prison crossbar on the window of progress. Circlism accepts the correctness of the basic need for contradiction but believes that the true way to a fertile art theory is the visual presentation of opposites expressed by the positive/negative forms. The black circle opposed by the white circle permits an uninterrupted flow of visual sensation. Thus the mind can pass freely from the opposites of light and dark to the idea of opposite itself.

—Statement on Circlism, 1962

**75**

75. *Cycles*, 1951
Enamel and oil on canvas, 30 x 30 in.

76. *Two Circles*, 1950
Enamel on masonite, 40¼ x 40¼ in.

eously were Liberman's primary concerns in the Fifties. Symmetry was, he felt, one way of negating composition. For the announcement of his first one-man show at Betty Parsons, which illustrated three of the paintings (*72, 73, 74*), Liberman chose as his motto a line from Kierkegaard: "Immediate sensation and immediate cognition cannot deceive." As a means to avoid composition, he also experimented with chance. Sometimes he used the *I Ching*, which John Cage consulted in composing music, to choose colors. In *Blue Opposite Red* (*100*), he threw poker chips at random on a surface and outlined them. Through every means he could find, he sought to avoid the predictable, the known, the contrived, the remembered, and the composed.

Op Art, or Optical Art, only became popular after William Seitz organized the exhibition "The Responsive Eye" in 1963 at The Museum of Modern Art. However, Liberman had been intensely interested in after-images and other optical effects throughout the Fifties. By the time *Continuous on Red* (*103*), a hard-edge tondo he painted in 1960, was shown in "The Responsive Eye," his own style had become increasingly free and painterly: hard-edge geometry had given way to the free flow of liquid paint.

The evolution of Liberman's painterly style was more gradual than it might appear from the public exhibitions of series of his works, which have omitted intermediate stages. The first step was to broaden his palette from the narrow purist range of black, white, and the primaries to a full spectrum of mixed color. He had a sophisticated grasp of Chevreul's theories of the laws of interacting colors, which caused complementaries to appear more intense when juxtaposed. This effect was of particular interest to Liberman, who had been concerned with the dazzle of light and with the maximum intensity of color ever since his neoimpressionist paintings of Venice.

In the circle paintings, Liberman felt at last that he had found an individual identity, a radical style free of cubist relational composition, as well as cubist illusionistic shading. It was free, in short, of ties to Europe. By now, he was in his late thirties, and really on his own for the first time. His father had died in 1946, and his mother had returned to Europe the following year. Although unconscious of it at the time, he had found freedom from French art by picking up the threads of some of the revolutionary ideas first expressed by Russian abstractionists like Malevich and Rodchenko, whose work he had seen in Paris as a boy.

In New York in the early Fifties, Liberman's radically simplified geometric paintings had no contemporary context. Ellsworth Kelly was painting in a style related to Liberman's researches, but he was still in Paris, and the two men did not know each other's works. During the Fifties, only one hard-edge painting had received wide visibility. *Two Circles*, an

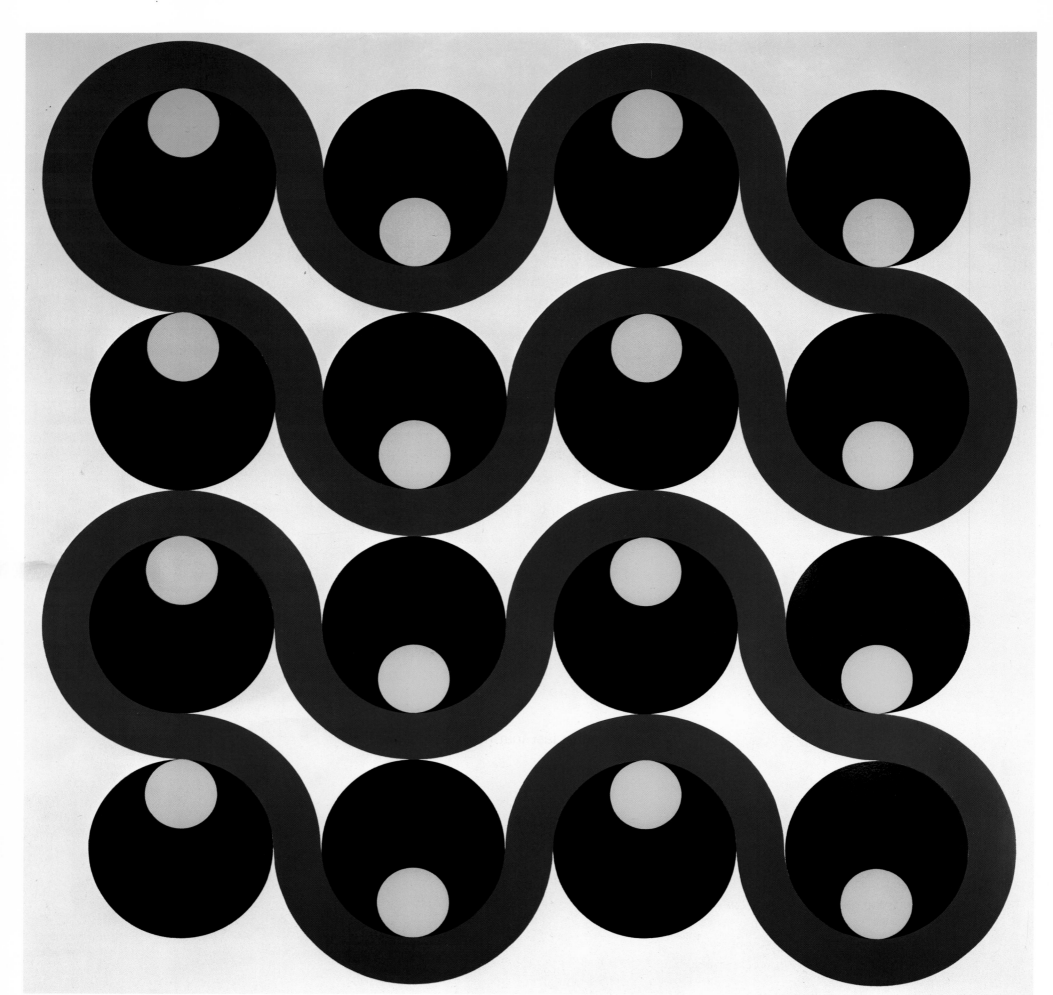

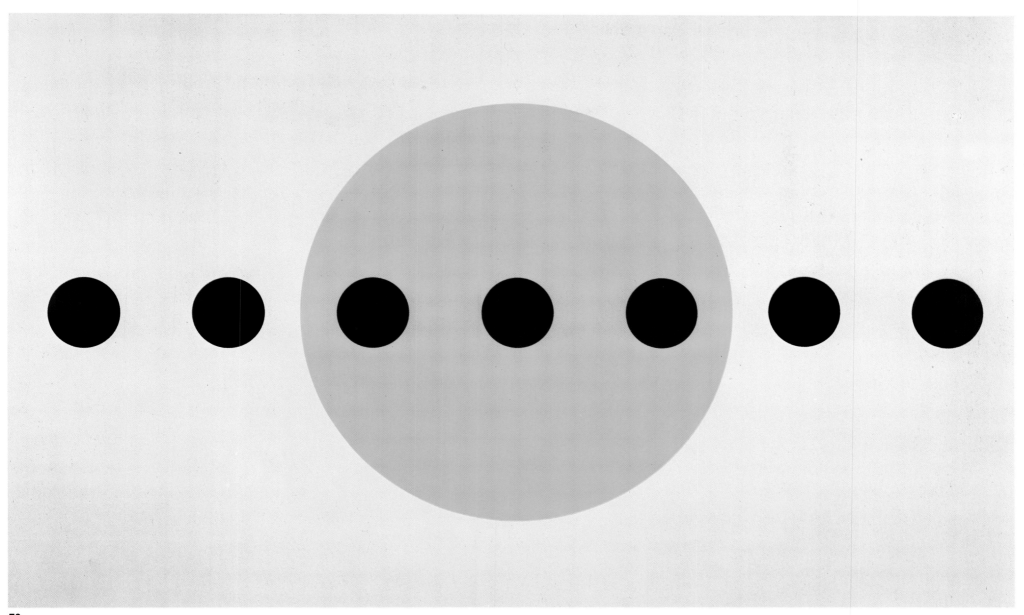

**78**

77. *Beat*, 1952
   Lacquer on aluminum, 42 x 42 in.

78. *Time*, 1952
   Oil and enamel on masonite,
   37¼ x 77¾ in.

The early work was "totally impersonal." I suppose I was still involved in the French classical concept of the ego being hateful. You're taught that "Le moi est haissable." So you didn't sign, you didn't show your handwriting. All of this had to disappear because the classical tradition is basically directed to the creation of great impersonal art. Free art is really the domination of the classical spirit by the romantic spirit.

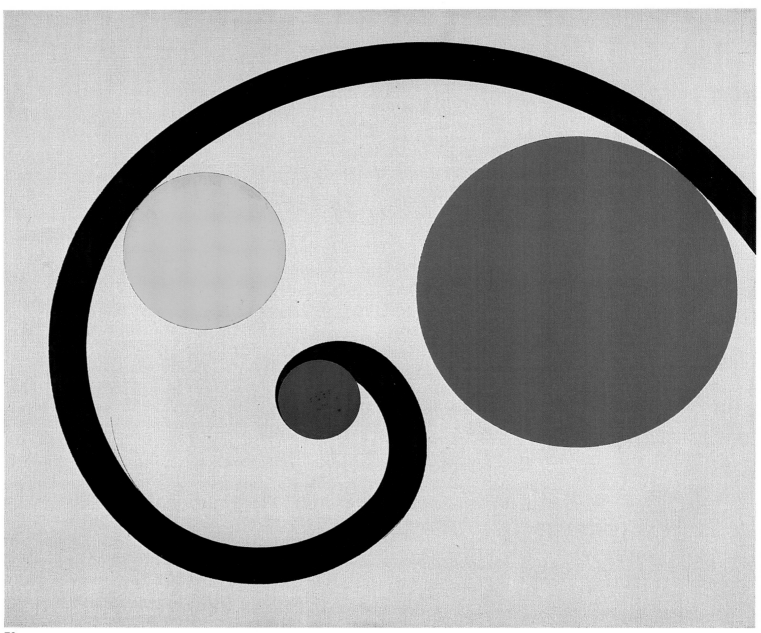

79

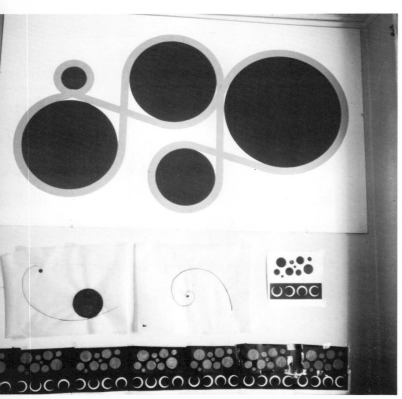

80

*This painting was based on the Fibonacci curve. I was very interested in trajectories of the mind reading on a surface, expressing time and continuity, permutation, linking, movement.*

*I thought perspective was deceit, illusion; I attempted to arrive at the third dimension through flat means. Then as I worked on and expanded, I thought that the physical experience of penetration was important to communicate.*

79. *Path I*, 1952
Oil on canvas, 20 x 24 in.

80. Detail with *Path IV*,
studio at 173 East 70th Street,
New York, 1953

81. *Circle Path*, 1952
Oil on canvas, 22 x 28 in.

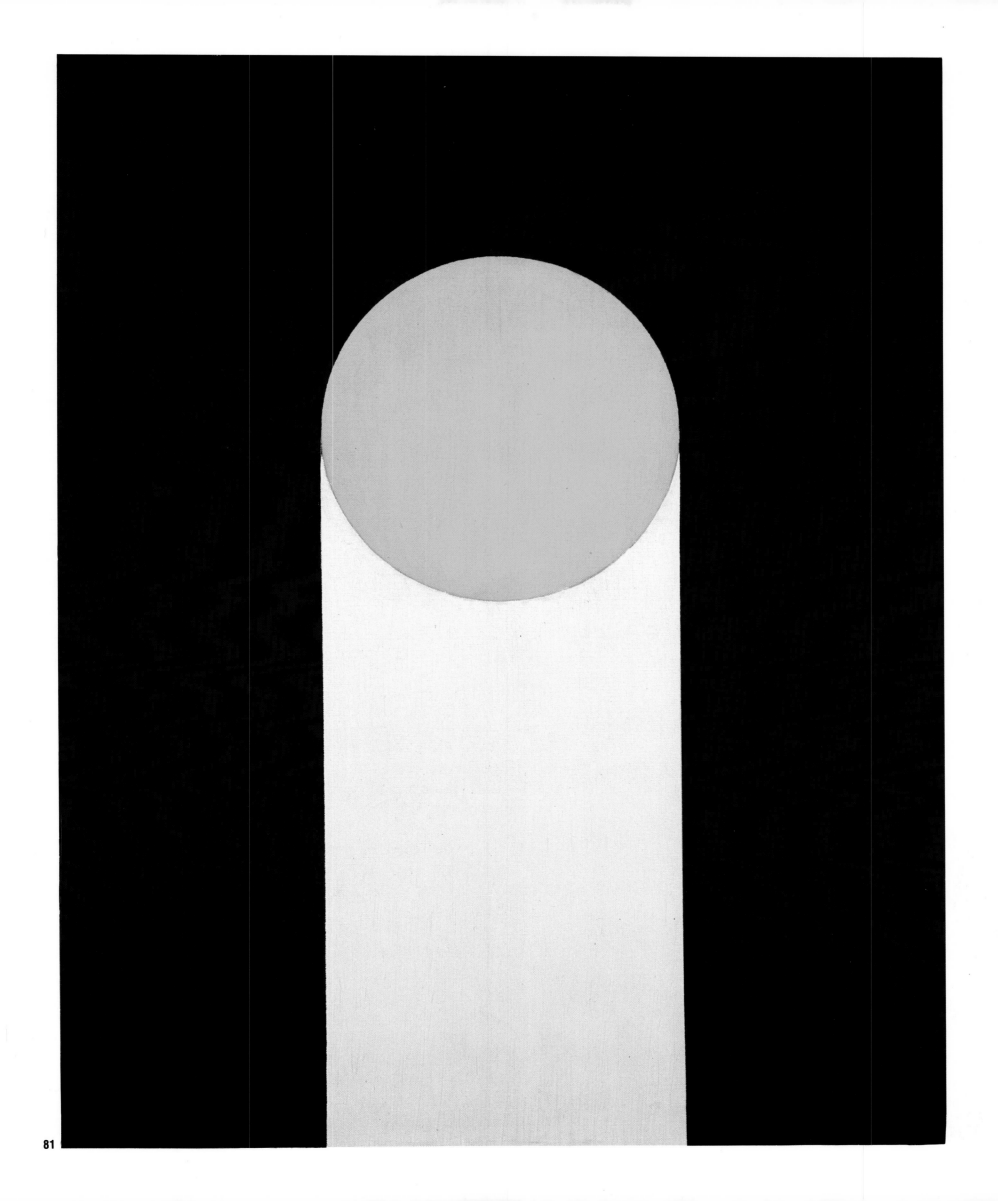

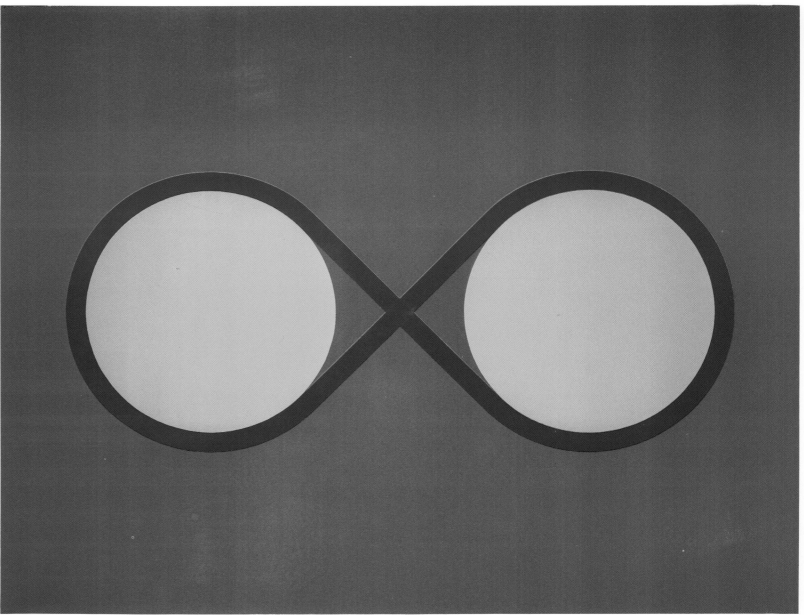

82

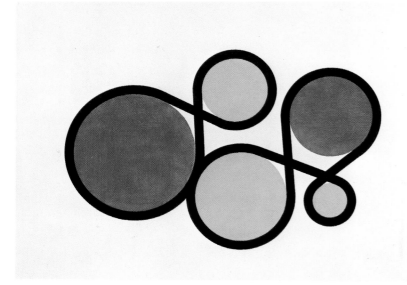

83

enamel painting of two adjacent black discs floating on a stark white field, was selected by James Johnson Sweeney for an exhibition of "Younger American Painters" at the Guggenheim Museum in 1954. (76) At the time, Liberman was involved with the idea that paintings could simply be given a fresh coat of paint like buildings, so they would always look brand new. He offered Sweeney a fresh version of the painting, but Sweeney took the one in the studio. *Two Circles* was the first Liberman painting to be seen outside his small circle of family, friends, and acquaintances like Betty Parsons, Barnett Newman, and Clement Greenberg, who saw the work earlier and encouraged him.

Most of the circle paintings are static and iconic. They are as strictly disciplined as Liberman's classical education, as reserved as the stoical demeanor he had been taught. They express a tension, not just in their resistant industrial surfaces, but also in the way the image fills the field, expressing psychological tension. In some of these paintings the circles

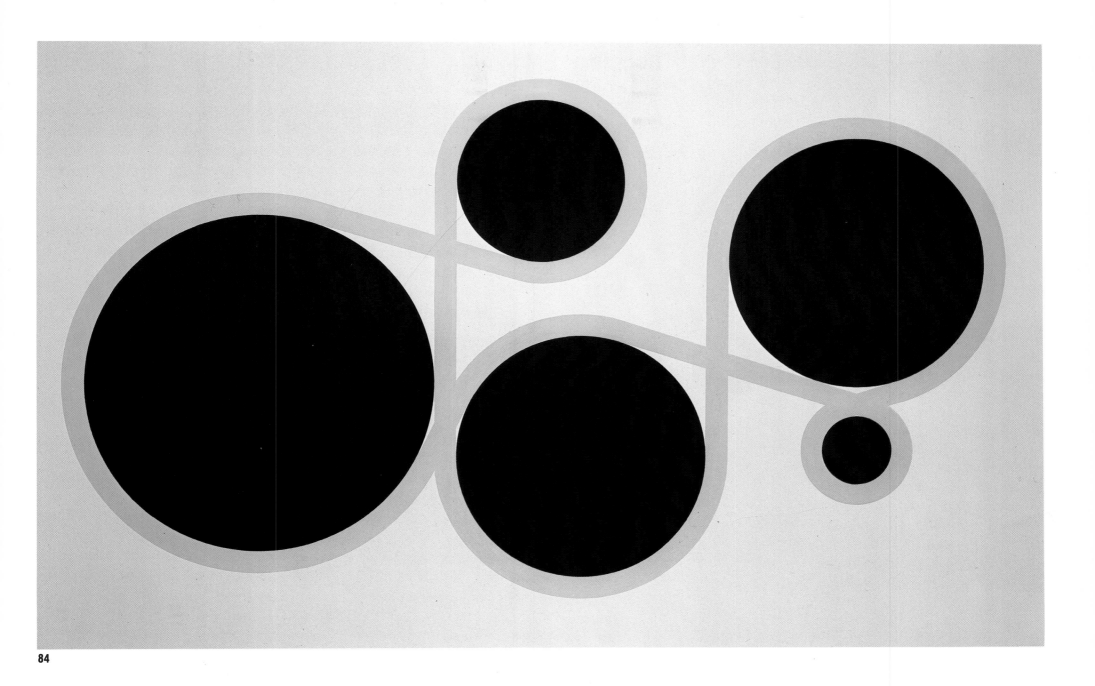

84

expand, pressing against the framing edge as if to burst the boundary beyond. The same is true of the tension created where circle presses against circle, crowding and bumping its neighbor. However, decorum is never violated. Aggression is checked: the forms never break the frame, overlap, or spill over into one another. Unbroken boundaries also give a sense of freshness, pureness, and clarity Liberman sought.

In a series of tondos begun in 1959, Liberman disposed of the rectangle altogether. He thought of the rectangle as a relic of easel painting reminiscent of European art. He began stretching canvas onto large hoops his assistant Ed Kasper had found. These became circular frames. The tondos were actually shaped paintings: The framing edge was dictated a posteriori by the circular contents of the field. Liberman had been fascinated with the idea of rotation, of the eye rather than the body working out kinetic exercises. In 1950, he had experimented with a circle cut out of wood, on which he painted a blue dot within a black circle. (71) The disc was

82. *Path II*, 1952
   Oil on canvas, 44 x 56¼ in.

83. *Path III*, 1952
   Gouache and India ink on paper,
   12 x 19¼ in.

84. *Path IV*, 1952
   Oil and enamel on masonite,
   37¼ x 77¾ in.

85. Detail, studio at
   173 East 70th Street,
   New York, 1952

85

86

I did study icons. The nimbus around the heads always interested me enormously. In icons there is always this nimbus around the face. I was preoccupied with that idea, and then I even tried to trace eye trajectories, as I called them. I thought, how does the eye travel from one nimbus or from one circle to another?

86. *Trajectories*, 1953
   Lacquer and enamel on aluminum, 48 x 48 in.
   Collection Neuberger Museum,
   State University of New York College at Purchase.
   Gift of Mrs. Enid A. Haupt

87. *One Trajectory*, 1952
   Enamel on masonite, 48 x 48 in.
   Collection Neuberger Museum,
   State University of New York College at Purchase.
   Gift of Mrs. Enid A. Haupt

to be rolled along the floor like a hoop, so that the dot would move in a circular trajectory. In 1959-60, he revived this idea in the canvas tondos, which alluded to rotation optically rather than literally. (*118*) He had also become interested in peripheral vision—in pulling the eye forcibly to the perimeter of an image. He believed that by cutting the circle out of its rectangular frame the shape would no longer be separable from the field, and the eye, therefore, would be jerked to the edge of the painting.

Through a concern with physiological optics rather than with formal relationships, he began to paint shaped canvases. Since he was not interested in eccentricity for its own sake, or in creating any relieflike literal forms, his tondos, and later his triangles, were the only shaped canvases Liberman painted. The gradual introduction of painterly elements into the tondos of the early Sixties would bring him to a new idea of space that was less conceptual and more sensual. When the circle was transferred back onto a rectangular field, the result would be color-field paintings, which are intelligible within the context of the New York School. A tondo was exhibited in Liberman's first one-man show, which William Lieberman persuaded Betty Parsons to hold in 1960. By this time his hard-edge style was ten years old. Newman also installed the show, which included several early miniature sculptures. (*199*) The exhibition was a *succès d'estime* among many avant-garde artists. Other artists made it a *succès de scandale*, accusing Liberman of abdicating responsibility by having his work fabricated. (In fact, he often hand-painted parts of works whose backgrounds had been sprayed.) By the late Fifties he had returned to brushes, and to oil on canvas, to obtain greater color intensity and depth.

The press and public took virtually no notice of the show. Only one painting, a tondo, *Continuous on Red*, and a small sculpture were sold. They were acquired by Alfred Barr, Jr., for The Museum of Modern Art. The lack of response to his paintings was particularly disappointing to Liberman because his exhibition of photographs of artists in their studios held in 1959 at The Museum of Modern Art had been enormously successful. Steichen called his portraits of the School of Paris masters "sensitive and probing." It was obvious Liberman could have become a leading photographer, but he has always chosen to negate his photography, to use it mainly as a tool in working out sculptural problems (see Chapter IX). For Liberman, photography was only a document rooted in fact, incapable of evoking the intangible, the visionary, and the metaphysical. However, he continued to photograph, and in 1965 produced a book on Greece and Greek art. In recent years he has concentrated on the Campidoglio in Rome, which he visits and photographs each summer. Occasionally, he will photograph a contemporary artist he admires, like Johns or de Kooning, as an act of

88

homage. He always maintains, however, that photography is not the highest art, because it is only a record of reality, not an intuition of other worlds.

In his introduction to *The Artist in His Studio*, Liberman wrote that he had undertaken his pilgrimage to the studios of the titans of the School of Paris because he feared that with the war "a heroic epoch might vanish." The book was an act of respect, as well as an homage to those artists he believed were dedicated to art like "men to religious orders." Echoing the sentiments his mother had inculcated, he praised the moral virtue of art as a religion. The introduction ends with a quote from a fourteenth-century text by Cennino Cennini, which identifies painting as a religious consecration. This passage expressed Liberman's belief that painting is the transcendent art—the ultimate metaphysical experience, superior to any art that is literal or in material form.

Photographing and writing *The Artist in His Studio* was both a first-hand crash course in modernist aesthetics and a catharsis for Liberman. He had returned to Europe, to the sources of modern art. He realized that the past cannot be denied, that the history of painting cannot be artificially ruptured by an act of will, because it has an unbroken tradition all the way back to Cennini. History—his own included—was no longer to be feared or rejected, but embraced.

89

88. *Duration*, 1953
    Lacquer and enamel on aluminum,
    9½ x 132 in.

89. *Untitled*, 1953
    India ink on paper, 13 x 20 in.

90. *Black End*, 1959
    Oil on canvas, 24 x 30 in.

78

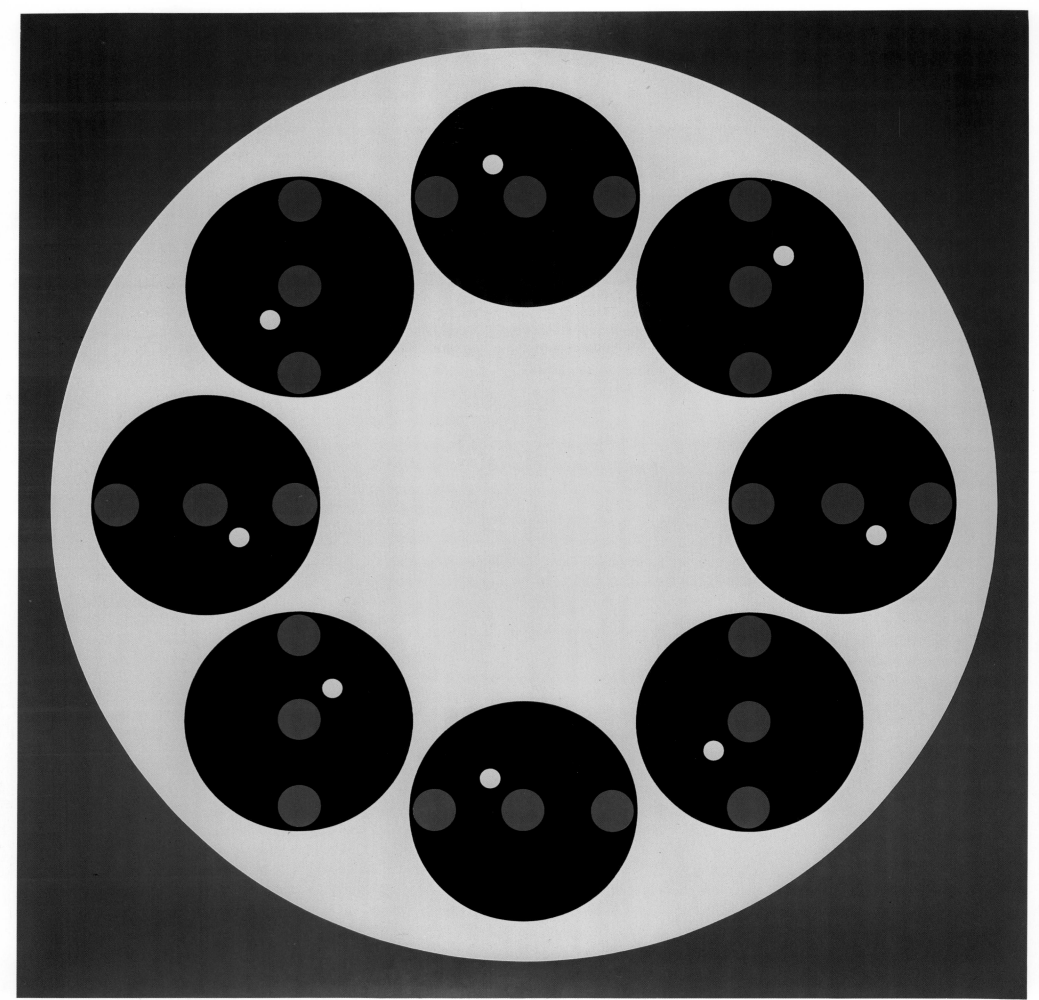

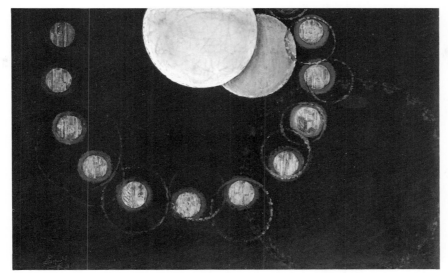
**92**

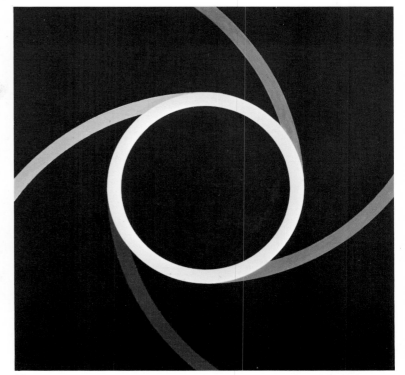
**93**

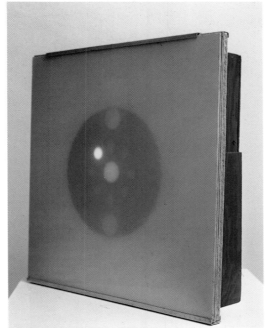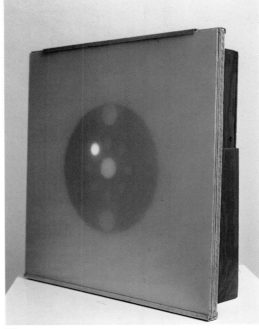
**94**

**95**

91. *Rotating*, 1955-56
    Lacquer on aluminum, 45 x 45 in.

92. Frantisek Kupka
    *The First Step*, 1910-13? (dated on painting, 1909)
    Oil on canvas, 32¾ x 51 in.
    Collection The Museum of Modern Art, New York.
    Hillman Periodicals Fund

93. *Untitled*, 1955-56
    Lacquer on aluminum, 45 x 45 in.

94. *Light Machine*, 1956
    Electric bulbs, with motor-driven construction,
    groundglass, and wood, 15¼ x 15 x 5 in.

95. Marcel Duchamp
    *Rotary Demisphere (Precision Optics)*, Paris, 1925
    Motor-driven construction: painted wood demisphere,
    fitted on black velvet disc, copper,
    collar with plexiglass dome, motor, pulley, and
    metal stand, 58½ x 25¼ x 24 in.
    Collection The Museum of Modern Art, New York.
    Gift of Mrs. William Sisler and Edward James Fund

96. Marcel Duchamp
    *Corollas*, n.d. (from 12 *Rotoreliefs*)
    Offset lithograph, printed in color; set of six discs with
    design on either side to be seen in revolution, 7⅞ in.
    Study collection, The Museum of Modern Art.
    Gift of Rose Fried

97. *Untitled*, 1954
    Enamel and oil on aluminum, 30 x 30 in.

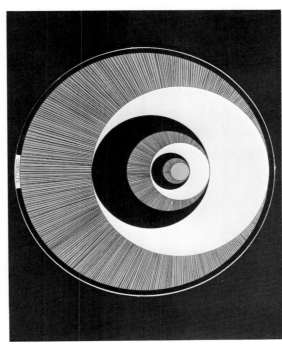
**96**

**97**

98. *After Image*, 1955
Oil on canvas, 61¾ x 98¾ in.

**98**

**99**

99. *Yellow Continuum*, 1958
Oil on canvas; four panels, each 18 x 24 in.

83

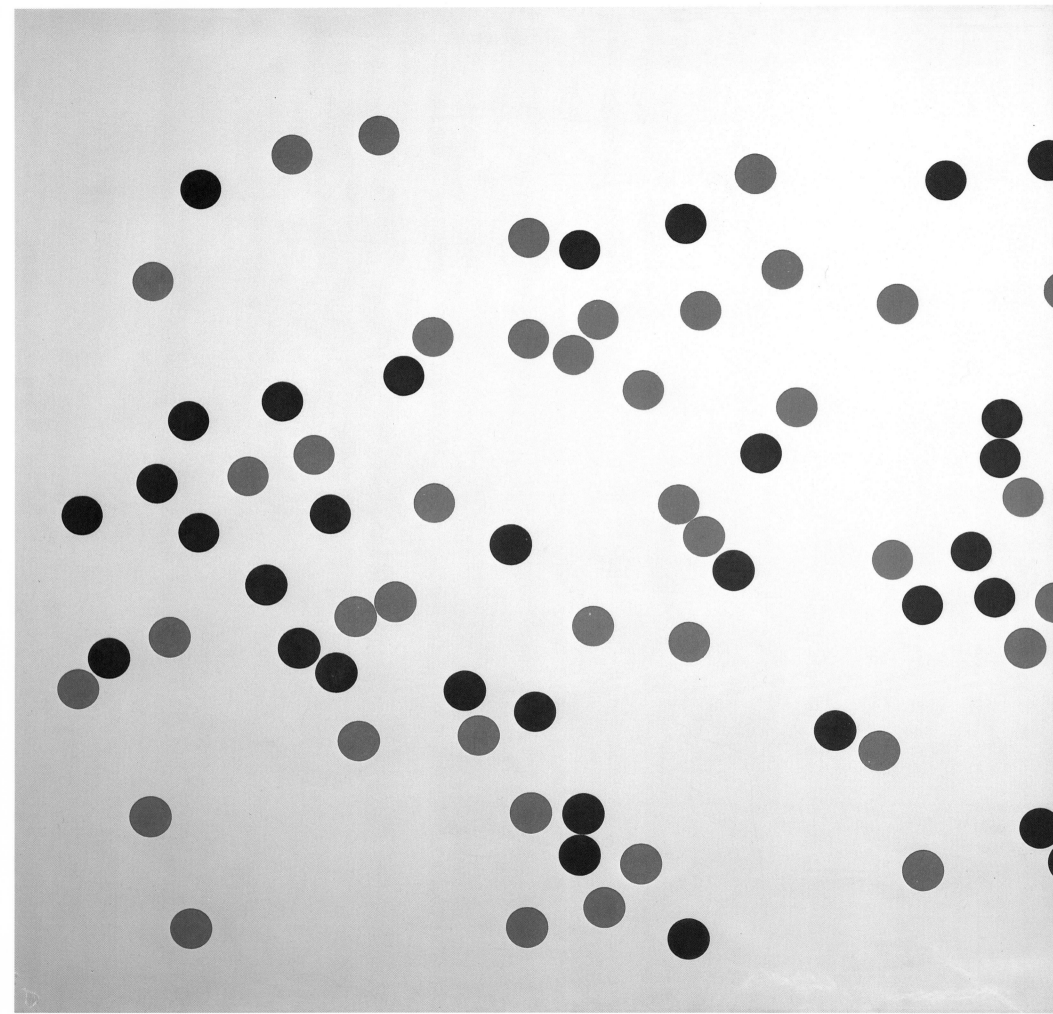

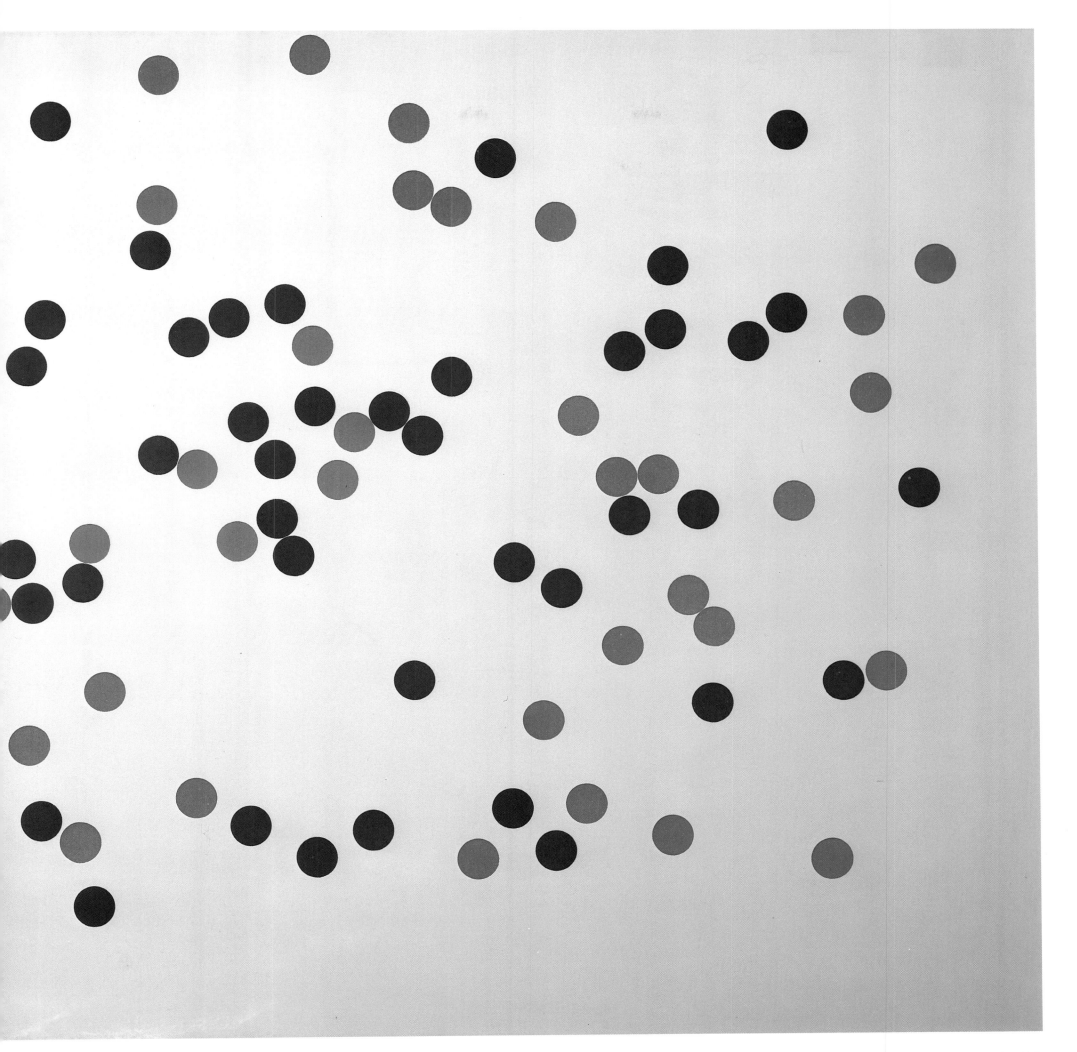

100. *Blue Opposite Red*, 1959  Oil on canvas, 40 x 82 in.

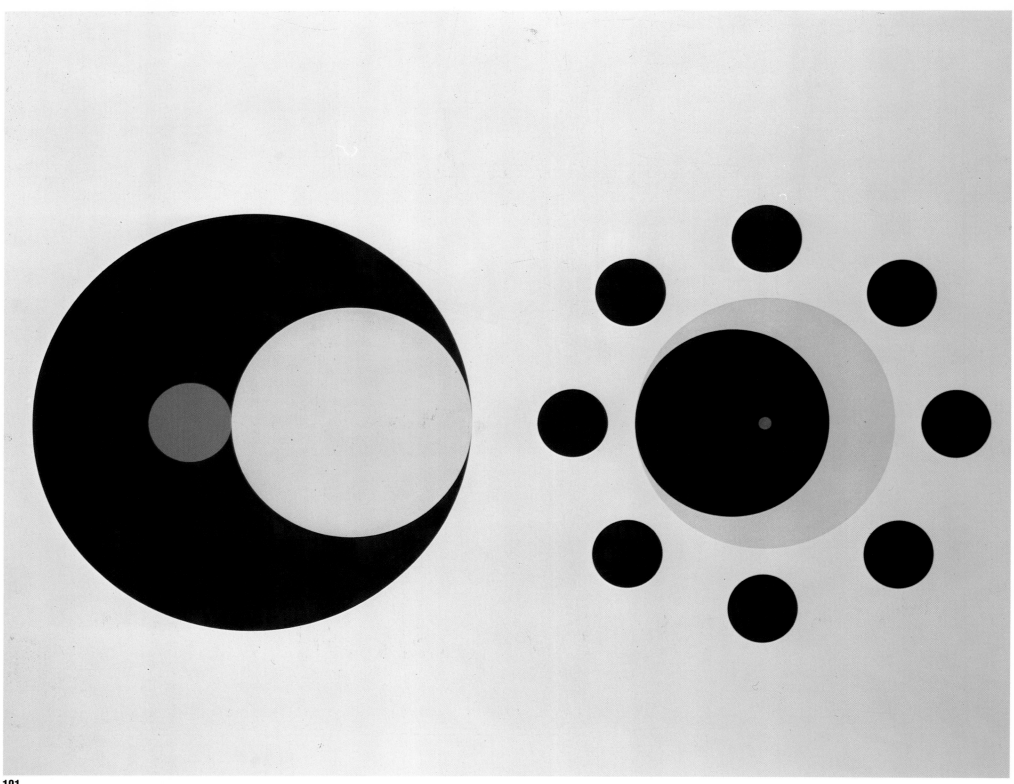

**101**

**102**

101. *Gravitation*, 1959
Oil on canvas, 80 x 96 in.
Collection Mr. and Mrs. S. I. Newhouse, Jr.

102. One-man retrospective,
Corcoran Gallery of Art, Washington, D.C., 1970.
Detail of installation with *Prometheus* (1964),
*Six Hundred and Thirty-Nine* (1959), *Passage* (1959),
*Time-Space* (1960), and *Gravitation* (1959-60)

103. *Continuous on Red*, 1960
Oil on canvas, 80-in. tondo
Collection The Museum of Modern Art, New York.
Gift of Mr. and Mrs. Fernand Leval

**103**

# CHAPTER

## IV

## PARTING OF THE WAYS

To paint, or to be involved in painting, is to affirm one's existence, which has no validity without freedom. Within the realm of one's canvas or sculpture I believe that the individual can sense the limits of freedom. I have a feeling that more of life and art can be experienced within the so-called accident because we cannot preconceive life. We cannot envision all that's in us. We cannot plan our inner life.

If I hadn't done big paintings, I wouldn't have done big sculptures. And in a curious way, if I hadn't done and seen the big sculptures that sort of surprise me even though I have done them, I wouldn't have had the courage to plunge into new adventures in paintings. I don't think their relationship is necessarily literal. I think it's gestural. After one has seen tons of steel suspended on cranes and in light, to draw a stroke across a painting one has much more energy . . . one is charged by the physical courage of the sculpture. And for me there is a sort of constant interchange between the two.

The most difficult and interesting thing is not to start creating a work of art, but the fact that I'm doing one thing, when the result will be something else. I've always been very interested in gestures. I'm always fascinated when I see window washers. You see enormous panes of glass covered with some kind of white compound. What are they doing? They put on this paste to clean the window. When you look at it from an aesthetic point of view, you suddenly see a very remarkable painting.

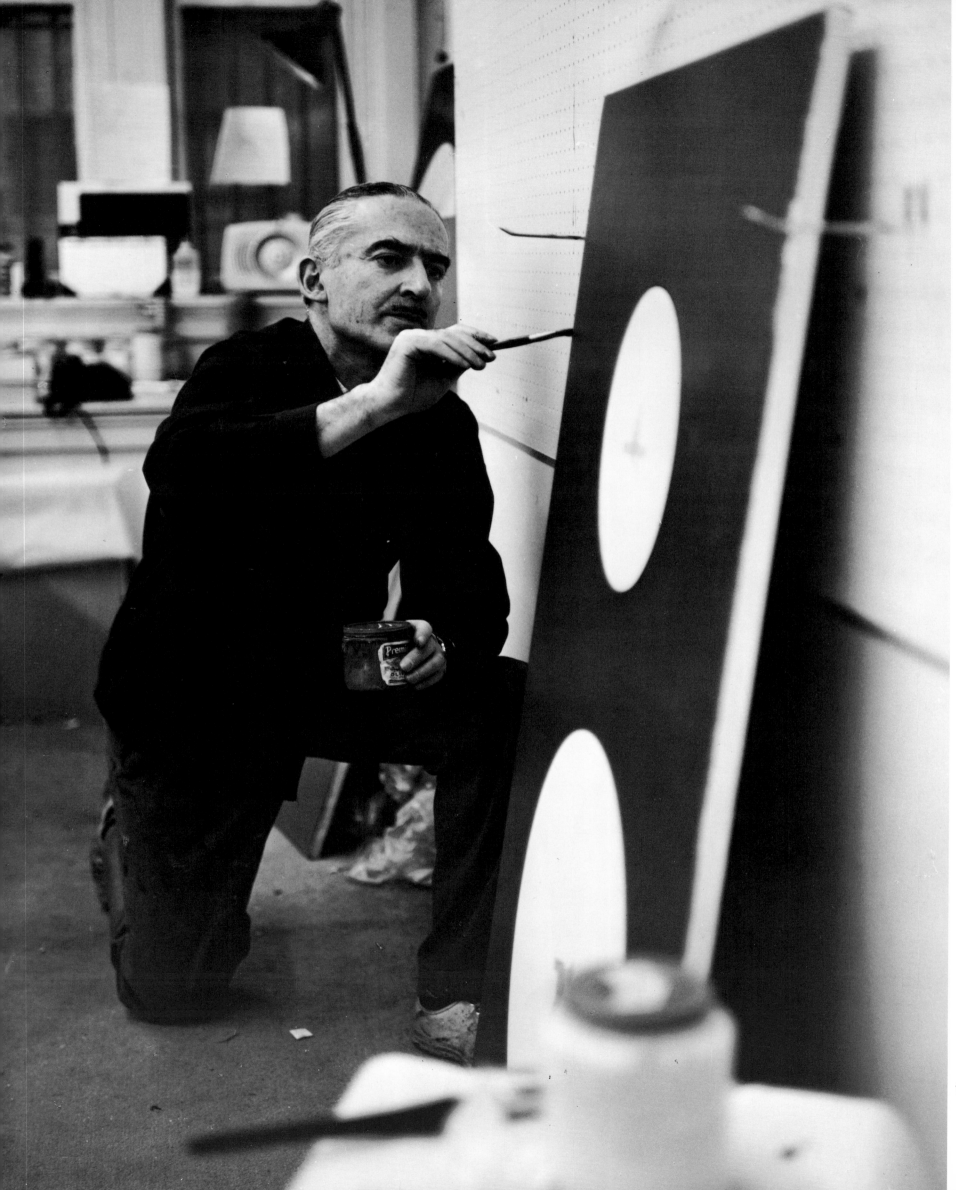

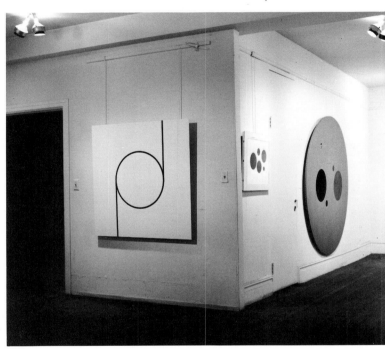

105

104. Liberman working in the studio at
132A East 70th Street, New York, 1960

105. First exhibition
at Betty Parsons Gallery, April, 1960.
*Continuous on Red* (1960) is visible at right,
*Trajectory* (1952) at left

LIBERMAN'S FIRST ONE-MAN SHOW in 1960 established him as an original abstract artist working in a cool, rational, geometric style radically opposed to "action painting." By now, he was beginning to paint on the large scale of the New York School and to meet the New York School painters. De Kooning, Kline, and Newman, as well as critic Clement Greenberg attended the opening of his Betty Parsons show. Greenberg was particularly encouraging. He urged Liberman to continue painting colorful geometric abstractions, which had a heightened clarity in the context of the muddy over-painting of late abstract expressionism.

The year 1960 was pivotal for the New York art world. It was no less so for Alexander Liberman. He took the opportunity of his first show to assess his position in relationship to the declining fortunes of abstract expressionism and to the rising tide of pop and minimal styles, which his flat, graphic, optical paintings of the Fifties anticipated and, it would appear, influenced. Liberman's later decision to cast his lot with the more complex, metaphorical, content-oriented aesthetic of his own generation, the pioneers of the New York School, was perceived as both shocking and reactionary. Had he not made such a choice, he would undoubtedly have been a far more successful but a far lesser artist. In many respects, Liberman's geometric paintings had anticipated the direction of Sixties art. They were not only shaped canvases and serial images, they were also "holistic gestalts," which communicated themselves instantaneously. They were unified, frequently symmetrical images, which could only be perceived as indivisible and without separable parts. Such centralized and symmetrical images came to be a hallmark of American painting in the Sixties, which aimed to strike the viewer with the immediate impact of an arrow right to the bull's-eye. (*106*)

The issue of instantaneous communication had preoccupied Liberman since 1950, when he drew a series of diagrams of the shortest circuit from brain to eye. (*108*) This preoccupation had initially been triggered by looking at Gyorgy Kepes's *The Language of Vision*, which compared abstract art to information theory. Stimulated by Kepes, Liberman began to approach abstraction as a visual language with a grammar of geometric elements, whose meaning was altered by placement and context. At first, Liberman played with positioning elements in relationship to one another. He saw these relationships as a means of expressing psychological dominance, optical rotation, and the creation of space without perspective or shading. He was sympathetic to the progressive world view of Kepes, a Hungarian-born Constructivist who helped set up the New Bauhaus in Chicago during the war.

Kepes's ideas coincided with Liberman's view that a new art of order was needed after the chaos of World War II. The

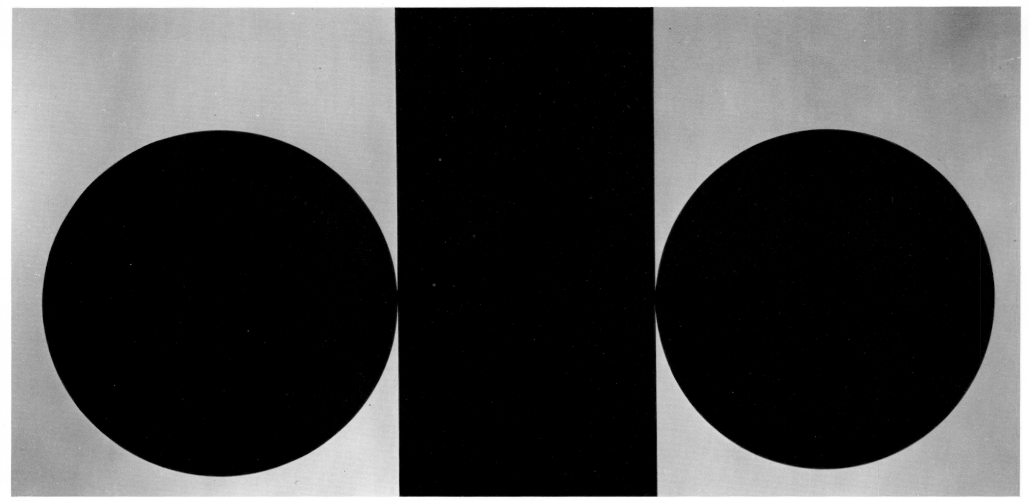

106

106. *Omega XIII*, 1959
     Acrylic on canvas, 80 x 160 in.

107. *Omega III*, 1961
     Acrylic on canvas, 80 x 160½ in.

first artist to translate gestalt-psychology principles into a systematic aesthetic theory, Kepes also reinforced Liberman's feeling that art was, above all, a language of communication. During his formative years, Liberman wrote essays about the giants of modern art. While his contemporaries were engaged in various kinds of self-promotion, he had nothing to say about himself or his intentions. The exception appears in the questionnaire The Museum of Modern Art sends to artists when it acquires a work. In response to their request for information about *Continuous on Red*, Liberman submitted his statement "Circlism," apparently summarizing notes taken much earlier. The superiority of the circle was that "it is visible in its totality instantly. A triangle or a square has to be figured out by our vision. In order for sensation to act upon us with the greatest intensity, we have to cleanse our mind of the accumulated deposits of art memories." Brushstrokes were to be eliminated because they distracted the attention of the spectator with minor incident, and speed was identified with precision: "In our epoch of speed," he wrote, "precision is essential."

In "Circlism" Liberman acknowledged his debt to Hegel, and to dialectical thought in general. The relationship of the circular figure to its surrounding field was a deliberate polari-

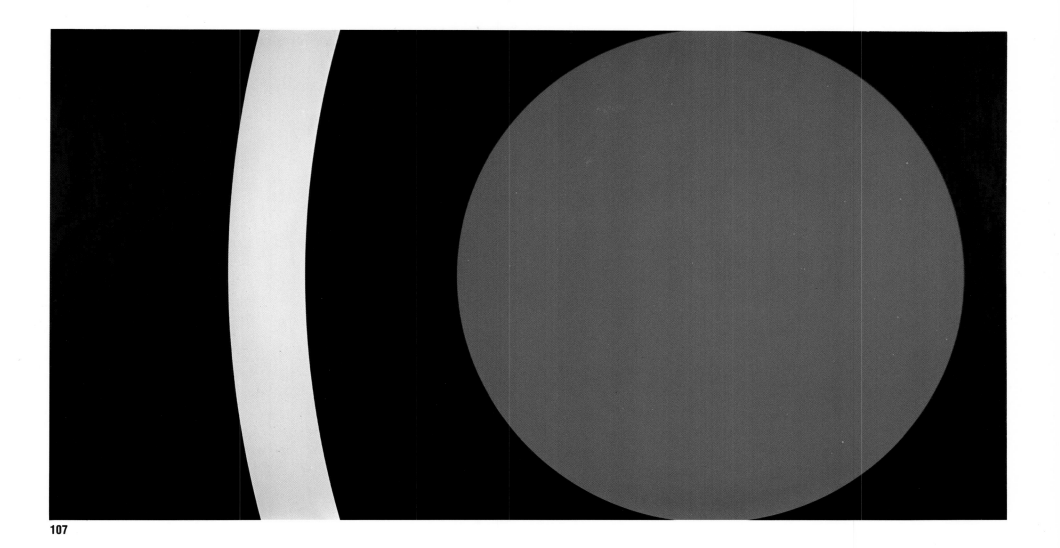

**107**

ty, a ying-yang construction of reversible positive and negative forms. His attraction to contrasting polarities, such as black and white (*110, 111*), may explain why the nuanced, painterly, baroque style that evolved out of the classicism of "Circlism" was as passionate, as physical, and as intense as the geometric style had been precise, intellectual, and detached. If "Circlism" was the thesis, color-field, lyrical, painterly abstraction was the antithesis.

Although Liberman was beginning to meet the New York School painters, he remained isolated from the art scene. Tatiana always organized their social life, and Russian and French were spoken more often in the Liberman household than English. When Liberman began to see more of his contemporaries, his natural affinity was for the "uptown" artists like Motherwell, Rothko, and Newman, who lived in apartments rather than "downtown" lofts, who were married, well-educated, and preferred discussing philosophical issues to drinking at the Cedar Bar.

When he wrote "Circlism," Liberman was obviously thinking of European manifestos, which were anathema to the anarchic New York School. However, like the styles of the New York School masters, "Circlism" was a one-man art movement. In the same sense as the Abstract Expression-

ists, Liberman was searching for a personal symbol. For him, the circle reverberated with the requisite multivalence: "The circle," he wrote, "is the common property of the two infinities from the immense sun to the infinitesimal atom. It is no accident that our eyes see through the round iris." Liberman continued to be a geometric painter until 1962, and geometric structures underlie even his freest paintings. However, as he became increasingly aware of the intention of the Abstract Expressionists to create an art of content, optical experiments began to appear too exclusively formal to communicate a profound statement. Thus, while he continued to exploit the optical possibilities of gestalt psychology, he also searched for symbolic forms. He began by drawing in his notebooks symbols that reduced human forms to phallic symbols, translating the erotic impulse into abstract geometric form.

For Liberman during the Fifties, art had been a kind of mental hygiene, a catharsis of history. His search was for a grammar, for a new language of art. Slowly, he began to approach these intellectual and theoretical concerns with a distrust of the intellect. This would lead to a more romantic style expressive of emotional and physical release. An almost trancelike state would be required to produce paintings

thigh

breast

knee

hole

finger

sex     back

torso

**108**

see us upside down

torso = phallus

catch

direct

penetrate

1

2

3

1A

2A

3A

3

in the new style. He was no longer concerned with speed of image perception as he had been in "Circlism," nor was he concerned with speed as a means of achieving precision. Speed of execution was still important, but now solely because it prohibited the brain from censoring the emotions, and so kept ingrained classical discipline from inhibiting emotional expressiveness. Thus the choice of a new style was directly tied to a distrust of the intellect and to a rejection of classicism, resulting from his attraction to the romanticism of the New York School, and his increasing conviction that less was not necessarily more.

Reading *The Artist in His Studio*, one realizes that Liberman's greatest hero is Picasso—as much for his character as a gambler and an unpredictable inventor who repeatedly changed styles—as for his art. In the essay on Picasso, Liberman focuses on the master's speed of execution as a means to maximize the role of chance. The essay, written in the late Fifties, expresses what was uppermost in Liberman's mind at the time: the means to transform Platonic absolutes into an art of chance, risk, and daring. Throughout his life, Liberman had been fascinated with the idea of the artist as Dostoevskian gambler. He reserved his greatest admiration for those he perceived as the greatest gamblers of the century: Picasso and Pollock. (In life, Liberman enjoys gambling, and games of chance are one of his wife's passions.) Slowly, the idea of gambling with his art in new ways began to take shape in Liberman's mind. Of Picasso he wrote: "He knows that his faith in the accidental, in the so-called laws of chance, is his best guarantee of continued creativity."

*Reproduction of the species is basic to the human condition. Wouldn't one of the ways of entering the preprinted brain be through a certain sexual representation? After all, breasts, spheres, cylinders—why all are these elements interconnected? Meditating on this, and looking at paintings ranging from Matisse to the primitives, one discovers certain constants. I wanted to schematize them and arrive at a system of symbolic forms.*

108. Visual diagrams, 1950-51  Pencil on paper

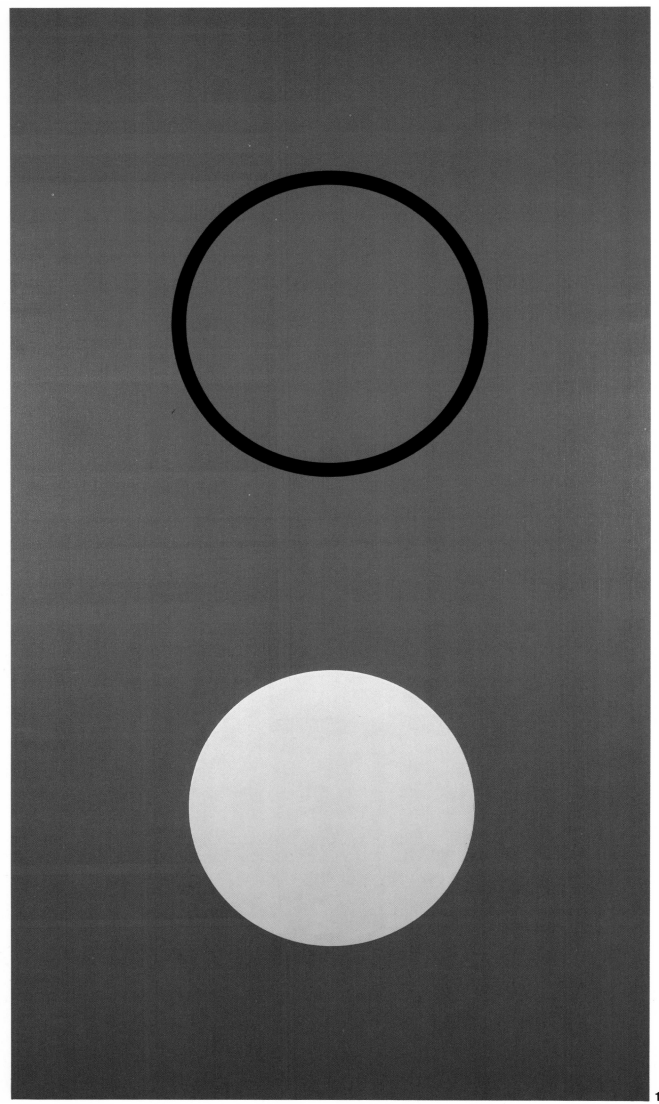

Although the hard-edge circle paintings of the Fifties seem stylistically opposed to the freer, more painterly images that succeed them, common to all Liberman's paintings of the Fifties and Sixties is the sense of weightlessness, the allusion to sensations that are not earthbound. (*109*) We have seen how neo-Platonism was the source of the circle as symbol of the infinite. In America, Liberman also became acquainted with Emerson's Transcendentalism. Emerson, too, saw the circle as an important cosmic symbol. In his essay, "The Eye Is the First Circle," Emerson speaks of the "transparent eyeball." In Liberman's paintings, weightlessness became an analogy for the cosmic consciousness of the transparent eyeball of visionary sight.

In aligning himself more closely with the Abstract Expressionists, Liberman was free to adopt a painterly style that could now incorporate the sense of luxury and sensuality he loved in Venetian paintings. But constructivism was too deeply ingrained in Liberman's thinking for him not to seek an outlet for the more practical part of his nature. The only way he could shake off geometry as a painter, it seemed, was to find another outlet for it, and in these years he began to find this outlet in sculpture. There, geometry could find an even more powerful expression than in painting. The importance of constructivist thinking was considerable in molding Liberman's style as a sculptor. He frequently uses the phrase "imprinting" to describe the signaling function of art. Recently, psychologists have written of the importance of the imprinting process during early childhood. It is in this sense of a formative "imprint" that we must view Liberman's relationship to constructivism. Both the emotional turmoil of living through the Russian Revolution and the geometric clarity of form that emerged as the mystical, sociopolitical symbol of that revolution were forever imprinted on Liberman. They formed his inspirations regarding the social role

of art, as well as his ideal of the function of art as a visionary experience.

From the mid-Sixties on, however, his art was split in two. Geometry became the basis of sculpture, which he conceived of as a public symbol for a public place. Painting, on the other hand, became the expression of subjective emotion. Simply put, sculpture represented for Liberman the outer world of public affairs and the urban environment—the echo of the projects he designed as an architectural student in Paris—but painting was a private activity, the representation of an inner world, a means to transcend matter through creating space and light that were not of this world.

Although his mother later covered the walls of their European apartments with copies of the Venetian masters, in Russia she had created a purist atmosphere for her son in an all-white nursery. Painting for her was a matter of conventional representation, but she insisted that her theater sets, backdrops, and costumes should be abstract. Aware of Meyerhold's revolutionary art theater in Moscow, as well as of the Proletcult and Theater of Satire, she chose, in the theater at least, to reject realism in both action and decor. She describes her discovery that "the creative fantasy of the child reclaims images conceived in a synthetic form. An original decorative composition, with simplified elements, with somber colors and a grand concept, would strike the spirit and awake fantasy." She might have been describing the paintings her son Alexander would make in the Sixties in New York.

It may seem exaggerated to claim that so young a child could have been so strongly affected by the geometric art he saw in Russia, but his mother's description of her son in her memoir indicates how precocious and aware he was: "The child, fragile and sensitive, became in this nightmare the worst victim." Her description accounts for much that formed

109. *Iota III*, 1961
Oil on canvas, 80 x 45 in.
Collection Albright-Knox Art Gallery,
Buffalo, New York.
Gift of Seymour H. Knox

*I was interested in forcing the spectator to experience the dimension of space through a logical brain process. I expected that through the mind's need to assemble and identify identical parts, the spectator would discover the relationship between the white disc and the black circle and perform a mental somersault in space—thus from a flat image a deeper space than the one created by illusionistic means could be experienced.*

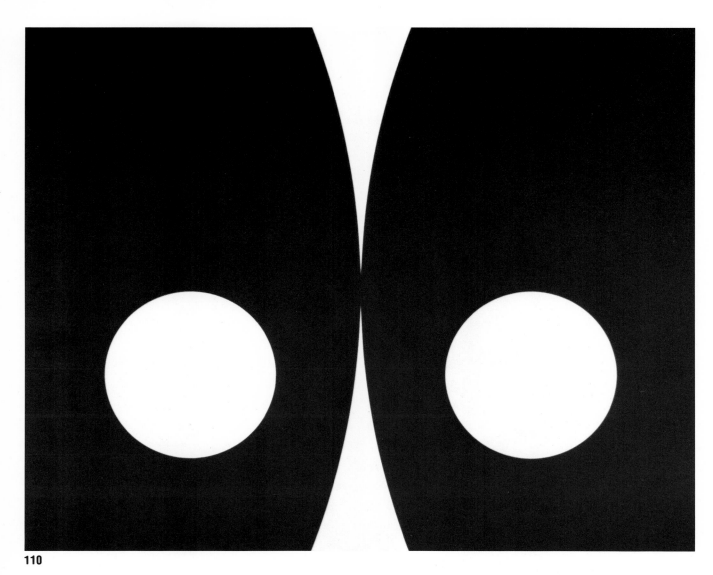

110

*What interested me were all the signals: flags, heraldry, the images that through the centuries had had a quick rallying effect. I was fascinated that in the bullring, the place where the toreador runs for safety had a white circle and a red background. Here was a man in danger of his life. The quickest signal that could be given to him was a circle on a red background.*

110. *Alpha VII*, 1961
    Acrylic on canvas, 80 x 100 in.

111. Sketch for sculpture, 1963
    Pencil on paper

112. *Alpha III*, 1961
    Oil on canvas, 60 x 80 in.

111

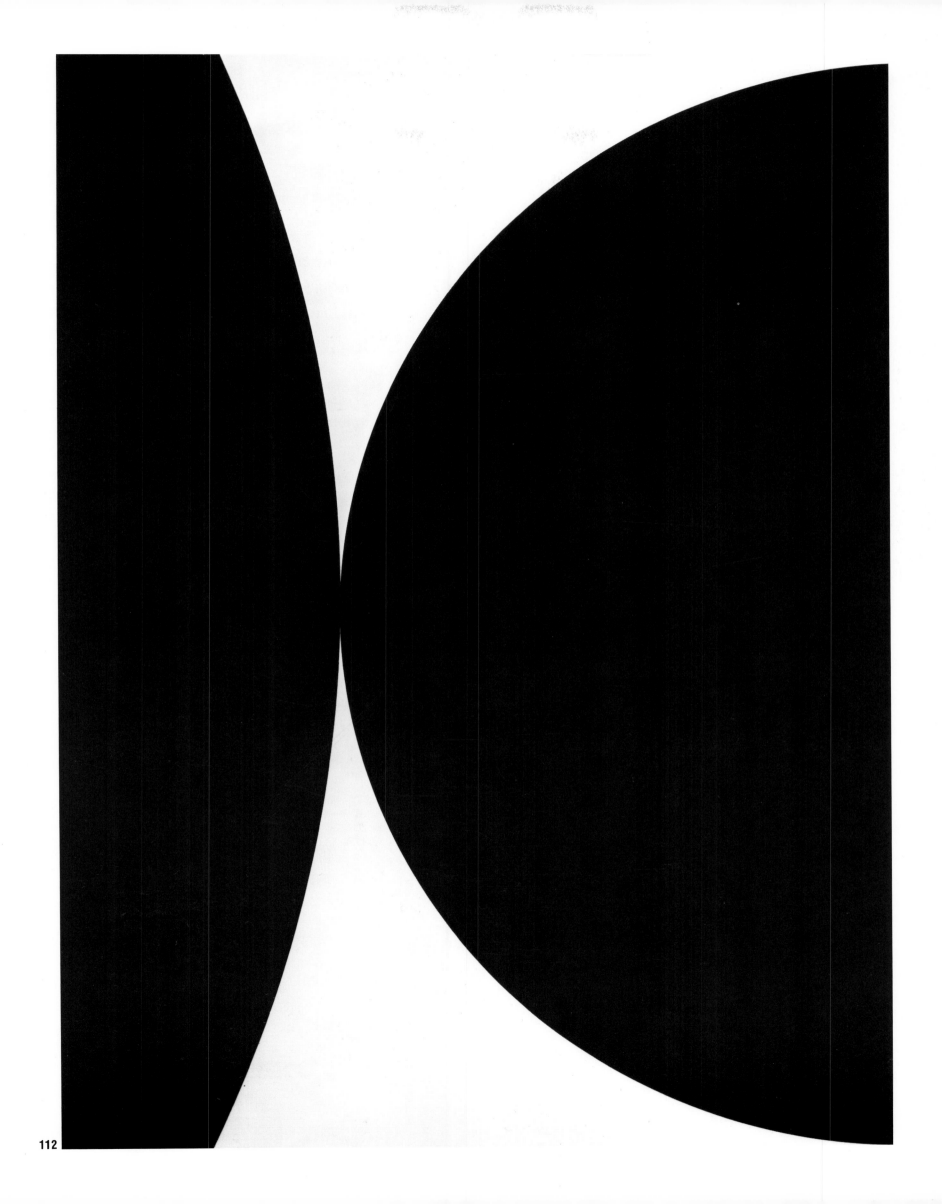

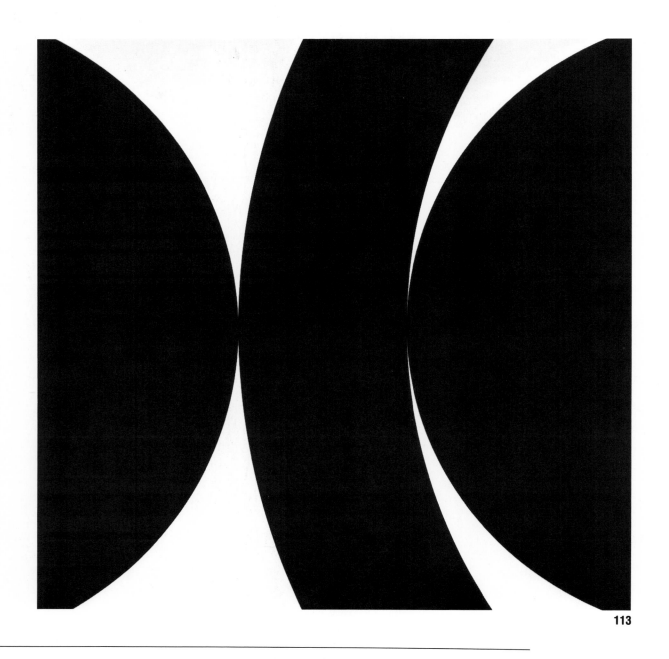

**113**

The cover of my second show with Betty Parsons was a black and white painting: two circles with a form in the middle. After it was printed, the engraver gave me back the metal. It was like a small sculpture.

In photoengraving when you make a plate, the engraver gives you back the piece of metal shaped to the shape of the drawing. They then attach the metal cut-out to a piece of wood from which they print. Theoretically from a flat object, a drawing, you have this three-dimensional object—a miniature sculpture. Photoengraving led me to give some drawings to a fabricator to cut a three-dimensional sculpture.

113. *Omega XI*, 1961
Enamel on aluminum, 48 x 48 in.
Collection Mr. and Mrs. S. I. Newhouse, Jr.

114. Sculptures photographed
for article by Peter Blake in April, 1963 *Forum*.
(Left to right) *The King* (1962),
*Tiresias* (1962), *Sigma II* (1962)

**114**

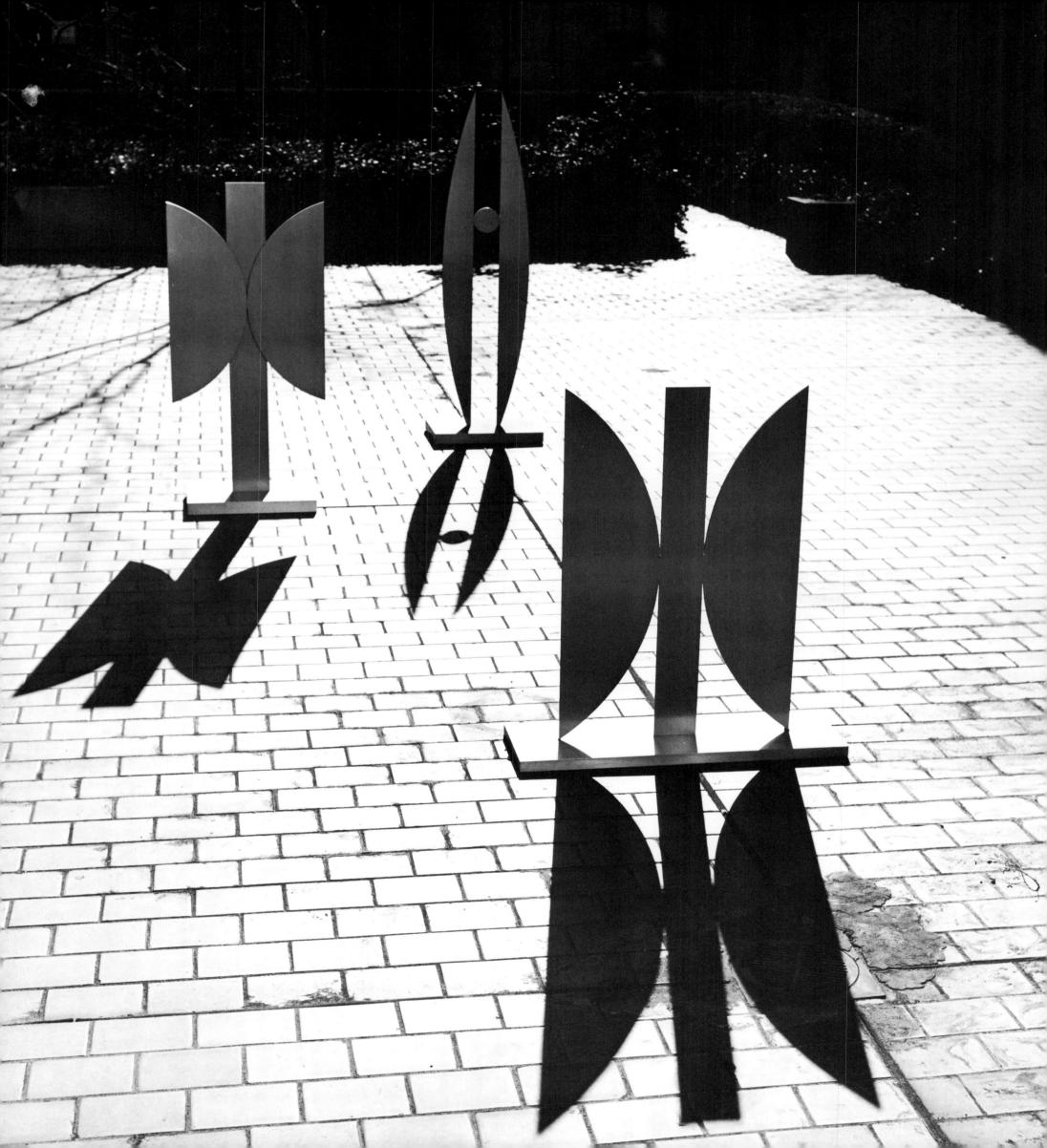

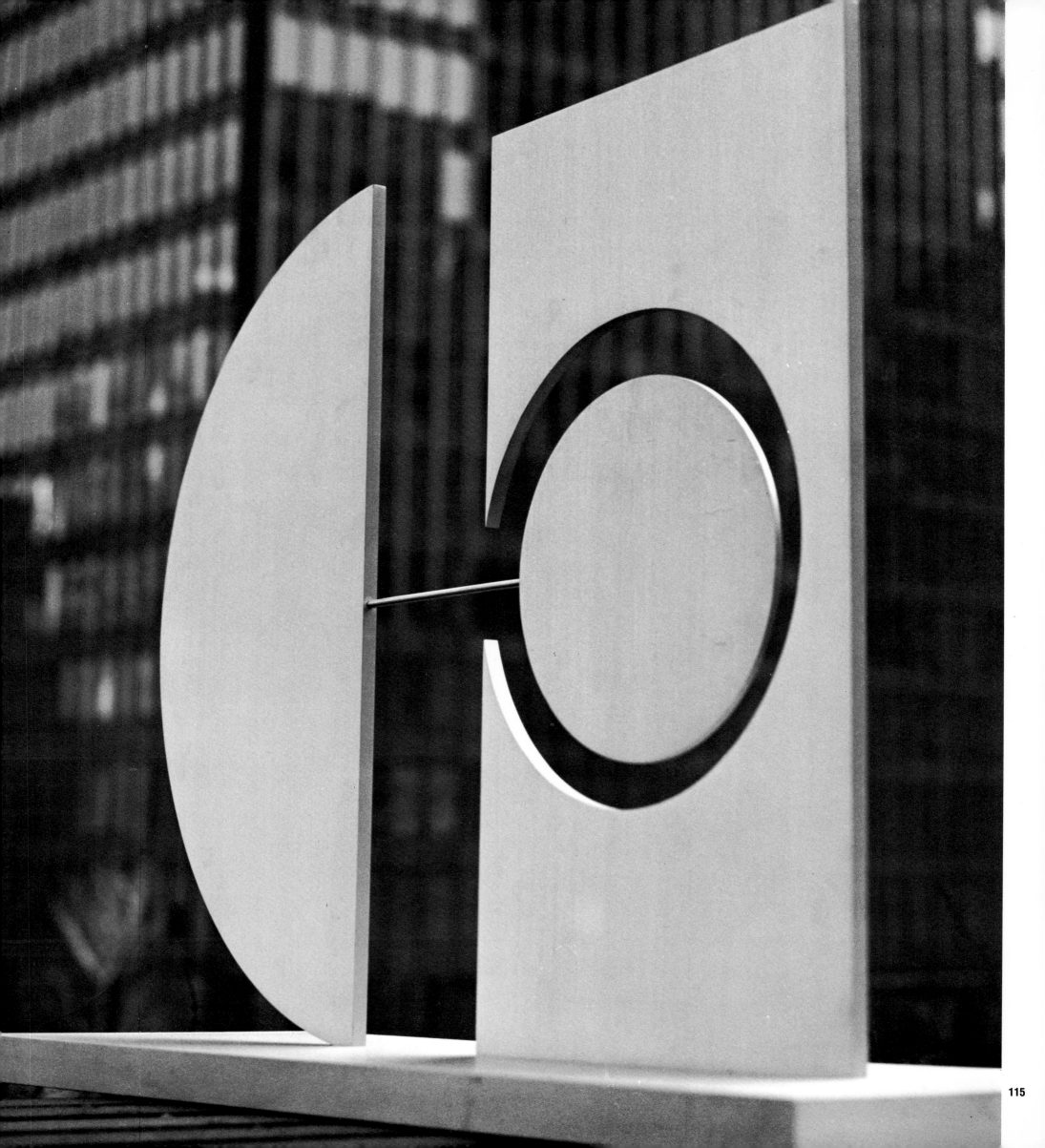

Liberman's conception of art. "The Russian child," she wrote, "above all, that of the revolutionary period, was surely more mature, more rational than any other." Moreover, she maintained that "the innate idealism of the people, the mystical tendencies, were ardently revived in the souls of Russian children. They aspired to heroism in life, as in the theater: They loved beautiful adventures, glorious exploits and great sentiments. . . . And the history of their country, so rich in great struggle and tragic episodes, also contributed to their need to have an ideal in life."

Whether Mme Pascar's observations were true or not is immaterial. She believed that art was heroic and she communicated that belief to her son. She also passed on the mystical conception, popularized by Tolstoy, of the *russkaia dusha*—the profound romanticism and religious yearning of the Russian soul. This mystical tendency was reinforced by the philosophical ideas of Simon Liberman, who aligned himself with Berdyaev's more modern theology. Alexander Liberman's maturation as an artist would come as a result of his recognition of the spiritual, transcendental dimension in art. This growing urge to express the visionary and the ineffable would cause him to react violently against his own work, to criticize and reject its content as overly intellectual and rational, in his pursuit of higher truths only gradually grasped.

Liberman had always been interested in mystical literature, particularly Ouspensky's *Tertium Organum*, which he read in 1946. Ouspensky had devised an elaborate cosmology based on circles and spheres indicating higher levels of consciousness, which probably reinforced Liberman's appraisal of the circle as an occult symbol. The same year that he read Kepes's book on the semiology of vision, Liberman was also reading Kandinsky's *Concerning the Spiritual in Art*, which Baroness Rebay republished in English in 1947.

Kandinsky died in 1944, ten years before Liberman photographed his Paris studio. In his long essay on the Russian-born mystic, Liberman noted the presence of souvenirs of Russia in Kandinsky's studio: icons, peasant carvings, children's toys, which were familiar to him as well. To prepare himself to interview Kandinsky's widow, Nina, he reconsidered Kandinsky's writings, which stressed the relationship between painting and music. That Kandinsky arrived at abstraction not by analyzing nature, like the Cubists, but by inspecting his own paintings fortified Liberman's conviction that the road to originality was through auto-inspiration. Elegiac in tone, Liberman's essay on Kandinsky amounts to a personal credo. Written in 1954, this essay is the first indication of disenchantment with Duchampian intellectual games and with Kepes's and Moholy-Nagy's optical experiments. To engage and entertain the brain and the eye were no longer sufficient. Through Kandinsky, Liberman came to

*At first, I wanted art to be reproducible, not original, not fine. I was working against the grain of everything, against value. That was the idea. No value. I had theories about paintings being imprinted on the mind. I resented Abstract Expressionism. I felt I was involved with antipainting. The ego was hateful, the hand of the artist shouldn't be seen.*

**116**

**117**

115. *Clytemnestra*, 1962
Polished aluminum, 28¾ x 40 x 13 in.

116-117. Two views of the 1962 one-man show
at Betty Parsons Gallery

realize that the artist had to address himself to the emotions. He wrote:

*Logic, understanding cannot prove everything, but emotion, by upsetting our contact with reality, can put us into a state where without proof we are willing to believe; intuitively we sense the truth.*

Throughout the Fifties, Liberman had searched for the visual shortcut—the quickest route from eye to brain. By the mid-Fifties, his feeling, intensified by his reading and his experience with Kandinsky, was that intellect was the enemy of emotion, and the brain the blockade on the road to spiritual enlightenment:

*For the spectator the way to abstract art is through an emotional reaction. Between the painting and the onlooker a bond of sympathy and attraction has to exist. One must literally fall in love with a painting. The bypassing of the intellect is a direct appeal to feeling.*

In February, 1962, Liberman had his second show of circle paintings at Betty Parsons, including several tondos. *(121, 122)* The titles were derived from the Greek alphabet, suggesting a continuing involvement with neo-Platonism. However, the paintings were larger, bolder, and both physically and formally more expansive. *(123)* They were painted on canvas with acrylic paint or with oil, which gave them a greater depth and intensity than the enamel-on-panel paintings in his first show.

Lawrence Alloway, the English critic who invented the term "pop art" wrote the catalog introduction. For Alloway, the most significant element in these works was their symmetry, which he found familiar in architecture and ornament, but rare in painting. Liberman, of course, had studied architecture and understood the implications of symmetry well. However, Alloway reasoned that Liberman organized his paintings symmetrically because he was concerned with art as an idea "rather than as the issue of a highly physical creative procedure." Liberman was soon to change this or-

der, elevating action over contemplation. Alloway correctly observed that although Liberman's circle paintings were rooted in a classical tradition, the art was beginning to be critical of Platonic absolutes.

A critic identified with populist causes, Alloway was particularly impressed by Liberman's ideas regarding the democratization of painting through the possibility of multiple originals, which could be fabricated according to the blueprints and instructions Liberman provided. "If one of Liberman's paintings were destroyed," he wrote in his catalog, "it could be remade if an adequate record existed. The uniformity of the surface and the absoluteness of the transitions between one area and another, could be recorded, whereas the facture of a highly manual work could not, at present, be encoded practically and repeated without loss."

Given that Liberman had seen the world shattered twice, two societies destroyed, and cultures decimated, his preoccupation with art as an indestructible idea rather than a perishable object becomes comprehensible. By the time of his second New York exhibition, however, memories of Lenin and Hitler were no longer uppermost in his mind, and his attention turned toward intensely individualistic and subjective work that could not be made by anyone other than himself. There is a curious coincidence regarding the relationship between conception and execution in Liberman's works of the Fifties and Ad Reinhardt's conclusions regarding the method of democratizing art, expressed in the statement: "This is your painting if you paint it." Reinhardt, who wrote and published his theories extensively, is often considered the originator of the premise that the idea of art is the essence of creation. The precedence of the original idea over the quality and content of the object is the point of minimal and conceptual art, beginning with the fluorescent light environments of Dan Flavin and the standard construction units of brick and steel plates of Carl Andre and the I-beams of Robert Morris. Liberman anticipated these concerns by over a decade in his fabricated hard-edge paintings.

*Circles were forms of hypnotic withdrawal from the world. The basis of it all is a withdrawing from reality in a deep sense, of going beyond human limitations, which is to me the realm of serious art: to treat matter as if it were not a limiting factor, to engage in the struggle with matter. It's a question of transmutation. This is the alchemical challenge of the artist. Alchemists were not philosophers. They were artists without knowing it—they were magicians.*

118. *Sun II*, 1962  Acrylic on canvas, 80-in. tondo

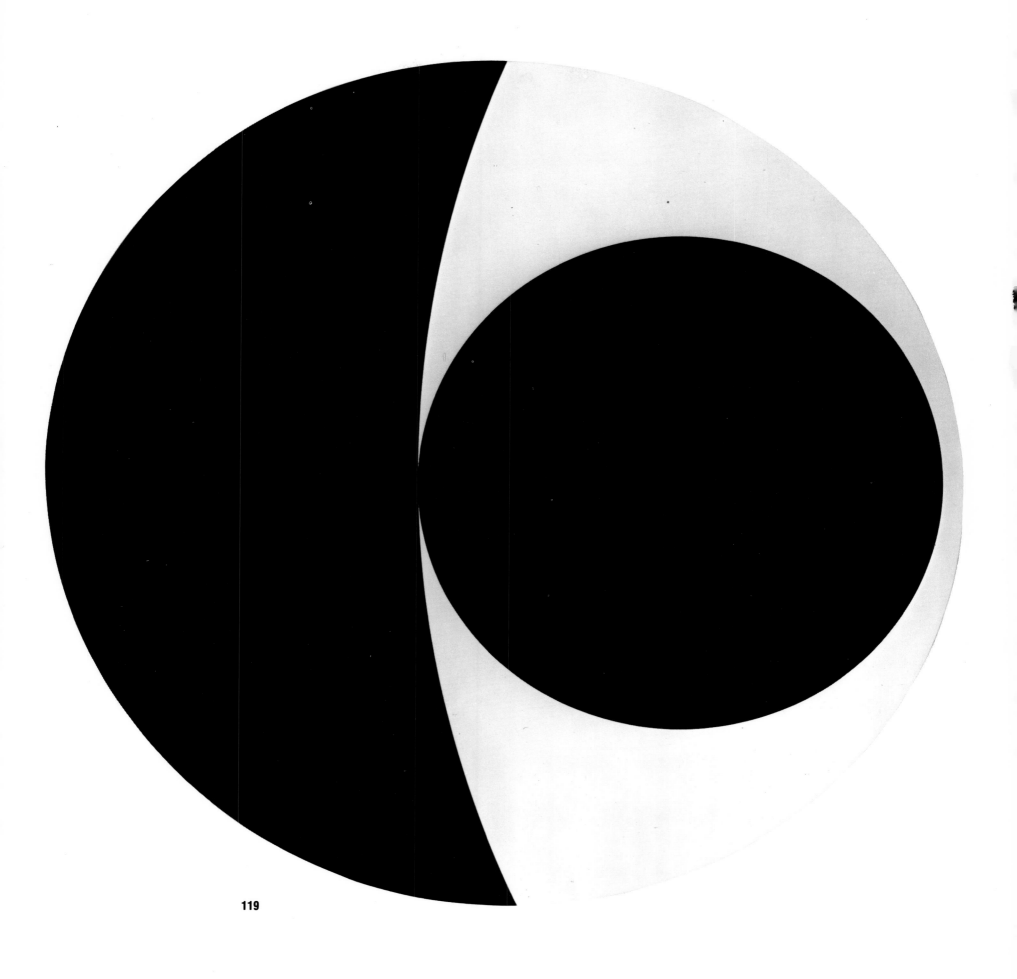

**119**

*I came to understand that you should express your-self—that way you finally communicate a deeper uni-versal. Classical art is a cover-up—basically it's a court art. Real art cannot stand academic rules. Clas-sical art is really an academic art.*

*I stopped making a given series when I felt the search had ceased, and that I was just fabricating images. The image, in itself, didn't interest me that much. I wanted to go beyond images: I have no particular respect or admiration for the finished work as an ob-ject. What interests me is its impact—on the spectator or maybe on me as a spectator. In the long run, the best means of arriving at the universal is to please oneself, to test through oneself in searching.*

*I think the whole physical relationship of men and women in the sexual act, and all it involves, is the core of life. Any art that ignores the central core cannot achieve real universal communication. The concept of the full and the void is at the base of human com-munication. To translate this human relationship into graphic terms is part of an artist's mission, if he is an artist.*

*I never thought of my painting as flat. I was drawing a circle on a surface that I thought should be a perfect surface—that was it. There was an element of Dada, too, in making art that isn't art. I was not making fun of art, but seeing how one could create something which would pose a visual problem to oneself. I was not try-ing to do art. I was drawing my circle. I wasn't saying to myself, "Let's do something terribly flat, let's negate space." I never thought of that. I only started thinking of space when color came into my work in 1963. Color, for me, is space. Through color I became really in-volved in sculpture—in texture and space.*

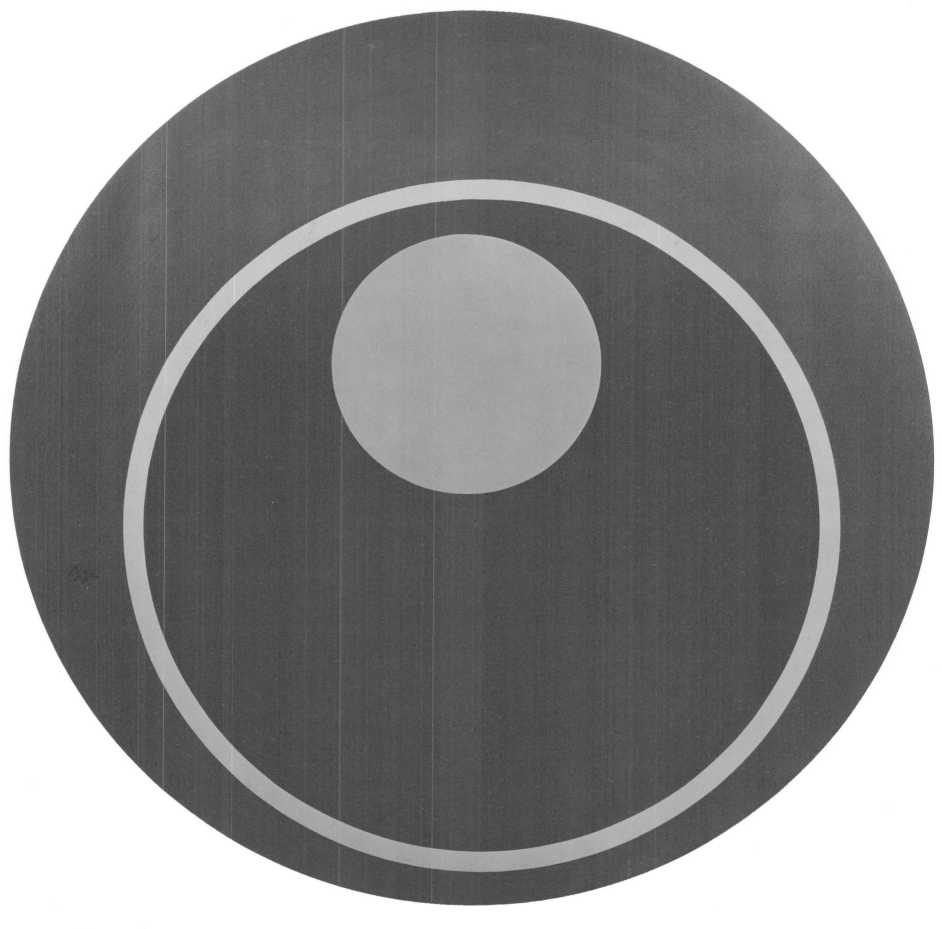

118

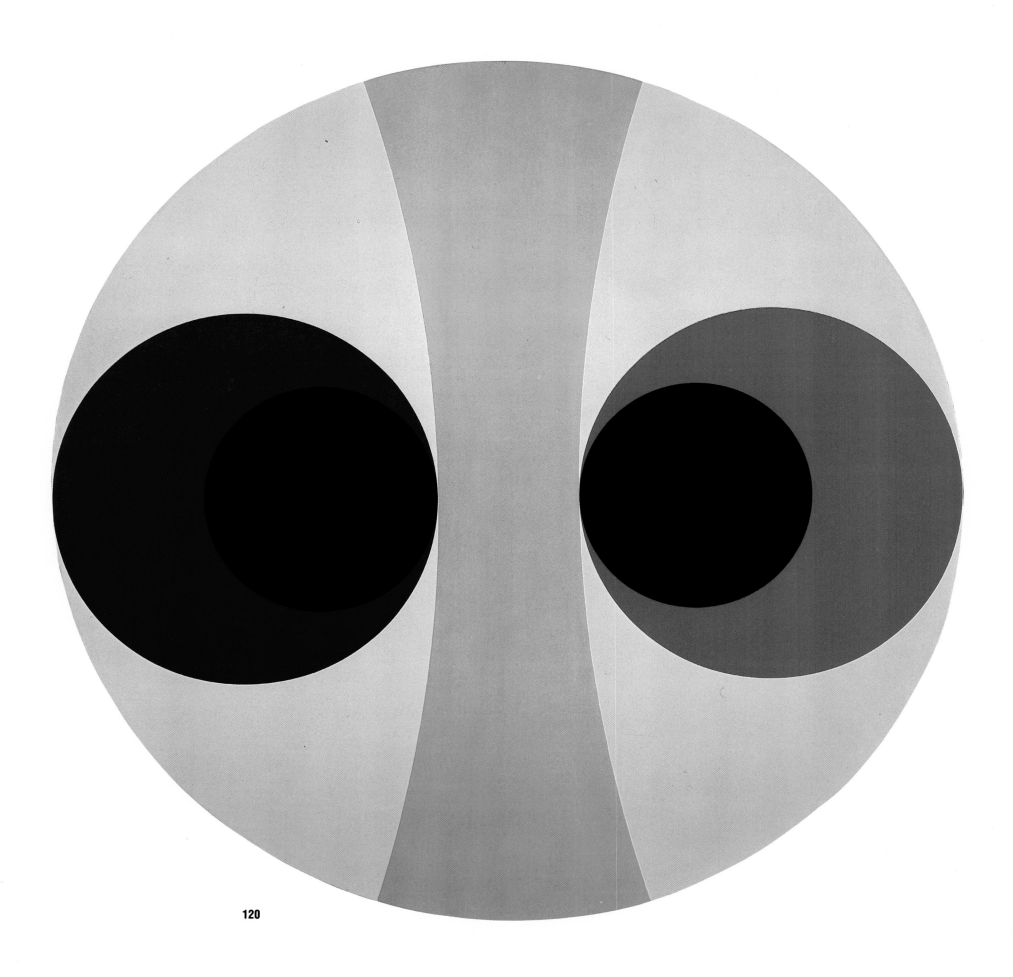

120

◁

119. *Omicron IV*, 1961
Acrylic on canvas, 80-in. tondo

120. *Omicron VII*, 1961
Acrylic on canvas, 80-in. tondo

121. *Omicron III*, 1961
Acrylic on canvas, 80-in. tondo
Collection Everson Museum of Art,
Syracuse, New York.
Anonymous gift

122. *Omicron II*, 1961
Acrylic on canvas, 80-in. tondo

**123**

123. *Socrates*, 1962
Acrylic on canvas, 80-in. tondo

124. *Sybil*, 1963
Painted aluminum, 96 in. h.
Collection Mr. and Mrs. Burton Tremaine

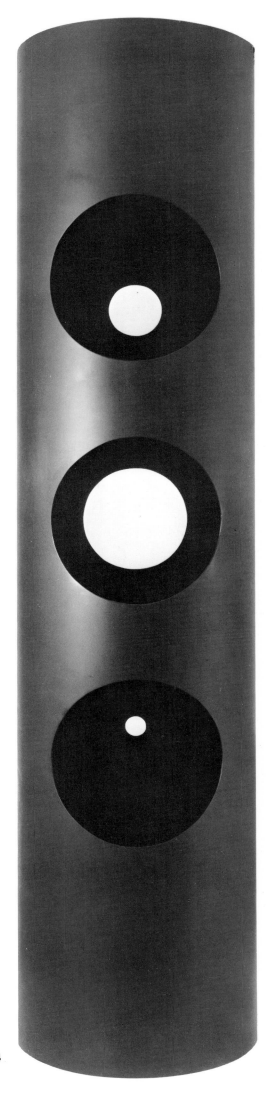

**124**

That the idea of art took precedence over its execution was the most radical assumption of constructivist splinter movements like productivism. One major difference between Liberman and Reinhardt's minimalist followers, however, was that Liberman's relationship to constructivism was a matter of personal experience. The New York School only became acquainted with constructivist intentions with the publication of Camilla Gray's *The Great Experiment* in 1960. The first book on constructivism widely distributed in the United States, *The Great Experiment* introduced the ideas and images of Russian revolutionary artists to Americans in search of an aesthetic with the connotation of political radicalism.

If Liberman had been content simply to translate his two-dimensional shapes into three-dimensional equivalents, his career as an artist would have had the logical consistency that formalist criticism demanded. But inspiration is not logical or consistent. While critics like Alloway and Greenberg praised Liberman's geometric paintings, Liberman was, as we have said, in the process of subjecting himself to a rigorous auto-critique. He was dissatisfied with his own work: it was too neat, too tidy, too well organized, too intellectual, and too rational. His decision to change his style at a moment when he could have claimed the role of pioneer of hard-edge abstraction effectively destroyed his chances of art-world success. By rejecting the aesthetic he had contributed to forming, he isolated himself once again.

Liberman's decision to alter his painting style radically, rejecting the a priori idea for physical accident and risk, was intimately tied to his decision to become a serious sculptor. Projecting his geometric shapes into the third dimension—first as reliefs, then as free-standing cut-outs (*114*) which stripped the background away from depicted circular forms, and finally as fully three-dimensional volumes—he anticipated the push of minimal art into literal objecthood. (*124*) To thrust his two-dimensional geometrical shapes out into three-dimensional space was certainly the next logical step. This process satisfied the primary demand of literalism: to eliminate figure-ground relationships by cutting the figure out of the ground. Literal projection into real space was the route pursued by object artists Don Judd, Robert Morris, Carl Andre, and Dan Flavin, as well as George Segal and Frank Stella. In the mid-Sixties, the goal of objecthood was so compelling that even Kenneth Noland painted shaped canvases. Liberman, on the other hand, performed an about-face that stunned those at last ready to acclaim his art.

Liberman's enamel panel paintings seemed so advanced, furthermore, because they were conceived as permutations, and they also interpreted light in a literal fashion. Their hieratic composition and hard glossy finish derived from Russian icons. The enamel paint permitted Liberman to interpret his

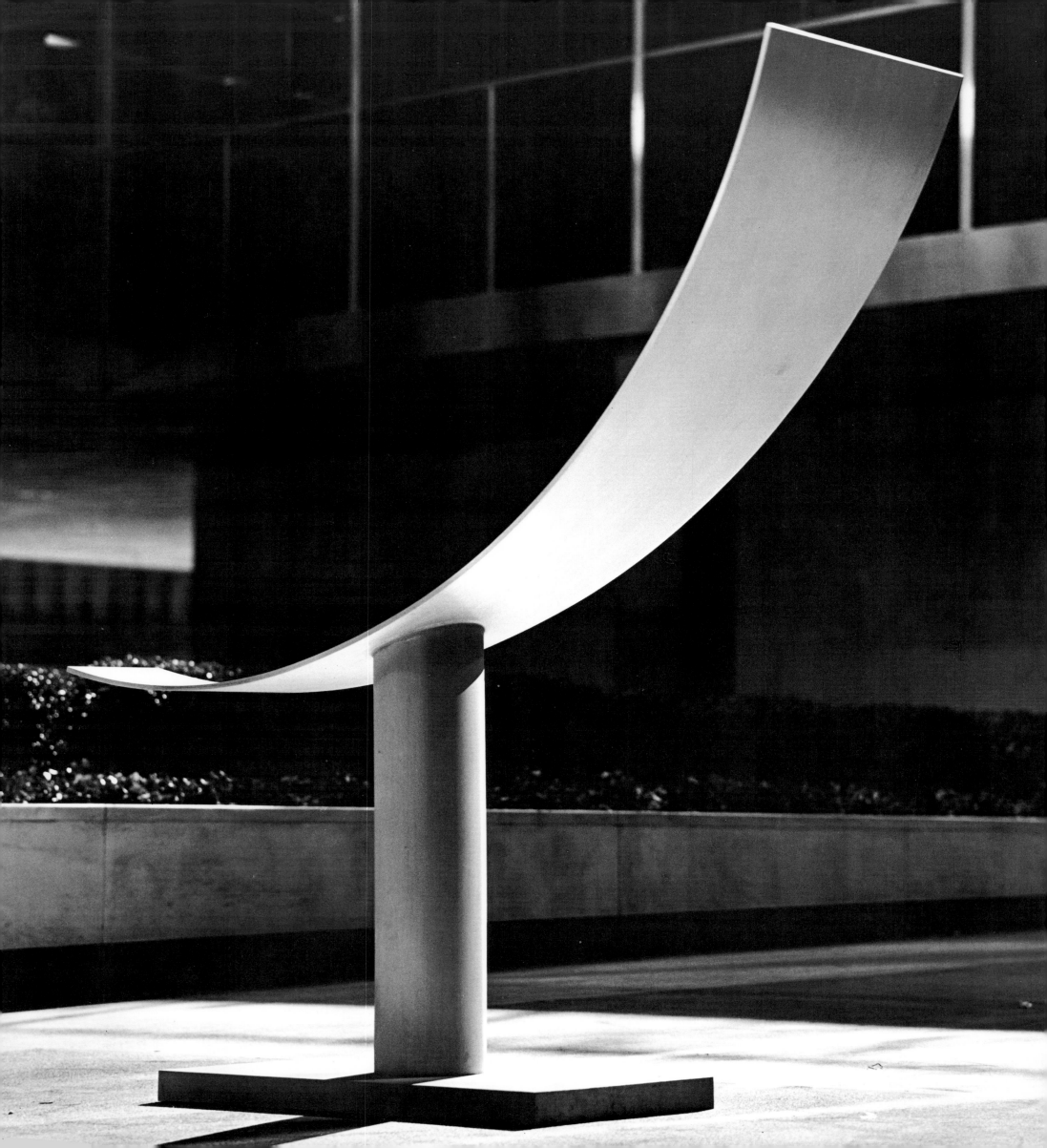

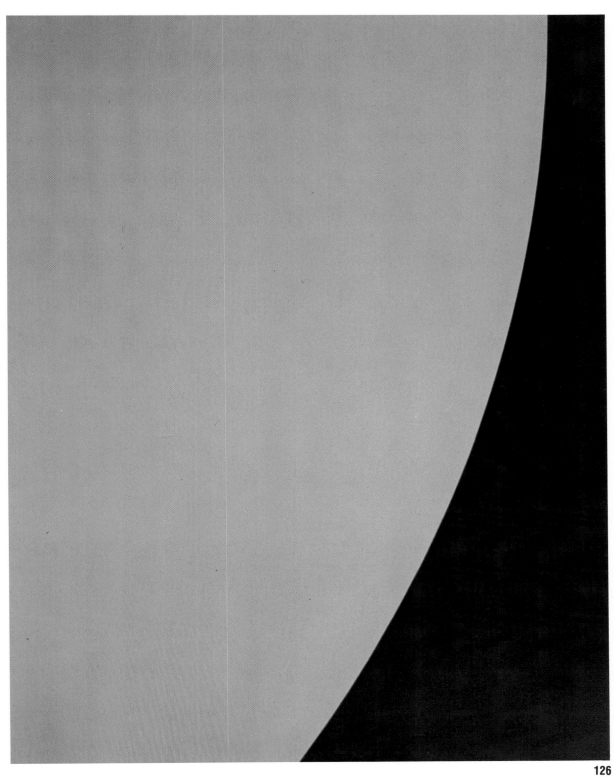

**126**

125. *Aphrodite II*, 1963
Polished aluminum, 76 x 83 x 20 in.
Collection Mr. and Mrs. Joseph Lauder,
Palm Beach, Florida

126. *Untitled*, 1962
Acrylic on canvas, 42 x 33 in.

*Large scale implies transcendence. It implies human beings going beyond their means, which I think is a cardinal element of inspiration. I believe in a potential in all human beings that is there to be awakened. Art is the great moralizing force.*

life-long concern with dazzling light through literal reflection. In his later paintings, he had to discover new ways to create an illusion of such light streaming through color from within the canvas.

Liberman's rejection of literalism and objecthood in his painting meant a rededication to a tradition of European art. As soon as the war ended, Liberman had returned to Europe, surprised to find that the villa his father had given him in Ste. Maxime, which the Germans had occupied, was still standing. From 1947 to 1963 he and Tatiana spent summers on the Riviera in the Villa Va-et-Vient ("come and go"), as it was called. In the summer of 1959, their housekeeper married an iron-worker who made balconies for the villas in the area. He taught Liberman how to weld, which not only opened a new road in terms of the possibilities of sculpture, but also suggested to Liberman a new kind of imagery, of sparks and startling bursts of light like those produced by the welder's torch. Two other events of 1959 also contributed to the change of style in his painting: a successful stomach operation cured Liberman of the bleeding ulcer attacks that had kept him periodically bed-ridden, and enabled him to be more physically active; and he began to draw—abstractly now instead of precisely. These drawings, which were often technical experiments with chance procedures including erasures, dripping, and splattering, were the result of Liberman's increasing sense that what counted in art was risk, and that those who dared were the heroes of art. For him, Picasso and Pollock, whose drawings he owned and studied, were the greatest adventurers. They also impressed him as artists who had radically altered their styles. Duchamp's idea that the artist should not repeat himself now seemed to him to count only if the refusal to repeat were made in the name of some higher goal. For Liberman, that goal had to be to ascend the rings of Ouspensky's *Tertium Organum* to the higher levels of consciousness.

In his essay on Kandinsky Liberman quotes from the master: "Do not fall into a manner. Change; find by yourself and do not copy, make it your own." Like Picasso's abrupt stylistic ruptures, the extremity of Kandinsky's shift in style from the painterly expressionism of his Blaue Reiter period to the hard geometry of his Bauhaus style encouraged Liberman to change himself, to risk more, and to ask more of painting than optical excitement and formal arrangement.

Taught from childhood that earth and matter are dross and that the spirit ascends toward a heavenly realm, Liberman believed Brancusi's advice, which he quoted in his book: "If you live well, if you purify yourself, you go up into the heavens and stay there. If you live badly, you come back onto this earth or another earth. Earth is a hell." Brancusi's obsession with ascension became his own and is reflected in both his painting and sculpture. To expunge any reference to the earthbound became a principle drive in his painting. The image he sought could no longer have anything to do with the mechanical forms of industry: Liberman aspired now to paint the emotions evoked by the ineffable and terrifying cosmos itself. This transition to a fluid, painterly style took place in the early Sixties. As the formalistic idiom of "hard-edge" painting gained popularity, Liberman was searching for a cosmic image that was neither Platonic nor Pythagorean, an image that broke with classical norms of decorum to engage with the unpredictable elements of risk and accident. During a decade when the rational and the positivistic dominated art in New York, Liberman stubbornly turned toward a romantic, expressionist, baroque style by then out of fashion. Its only apparent continuity with his earlier work was a commitment to communicate universal symbols.

127. *The Great Mysteries I*, 1962  Acrylic on canvas, 11¾ x 80 in.

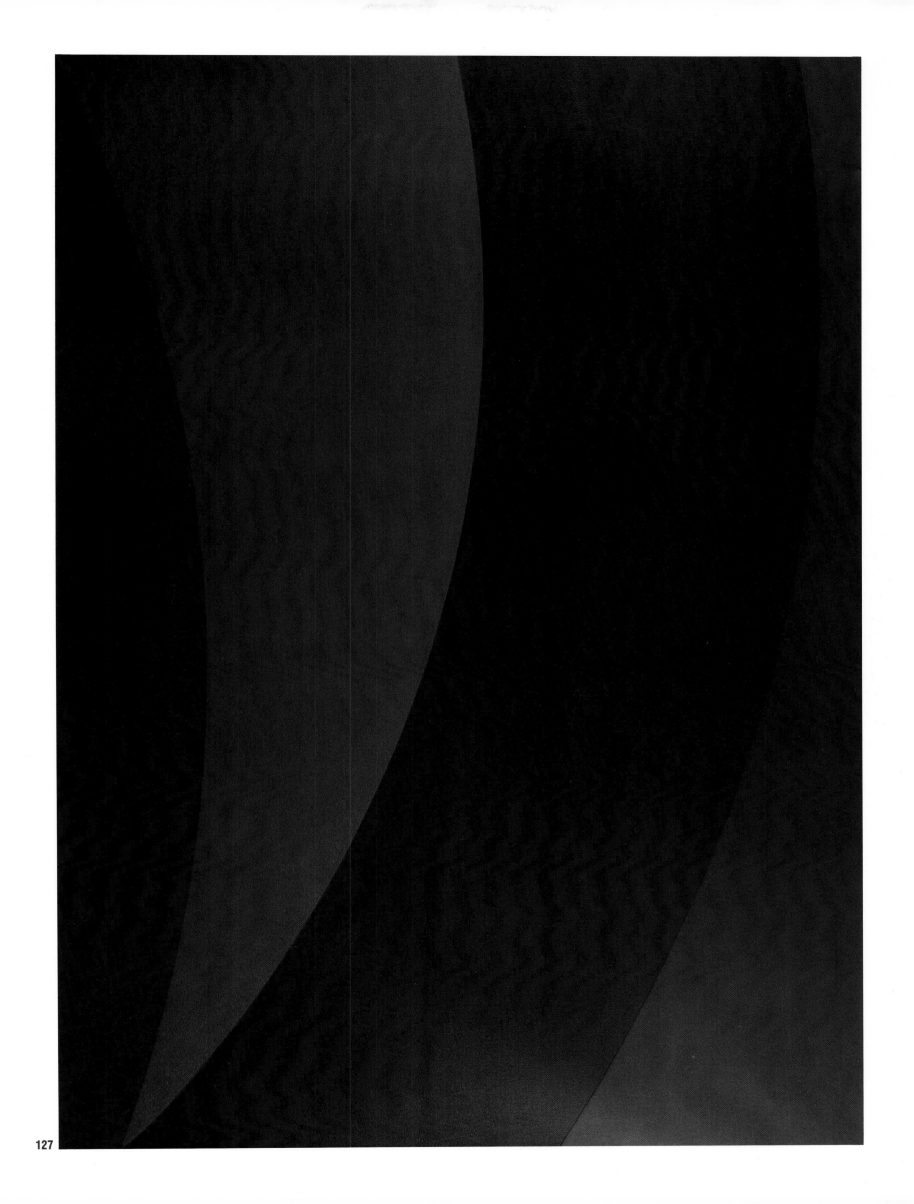

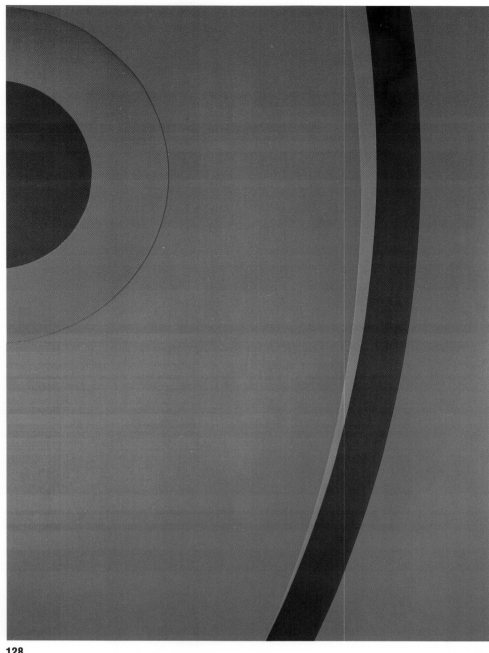

The new concept of a cosmological image began to take form in 1962, in Liberman's first color-field abstractions painted with Liquitex, a new fast-drying water-based plastic paint that covered large areas evenly and quickly. The series of the Great Mysteries interprets hard-edge painting in terms of spreading fields of colors. These luminous fields are reminiscent of the deep, resonant tones of the Venetian paintings that Liberman returned every summer to study. The image of a great circle alludes to infinity by breaking the frame, soaring beyond the limits of the canvas. Now the circle is no longer inscribed within the field, but breaks the frame to expand beyond the edge. The center of the circle is outside the frame: the segment of the radius within the painting field implies a much larger whole. A new element of scale beyond literal bigness is created. Sweeping arcs carry the eye quickly from bottom to top, alluding to a circle so vast that one sees only an infinitesimal part of a grander whole. (*126, 127*) In these paintings, the depiction of planetary motifs is transformed into suggestions of infinity. Symbol and sign are displaced by the greater ambiguity of metaphor. Thus, by 1962, Liberman had found his personal metaphor—the elusive "content" that the Abstract Expressionists deemed essential to defining art as more than decoration. For Liberman, this metaphor—nascent in the planetary orbits of his circle paintings—was the cosmological image. Essential to the sense of cosmic space is the absence of any horizontal line in these paintings, which do not attempt to abstract from nature, but rather to allude to the processes of natural phenomena.

Liberman's thinking evolved along the same lines as that of the Abstract Expressionists, whose images are often subjective metaphors rather than abstractions from nature. Although de Kooning and Hofmann painted abstractions from the figure, and Kline was inspired by urban structures, Motherwell, Krasner, Pollock, Newman, Still, Rothko, Reinhardt, and Gottlieb on the other hand were involved in finding universal symbols. Unconscious metaphors were an important source of such potent imagery. In Motherwell's case, the metaphor was initially phallic, as in Krasner's it was floral. Thus visionary imagery was the goal for the greatest Abstract Expressionists. By the mid-Sixties, Liberman was entirely aligned with their aesthetic.

The theme of the Great Circle, only a small portion of which is represented within the canvas, was suggested to Liberman by the theories of the Russian mathematician Lobachevsky, who challenged Euclid's assumption that parallel lines could not meet. Liberman imagined the vastness of a universe in which parallel lines could somewhere intersect. He aimed at creating an image that would suggest such infinity. At first, he thought of this concept in geometric terms. Because the area of the circle, whose circumference is indi-

**128**

128. *Light XI*, 1962
Acrylic on canvas, 80 x 60 in.
Collection Hirshhorn Museum
and Sculpture Garden,
Smithsonian Institution, Washington, D.C.
Gift of Joseph H. Hirshhorn

129. *Little Mysteries*, 1962
Acrylic on canvas, 80 x 60 in.

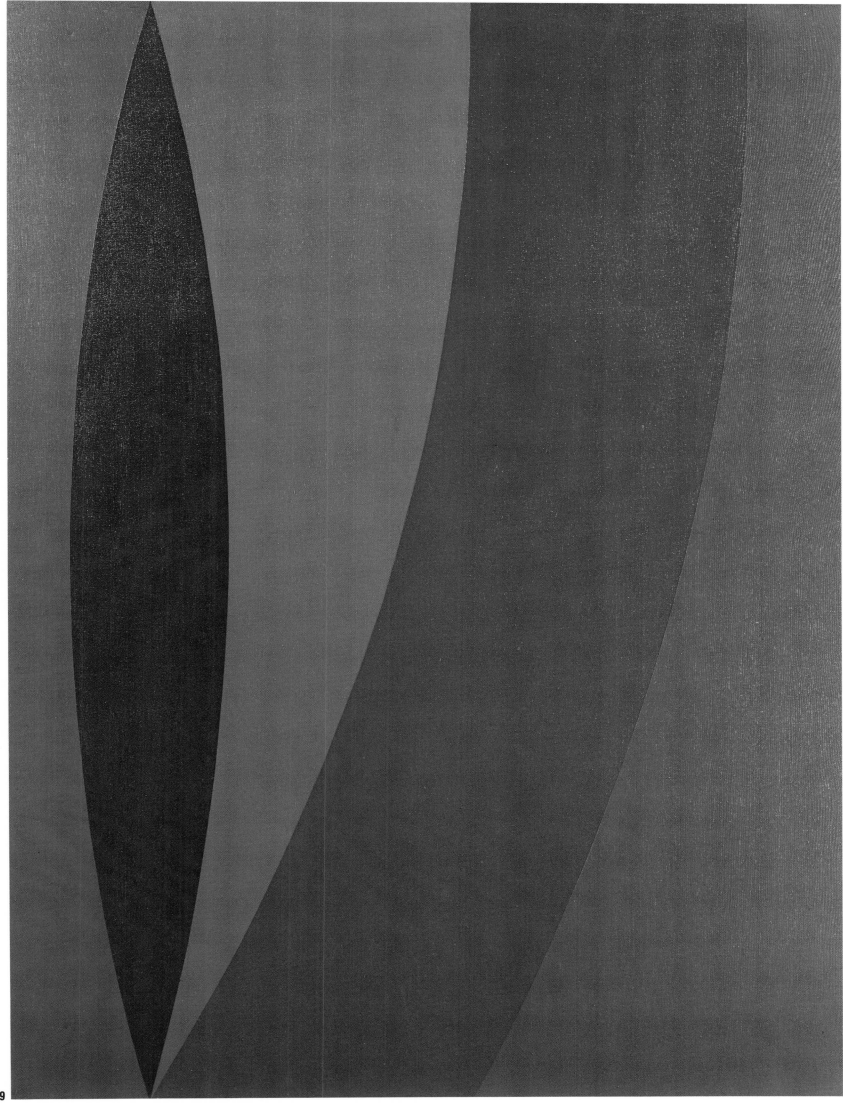

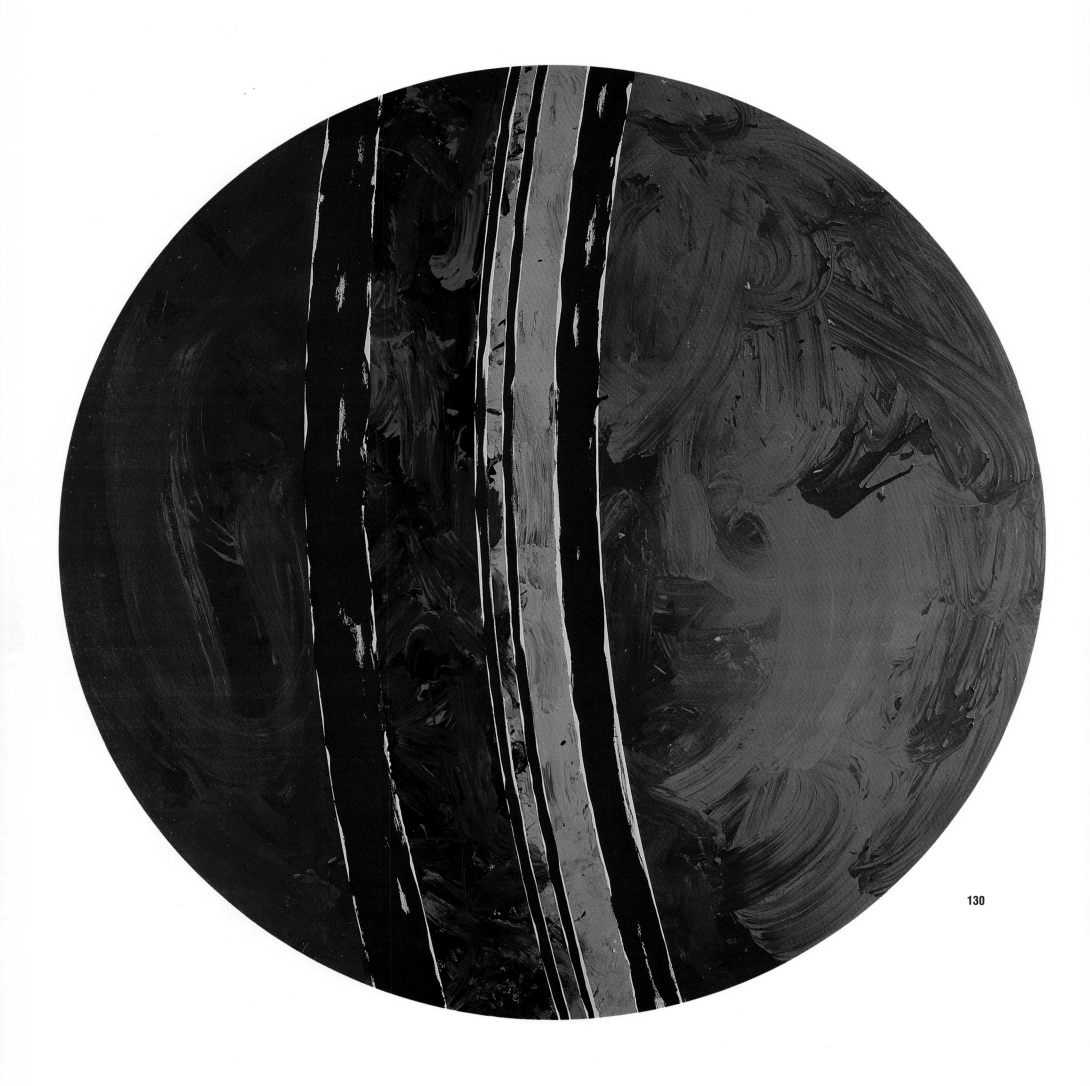

cated by a slash inside the painted field, is so enormous, and because it lies outside the canvas, it suggests infinity beyond the frame. (In the Seventies, Ellsworth Kelly based paintings and reliefs on the "Great Circle" motif.) The paintings actually were done with a giant compass Liberman ordered from a French cabinet maker. This specially designed compass had a radius of sixty feet. To draw the arc, Liberman had to stand in the vestibule of his studio. (*126, 127*)

By this time, Liberman's technique as well as his palette had changed. Both were more personal and subjective and less conventional and mechanical. Late in 1961, he began to paint on raw canvas. Photographs of Pollock at work suggested working on the floor. This permitted him to paint larger, and Liquitex allowed him to cover big areas faster as well. Through Newman, Liberman was introduced to bolts of cotton duck, purchased at Boyle's, a company that made sails. These bolts could be purchased in any length, which also encouraged an expanded field. During 1962-63, the experiments with random procedures for applying color, which he first attempted as drawings, became part of his painting technique with rollers instead of brushes. (*134, 135*) However, the transition to a painterly style from a linear graphic style took place in steps. Gradually, the circles were invaded by freehand painting. The tapes that created the hard-edge of closed shapes were also abandoned. (*130*) At this point, the baroque impulse toward painterliness and expansion was further emphasized. In addition to breaking the frame as in baroque compositions, Liberman also abandoned the closed contours of the classic linear style for the open contours of the baroque painterliness. Slowly, even the obsessive circle itself disappeared. (*141, 142*)

By the time the minimal and pop artists became dedicated to throwing off the weight of the dead centuries of art history, Liberman, who had witnessed the Great Experiment at first hand, was delving deeply back into the storehouses of historical memory, turning his attention to the Venetian splendor and pageantry of Tintoretto and the baroque fullness of Rubens, and to a new conception of Greek art that focused on the operations nature had performed on the timeless archaic forms. The 1962-63 transformation in Liberman's art required the splitting of his personality once more: this time into a painter of mystical images and a sculptor of public structures. In the sculpture could be expressed the drive to power and the mastery over materials on the grand scale of the architect Liberman never became; in the private world of mystical communion, the romantic yearnings of the *russkaia dusha* could burst forth. If the circle was the path of the dervish, the cosmic images that replaced it would allude to the paths of meteors and comets, to the revelation and new dawns of auroras, and the forbidding moments of dark eclipse.

131

*I wanted to use my hands. I was working with the anonymous hard-edge paintings, but I'd also done a lot of drawings. I had a tremendous desire to create irregular form and to use a different texture. One works by thesis vs. antithesis or counterpoint. 1963 was also the year when the hard edge was breaking up in my painting. I was very interested in flow of paint, and even the sculptures were called by nautical terms like "Reach." I've always loved the sea.*

130. *Phaedo*, 1963
Acrylic on canvas, 80-in. tondo

131. The artist in the studio
at 132 East 70th Street,
photographed by
Henri Cartier-Bresson, 1963

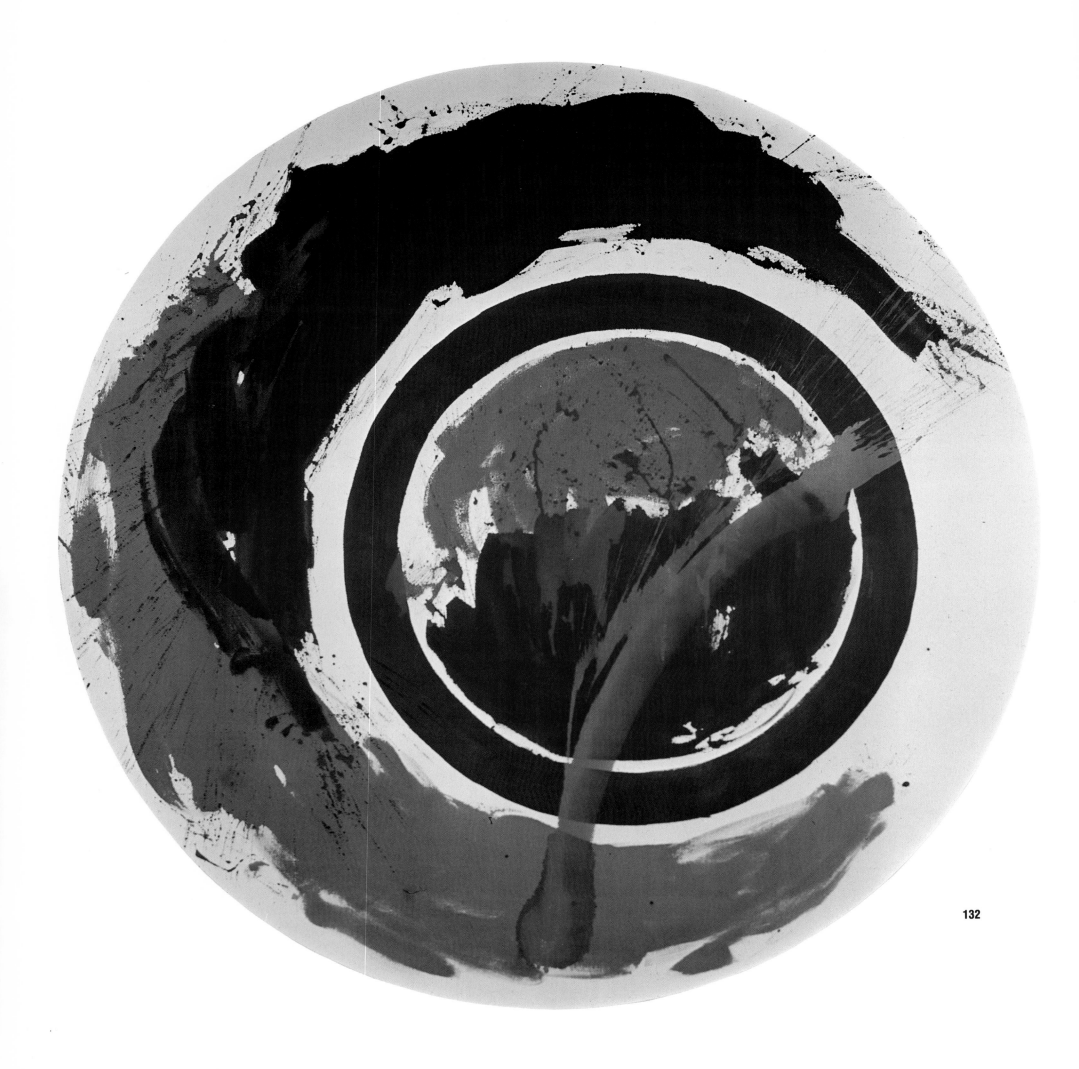

**132**

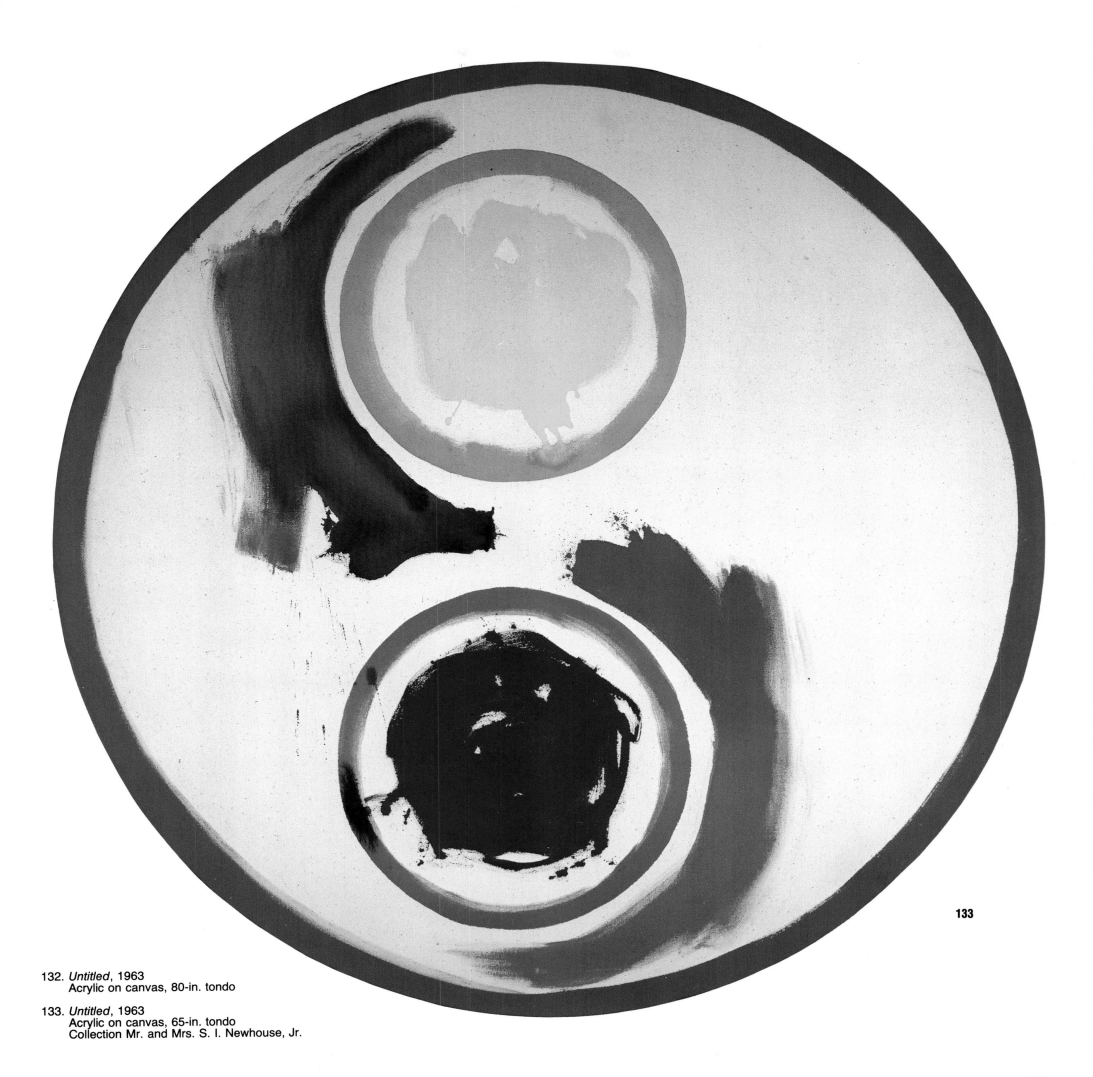

**133**

132. *Untitled*, 1963
  Acrylic on canvas, 80-in. tondo

133. *Untitled*, 1963
  Acrylic on canvas, 65-in. tondo
  Collection Mr. and Mrs. S. I. Newhouse, Jr.

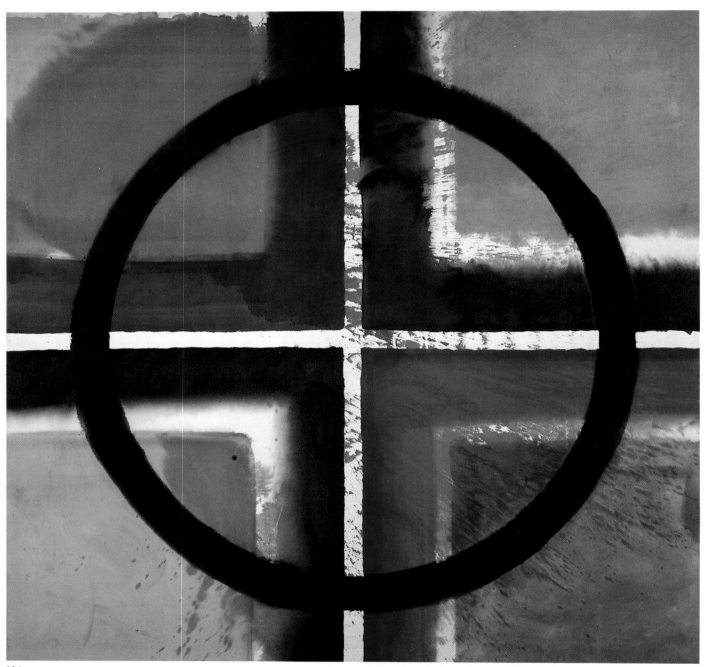

134

*In watery paintings, there's an enormous element of risk. In this technique, there's an incredible unknown that cannot be controlled. I find using the unknown a challenge. When you're using water, paint is very fluid and hard to control. It is almost an acrobatic feat to control the flow of very thin paint. It's very much a gamble, but you have to have some idea of what you're trying to do and hope that you can do it.*

134. *In Between I*, 1964
Acrylic on canvas, 114 x 114 in.

135. *In Between*, 1964
Acrylic on canvas, 115½ x 127½ in.

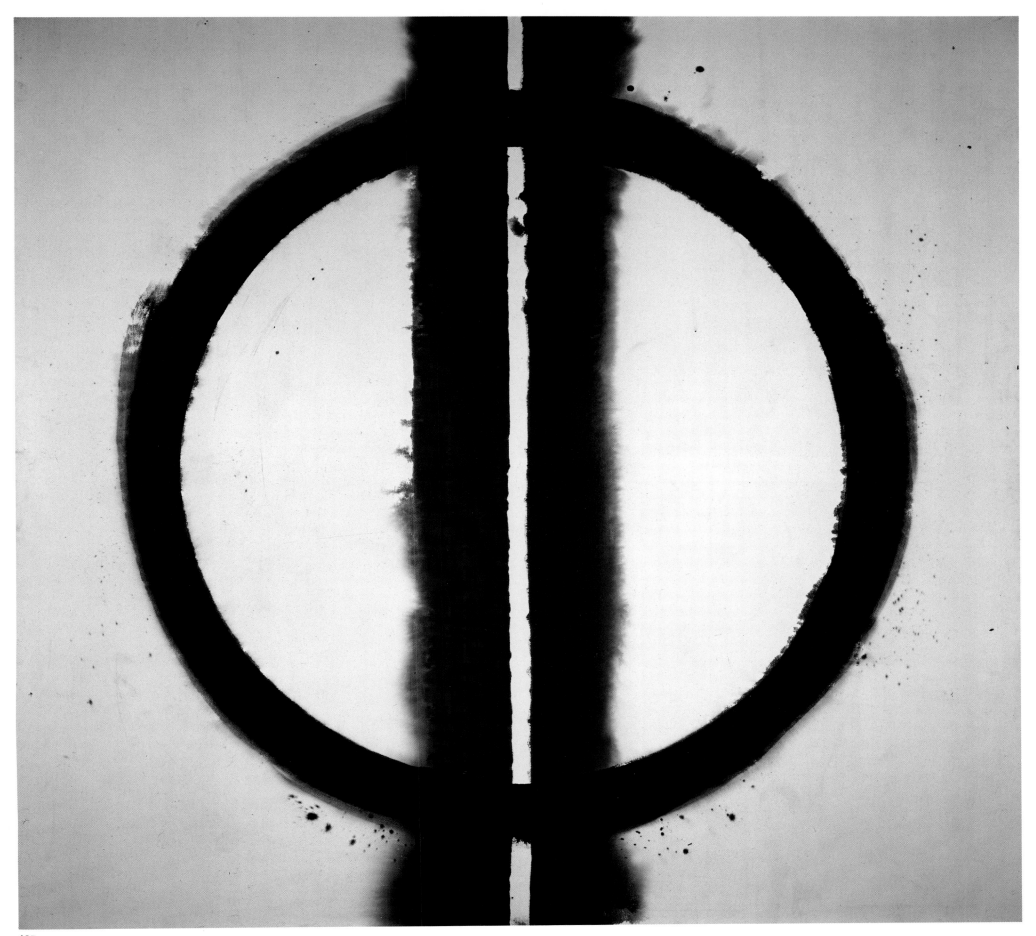

# CHAPTER

# V

# THE COSMOLOGICAL IMAGE

I had to change. I thought hard edge was a dead end—a trap. I find geometric art is a trap. If it stays purely geometric, it's very constraining, and I don't think it can really fulfill. Art has to be as complete as possible. I thought every painting should have color, line, but it had to have everything—a total expression—the way life is very complex and has everything. Hard edge for me was an absolute, but an easy absolute.

I don't think I believe in a unity of style. I think style is a superficial part of the creative process and what counts is to be involved, as Plato says, in a conversation with the soul. The important thing is to arrive at one's inner image structure. If one can find it after creating a vacuum that eliminates all superficial influences, a deeper image will keep reasserting itself, reappearing. This may then be called style because of the repetition of the inner obsession.

I always thought it was mysterious that the word "God" could be written with very circular letters. It was part of my obsession that everything basic was circular. There's something beyond us that I think we can discover or help discover through art. And that is what I think the search in art is about. Art is a search. It's not an achievement.

In gambling I get more of a kick if I lose a lot than if I win one dollar. Winning is not important. But to have attempted the impossible, to really gamble at getting something extraordinary, that's creating a situation that might provoke new, exciting experiences.

The limit of the beautiful is seduction—seduction is a trap one has to get beyond. What is the beautiful? The beautiful is not a question of ugly as opposed to beautiful. For me the beautiful is something that inspires . . . I was going to say a "moral action." There's an element of good that has to be in the beautiful— for me. It has to do with taking human beings out of everyday existence and revealing to them something that is in them that they haven't felt before. The beautiful was captured by a class that demanded flattery of its lower instincts. The resentments against the canons of the beautiful had to do with resentment of this domination of a class taste.

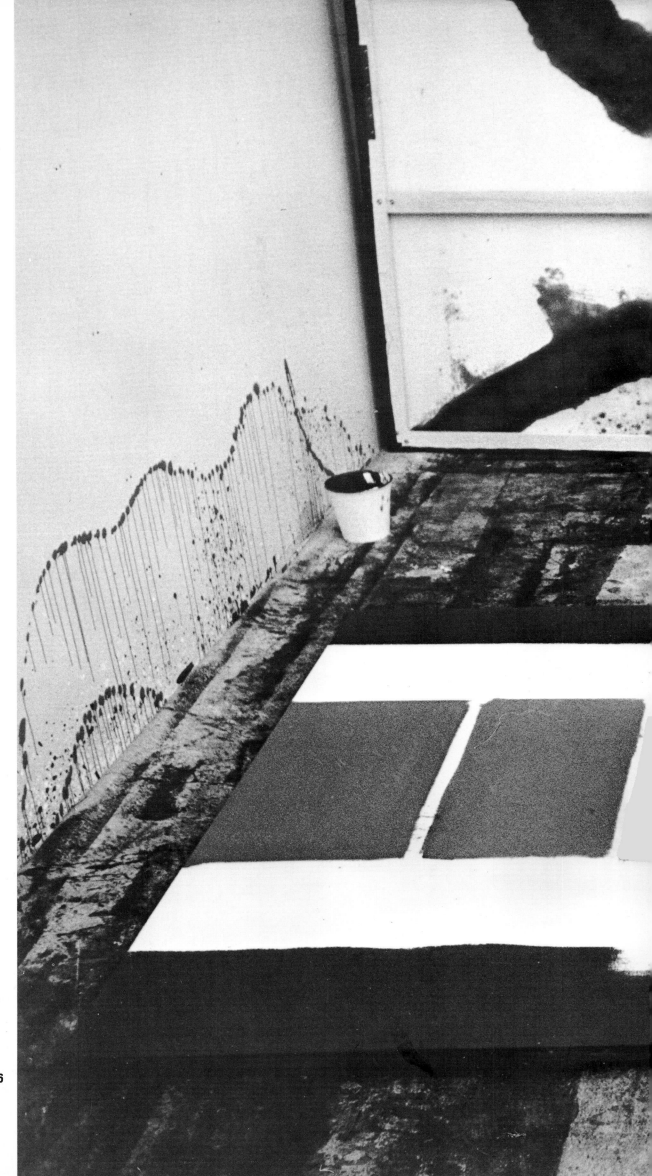

A lot of the windows came from watching people wipe windows and clean windows with big squeegees. I also saw a photograph of Gottlieb in a catalog using a squeegee. I started doing freer paintings on canvas on the floor so that the paint would not run. I could control it, let it dry in given positions. I used to hit the crosspiece, so in 1963 I decided to eliminate the crosspiece and to work on the floor.

I believe that creativity is conditioned by technical means. I discovered duck canvas in huge rolls, and the possibility of using Liquitex and plastic paints, in abundance. They permitted a generosity of statement that I found was not possible in the more precise media. Also, perhaps, more attention should be paid to the apparently unpleasant elements: dirt, uncleanliness. Sometimes I use them, too.

It is impossible to draw on the floor. You can pour paint on the floor. You can push paint. But you cannot do a stroke. You don't know what you are doing on the floor. If you want to draw a line, you don't really see it. On a vertical surface you can draw and you can step back and you can look. On the wall something else happens because greater speed is possible.

136. Liberman working in the studio at 132A East 70th Street, 1965, photographed by Hans Namuth

**136**

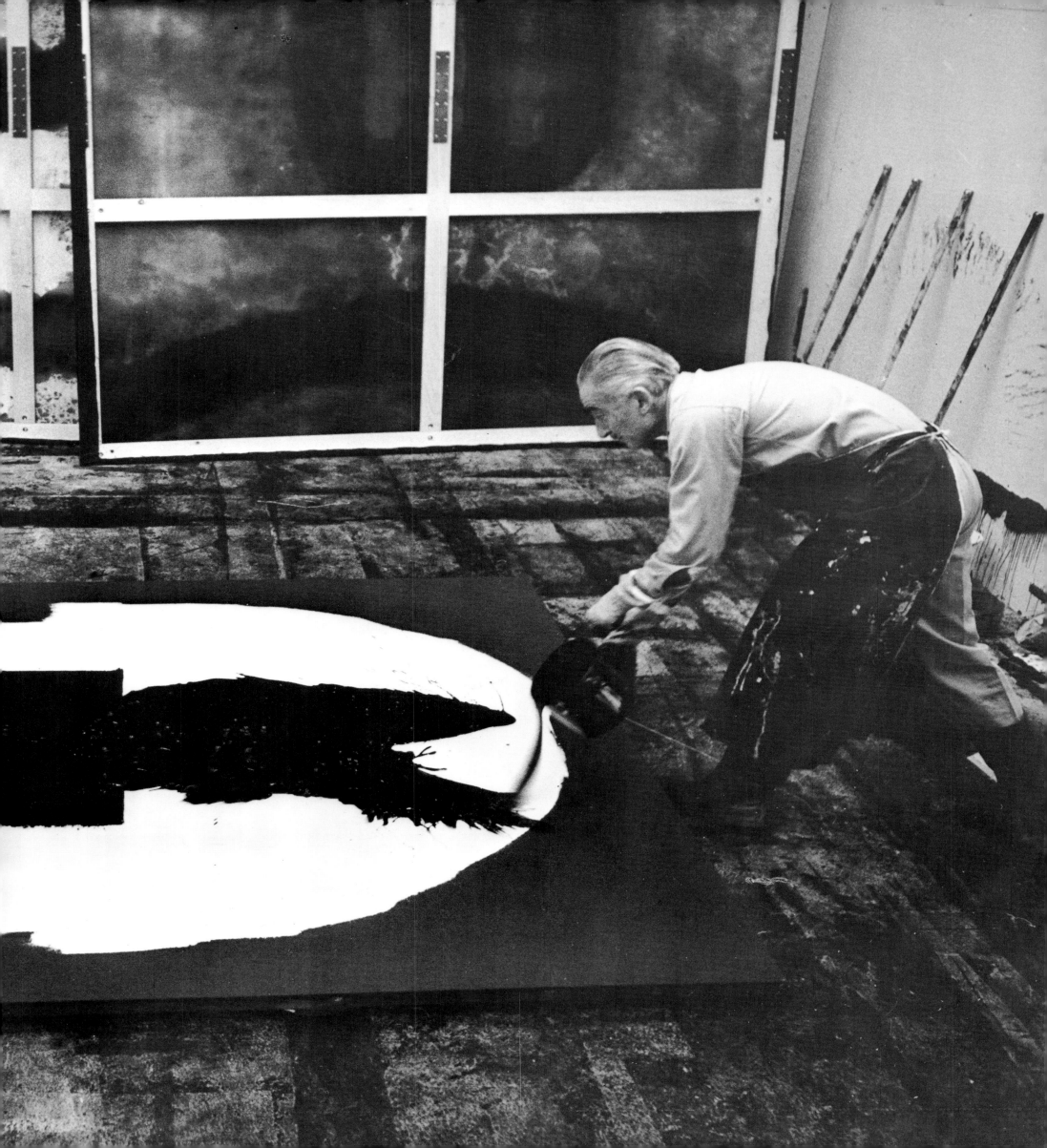

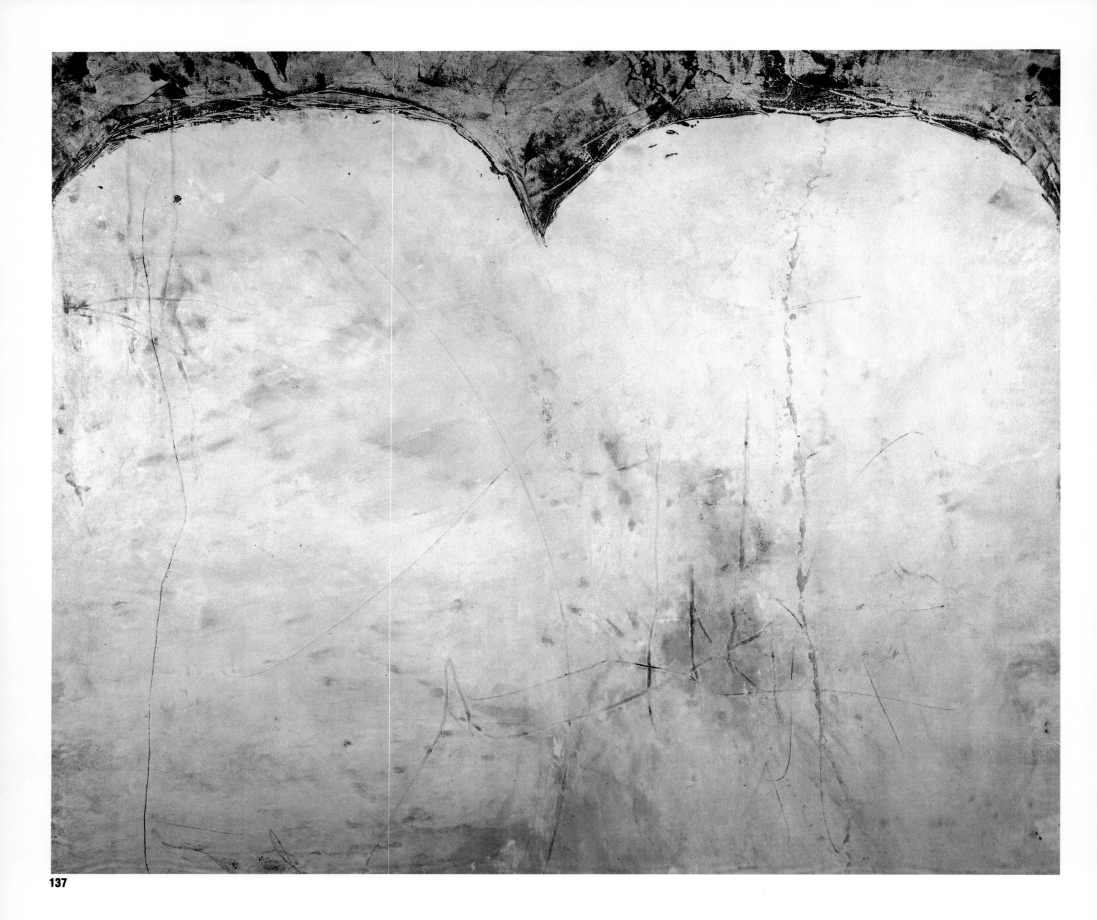

**137**

137. *The Law*, 1963
    Enamel on canvas, 94 x 191 in.

138. *God*, 1959
    India ink and enamel on paper

139. *Erasure*, 1959
    India ink and enamel on paper with erasure

Liberman's transition to a painterly style began with the series of automatic drawings of 1959. Pollock was certainly an inspiration for scribbling, splattering, and calligraphic drawing. Significantly, one of the first words Liberman wrote in cursive script was "God." (138) The sacred name is reduced to three circles, but these circles now are broken open. Liberman's newly found ability to write script instead of print was a manifestation of the release from the rigid confines of the hard-edge geometric style. The drawings of 1959-60 were not only technical experiments, they also prepared the way for the emergence of a freer style of painting. This new style utilized chance procedures and technical experiments to create a new category of cosmic image that was not so much based on symbols of the universe as on metaphors for natural phenomena. (139)

In 1959, the French atomic physicist, Serge Gorodetsky, whom Liberman met through a mutual friend, invited him to observe the experiments taking place at Brookhaven. Liberman, always fascinated by scientific research, observed linear traces of the paths of atoms visible under laboratory conditions. This inspired him to make a drawing of random motion and linear orbits that was among his first freehand nongeometrical works. (140) The observation of the behavior of atomic particles confirmed his sense that corresponding microcosmic and macrocosmic phenomena were symbols of both chance and order operating in the universe.

Initially, Liberman's conception of chance was based on Mallarmé's "throw of the dice," which had earlier inspired Arp to scatter shapes at random. The poker chips strewn randomly across the painting *Blue Opposite Red* produced an image prefiguring Larry Poons's later use of dots scattered at random on a field. (100) But this intellectual conception of chance came to seem too abstract to Liberman. His change of heart as well as his change of technique arose from his growing interest in Pollock's interpretation of chance as physical accident, which, in turn, implied a potential for physical destruction. His health regained, Liberman was able to work actively and on a large scale. This physical vigor seems to have inspired him with new daring. That a work could be lost in the process of creation—if the techniques involving accident did not yield the proper results from a formal point of view—excited him more than the idea of a predetermined classical order.

The dual aspect of his character began to assert itself more and more as he became a successful man of the world. Mundane order permitted artistic liberation. Paradoxically, as his art grew wilder, his personal life, which had always tended to be conservative in relationship to the world of fashion, became, if anything, even more conventional. In 1962, Liberman was named editorial director of the entire

**138**

**139**

**140**

**141**

140. *Untitled*, 1960
India ink and enamel on paper

141. *Untitled*, 1959
India ink and enamel on paper

142. *Untitled*, 1963
Liquitex, acrylic, and enamel on canvas,
73½ x 80 in.

Condé Nast magazine empire. Success at *Vogue* meant he did not need to worry about supporting his family. It also meant he could afford to be wasteful about materials. Paintings did not need to be perfect any longer. They could always be rejected—an important assurance for the artist who risks failure by permitting greater and greater areas of control to be taken over by unpredictable elements, such as how paint may splatter, spill, or spread. This freedom to fail, to make works that need not please anyone, heightened the gambler's instinct in Liberman. In 1963, Liberman started working on big rolls of canvas on the floor. The structure and image of the paintings began to depend more and more on accident. A bad throw of the dice meant the entire canvas was lost and destroyed.

During the period of his search for universal cosmic symbols, Liberman was particularly interested in Jung's writings about mandalas; the ogival or circular aura of holiness; and in alchemical texts, many of which were illustrated, like Ouspensky's *Tertium Organum*, with geometric diagrams. Among the books that most impressed him was Robert Fludd's *La Philosophie Mosaïque*, a seventeenth-century alchemical text he owned, which reproduced diagrams of circles combined with triangles taken from the occult Hebrew book, the Kabala. It confirmed his feeling that the circle and the triangle were ancient sacred forms. (*163*)

During the Sixties, this search for potent, highly charged imagery continued. A number of the symmetrical, hieratic, iconic paintings in the 1962 Betty Parsons exhibition suggest shields and heraldic devices. Shields and heraldry were fascinating to Liberman, who as a boy had arranged mock battles in his nursery and engaged in street wars in the rubble left after the Revolution. The scale of these heraldic paintings was considerably grander than the paintings on industrial panels of the Fifties, and their imagery was bolder and more expansive. (*109, 113*) Liberman was impressed at this point by the power of the phallic symbolism thematic in Motherwell's *Elegy to the Spanish Republic.* Newman's exhibition of immense horizontal color-field paintings in 1959-60 at French and Company convinced Liberman that large scale was a critical element in ambitious art. In the luminous field of saturated color, which encompasses the viewer in an environment of radiating light, Liberman saw another means to transcend the objecthood of painting. In an article he wrote on Monet in 1955, he had already discussed the issue of large scale.

Since his essential search throughout his career was to transcend the material object, it was logical that he had to change the scale of his work, and that he had to create a source of light within the painting as opposed to counting on the reflectiveness of enamel to bounce light off the surface. Beginning in 1962, with the series of paintings based on the

142

The traditional concept of art was to reach emotion through so-called beauty. I thought that was a trap. If a thing pleased me, I was worried. It was hitting the memories of my education. The pleasing in our century is no longer the thing that can have a really lasting impact. Terror or terribilità—the unknown—is what affects the spectator.

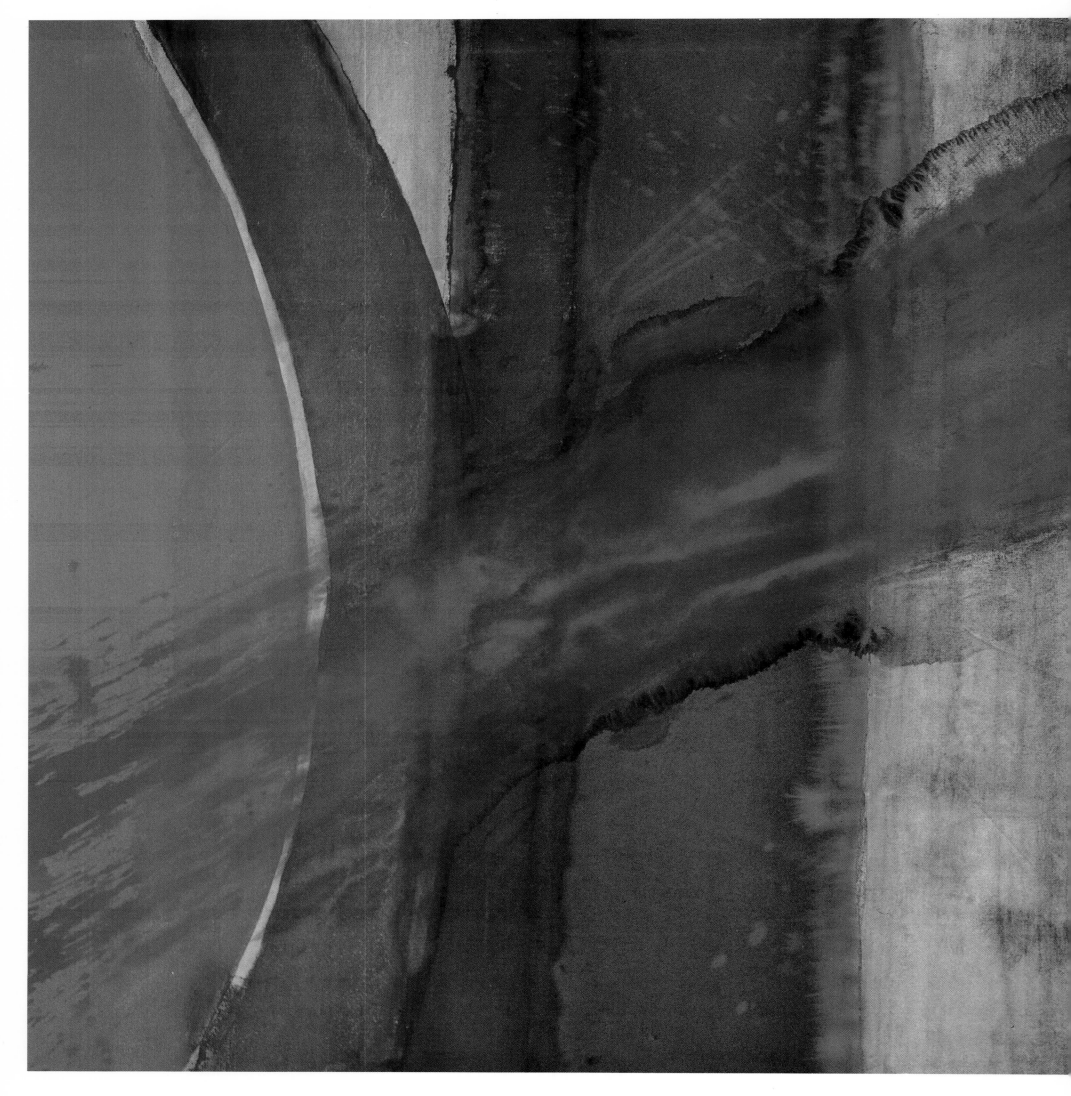

143. *Orange Splash*, 1963  Acrylic on canvas, 82 x 165 in.

"Great Circle" motif, the concept of painting as color-light environment replaced the repeatability of the abstract idea in Liberman's work as a means to transcend the materiality of the object.

Although Liberman's paintings of 1960-62 are related to the large-scale paintings of Motherwell and Newman, their geometric style and holistic gestalt structure issue from Liberman's own past experience. We have seen that he was already involved with symbolic imagery in his earliest abstract circle paintings. Contact with Motherwell, Newman, and Rothko, who had a studio near Liberman's house, certainly reinforced his desire to create an abstract art of metaphysical and metaphorical content. He had already located one source of universal content in cosmic imagery. By the Sixties, he found another source in the universal symbolism of the erotic encounter. Thoughts regarding erotic symbols had been germinating for some time in his notebook drawings, and in paintings like *Black End*. (90) The source of the planetary imagery, as we have seen, was related to Kupka's cosmic paintings. (92) Finally, an encounter with Brancusi in Paris in 1959 was decisive in helping Liberman formulate his ideas regarding the universality of erotic imagery and the way to translate that into art.

Duchamp had based his entire iconography on the universality of sex. Liberman knew Duchamp's pseudonym, Rose Selavy, (a respelling of *"Rose C'est la Vie"*) had been interpreted as "eros c'est la vie" or "sex is life." However, Duchamp's concept of the erotic was entirely arid and intellectual. In 1955, Duchamp's great friend Henri-Pierre Roché, introduced Liberman to Brancusi in Paris. The meeting was critical for the future of Liberman's art as both painter and sculptor. Brancusi's idea of Eros as the life force itself was an earthier view that seemed to Liberman to be more com-patible with his own ideas. In Paris, Liberman studied and photographed Brancusi's sculpture in the studio at the Impasse Ronsin. He also took more formal photographs of individual Brancusi pieces in Roché's apartment, where the aging author of *Jules and Jim* kept works by his favorite artists—Duchamp, Man Ray, Brancusi, and the unknown American abstractionist, Patrick Henry Bruce. Liberman tried many times to photograph Brancusi himself. He describes the frustration of these encounters: "For years I tried to photograph him, but toward the end of his life he had a superstition that if his picture were taken he would die."

Born in Rumania, Brancusi was another Eastern European mystic whose occult religious ideas were familiar to Liberman. Brancusi's reduction of natural forms to geometric elements, which implied great mysterious forces soaring, aspiring, and reaching upward, inspired Liberman to pursue the theme of penetrating *lingam-yoni* configurations symbolic of sexual union he had drawn in his notebooks. Brancusi told Liberman that erotic union "gives us a glimpse of the Divine." This affirmed Liberman's growing conviction that the visual equivalents of sexual union in images of phallic concentration, and in forms that swelled and expanded like *Aphrodite*, would have a powerful and universal emotional impact. Brancusi's antipathy for the earthbound also struck a chord in Liberman, who had always sought images that denied gravity.

The notion that painting had to express an erotic content led Liberman to search for forms capable of communicating the theme of eros as sexual penetration. Before his encounter with the ideas of Kandinsky, Brancusi, and Kupka—the three great Eastern European mystical abstractionists who had lived out their last days in Paris—Liberman's ideal artist had been Duchamp. It is significant, however, that by the

*Some of the media I use seldom permit correction, so working has to be a total commitment. One of the things that I have to solve in my own creative work is arriving at the point where the thing looks like a thing. One has to take one's whole life and risk its total destruction for the more important goal of reaching the unknown. In the process of revelation, the painter wants to see what he is not supposed to see.*

time *The Artist in His Studio* was published in 1960, Liberman devoted only two short paragraphs to Duchamp, whereas three pages are devoted to Kandinsky, whom he had never met. Clearly the hierarchy of his pantheon had changed. "Duchamp," he wrote, "is the aristocrat of modern art. He has the haughtiness that comes with the dismissal of creative torment. He has put an end to his creative suffering. . . ." Liberman's paintings of the Fifties were similarly the work of an aristocrat, who had ordered others to do his bidding and avoided emotional suffering. But in the Sixties, he became a worker himself, which brought him closer to the physicality of the New York School. Moreover, by grafting his uprooted psyche back to its origin in Russian mysticism through the experience one might describe in equally mystical terms as "meeting with remarkable men," he reestablished contact with the metaphysical concept of art as spiritual transcendence. These "meetings" with the living and dead masters as he photographed their studios changed Liberman's art by reuniting him to his own roots after the war. History had ruptured the continuity of his life. Now, in control of his life, he could afford to rupture the style of his art.

By 1963, Liberman was throwing and heaving paint out of buckets. The target now was not a perfect bull's-eye, but the creation of a fiery, volcanic image that appeared made by nature, not by man. (*144, 151*) Not the orderliness of planetary orbits, but the unpredictability of worlds in collision, of an expanding universe of exploding suns, stars being born and dying, the whole panoply of cosmic fireworks, is the theme of these intense paintings. Although Liberman did not compose consciously, there is an awareness of the framing edge as a determining factor that is an a priori structural consideration. Working on the floor, often using the squeegee to mop on broad areas of color as Gottlieb had applied

paint, Liberman used techniques in some ways related to the stained post-painterly abstractions of Morris Louis, Kenneth Noland, and Helen Frankenthaler. (*143*) However, unlike them, Liberman never cropped his images. This is another curious refusal, since he was both an editor and photographer. (Preferring the spontaneity of the *paparazzi*, he does not crop his photographs either.) His attitude was always a fatalistic acceptance of the given, an unwillingness to intervene with destiny. He depended entirely upon the accuracy of his "throw of the dice." But by now the "throw" had become more like the pitching of a *bocce* ball in its breadth of physical gesture. There is a kind of exuberant release in these paintings of the mid-Sixties, which we can imagine resulted from Liberman's first sense of his ability to move and act, both in art and in the world.

Health and worldly success gave Liberman new daring, but they did not change his primary concern for visionary experiences. Many of the paintings of the mid-Sixties are not total abstractions. They do not imitate nature, but they do allude to the mysterious changing imagery of the sky at its most dramatic. At times, there is an odd coincidence between these fiery paintings and the glowing skies of Hudson River School painting. By now, Liberman was spending every weekend in Warren, Connecticut, with his daughter Francine and his son-in-law, painter Cleve Gray. In wooded Connecticut, the intense Russian preoccupation with nature was revived in metaphors for natural phenomena.

Trips to Greece in 1964-65 to visit ancient sites and photograph works of art brought further stylistic changes in Liberman's art. The text for *Greece, Gods and Art*, the book that resulted from these trips, indicated Liberman's reflective philosophical state of mind at the time. In 1964, artist Paul Feeley had arranged an exhibition of Liberman's "post-

---

*I sometimes have an awful feeling when I put down the first spot that I am pursuing an error all the way, but I still pursue it because an error sometimes ends up by leading me towards totally unexpected realms. I have a feeling that one spot, the first spot, forces us to live within that painting a certain way.*

*Once this first area is put down, or any area is touched on the canvas, the second area or the sec-* *ond movement is absolutely conditioned by the first trace and from that point on there is a constant feedback of information. The rims or edges of the first spot must in some mysterious way create urges or awaken urges and desires. It's this involvement, which could be called not structural but gravitational and, perhaps, emotional. It corresponds to a feeling of necessity that has its own sort of logic.*

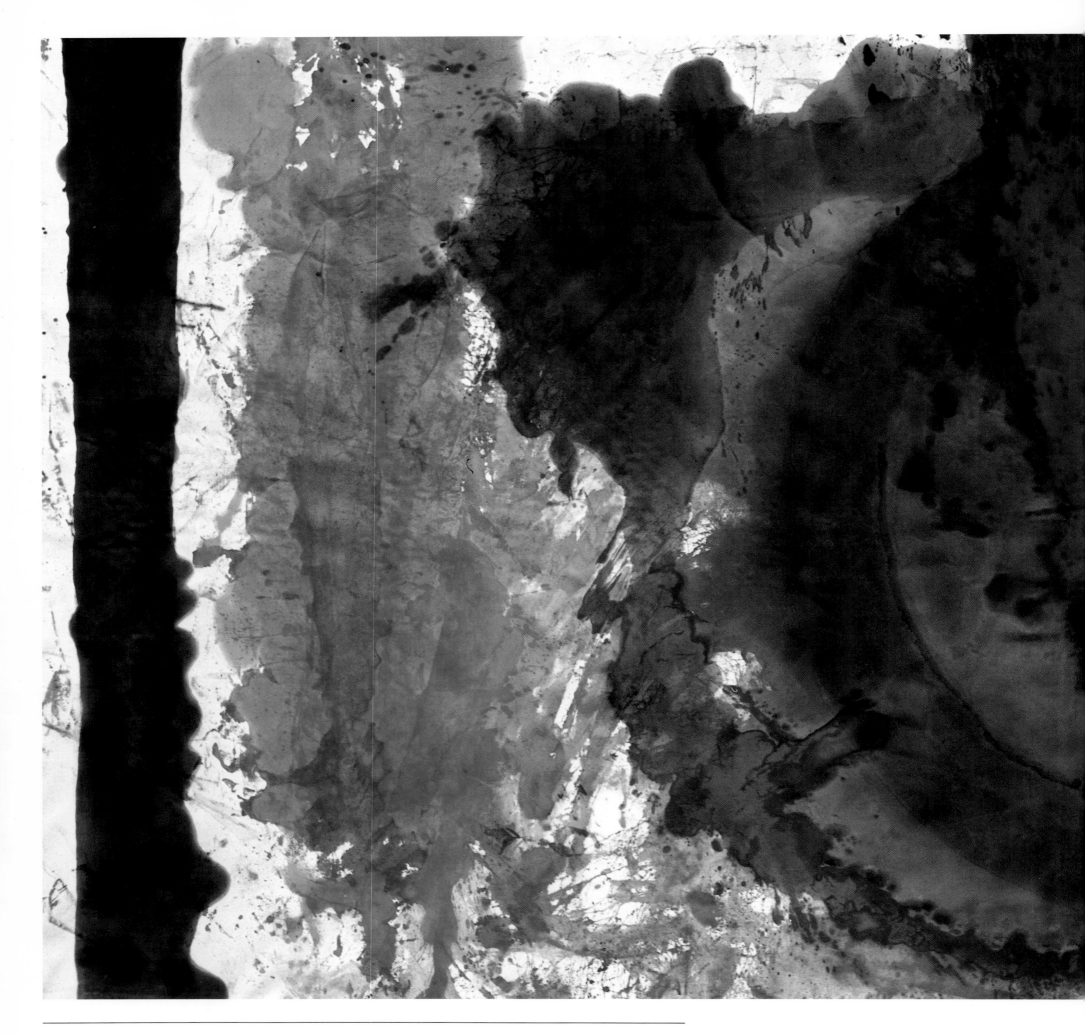

I started pouring paint on a horizontal canvas spread on the floor. I tried mixing turpentine with plastic, which one was not supposed to do. I noticed that when I put it on the canvas it would bleed, and spread in an uneven way, especially if I used black. If I put some turpentine into the black enamel, it would then spread into a marvelous miraculous black cloud. That fascinated me.

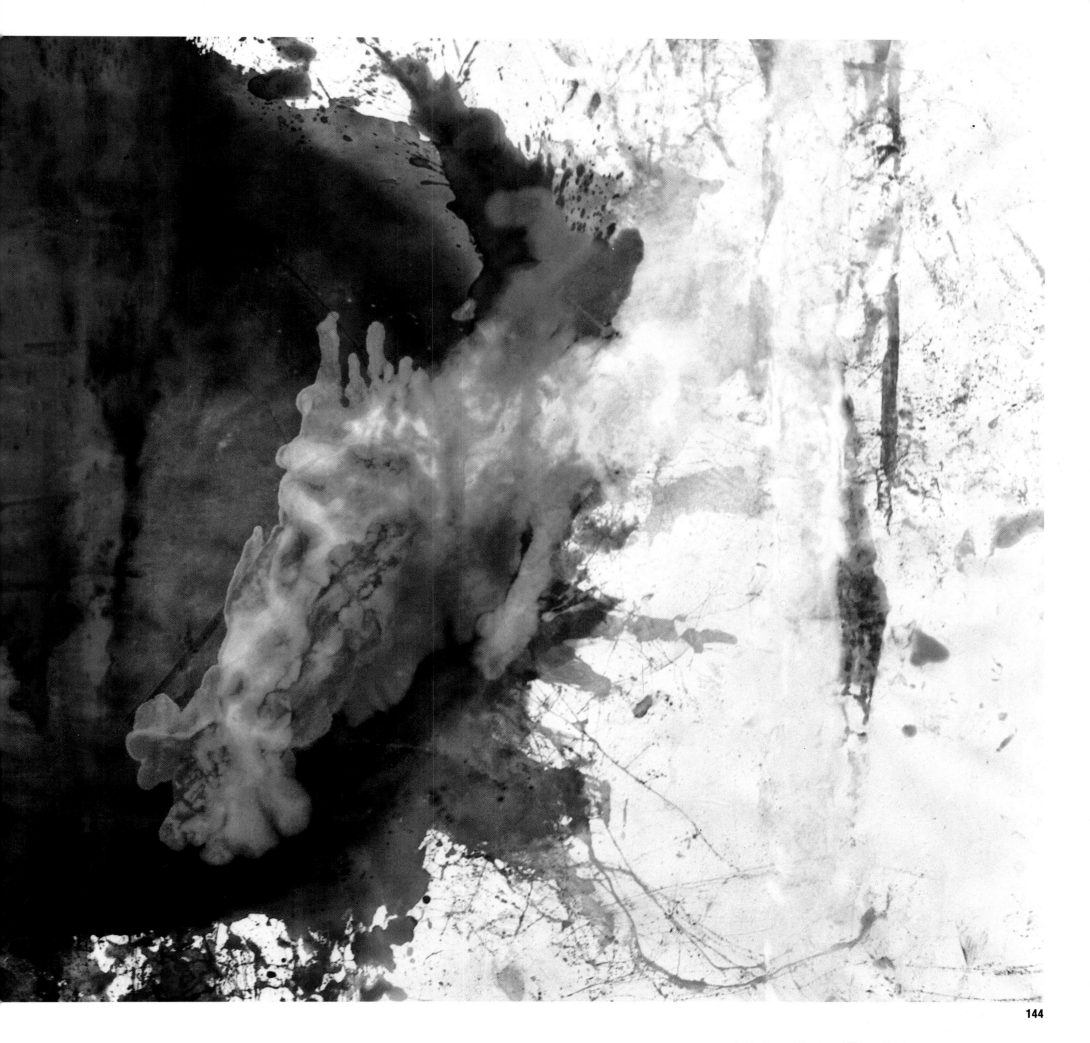

144. *From Black to White*, 1964
Acrylic and enamel on canvas, 111½ x 236 in.
Collection Corcoran Gallery of Art, Washington, D.C.

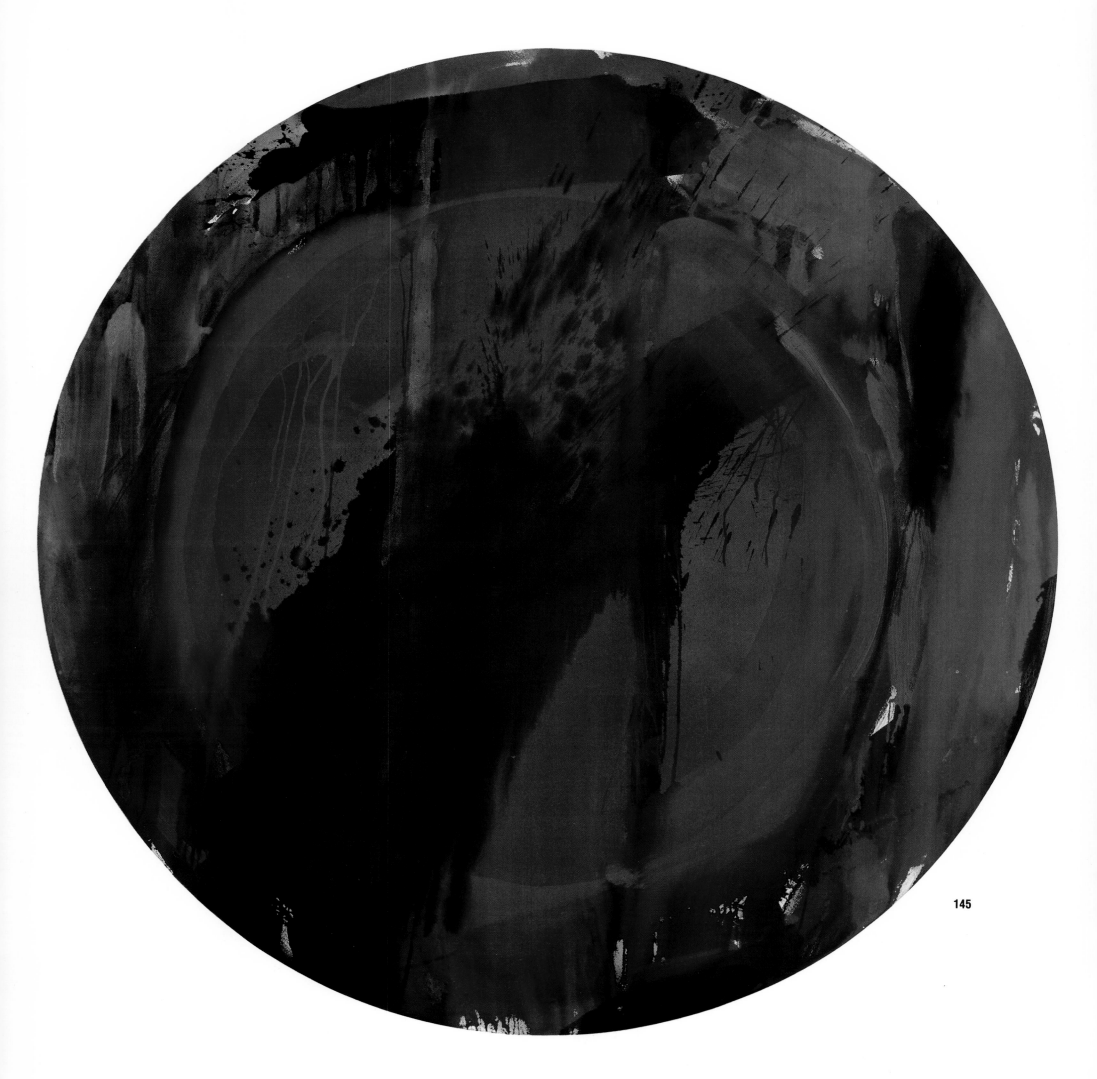

145

painterly abstractions" of 1963-64 at Bennington College. The trip to Greece the subsequent summer provided an opportunity to assess his work. It was a time "to clarify and reexamine our thoughts about art and life at a time when the standards and tastes of our own civilization are changing drastically. The journey is not so much a return to the past as the reseeing of our time, and ourselves, in a different and richer perspective."

This new perspective took Liberman back to the origins of Western art. Originality no longer seemed the primary goal of art in the light of this reassessment. In 1965, having embarked on a more profound, if riskier conception of the cosmological theme, he wrote: "Today, when we are conditioned to look for originality, striking innovation, the individual sledgehammer statement that seems unconnected with any other creation, as if born *sui generis*, the Greek lesson of the importance of the small variation, of subtlety and of a continuation of tradition is revealing and meaningful. No art is born in a vacuum. Even the most startling individual discoveries of contemporary art are linked to man's artistic and spiritual evolution." This new veneration of the past was a far cry from his intention in the Fifties to create a *tabula rasa*, an art without history.

To see himself as part of an ongoing tradition of painting, to use as his palette the sumptuous royal purples and magentas, the brilliant blues and greens of Titian and the phosphorescent hazes of Tintoretto rather than the enamel white of refrigerators was worlds away from Liberman's intention in the Fifties to look "brand new." Returning to Greece and Italy, the cradle of Western civilization, Liberman felt a renewed connection with art history. He had, moreover, joined his art so securely to the fortunes of American painting that European art could no longer threaten him. Experiencing Greek art firsthand, instead of through the anemic casts he saw at the Beaux-Arts, as a student in Paris, convinced him of the superiority of the most archaic styles. Now he esteemed Cycladic and Minoan idols, not for their purity, but as he wrote, for "the havoc wrought by nature." In his photographs of a terra cotta mother goddess, he focuses on its exaggerated violin shape and on the pitted surface. (*146*) His paintings of the Sixties show a similar involvement with surface texture. A series based on the theme of Moses, symbolized by an image of the Tables of the Law, was never completed. (*137*) However, its gouged-out surface looks forward to the heavily worked and scratched textures of his recent paintings, in which eroded forms appear to have been eaten away or molded by natural forces working for centuries. The importance of surface and texture was also brought home to him at this time by his continuing experiences with welding. The heated metal was like liquid paint; working with it caused Liberman to realize the potential of

146

145. *Blue Splash*, 1964
Acrylic on canvas, 80-in. tondo

146. Violin-shaped figurine from Knossos, 4000-3000 B.C.,
Heraklian Museum, Crete,
photographed by Liberman, 1963

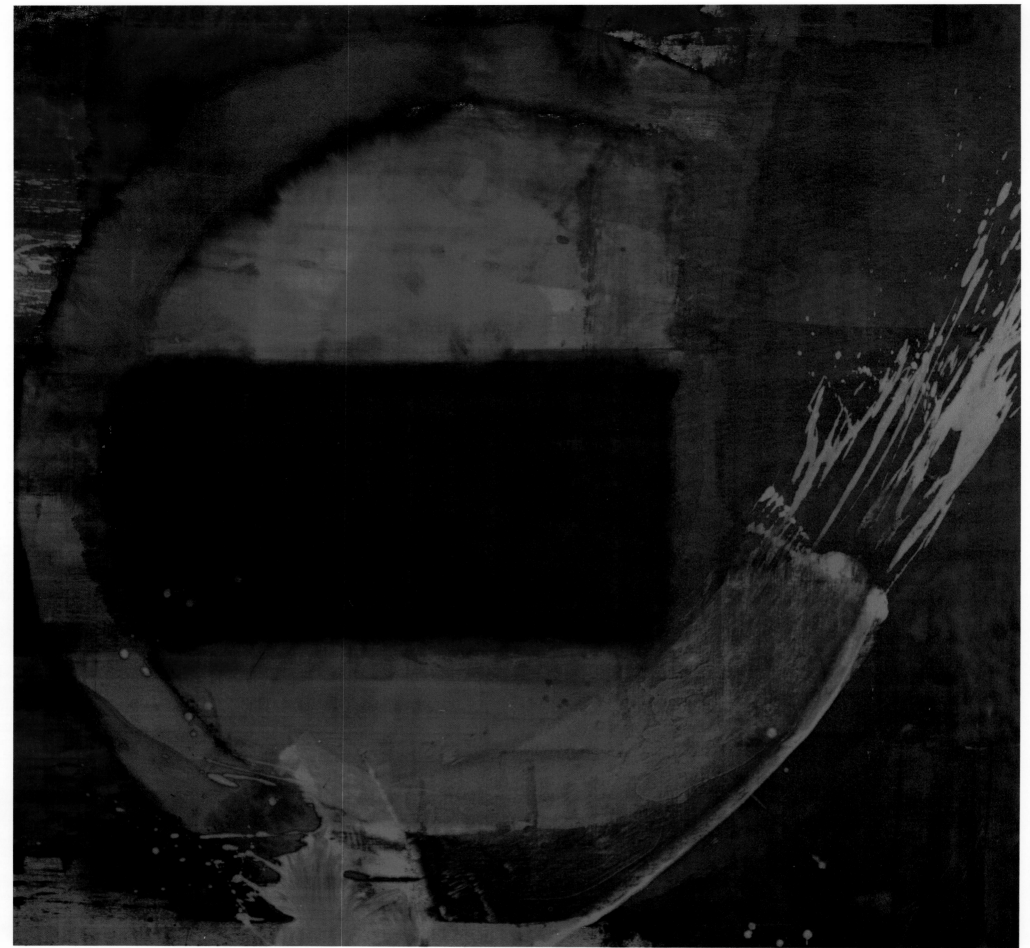

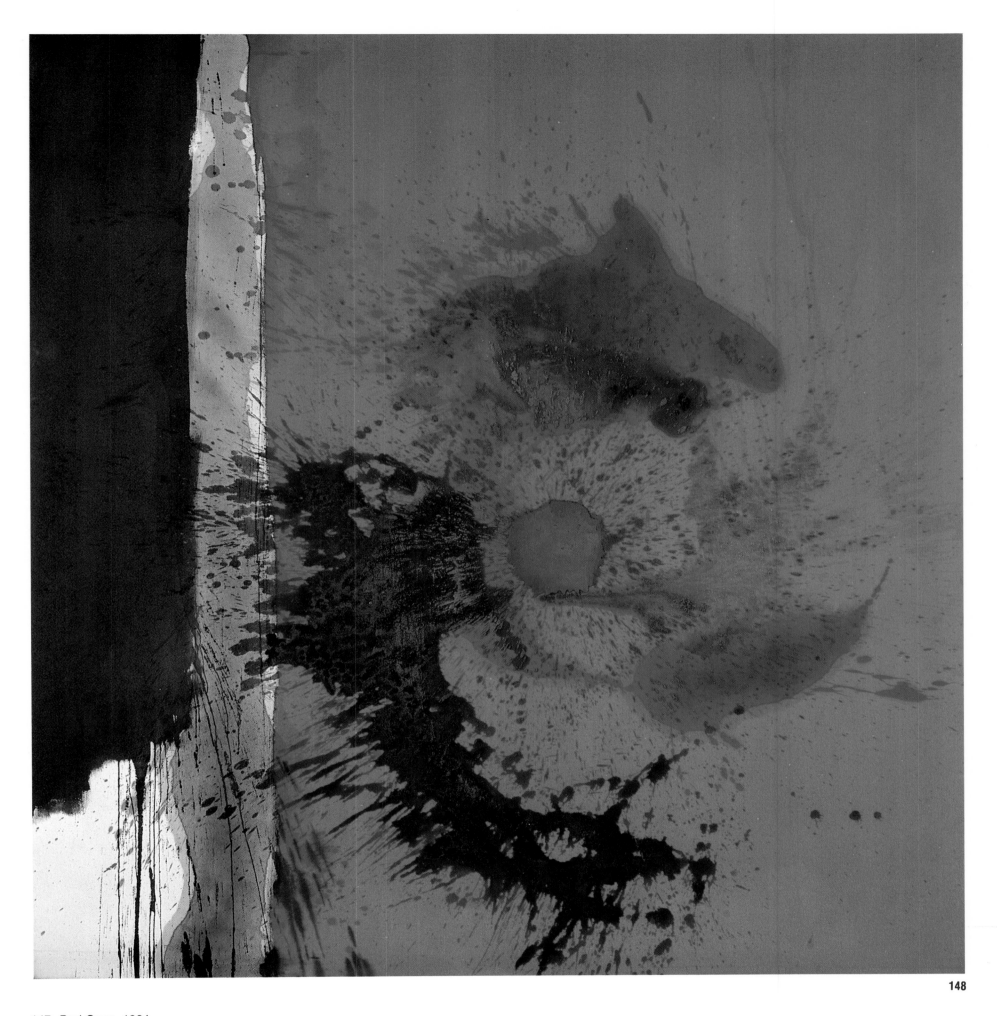

**148**

147. *Red Open*, 1964
     Acrylic on canvas, 74 x 76 in.

148. *Blue Spot*, 1964
     Acrylic on canvas, 78½ x 74 in.

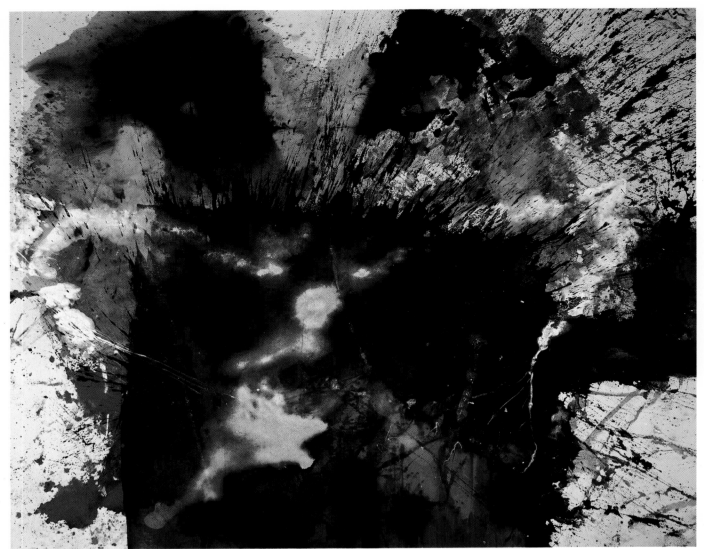

150

Maybe my paintings have become freer because of my work in sculpture. Sculpture has in it the necessity for structure, a certain logic of mass, and the ability to stand. I have a feeling that once this has been satisfied by sculpture, painting is the freest medium. It has absolutely no need for anything to be able to stand up in a certain direction. The all-directional fluidity of color on the plane of the canvas seems not to have been fully explored.

Unquestionably, for me, Beckett is the most important writer today. That marvelous sentence "Why does one create?—to leave a stain on the silence." I think that's the heroic. Creative art and heroism always involve self-sacrifice, and maybe artists are the victims of art in a certain sense.

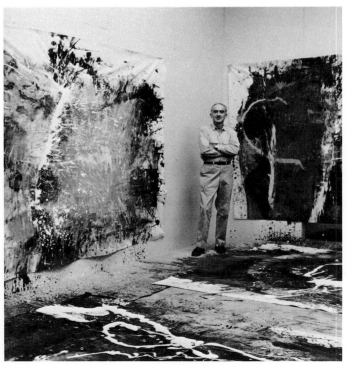

149

149. *Light Bolt*, 1965
Acrylic and enamel on canvas,
80 x 98½ in.

150. Liberman in the 70th Street studio,
photographed by Cecil Beaton, 1967

151. *Light Bolt II*, 1965
Acrylic and enamel on canvas,
116½ x 93 in.

144

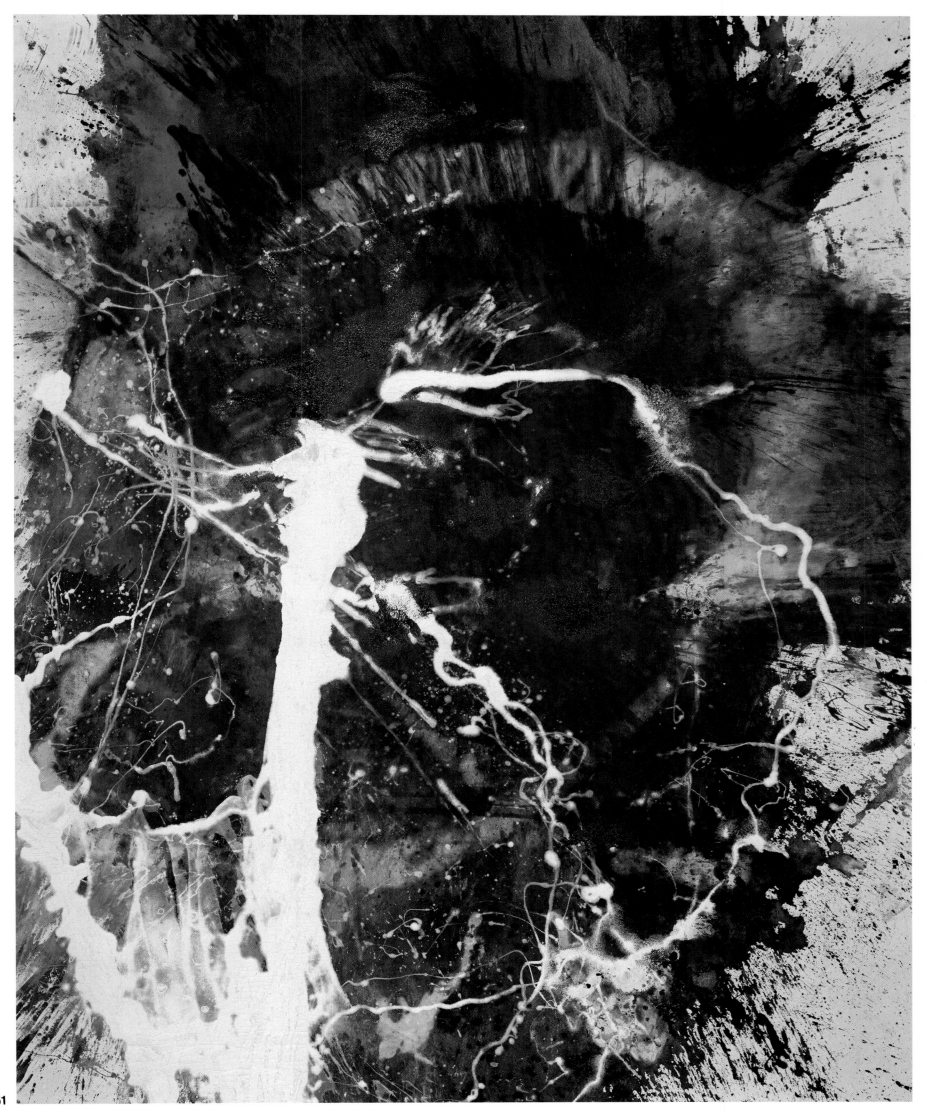

**153**

152. *Job*, 1965
Acrylic and enamel on canvas,
120½ x 109 in.

153. *Light Given I*, 1965
Acrylic and enamel on canvas,
116 x 110 in.

molten matter cooled into solid form and of erosion as a metaphor for the antiquity, not of art, but of nature.

More and more Liberman began to see art, or painting at least, as a process of destruction as much as a creative process. For him, this simultaneous duality resembled nature's operations. "The creative process," he wrote, "is a series of destructions. Perhaps it is this process, almost a ritualistic exorcism of the fear of death, that reveals to an artist the vision of survival after death, a suggestion of immortality." The series of paintings Liberman painted in 1966-67, many never exhibited, are somber meditations in this vein. (152) The first of the series suggest the curving contours of the violin-shaped idol he had photographed. (146) They are also painterly recapitulations of certain of the hard-edge configurations. (147, 148) Slowly, however, the pressing in from the sides yields to a motif Liberman refers to as "the message from above." (156) A descending phallic form penetrates the canvas from above, emanating light. (154) In other variants, the light-surrounded islands of color press in from the sides of the canvas. (155, 157) In either case, the sense is not that the form expands beyond the frame, but rather that a form from without penetrates the painting field. The theme of penetration is investigated in many of the paintings and sculptures of the Sixties. (159, 161)

Liberman has always disliked academic theorizing. He was drawn to artists like Motherwell, Newman, and Rothko because their conversation was about literature or philosophy or else about practical technical matters, rather than about academic art theory. He particularly enjoyed talking with Newman about technique—how an effect of light or surface might be achieved. In painting the series of dark, blackish paintings of the late Sixties, Liberman evolved a special technique through experiment to create their rich velvety surfaces. Unlike the stained paintings that preceded them, these "black" pictures were painted on stretched canvases because Liberman realized he could not draw on unstretched fabric, and he wished to draw shapes to provide a structure. However, they were painted on the floor like the other works of the Sixties. Although they do not have hard-edge shapes, these paintings are more intentionally structured than the earlier stained paintings, and they are less involved with pure chance. The vertical ascending or descending form echoes the framing edge, implying infinity where it breaks the frame to extend beyond its parameters.

Liberman would begin by drawing a large area, onto which he would pour black Liquitex, mopping it into the unprimed ground. When the Liquitex was semi-dry, he would pour over it a coat of diluted black enamel. With a squeegee he would scrape off the excess enamel; the whole surface then took on a mysterious glow from the interaction of the two media— one matte and one shiny. The thinned enamel, diluted with turpentine, would bleed beyond the edge of the shape, creating a halo, further softening the edge of the form. Contours consequently were soft and painterly, rather than sharp, linear, and hard-edge. In these works, colors are separated from one another by areas of raw canvas and surrounded by the expanse of black field. (158) Indeed, one of the reasons Liberman began to use black enamel for painting—as he also did to cover his sculptures of the period—was that the black created the strongest contrast against the raw light canvas. The opposition of darkness and light suggested a Manichean drama.

In these stained paintings, Liberman continued to avoid any figure-ground discontinuity, as he had from the moment he became an abstract painter. However, the mid-Sixties changes in scale and technique, as well as in style, brought with them a new attitude toward color. This, in turn, affected both the space and content of Liberman's painting. A deeper change than merely expanding his palette from the primaries to the full spectrum, this new attitude allowed color to resonate with meaning. Color now had an emotional and sensual role, which complemented the bleeding, spreading, and organic forms of the painterly style that replaced the hard edge. In the paintings of the Fifties, Liberman used color to define a shape or to denote spatial projection or recession. Beginning in 1962, color took on an emotionally connotative role: it became a means to express poetic and subjective feeling and mood. The mood of the dark paintings of 1966-67

*Perhaps the greatest difficulty in painting is to arrive at a unified field—to paint a color that will show no brushstrokes, will have total equality of surface— certain areas won't shine more than others.*

154. *Eyes of Flesh*, 1965
Acrylic and enamel on canvas,
80 x 60 in.

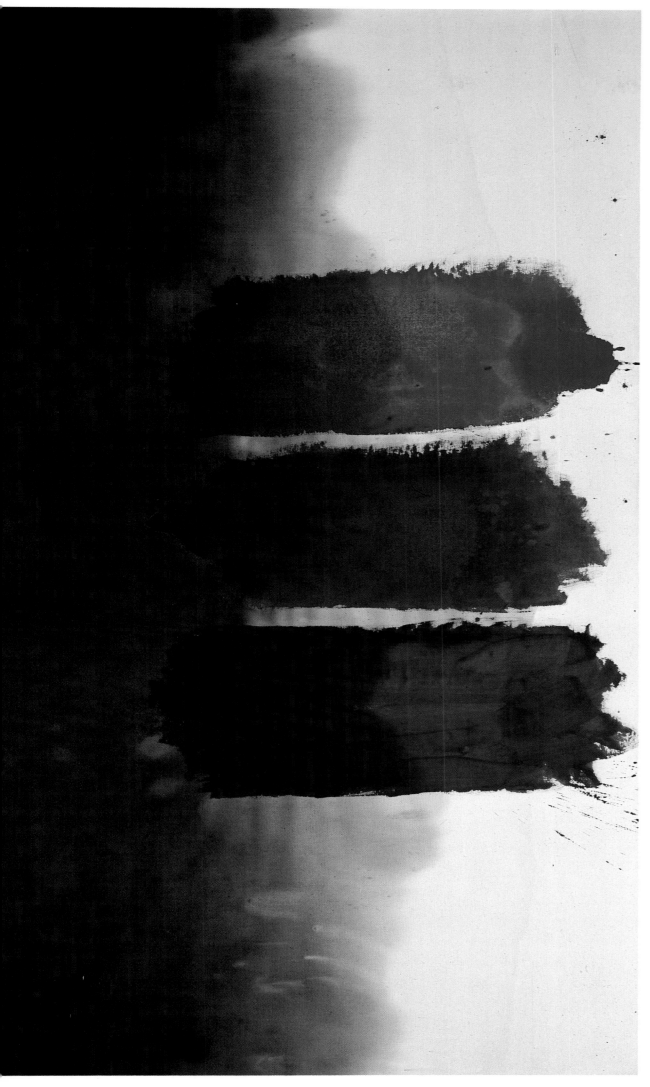

Cropping destroys the value of what has been done. Whatever emotional involvement there is gets negated by an intellectual judgment that destroys the creative statement by falsifying it; art becomes a leftover from photography, where everything is so easily cropped. Photographs are overpurified by the elimination of what seems objectionable, whereas what seems objectionable is really what makes the document original. I think that, in painting, the act of cropping a work of art reduces it to one's conventional conception of what a work of art should be.

155. *Within Black*, 1967
     Acrylic and enamel on canvas, 81 x 126 in.

     FOLLOWING PAGES

156. *Color High*, 1967
     Acrylic and enamel on canvas, 90 x 70 in.

157. *Triad on High*, 1967
     Acrylic and enamel on canvas, 73 x 97½ in.

**155**

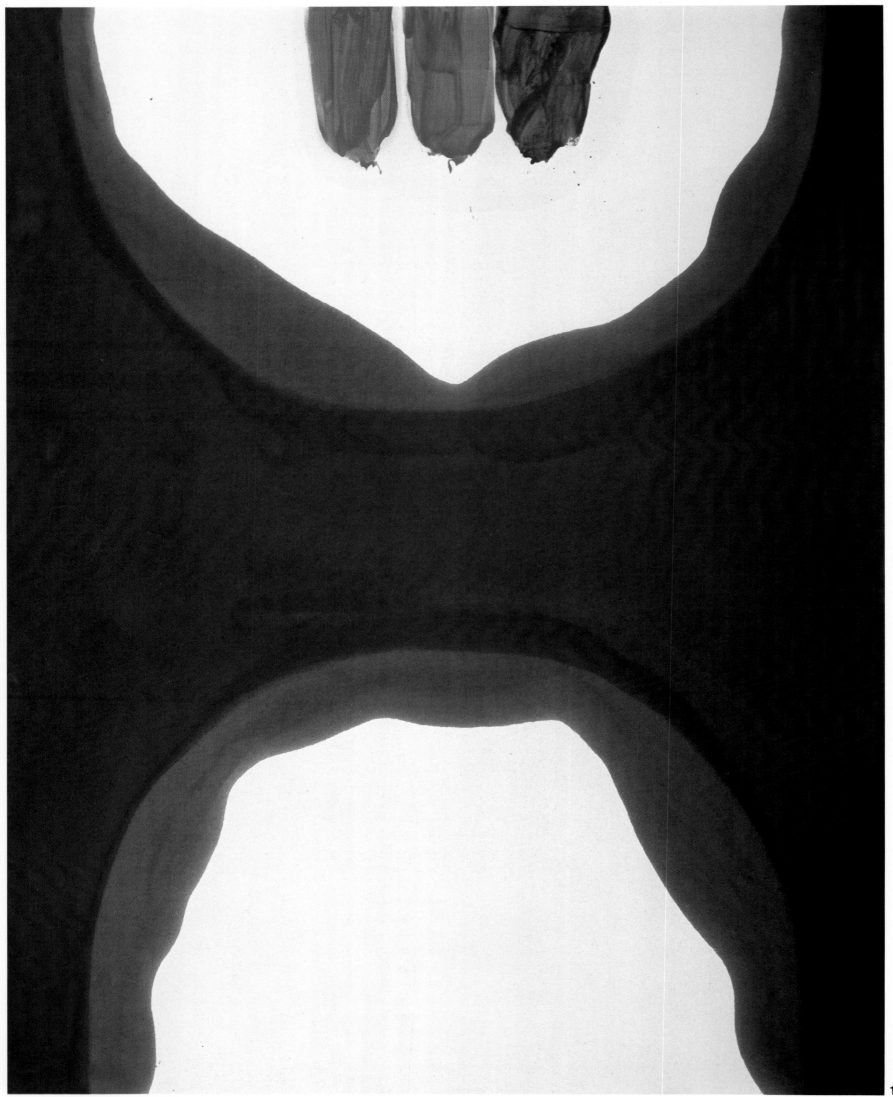

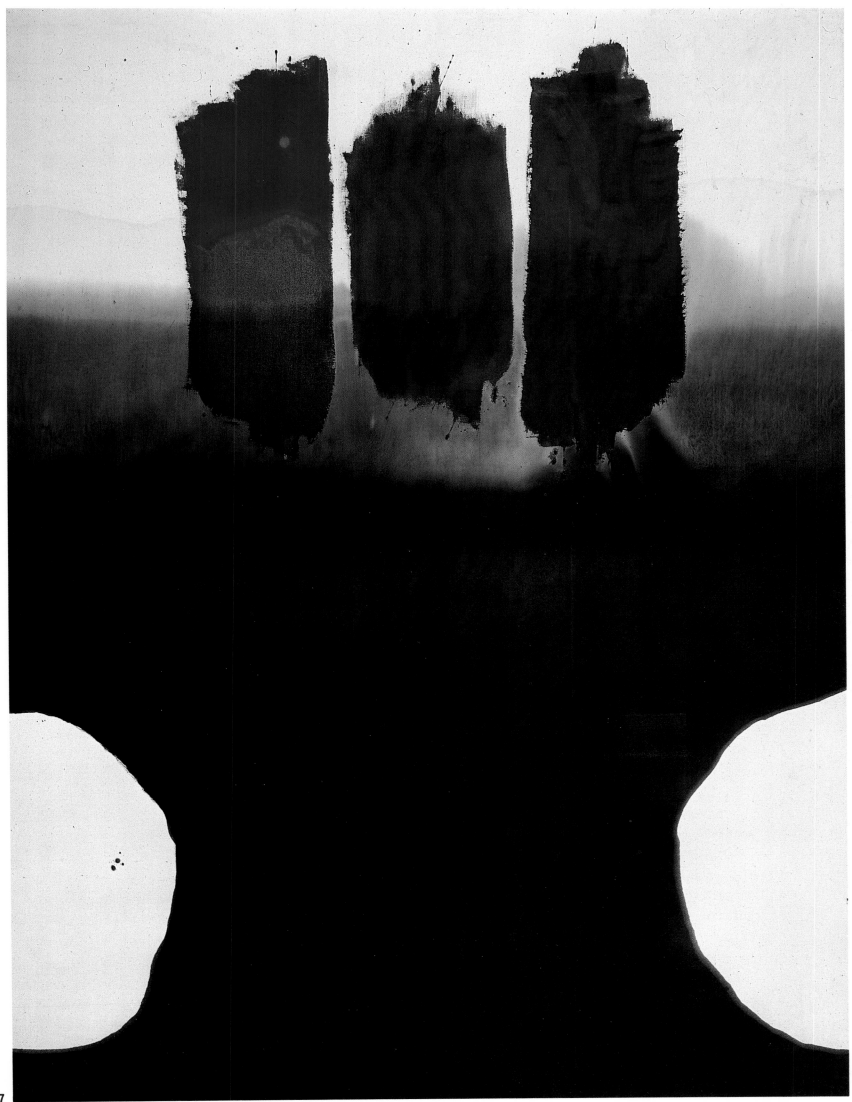

differs significantly from anything else in Liberman's oeuvre. Shadowy color reinforces the majestic *lento* movement of the arrow-headed "message" as it traverses the length of the canvas field. Significantly, these are vertical paintings as opposed to the mainly horizontal paintings of 1963-64. Neither landscape nor sky is evoked by such a format.

Liberman's enlargement of his studio in 1964 to include the upper floor of the building gave him ceilings high enough to permit him to paint these large vertical paintings. The first of the "black" paintings, *Within* and *Untitled*, were painted there in the winter of 1964. Least known and probably his least understood works, Liberman's "black" paintings reveal the dark side of his complex and multifaceted personality.

Liberman had already been criticized for abandoning his successful hard-edge style. The "black" paintings seemed particularly out of tune with their time. The art of the late Sixties was remarkable for its exuberant flash and high key, and its often fluorescent brilliance of color. At the height of this euphoria, Liberman was painting his meditative, "black" paintings. Once again, his choice was to draw away from the crowd and to align himself with the artists of his own generation, the Abstract Expressionists. As "lyrical abstraction"— the fluid painterly style he had pioneered in his flowing Liquitex paintings—was about to become the mode of the day, Liberman found "lyrical abstraction" looked too easy and too thin, with its diluted layers of paint. So he decided to pursue a more difficult course, which coincided with the darkest paintings of Rothko and Reinhardt and Newman's most ascetic works, the black-and-white *Stations of the Cross*.

Liberman first began thinking of painting a series of black paintings when he saw the black painting by Clyfford Still acquired by The Metropolitan Museum of Art. He recalled the strong impression made on him by Goya's *pinturas negras*, which he saw in the Prado in 1964. Liberman perceived the *terribilità* or awesomeness that inspired Michelangelo in Still's difficult, harsh abstraction. He was also familiar with Newman's *Abraham*, a dark vertical painting, and with Reinhardt's almost imageless black paintings. These men were serious and involved with questions of content in a way Liberman found compatible with his own search for meaning in art. Black paintings—especially large black paintings— were anathema to the market when the taste was for decorative colorful works. In retrospect, the series contains some of Liberman's most beautiful and moving works, dark reveries on the theme of spiritual ascension, and the triumph of light over darkness.

In a statement written in 1969, Liberman described his work of the late Sixties as involved with "ascension and elevations," and his hope that "through a work of art (he might) transcend the human condition." The late Sixties were also the period of Liberman's greatest intimacy with Newman, whose death in 1970 faced him with irreplaceable loss. Fascinated by technical matters, the two discussed media mixtures the way cooks trade recipes. Newman particularly admired Liberman's "recipe" for the mysterious black produced by mixing acrylic with enamel. The interaction created two kinds of light, one apparently emanating from within the canvas, the other reflecting from the surface. With Newman, Liberman could discuss the mystical and metaphysical literature that had always fascinated him. The meaning of light as a metaphysical symbol of divine illumination was a matter on which the two agreed. Liberman's personal quest for higher knowledge, as we have seen, was the path first set for him by his parents, and then reinforced by reading the theosophical theories of Ouspensky and Kandinsky. If we consider the "black" paintings a step in his quest for enlightenment, they become more intelligible. In the *Tertium Organum*, the book that had made such a deep impression on Liberman, Ouspensky writes of the transition between one level of consciousness and the next: "This sensation of *light* and of unlimited joy is experienced at the moment of the expansion of consciousness, . . . at the moment of the sensation of infinity, and it yields also the sensation of darkness and of unlimited horror." In Liberman's "black" paintings, the portentiousness of the void is countered by the light streaming through from behind the black surface—a technical effect essential to the symbolic content.

The somber, brooding quality of the black paintings expressed a side of his personality rarely given public view. They are not pessimistic because light shines through the darkness, but they are reminiscent of the harsh, puritanical sermons of the Calvinist priest charged with the spiritual education of all the non-Catholic students at the Ecole des Roches. Liberman recalls the long discourses and arguments on theology held with this priest. His later dialogues with Barnett Newman, who preferred theology to aesthetics, may have revived memories of the dark messages of Calvin as much as they spurred him to rethink his own Hebraic heritage in paintings like *Moses*. Newman's death in 1970 left Liberman once again isolated. The future direction of his painting required another look into himself, another point of departure for auto-inspiration.

The auras in my paintings—where the black stops—
were created by underpainting with acrylic, covering
the acrylic with a fluid mixture of turpentine and
enamel. Where it went over the acrylic edge, it bled.
The enamel was solid black over the acrylic. Where it
bled into the raw canvas, it became a very beautiful
gradation of black that could never be painted! You
could never paint such an extraordinary, progressive
gradation of color.

In our day and age one cannot paint bodies as the
French painted allegories of electricity with a beautiful
nude woman. Our gestures are symbolic: the big
mass descending from above to an area below, a
spark or a trace coming from one mass to another, is
very much the relationship between God and Adam—
the spark between the hands. I loved the Paradise
of Tintoretto in the Scuola San Roceo—the sky and
firmament.

◁
158. *Auras*, 1967
   Acrylic and enamel on canvas,
   141 x 202 in.

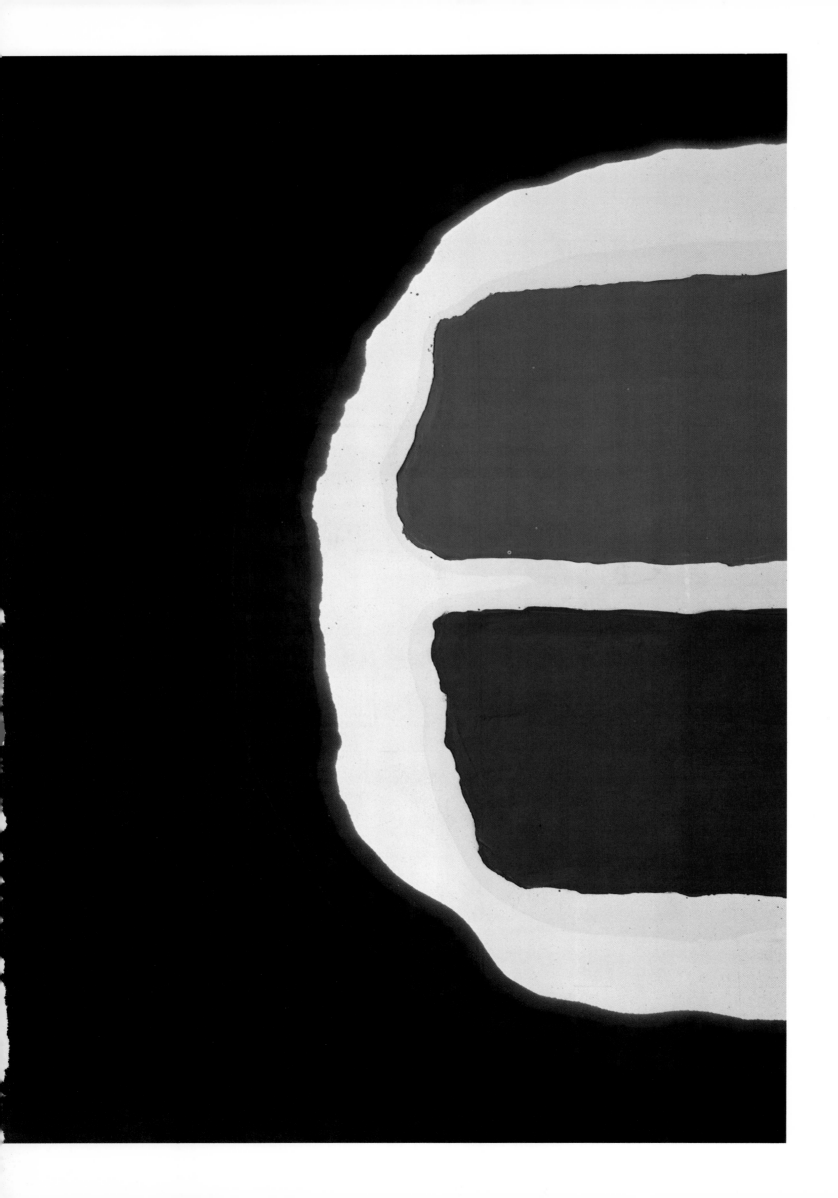

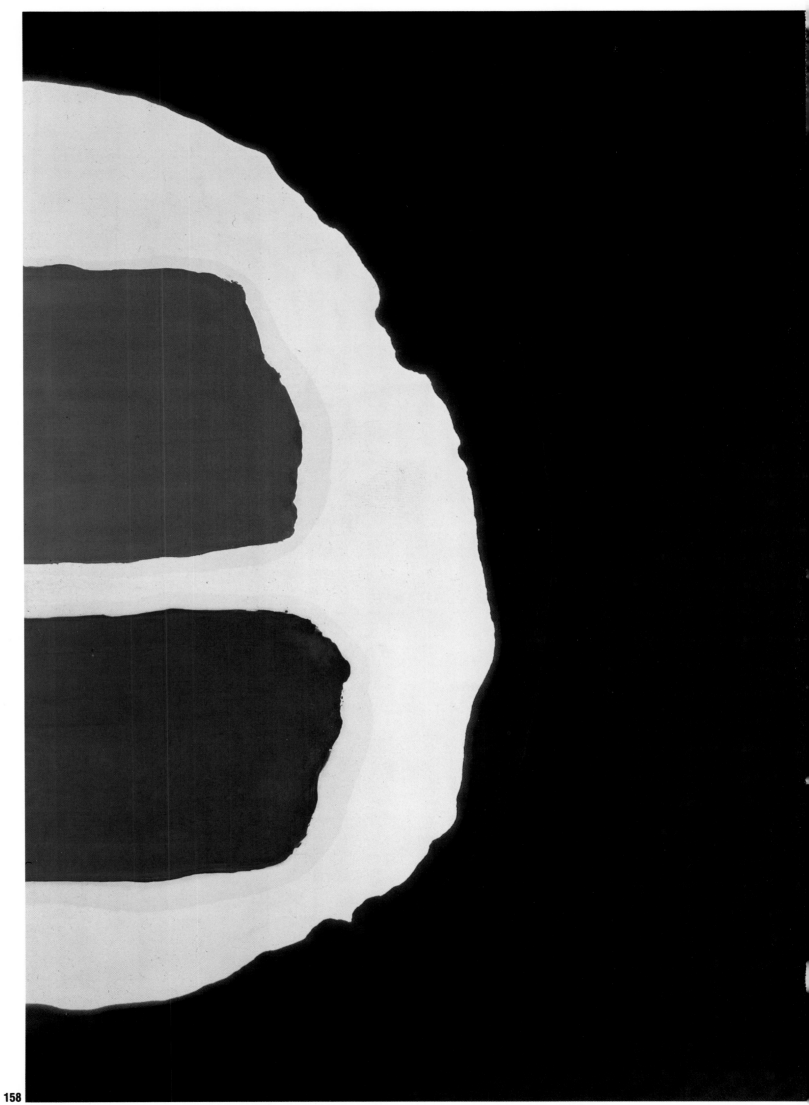

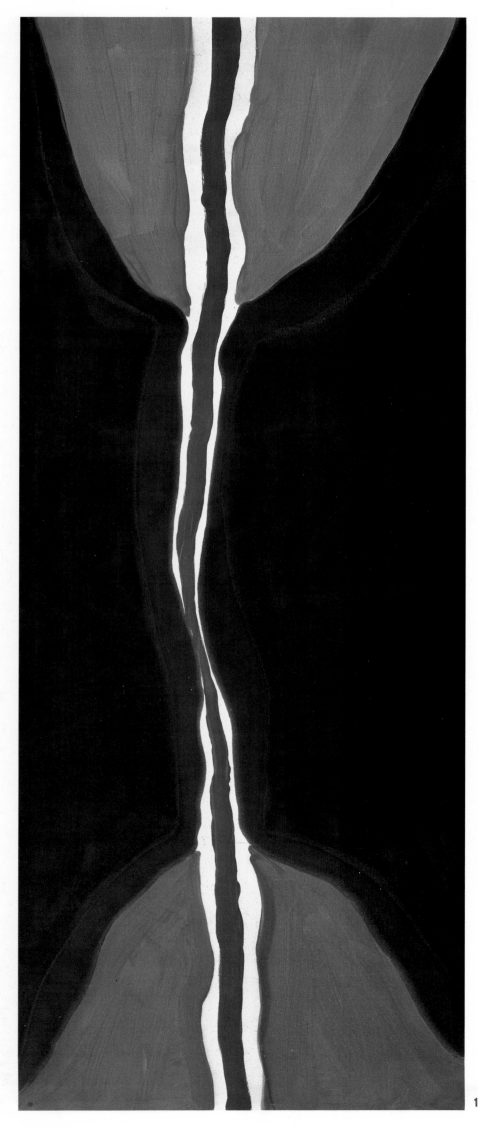

*I think a new idea comes from an old idea that is in the process of being either destroyed or created. You prepare the canvas for an action that you expect to do, and suddenly you see a different revelation. Matisse said he took the train in Paris for the Côte d'Azur, but he might want to stop in Lyon. The same thing happens in the artistic process.*

*I think of art as a call to spiritual arms, a call to the superior qualities of human beings. This is what art is about, and is supposed to do to other people who look at it. Art does call people to religion—not the literal imagery of religion, but the yearning for something beyond to fulfill a potential—a subconscious feeling of what is put into us.*

159. *Link III*, 1967
   Acrylic and enamel on canvas,
   100 x 39¾ in.

160. *Auras II*, 1967
   Acrylic on canvas, 120 x 116 in.

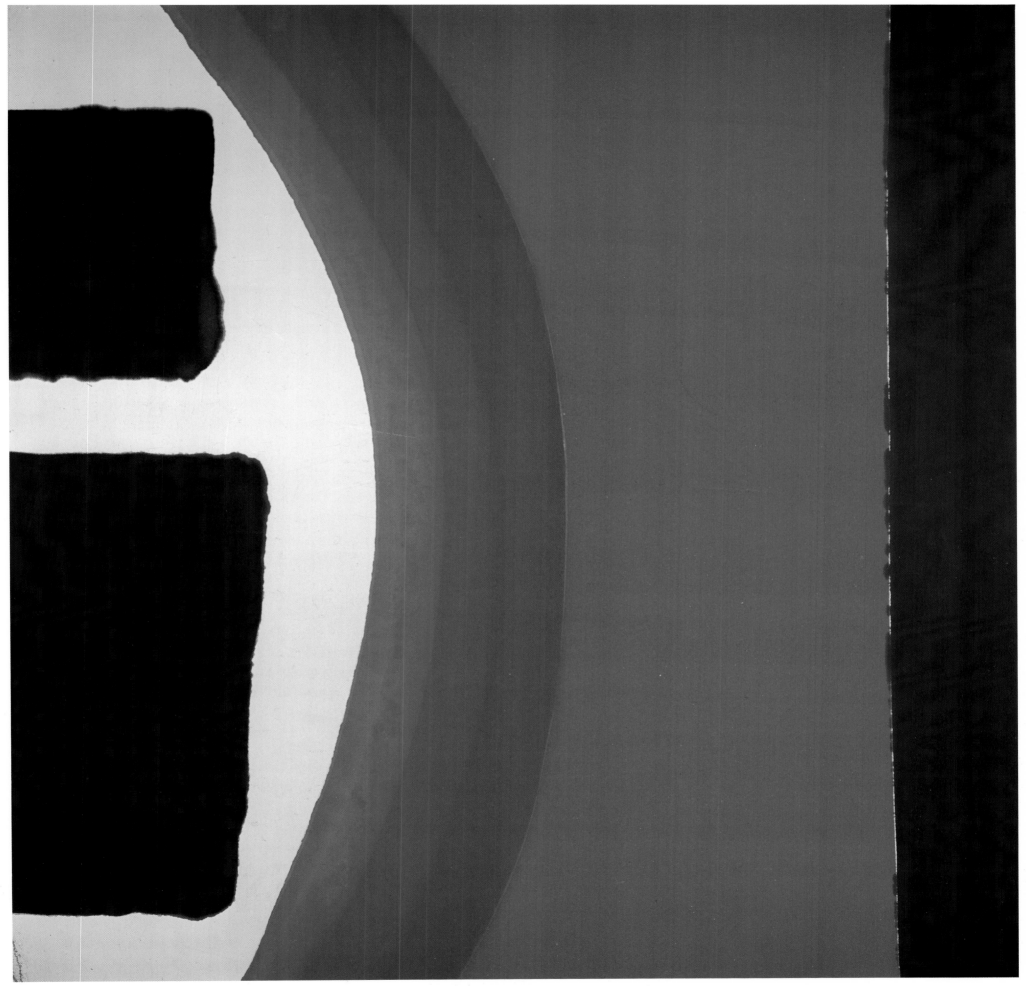

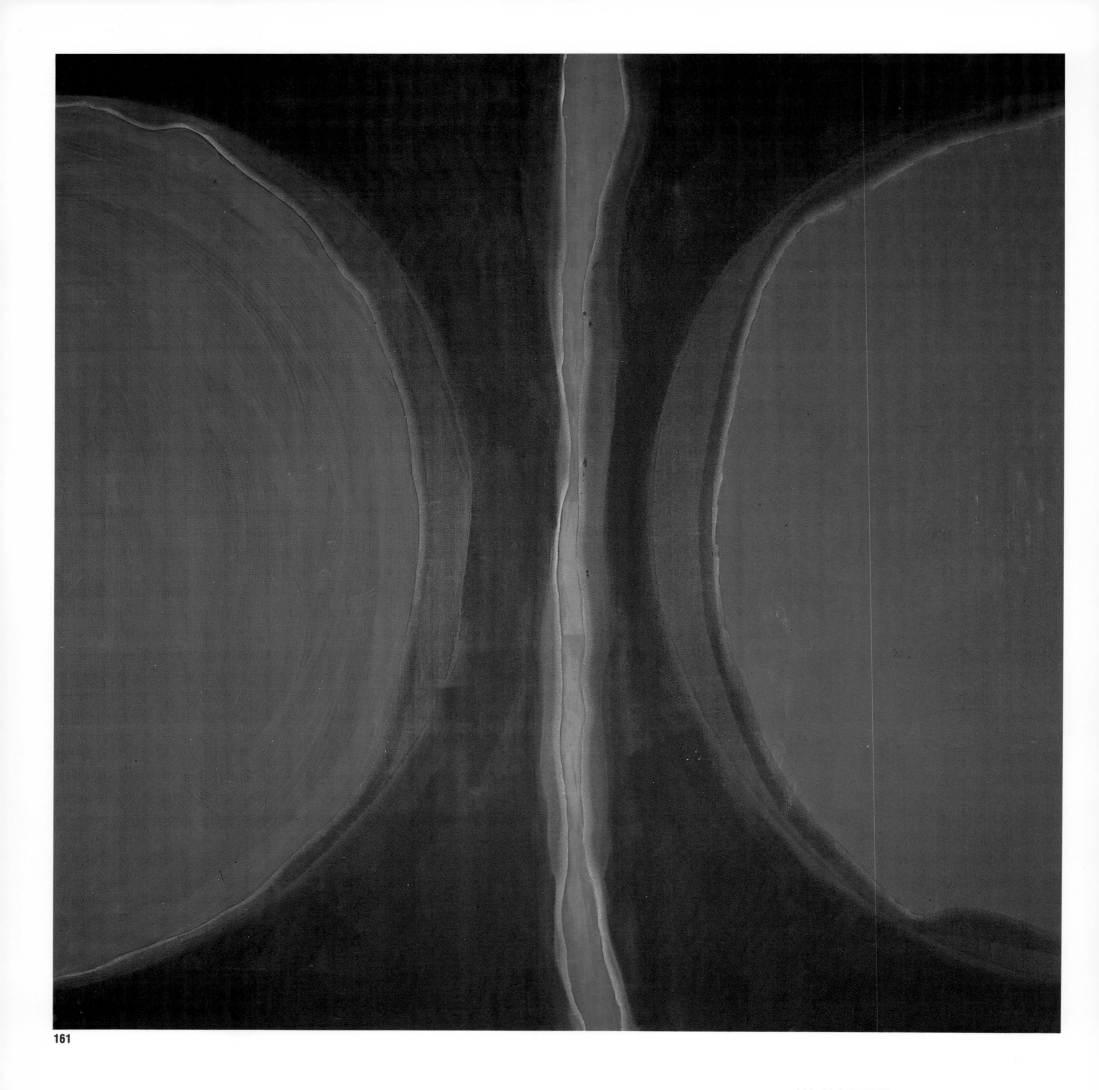

**161**

161. *Link II*, 1967
Acrylic and enamel on canvas, 89 x 90 in.

162. *Link I*, 1966
Acrylic and enamel on canvas, 89 x 89½ in.

160

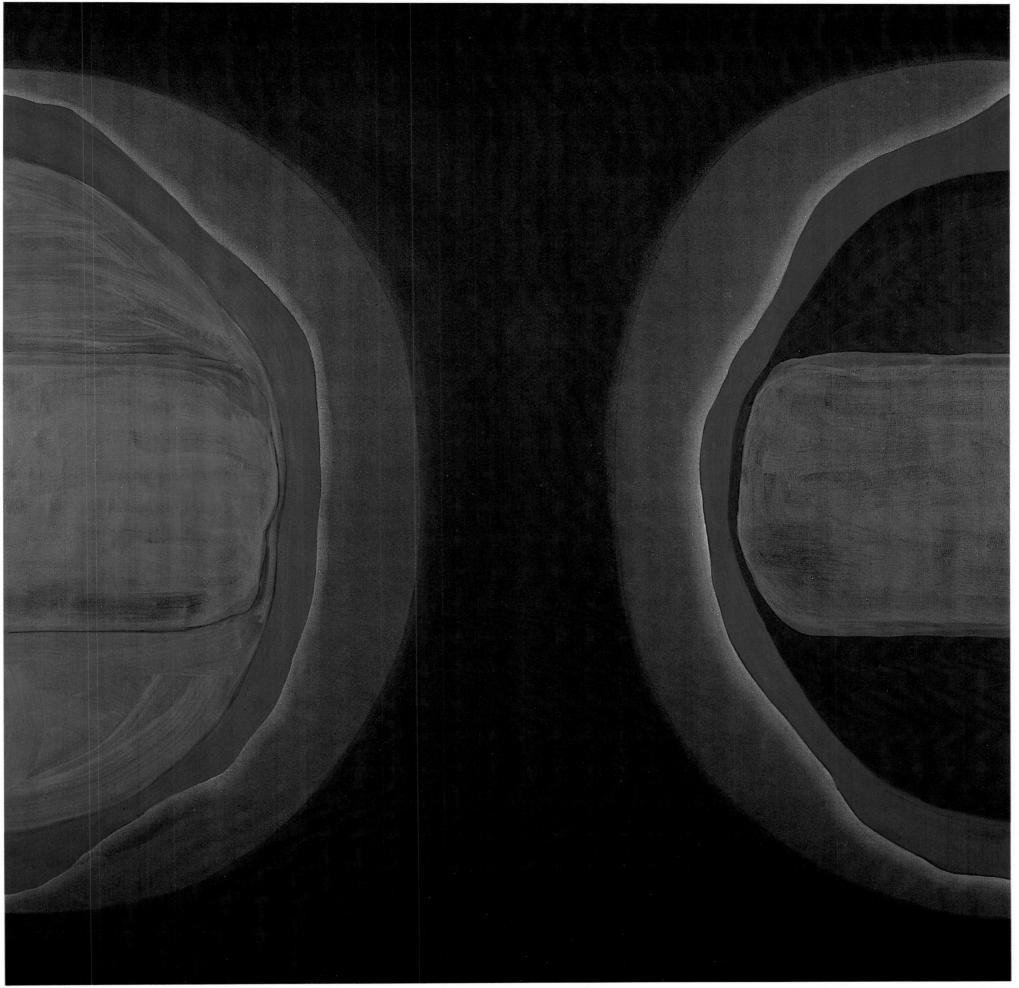

CHAPTER

---

# VI

## THE PATH
## TO
## THE UNKNOWN

*I consider no work finished. I will repaint a painting if it's left in my studio twenty or thirty times. I force myself to get rid of them, otherwise I'd be repainting them—because I may not like them. I have many successive likes, and some very interesting work happens through accretion. Sometimes for the sake of getting a more interesting work, you have to destroy, overpaint on a quite good work. You can never arrive at a textured surface unless you overpaint. It's a very tormenting situation. You know that if you're looking for a certain texture, you cannot artificially built it. The texture that interests you has to come from the destruction of the preceding painting, which was already as good as you thought you could make it. One is alone in the studio. One has to make these decisions and one just plunges—it's like diving into the sea.*

*Art—the art that interests me—is an art of extremes. I think the art that would be the armchair art of Matisse, frankly I wouldn't want to do it. That is the weakest statement that Matisse ever made. But his paintings transcend his statement. Art that creates any kind of impact is an art of paroxysm, is an art that really can create an emotional state, that can then bring revelation. So it has to be extreme, I think.*

*I used to erase through geometry and now I attempt to erase through quickness and spontaneity. Instead of the so-called impersonality of geometry, I use speed to encourage the process of disconnecting the mind. A different approach may give better results because one of the great problems is to withdraw from the millions of superficial imprints that surround us, like television, photographs of paintings, movies, newsprint—life around us.*

*Painting is an area set for destruction, but only after one has pursued a certain constructive process. One doesn't just destroy the first stroke that one does. The first mark put on a blank canvas dictates the whole picture, and I think the picture, in a way, is already finished with that first line or the first spot. From that moment on, the artist has to hit the right notes all the way, because that one spot has conditioned the picture. That is a thing that cannot be given to anyone to execute.*

AN APPARENT JOLT of energy in 1968 and a new studio brought another theme: the triangle and its permutations. In the first paintings involving triangular motifs, triangles respond to circles; indeed they resemble bent half-circles. The logic of Liberman's using the triangle as a motif becomes evident if we think of the importance of the mystical three-sided figure in occult literature. In Pythagorean, Kabbalistic, alchemical, and Tantric diagrams—all of which interested Liberman—as well as in Ouspensky's ccsmogony, the triangle is depicted either alone or in conjunction with the circle as an occult symbol. Given Liberman's involvement with hermetic ideas, the triangle was the natural successor to the circle as structuring device with symbolic overtones. This interest in the occult was stimulated early in life by his mother's frequent visits to Berdyaev, who lived outside Paris. He was supported by Simon Liberman, who had been able to get the religious philosopher out of the Soviet Union. Liberman's acquaintance with theosophical texts and his subsequent involvement with Kandinsky's translations of theosophical concepts into ideal forms illustrated in the diagrams in *Point and Line to Plane*, certainly added to his regard for the circle and triangle as metaphysical forms. Moreover, Malevich, whose

163. From Robert Fludd, *La Philosophie Mosaïque*

164. Liberman working in the Warren painting studio, photographed by Dominique Nabokov, 1979

164

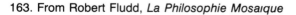

164

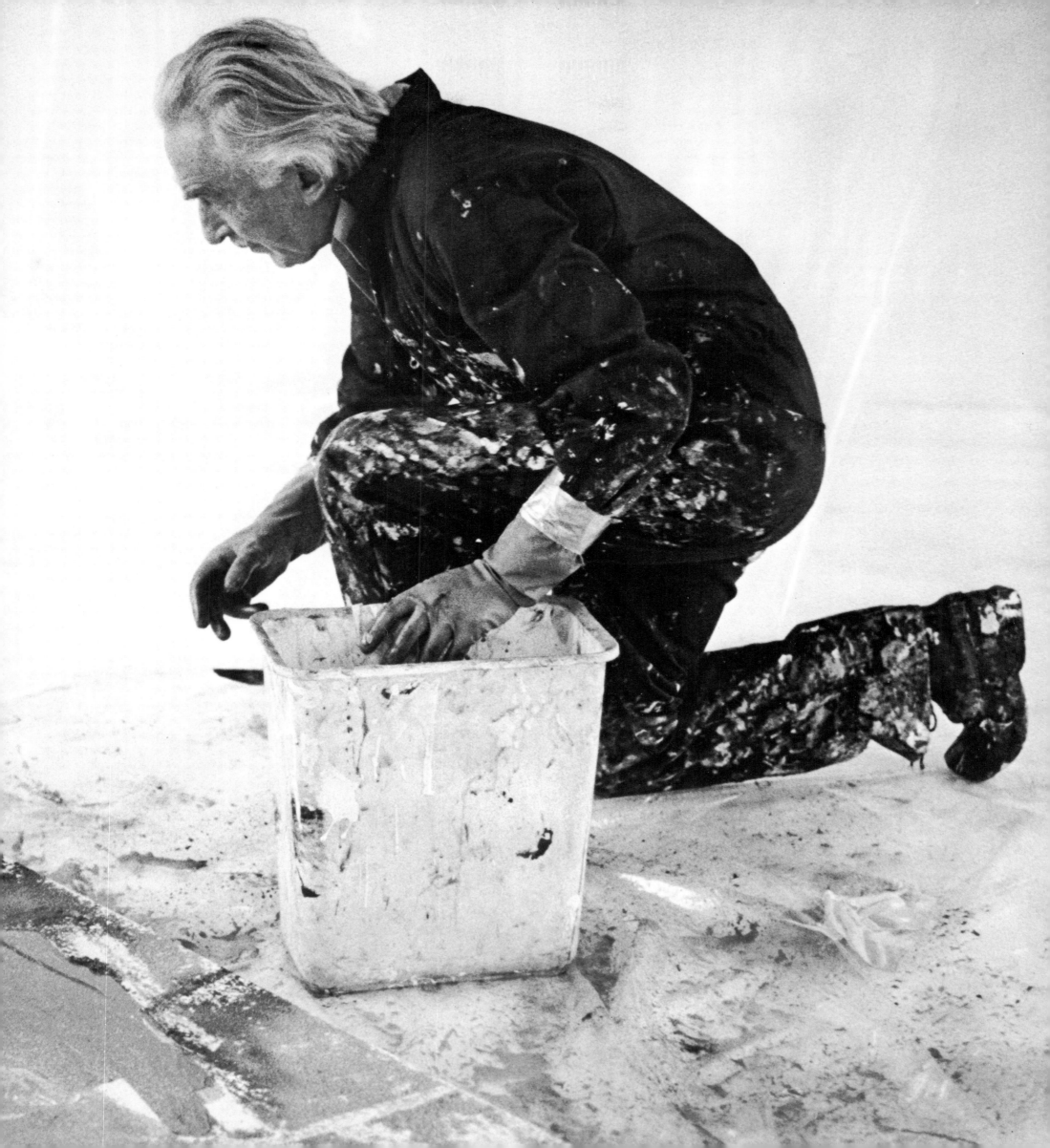

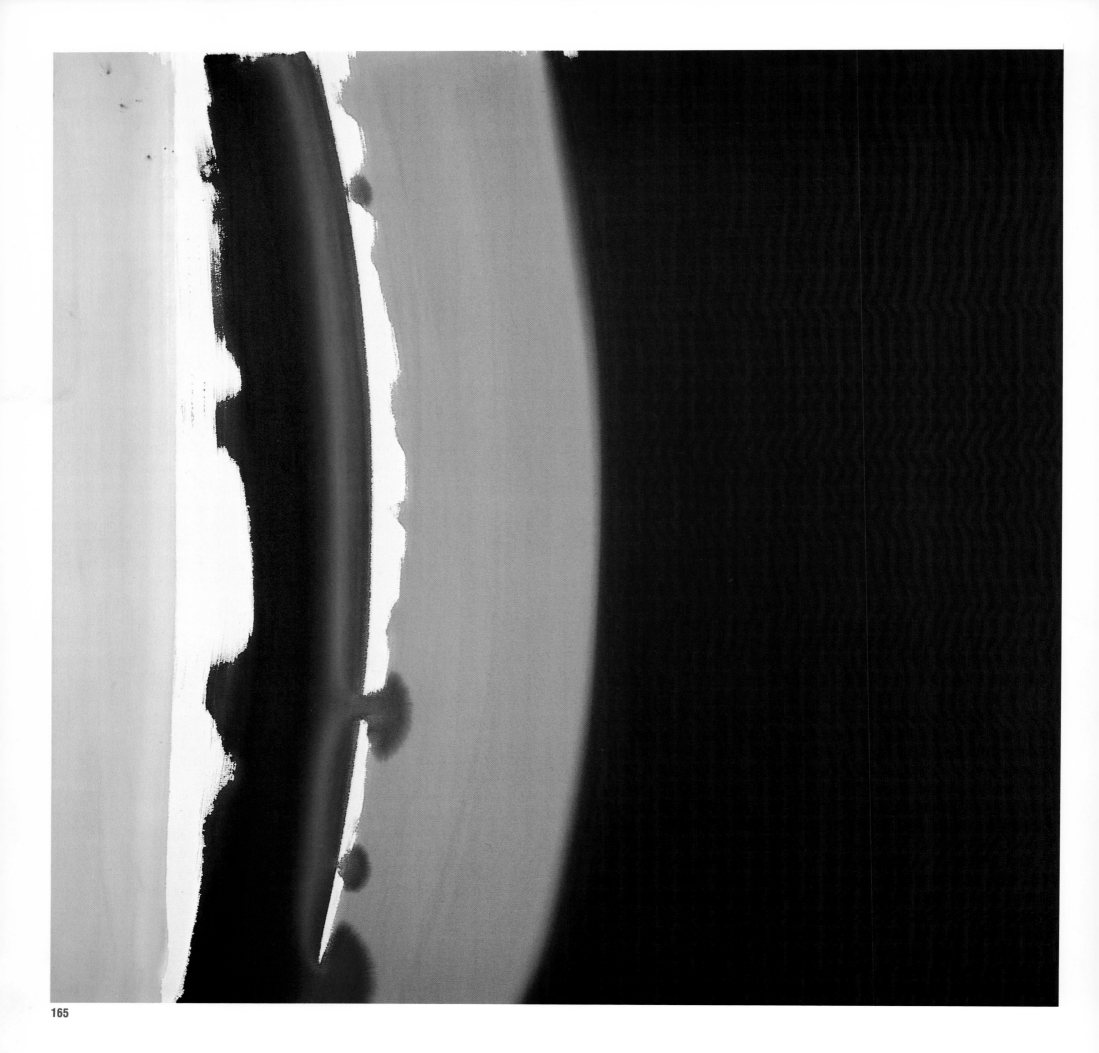

165

165. *Orb I*, 1967  Acrylic on canvas, 100 x 100 in.

Suprematist paintings Liberman had seen in Paris in the Twenties, considered the triangle an important spiritual symbol.

Thus, in the late Sixties, the elegiac mood of Liberman's black paintings—an expression of the melancholic side of his temperament hinted at in his early turgid studies of dark pianists—gave way to a brighter, if not necessarily more joyful mood. Bright color, as John Ashbery once explained in describing Frank Stella's palette, is not necessarily cheerful. How could any artist, authentically in touch with his times in the anarchic period of the late Sixties and Seventies, paint with Matisse's hedonistic abandon?

Matisse was nevertheless very much on Liberman's mind during this period—but it was the spiritual solemnity of Matisse's late works decorating the chapel at Vence and not his gay Fauve pictures that concerned Liberman. Matisse had always loomed large as a father figure for him, almost as large as Cézanne—whom Matisse had identified as the "father of us all." The pilgrimage to Cézanne's studio in 1948 was an important event in Liberman's life. Meeting Matisse in 1949 was a revelation. Matisse was seventy then, one year older than Liberman is at the writing of this book. For Liberman, he was the most profound artist alive. Liberman's essay on Matisse in *The Artist in His Studio* is a paean to the French master's genius. (Liberman took special pride in the fact that Matisse's first great patron, the Russian collector Shchukin, was, coincidentally, a relative of Tatiana Liberman.) In Matisse, as in Picasso, Liberman appreciated the capacity to evolve, to change, to remain like a child. He was particularly impressed that Matisse, unlike the Cubists, used collage not as an end it itself, but as a way to experiment with form and color.

For Liberman, Matisse's greatest work was the chapel at Vence. He wrote that it was "the tangible expression of his fervent belief in the unity of the world.... This final unification of all creative faiths was Matisse's supreme homage to the creator of all." Liberman was the only photographer permitted to photograph the chapel at the time, and he spent hours studying the stained glass windows and the black drawings on glazed white tiles. "This chapel is Matisse's masterpiece," he wrote, "his message to the artists of the future; line is used as a stenography of communication, color, used separately from form and line." Liberman believed that at Vence, Matisse had predicted the future of modern art as a religious message of celebration.

As an art student in Paris, Liberman was familiar with Matisse's celebrated confession to Apollinaire: "For my part, I have never avoided the influence of others. I would have considered it cowardice and lack of sincerity toward myself." In working out of his "admirations," as Liberman referred to his regard for the masters of the School of Paris, he took Matisse's advice. In 1945, Matisse had given an interview, which Liberman had read. The master advised that "to protect himself from the spell of the work of his immediate predecessors, whom he admires . . . (the artist) can search for new sources of inspiration in the production of diverse civilizations, according to his own affinities." In Russian icons, Italian Renaissance and Baroque art, and Greek sculpture and architecture, Liberman found ways of enriching his own art. He also took literally another of Matisse's admonitions, when he quoted Cézanne: "Challenge the influential master."

When Liberman began painting seriously, Picasso was clearly the influential master. "Circlism" was his challenge to cubism. Matisse certainly inspired Liberman to use edge as contour in his circle paintings. The clarity of the hard-edge paintings is reminiscent of the sharp contours of Matisse's cut-outs. Like the cut-outs, Liberman's circles are not outlined shapes but shapes whose edge identifies boundary. The black-and-white theme of the circle paintings, which reemerges in Liberman's latest paintings, is associated with the memory of the shock of seeing Matisse's black drawings silhouetted on the immaculate glossy white tile at Vence.

Liberman's color-field paintings can be seen as another challenge to Matisse. Later, Matisse inspired Liberman to use collage in a noncubist fashion. However, by the time

*I used mops that are used for waxing floors. They gave me a larger stroke, and I didn't want to feel the brush stroke. I avoided the brush stroke because I was still disgusted by oil paint. The brush stroke revealed the hand, and at the time I wanted to avoid any direct contact with the canvas.*

Liberman began collaging on canvas in 1973, he had turned to a painterly style that opposed the crisp hard edges of Matisse's cut-outs. The ragged edge of canvas, crumpled and pasted, is a device to provide structure to painterly surface. (181)

Having worked out his admirations of the School of Paris masters, in the circle-motif paintings Liberman felt impelled to challenge the leading New York School painters. In his interpretation of black as a color field radiating light from within, he threw down the gauntlet to Rothko and Reinhardt. Similarly, one can see the heavily impastoed brushy works of the early Seventies as an épée thrust at de Kooning. Only in the last few years, however, at the peak of his powers, has he felt equipped to challenge the most remote and difficult New York School master: Jackson Pollock.

Liberman had already come to terms with the all-overness of Seurat in his still lifes and Venice scenes of the late Forties. His own more radical conception of the all-over was explored in the paintings created by tossing poker chips. This created an all-over pattern, random in organization, but dealt with only one dimension of Pollock's work. The poured Liquitex paintings of 1963-64 were more complex, both spatially and conceptually, and closer to Pollock's intention in using controlled accident as a metaphor of man's fate and as a means of evoking cosmic images that seemed mysteriously self-created. In *Invisible Order*, Liberman combined his admiration for *Oceania*, Matisse's cut-out of white paper pasted onto linen and for Pollock's method of applying paint through an automatic process. In his recent paintings, Liberman has added the layer of apocalyptic imagery one senses in Pollock's late works. He claims his work changed when he fully understood that Pollock's structure was no longer compositional but rhythmic—a coherence imposed by a consistent impulse and pressure and not a design.

In many respects, Liberman was as absorbed by Pollock, as conscious of his genius as early as Matisse was of Cézanne's. Accident, which Liberman came to understand profoundly through Pollock, plays a primary role in the series of *Orb* paintings, which were painterly versions of the Great Circle. (165, 166) The triangular motif that succeeded the "Orbs" seemed, at first, more conceptual and geometric, less involved with process and accident than the previous paintings made by pouring and spilling onto unstretched canvas. Liberman believes this reintroduction of geometry was inspired by his sculpture. Manipulating huge cut-out triangles that he painted on heavy stretchers in 1969, as he moved them from floor to wall, inspired a more fully three-dimensional understanding of sculpture. As we have seen, he was familiar with the occult diagrams in Robert Fludd's metaphysical treatise, which identified the triangle as a primary mystical sign, inscribed into a circle. (163)

Although Liberman's painting has an evolution of its own, there is an inevitable dialogue between his painting and his sculpture. For example, we have seen how experiences with welding triggered the creation of the fiery imagery and painterly style of his "lyrical abstractions" of 1963-64. Similarly, the black Duco enamel he was using to paint his sculptures in the mid-Sixties became the medium for the series of predominantly black paintings of 1965-67. That the triangular forms he had begun to use in his sculptures inspired the reintroduction of geometry in paintings is another evidence of the dialogue. By the time he had exhausted the triangle motif, however, it was hardly recognizable as a geometric shape because of his commitment to the idea of destroying as well as building form in a reciprocal process.

The triangle, which first appears in Liberman's paintings in 1968, is a further transformation of the "arrow" motif of the black paintings. The arrow shaft is eliminated, and the arrowhead expands until it is a perfect triangle. (167) Like the integral circle, the triangle was a unitary gestalt. The circle was the theme of twelve years work from 1950 to 1962. It continued to be used in 1963-64, combined with other forms that penetrate and break into it. The triangle, although not so long-lasting a motif, played a similarly protean role in Liberman's art between 1968 and 1973. Initially a relatively placid field for transparent washes of color, the triangle was quickly transformed into a charged and thrusting wedge. (168, 169) Many found this new aggressive, impastoed style puzzling. Describing Liberman in 1970, Thomas B. Hess called him "a fanatic, even a ferocious character." He saw in his paintings "a chaos lurking behind the expertise of their technique." These are hardly the terms one would expect to be used in a description of the worldly *Vogue* editor. Yet Hess was among the few in the art world who knew Liberman well enough to detect the inner man imprisoned behind the façade of diplomacy and decorum. Among the first and most vociferous champions of "action painting," Hess was excited by the more expressionist direction Liberman's paintings took in the Seventies. Their agitation and physical gesture struck Hess as authentic statements of a repressed rage that Liberman personally, and the modern artist generally, seemed fated to vent through art.

166. *Orb II*, 1967 Acrylic on canvas, 110 x 90 in.

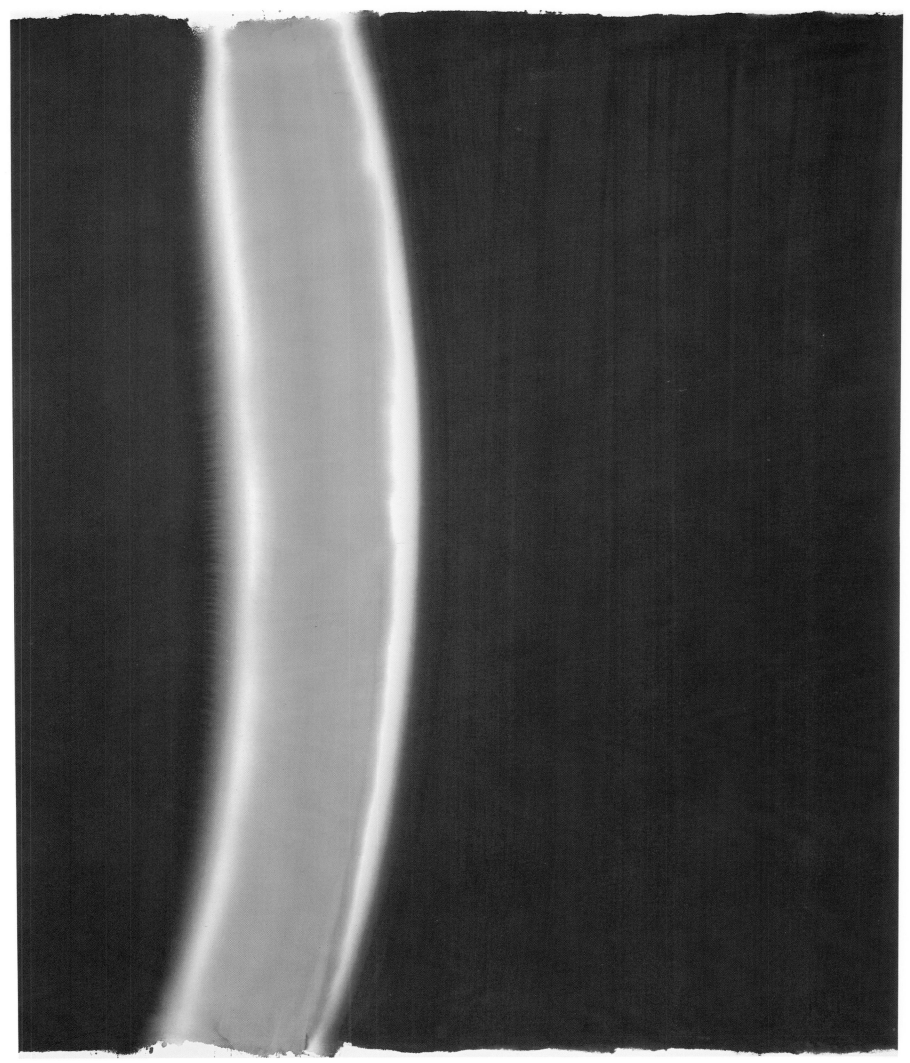

167. *Invisible Order*, 1970
Acrylic on enamel, 10 x 25 ft.

Liberman's first triangles were clear closed forms whose edges are soft because he was still staining paint into raw canvas. (*167*) Some of these early triangles were shaped canvases, a later version of the tondos of 1962. In the catalog of Liberman's Corcoran Gallery of Art retrospective held in 1970, Hess pointed out that in 1969 both Liberman and Newman exhibited paintings based on triangular motifs, although they had not seen each other's works. Their respective interpretations of the triangle, to be sure, were quite opposed. Newman's triangle had its base solidly grounded along the bottom edge of the frame; it pointed upward, a symbol of stability. Liberman's triangles, an outgrowth of the descending "arrows" of his black paintings, pointed down, levitating in a vague ambiance. (*172*) They suggested ascension rather than gravity and stability. By inverting the triangle, placing it apex down and building it sideways into acute angles, Liberman associated the image with the spread wings of a bird or a seraphim. Floating freely in an ambiguous color space, as his circles had previously bounced in their glossy surrounding fields, Liberman's triangles were likewise at times involved with symmetry, suggesting equilibrium, and at times with asymmetry, associated with dynamism and instability. In their precarious placement, the off-center triangles suggest a man on a tightrope, trying to find his balance. (*171*) As the series evolved, the contours of the triangle were blasted open. Liberman

was in fact dynamiting his sculptures at the time, in an analogous sculptural development. Field invaded figure, an indication perhaps that the artist himself was now more open to experiences outside the self.

In some of the large horizontal field paintings in the series, the triangle bifurcates two corners of the painting in a manner reminiscent of Morris Louis's "unfurleds" and Kenneth Noland's "chevrons." Louis and Noland left large areas of canvas raw and unpainted. Liberman, on the other hand, covered the whole surface with color. Because he left little, if any, canvas unpainted from 1963 to 1972, during which he used the stain technique, Liberman's paintings have not suffered the yellowing process that canvas naturally undergoes if it is exposed. The explanation of why Liberman neither cropped his paintings nor left bare large areas of canvas lies in his primary reluctance to define his formal structure by sinking the image into the canvas or anchoring it to the frame. Throughout his career, whatever technique he used, Liberman's principal goal was the creation of an ambiguous metaphysical image rather than any exclusively formal concern. Technical considerations mattered only insofar as they furthered his search for metaphysical content. This primary commitment to a psychologically charged image explains why, although he was attracted to the style of stained painting lauded by Clement Greenberg as "post-painterly abstraction," the artist whom Liberman personally revered and

**168**

168. *Up—Orange Between Yellow*, 1968-69
Acrylic on canvas, 81 x 237 in.
Collection Mr. and Mrs. Ezra Zilkha, New York/Paris

studied was Pollock, himself the inspiration behind stained painting. Liberman admired Pollock for using technique as a *means* to create cosmic and mythic imagery, and not as an end in itself, just as he admired Matisse for using collage as a means and not an end. They were his heroes because formal concerns were only a part, not the sum of their art.

As a result of his search to understand how Pollock arrived at his mysterious and dangerous balance between creation and destruction, order and chaos, accident and control, Liberman found his own way to a new style that was based on a more profound conception of the role of chance, both as metaphor and as a means to create potent and unpredictable images. The transformation of the triangle from inert cut-out to activated surface, boiling with energy, was like the deconstruction of the circle, a gradual process. It paralleled the development of the circle from disc to tondo to streaming planetary image. Both circle and triangle were, for Liberman, fundamental units of a pictorial language that became increasingly complex in its syntax. By 1970, the drawn triangle was used to structure a painterly field, rather than to describe a solid shape. In this connection, one recalls the voided circle of *Minimum*. (*68*) The gradual disappearance of shape is common to the evolution of both the circle and triangle motifs in Liberman's paintings. The triangles, which had been the basic constructive unit, began to be destroyed by the incursions of graphic overlays, the chalk

and pastel scribblings that were applied to their surfaces. The triangles themselves became more graphic and ephemeral and less solid as more paint was applied to the canvas. Once Liberman abandoned the stain technique in 1970, his color became richer, denser, and more opaque.

The introduction of the graphic element to painting was the result of Liberman's experiences with printmaking. He made his first woodcut as a teenager in Paris. (*30*), and his first lithographs with Mourlot, the great School of Paris printmaker, in 1963-64. Working with tusche on stone apparently contributed to his new appreciation of black as a color, the basis of his 1966-67 paintings. In 1968, at the suggestion of Danny Berger, he did his first aquatints at 2 RC, an experimental print workshop in Rome which Berger managed for Walter and Eleanor Rossi. (*191*) Scratching into the metal plates was an eye-opening experience for Liberman, and it changed his painting style dramatically. A new kind of vehement drawing, which animated the surfaces of his painting, redefining *éblouissement*—Liberman's word for the optical dazzle he has always sought—was the result. For the first time, surface and texture became major considerations in Liberman's painting, which heretofore had been mainly involved with color and space.

Liberman's 1973 exhibition of triangle paintings loaded with exploding pigment and covered with graphic scribbling once again astounded the critics by his abrupt turn-around.

**169**

In my mind the triangle had to do with Byzantine wings in Byzantine paintings—wonderful crossed wings of the angels. At a certain period in history, throughout civilized humanity, the wing had such an extraordinary importance. Wings allowed flight, levitation. Tatlin's glider had wings for movement and flight. Wings also had a quality of envelopment. When I did those big triangles, I thought that anybody standing in the middle would be surrounded by the wings. I argued with Barnett Newman, who felt the triangle was stronger the other way. I didn't want the triangle to be stronger, I wanted the triangle to imply ascension.

169. *Triad VII*, 1972-73
    Acrylic and chalk on canvas, 90¾ x 114½ in.
    Collection Mr. and Mrs. S. I. Newhouse

170. *Open Triad*, 1973
    Acrylic and chalk on canvas, 93½ x 79½ in.

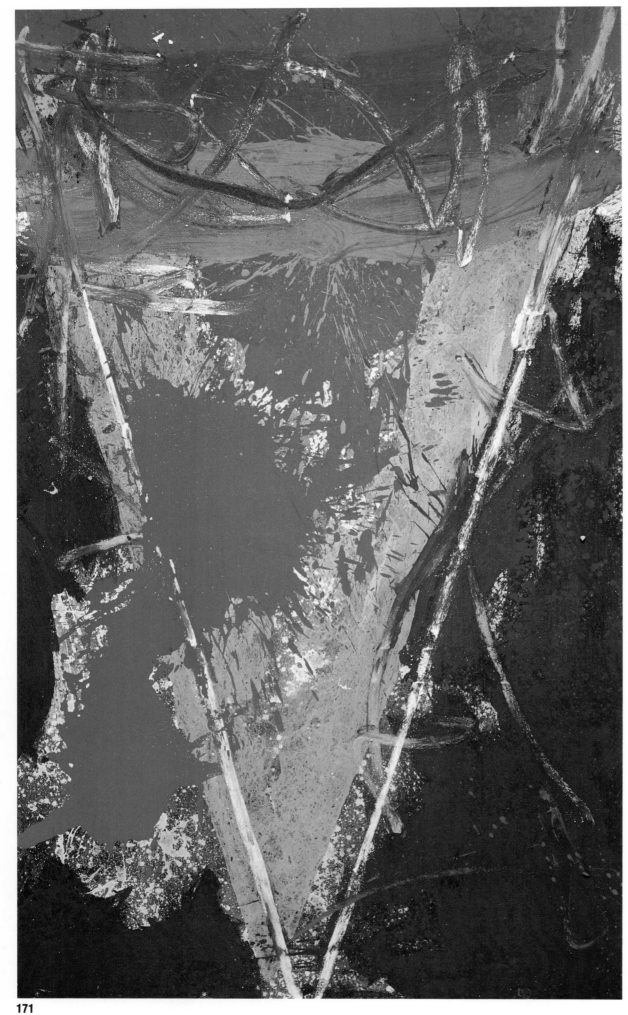

171

*A triangle as a pyramid is a sign of death: pyramids were death monuments. But the triangle inverted, open, rising, like the circle, implies elevation of the spirit into realms beyond the material.*

171. *Open Triad V*, 1973
Acrylic and chalk on canvas,
99 x 61½ in.

172. *Triad V*, 1972
Acrylic and chalk on canvas,
88½ x 86 in.

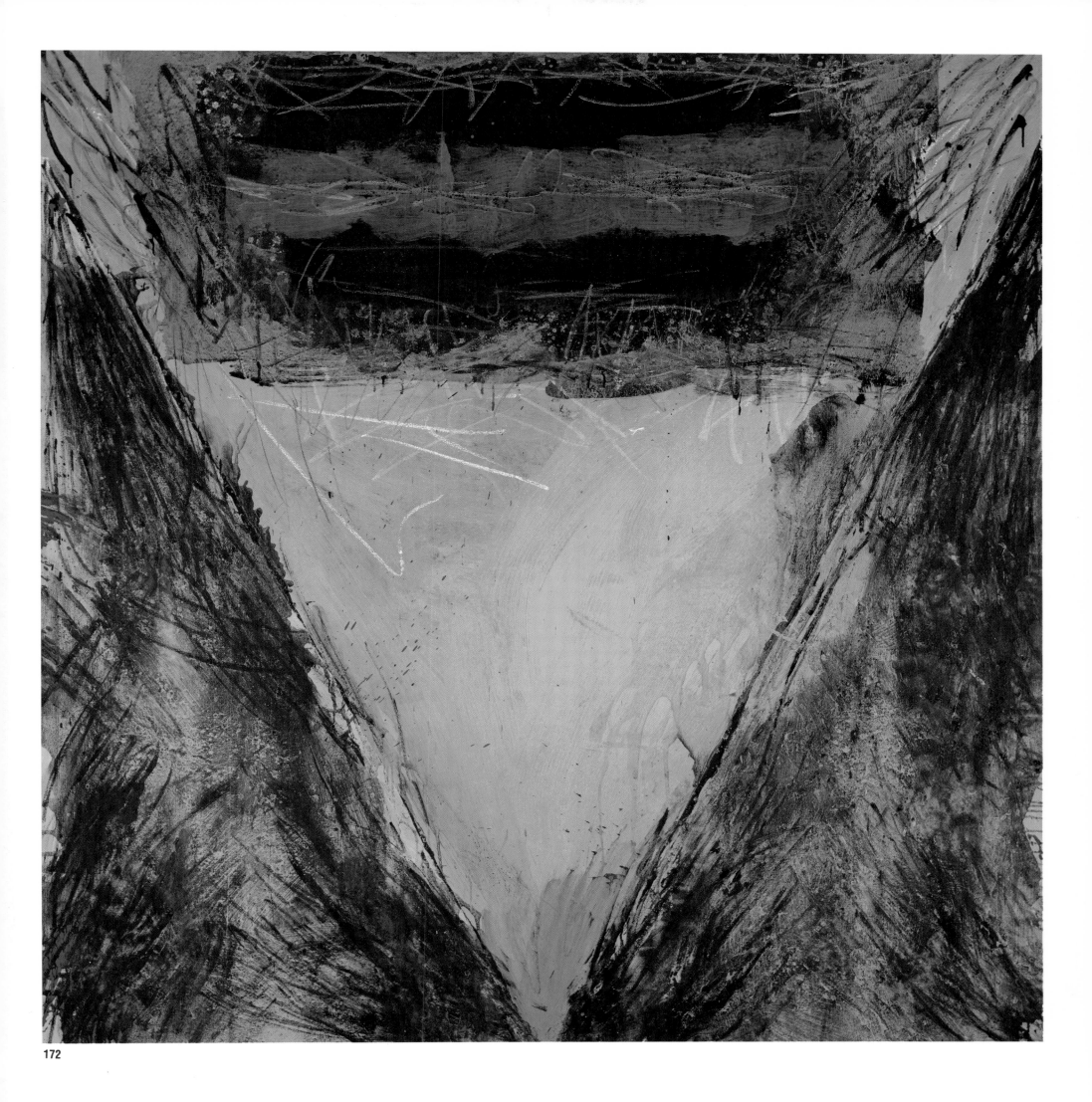

According to *Newsweek's* review, "Liberman's familiar triangle has exploded. Its once razor-clean boundaries are smeared and bleared with garish swipes of color . . . the triangle is turned upside down and gored with dark, dank strokes. . . . These are horrific paintings to look at, bordering as much on ugliness as on beauty." The critic perceived that Liberman was now more involved with passionate *terribilità* than classical decorum, and that a new element of "action painting" had found its way into his art. Surfaces were piled high with pigment, scarred and gashed with violent color. Paint no longer flowed serenely across placid color fields. The hand of the artist, absent until now, was very much in evidence—scribbling, scratching, and scarring his own surfaces. Hess apparently had been right; behind the lacquered cage of the circle paintings, a tiger was prowling.

We have seen how at the end of an earlier evolution the circle threatened to break the boundary of the frame against which it pushed with contained aggression. Now the triangle began pushing out explosively from its center, violated and invaded by aggressive brushstrokes and surface *sgraffito.* Coincidentally the triangles were the first paintings Liberman executed with a brush since the impassive, anonymous circles. During the Sixties, he had applied paint through the automatic processes of pouring, spilling, and mopping. The introduction of his own personal gesture through drawing was unprecedented in his art. In the past, Liberman had always eschewed personal expression. Now he embraced it. As usual, his approach was extreme. Before long, the entire surface of the canvas was covered with chalk marks, until gradually the triangle submerged and vanished, as if destroyed by erosion. (*176*) By 1977, the last vestige of geometry had been expunged by Liberman: drawing per se had become his subject. Here it should be pointed out that Liberman did not use drawing in the traditional way to describe form or create shapes. Matisse's prophecy, that drawing was an autonomous element like color, to be used for its own sake, Liberman now understood to mean that the function of drawing was not necessarily descriptive. Working with the gesture of the hand rather than the arm, on the etching plates at 2 RC, suggested the means to introduce drawing as a free element into painting. (*174*) For in printmaking, drawing is literally separable from color: drawing is done on a different plate, and only combined in the superimpositions of the final printing. In the Fifties, magazine and poster design had suggested a flat graphic style. Now etching and aquatint inspired a deeper, exclusively pictorial space, created by superimposing layer on layer of pigment and charcoal.

The range of color in the triangle paintings is extreme also. From the earliest Matisse-inspired pure hues of the stained triangles, with their langorously spreading "wings," Liberman switched to the intense palette of complementary colors juxtaposed in riotous cacophony. (*171*) Then, as with the geometry, color gradually disappeared from these works. In 1976, Liberman applied a surface coat of titanium white paint, mixed with gel, which "erased" layers of color underneath by covering them over. The idea of creation through destruction had begun to obsess him. The color now asserted itself only in shreds and fragments where the white paint mixed with glutinous gel was scraped away by charcoal or sticks vehemently lashing the surface to reveal layers beneath. This effect of negative drawing created a space literally behind the surface relief. Although actual depth could also be optically measured, the illusion was one of indefinite space. (*177, 178*)

Throughout the Seventies, Liberman worked only on stretched paintings. Since drawing was a major concern, he had to work once more on taut surfaces. He mixed techniques and materials in wild bouts of experimentation with various media as he searched for new images. Most of these paintings were done on stretched canvases, because you cannot draw on unstretched canvas. Though not as literally involved with grafitti as Dubuffet or Twombly, like them Liberman was also considering the blank canvas as a wall to be covered with the painter's personal mark or handwriting. His marks were obviously and deliberately made quickly—as if in a frenzy or a fit of anger—perhaps in the same kind of fit that frightened his teachers when he was a child. These are strangely energetic and athletic works for a man in his sixties. It was as if all the anger, aggression, and bottled-up emotion that had been steaming within for years finally exploded on the canvas. Liberman, who had first learned discipline through understanding that they stop beating you when you stop crying, could finally afford to lose control. In fact, he could feel free enough to destroy what he had created.

Among the experiences that shaped his new conception of nature as destructive as well as creative were his trips to the volcanic island of Ischia beginning in 1965. Photographing the bleached porous rocks, he mused on the antiquity and grandeur of nature. (*173*) In many respects, the effects he achieved through technical experiment in the late Seventies are reminiscent not only of the formations of the rocks created from the cooled lava, but of the idea of time acting on nature, of surfaces eroding and volcanoes erupting and cooling.

The theme of destruction had already cropped up in his work. In 1959, he had made a drawing by scraping part of the ink away. *Grattage*, as Max Ernst called it, was one of the automatic techniques advocated by the Surrealists. As we have seen, it was through his study of Pollock that Liberman came to have a deeper conception of accident as existential

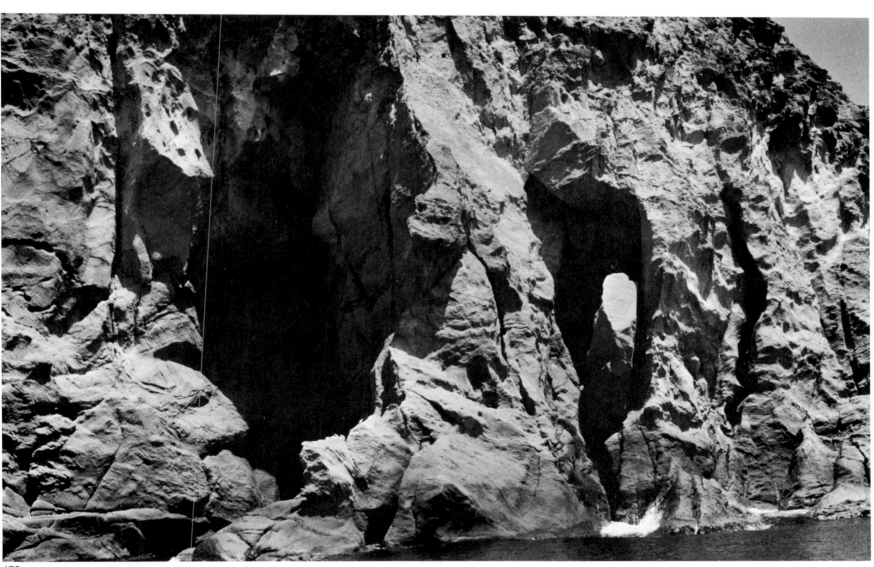

**173**

173. Rock formations at Ischia, Italy,
    photographed by Liberman, 1970

◁

174. *Triad I*, 1973
    Acrylic and chalk on canvas, 70 x 146 in.

*I've been coming to Ischia since 1967. The lava rock formations are all gray. They're extraordinary massive hunks. I suppose I took Leonardo's advice and studied the moisture on the walls for ideas of painting. I think a lot of what has happened in my recent paintings, and perhaps in the crushed metal that I experimented with, is related to these structures.*

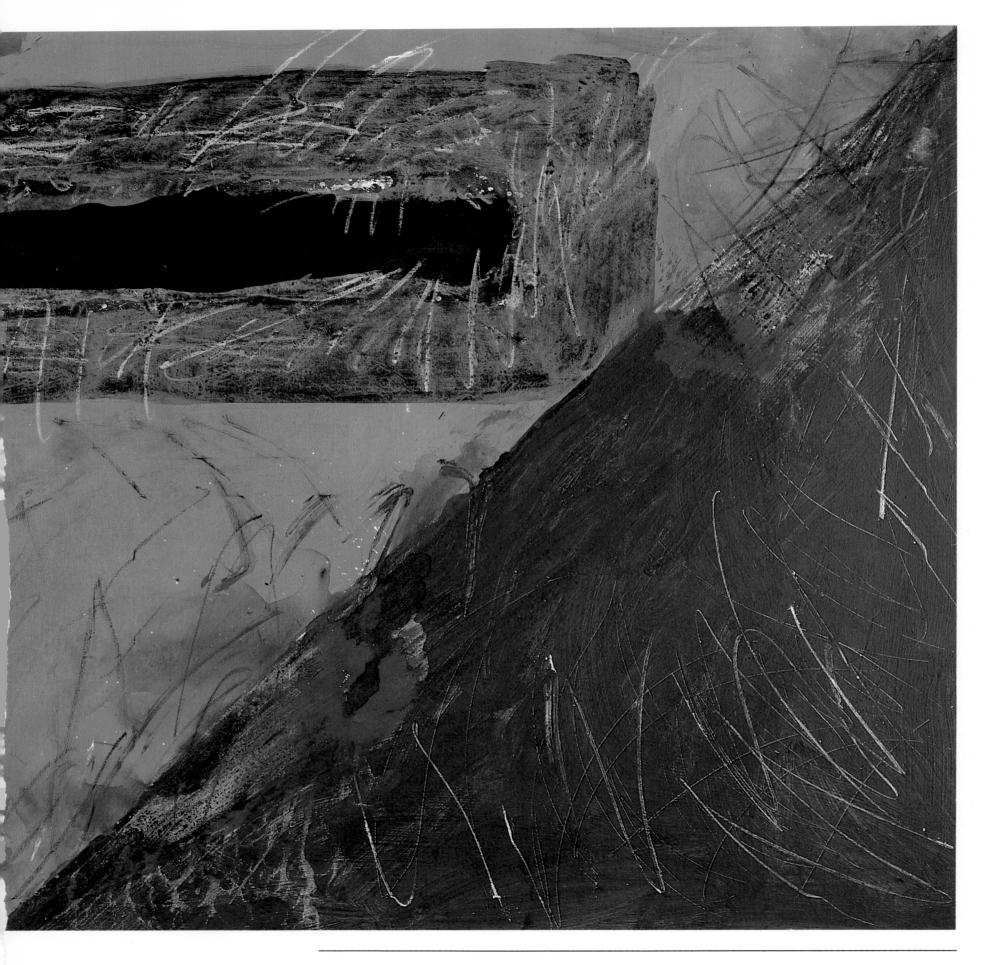

I was thinking of Nebuchadnezzar's feast, of the writing on the wall: Mene Mene Tekel Upharsin. This question of the wall was very much present in the triangles. The triangle was elevation and at the same time was a wall. So then the handwriting started coming in—the fire. I started "writing" at the top, trying to break the surface.

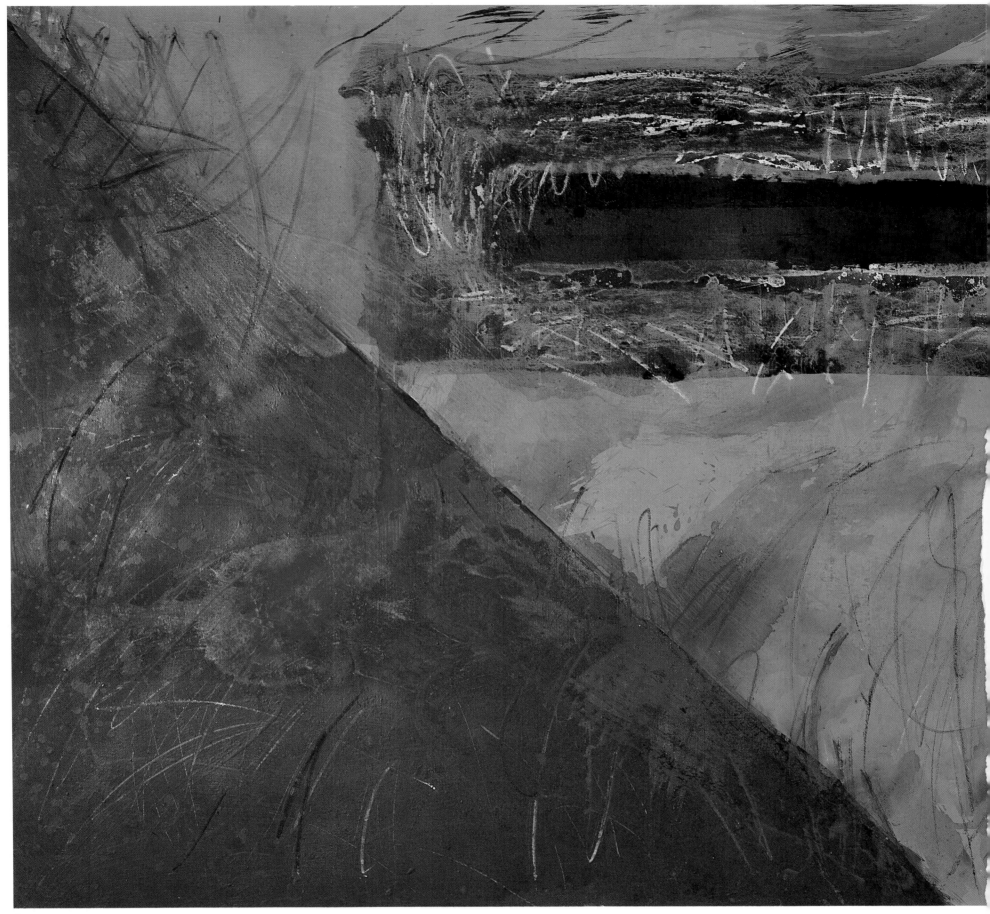

174

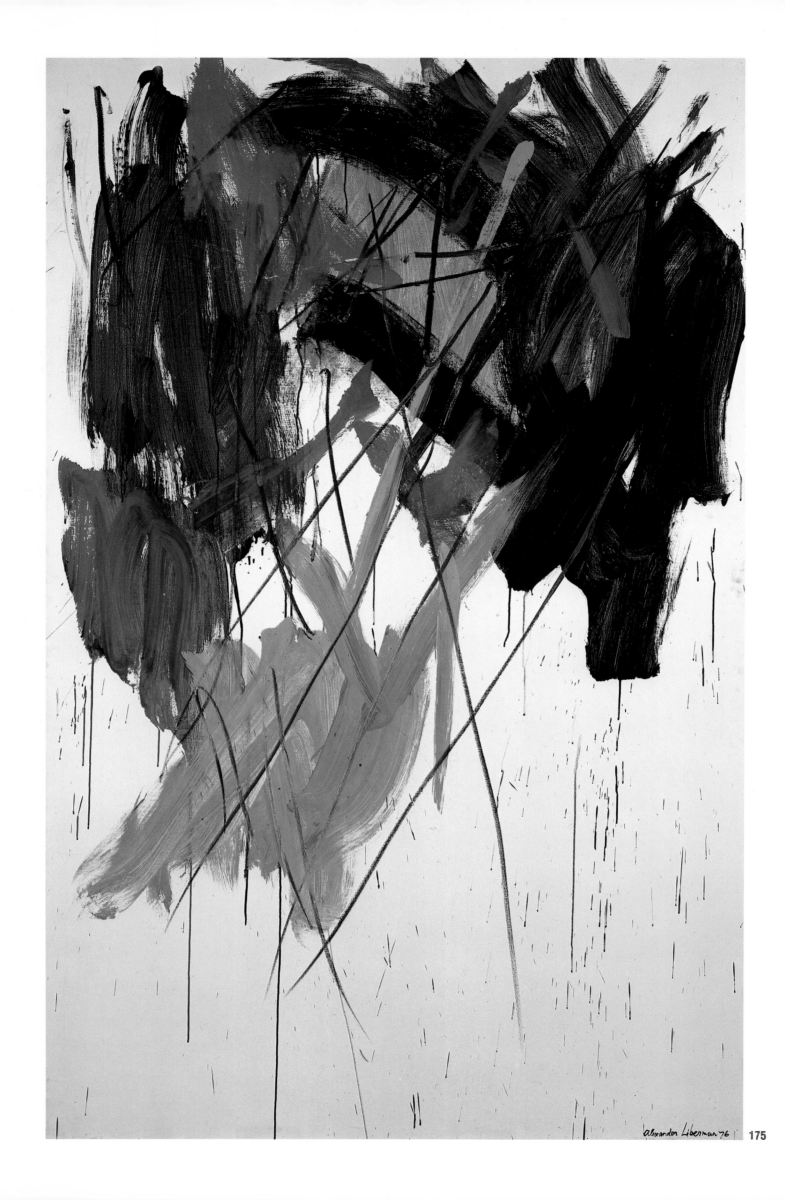

Alexander Liberman '76

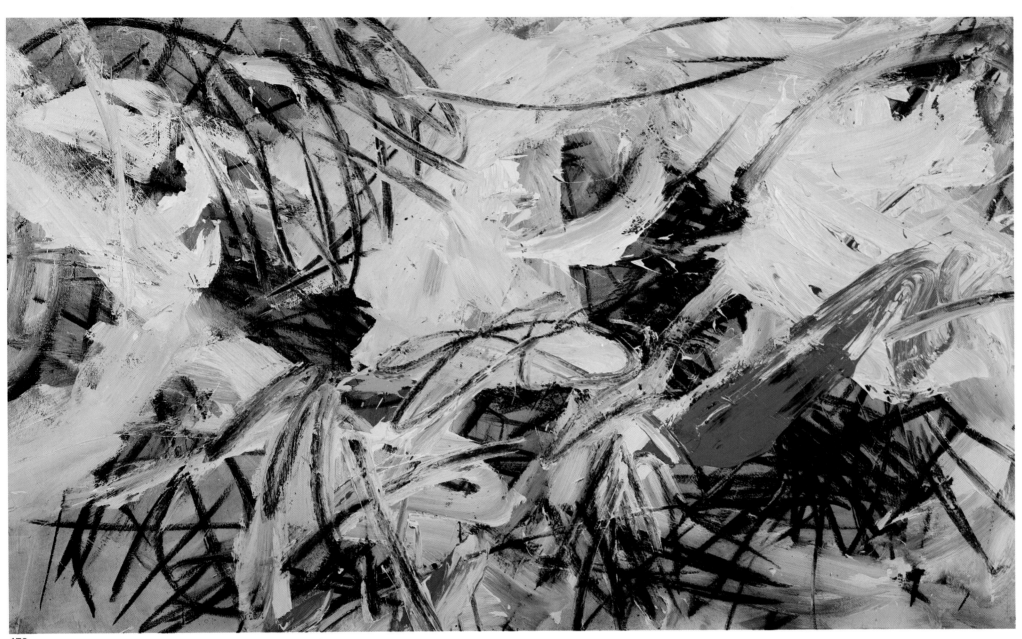

**176**

175. *Sign*, 1976
Acrylic on canvas, 96 x 60 in.

176. *Erg*, 1977
Acrylic on canvas, 55¼ x 84 in.

*Somewhere I am still pursuing the clear statement made in one piece. I believe that one has to destroy all concepts of composition and I feel that, although Pollock destroyed the traditional concept of composition, which was a structural one, he introduced a new composition, which was a rhythmic one.*

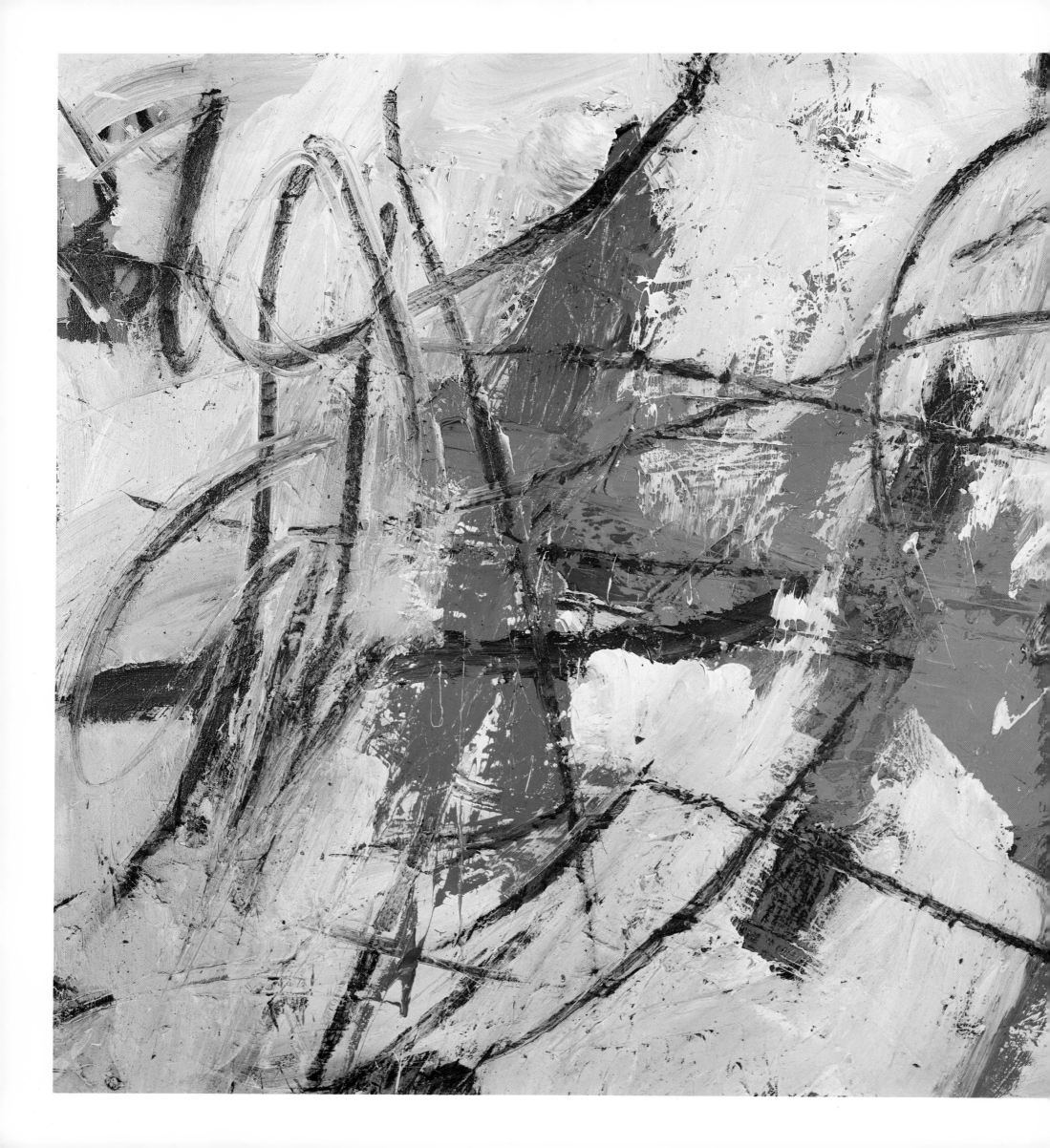

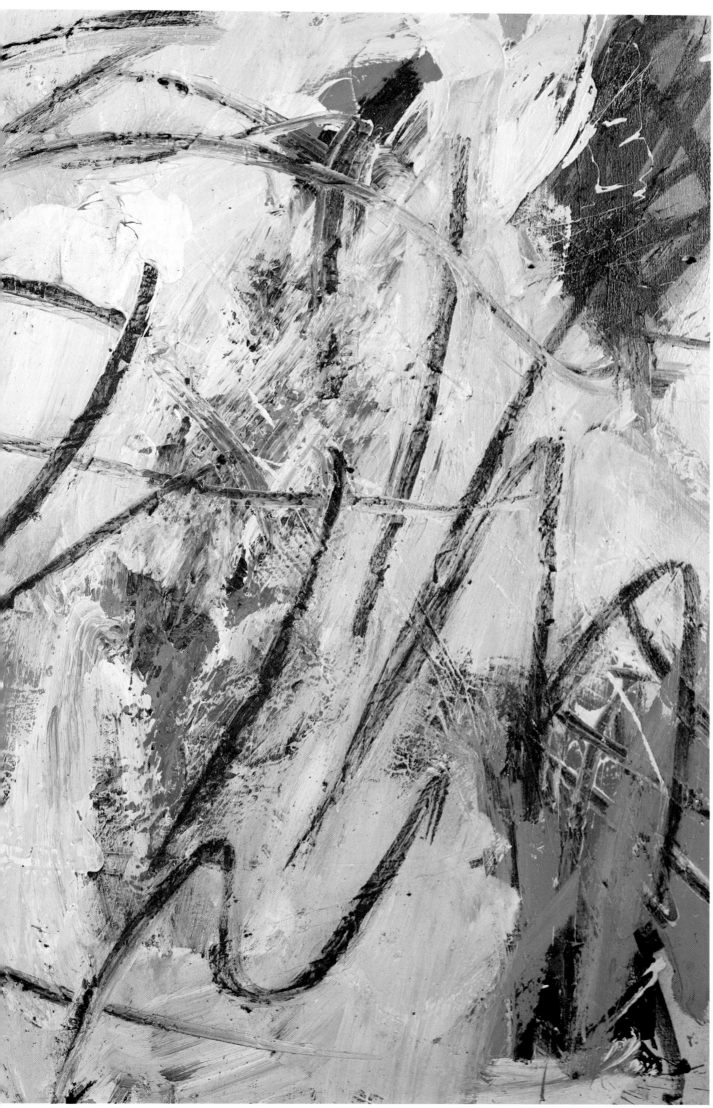

Precision is eliminated working on the wall. Something else happens because greater speed is possible. You are on your two feet so you can move faster. You slash through the painting. On your knees you are absolutely paralyzed. Paintings on the floor are soft paintings. Paintings on a stretcher are harder paintings.

Without physical action, nothing gets done. I've always believed that doing was the important thing. In art, in the long run, there's no point dreaming of certain things you'd like to do. You've got to do them. Do it, risk, make a mistake, start again.

177. *Erg XXIII*, 1977
Acrylic and charcoal on canvas,
60 x 96 in.

**177**

metaphor. Pollock, a student of Eastern religions, was acquainted with the Oriental principle that artists should imitate nature in its operations, rather than depict nature literally. During the Seventies, Liberman, who began as a landscape painter, found ways of using automatic technical processes to produce images that went beyond literal mountains or beaches to suggest the ways natural forms were altered by time, cracking and splintering into gorges and ravines or erupting in molten geysers that reminded him of Ischia.

The transitional paintings between the triangles and the austere black-and-white paintings of 1979 involved a destruction of the images extreme enough to threaten structure itself. There is a connection between these paintings and Rauschenberg's act of erasing a de Kooning drawing. To erase a de Kooning was both destructive and creative; the gesture created a new work by destroying one that already existed. In many respects, Rauschenberg simply continued de Kooning's own process of revising an image, often through erasure. There is also a relationship between Liberman's impastoed painterliness, first evident in the later triangles, and de Kooning's loaded brushstroke. This relationship continues in the "white" paintings to which the triangles gave way. However, there is an essential difference between de Kooning's concept of drawing and Liberman's. This difference locates Liberman's goals as closer to Pollock's than to de Kooning's. De Kooning's gestural style is rooted in cubist figuration; even in his most abstract works, one senses the figure or landscape in the real world from which the image has been abstracted. Earth and flesh are always suggested in some way by de Kooning. Pollock, on the other hand, even in his figurative works, never looks outside at the real landscape or figure; he finds his imagery only within his own subjective dreams and obsessions. Pollock thus is both a

178. *Erg XIII*, 1977   Acrylic on canvas, 85 x 120 in.

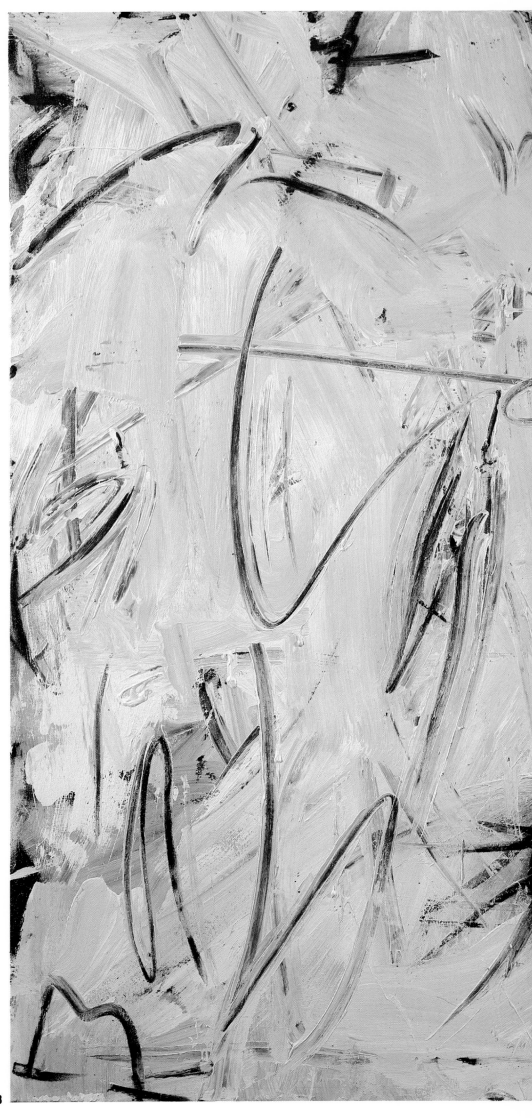

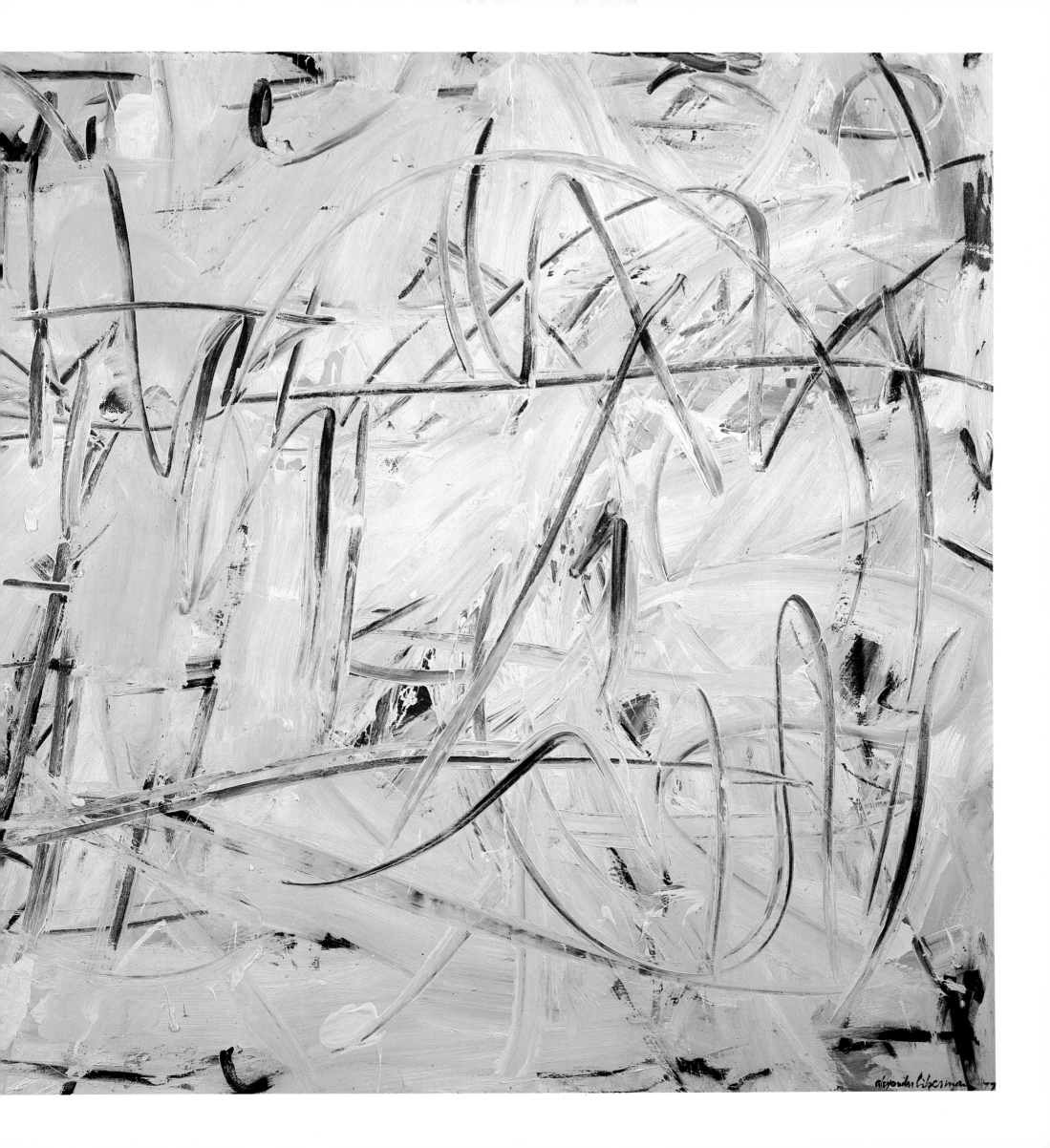

visionary and a nonobjective artist rather than an abstract one. The great difference between abstraction and nonobjective art is measured by visionary and unreal experience, inexplicable epiphanies and revelations. Thus Liberman also differs from a hard-edge painter like Ellsworth Kelly, whose images are all based on observation of the real world. Once Liberman, in 1949, had decided that only auto-inspiration was valid, and so gave up painting from nature, he never looked outward again, at least for painting ideas. Not even his circles or triangles are real or solid. The linear element that enters his work in the late Seventies as a graphic scrawl no longer describes shapes; drawing does not depict shape but exists only to enliven surface and to provide a mobile and protean structure.

That line did not necessarily have to describe solid form, as it did in cubism, was obvious to Liberman at an early date. Among the circle paintings, for example, are black-and-white works like *Minimum*, and *Complementary*, in which linear circles do not create figure-ground discontinuities because the color within the contour is the same as that without. Instead of a shape against a background, the effect is like a magic trick of a hoop suspended mysteriously in thin air. In *Yellow Slash* of 1961 and in a number of tondos done that year, Liberman experimented with a radical separation between the spreading field of yellow and the black slash drawn on it.

The idea that line could be entirely separated from color and its shape-creating functions was suggested to Liberman much earlier by Léger, who used planes of color independently of the thick black lines in his late works. In the Seventies, the possibilities of using autonomous calligraphy to enrich surfaces and evoke tactile sensations—the antithesis of the purely optical appeal of his paintings from 1950 to 1968—are fully explored by Liberman. The result is that another element in traditional art, its capacity to stimulate tactile as well as optical sensations, was added to Liberman's growing mastery of his medium and to his new ideal of maximum complexity. The ideal of maximum complexity now is experienced as the necessary antithesis of the initial minimal reductions.

Liberman's search, like that of any serious artist, has always been a quest both for knowledge and for the self, a quest which he had been taught was to be avoided at all costs. His sculptures adequately suit formal criteria and pose no great problems of interpretation because they appear to follow a consistent path of development within a consistently geometric idiom. His paintings, on the other hand, confuse the strictly formalist critic looking for the neat and tidy evolution Liberman rejected when he renounced the hard-edge style in painting. Yet it is the paintings, in their variety, in their searching and restless energy that more truly reflect the complexity of Liberman's personality and experiences. He

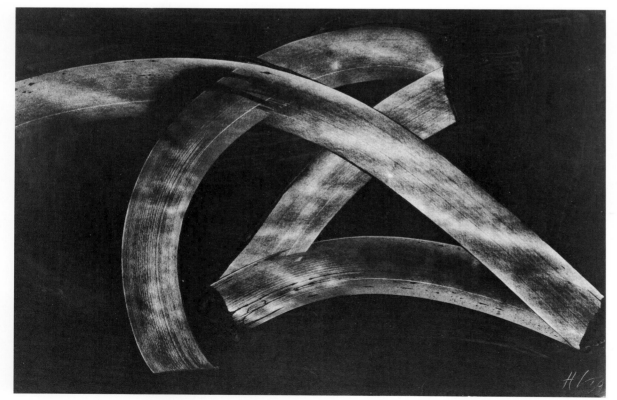

**179**

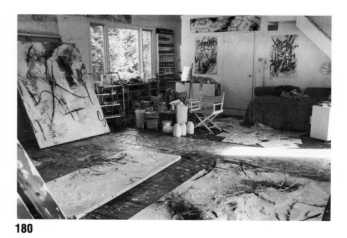

**180**

179. *Erasure*, 1959
Enamel on paper

180. View of Warren painting studio, 1978

181. *Erg*, 1977
Acrylic and collage on canvas,
96 x 60 in.

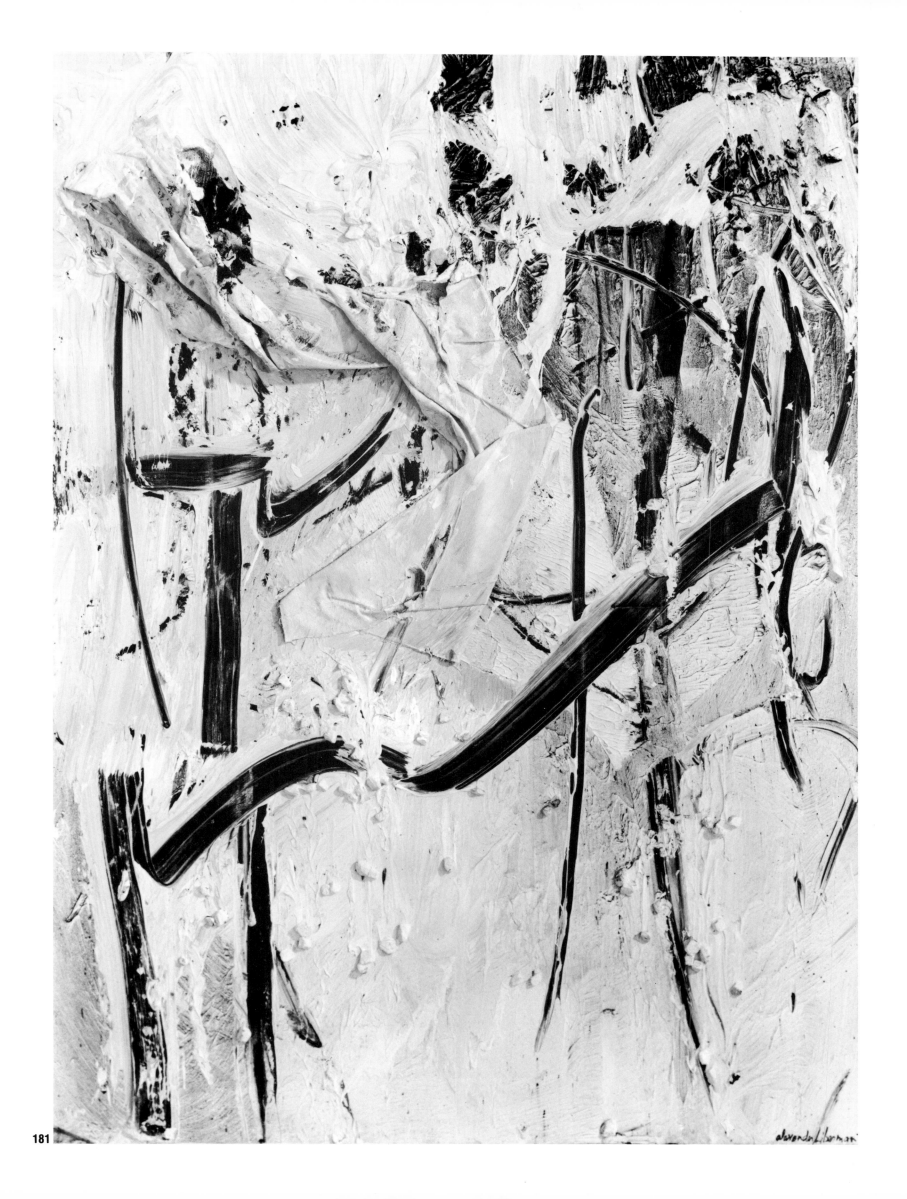

has always maintained that his paintings—in contrast to his sculptures, which are clearly finished—represent a process, a path without end. It is in this concept of art as a continuing search rather than as finished product that he is closest to his most admired model—Cézanne, who held that meaning was to be found in the subjective perception of awesome nature.

Liberman is discovering his own meanings in replicating the processes of nature in its operations as much as in finding images that allude to such natural phenomena as energy and light. In his latest works, the series resembling extraterrestrial landscapes that was begun in 1977, legible form has once again started to emerge as an antithesis to the relatively formless graphic style of the "white" paintings. Scraping away parts of forms or of the collage over them, he builds up texture to variegate surface and appeal to tactile responses. In this preoccupation, Liberman appears involved with philosophical ideas older than the Greeks, such as the Hindu concept of simultaneous destruction-creation. For Liberman, this is a metaphor for the disappearance of old cultural forms and the birth of the new, which from our vantage point constitute the unknown future.

Using mixtures of pigments as well as marble chips, sand, gel, varnish, and any other material that may produce the desired effect, Liberman has arrived at a sophisticated form of automatism, creating images that look like natural forms rather than man-made objects. Both the way he works and his desired result are related to the early matière paintings of Dubuffet, whom he photographed working with strange pastes and gluey mixtures in 1951. There is also a relationship between the techniques Liberman is using currently, and the mixture of sand and radioactive mud washed up on the beaches at Ischia, where he continues to spend summers.

Anonymity and impersonality reinforce the artist's role as medium: If the "I" did not make the painting, some force greater than man must have been at work. In his latest paintings, Liberman creates images with potent associations —an apocalyptic world of fire and ice, of glaciers and volcanos, of lunar and polar landscapes—either the first gestating explosion of creation or the last big bang of cosmic catastrophe. It is an image that appropriately reflects a universal consciousness of the eschatalogical vision described by a poet like Yeats in *The Second Coming*. As in all his paint-

182. *Unknown II*, 1978   Acrylic on canvas, 96 x 144 in.

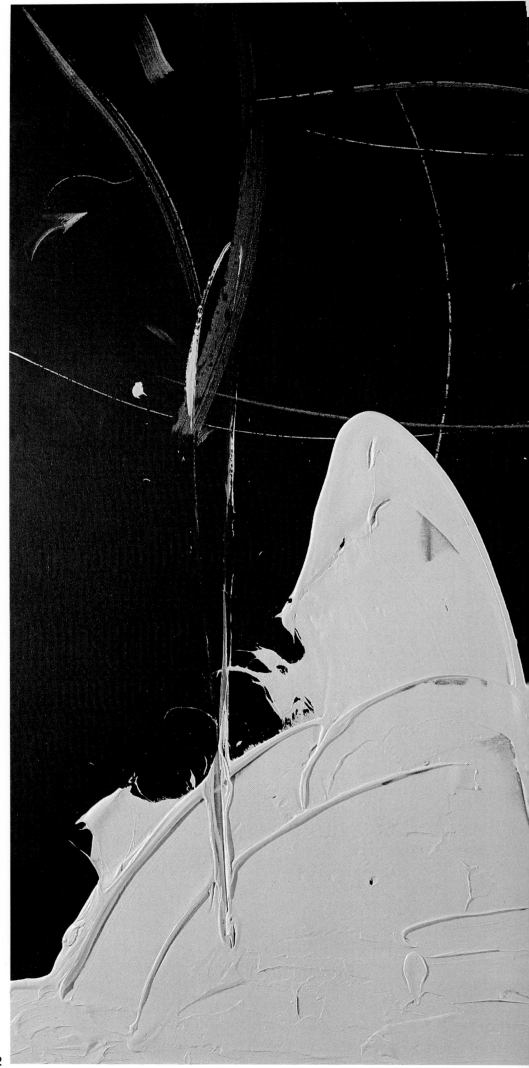

**182**

188

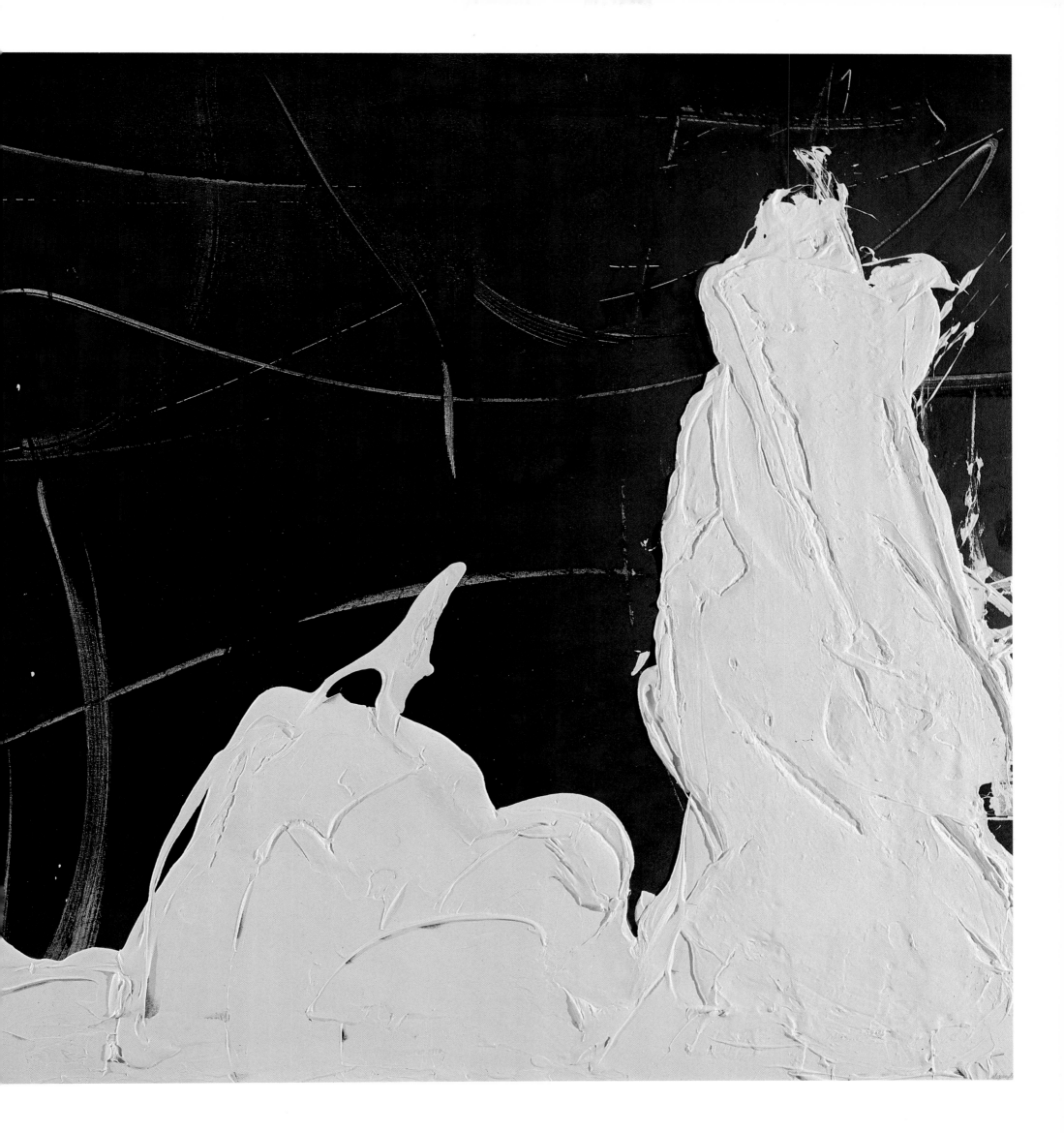

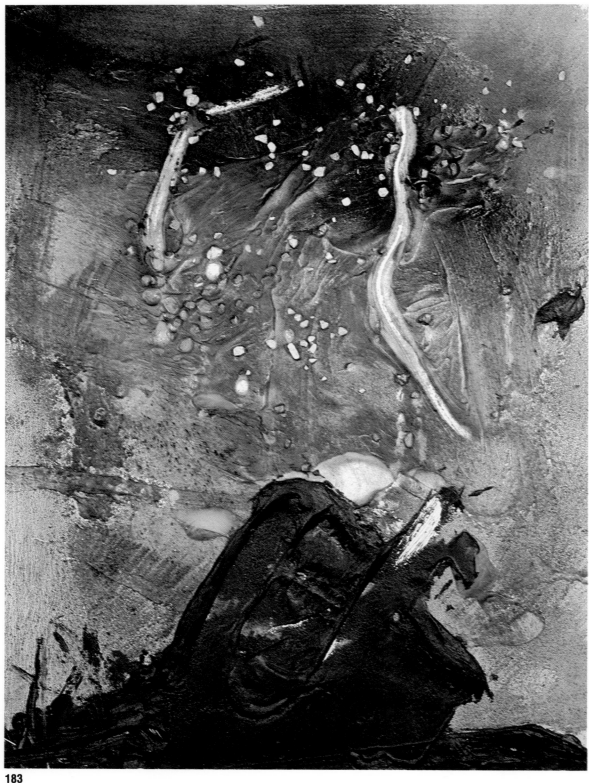

183

184

183. *Beyond XV*, 1979
Acrylic and marble chips on canvas,
60 x 45 in.

184. *Beyond XIV*, 1979
Acrylic and marble chips on canvas,
60 x 45 in.

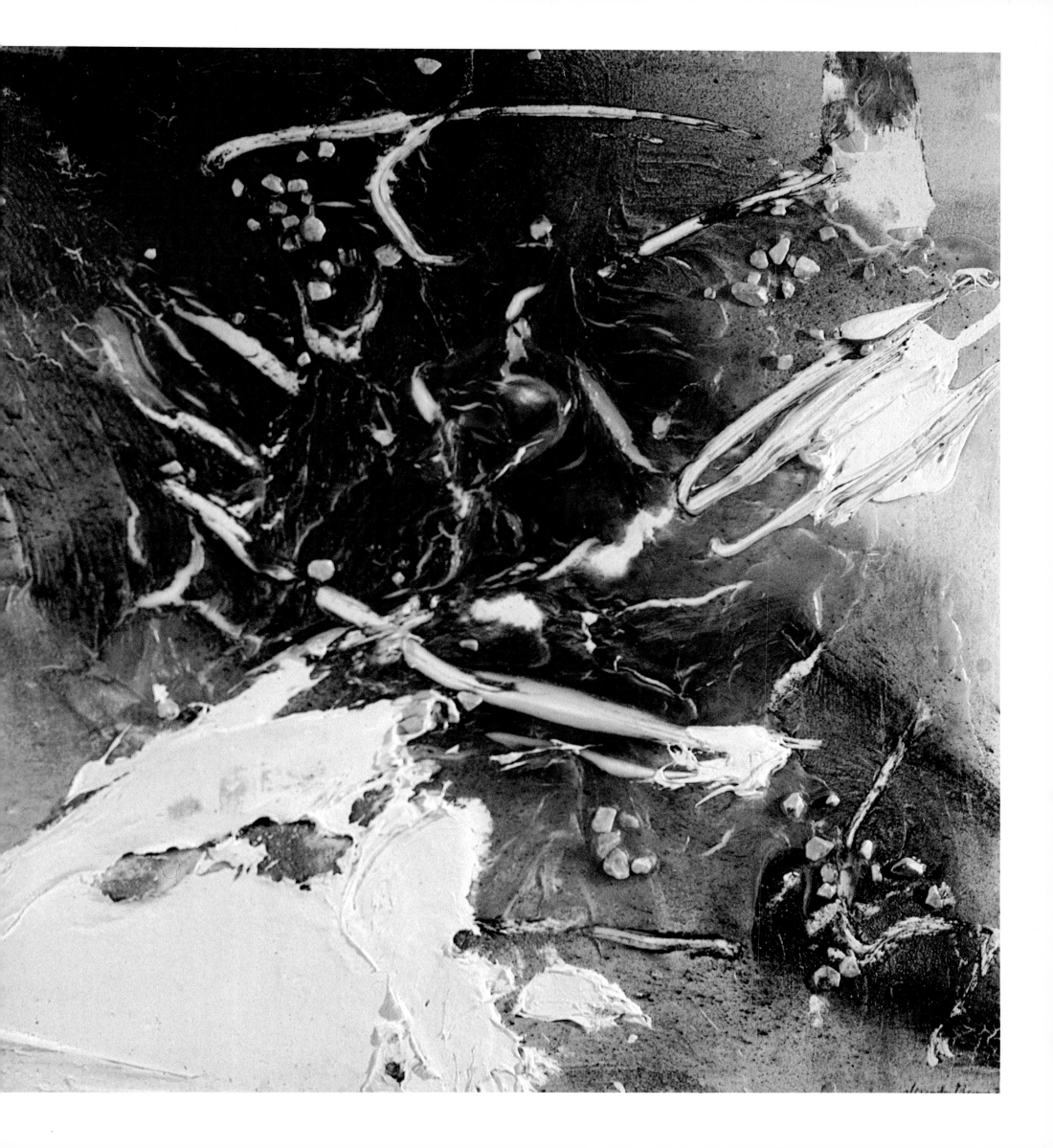

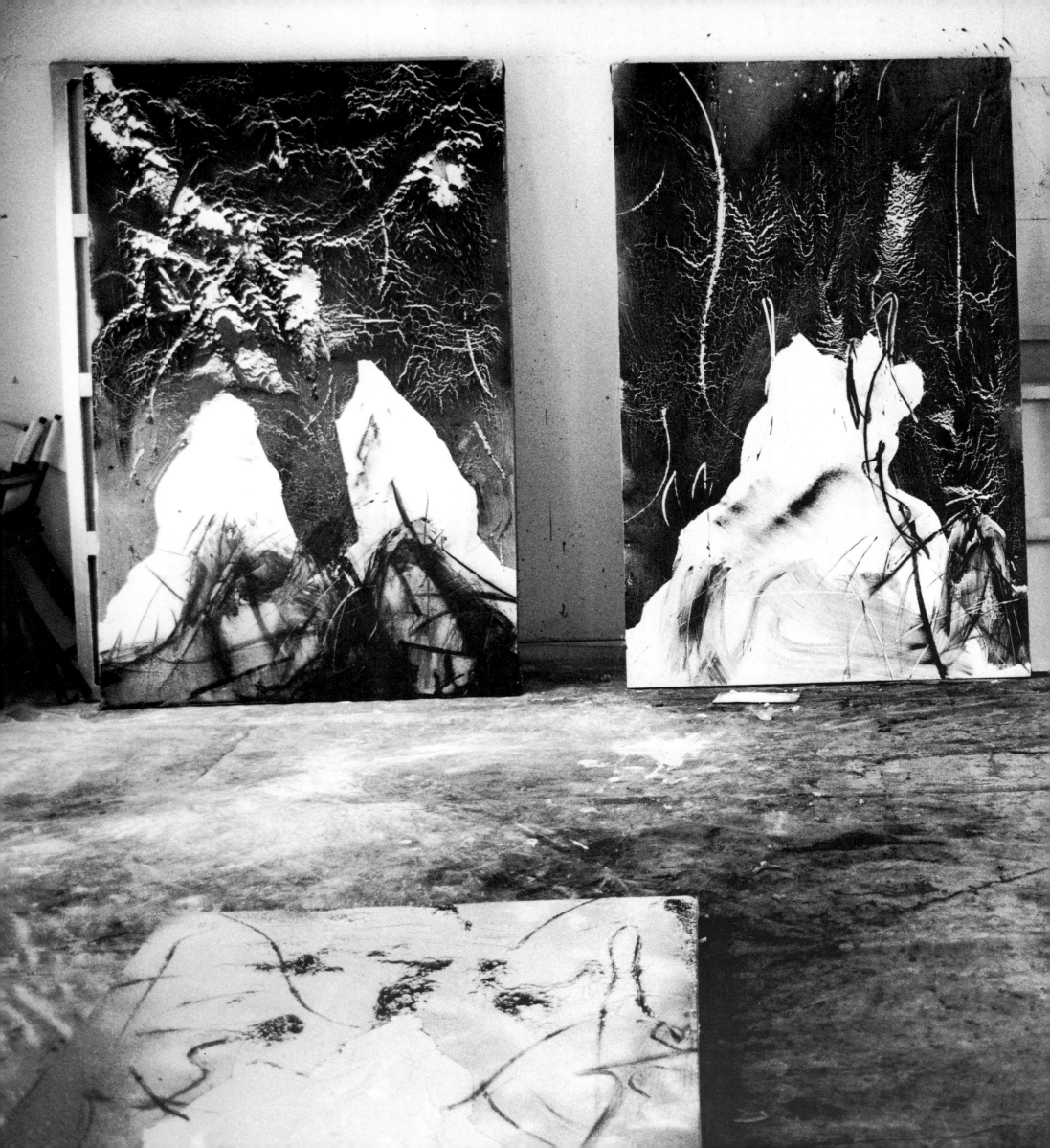

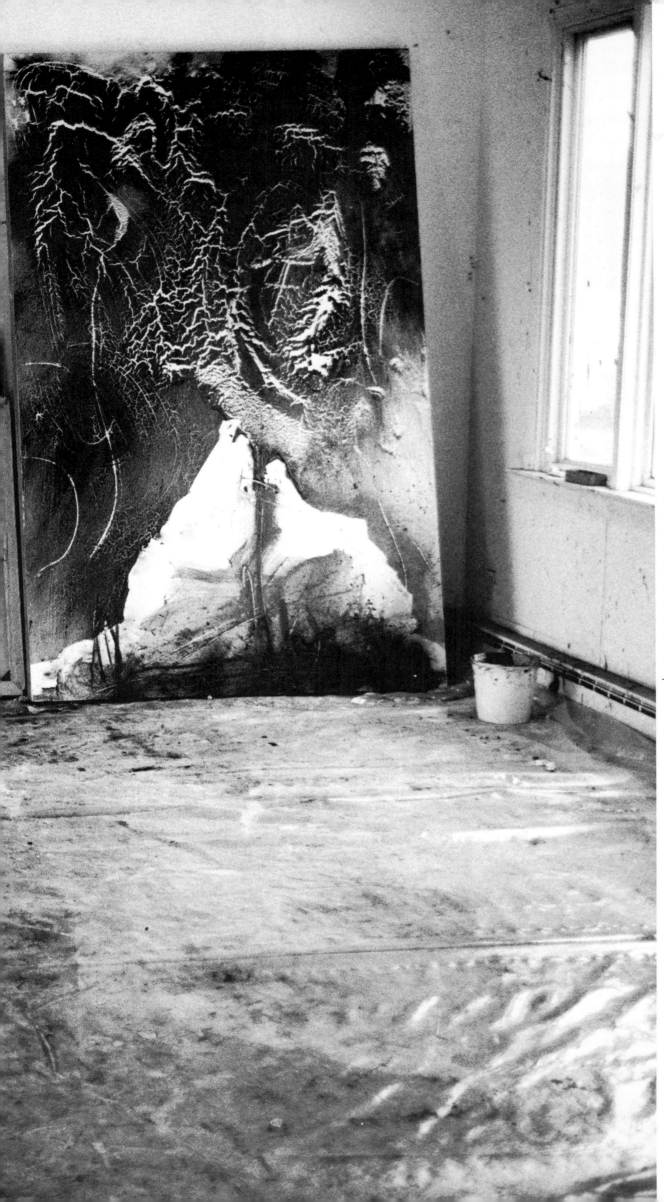

The artist is a hunter, he has to keep his eyes always peeled for a discovery. Picasso said, "I don't search, I find." Only recently, did I understand what he meant. One does not set out searching for an idea. One does not set out and say, "Ah, I am going to create something new that's never been created." One works and at a certain moment, out of the work—the accumulation of small sights or sightings—a thought slowly is born. One day you have the courage to say, "Let's see if I could put that thought into action." And that's how I think a new idea, if you call it a new idea, is born.

185. The Warren painting studio, 1978.
(Left to right) *Beyond I,*
*Beyond II*, and *Beyond III*.
Acrylic on canvas, each, 96 x 60 in.

**185**

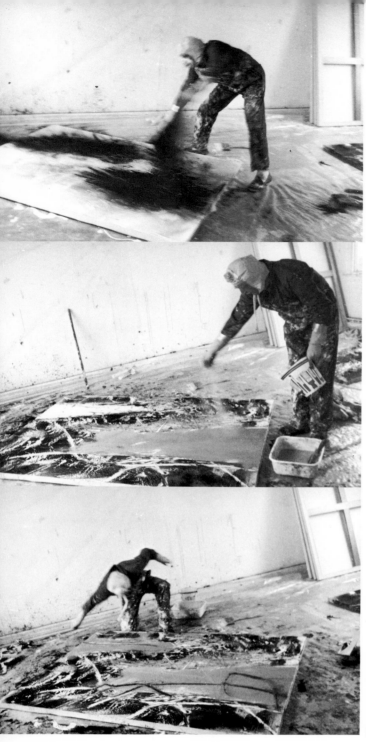

**186**

At a certain point, I throw black dust on paint or do a stroke. I have no idea what it's going to look like; I hope it's going to come out all right. If it comes out all right, it's lucky. But even chance is slightly predictable. After all, if you throw, you do aim. You should really throw with your eyes closed. You throw, but you cheat a little because you are looking where you are throwing.

186. Liberman at work on *Beyond XI* in the Warren studio, 1979

187. *Beyond XII*, 1979
Acrylic, sand, and collage on canvas,
70 x 60 in.

ings, these are cosmic images. Now, however, the image of bursting galaxies has replaced the Platonic harmony of the spheres.

Liberman's stylistic evolution has mystified critics seeking logical consistency. He does not think of his paintings as solutions to formal problems but as life experiences. His greed was never for material possessions, but for experiences, and that is the greed he has expressed. In his art, Liberman has lived out a life that no man of our time is permitted to live. He has risked destruction, pursued visionary phantoms of unreality, performed daring and heroic feats, traveled through the whole world of art, and sought to plumb the secrets of the alchemists and astronomers. His sculpture studio looks like a battlefield, the tanks and guns he played with as a child are realized on a superhuman scale, whole cities are built to suit his whim. In his art, *he* is the czar who rules an imaginary empire. His despotism is strictly fantasy—the reason, perhaps, he could not be either an architect or a politician.

The different series of paintings are the love affairs he never had with many women of different cultures and temperaments. (He explains that he can work so much because he is not distracted, since Tatiana has been his only love.) Indeed, if one could associate Liberman's stylistic changes with specific women, as one can explain Picasso's abrupt switch from period to period—each one dedicated to a different mistress and her personality—the evolution of Liberman's paintings would not seem strange. As it is, however, one can pinpoint consistent concerns that unite all his paintings: He has always been involved with chance in one form or another and with the denial of gravity, and he has always been drawn to the idea of risk, of art as a form of gambling. He has never used technique as an end, but only as a means. He has always fought against composition. Not to compose has been a consistent goal throughout his career as a painter. His paintings have an image structure, but that structure is not a matter of conventional composition. From the earliest circle paintings, the image is related to the frame, and not to other images or shapes within the field. The way Liberman relates image to frame is also consistent: either the central image pushes out against the frame, or the frame is broken by forms that invade it, which lie outside its boundaries. In either case, there is a battle over the borderline. In some paintings of the Sixties, the image is parallel to the frame, echoing its vertical axis. Generally, however, the frame is considered by Liberman a constricting factor to be battled against rather than accepted. Aggression becomes more intense and overt as Liberman's work evolves.

The black and white paintings burst and bubble with energy that may at times seem an expression of anger. Describing these paintings, *Times* critic John Russell observed:

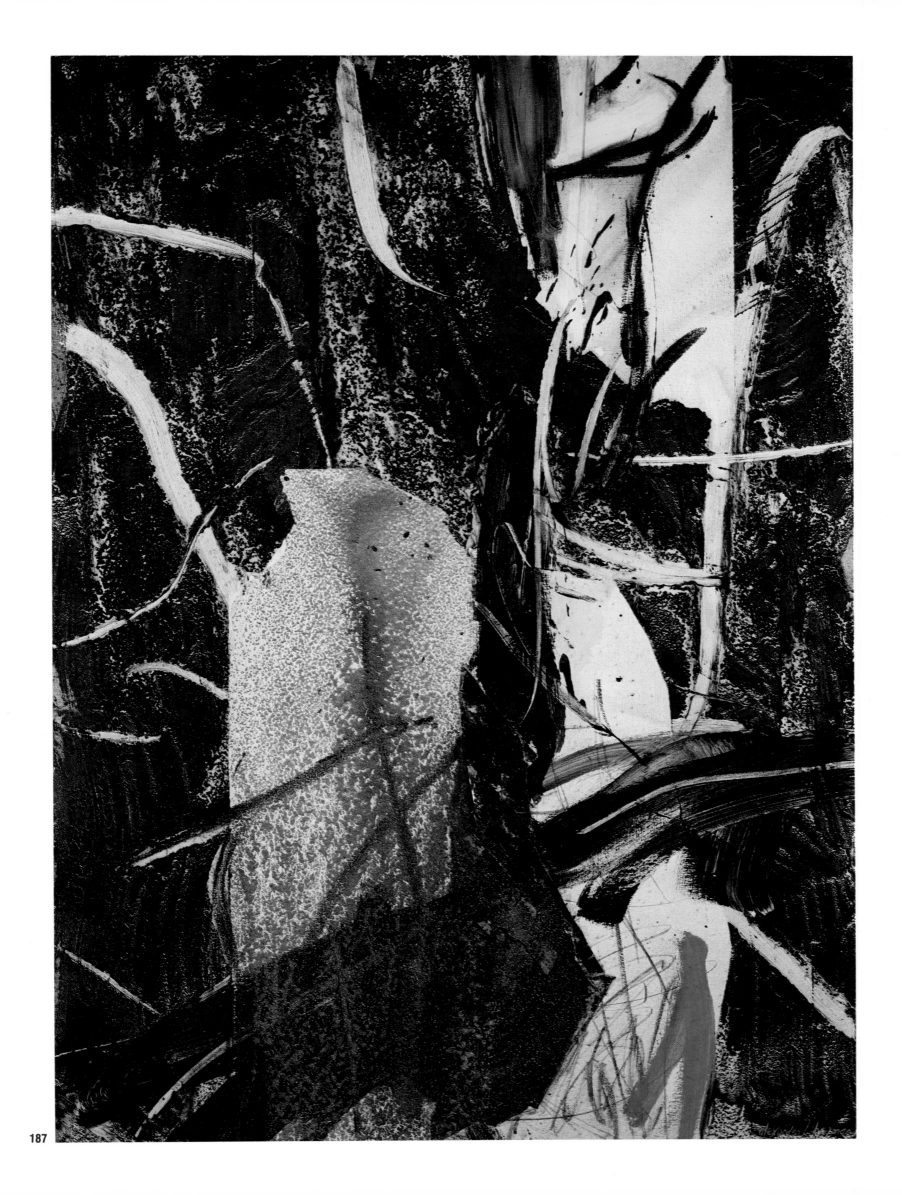

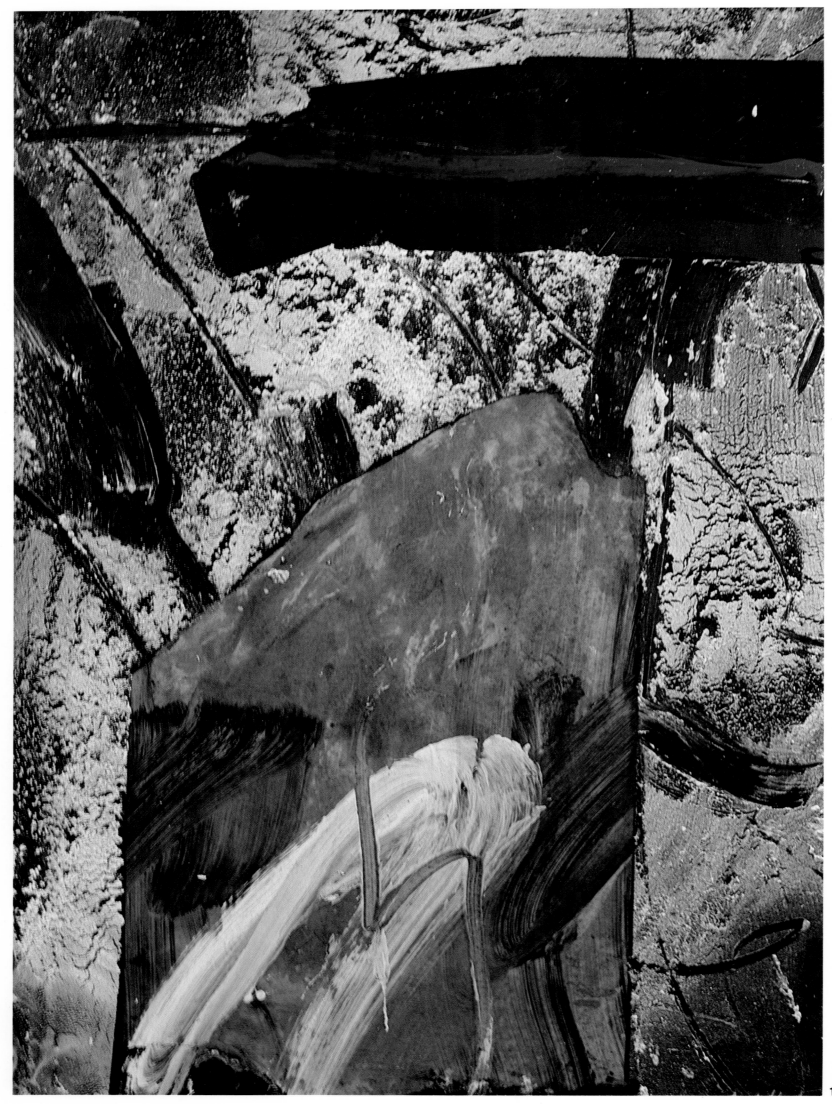

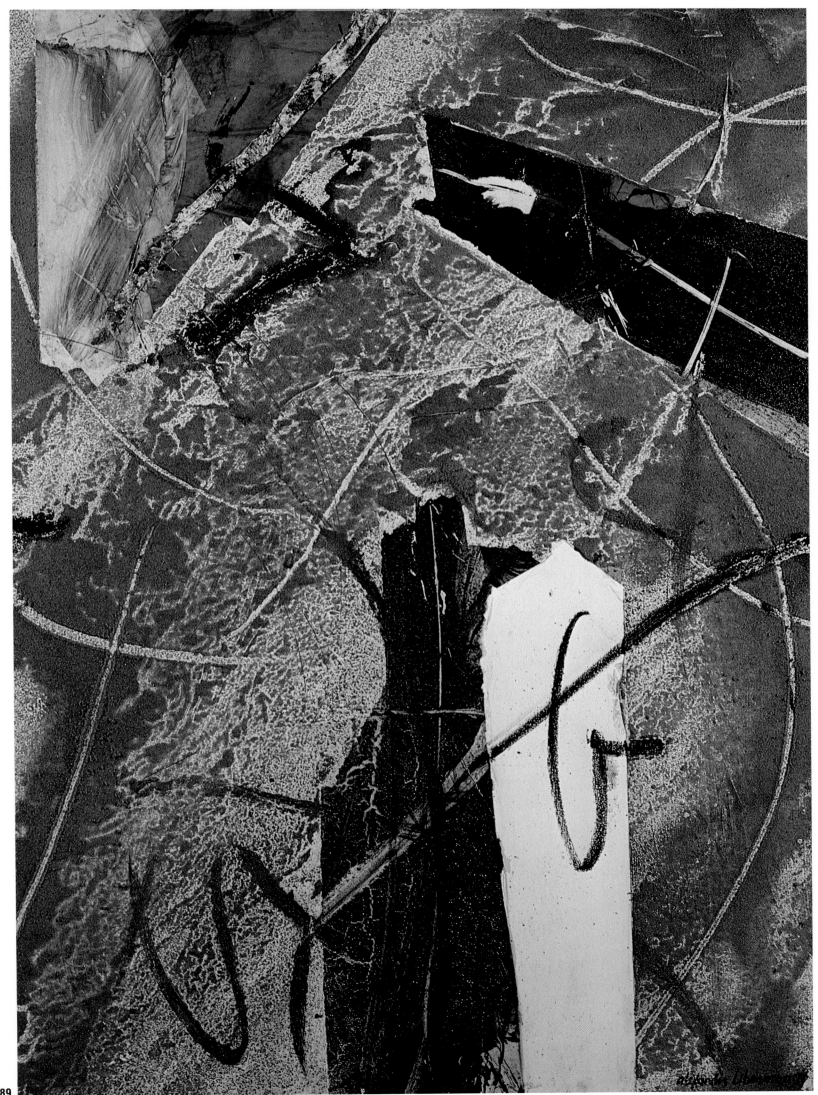

188. *Omen VIII*, 1980
Acrylic, collage, and sand
on canvas, 70 x 50 in.

189. *Omen XII*, 1980
Acrylic, collage, and sand
on canvas, 70 x 50 in.

**189**

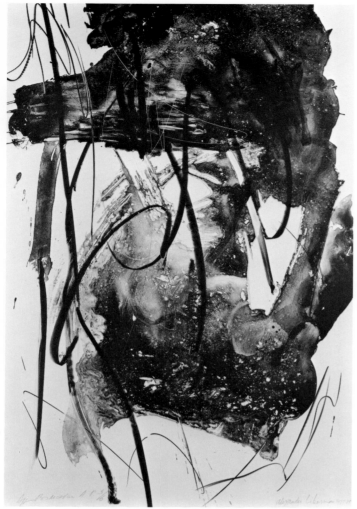

**190**

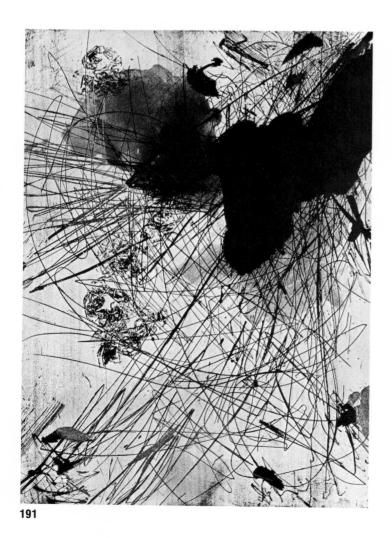

**191**

"When his huge, unilateral white shapes march themselves against a black background that looks like hostility made visible, we sit back and wait for the crunch. He also employs on occasion a bent line that looks as if it could suddenly bend right back and do us an injury."

If Liberman's images are not composed, they are nevertheless structured. The "white" graphic paintings of the Seventies were the closest he has ever come to the *informel* reliance on surface texture and literal relief to sustain the entire image structure. Another consistent element is a rejection of figure-ground discontinuities characteristic of cubism, beginning with his embrace of neoimpressionism. Later, different strategies—such as staining, collaging, and separating line from color—are evolved to avoid figure-ground relationships. The distaste for cubist figuration is linked to the avoidance of composition, which connotes cubist relationships among depicted shapes.

One way or another, Liberman's classical training in France marked him for life. The Aristotelian aesthetic of the three unities on which French classical theater is based—a single action in a single place in a single day—haunts him to the extent that he feels a painting must be made to conform to these rules. Pascal's *pensée* that the self is hateful has never really been exorcized either, perhaps for good reason. What Liberman distrusts, perhaps not consciously, is an aspect of himself that is inimical to his struggle in art. Alexander Liberman, editorial director of Condé Nast, is, above all, a man of taste. Alexander Liberman, the artist, is deeply suspicious of taste just as he is suspicious of composition—because it expresses taste. As Reinhardt used his cartoons to purge surrealism and literary content from his art, Liberman uses *Vogue* to siphon off good taste and any urge he might have to compose in conventional terms. *Vogue* layouts are Liberman's only cubist expression, composed according to tasteful adjustments.

If we trace Liberman's evolution as a painter, we can see the progression from simpler to more complex form, from the optical to the tactile, from the linear to the painterly, from the conceptual to the physical. One way of understanding his painting career is as three chapters in his autobiography: the

190. Lithograph for
Andrei Voznesensky's book
*Nostalgia for the Present*, 1980,
made with Tatyana Grosman for
Universal Limited Art Editions

191. Aquatint, 1977. 2RC in Rome

192. *Omen V*, 1980
Acrylic and collage on canvas,
70 x 50 in.

198

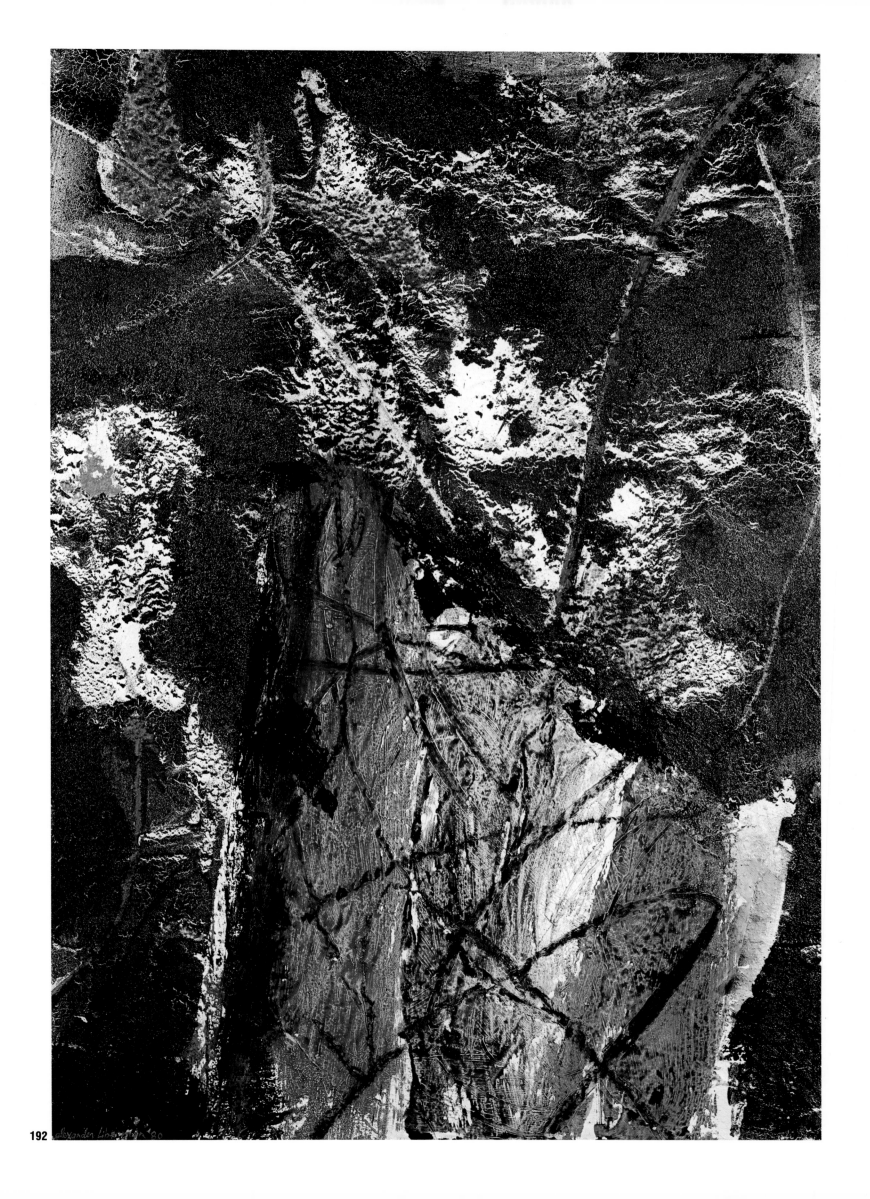

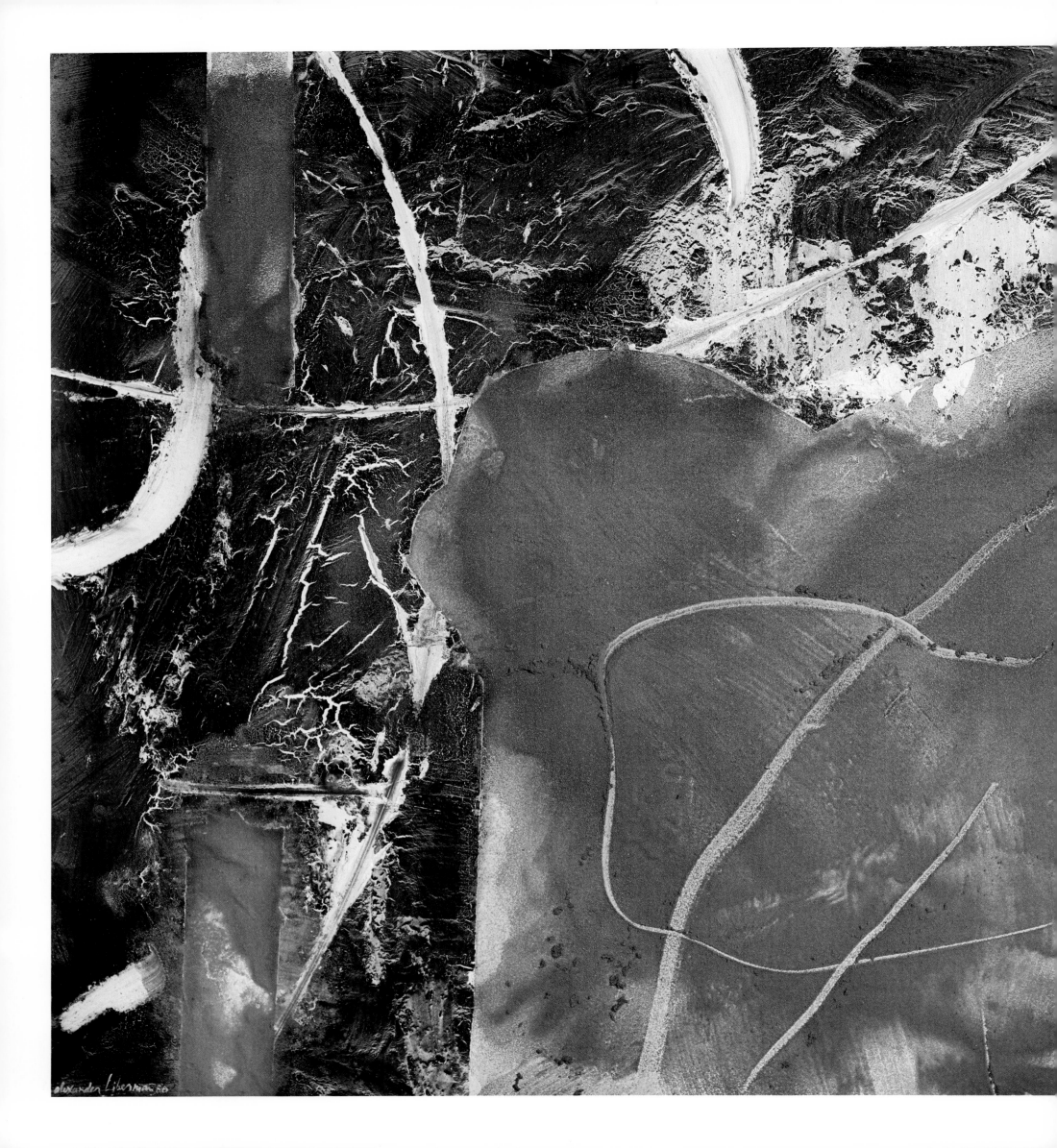

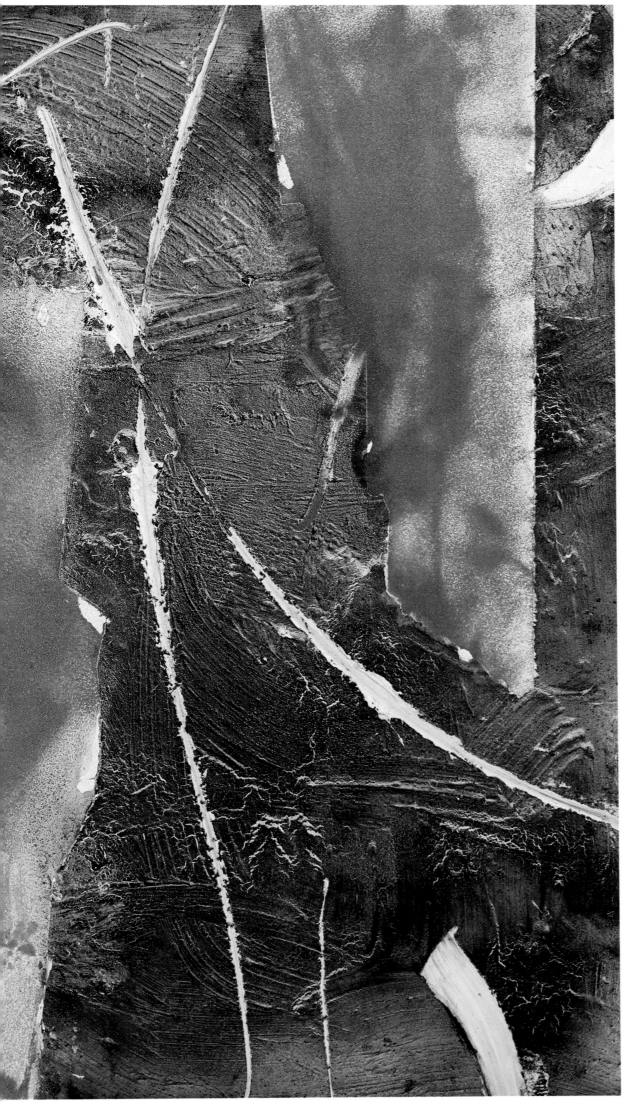

All education is really meant to achieve civilized behavior. More and more I rebel—maybe even because I work in a magazine that surrounds itself with civilized behavior, taste, etc. As an artist, one feels that conventions exist to discipline society and to allow a great number of people to live together. As one grows, meditates, one feels that art has to go beyond that, to break those barriers. As one gets older, there's a rage against one's inability to express certain things. Perhaps one vents this rage on materials. Out of this rage, out of this desire to force the material to say something—out of this struggle, this fight, comes a revelation. But it's a blind rage. The canvas or steel takes a terrible beating. At a certain moment, I think an artist doesn't quite know what he's doing. He mustn't know what he is doing. However, the stage is set for this sort of intimate happening, which becomes a public happening. But when it is being done, it's blind experience.

I love to listen to opera when I work. Opera is the only civilized orchestrated passion that allows a human being to scream at the top of his voice. It's accepted because it's called art. I think the human condition is not a happy condition. Artists who are involved with deeper thoughts have some sort of scream inside of them. Art is a violent expression of resentment against the human condition.

193. *Omen I*, 1980
Acrylic and sand on canvas,
96 x 144 in.

first is French and classical, the second is American and romantic, and the final chapter, now being written, is Russian and possessed. In many respects, the facts of his life accord with this division. The period of photographing School of Paris artists corresponds to his hard-edge linear, classic style. His involvement with the leading Abstract Expressionists and their critics corresponds to his work in the Sixties and early Seventies. The deaths of his friends Newman, Rothko, and Hess, as well as Motherwell's increasing seclusion, deprived him of contact with his American peers. More and more, Liberman's private conversations are with Russian emigrés who gather around Tatiana to speak Russian, celebrate Russian Easter, recite poetry, and feel a sense of the lost homeland in the Libermans' Connecticut *dacha.* It is no accident that the imagery of the recent black and white paintings suggests the Siberian forests of his youth as well as the tracery of Chinese landscapes and the glimpses of lunar landscapes. The past is recaptured in the Russian love of nature, the Byzantine gloss and opulence, and the obsession with the occult, the essence of the *Russkaia dusha* at the heart of Liberman's paintings today.

The three phases—one cannot refer to them as "styles" in the purely formalist sense—also correspond to his three languages: French, American English, and Russian. Russian temperaments tend to swing between extremes. Thinking his private thoughts in Russian, Liberman oscillates back and forth between stylistic polarities. The doubling of images and their permutations explains why Liberman has never sought to create any new or novel shapes. His acceptance of first the circle and then the triangle is a way of admitting that one cannot invent new plots but only new ways of telling the same universal and timeless stories. The message of his paintings is the same as that of Berdyaev's philosophy: there is only one truth, but it may be stated in many ways.

194. *Omen II,* 1980
Acrylic and sand on canvas;
triptych, each panel, 20 x 72 in.

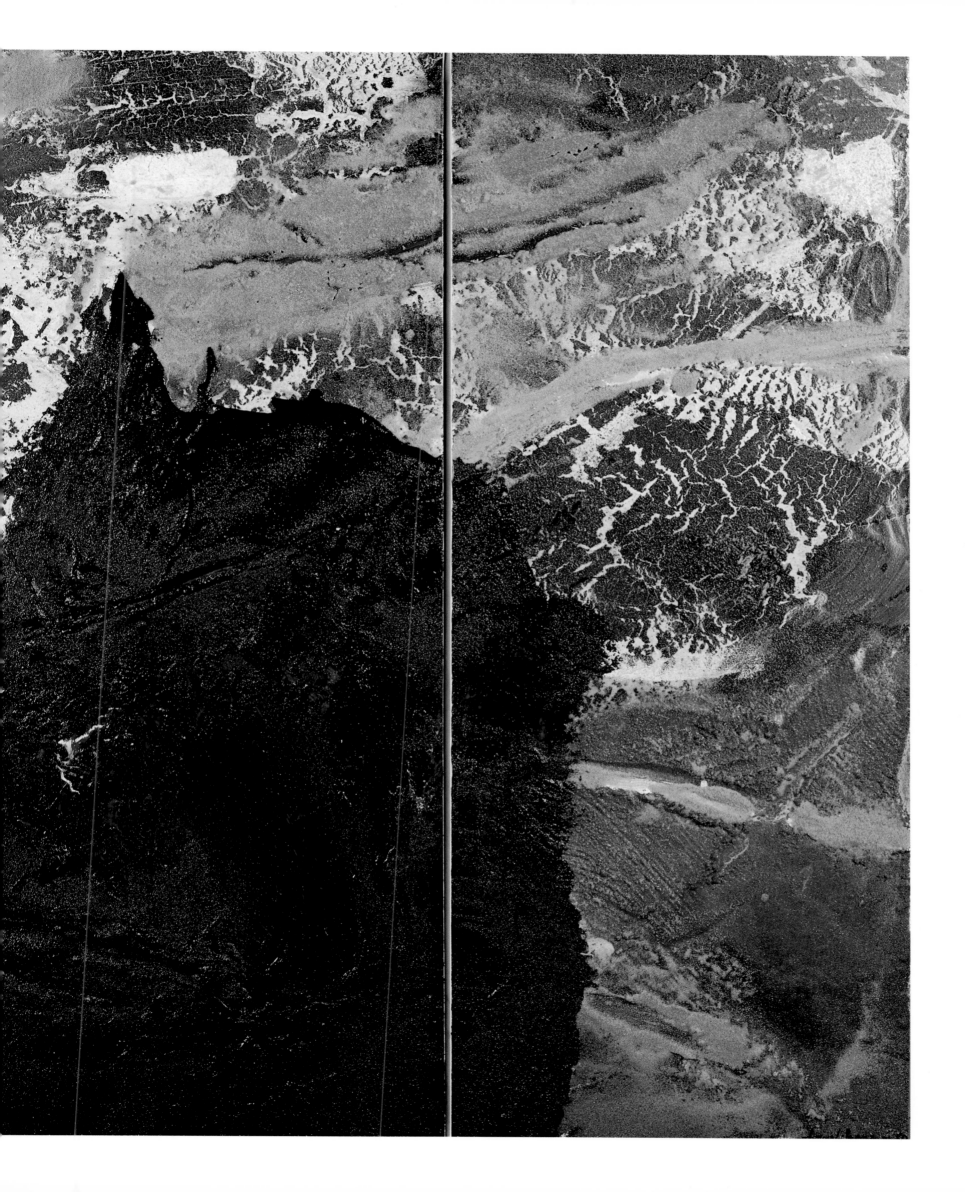

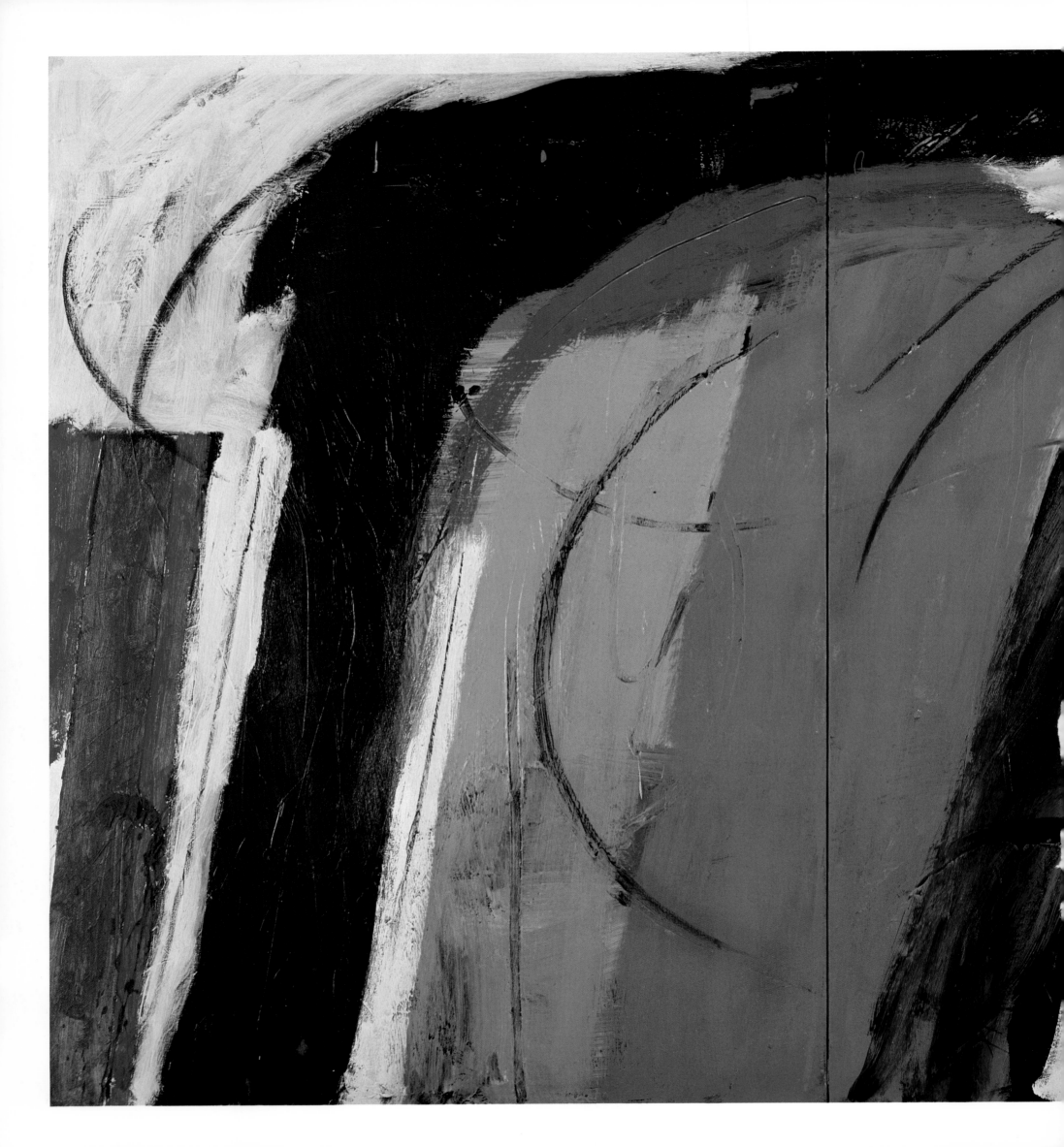

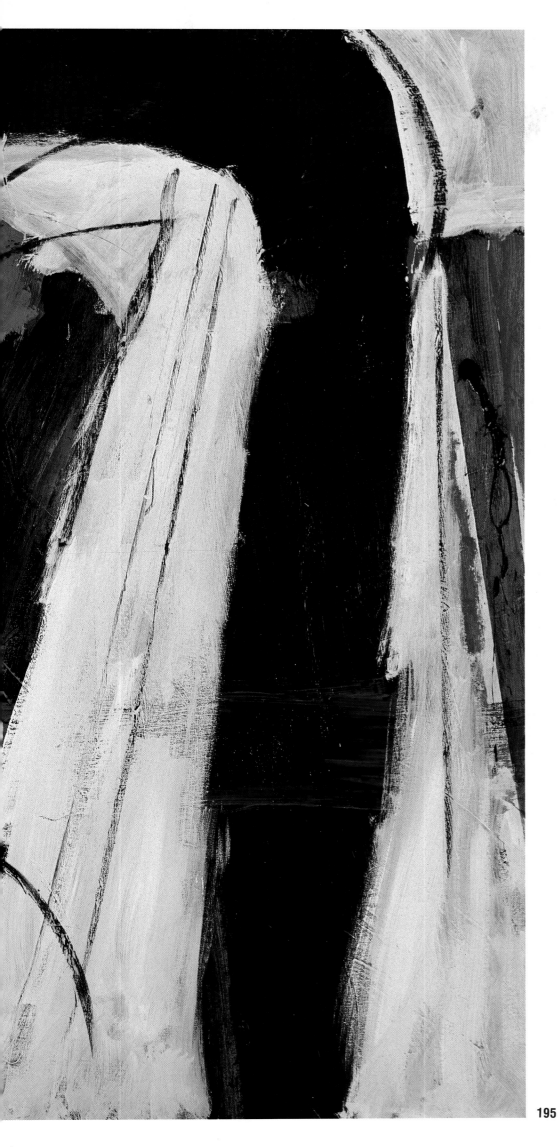

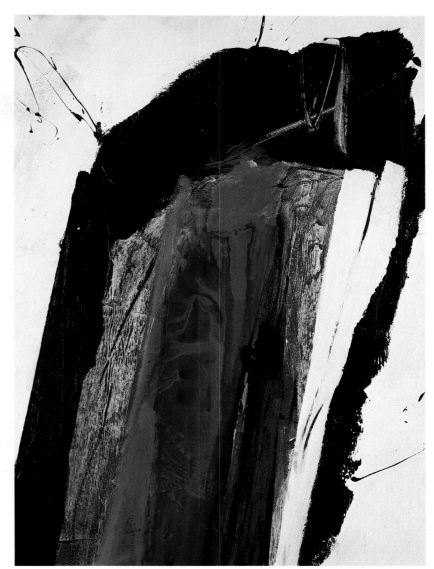

**196**

*To reach that state beyond fatigue when at a certain moment one loses control—that's the issue. I think a tremendous amount of my search was to get rid of what had been drilled into me through culture and civilization and to break those chains and inhibitions and perhaps arrive at a certain freedom beyond the learned—this is where speed of execution counts.*

195. *Gate XIII*, 1981
    Acrylic on canvas; diptych,
    outer dimensions, 84 x 120 in.

196. *Gate IX*, 1981
    Acrylic on canvas, 84 x 60 in.

CHAPTER

---

# VII

## THE LANGUAGE
## OF
## SPACE

I believe the artist has a mission. The artist has to do what he has faith in. If it has real quality—if it touches some inner spring, if it communicates, that is success. Communication is the purpose of art.

When the pre-existent matrix in our brain finds its exact counterpart, then the sensation of plenitude comes from the fact that the whole surface of the matrix is in complete total contact. If the most infinitesimal part does not find its contact, there is no longer a fulfillment of sensation. But as soon as there is this total contact, the human organism rejects the "occupier," the foreign body, in order to be able to re-enjoy, resee, rehear, refeel the alternating rhythm. From this biological "come-and-go" stems our human ability to survive. From this sensation of fullness and emptiness comes the beat of our rhythm—heart, blood, breath—the full, the void.      —Statement on Circlism, 1962

I was always fascinated by Bernard Palissy, the Frenchman who invented the Limoges enamel. Legend has it that in order to get the final enamel, he had to break up and burn his furniture in the stove to get the correct glaze. To a certain extent, I live like that. I live very well, but from day to day.

I destroyed illusionism in painting because I resented perspective, and I resented anything that was trompe l'oeil. In sculpture, without working with trompe l'oeil, one still is able to create a three-dimensional experience. This is one of the excitements of sculpture as against painting: one can create a three-dimensional object instead of doing the traditional thing of painting a so-called three-dimensional object.

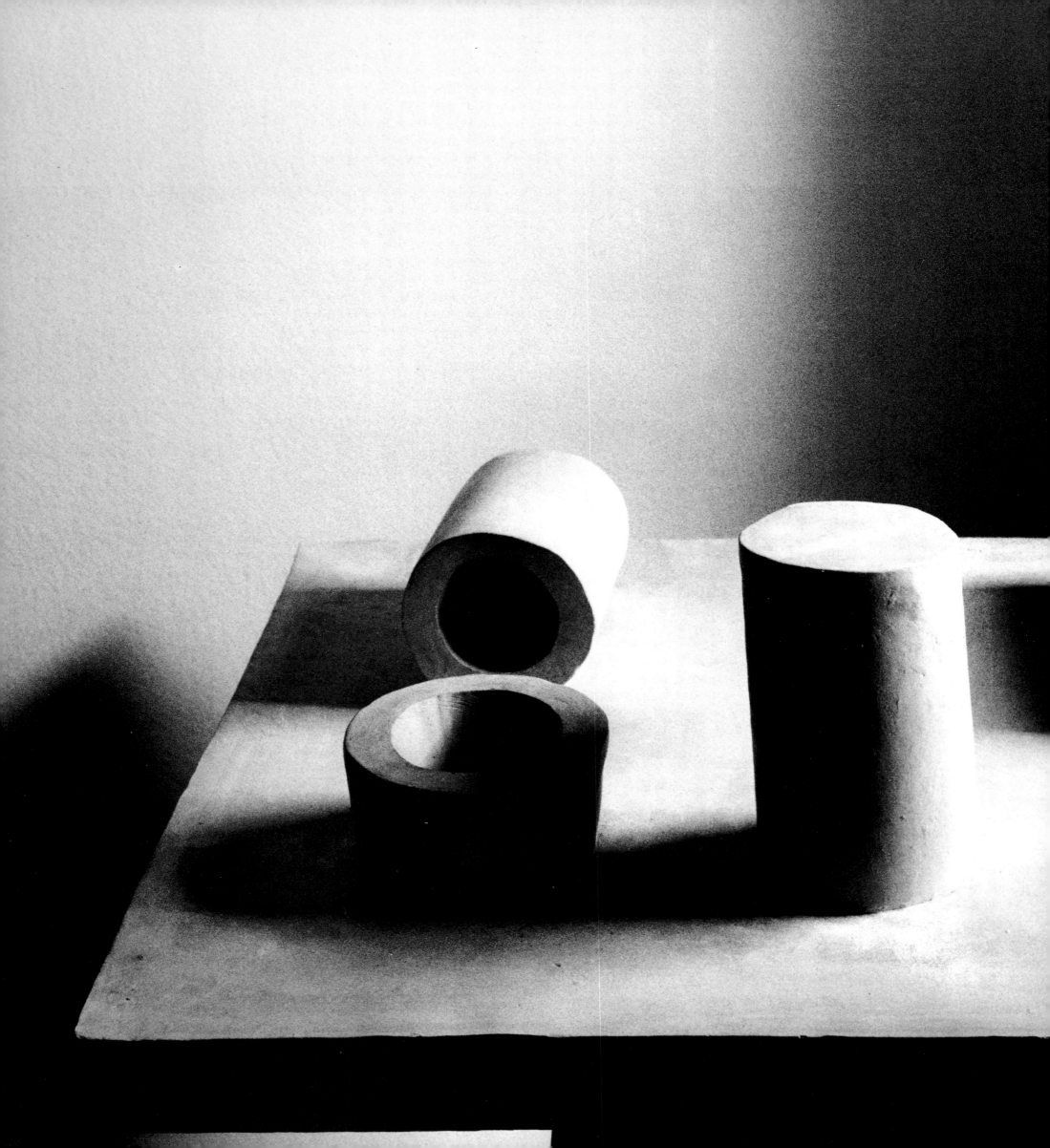

Considering that perhaps we are imprinted, our first imprint is the sexual imprint. Otherwise the species wouldn't reproduce itself. I thought it would be very interesting to see if art could reach the same imprint and thus attempt the same motivation.

197. *Space*, 1950
Plaster, 7½ x 18 x 21½ in.

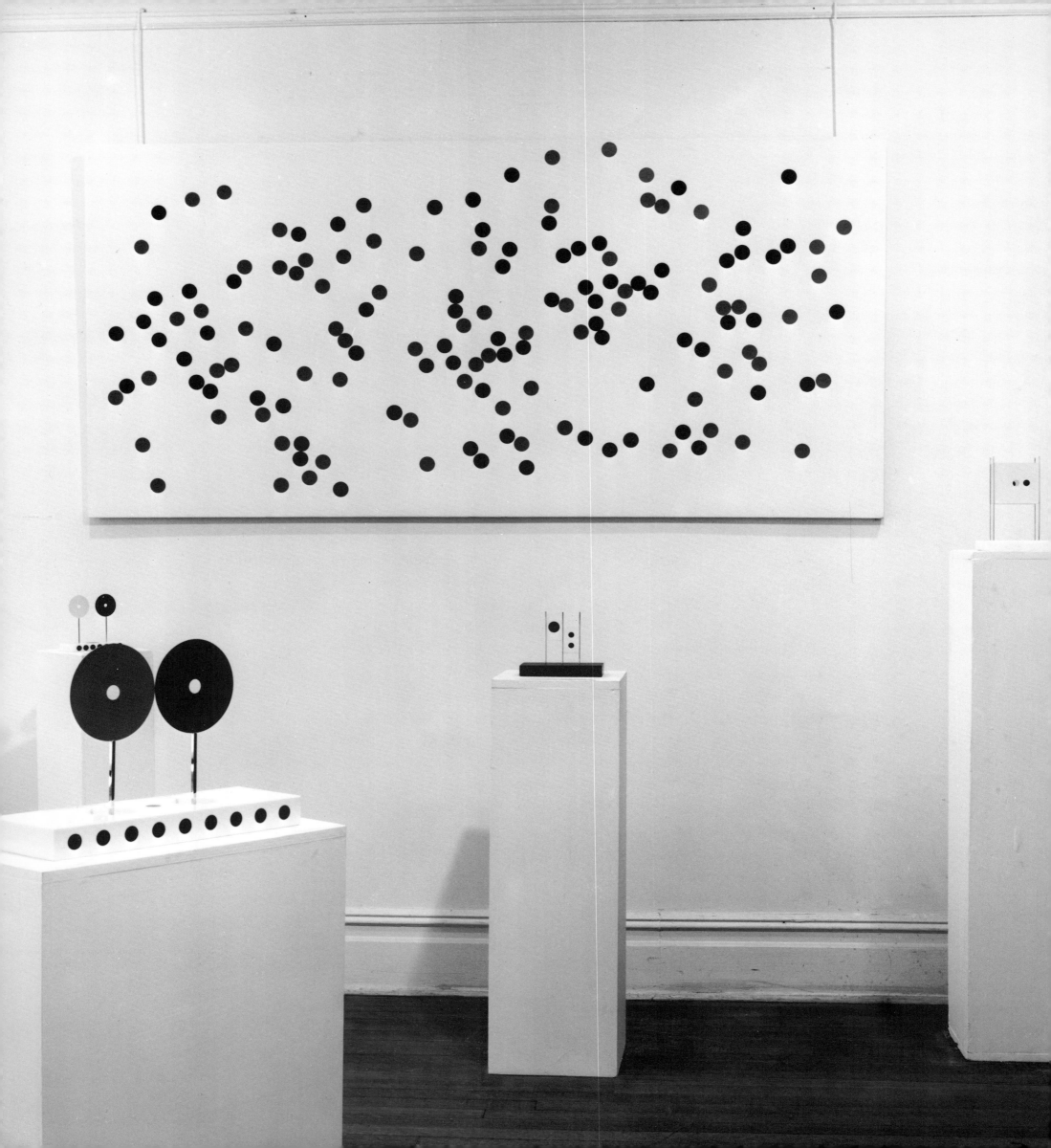

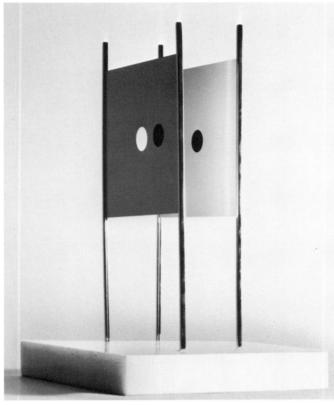

199

198. Installation at Betty Parsons Gallery,
April, 1960. Small sculptures and
the painting *Blue Opposite Red* (1959)

199. *Passage*, 1959-60
Enameled copper with marble base,
9¼ x 6¼ x 5½ in.
Collection The Museum of Modern Art, New York.
Gift of Mr. and Mrs. Jan Mitchell

198

TODAY, ALEXANDER LIBERMAN is better known as a sculptor than as a painter. However, he did not begin to sculpt seriously until a decade after he painted his first nonobjective works. He began to work three-dimensionally by experimenting with a few small pieces in the Fifties. These were closely related to his circle paintings, but they were isolated works. Some were miniature freestanding translations of the panel paintings that had been intended to offer possible permutations akin to changing sets in the theater. These elegant plexiglass, enamel, and copper objects were table-top versions of Liberman's geometric circle paintings. Liberally extending the idea of moving the panel paintings around like Kabuki sets, they, too, suggested that their sections could be rejuxtaposed. (*199*)

For his earliest sculptures to be miniature sets is not surprising. Throughout Liberman's career as a sculptor, the theatrical metaphor has been dominant. Affinities with the slow twists of Noh gestures in his black metal sculptures of entwined circles are among the first intimations of a theatrical element. (*221*) The eventual analogies in his mature sculptures, not only with the elements of theater sets, but also with the flying leaps of ballet and the dramatic exaggerated scale of grand opera echo Liberman's childhood in his mother's theater—where he literally lived and which served him as a playground—and at the Bolshoi. It was probably unavoidable that his sculpture eventually found its fullest flower in theatrical environments suggesting the fullness and grandeur of baroque public monuments, the apogee of sculptural theatricality.

Several of the small panel sculptures, including one purchased by Alfred Barr for The Museum of Modern Art, were included in Liberman's first show at the Betty Parsons Gallery in 1960. (*199*) Among the sculptures exhibited was a prophetic plaster piece, *Space*, which Liberman had made in 1950-51. (*197*) This and its companion plaster work, *Positive/Negative*, consist of two adjacent cylindrical elements lying horizontally on a rectangular shelf. (*200*) The larger element is hollow; the smaller one is solid, suggesting that it could be inserted into the round orifice of its more powerful mate. The male-female imagery recalls the ancient Hindu *lingam-yoni* symbols, which identify erotic content with religious imagery. The reclining posture of the cylinders evokes additional associations of potential sexual union. The closed male element confronting the hollow female is recalled in Jasper Johns's 1960 *Cast Bronze*, a small sculpture on a platform of two ale cans, upright like columns, one of which is solid and closed, and the other open and hollow.

Since his days as a student of architecture in Paris, Liberman has been fascinated by columns. He particularly admired Joseph Cornell's stagelike boxes with columns defining an

interior proscenium. On a trip to Greece, he photographed the ruins of a classical temple at Delos. (201) The photograph postdates the sculpture, yet there is an unmistakable unity of vision in the focus on the image of the broken column—the symbol of a great civilization in ruins. It was a metaphor Liberman would later elaborate on a grand scale during the Seventies, in his colossal environments.

In *Space* and *Positive/Negative*, broken columns rest on platforms. Like every other serious modern sculptor, Liberman has wrestled with the problem of the base, which supports sculpture but also, by elevating it, removes it from the spectator's own world of space. *Space* and *Positive/Negative*, which first indicate the erotic content of Liberman's late sculpture, were made when Brancusi's streamlined volumes were very much on Liberman's mind. Liberman loved Brancusi the man. He spent long hours talking with him, discussing mystical concerns, and was a help to the aged sculptor, who had difficulty functioning physically. His attitude toward Brancusi's works, however, was decidedly ambivalent. On the one hand, he immensely admired the public sculptures in Rumania—the ascending *Endless Column* and the embracing *Gate of the Kiss*, of which he had seen photographs. On the other hand, he considered Brancusi's attitude toward materials precious and Parisian—it reminded him of Art Deco. He also disliked the monolith, the heavy closed form that suggested gravity at work. It is significant that as a sculptor, Liberman has used virtually every material except stone. Perhaps he avoids stone because of its inevitable association with the earth rather than with his favored themes of flight or of ascension. Stone, moreover, lacks for him the light-reflecting potential to dematerialize solid form. His greatest argument with Brancusi, however, was with the latter's wooden bases. Liberman felt they were a folkloric element that detracted from the monumentality of Brancusi's immaculate polished forms. An enemy of any kind of provincialism, Liberman dislikes folk elements. This distaste was

so strong that when he photographed Brancusi's sculptures he ignored the bases, which infuriated the master.

The base—that remnant of the pedestal in traditional sculpture, which separates the art object from the real world—has been a central problem, if not *the* central problem, of modern sculpture. Liberman's first large-scale sculptures, executed in the early Sixties, are totemic abstractions reminiscent in their stanchionlike verticalities of ancient herms. However, unlike herms, they are freestanding, rather than attached to façades. Therefore, they continue to require bases. (*202, 214*) The relationship of sculpture to its architectural context—or rather to its lack of an architectural context—is the reason it requires a base. Liberman was painfully aware of this problem. Ultimately he would solve it by enlarging sculpture to architectural scale. On this scale, the sculpture could stand alone like a building, supported by massive, structural elements. It required Liberman, however, to find a new way of working, since stainless steel would be prohibi-

*For me, the Roman ruins had an enormous importance. I am attracted to ruins in general. The feeling of ruins in Greece was more important for me than the pictures of the finished temples. Seeing broken columns on the ground of Olympia, which are just enormous cylinders cut into slices like giant salami was much more revealing. The experience of those ruins taught me that accidental destruction can be a source of important emotional experiences. To see those columns fallen or knocked down by an earthquake—why not create one's own earthquake?*

200. *Positive/Negative*, 1950
Painted plaster, 6 x 10½ x 18 in.

201. Delos, Greece, photographed by Liberman, 1964

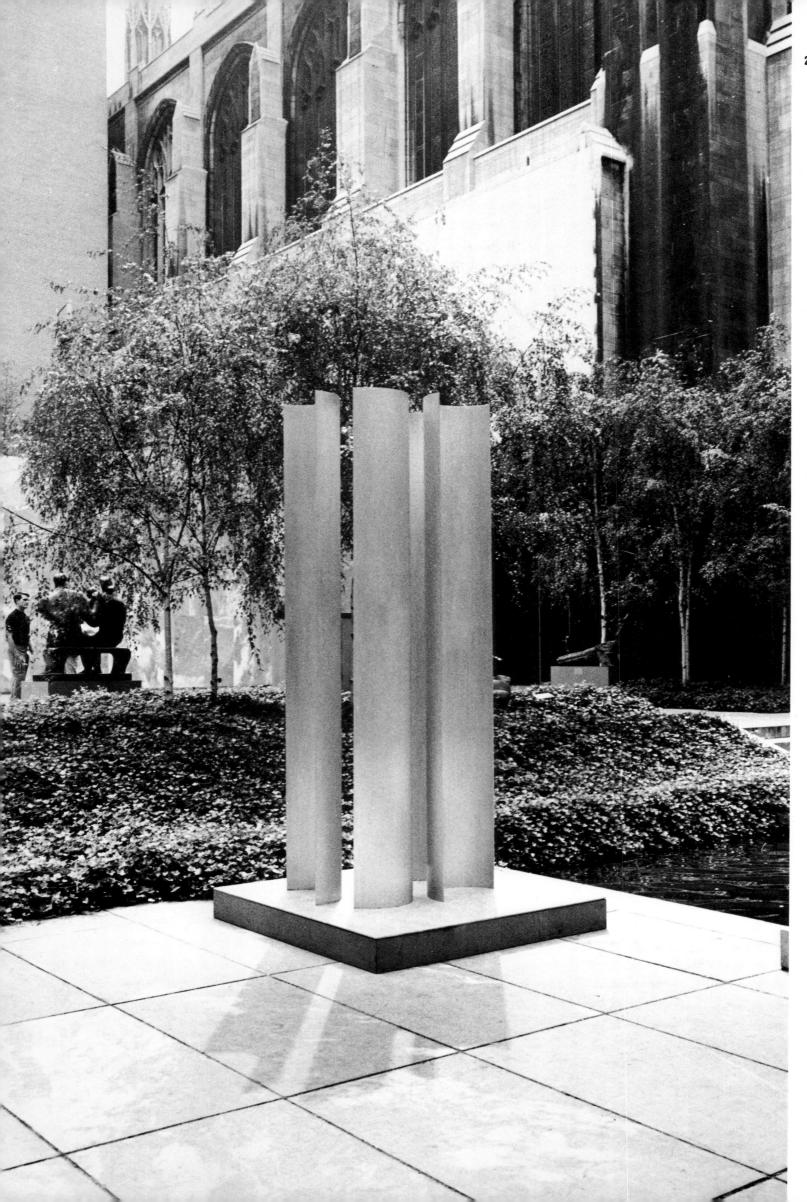

**203**

202. *Temple I*, 1963-64
Polished aluminum, 111 in. h.;
base, ⅜ x 60 x 60 in.
Collection The Museum of Modern Art,
New York. Given in memory of
Fernand Leval by his wife and children

203. Maquette for Temple series
Cardboard and Plasticine

204. *The Black Riddle*, 1963
Anodized aluminum, 36½ x 14 x 18 in.
Collection William Rubin

tively expensive. He found the means of enlarging his scale by changing his materials and technique.

It is surprising to realize that Alexander Liberman is the most successful and ambitious junk sculptor in history. Sleek appearances to the contrary, most of his sculptures have been created with machine-age discards. With the spirit of the born *bricoleur*, he has haunted junkyards and abandoned barns for materials to recycle. This aspect of Liberman as the foraging metal beggar is completely at odds with the widespread image of him as the gentleman artist. His ability to transform trash into treasure is a skill he learned early, during the hard times of the Revolution. When there was neither food nor money, his mother had improvised spectacular scenery and costumes from rags and remnants for her childrens' theater in Moscow. She believed the imagination could transform the basest materials into the most magnificent, and she inculcated this belief into her son. Henriette Pascar's revolutionary theater was an original form of *arte povera*—or as Lunatcharski called it, "the art of five kopeks." She herself, according to accounts of those who knew her, was a kind of permanent happening—improvising, acting out, using whatever materials were at hand to create theatrical effects to astonish and entertain. This may explain why, when Liberman turned away from the purism of mechanically fabricated sculpture in the mid-Sixties, he aligned himself with younger artists like Claes Oldenburg, who created giant soft sculptures from his theatrical happening props, and junk sculptors like Mark di Suvero and Richard Stankiewicz, rather than with the formalist sculptors of his own generation.

To make something out of nothing was the aim of assemblage artists like Robert Rauschenberg, Lucas Samaras, and John Chamberlain. By the mid-Sixties, Liberman had joined his aesthetic more closely to theirs for a variety of reasons: Junk was cheap, for one thing, and universally available. It freed him from economic constraints, enabling him finally to build the monumental public sculptures he seemed destined from his childhood to produce. Yet another affinity Liberman felt with junk sculpture was that it represented an uninhibited appropriation of *objets trouvés*, given new life and new identity as art, as he himself had become a new man in America. This idea of a new life and a new identity as an American artist was, as we have seen, the critical impulse behind his emergence as a hard-edge conceptual painter after World War II. As E. C. Goossen has pointed out, Liberman's artistic formation was entirely European. Logically, he should have returned to Europe when his mother and the other émigré artists went back after the war. Instead he chose to become an American citizen.

In his enamel panel paintings of the Fifties, Liberman had used found objects in the form of standard industrial con-

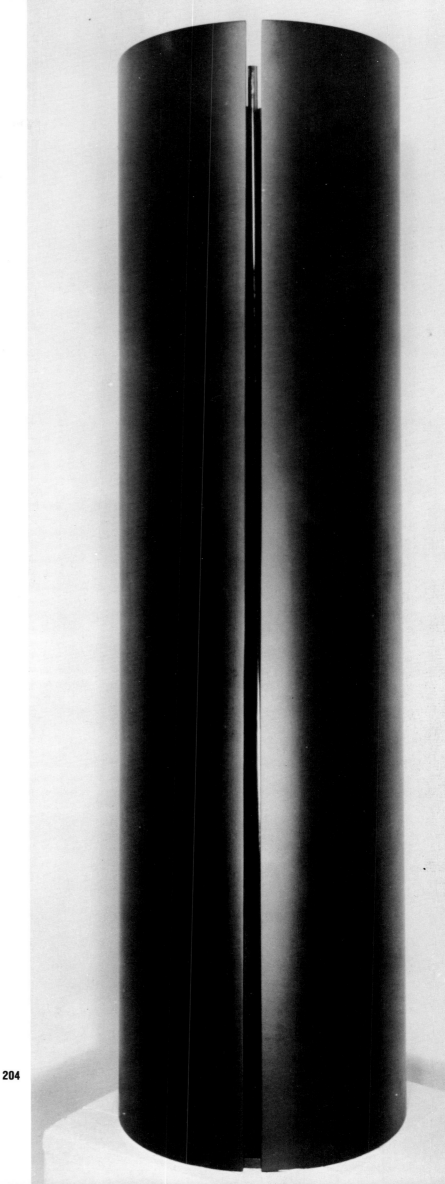

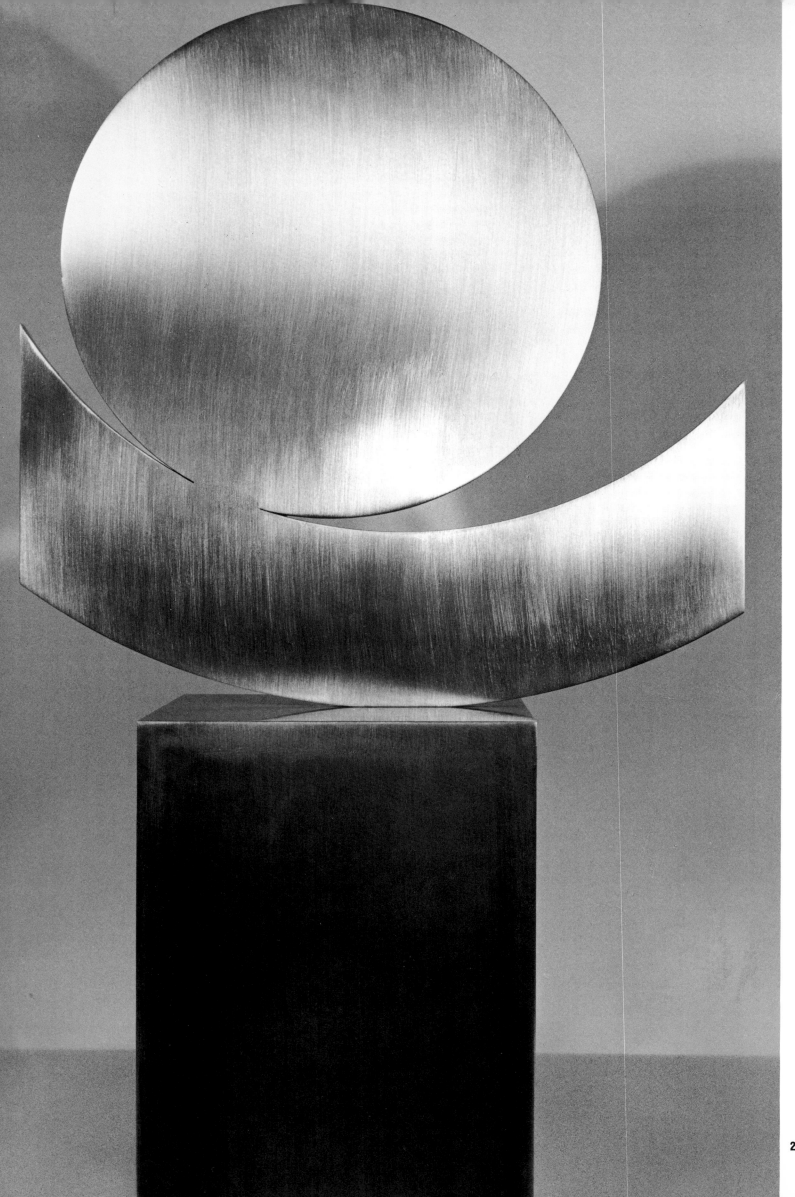

205

**206**

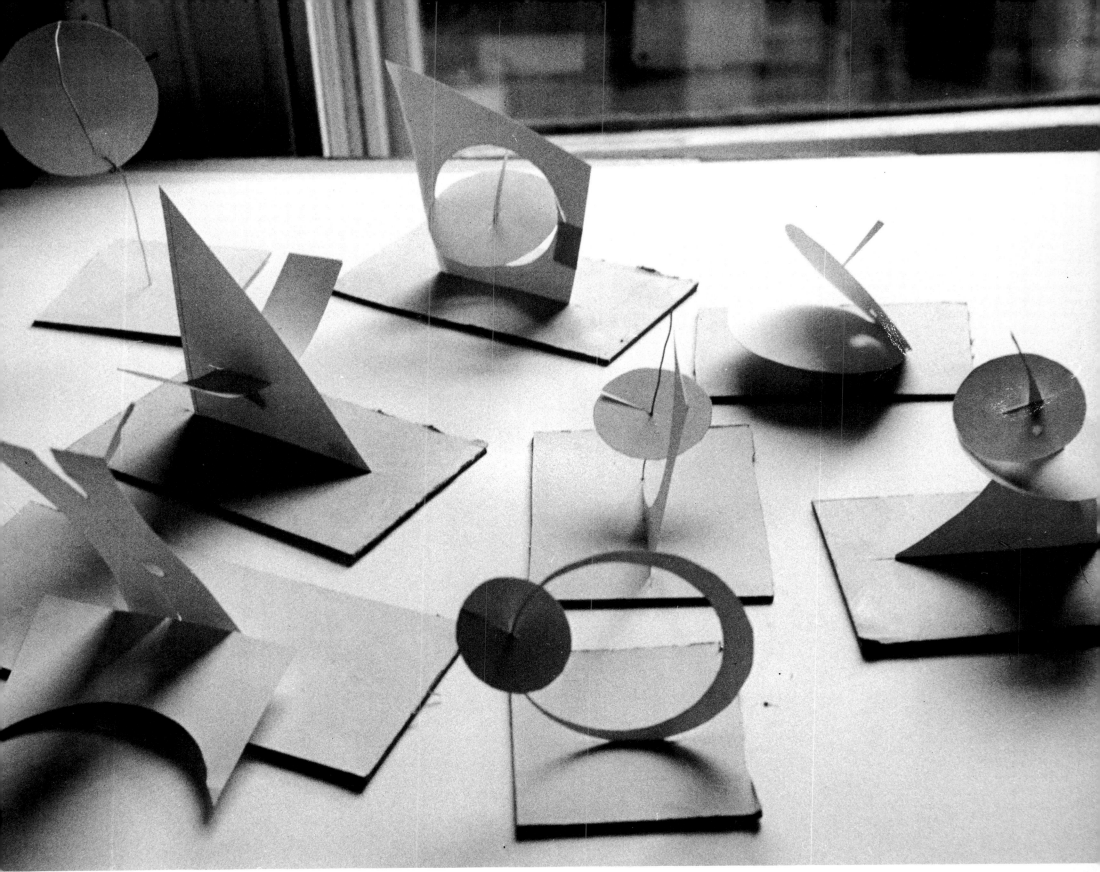

205. *Circle*, 1962
   Polished aluminum, 24 in. h.
   Collection Gaia Aulenti, Milan

206. Sundial projects, 1963
   Paper
   Destroyed

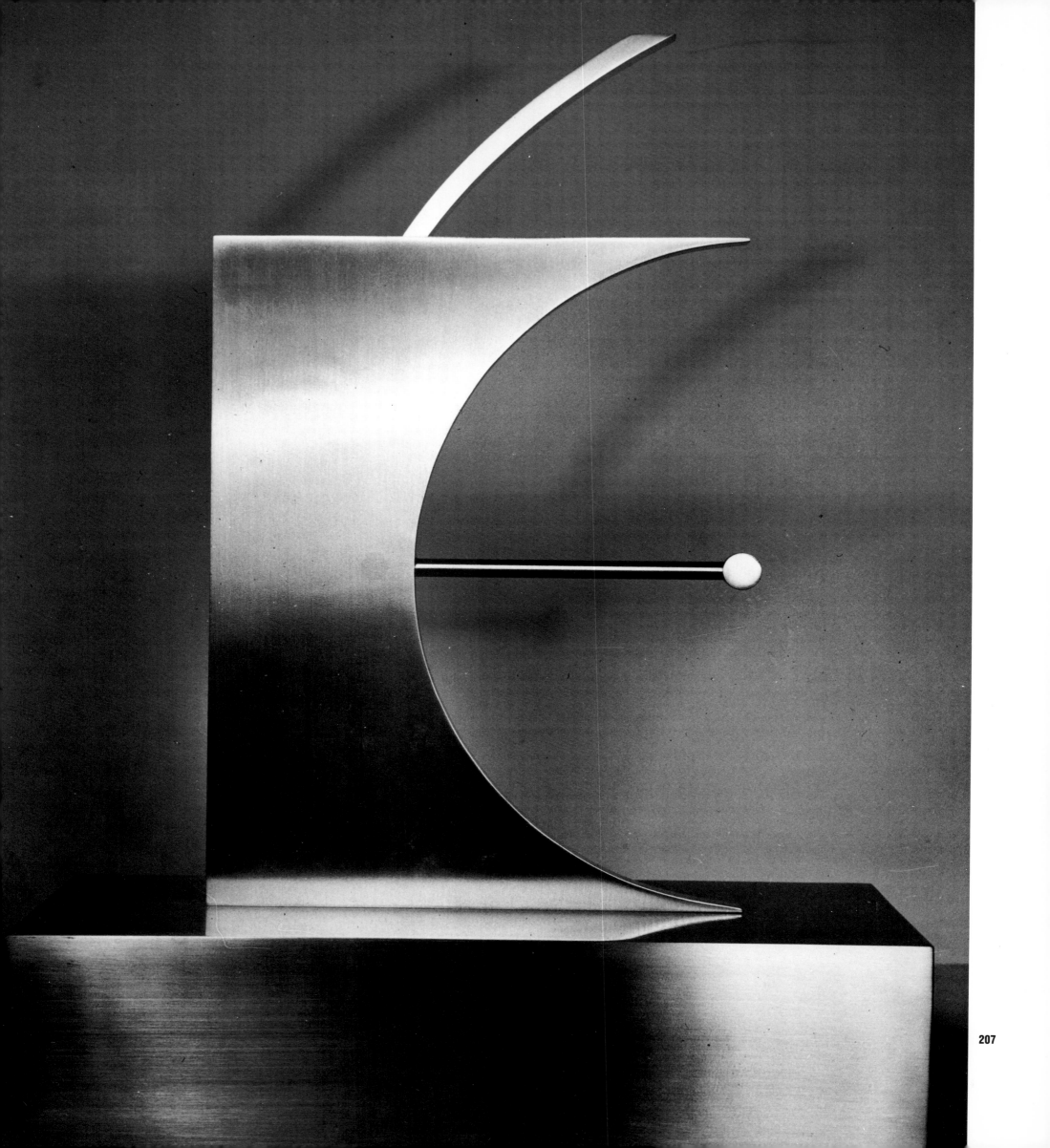

**208**

207. *Sigma 4*, 1962
Anodized aluminum, 18½ in. h.
Private collection

208. Sketches for *Sigma 4*

209. *Orpheus*, 1963
Anodized aluminum, 38 x 14½ x 11 in.
Collection Mary McFadden

**209**

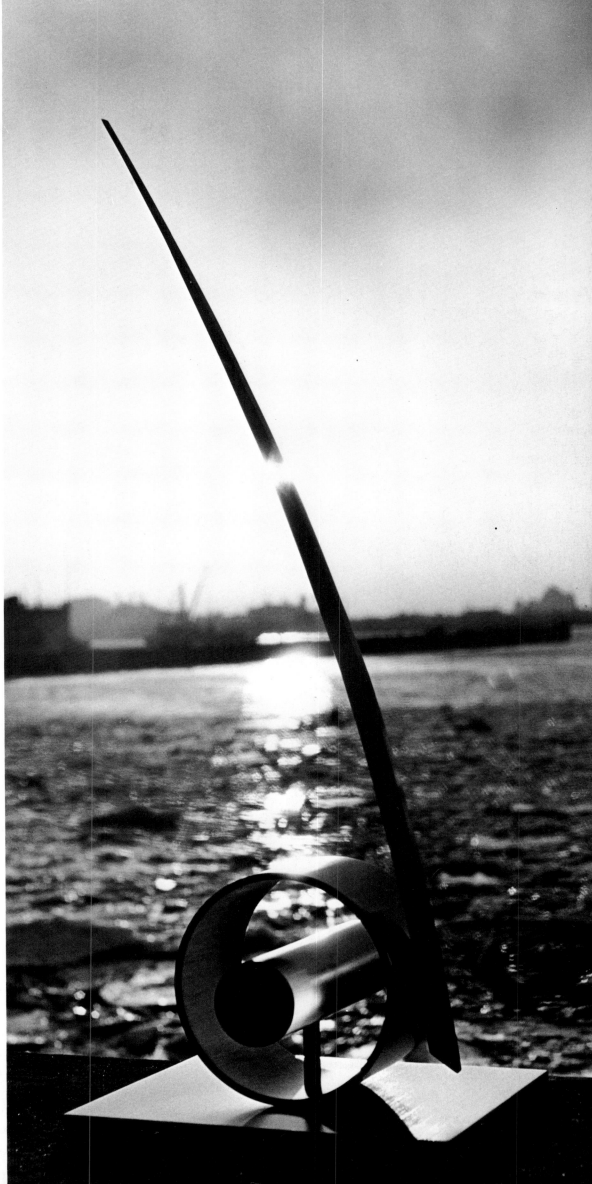

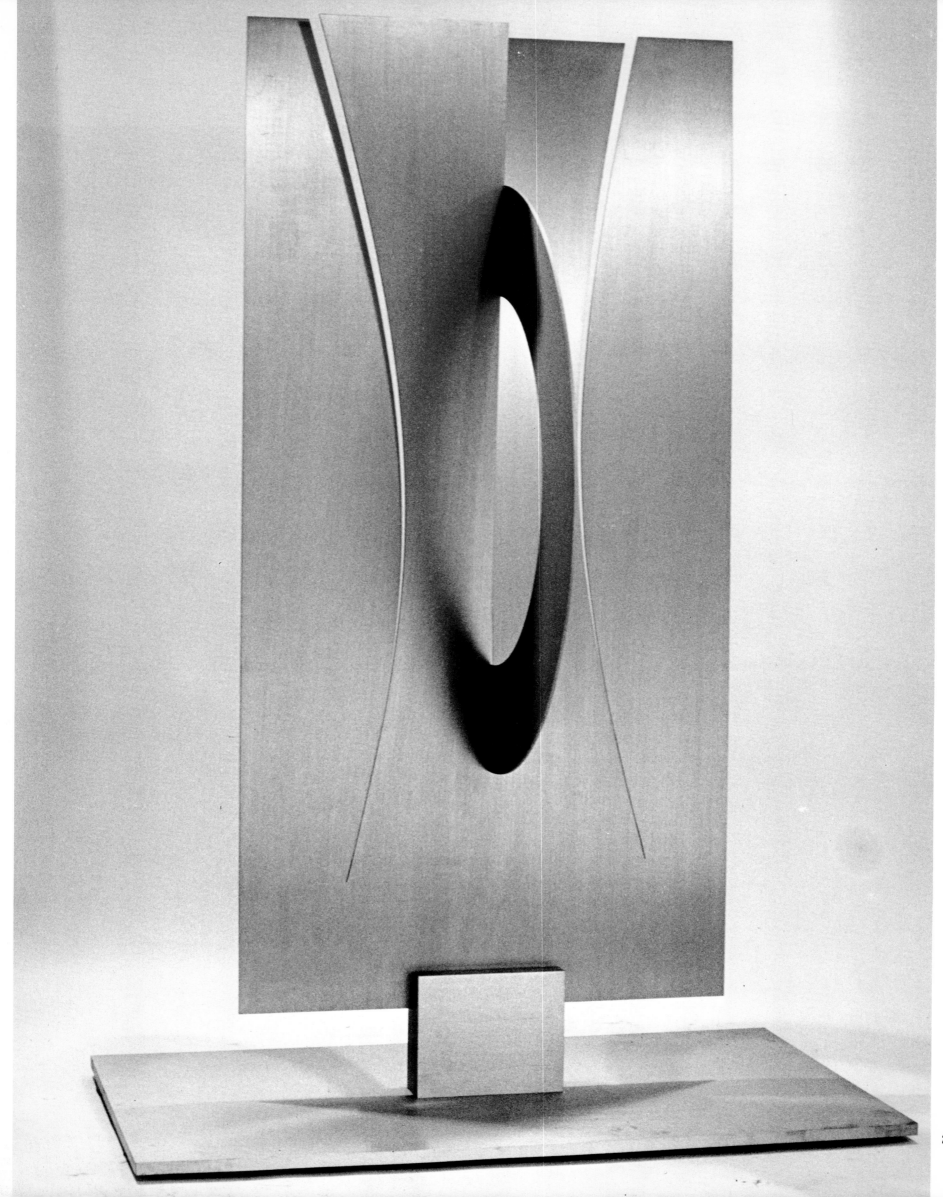

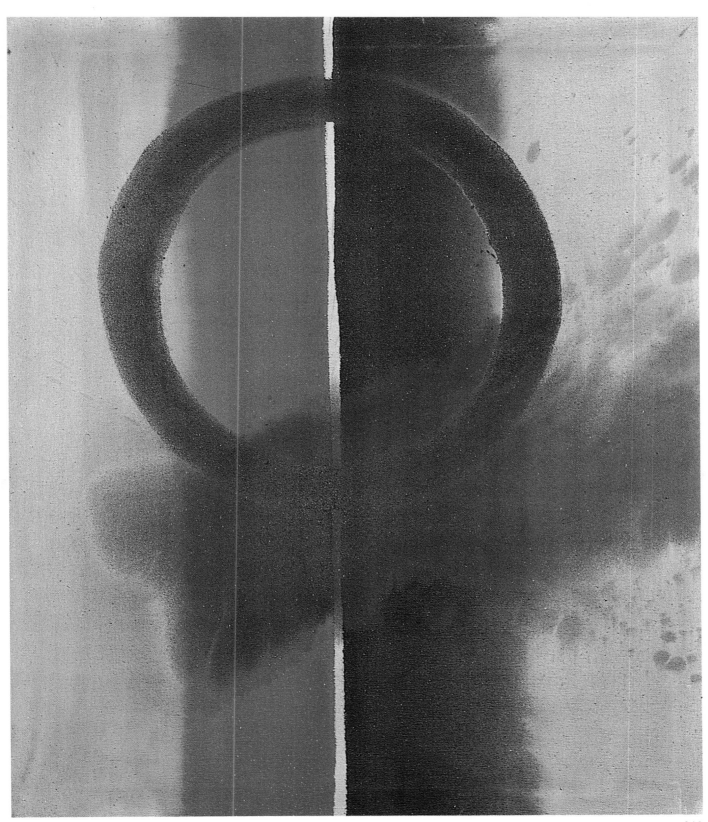

212

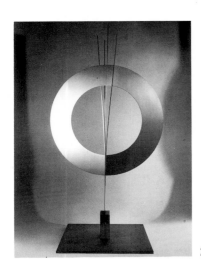

211

210. *Neptune*, 1963
Polished aluminum, 89 in. h.
Collection The Art Museum,
Princeton University.
Gift of the artist in memory
of William C. Seitz

211. Side view of *Neptune*

212. *Between II*, 1963
Acrylic on canvas, 36 x 30 in.

struction panels as supports. Junk sculpture, the term for welding together used materials that William Seitz coined for his historic "Assemblage" exhibition at The Museum of Modern Art in 1961, is predicated on chance encounters with discarded found objects. For that reason it is often rich in personal associations. Chamberlain's scrambled auto parts cannot fail to suggest wrecks and violence; Rauschenberg's "combines" play on the lived-in past history, the nostalgia of aging objects. Liberman, on the other hand, effaces the history of the junk he appropriates so that its original identity becomes unrecognizable. Disliking sentimentality and nostalgia, he finds ways of neutralizing his materials. As in painting, his impulse in sculpture is consistently toward the nonobjective—the mystical interiorized sensations of soaring, ascending, reaching, leaping, defying gravity—rather than toward the abstraction of any concrete material object or specific sentimental or literary experience.

Junk is available to anyone (like Liberman's reproducible paintings); a covert political message is implied in using it as material. Although Liberman did not share the Marxist background of the American Abstract Expressionists, he was brought up on his father's ideas of social democracy. His initial efforts as a modern artist were conditioned by a revulsion against the elitism of the high art tradition, which kept the public from the art of the privileged. His own personal history destined Liberman to attempt to transcend the barriers of museum walls, and to use art to enrich the daily life of the people. Because of his early exposure to constructivism, it was inevitable that Liberman's art should resolve itself ultimately on the public scale. Before he could conceive of working on such a scale, however, Liberman had to define a point of departure for his identity as a sculptor within the geometric tradition. We have seen how his earliest exhibited sculptures are extensions of his geometric paintings into three-dimensional space.

Like the hard-edge paintings and tondos that Liberman executed in the early Sixties, the polished, highly reflective aluminum sculptures he made in 1962-63 were conceived and drawn by Liberman, but were industrially fabricated. Smooth, svelte, and as immaculate as the latest machinery, these elegant works have the same air of detachment, impersonality, and objectivity as his hard-edge paintings. A

213. *Inaccessible*, 1963
   Acrylic and charcoal on canvas, 82 x 82 in.
   Collection Phillips Academy,
   Andover, Massachusetts

214. *Realm*, 1963
   Polished aluminum, 9 ft. 10 in. h.
   Collection Philippe Venet, Paris

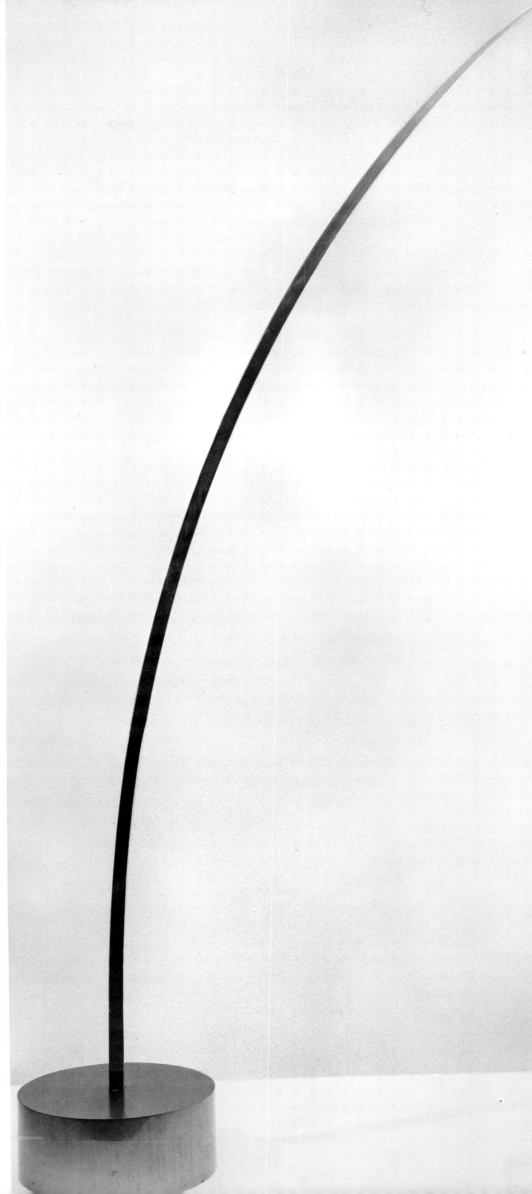

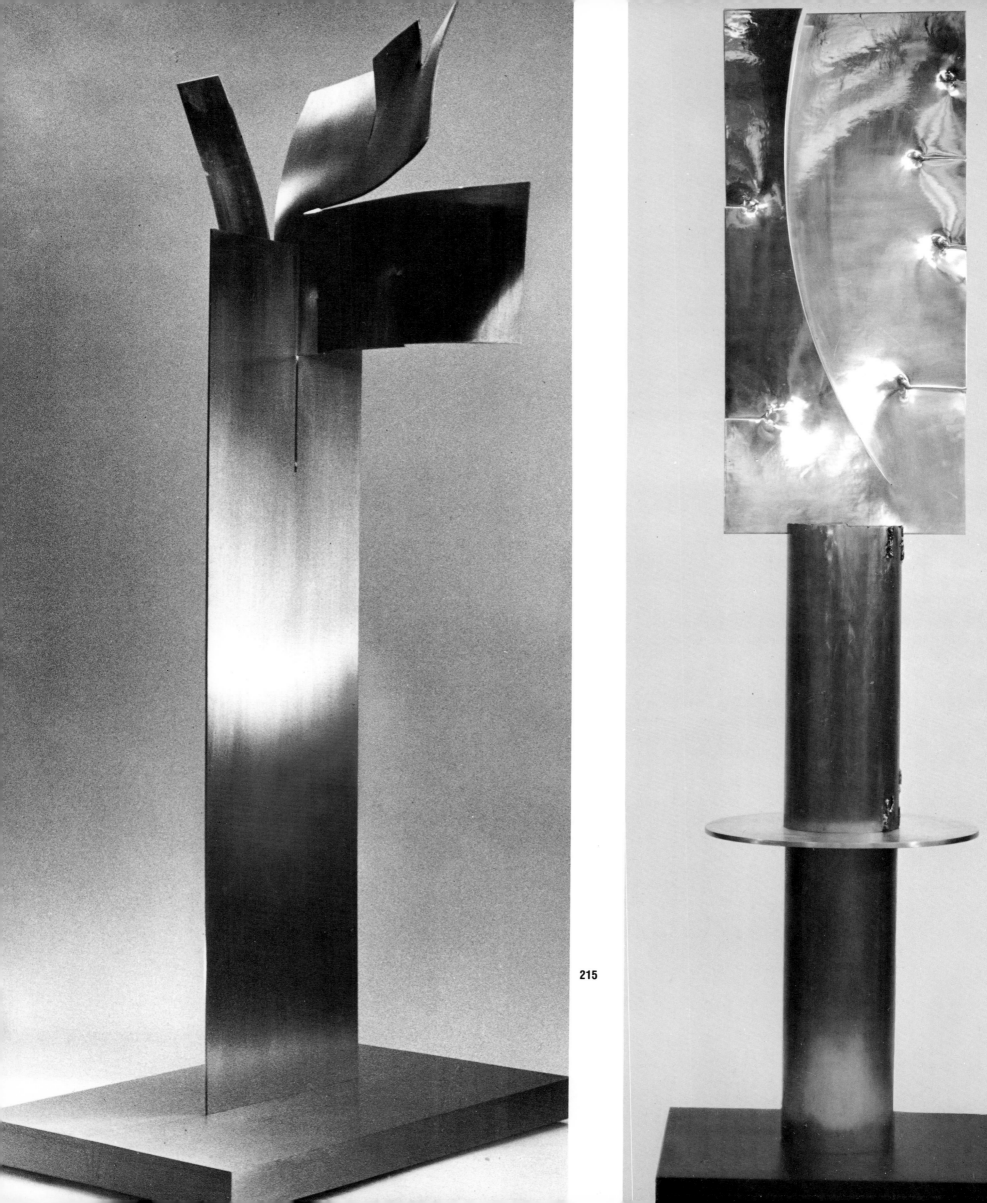

215

216

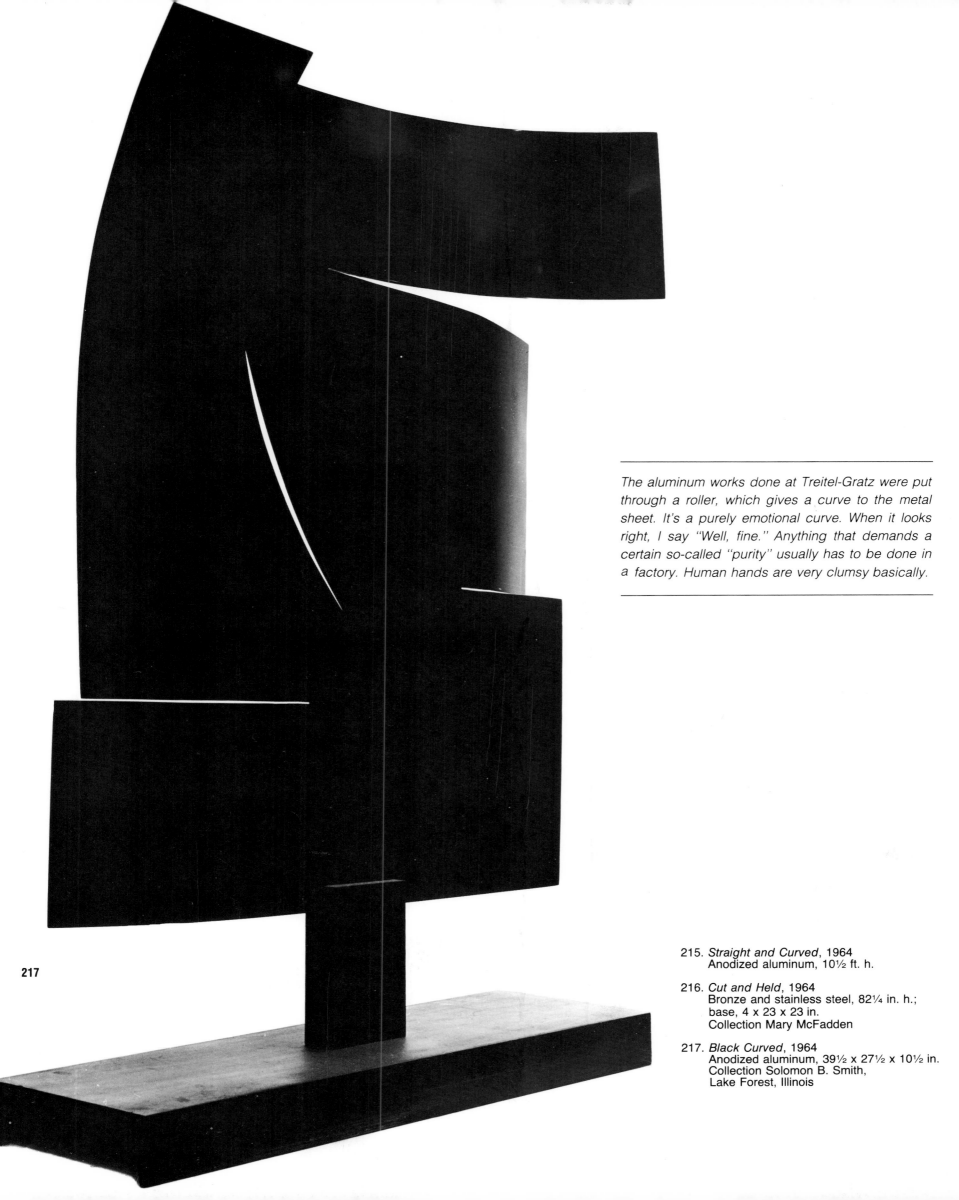

The aluminum works done at Treitel-Gratz were put through a roller, which gives a curve to the metal sheet. It's a purely emotional curve. When it looks right, I say "Well, fine." Anything that demands a certain so-called "purity" usually has to be done in a factory. Human hands are very clumsy basically.

**217**

215. *Straight and Curved*, 1964
     Anodized aluminum, 10½ ft. h.

216. *Cut and Held*, 1964
     Bronze and stainless steel, 82¼ in. h.;
     base, 4 x 23 x 23 in.
     Collection Mary McFadden

217. *Black Curved*, 1964
     Anodized aluminum, 39½ x 27½ x 10½ in.
     Collection Solomon B. Smith,
     Lake Forest, Illinois

series of sentrylike sculptures, suggesting glamorous armor, were manufactured in 1962-63 at Treitel-Gratz, a Manhattan metal shop specializing in high-quality polished steel and aluminum. (After Liberman discovered the shop he sent other New York artists to work there.) These sculptures were basically vertical sheets of aluminum, slit and bent. Some had plates inserted at various angles to suggest torsion in space. Although Liberman generally eschews the anthropomorphic at all costs, these aluminum sculptures show analogies with the human figure rare in his work. To see connections in them with David Smith's "sentinels" is unavoidable. However, Liberman does not attach or collage planes together, but works with the single sheet, extracting meaning from a minumum as he had in his early paintings, deliberately restricting his options and stretching those restricted choices to maximum potential. Moreover, the thickness of the polished stainless steel Smith used suggested a weight and gravity that the fragile, malleable aluminum sheets Liberman used did not. The extreme two-dimensionality of the frontal plane that virtually lacks side views because of its thinness is contrasted with angling, bending, and curving sections of the plane back into space. The thin metal sheets, as Liberman puts it, are "tortured" by the artist. This bending back and around into space is Liberman's first attempt at contrapposto effects. (215, 217) Although three dimensions are addressed in these freestanding aluminum pieces, the basic conception is an extension of pictorial concerns, and they remain, like David Smith's work, a kind of three-dimensional collage. Liberman's gradual conquest of the in-the-round sculptural extension would prove as arduous as was his creation of depth in painting. As he moved into space, he moved farther from the world of graphic effects, both in painting and sculpture. That he chose to do so at a moment when the graphic element—the sharp silhouetting of clearly legible geometric shape—became the dominant element in American art did not aid in the understanding of his work.

Although the aluminum sculptures were not literally monoliths, their closed forms and smooth surfaces continue the veins of streamlining announced by Brancusi, and they reveal Liberman as still deeply involved with Brancusi's aesthetic. Sometimes their imagery is reminiscent of Brancusi's touching forms of *The Kiss* or his soaring linear *Bird in Space*, or the phallic diagram of his *Torso*. (205, 210) Also related to the planar aluminum pieces were a series of projects for sundials Liberman made out of paper in the early Sixties. They are, like the aluminum pieces, still closely tied to the pictorial concerns of planar organization. (206) Liberman was critical of this pictorial element in his sculptures and acutely aware of the limitations of frontality and of machine-polished surfaces.

Ironically, the pursuit of a machine aesthetic that persuaded David Smith to turn his blacksmith's shop into a factory for heavy industry, and impelled minimal artists to have their works industrially fabricated, triumphed at exactly the moment Liberman became disgusted with industrial fabrication. As a sculptor, he made the same untimely about-face as he had as a painter. Between 1962 and 1964, he turned from purist precision to activated painterly gesture. Just as his fabricated sculpture was about to be acclaimed as "advanced" minimal art by formalist critics, he turned against his own industrial style. He extended the machine aesthetic to its limits in 1964 by giving instructions for the fabrication of a piece of anodized aluminum over the telephone. It turned out to be an experiment that he found flat and cold, devoid of the subjective content and personal search he cared about most. He had pursued the industrial aesthetic to its logical conclusion. Self-criticism caused him to reject machine-shop fabrication for the freer, more subjective technique of assemblage.

Through assemblage, Liberman found a way to abandon his closed forms for good, to open interior space, and to use gesture as a means of expression.

---

*When I first looked at the blinding spark of the welding arc, I thought of St. Paul's revelation. It's an experience that I cannot forget. There's that moment of terror when that arc hits. It's like a miniature atomic explosion, and it's beautiful, absolutely extraordinary. It's a bit frightening even. You have darkness, and suddenly you touch a piece of steel and a blinding electric explosion occurs. When you leave the arc connected, the metal begins to boil. You get bubbles, the flux that surrounds the rod melts—and when you look at it very closely it's like lava flowing, it's a volcanic experience. The material changes states. I can't help but think of Vulcan and the forge—imagery of the gods involved with fire. Welding is a physical experience of fire.*

218. Liberman welding in the Graystones studio, Warren, Connecticut, 1963

**218**

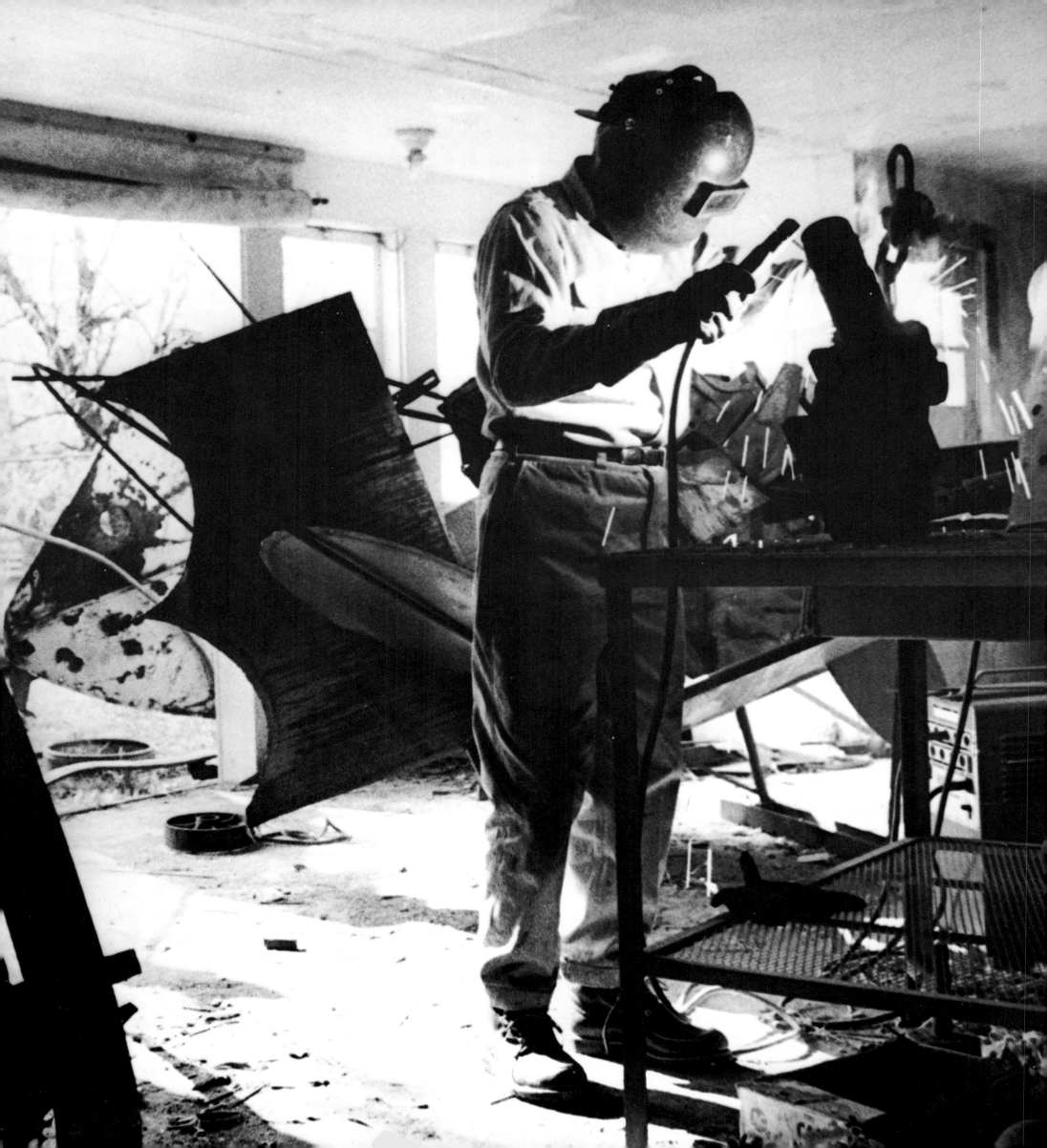

We have remarked on the relationship of Liberman's aluminum pieces to David Smith's "sentinels." However, Smith did not begin to thrust his volumes above the supporting stanchion until Liberman met Smith in 1965, when Robert Motherwell took him to Bolton Landing. Liberman recalls the visit as a rich experience. He remembers particularly Smith's pride in how durable his painted surfaces were. Smith compared the coats of paint on metal with the finish on a Mercedes-Benz. He was sure they would last forever.

Liberman's feelings about Smith were even more ambivalent than his feelings about Brancusi. It was obvious that Smith was a master, but Liberman felt that his work was too rooted in a pictorial tradition. He watched Smith lay out the parts of his sculpture on the floor like a drawing, and then hoist them up into the air with complicated machinery. Frontality and two-dimensionality were qualities he had already rejected in his own sculpture as inimical to the essence of the medium and belonging more properly—like opticality—to the realm of the pictorial. He also disliked the obvious anthropomorphism of Smith's works: he found them abstract rather than nonobjective and symbolic. And he was particularly critical of what he perceived as a sentimental reference to the former life of the tools that Smith incorporated into his works. He personally wanted to efface history from his materials. Moreover, he thought that Smith's involvement with turning the studio literally into a factory had become obsessional, and that he was harming his work by making it too technically perfect. These were all aspects of his own work Liberman had rejected.

Even so, Liberman looked forward to a friendship with another sculptor of his generation; yet it was only two weeks after the visit to Bolton Landing that David Smith died in a driving accident. Liberman felt it was a tragedy that Smith, like Pollock, had not lived to fill out his career, to finish his oeuvre, like the aging School of Paris masters Liberman had photographed. However, Liberman's own work had already taken a very different direction from that of Smith. He was liberated, curiously enough, by the daring of an artist much younger than he, whose background was coincidentally similar to his own. In the early Sixties, he had seen a reproduction of an assemblage by Mark di Suvero. Like Liberman, di Suvero had been born into a rich and powerful international family, forced to flee Europe because his father, a naval architect and submarine commander, was, like Simon Liberman, Jewish. Di Suvero's childhood had also been spent as a gypsy, traveling from place to place. Most important, di Suvero was committed, because of his political idealism and knowledge of Baroque sculpture in his native Italy, to creating public art.

Using a crane, di Suvero expanded assemblage on to a totally new and heroic scale. In the early Sixties, Liberman

219. *Sweep*, 1963 Welded steel, 8½ ft. x 10 ft. 8 in. x 9½ ft.

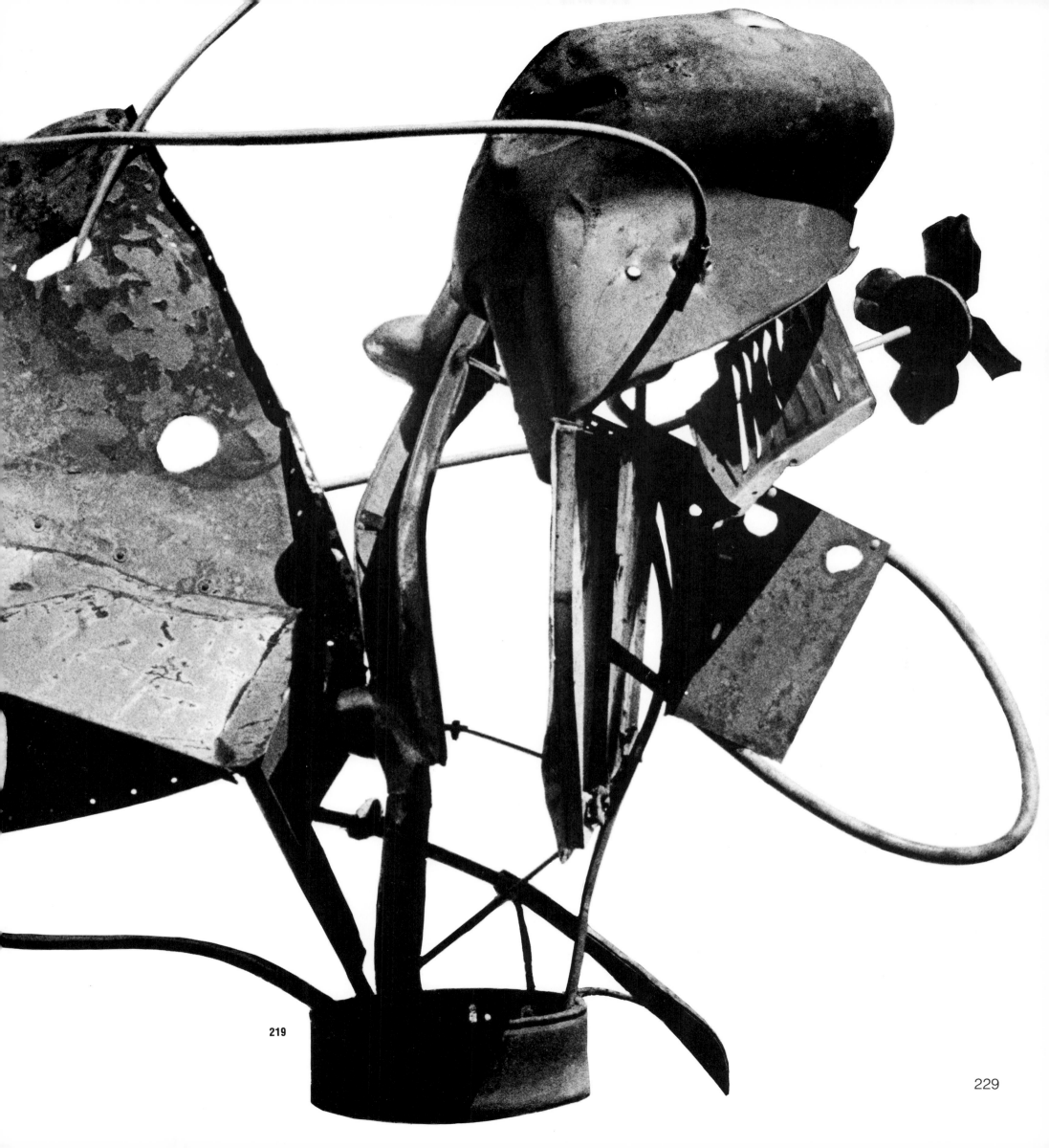

219

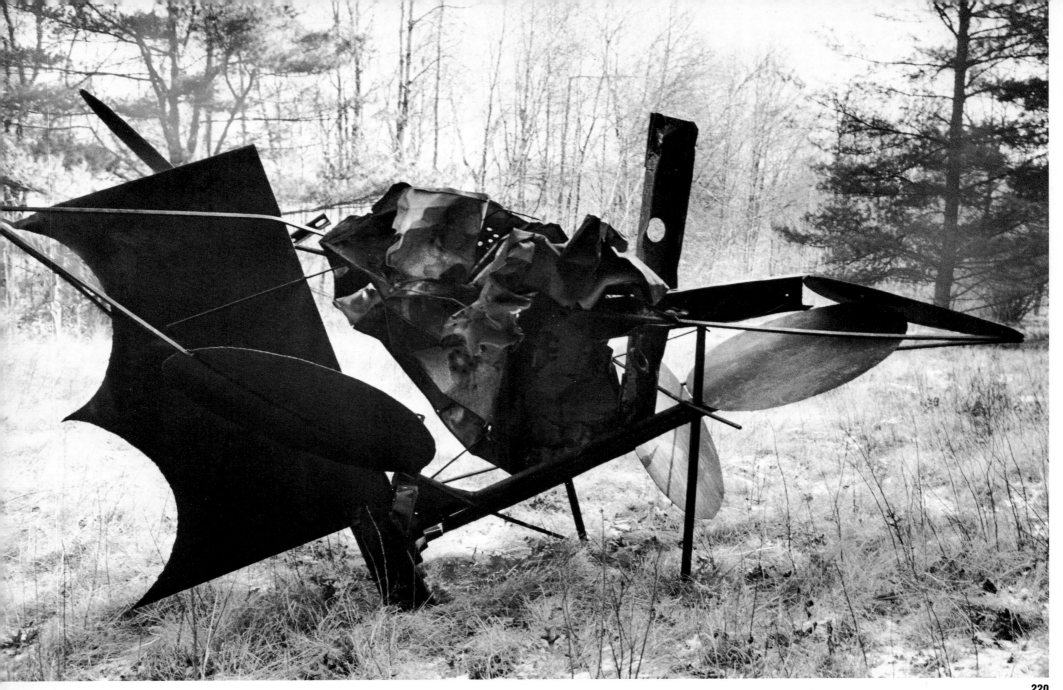

saw a photograph of a work by di Suvero, which impressed him with the potential for extending forms into fully sculptural in-the-round projections, with views changing from every angle in space. One of his earliest essays into space-embracing sculpture, *Multiple Orbits* (*220*), rejected solid mass for the greater excitement of animated gestures and resembles the structure of di Suvero's *Love Makes the World Go Round*. Liberman continued to use mostly junk in his sculpture from this time on, but he no longer wished to refer to the past history of his materials in the way that di Suvero, for example, insisted on the found-object identity of the elements of his assemblages.

The evolution of Liberman's style as a sculptor thus paralleled his evolution as a painter from the intellectual and conceptual emphasis to an emphasis on action committed to spontaneous improvisation. That this evolution was against the grain of prevailing taste did not dissuade him from taking his own course in the pursuit of a greater and greater libera-

220. *Multiple Orbits*, 1963
Welded steel,
5 ft. 9 in. x 11 ft. 2 in. x 7 ft. 7 in.

221. *Bond*, 1963
Welded steel, 57 x 67 x 36 in.

FOLLOWING PAGES

222. *Agricola*, 1963
Welded steel, approx. 60 in. h.

223. *Trophy*, 1963
Welded steel, 76 x 63 x 64 in.

221

230

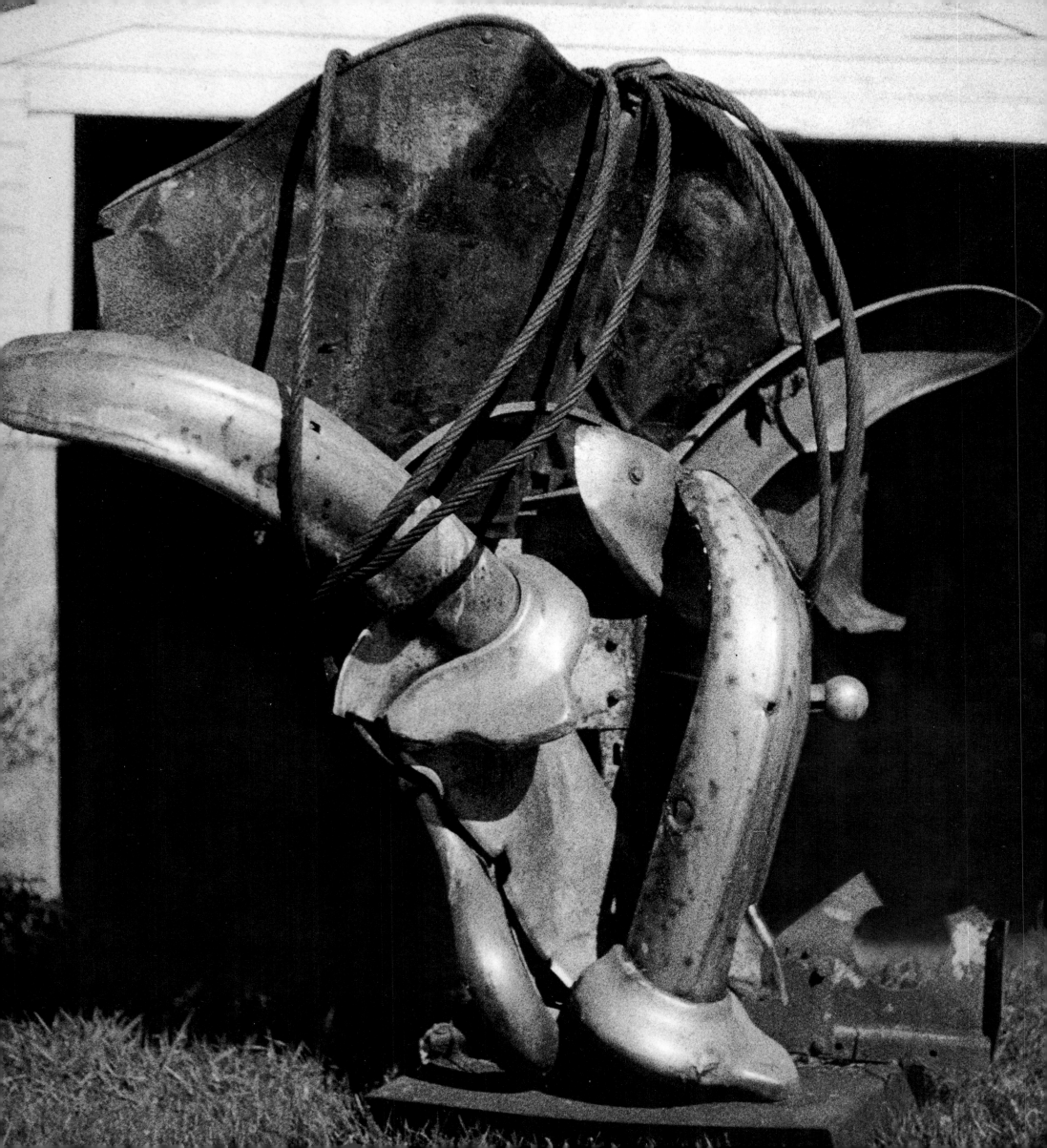

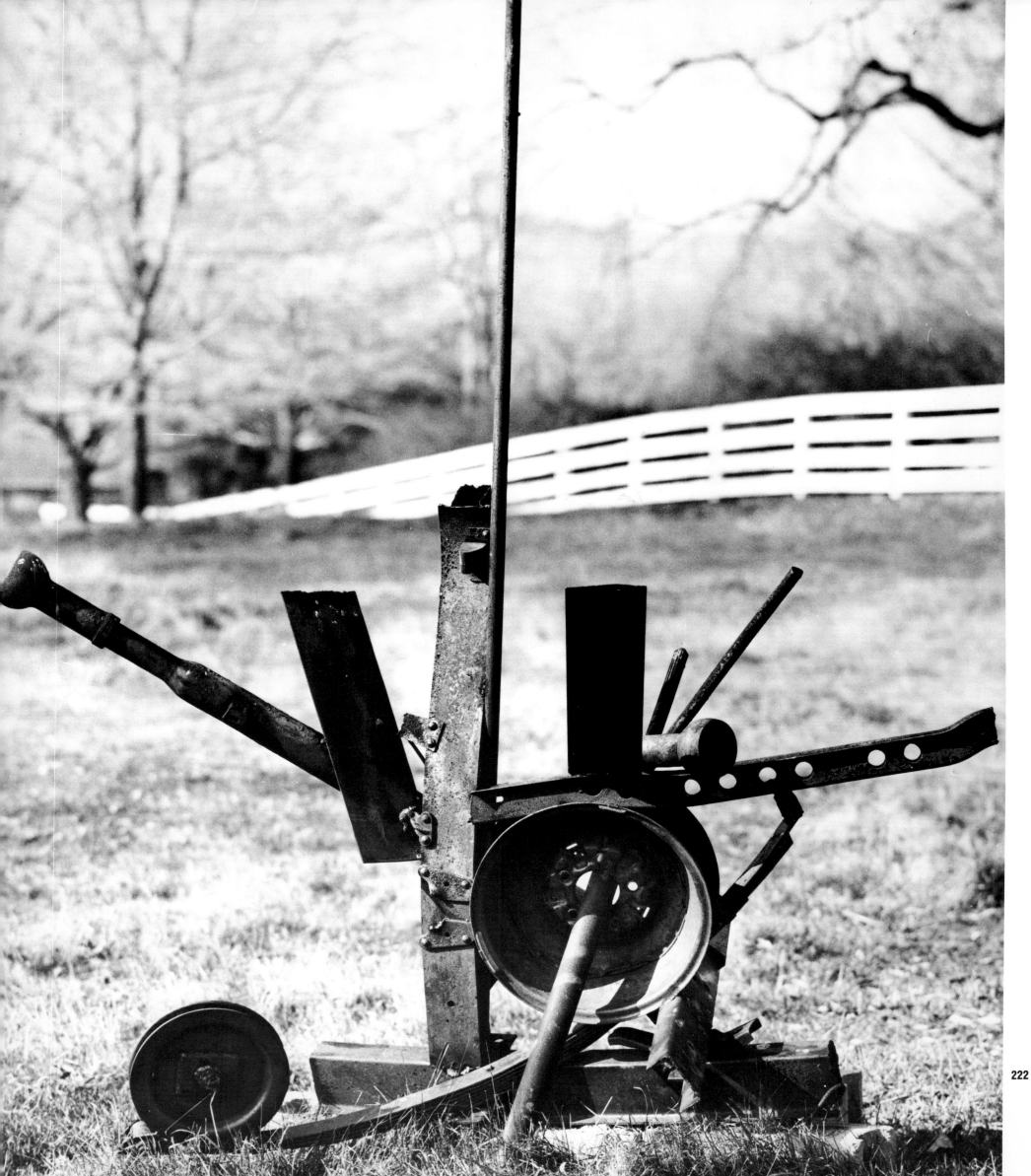

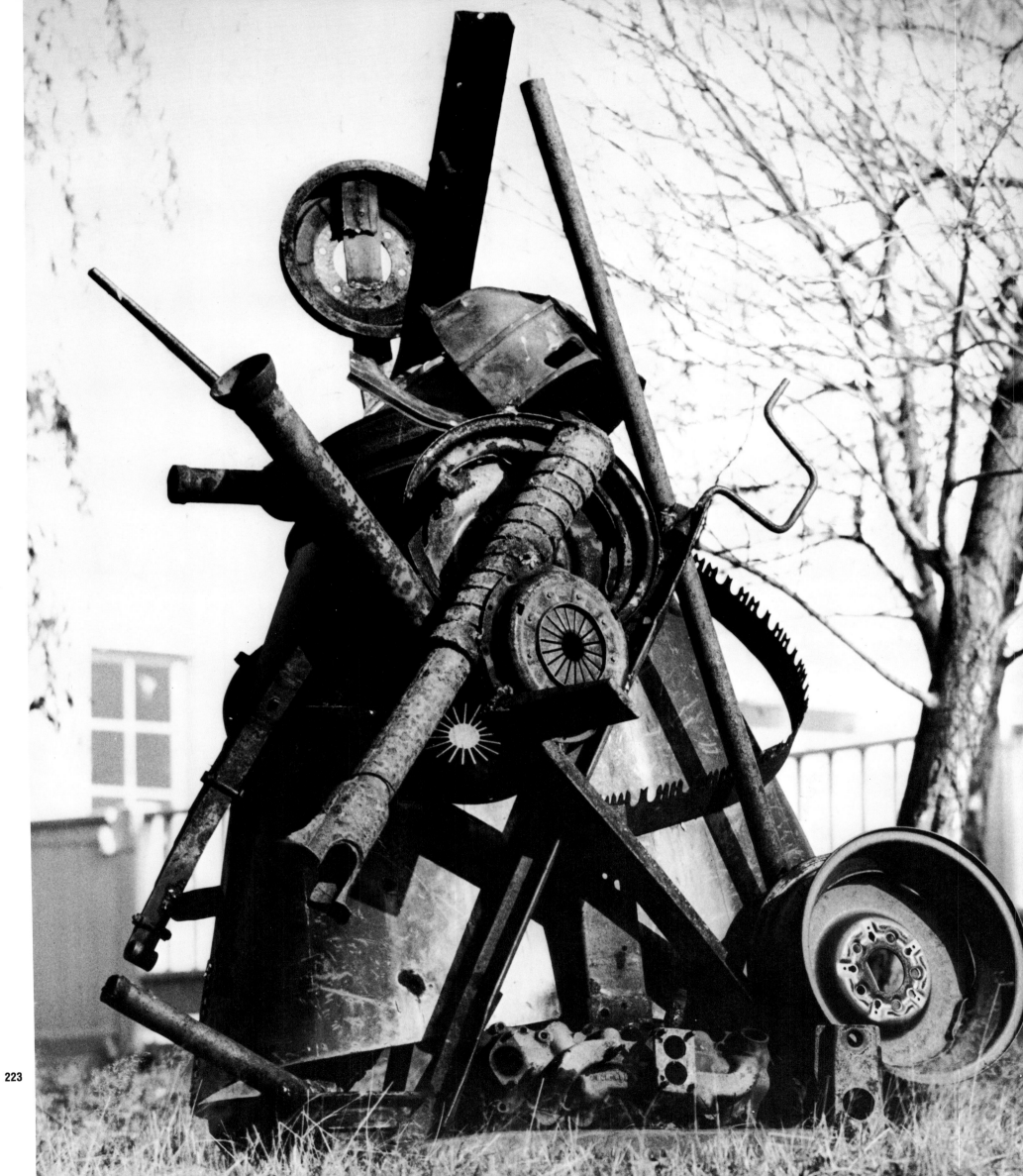

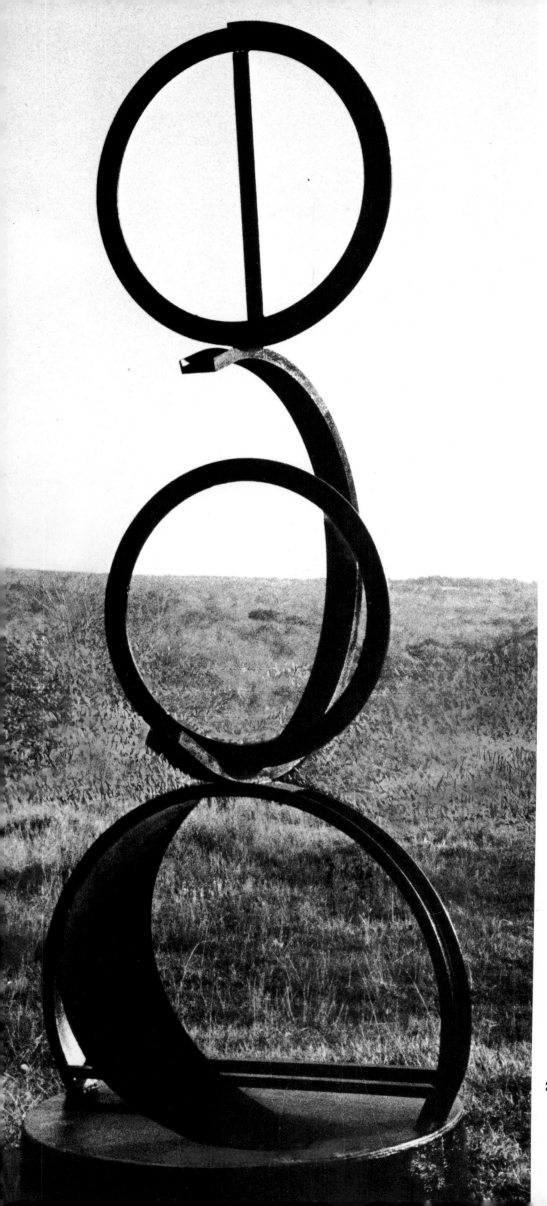

tion of thought, action, and gesture. Beginning his career as a contained, conceptual, classical, and serial artist, he evolved into a romantic, expressionist, and stubbornly defiant master of the grand gesture in both painting and sculpture. Formalist critics who applauded him as the inventor of a polite and disciplined classicism saved their praise for those who continued in the direction Liberman pioneered, while Liberman went his own way. As his paintings have became more concerned with depth and texture, his sculpture has focused on gesture and extensions into three-dimensional space. In both cases, the impetus has been toward a fuller and richer expression.

New techniques helped him to change his style in both media. In these researches, his son-in-law, Cleve Gray, played a decisive role. It was Gray who had originally introduced Liberman to acrylic paint, which permitted him to change his style in painting. Although Liberman had learned to weld in 1959, he had no place to work on sculpture himself. His physical health restored, he was anxious to make the sculpture with his own hands as he was now doing his paintings, and to work larger. Gray lived on his family's farm in Connecticut, where he had his own painting studio in a barn. He offered Liberman one of the barns on his property in which to make welded sculpture; he let his father-in-law use the old farm machinery and gave him money to buy scrap metal. In 1961, Liberman began making welded sculptures in the small barn on the Grays' property. At one time, Cleve Gray raised Angus cattle. Liberman was fascinated by the odd curve of the feed racks. Several of the early assemblages incorporate parts of these feed racks and other parts of old farm machinery. (*226, 227*)

Liberman's early assemblage sculptures are unpainted. They do not conceal the origin of the materials. (*219, 220*) They have a rough, coarse brutality offensive to conventional taste. Like his black paintings, Liberman's raw, unpainted junk assemblages of 1963-64 are among his most brilliant works, but they too have never been exhibited. Assemblage

224

224. *Rhythm*, 1965
   Welded steel, 10 ft. 9 in. h. x 4 ft. 4 in. w.
   Collection Rhode Island School of Design
   Museum of Fine Arts

225. *Wheels Within Wheels*, 1965
   Painted steel, 8¾ ft. x 6 ft. x 3½ ft.

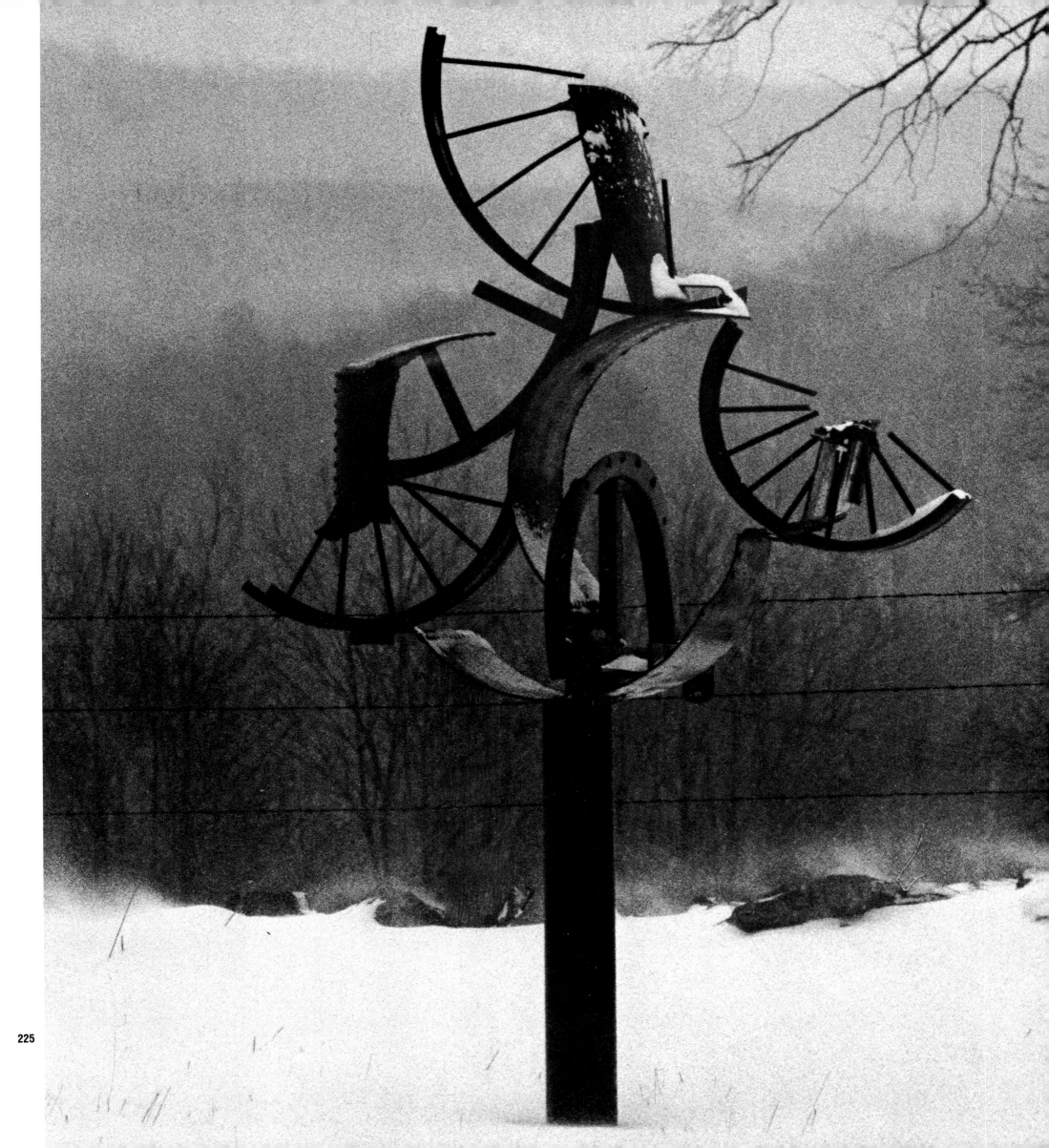

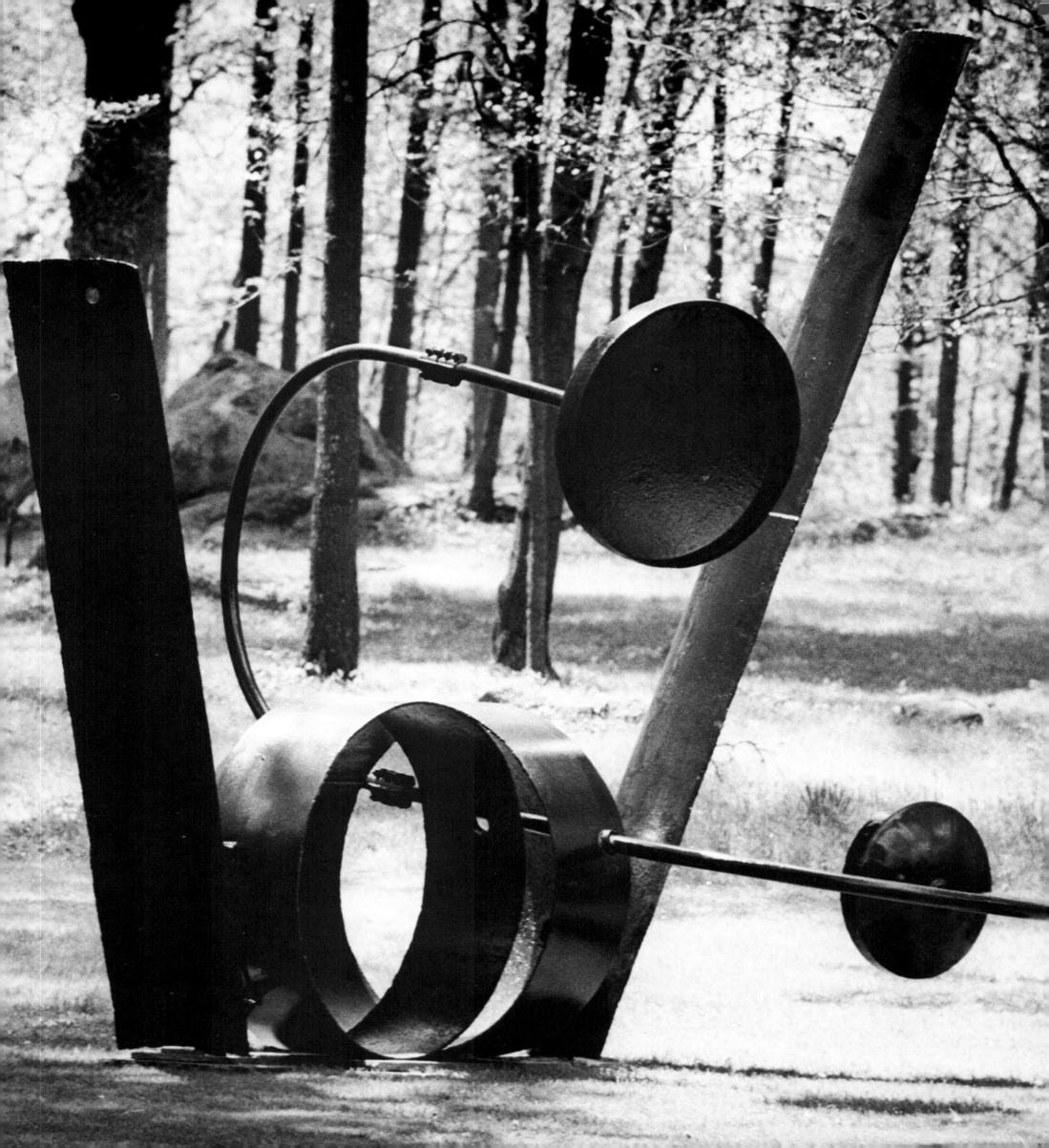

resolved a number of problems, not the least of which was the economic factor in constructing monumental sculptures. Junk permitted Liberman not only to work large, but also to revise work in progress. This development paralleled his adoption of an *alla prima* painting technique in his "lyrical abstractions" of the mid-Sixties. Extension into fully three-dimensional work that was no longer cubist, as well as the final elimination of the base, were both made possible through the process of welding and torch cutting. Giant chunks of metal could be held together with what Liberman termed "electric glue."

In 1959 he first experimented on paper with automatic drawing techniques, and in a few small pieces of sculpture with welding. But the explosion into a freer style of action painting and gestural sculpture did not actually occur on a large scale until 1963. Because the work he was exhibiting publicly was geometric, a confusion regarding his stylistic development resulted. Much work also remained unexhibited—for example, his unpainted assemblages of farm machinery—so the confusion was exacerbated. The fact is that Liberman's style has a kind of rhythmic ebb and flow. An

*I think cutting with a torch is marvelous. Welding is beautiful. If you are dealing with basic subject matter, as I think one tries to, it's good to have basic tools. I would be very annoyed to have some kind of electronic arc that would cut things in three seconds because while you cut, or while you execute, you think.*

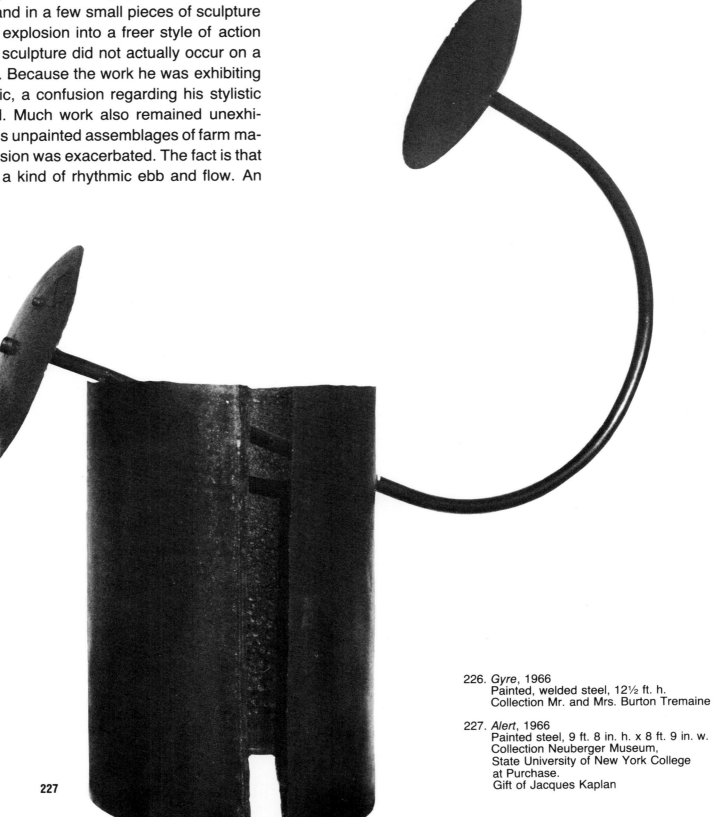

226

227

226. *Gyre*, 1966
Painted, welded steel, 12½ ft. h.
Collection Mr. and Mrs. Burton Tremaine

227. *Alert*, 1966
Painted steel, 9 ft. 8 in. h. x 8 ft. 9 in. w.
Collection Neuberger Museum,
State University of New York College
at Purchase.
Gift of Jacques Kaplan

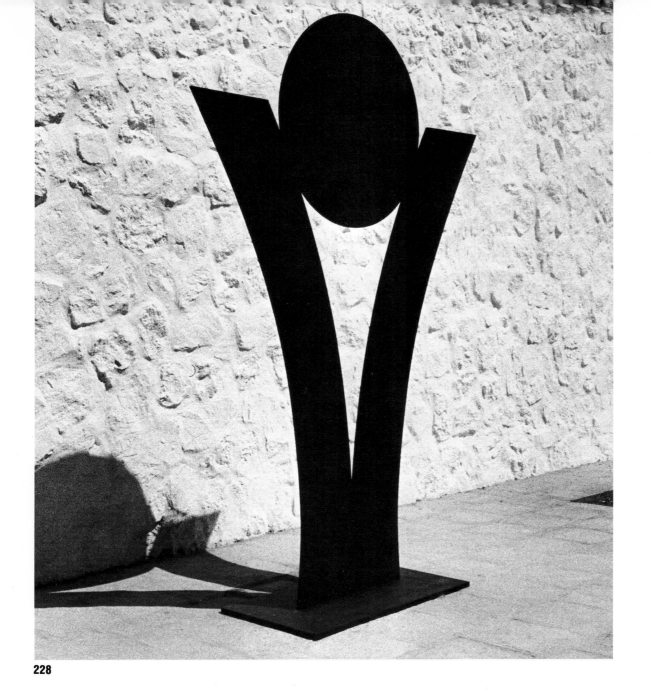

228

228. *Fire*, 1963
Painted aluminum,
9 ft. 7 in. h. x 7 ft. 4 in. w.
Collection Mrs. Woodward de Croisset,
Málaga, Spain

229. *Cardinal Points*, 1965
Painted steel, 10 x 7 x 8 ft.
Collection De Cordova Museum, Boston

undercurrent always exists as a minor theme he is experimenting on. Later, this undercurrent emerges as a fully developed concept. As he is exhibiting one style, he is usually experimenting in another.

Having used up the available machinery on Cleve Gray's farm, Liberman found the perfect form—a readily available module—in discarded boilers and gas storage tanks. These could be had for nothing at the time. The tank had familiar geometric associations for Liberman: It was a cylinder, a column, and it could be sliced into circular sections with a torch.

The first sculpture Liberman painted was *Fire* in 1962. (*228*) It was his first commission, and he felt it had to be more formal than the rusty junk he was experimenting with, so he covered it with a coat of black enamel. Once he started using old boilers and gas storage tanks as a module in 1964, he painted them with black enamel to efface any identification with the metal's previous history. In 1966, he painted a few pieces red, the color of nearly all his large public sculpture made since that time.

During his assemblage period, which brought him into contact with rusty and unfinished surfaces, Liberman was also experimenting with tactile effects in the more traditional idiom of cast bronze, the material associated with fine art and academic sculpture. As usual, his unconventional approach yielded new and surprising forms. His first bronze sculptures

229

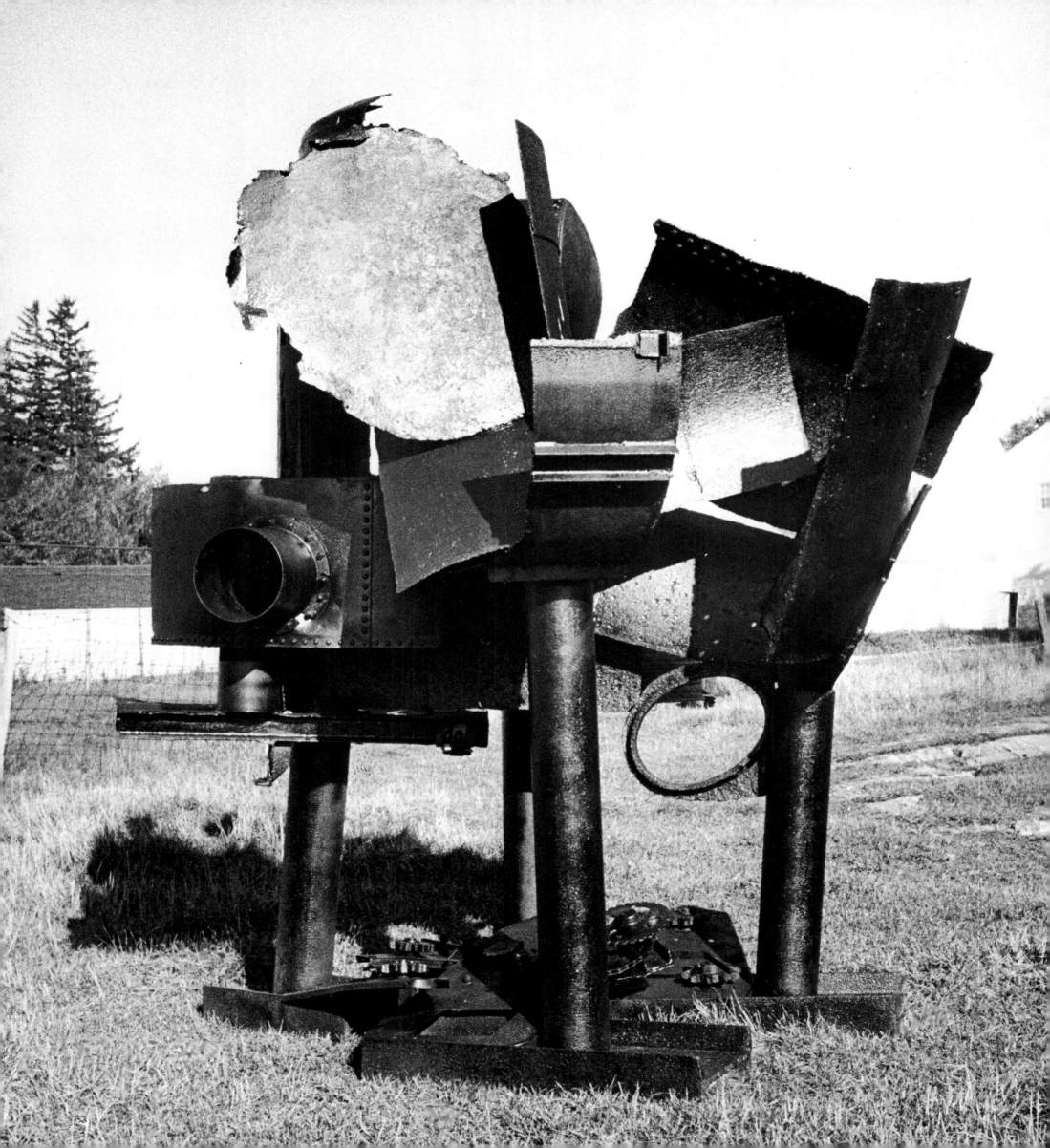

were made in 1963-65. Small in size, they were powerful in effect. They demonstrate that Liberman's capacity to convey monumentality is not dependent on large scale. (*230, 231, 232, 233*) Their concentrated imagery, which suggested figures worshipping in an abstract shrine, was the point of departure of a large group of sculptures with the theme of devotion. Their textured, modeled surfaces related to the painterly effects of the poured paintings Liberman was working on at the same time.

Beginning with small cubes of Plasticine, a claylike material available in hobby shops, Liberman modeled geometric solids into generalized curves, leaving the blocky forms somewhat visible to suggest that the form was built. The modeled Plasticine was cast in bronze, and the bronze patinaed an uneven black. The traces of the artist's fingerprints, which are deliberately left visible, lend these small but powerful works a painterly touch. Liberman could proceed no further with the textural effects of the mottled rusty surfaces of his unpainted assemblage. In the small modeled bronzes, however, he found a more subtle and refined approach to surface. These works were translations of Liberman's familiar geometric shapes and curves, but they are executed in a more direct and intimately personal idiom that revealed more of the artist's involvement. Their theme, too, was more intimate: the religious image of devotion—altarlike symbols—that is the leitmotif of much of Liberman's art.

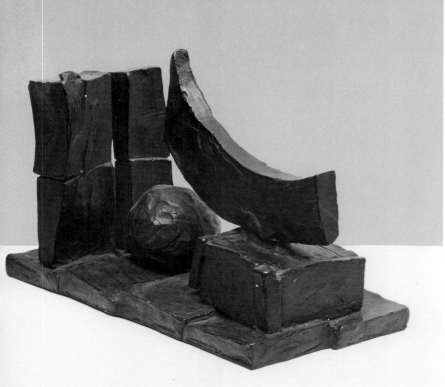

230

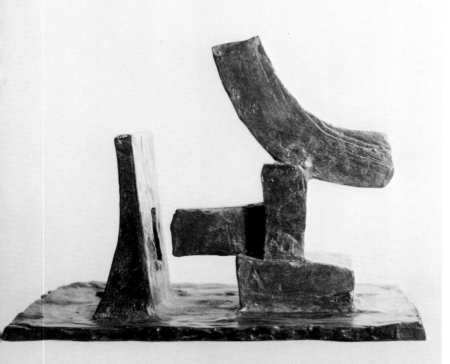

231

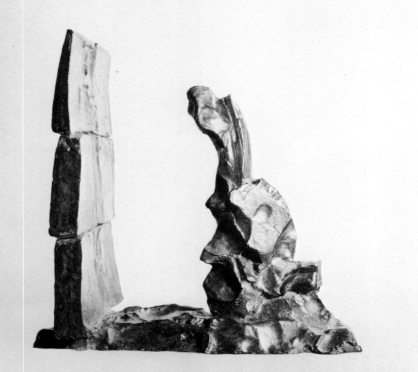

232

230. *Passage*, 1964
Bronze (edition of three), 7½ x 11½ x 5¾ in.
Collections Cast I: Mrs. Louise Smith;
Cast II: J. H. Hirshhorn: Cast III: the artist

231. *Opening*, 1964
Bronze (edition of three), 7¾ x 9 x 6 in.
Collection Mr. and Mrs. Cleve Gray

232. *Structure*, 1964
Bronze (edition of three), 9⅛ x 9¼ x 5½ in.
Collection Helen Frankenthaler

233. *Reach*, 1965
Bronze (edition of three), 11¾ x 14¼ x 9 in.

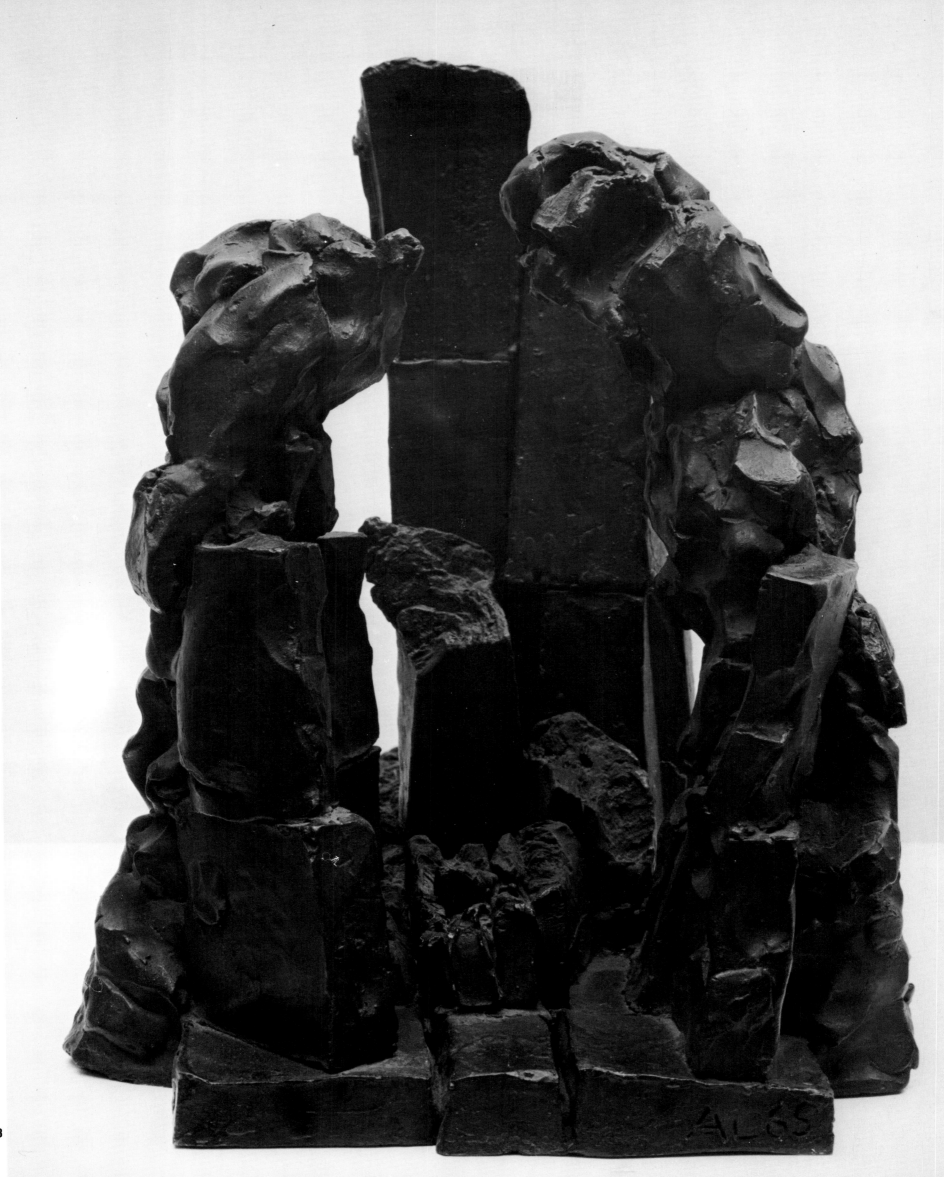

CHAPTER

ICON, TOTEM, TEMPLE

For me the real sculptor is Michelangelo. It's gesture in sculpture that interests me. In the Bernini, the dynamic action of St. Theresa is extraordinary. It's the gesture of Michelangelo's slaves, not the slaves themselves, that is emotionally moving. Sculpture is not static. Sculpture should inspire movement. Architecture is supposed to be frozen music, and I think sculpture can be frozen movement in many ways. The static doesn't interest me. Sculpture should invite movement, should invite penetration, should create a sort of a dynamic of life.

I realized that a gas tank was a column. It was the cheapest available scale material. In the days when I started, people would pay you to remove a gas tank. The earliest big sculptures I attempted in '61, '62, '63 were made of discarded gas tanks. I cut them up to get the shapes and the curves. I was still very much involved with the circle. I always come back to the circle.

I believe in a certain poverty of means that then forces the imagination or the desire to create, to really find solutions. And I think it is out of the discovery of solutions and from want or need of missing tools or elements that sometimes the most interesting things can happen.

I liked in Giacometti the mystery, the extraordinary, the attempt at the impossible—to make a wide face as narrow as possible, to make a body as thin as you could make it and still give a three-dimensional feeling. I think Giacometti is a great philosopher, he's like a monk meditating. He is very much like Godot—Beckett in a sense. All these staring three-quarter people coming out of the ground. This is terrible and tragic.

Artists in the religious periods and artists even in royal periods led much grander, more interesting civilized lives, and were treated with much greater respect. In Greece, where art was infused with a religious meaning, temples were built around a work of art because that work of art had a religious meaning. Progressively, with the merchant classes, art became more and more a decorative adjunct to a sybaritic life. I think art should be more vital to life—more as it was for the Greeks.

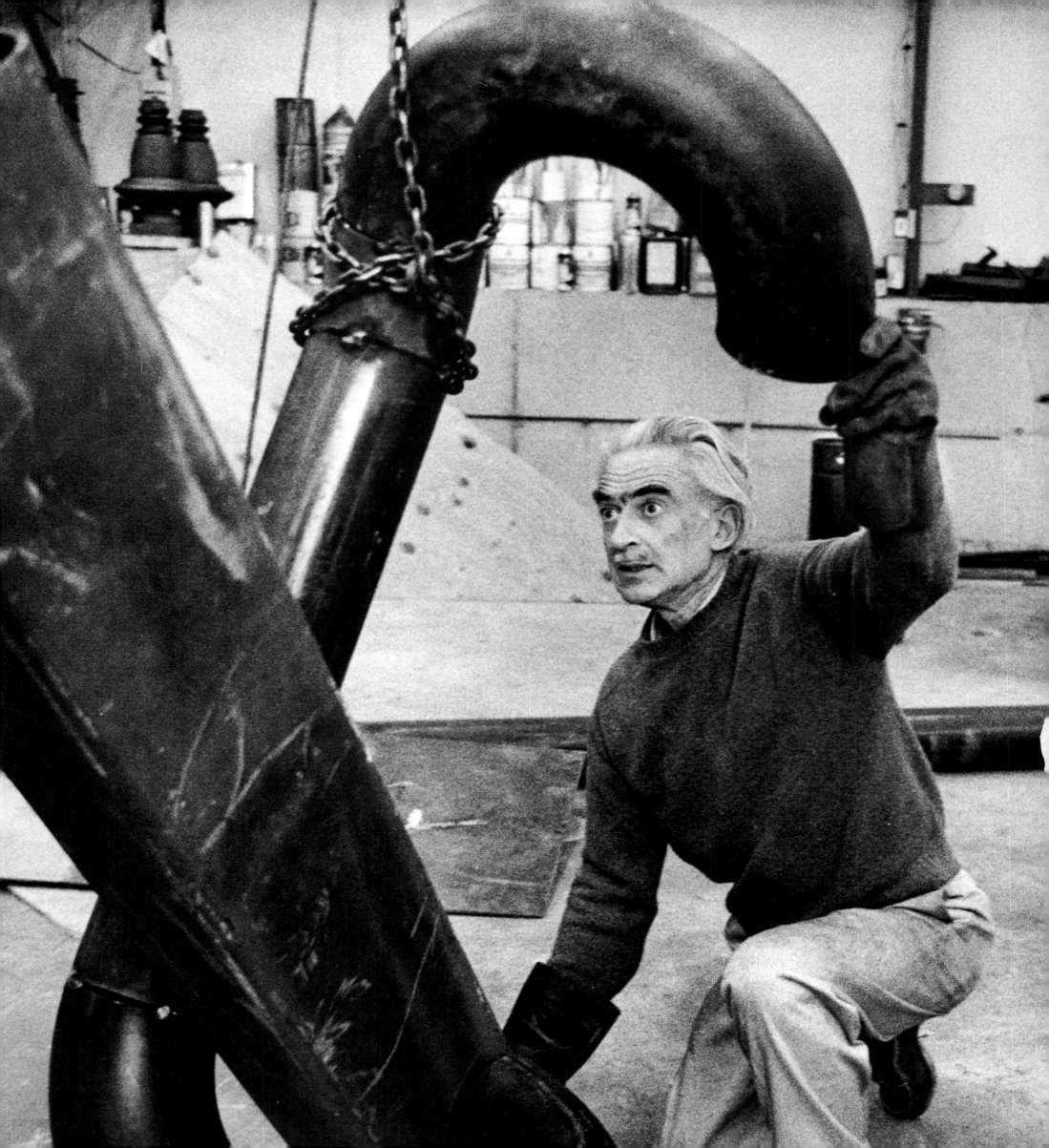

ONE OF THE FIRST metal pieces Liberman made when he learned how to weld in 1959 in France foreshadowed the structure of his large-scale sculptures. Like the circle paintings that began to press expansively against the frames of his paintings, this early assemblage explodes outward. Its central core, ringed by spiky projections that terminate in open circles, extends into the space beyond. (235) The center of the sculpture, like the bent metal sheets of the anodized aluminum "herms" of 1963, is thrust upward above a vertical rod, as branches top the trunk of a tree. This thrusting of mass upward and skyward, the gesture of defiance of gravity, links the buoyant imagery of Liberman's sculptures to that of his paintings.

Made up of curved sections welded together, Liberman's first assembled piece already grasps outward into space with aggressive projectiles. The conjunction of the triangle with the circle, the push outward and upward into space, the elevation of the central element, preview the direction of Liberman's sculptures in the Sixties and Seventies as he became master of a new medium. With old boilers as material and welding as a technique for joining parts of machinery or discarded metal into daring configurations, Liberman had at his disposal the means for working on a large scale. Through the ingenuity that always helped him survive, he contrived to outwit the limitations economics imposes on the contemporary sculptor. Liberman's pragmatism and inventiveness in resolving the problem of scale identified him now as a truly American artist.

---

*One has to be quick-witted to catch the accident. It happens to me many many times that I design a piece or draw it out, and I plan it to go in a certain position. Then when it's being picked up, I get a flash that the piece looks totally marvelous in a totally different way. You must quickly seize on that chance and place it in a totally unexpected position. Suddenly a link is created that you cannot envision beforehand. That's why I think the open mind, quick observation, are essential to my kind of work.*

---

234. Liberman, Warren studio, photographed by Inge Morath, 1967

**234**

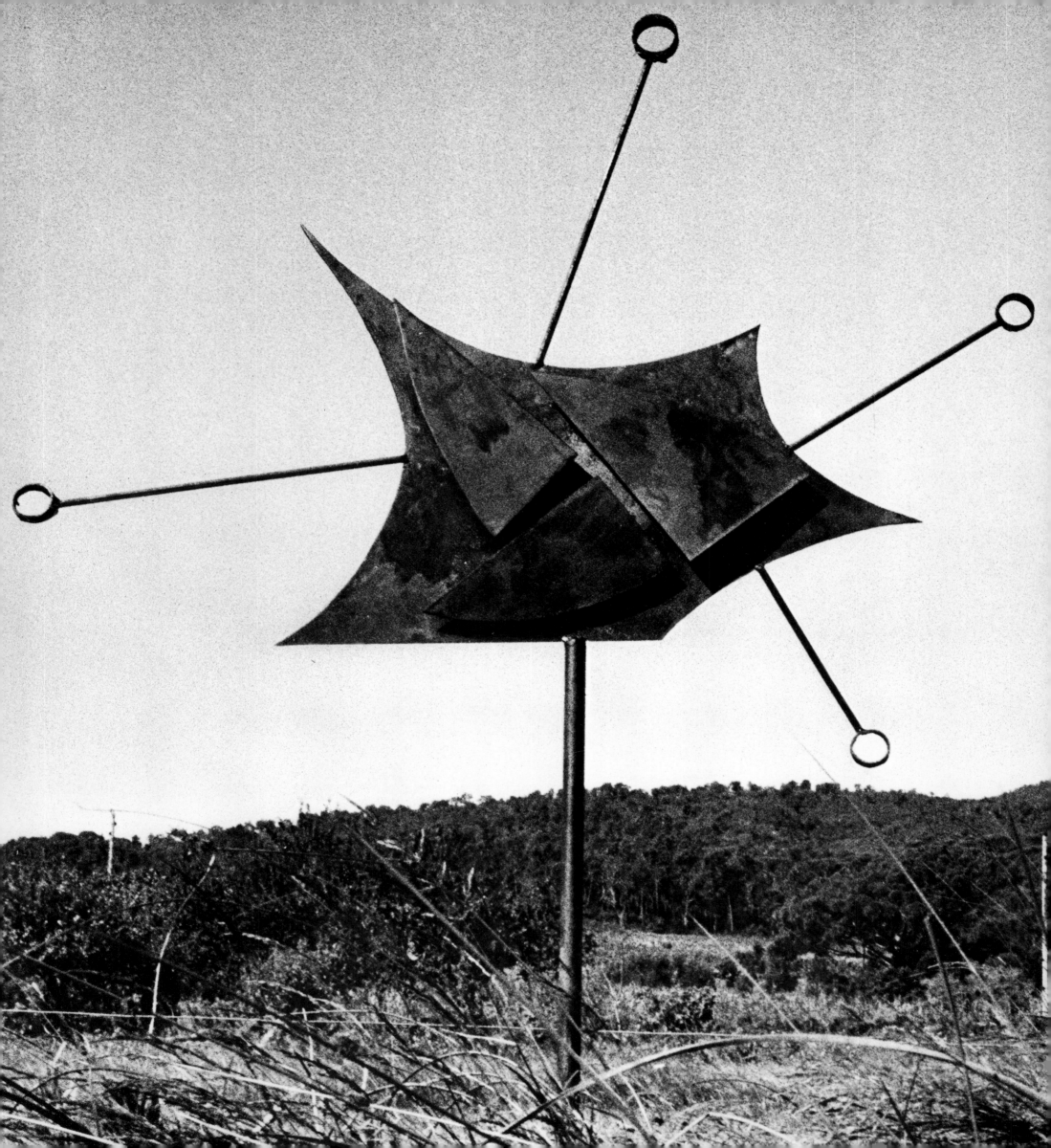

Observing that boilers were sometimes cut into longitudinal sections when they were stored as scrap, he began to work with long sections rather than circular slices of a cylinder in a series of bigger-than-life-size sculptures in the mid-Sixties. (236, 237) His thinking process began with a series of vertical maquettes made out of cardboard cylinders, which he sliced and embedded at angles into Plasticine. (203) The Plasticine was malleable enough to permit him to play with the angle of the elements jutting into space. Yet it was also strong enough to hold the cardboard upright. These maquettes were the working studies for *Temple I* (202) and *Temple II*. At first, Liberman worked alone, carving up the gas tanks he retrieved, which came in six-foot sections. However, he had always aspired to a larger-than-life scale. In 1963, Cleve Gray suggested that Liberman hire Bill Layman, a local road builder who owned some land and a shed nearby and who knew how to weld and how to operate a crane. Liberman began to work with Layman, who is still his assistant. In 1964, Liberman purchased a discarded truck with a rigging boom Layman found for $700. With this piece of equipment and Layman's help, he could lift heavier, larger tanks. He could also work with the whole tank. The possibility of turning the boiler on its end, fully upright, brought with it a new monumentality. Up-ended, the tank inevitably became a column. Although they were hollow, the tanks suggested an imposing volume. With the crane and new equipment, Liberman could now cut, weld, and assemble works that reached out into space, splicing through it or arching dramatically across it.

Inspired by di Suvero's baroque gestural style, Liberman started improvising on a larger and larger scale. He began filling the land around the shed with a black metal army. Some pieces suggested cannons with horizontal sections resembling wheels and vertical slices pressing forward like the snout. Others were like sentries. Still others suggested tanks and different kinds of heavy artillery. (240)

235. *Space Cut*, 1959
Welded steel, 96 x 66 x 6 in.

236. *Secret*, 1965
Painted, welded steel,
9 ft. 5 in. x 3 ft. 9 in. x 3½ ft.

235

236

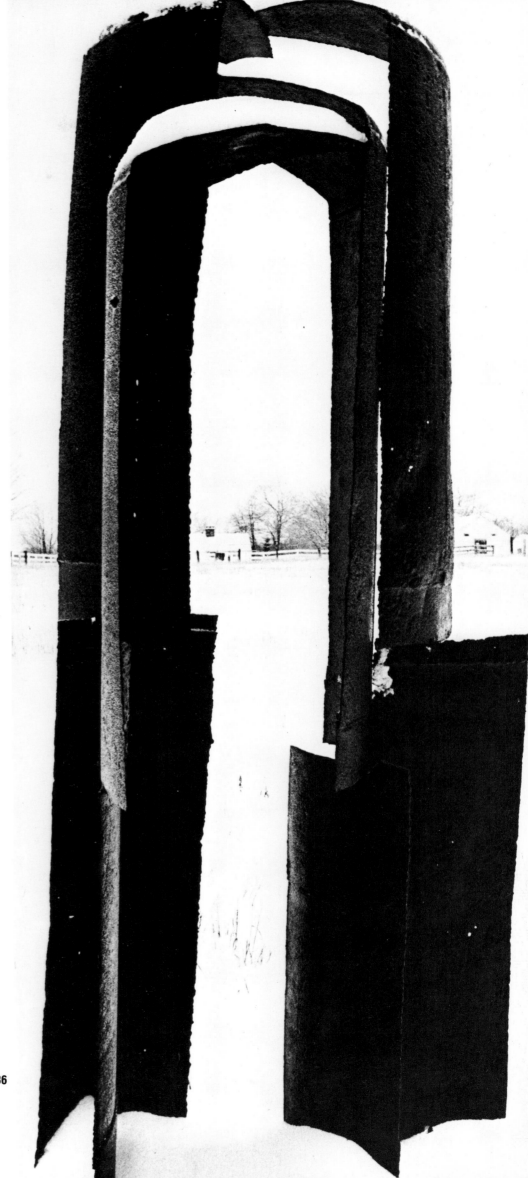

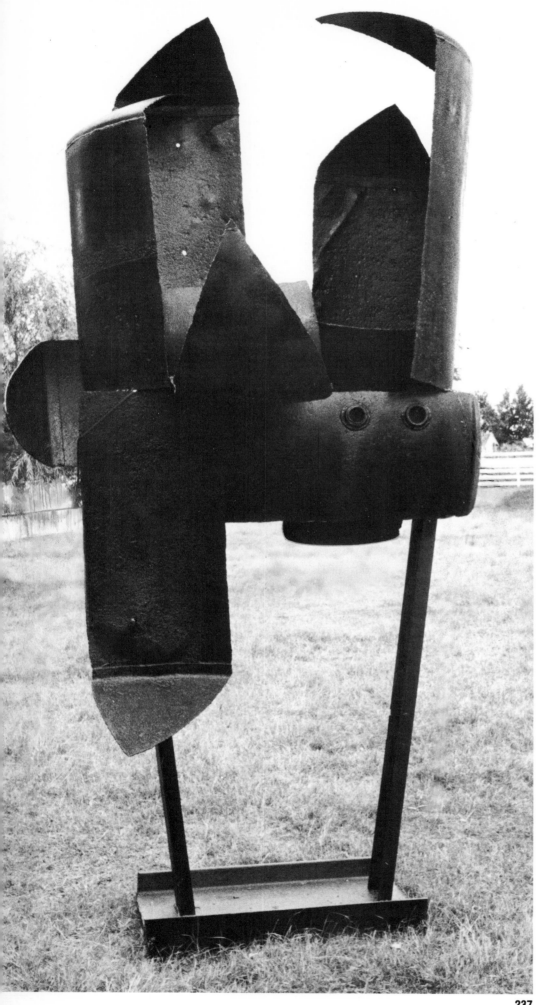

Between 1963 and 1966, Liberman expanded his vocabulary of form while continuing to use discarded boilers as well as flat metal pieces as material. The availability of the basic unit or module of the cylinder-column permitted him to improvise on a grand scale by slicing sections of the big cylinders with a torch. The result was two types of modular elements: the vertical curved section, which one critic thought looked like halved stringbeans, and horizontal loops, yet another version of the familiar circle, projected into the third dimension. The use of industrial modules, which became a staple of minimal art, was familiar to Liberman as a result of his architectural training with Perret, among the first to advocate modular construction. Unlike the minimalists, however, Liberman never used a standard industrial unit like an I-beam without transforming it. The element of metamorphosis is essential to his conception of art as a process of transfiguration, and not an imitation of either nature or industry. Once he has picked over the scrap heap and the factory yard, his mind focuses elsewhere, on form and metaphor. He gets a particular satisfaction, he admits, in finding a use for materials that was never intended. The double meaning of the industrial form rendered useless—if not unrecognizable—in art is an underlying irony in his sculpture, but because the identity of the found object is never emphasized, the irony does not become the subject of the work.

In the frontality and two-dimensionality of the anodized aluminum "herms," Liberman had been involved with metaphors for sentries or guardian figures. At the same time, he was making another series of hermlike figures. These were based on the sliced and pierced cylinders of boilers standing upright to their full height. Strictly vertical and of human scale, they were volumetric, not planar. This was an important departure and significant advance for Liberman as a sculptor. Unlike the aluminum "sentinels," the boiler-herms could not help but suggest totem figures. The first of these vertical totemlike guardian figures, such as *The Black Riddle*, were industrially fabricated in 1963, like the aluminum pieces at Treitel-Gratz. (*208*) By 1966, Liberman had given up the pierced but closed cylinder for the open forms of the more expansive and protective guardian images of *Ritual II* and *Tabernacle*. (*239*)

237

237. *Riddle I*, 1965
Painted, welded steel,
10 ft. x 5½ ft. x 5 ft. 8 in.

238. *End Free VIII*, 1965
Painted, welded steel, 86 x 60 x 33 in.

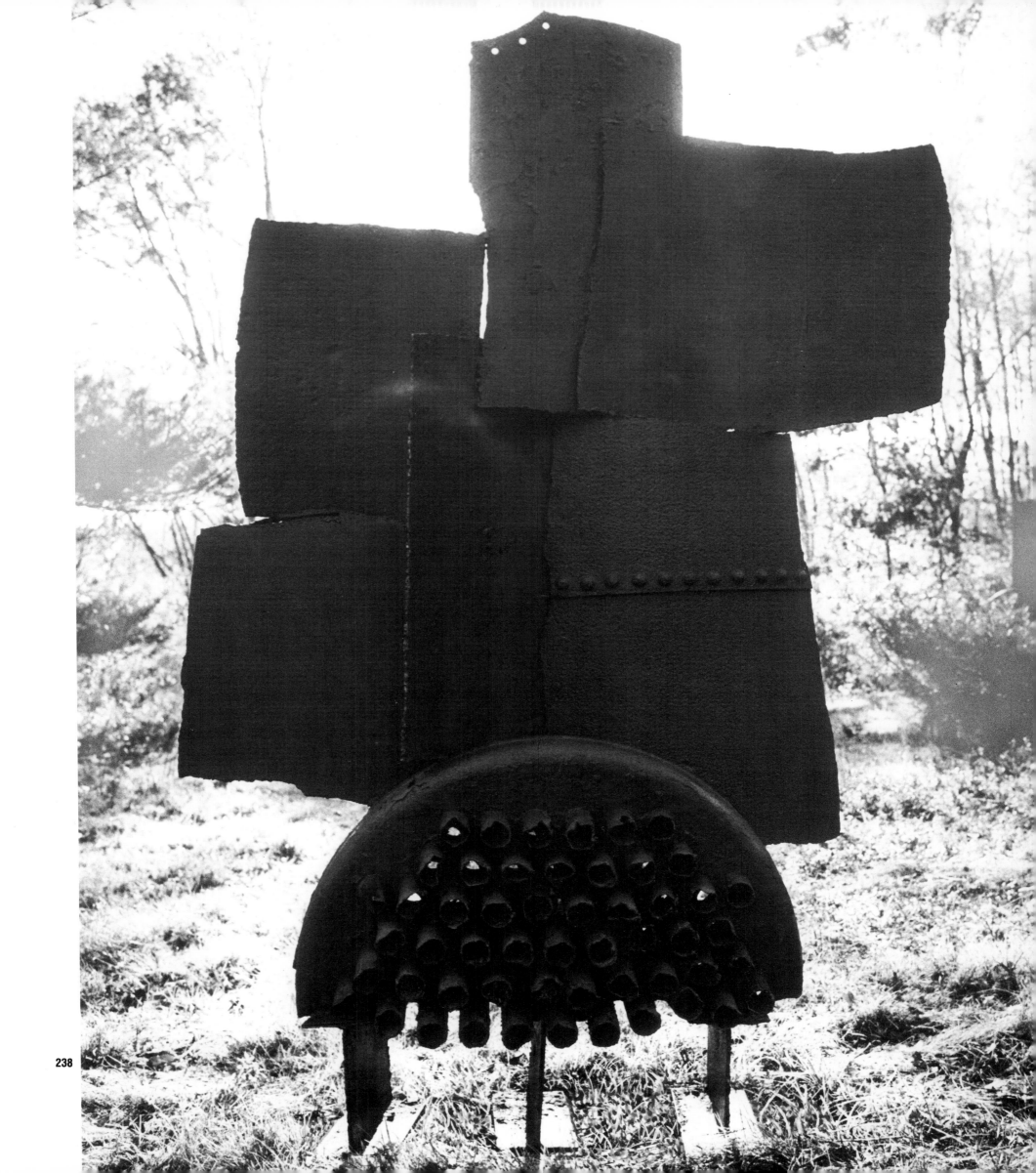

Between 1963 and 1966—years of rapid development—the space enclosed by the metal links and vertical slivers was a positive element, as important and active as the solid metal cutting through and embracing that space. This discovery of the active nature of the interior space became the central preoccupation of Liberman's work of 1966–67, a period of extraordinary growth, as he enlarged the physical scale and expressive potential in his works, reaching out into space with in-the-round sculpture, and mastering technical problems of structure involved with freestanding large-scale works. That the work should be autonomous of its context became a main focus of his energies as he evolved a more baroque and full conception of sculpture. This baroque conception implied that sculpture could become its own environmental context by subsuming certain architectural functions, permitting the viewer literally to enter it.

During this period, Liberman worked to resolve the problem of the base—by eliminating it. He saw it as a relic of the official pedestal that was the symbol of the authority of the leader seated (usually on horseback) high above the heads of the crowd. He wanted the monumentality, the power, and the public scale of great sculpture, but he did not want the emotional connotation of submission such work usually implied. In a large work like *Cardinal Points*, he sought to thrust forms into the air by cantilevering them, as the early modern buildings he had seen as an architectural student in Paris had been raised off the ground. (229) In his recent environmental sculptures this motif of cylindrical pillars thrusting forms up into the sky has been carried to new extremes of daring.

Rather than the cubist sculptors, Giacometti was Liberman's hero in modern sculpture. The series of totemic figures titled *Ritual* are related to both Giacometti's attenuated vertical standing figures and to Brancusi's erotic geometry. However, they remain essentially planar extensions of cubist assemblage, with its sharp silhouetting of shape and angles, despite their heightened concern with the displacement of space in the sculptural tradition.

The works that succeed the totemic-iconic closed forms of the black Ritual series become increasingly aggressive in their demands on space. Noticing that the exhaust pipes of different trucks and cars differed in shape and structure, in

239. *Tabernacle*, 1966
 Painted, welded steel, 12 x 5 x 5 ft.

240. *End Free IV*, 1965
 Painted, welded steel,
 8 ft. 7 in. x 9 ft. 7 in. x 5 ft. 4 in.

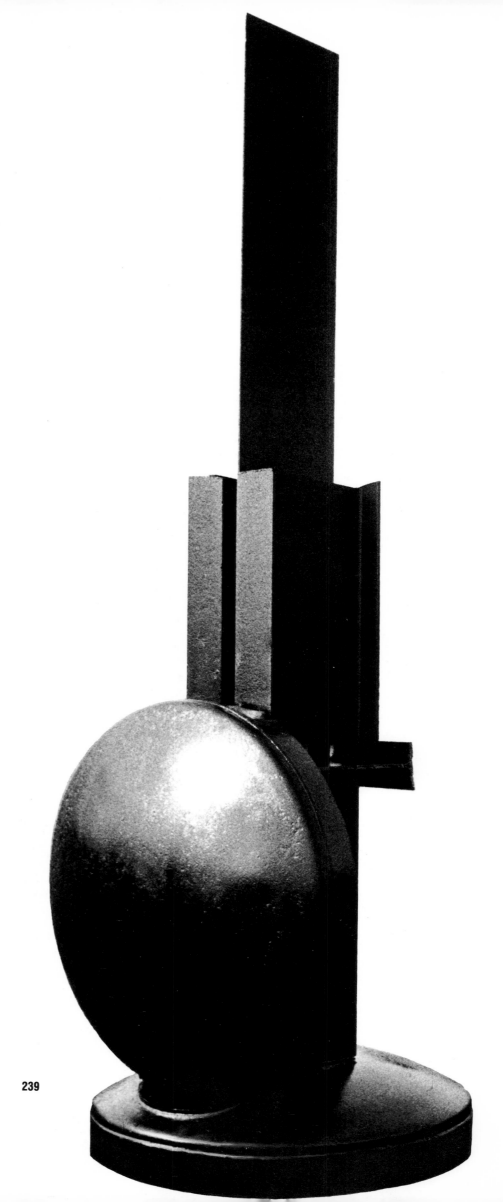

**239**

250

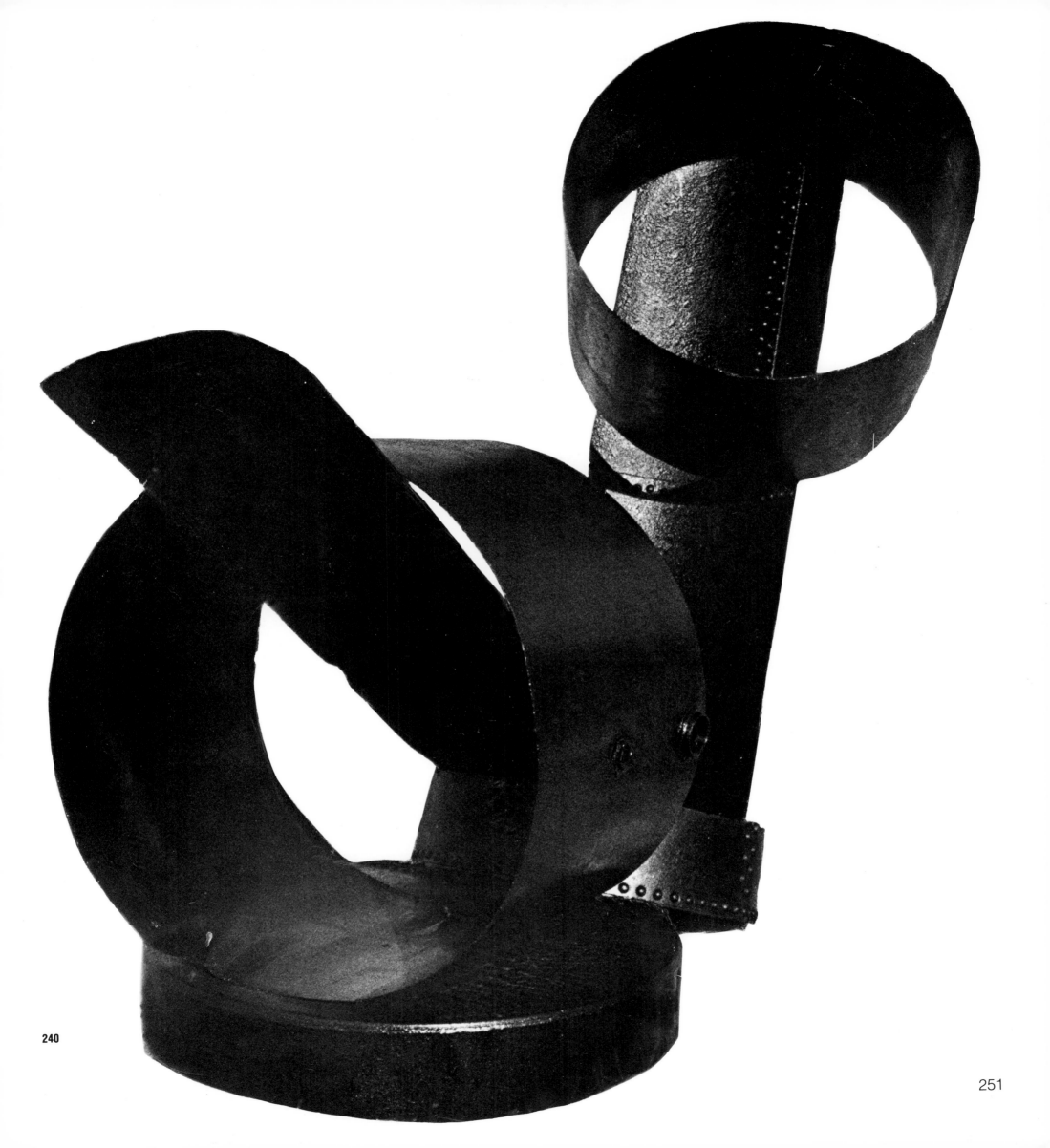

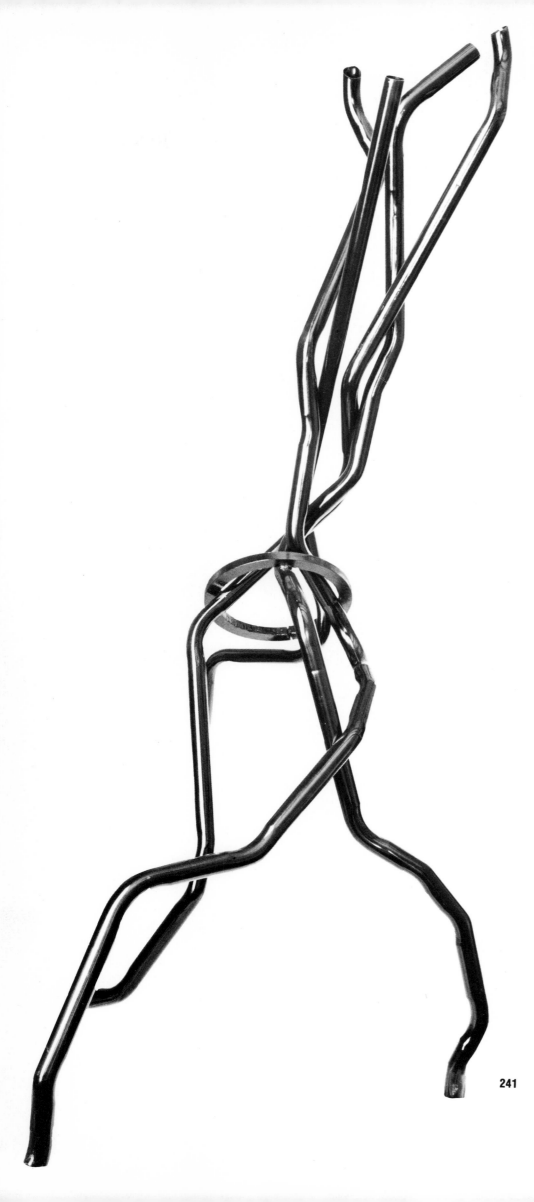

1967 Liberman began a series of linear sculptures, including works like *Knot, Gyre, Interference, Turning*. (*241, 226, 243, 244*) These works constituted a kind of abstract drawing in space. The idea of sculpture as drawing in space—a linear tracery animating space as a positive element—had been the basis of David Smith's surrealizing work of the Forties, such as *Hudson River Landscape*. Smith's works, however, have specific iconographic meanings. Since they were based on paintings and brush drawings on paper, they imitated the frontality of drawings on a page, and silhouette and contour took precedence over extension into space.

Liberman may have been influenced by these linear works of Smith's. However, by the time he started to draw in space with a variety of types of metal tubes and rods, which he twisted, bent, and sometimes further mangled in machine shops, his concept of space was more baroque than cubist. Chance was involved in this process also. Liberman and di Suvero, perhaps because they had spent so much time in Italy studying the contrapposto of Michelangelo and its extension into the baroque by Bernini, were virtually alone in their preoccupation with creating an in-the-round version of assemblage that was not tied to painting. This concept of sculpture reached back behind modernism to a more dramatic and commanding vision of sculpture as medium independent from both painting and architecture.

The first linear pieces were made with combinations of found objects—automobile exhausts, industrial pipes, and the circular ends of boilers sliced into discs. They reached outward from a core of cylindrical boilers or sections of cylinders sometimes diagonally angled to create an even more dynamic configuration. (*243*)

During the late Sixties, the reserved, enclosed totemic "herms" gave way to a series of works in which the sliced sections of boilers were coiled, sprung, and stretched into space in works like *Contact* and *Tabernacle*. (*239*) Later, in 1973 in *Icarus*, a diagonal form thrusts out beyond the rooted core in a gesture of aspiration. (*296*) Frontality, the silhouetted sign and vertical icon—hallmarks of Liberman's early purist style—were exchanged during this period for contrapposto and volumetric in-the-round sculpture. This traditional form of full three-dimensional sculpture has its roots not in painting, like the planar style that developed out of cubist classicism, but in an older tradition of sculptural

241. *Knot*, 1967
Painted, welded steel,
8 ft. 10 in. h. x 6 ft. 8 in. w.
Collection Mr. and Mrs.
Donald Newhouse, New York

242. *Trio*, 1967
Painted, welded steel,
13½ x 15 x 5 ft.

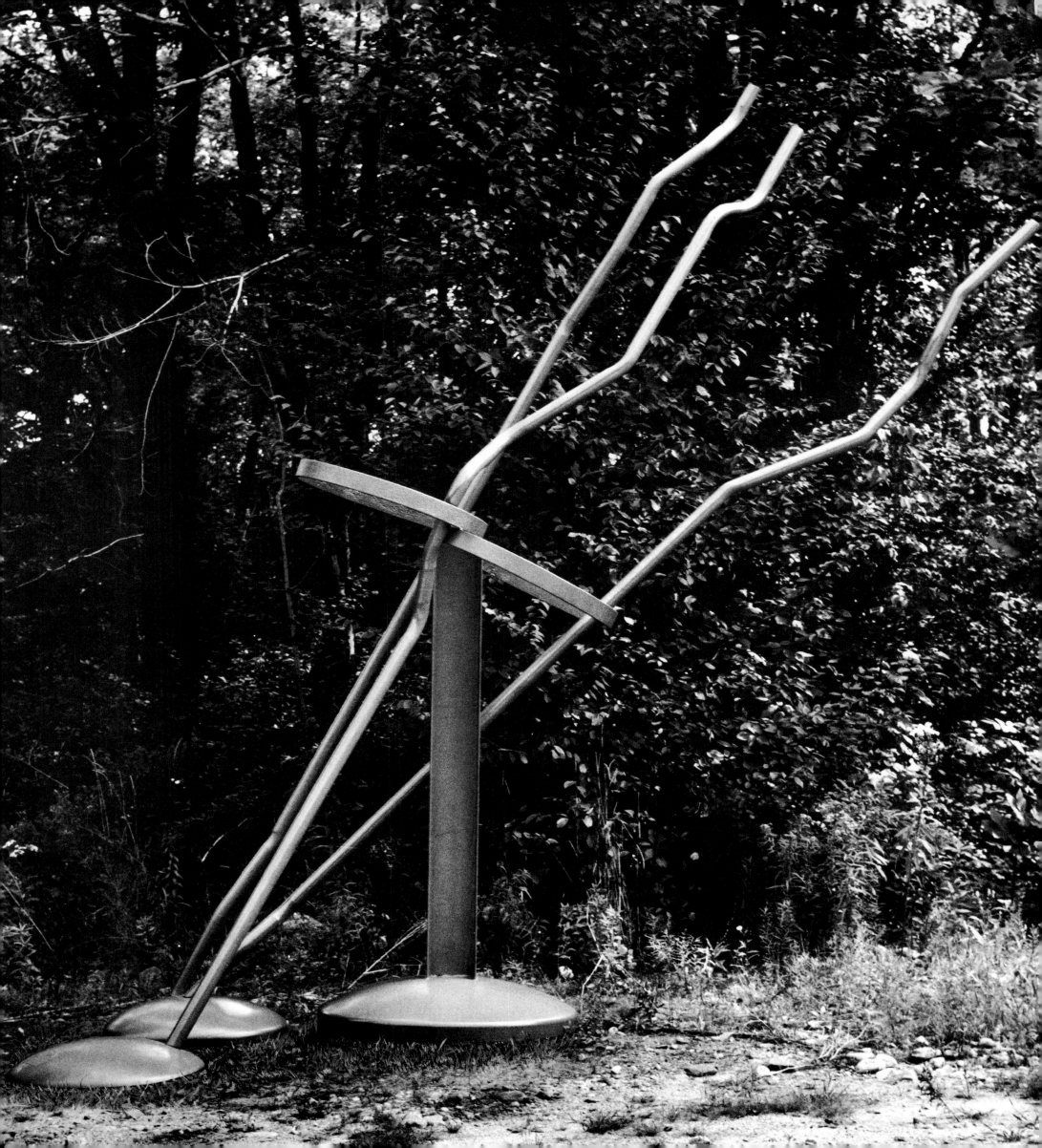

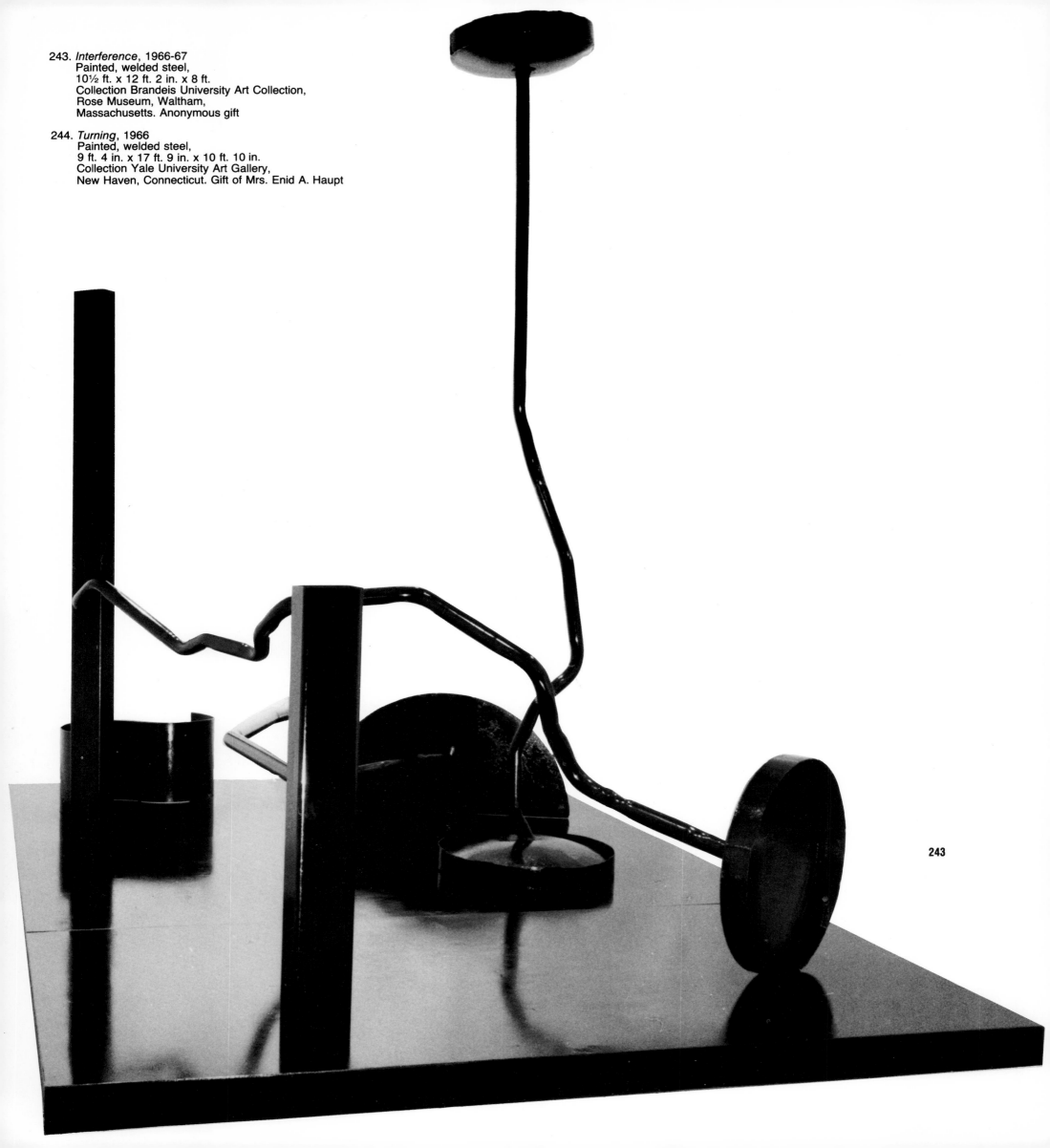

243. *Interference*, 1966-67
Painted, welded steel,
10½ ft. x 12 ft. 2 in. x 8 ft.
Collection Brandeis University Art Collection,
Rose Museum, Waltham,
Massachusetts. Anonymous gift

244. *Turning*, 1966
Painted, welded steel,
9 ft. 4 in. x 17 ft. 9 in. x 10 ft. 10 in.
Collection Yale University Art Gallery,
New Haven, Connecticut. Gift of Mrs. Enid A. Haupt

243

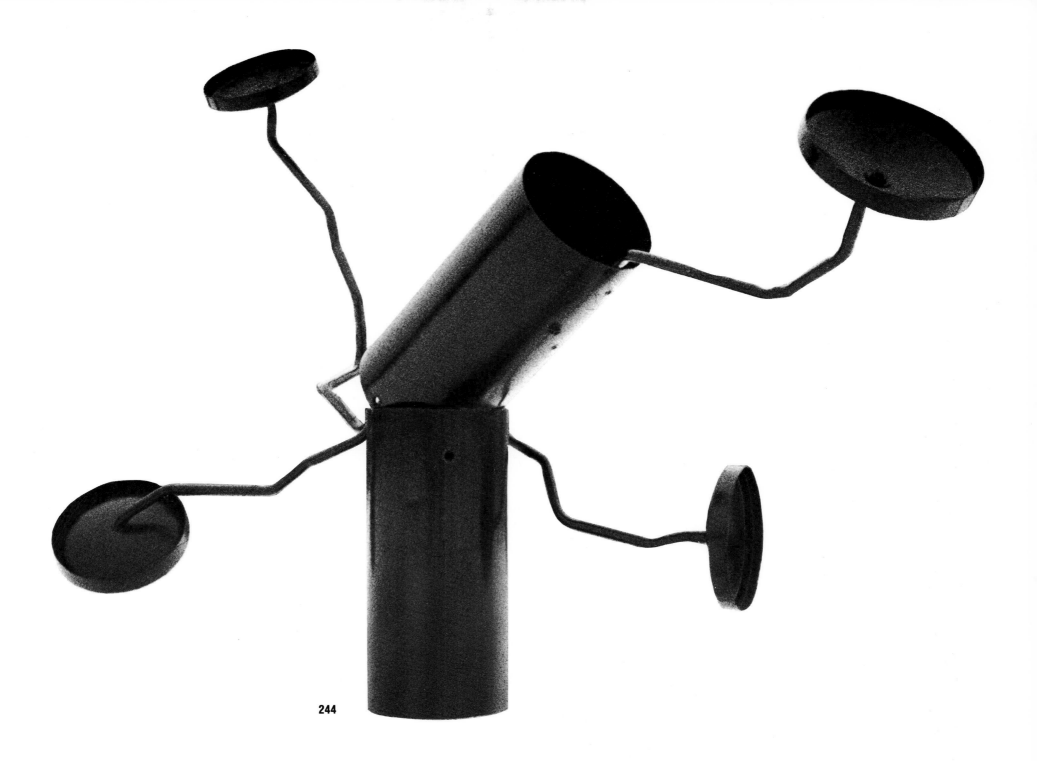

**244**

form that found its apogee in the baroque era, which stressed extravagance and dynamism as a means to capture the public eye. As he had looked back to Italian painting in his color-field abstractions, Liberman now began to study Renaissance and baroque sculpture and architecture during his annual visits to Europe. This reinforced his urge to produce outdoor work.

Liberman's impulse to work larger and larger was coupled by a growing awareness of sculpture as an expression of physical gesture into space, and of the psychological ramifications such extensions connoted. His study of Michelangelo's contracted bound slaves in the Louvre and of the concentrated imminence of the gesture of the hand of God pointing toward Adam's hand in the Sistine Chapel fresco (earlier he had interpreted the gesture of God to Adam in his painting *Light Given.*) focused his thinking on analyzing abstract gestures of reaching, embracing, and ascending as expressions not only of physical sensations, but also of intense inner emotional and spiritual states. He was also fascinated by the circular movement Michelangelo achieved. In 1967 Liberman began to combine linear elements with metal planes that were deliberately cut out rather than merely the found ends of tanks. *Alpha*, for example, combines a circle, a triangle, and a rectangular section with a looping linear element of tubing twisting and curving around through space until it crosses over itself. (*246*) The three solid planes are angled in space so that the viewer is forced to walk around the piece to experience it: there is no longer any question of a front or back or side view. Sculpture now has become a completely spatial experience.

Perhaps the most brilliant in this group of line and plane works, *Trace*, is also the simplest. (*245*) It consists of only two elements, a rectangular metal plate, and a looping linear element holding it in place, which Liberman made by welding pipes together and creating the eccentric curve he desired by turning the metal slowly in a hydraulic "pipe bender" by hand. *Trace* has an elegance and economy that is continued in the subsequent series of works Liberman made by taking curved sections of heavy industrial pipes, and reversing the curves by attaching sections at 45-degree angles to one another. Because their ends are sealed, the tubes appear solid, and so they contrast with the flat, transparent circular or rectangular forms they penetrate. (*249, 251*) The tubular structure has a vigorous muscularity and physicality distinguishing it from the passive element of the punctured plane. Curves reverse themselves so quickly they look as if they are coiled and ready to spring or snap. A disc is smashed against the wall in a surprising gesture. (*247*) This sense of imminence adds to the inherent drama of these works in which the mass of the thick tubing stands out against the open rectangle—a witty pun on the picture frame—and curve is paired against angle. (*248*)

By this time Liberman had stopped painting his sculpture black and had begun to use red paint to unify the disparate parts he collected, assembled, and transformed. His intention was to neutralize the former uses and unify the sculpture so that the eye would see the whole rather than focus on individual parts. It was probably inevitable that Liberman would identify his sculpture with the color red: The word for "red" in Russian, *krasnoe*, is the same as the word for

---

*I'm always intrigued with what's behind something. I always feel there's a wall, a mental wall, a physical wall; that the canvas, the blank canvas, is a wall. A sheet of paper is a wall for me, it's the first mystery. Life is surrounded with mysteries. Man's constant search is to find answers. It started with the Delphic oracle's interpretation of the unknown; then there was the penetration of telescopes into the space beyond. So this simple sheet of blank paper was a tangible reminder of the unknown: Any trace on that immaculate surface was in a way cutting through and penetrating the unknown. A wall suggests the invisible. How can you translate the invisible; how can you, in a visible medium, imply the invisible? You can do that only if art is a revelation.*

---

245. *Trace*, 1967
Varnished, welded steel,
8 ft. 2 in. x 6 ft. x 22 ft. 7 in.

**245**

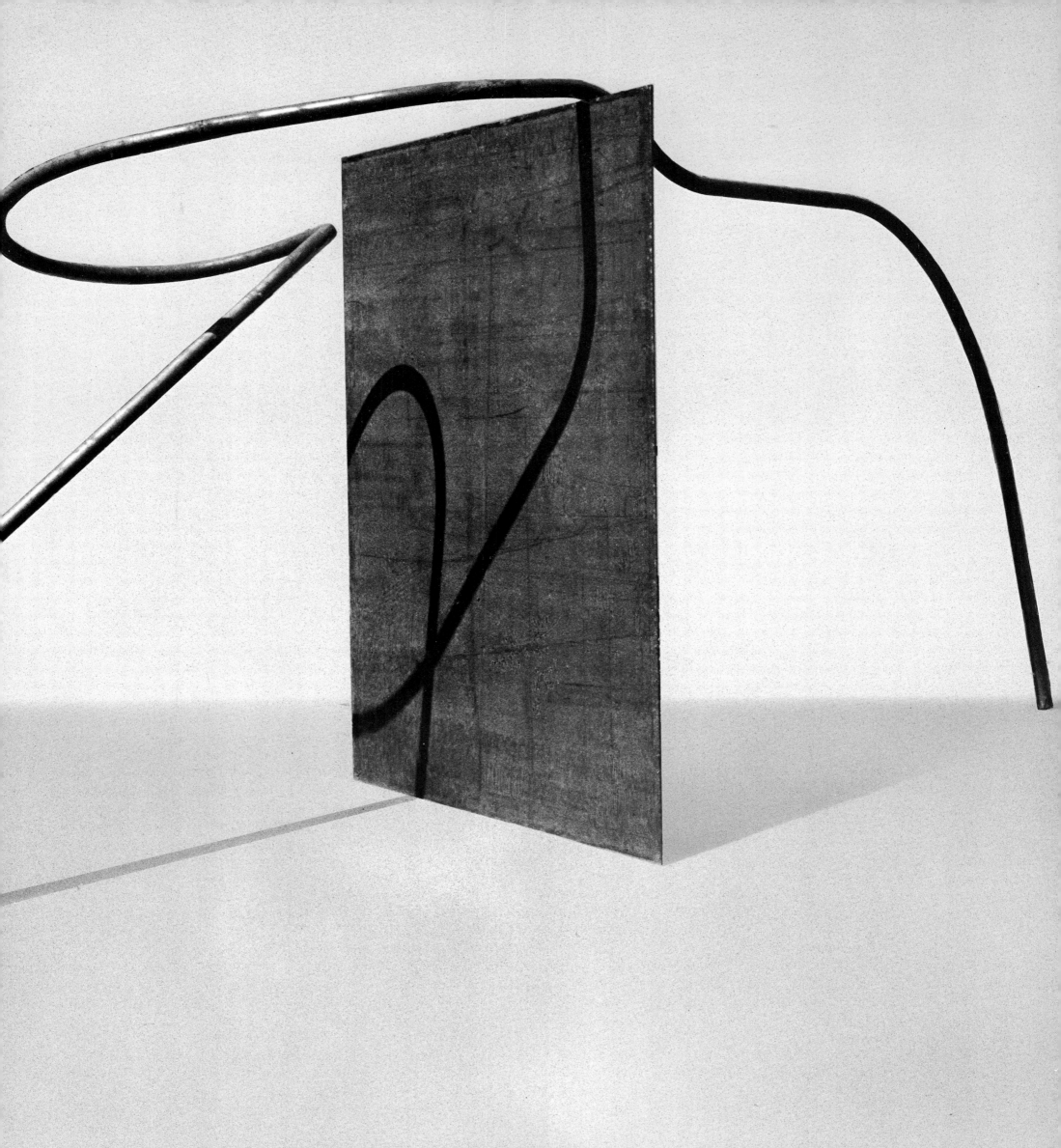

"beautiful." Moreover, red is the international signal for "stop," and Liberman, who had always been interested in signals, signs, and semaphores, wished to communicate with the color red the command "stop-and-look."

As Liberman enlarged his scale, the problem of keeping heavy metal members standing upright without a base became increasingly complex and problematic. He invented a number of unique solutions to the problem of balancing large works, relying on his training in architectural engineering. One of the means he found to anchor planes and volumes in space was to imbed them in low horizontal platforms. The platform was first used in a large-scale work in *Alpha*. Here the eight-foot-high circle and triangle each occupy a kind of metal island. The two islands are related by the encircling whiplash of twenty-four feet of metal tubing, which orbits them, activating the space around Liberman's two favorite shapes. The idea for the platform was suggested by the wooden rafts he puts under his sculpture to prevent them from sinking into the muddy ground while he works on them in bad weather.

Platforms isolate and carry the weight of the bronze and mixed metal elements in the series of "sacred precincts," which continue the devotional-shrine theme. (*255, 271, 272*) They are also used in large-scale works like *All*, a polished aluminum sculpture of tubes of different sizes, which rises from a basin of water in a circular platform that echoes its cylindrical module. The analogy between the platform and a stage set is obvious. The platform pieces tend to have dispersed, vertical elements or geometric shapes reminiscent of the constructivist stage sets Liberman knew so well as a child. He has also invented other kinds of balance that permit works to sit directly on the floor. A series of works pair plump, curving tube sections, tensely contorted by a rotation in different directions, with flat discs or pierced rectangles. These works are ingeniously balanced by weighting the bottom of the hollow pipe sections with lead. (*249, 251*) Some of the most imposing of Liberman's solutions to the problem of eliminating the base are found in *Contact* and *Taber-*

*nacle*. (*239*) Like *Trace*, which rests on the two ends of a bent pipe with the grace of a ballerina *en pointe*, these works are engineered to distribute their weight so evenly that the rounded, tubular element rests directly on the ground, requiring no further support. In later works such as *Icarus*, where extreme cantilevering is used, part of the piece is buried in the ground, and a complex network of underground buttressing holds it in place. (*296*) Finally, in the environmental sculptures of the Seventies, tanks are used vertically like columns to support the load of the piece.

That monumental sculpture was a kind of public stop sign became an increasing preoccupation for Liberman in the late Sixties, as the possibility of placing sculpture in public sites in America became an actuality. Only a handful of his works had been commissioned, so the idea of public sculpture had to arise from Liberman's own commitment to that ideal. Later, large-scale works he made for himself were bought for public places, which is where he hoped they would be placed. The larger-than-life size of his works of the late Sixties clearly identifies them as public sculpture. Works like *Tropic* (*291*) and *Arc* (*266*) turn thick industrial tubing into monumental arches and portals, architectural elements that embrace and enclose planes and discs in stable structures. This moment of relative repose, however, would soon pass.

In 1969, Liberman began to experiment with the destruction of form—an idea he was involved with in his painting at the same time. The means he chose to introduce a new element of the accidental and the unexpected into his sculpture were typically radical. The crushed elements in works like *Ascent* (*289*) and *Unfold* were created by dynamiting tanks and rolling over them with bulldozers. The violence implied in such acts is analogous to the vehement gestural style his paintings were taking on. Another work of the same period, *Logos*, suggests the aggressive forward thrust of the bulldozer itself. (*290*)

Liberman got the idea for dynamiting metal by reading about experiments in California with dynamiting underwater. The dynamite explosions turned Bill Layman's field into a

246. *Alpha*, 1967
Painted, welded steel,
10 ft. 3 in. x 11 ft. 7 in. x 18 ft. 7 in.
Collection Mrs. Alexander Liberman

FOLLOWING PAGES

247. *Thrust*, 1967
Varnished, welded steel,

Collection Whitney Museum
of American Art, New York.
Gift of Mr. and Mrs. Edouard Cournand

248. *Toll*, 1967
Varnished, welded steel, 60 x 85 x 48 in.
Private collection

**246**

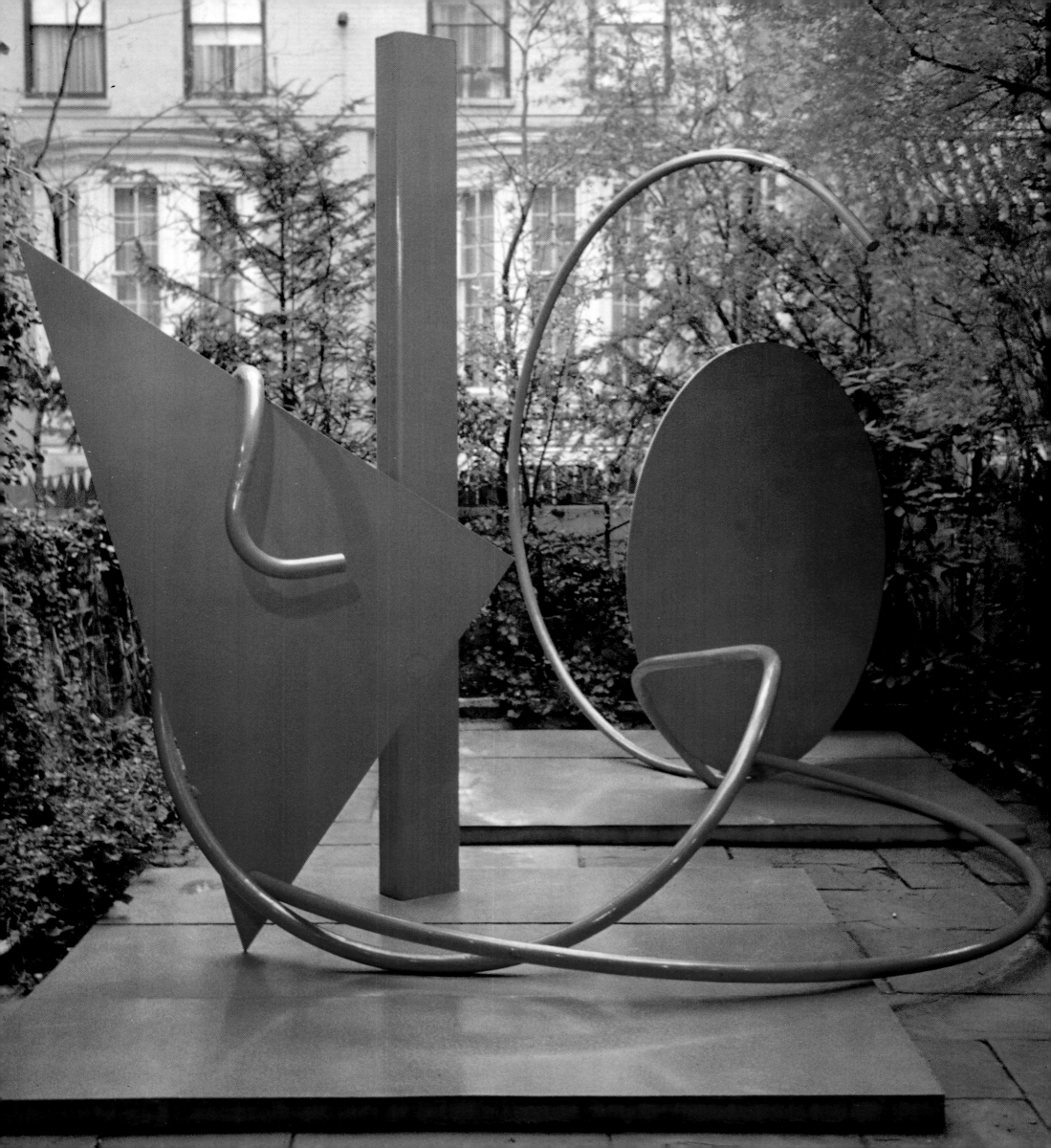

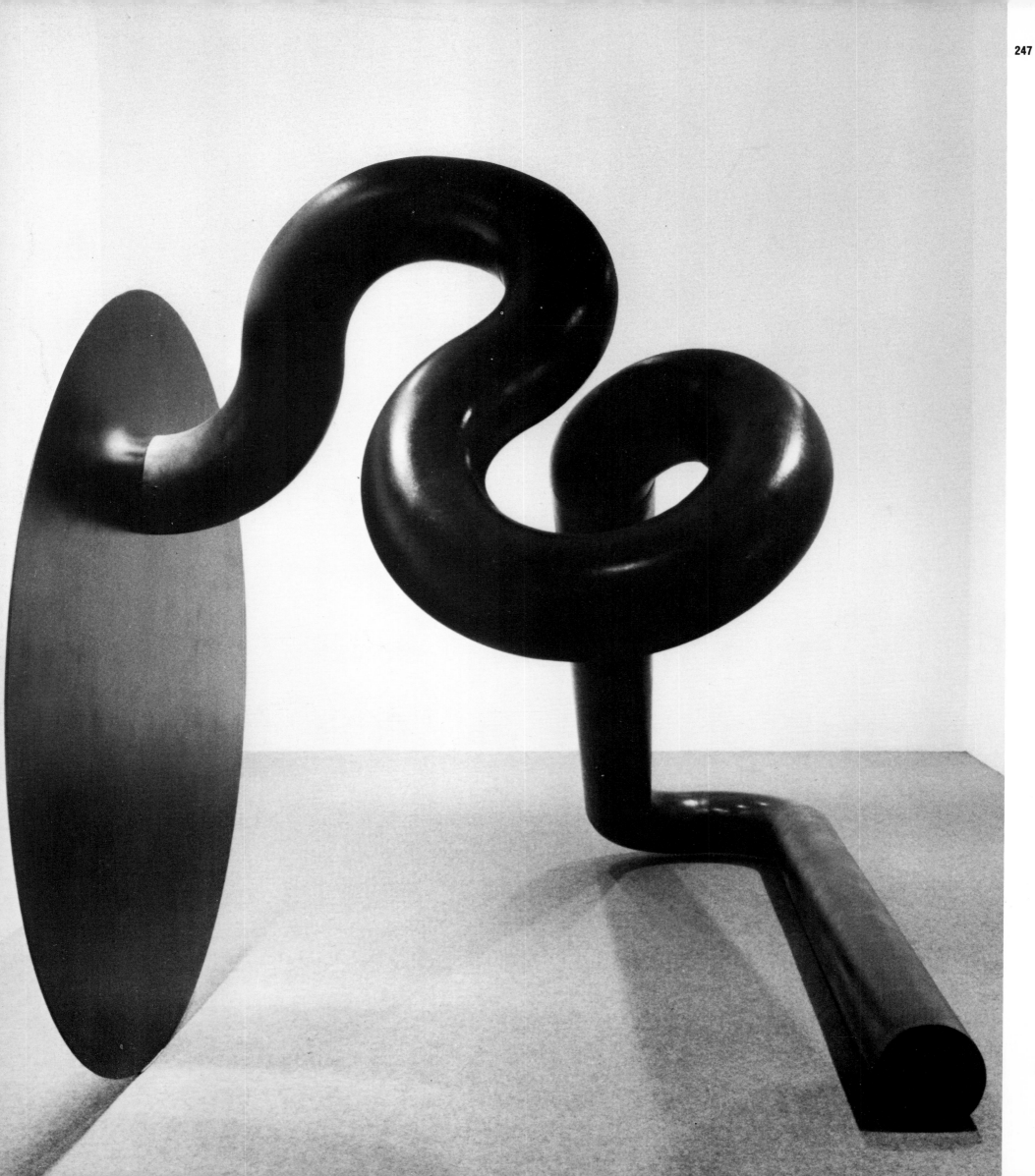

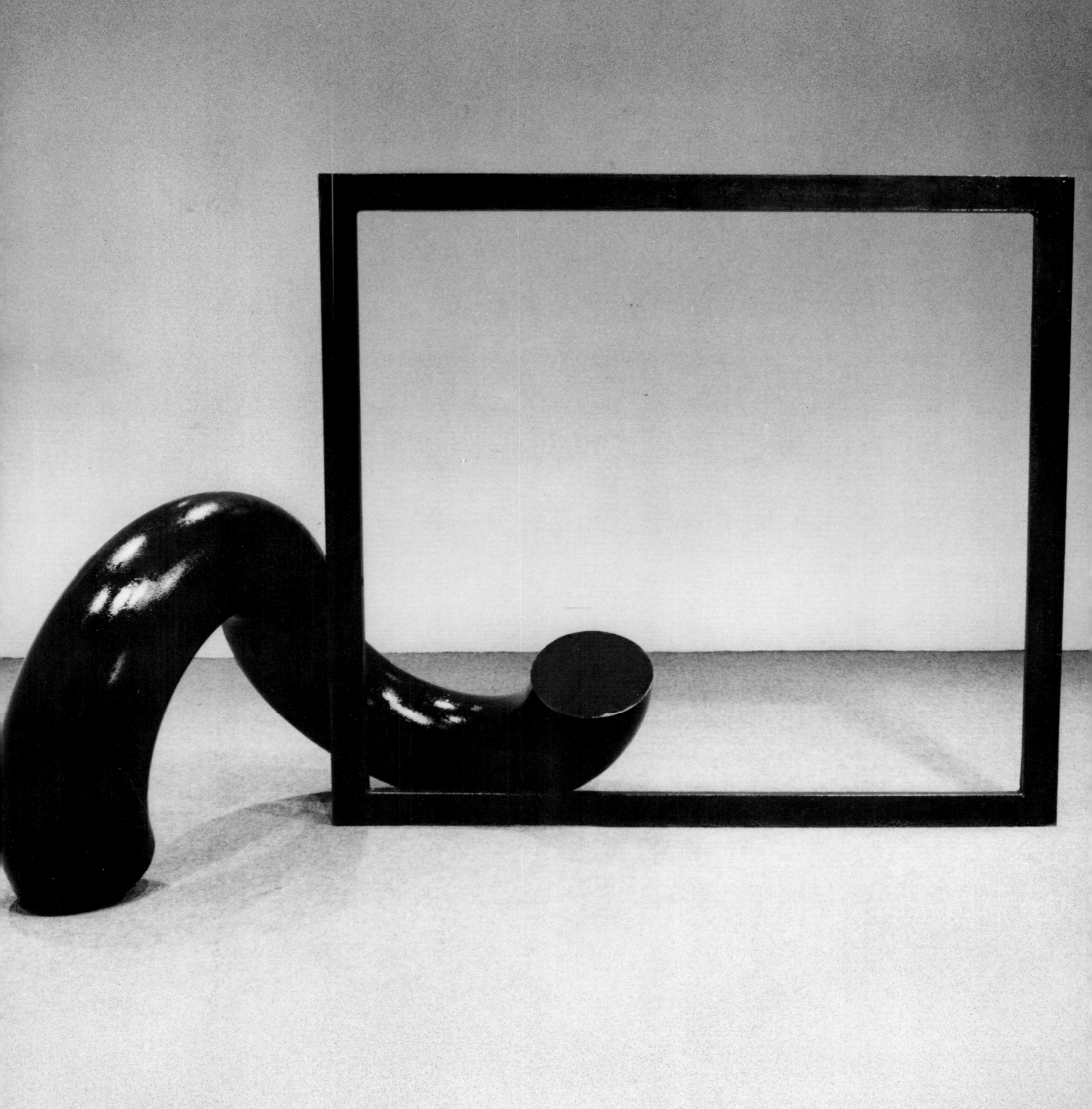

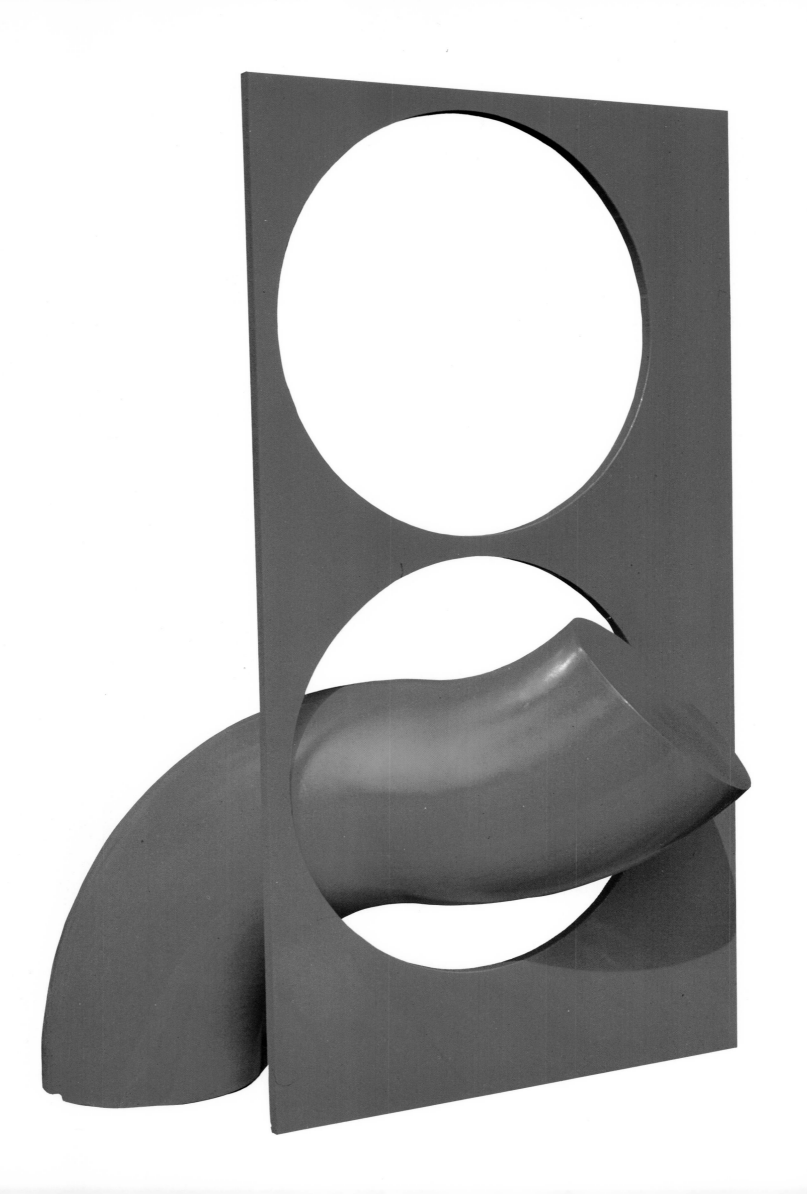

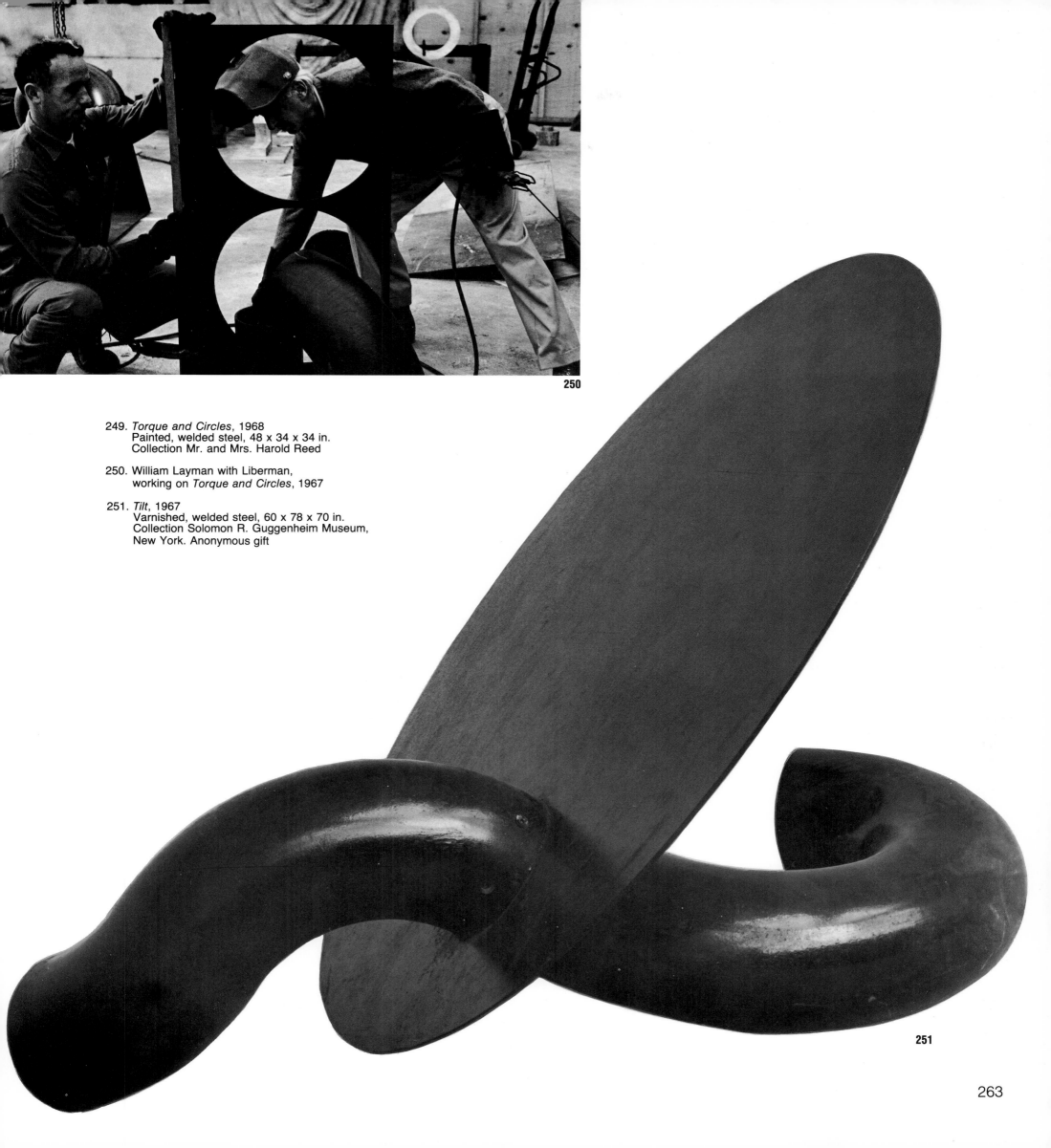

249. *Torque and Circles*, 1968
Painted, welded steel, 48 x 34 x 34 in.
Collection Mr. and Mrs. Harold Reed

250. William Layman with Liberman,
working on *Torque and Circles*, 1967

251. *Tilt*, 1967
Varnished, welded steel, 60 x 78 x 70 in.
Collection Solomon R. Guggenheim Museum,
New York. Anonymous gift

**250**

**251**

263

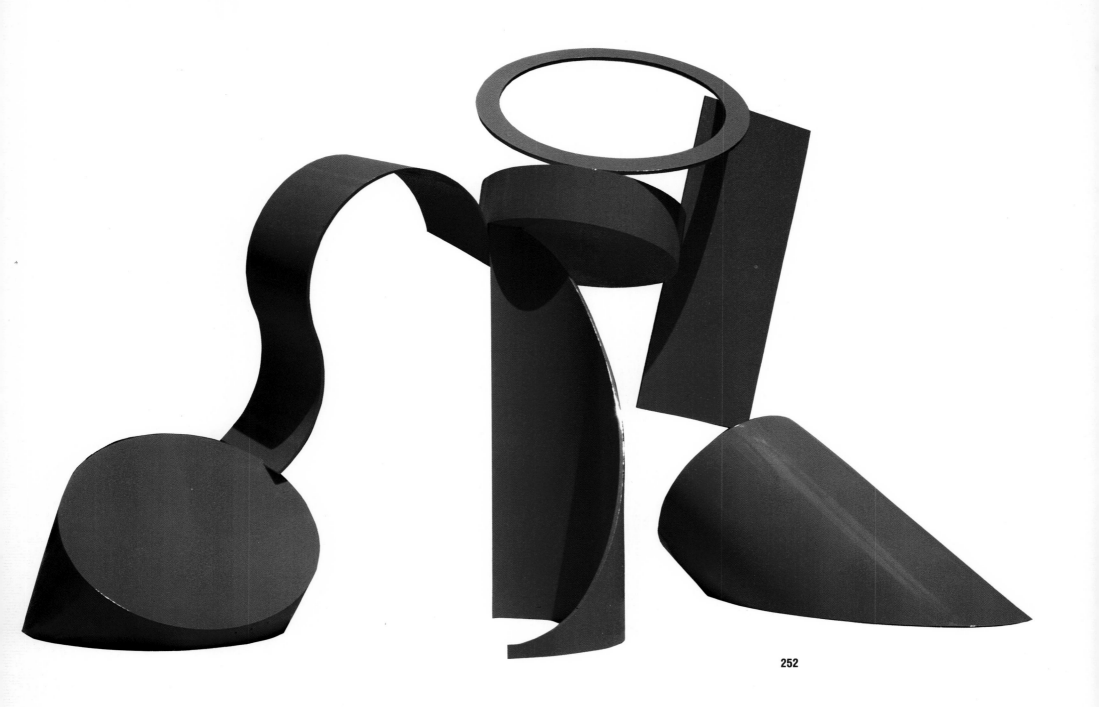

**252**

I admire an enormous number of artists, because I find it's thrilling to see what the human mind can do. All the things that I have not been able to do. To see that they are done. Matisse said, and I love that saying: "I will never be so insincere as to not work through my admirations." I think it's a marvelous statement. You take people like di Suvero, Serra, Heizer, Smithson, all these people who do things that, if I had three lives, four lives, I would like to have done in different ways. I like the grand scale in art in general.

252. *Turn*, 1971-81
Painted, welded steel,
11 ft. 10 in. x 17 ft. x 8 ft. 5 in.
Collection Museo Rufino Tamayo,
Mexico City

253. *Icon II*, 1972
Painted, welded steel,
10 ft. x 10 ft. x 8 ft. 8 in.
Collection Leon Stone,
Travelodge, Tampa, Florida

**253**

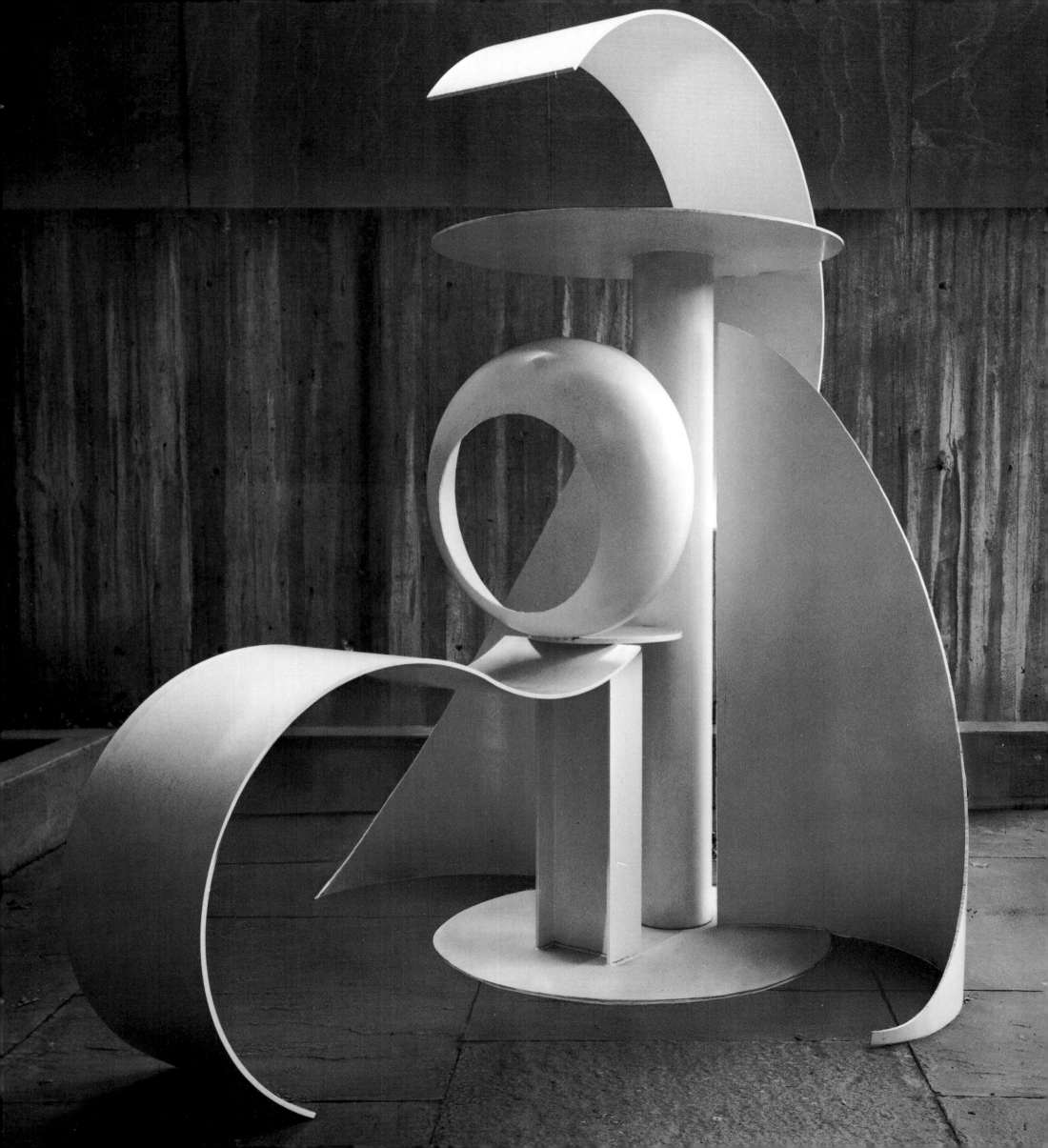

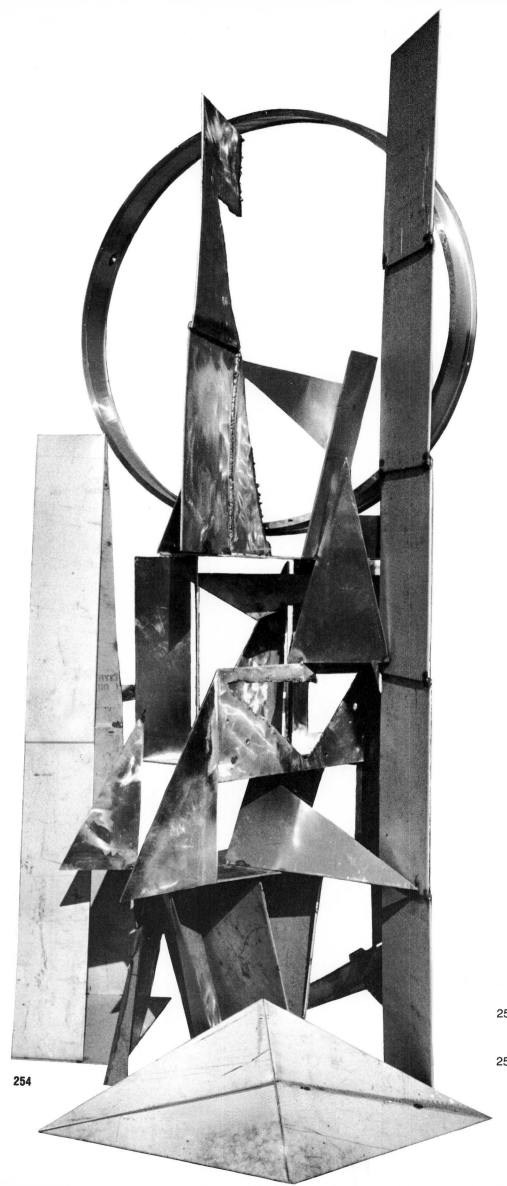

**254**

254. *Totem II*, 1975
Welded stainless steel,
10 ft. 2 in. x 4½ ft. x 5 ft.

255. *Sacred Precinct IV*, 1973-74
Painted and varnished steel and bronze,
72 x 37 x 37 in.

266

In sculpture I very often feel that a work should have a certain internal unity. I feel that if a certain object—let's say a circle cut in half—were placed in a certain area of a sculpture, I had to repeat that circle cut in half in other parts of the sculpture, so that there would be something like an emotional closure, like a sonnet. I was very interested in the systems of sonnets.

**255**

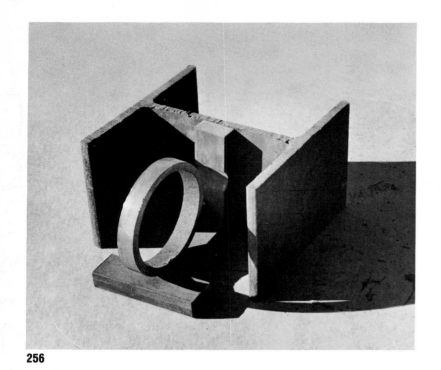

256

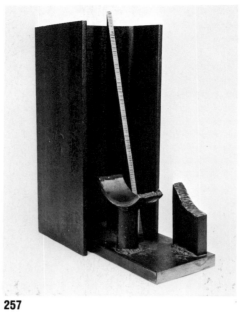

257

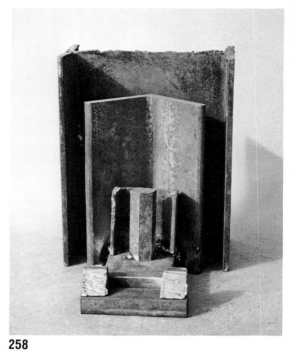

258

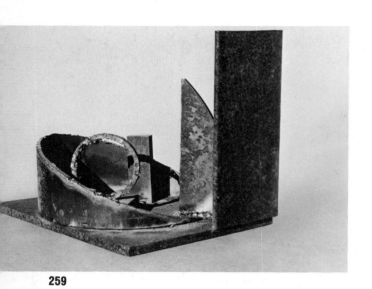

259

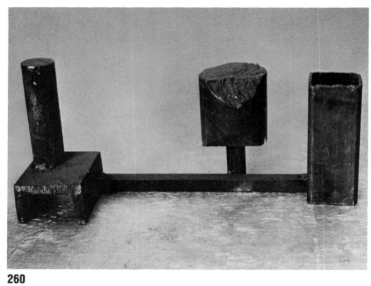

260

261

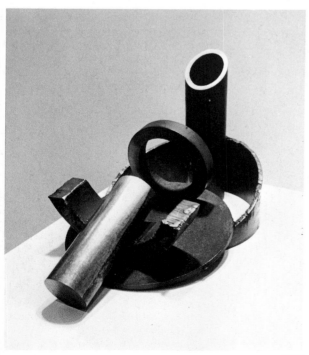

262

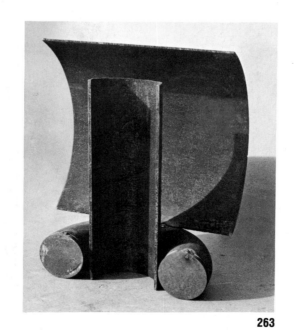

263

256-263. Votive series, 1970-73
Varnished, welded steel,
maximum size, approx. 24 in. h.

264. *Anew*, 1971
Painted, welded steel,
20 x 15 x 21 in.

264

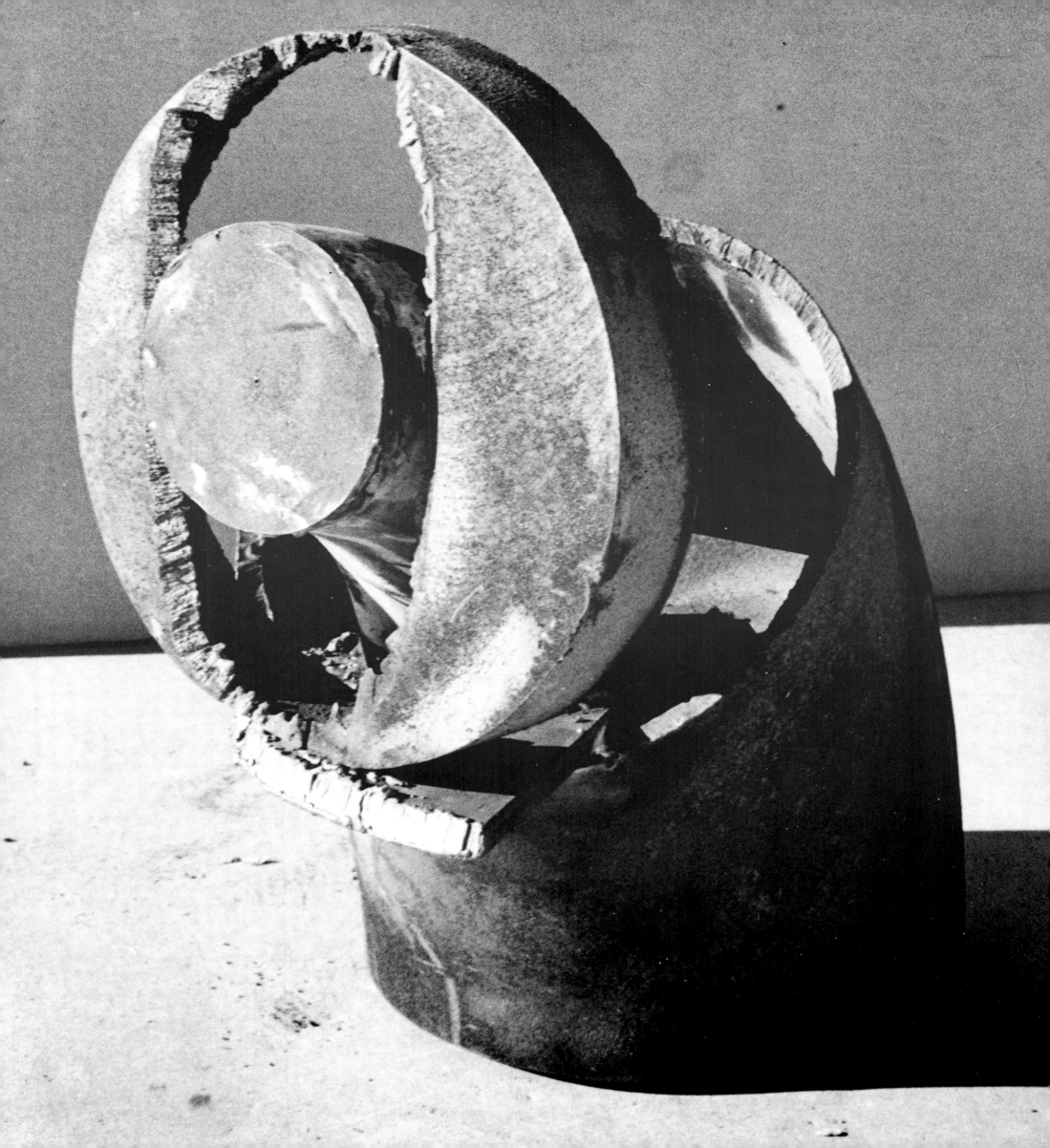

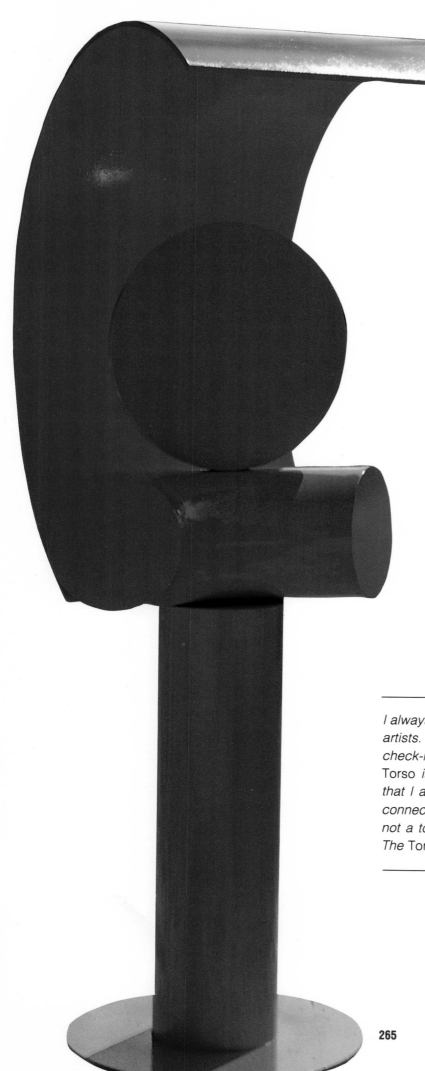

miniature battleground. In Connecticut, dynamite is always handy because of the need to blow up rocks to dig a well or build a road. Liberman asked a workman to put a stick of dynamite inside one of his tanks. The tops flew off, the yard was filled with metal fragments and smoke, and the fire department was called. Liberman was delighted with the crushed pieces of metal that were the result of this tremendous impact, and he used them in a number of sculptures in the late Sixties.

Other works of the late Sixties pick up themes related to the religious temple-shrine-altar-icon cycle that has continued to hold Liberman's interest. A work like *Icon I*, for example, refers to the sheltering shrine. (265) In *Icon II*, the embracing circle suggests a bowing head and the attitude of devotion. (253) The altarlike pillar and disc on which the offering—an open circle—rests also connotes an attitude of worship reminiscent of the small sanctuaries that Liberman had modeled and cast in bronze in 1963.

Although he believed bronze was the noblest medium for sculpture, Liberman could not afford to work in bronze on a large scale. In 1973, however, he found by accident a way of working in bronze that he could more or less afford. At the Torrington Metal Works in Torrington, Connecticut, a town near Warren where the Libermans bought a house in 1968, Liberman had begun to cast, cut, and fabricate additional solid elements, such as I-beams, that were needed for his sculpture. On one of these trips, he and Bill Layman visited Mr. Pusinski, an old man who cast small aluminum waffle makers; Cleve Gray had located him to help him cast his own sculpture. Liberman was fascinated that Pusinski cast in sand; it means that the objects he cast had an unpredictable texture, something that objects cast in lost wax—the conven-

---

*I always felt that Newman's line check-mated a lot of artists. I think Brancusi's endless column probably check-mated a lot of endless columns, too. Brancusi's* Torso *is a cylinder. I think even the cylinder tanks that I am working with now are somehow basically connected to* Torso. *Of course, Brancusi's* Torso *is not a torso. All Brancusi's work basically is phallic. The* Torso *is a phallic symbol.*

---

**265**

265. *Icon I*, 1969
    Painted, welded steel, 81 x 31 x 36 in.
    Collection Mr. and Mrs. Arthur Cohen, New York

266. *Arc*, 1968
    Painted, welded steel, 9¼ x 12¼ x 9 ft.
    Collection Robert Scull, New York

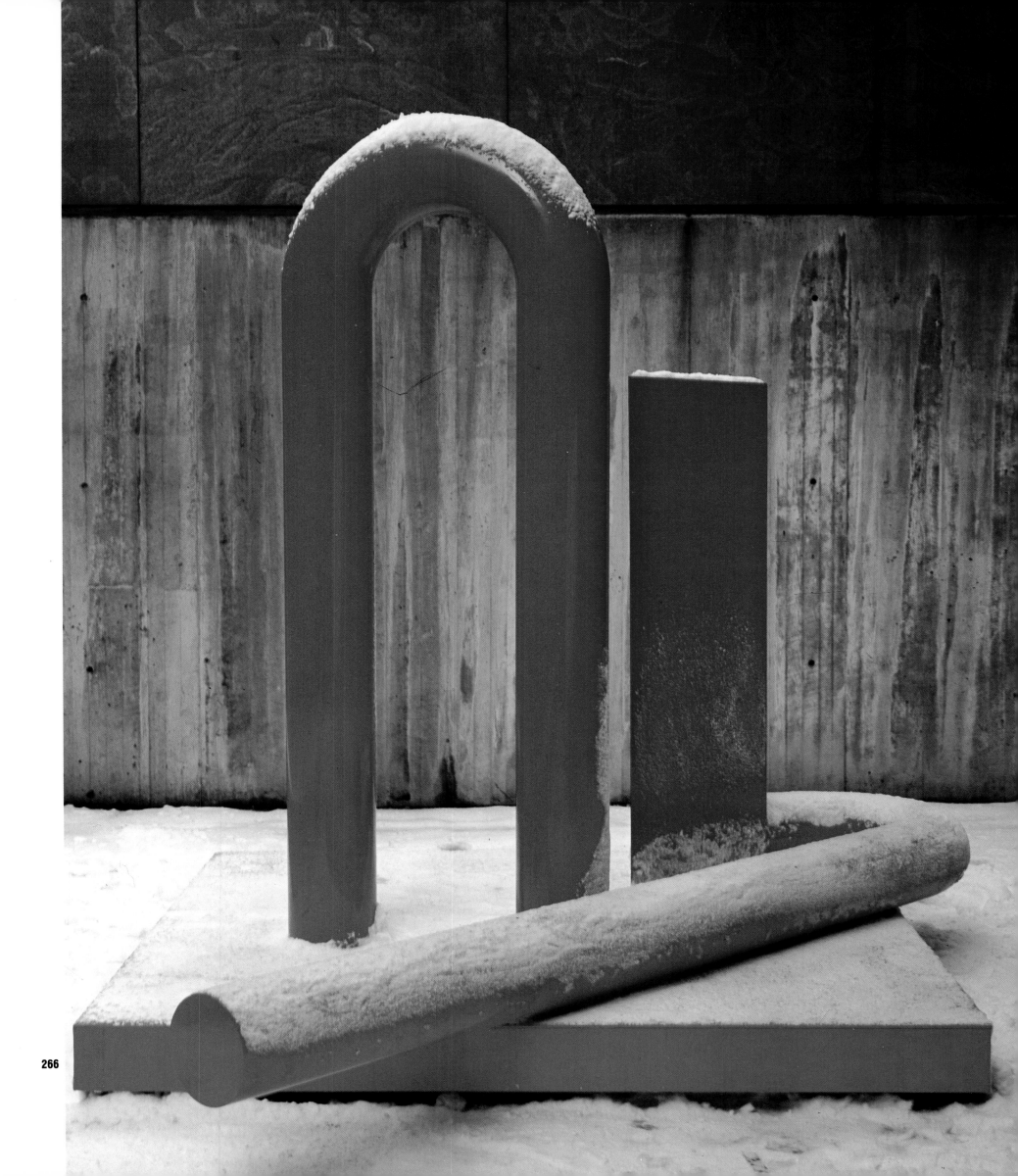

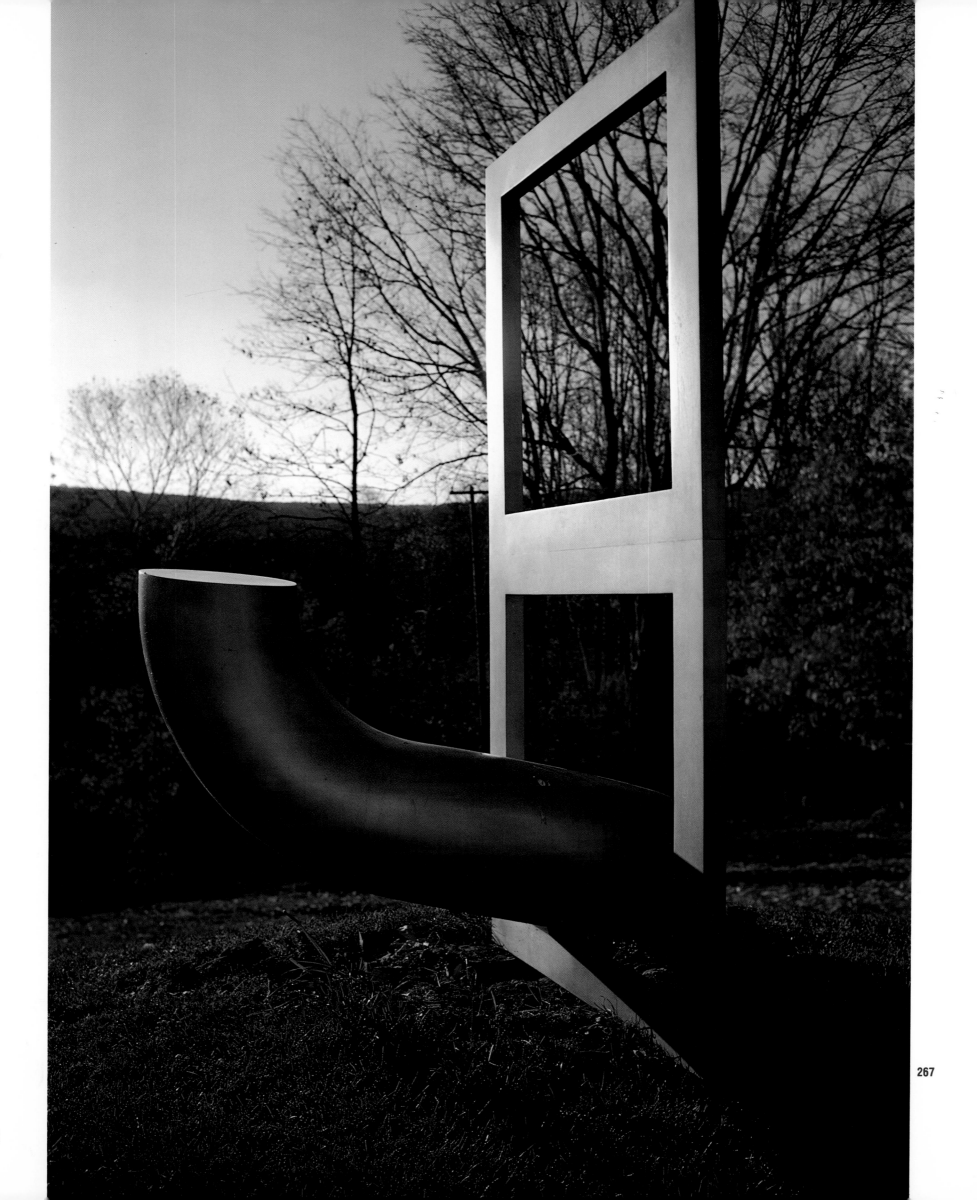

tional fine-art process—do not have. Liberman was familiar with Kiesler's bronzes cast in sand, and he knew something about the history of sand casting in Chinese art. It occurred to him that perhaps Pusinski could use an industrial technique to cast sculpture.

Ever since he had made his first small bronzes in 1963, Liberman dreamed of making large abstract bronzes. Now he felt he had discovered the means to work in the noble but costly material on an impressive scale. Earlier, he had experimented with casting aluminum in several works, including *Torque in Squares*. (*267*) His first piece of this kind was *Totem I*, a torsolike arrangement cast from two children's rubber balls and some wooden molds used for making old-fashioned machine parts that Layman had discovered in an abandoned foundry. *Totem I* was never polished, but two versions of *Torque in Squares* were hand polished to a matte finish. At the same time that Liberman made these cast aluminum pieces, he also experimented with welded stainless steel in *Totem II*, a construction based on triangular modules combined in various ways just as elements are added to stage sets. (*254*)

Another inspiration for casting found objects was Picasso's *Baboon*, whose head is a toy car cast in bronze. Similarly, Liberman cast found objects—elliptical or circular tank sections, I-beams, etc.—to provide himself with materials to assemble through welding. The idea of a bronze I-beam—an element he rarely used in its normal state because he felt its associations with construction were too obvious—appealed to his sense of humor in the way it reversed normal usage. In combining the modular elements Pusinski cast in multiples for him, there was a considerable and deliberate element of chance involved because Liberman could control only the assembly and finish. The result was a unique marriage of assemblage and bronze casting in forms that portend his favored paradox of an industrial classicism, referring to antique geometry as well as to the images and techniques of the factory.

The bronze parts were returned to him as rugged black objects with a rugged crust where the granules of sand had become part of the molten mixture before it hardened. Liberman ground these pieces himself until parts of them shone with a brilliance that dazzled the eye like the gold in the Byzantine icons he knew as a child. (*273, 274*) He was particularly attracted by the possibility of working directly with bronze, without preliminary studies. In fact, Liberman's remarkable series of large bronzes, executed in 1973, are apparently the first improvised bronzes. The idea of improvising with a material as permanent and unyielding as bronze also appealed to Liberman's sense of irony and his attraction to accomplishing the impossible.

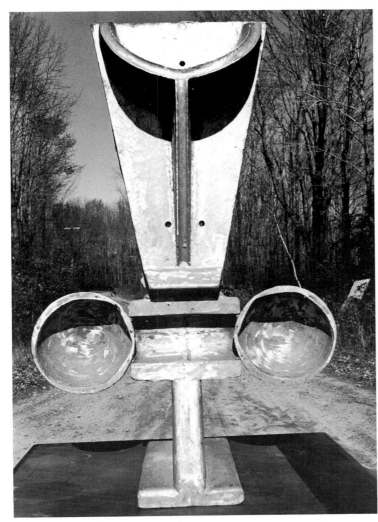

268

267. *Torque in Squares*, 1968
Cast aluminum, 58 x 29½ x 52 in.

268. *Totem*, 1968
Cast and welded aluminum,
45 x 24 x 16 in.

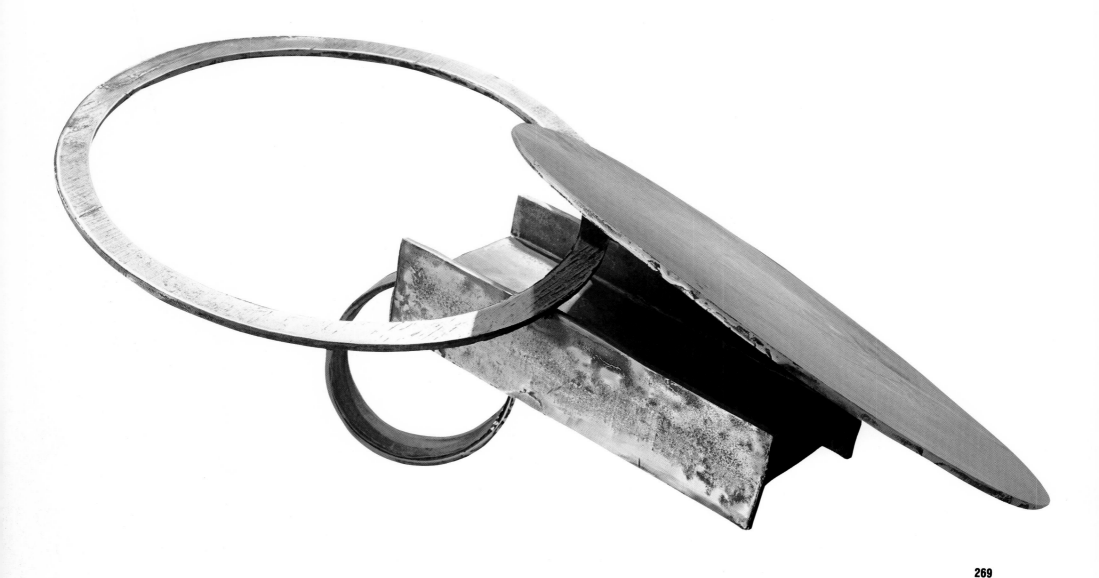

**269**

Although Liberman's large bronzes cannot be called classical in any literal sense—they are too dynamic, open, and assertive—they have a certain weight and gravity, a sober, monumental presence that makes them among his most stable and certainly his most obviously grounded works. The symmetrical *Ave*, *Ark*, and *Anima*, inspired by Giacometti's *Charioteer*, a sculpture he loves, and by the *Charioteer of Delphi*, which Liberman saw and studied on his trip to Greece, have a solid, grave sobriety that is qualitatively different from Liberman's general tendency to deny mass and gravity, as much in sculpture as in painting. (*273, 274*) Brancusi's polished bronze *Torso* was also undeniably in Liberman's mind during the conception of *Anima* as well as the earlier cast-aluminum *Totem I*.

Liberman's small modeled bronzes, done a decade earlier, were the precedent for the small architectonic bronzes based on the shrine or temple motif he also assembled from cast elements in 1973. These smaller sculptures elaborate the theme of the "sacred precinct" suggested by Greek temple complexes, which he had begun to explore in his first bronzes of 1963, and as we have remarked, also suggest devotional images. Altars, icons, temples, and shrines alluding to the general theme of worship are suggested by these inventive combinations of geometric elements. (*271, 272*) Some of these small sculptures, like *Votive*, suggest fragments of classical architecture—pediments, columns, and entablatures—which Liberman had drawn as a student at the Ecole des Beaux-Arts. (*256, 257, 258, 259, 260, 261,*

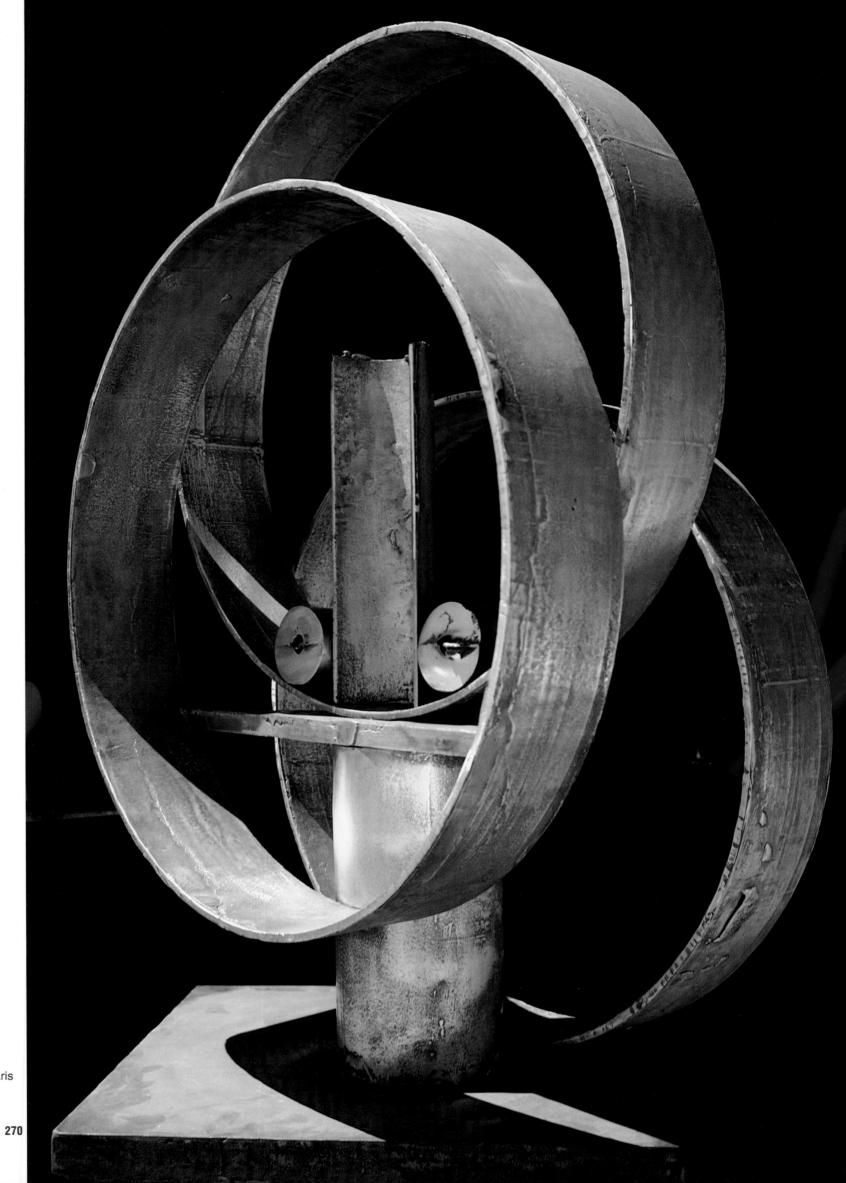

269. *Still*, 1973
Cast and welded bronze,
28¾ x 60 x 43 in.

270. *Ave*, 1973
Cast and welded bronze
(edition of two),
56 x 36½ x 24 in.
Collections Cast I:
Mr. and Mrs. Charles Merrill;
Cast II: Yves Saint Laurent, Paris

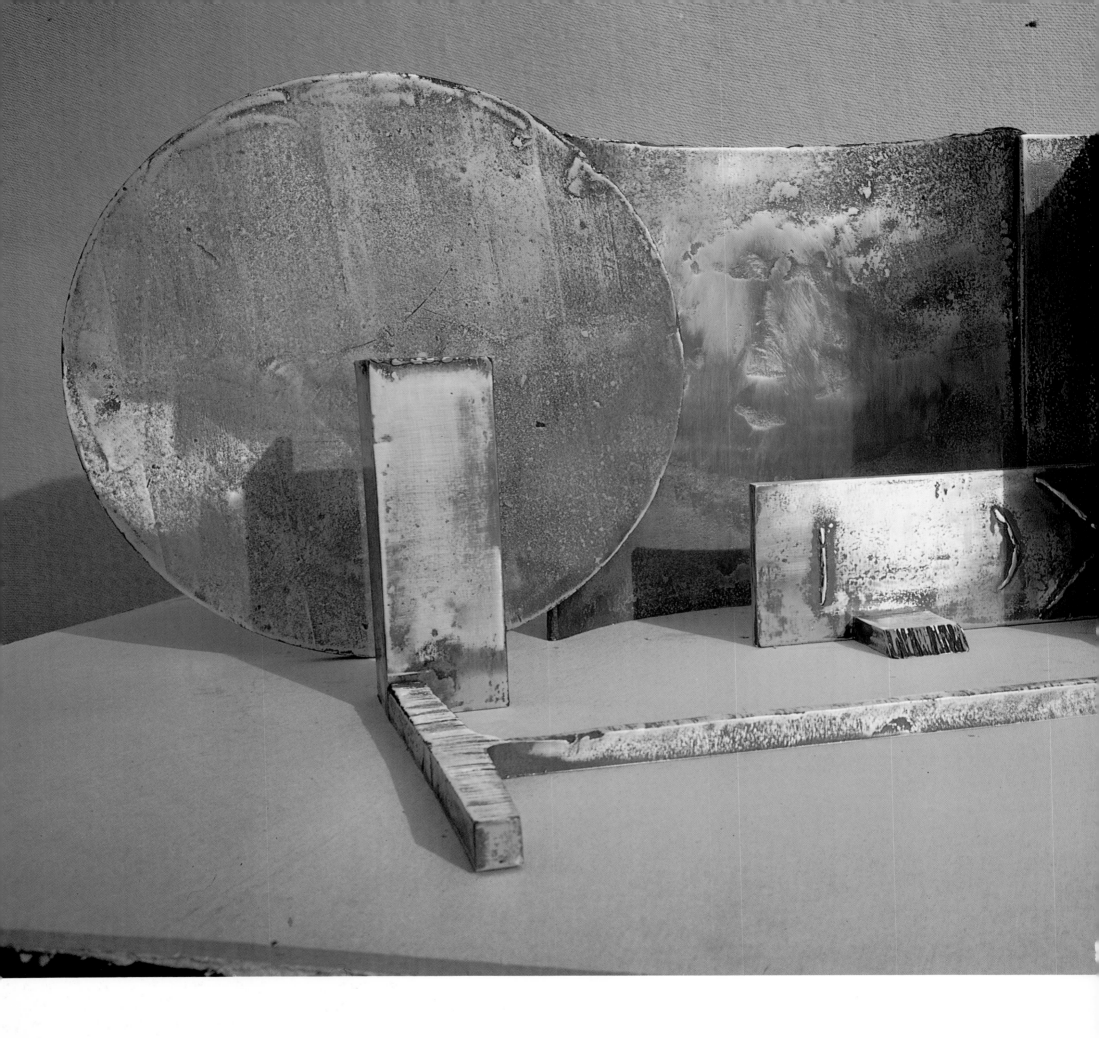

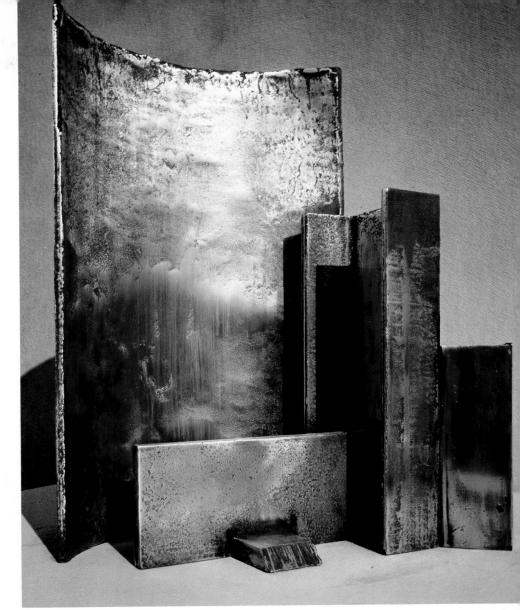

**272**

271. *Sacred Precinct III*, 1972
Cast and welded bronze, 20 x 38 x 27½ in.
Collection Dr. Hal Joseph, St. Louis, Missouri

272. *Sacred Precinct II*, 1972
Cast and welded bronze (edition of three), 27¾ x 12¼ x 24 in.
Collections Cast I: Estée Lauder Management Corp., New York;
Cast II: Mrs. Enid A. Haupt, Rye, New York;
Cast III: Janie C. Lee Gallery, Houston

*262, 263*) Later the architectural fragment would become a major theme itself. A unique work in steel that belongs to this group, but whose theme is the erotic *lingam-yoni* rather than the shrine, is *Anew*, in which a phallic element presses through a jagged torch-cut opening. (*264*) For Liberman, *Anew* was also a birth image, more explicit than Brancusi's *Newborn*.

Undoubtedly, the "sacred precincts" were as much inspired by the sets Liberman saw as a child in his mother's theater as they were by Greek art. They are, in a sense, bronze versions of maquettes for constructivist sets: the artist's equivalent of the baby shoes that are bronzed to preserve memories of early experiences. Among the most inventive of these miniature temples is *Sacred Precinct IV*, in which Liberman combines steel and iron with bronze to create variations of color and surface that are both elegant and painterly. (*255*) Eventually, the religious dimension of the "sacred precinct" would be enlarged, augmented, and elaborated to colossal scale in the huge environmental constructions that were like whole cities in themselves.

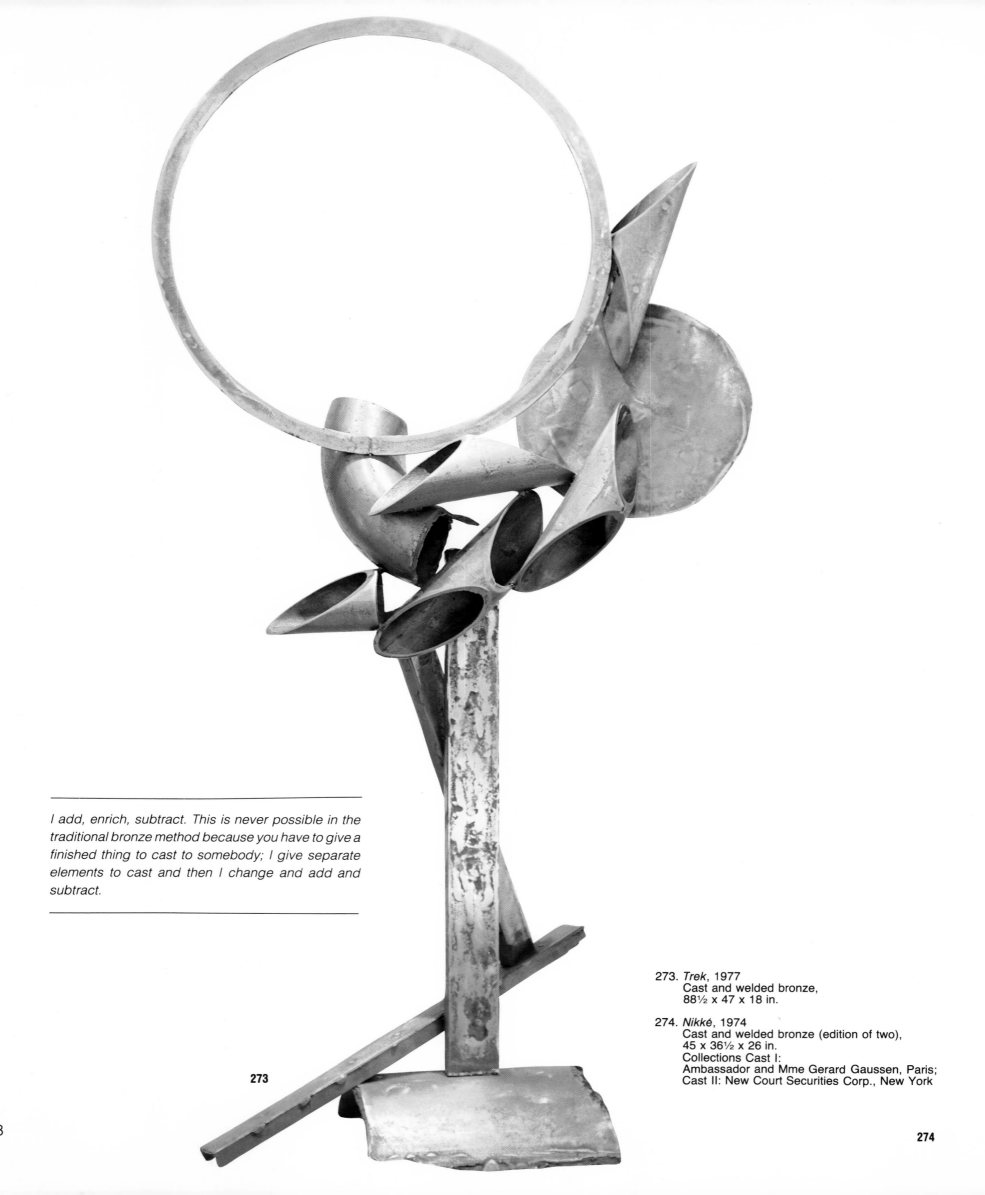

*I add, enrich, subtract. This is never possible in the traditional bronze method because you have to give a finished thing to cast to somebody; I give separate elements to cast and then I change and add and subtract.*

273. *Trek*, 1977
Cast and welded bronze,
88½ x 47 x 18 in.

274. *Nikké*, 1974
Cast and welded bronze (edition of two),
45 x 36½ x 26 in.
Collections Cast I:
Ambassador and Mme Gerard Gaussen, Paris;
Cast II: New Court Securities Corp., New York

**273**

**274**

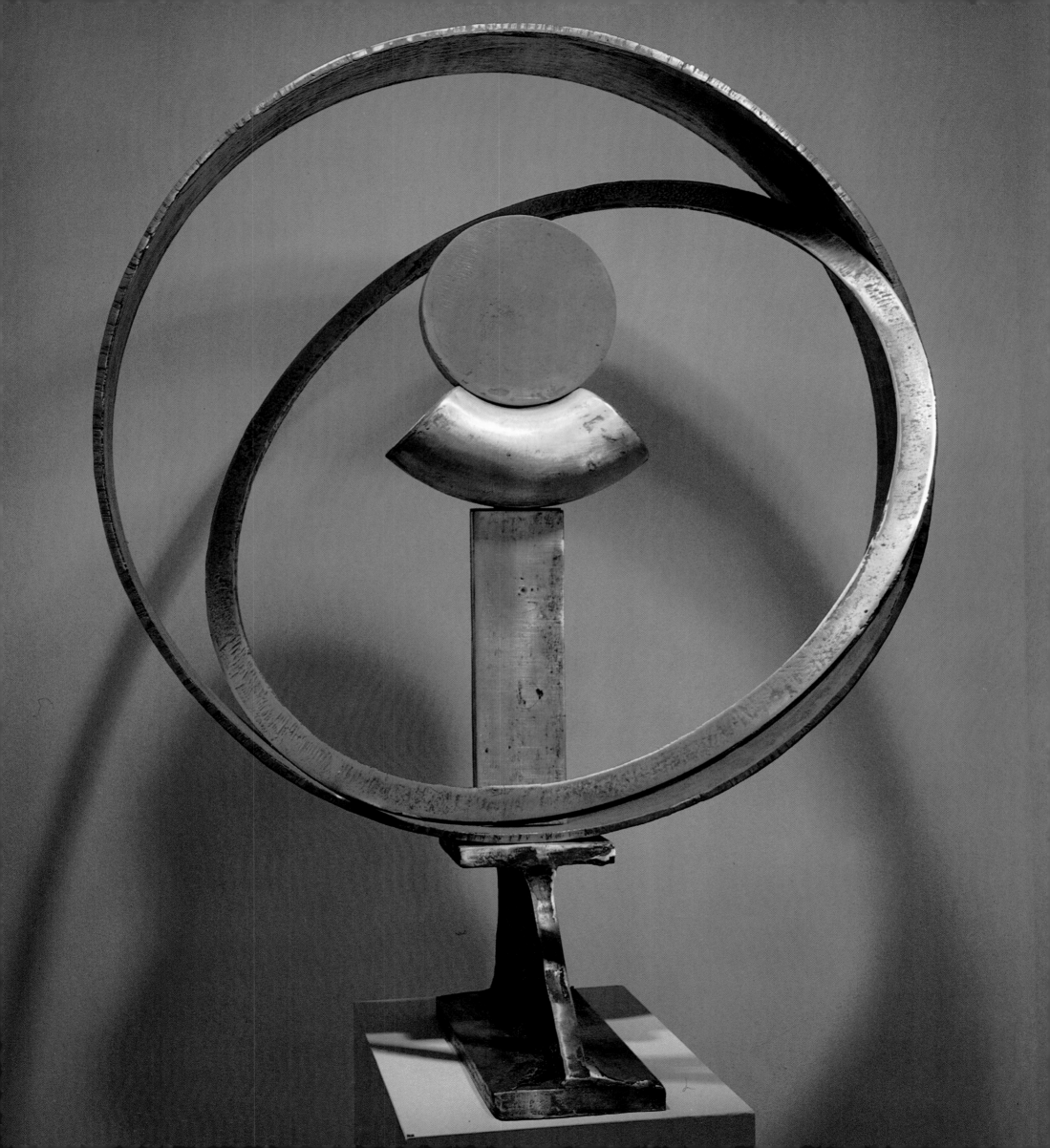

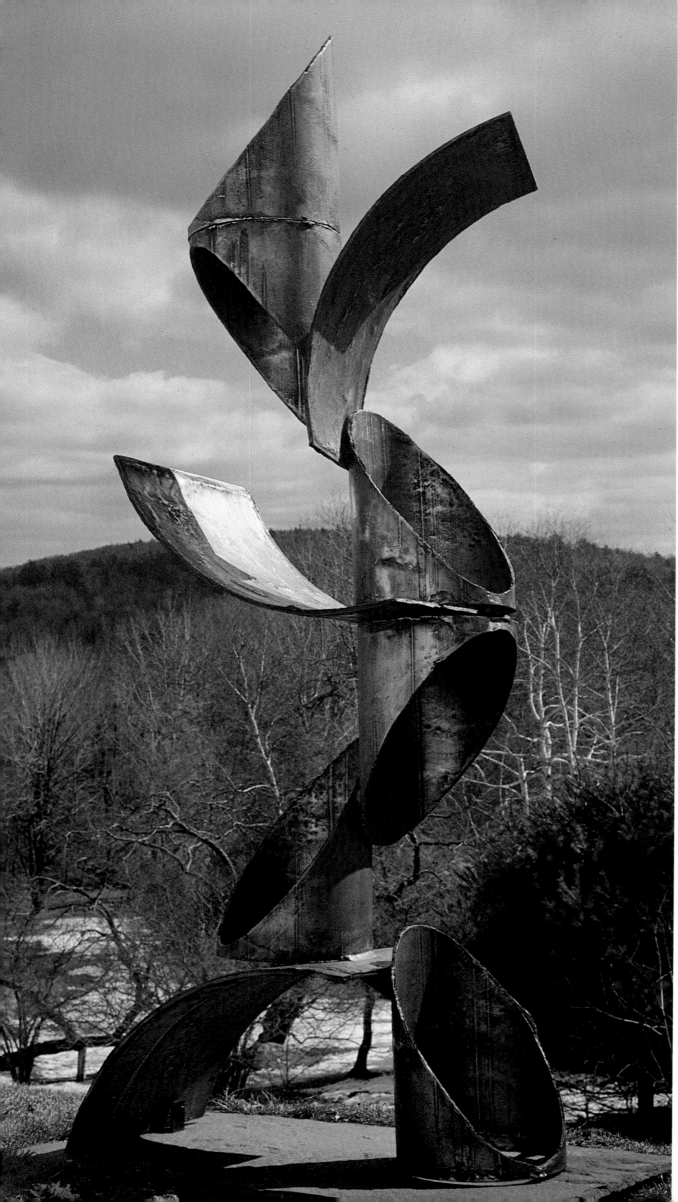

Bronze is prohibitively expensive if it's considered art. But if it's considered an industrial thing, as these were cast as separate pieces—I paid a dollar a pound —it was possible. Even so, they're very very heavy. But you could work on a monumental scale for very little money by treating bronze as an industrial material.

275. *Arise*, 1975-76
Cast and welded bronze,
9 ft. x 2 ft. 4 in. x 3 ft. 9 in.

276. *Ark*, 1973-76
Cast and welded bronze,
10 ft. x 4 ft. x 5 ft. 5 in.

275

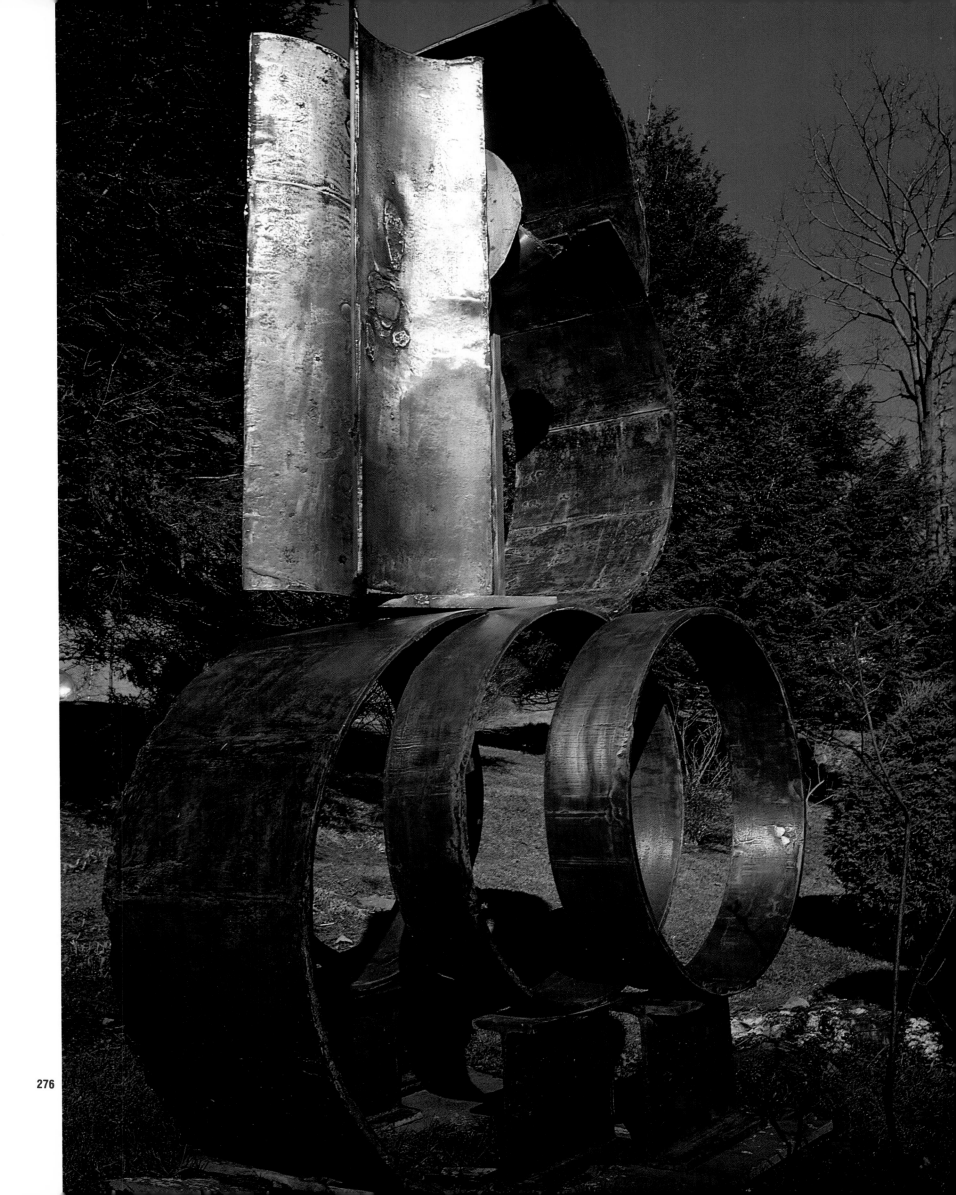

277. *Unto*, 1977
Cast and welded bronze,
9 ft. 2 in. x 5 ft. 10 in. x 7 ft. 3 in.

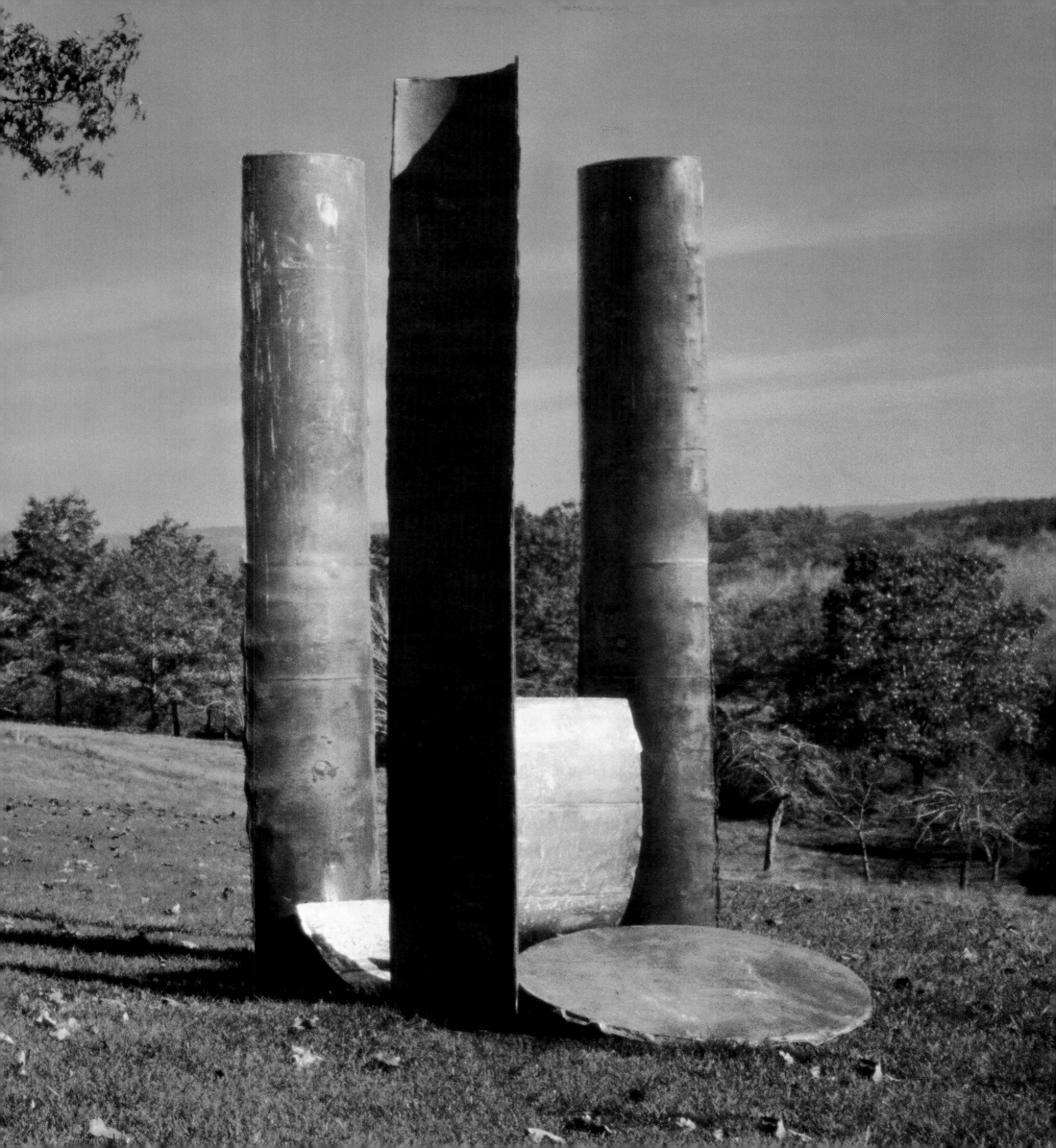

CHAPTER

# IX

## THE PUBLIC DIMENSION

*To see pieces of metal turning, suspended from a crane, is really the best source of visual ideas. You cannot (I cannot) pre-envision, because if you pre-envision in a drawing, you're limited. You only pre-envision what you have already seen. I don't think you can really discover through diagramming. Discovery comes from working and research. The best sketch for a sculptor is to watch the forms in space because as it moves in space you have a revelation, a real visual revelation.*

*Only through public art can the abstract be accessible. The authority of presence can convince people to stop and look. This is the chance that abstract sculpture has to be genuinely popular today. If all these commissions had been dismal failures, somebody would have stopped the whole procedure. But for some reason it has captured the imagination of the public. The public today feels that it is treated with a certain respect by the municipality, by the towns, even by the shopping center owners, even if a work of art is placed to redeem the commercial venture, the gesture is a symbol of respect to the public.*

*With all the technical possibilities suddenly available to sculpture, one is able to build impossible things— things made of heavy metal that look light, things that have enormous volume and can still express lightness. This ability to express contradictions is, I think, one of the excitements of working in sculpture today.*

*I keep coming back to ruins—the destruction of architecture, or the destruction of a work of art that one creates oneself, is one of the most creative elements. The preconceived is banal. One of the cardinal things in my new work is not to be afraid to destroy, hoping that through destruction suddenly one has a glimpse of something new. I crushed tanks with dynamite. We used bulldozers running over tanks. Metal is very reluctant to submit to any kind of change. To be able to utilize the unexpected inflexibility of metal is a great source of revelation!*

*You have to accept accidents. In flow, in finding, in accepting, you cannot have a preconceived idea. When I have the bulldozers bend a tank, it may end up finally as a completely different shape. That's the equivalent of pouring paint.*

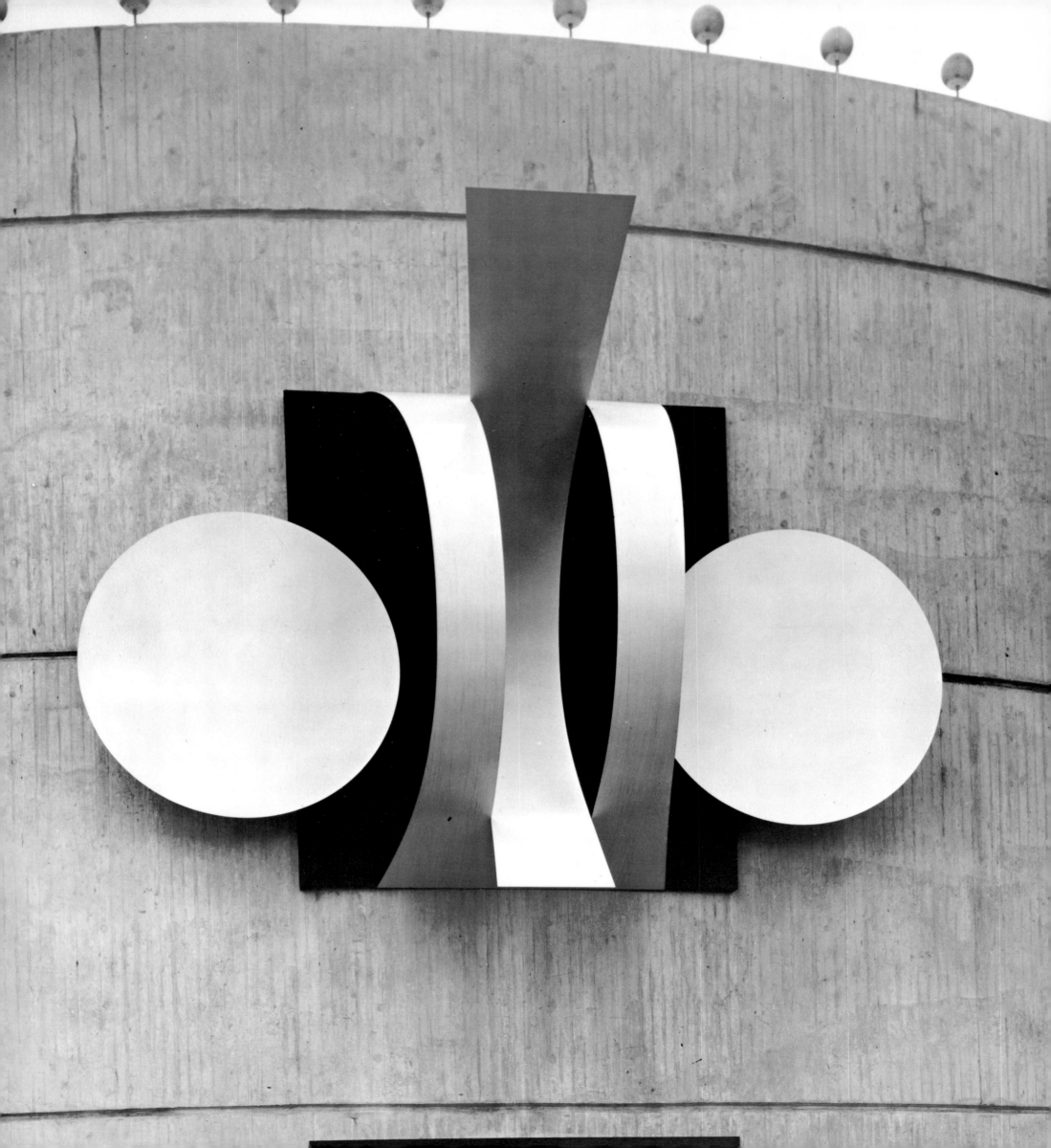

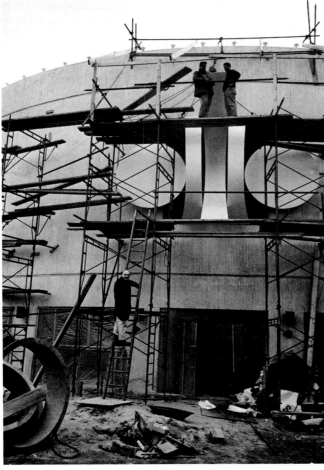

**279**

278. *Prometheus*, 1963
Painted aluminum, 19 ft. 7 in. w.
Originally installed at entrance
to the New York State Pavilion "Theaterama"
at the 1964 World's Fair;
now collection University of Minnesota, St. Paul

279. *Prometheus* being installed.
Shown are Liberman and Donald Gratz
of Treitel-Gratz Co., Inc.

**278**

ONE OF THE FEW LINKS between the classical, geometric, mechanically drawn forms of the Russian Constructivists and the romantic, painterly, expressionist style of the New York School artists is their common aspiration toward a public art. In Russia, the Revolution inspired the goal of an art for the people. In America, during the Depression years, the W.P.A. also encouraged public projects, whose scale was remembered in the masterworks of the Abstract Expressionists. Although the so-called "big picture"—the mural-size painting—did not become popular in New York until 1950, the aspiration toward a public scale was a goal of the American avant-garde since the Thirties. The "big picture" was done on a stretcher and not on a wall, but it was ill suited to domestic settings. Its obvious context was the public space.

American sculptors also dreamed of public works. However, not even David Smith, the leading sculptor of the abstract expressionist generation, was able to execute them. Smith only began to enlarge his scale late in life, as he sold enough work to set up his own personal factory at Bolton Landing. Yet even then, his inspiration and scale remained that of the human figure; the tallest of his last sculptures, the brilliant stainless steel *Cubi* series, was only slightly more than life size, i.e., not quite ten feet high. Smith's early work had been imbued with the fantasy of surrealism. The *Cubi*, however, were rigidly geometric, sacrificing gestural and linear elements to the stability and clarity of precise, squared-off volumes. In fact, abstract expressionism, with its emphasis on spontaneity and momentary improvisation, on the subjective and the dramatic, was a difficult style to translate into sculpture. Significantly, Tony Smith, the one sculptor connected with the Abstract Expressionists to create a body of public art, was trained as an architect and only emerged as a sculptor in the late Sixties with a reductive "minimal" style of boxy volumes based on geometric solids.

The failure of modern art to spawn a distinctive sculptural style with monumental or public dimension is understandable, considering its historical and social context. In the nineteenth century, public monuments like Rude's decoration of the Arc de Triomphe and Carpeaux's bronze figures in front of the Paris Opéra were executed on a monumental scale as decoration for public structures. Their symbolic function was to express the values of the state. Public sculpture suffered a decline, if not a demise, when the values of the artist became deliberately opposed to those of the state. This is not to say that governments ceased to glorify themselves in the twentieth century. In Rome, the monument to King Victor Emmanuel tops the Piazza Venezia like a giant tiered wedding cake, crowned with the requisite figure of the monarch in glory. But it is a ludicrous souvenir, not a work of art. Its symbolism is transparently hollow, its forms meaningless and rhetorical.

Between the two world wars, Mussolini thought of himself as a great art patron, Hitler considered himself an artist, and Roosevelt styled himself a cultured Maecenas. Coincidentally, they all preferred the same pseudo-classical style in art. Stalin, too, favored idealizing the worker with the proportions of the classical athlete.

The political ideologies of the great powers in the Thirties and Forties differed, but the decoration of public buildings in Moscow and Washington is remarkably similar. In a period when the masses had to be flattered rather than enlightened, the ideal subject was the muscled super-worker, the preferred style a vulgarized neoclassicism. This pseudo-classicism connoted "art" as well as imperial conquest to the uneducated. That the official art of the Soviet Union should, like the official art of the United States until quite recently, turn out to be neoclassical kitsch is ironic. For the unique instance in which art and politics meshed in modern times occurred in Russia during the October Revolution. Constructivists like Tatlin and Rodchenko, who identified themselves with the proletariat, dreamed of an inspirational abstract art looking as up-to-date as the factories that would house the workers' Golden Age. They held that not only the forms, but also the techniques of sculpture were to be altered to make it appropriate to the new industrial era. Behind this machine aesthetic of constructivism was the idea that modern industry would liberate the workers for spiritual rather than purely material pursuits.

Constructivism produced extraordinary works, even after many of its leaders were forced to flee Russia. The radicality of constructivist assemblage of forms balanced through engineering coincided with their objective: creating a public art that did not glamorize the masses, but offered them a way to reach higher realms of thought. This did not turn out to be a popular idea, however, and not a single constructivist monument was ever built in Russia. What we know of the plans of the Constructivists for monumental public sculpture, we know

from maquettes and photographs. After World War II, a few pieces of abstract public sculpture embodying constructivist principles, such as Naum Gabo's Rotterdam monument, were built. But until very recently, the kind of patronage necessary to the production of public art was generally unavailable to abstract sculptors. This made it virtually impossible for avant-garde sculptors to produce public monuments until after abstract painters were producing mural-size art.

The reason for this discrepancy was that a single patron may support a painter, or the painter may find ways to become his own patron, whereas the production of large-scale sculpture usually demands collective patronage. Few sculptors have been able to overcome the problem: Rodin, because of his fame, could sell enough of his more popular and sentimental sculptures to pay for works like *Balzac* and *Gate of Hell.* Brancusi's public art was done early, when the folk tradition of Rumania still unified public values, or later, under the patronage of an immensely wealthy Maharajah. Noguchi supported himself by doing portrait heads, and only in the Seventies was he in a position to execute the public works he had dreamed of in the Thirties. David Smith died before the usual patrons of public art in America—universities, communities, corporations, religious groups, and the government itself—began to commission abstract art.

The model and the major inspiration for public patronage of contemporary abstract sculpture in America was Alexander Calder's project for Grand Rapids, Michigan. Executed in 1967, this giant "stabile," as Calder termed his static planar sculptures, was industrially fabricated. Its popular success and the local pride the work engendered (it became the symbol of the city and its civic sense) encouraged other communities to commission public works of art. Once the National Endowment for the Arts began giving matching grants to cities wishing to commission public works, a demand for public sculpture was launched; it grew during the Seventies and continues today. Alexander Liberman's art

*I love the unfinished quality of Michelangelo's "Slaves," I often think of the space surrounding a sculpture as part of the sculpture. I think space is like a mass that surrounds sometimes the back of a sculpture, sometimes the front—it depends on which side of the sculpture you're working on at a given moment. And it is in relation to that space, to the void, that one really very often adds elements or subtracts elements.*

began to have an important place in these developments, although he was working on a larger-than-life scale long before a place for such works existed.

Liberman was impressed by the scale of Calder's stabiles, but he was against the idea of fabricating large-scale sculptures from miniature maquettes. Moreover, he was interested more and more in the mass, volume, and twisting contrapposto of traditional sculpture than in the planar organization Calder stressed. We saw that, in the Fifties, Liberman had experimented with the most extreme distancing between concept and process, idea and execution, by having his painting and sculpture fabricated on the basis of telephoned instructions. Perhaps because he had pursued the idea of art as disembodied concept to its logical and unsatisfying consequences, Liberman especially valued the qualities of spontaneity and personal involvement that his contact with the New York School convinced him were essential to authentic art. By the time he started working on a larger-than-life scale in the mid-Sixties, the idea of blowing up a miniature maquette to monumental proportions was thoroughly repugnant to him. Like di Suvero, the only other artist to create public art without mechanically enlarging it from maquettes, Liberman realized that the process of enlargement often produced sterile and lifeless art, lacking monumental scale and proportion.

The first sculpture Liberman conceived as a public work was one of the last he had fabricated at Treitel-Gratz; *Prometheus* was commissioned by Philip Johnson to decorate the New York State Pavilion at the 1964 World's Fair. (*278*) A frontal relief rather than an in-the-round sculpture, *Prometheus* was more closely tied to Liberman's geometric circle paintings than to the monumental sculptures he would soon make. Up until then, *Prometheus* was the first work Liberman had ever executed as a specific public commission. Indeed, the idea of public commissions had not entered his mind when he began to work with the oversize module of

the 24-foot-high steel gas tank in the mid-Sixties. Since then, a number of his large sculptures have been purchased as public works by museums, universities, and communities. However, they were not conceived for any specific site. Rather, were they part of Liberman's ongoing process of self-exploration and experiment, which still impells him to fill the land around Layman's shed—now grown into a small factory for cutting, grinding, and welding—with strange and mutable formations that flower and grow through time like a giant metallic forest. (*3*)

The huge dimensions of these works require Liberman to develop them slowly. Some pieces are not finished for years. Others are cannibalized for parts and left half-finished for further consideration. When Liberman decides he has finished a work, he often paints it and photographs it. At this point, the private dream of art becomes a public work, which he is prepared to move from his field to a permanent installation. In connection with the public sculpture, photography has an important role. Since Liberman improvises on actual scale, he often radically alters huge works, changing the position of their gigantic members or reworking them completely. Typically, he begins a piece with a crude drawing. Then he selects elements from his current stockpile, which is constantly being enriched by new scrap material found on his weekly drive between New York and his Connecticut studios. Metal sections are lifted into the air with Layman's crane and chained or welded temporarily in place, as Liberman deliberates on all possible views, moving great chunks of metal through the air. A work like *Eve*, for example, had fourteen different states during a five-month period of intense scrutiny. (*287, 288*) During this improvisational process, photographs are taken; various techniques, including photomontage, are employed. In creating *Adam*, for example, Liberman photographed the piece repeatedly, trying to find the appropriate angle on which to rest the downward pointing triangle so that it would be simultaneously stable

*You have to be careful to create small scale that can be big scale—scale that has a meaning beyond the colossal, with which you cannot compete. It's important to establish a scale of one's own that is monumental but, at the same time, work it out so that it doesn't look like a bad small building.*

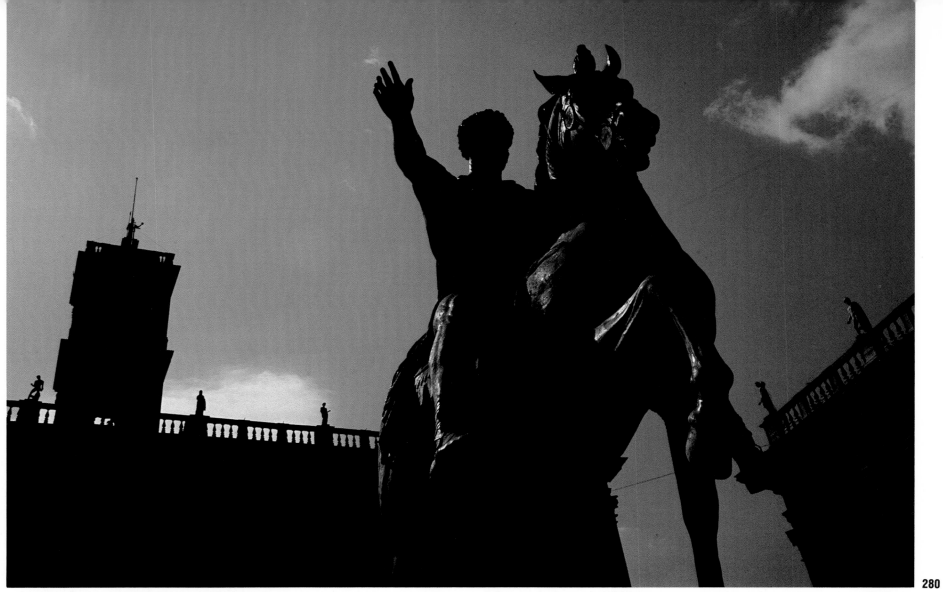

280

281

and soaring, dynamic and equilibrated. (282) *Adam* was photographed from different points of view at various stages. Then Liberman cut out certain elements in the prints, pasting them on in varying positions until he was satisfied. The triangle was drawn in grease pencil on the photographs until the desired result was achieved. Among the major revisions was the elimination of a crushed element that related *Adam* to *Eve.* The work was then altered, new photographs taken, new decisions made; the process continued until Liberman found the balances of thrust and counterthrust, of grounded and soaring elements, that make *Adam* so strong a work. Indeed, *Adam* was a powerful enough statement to invoke the wrath of President Nixon, who demanded that the offensive sculpture be removed from its site in front of the Corcoran because he could not tolerate the sight of it. But art endures longer than politics, and *Adam* was appropriately returned to Washington by I. M. Pei, who installed it outside the National Gallery of Art when the new East Wing he designed was opened. (286)

Like Liberman's paintings, his sculptures exhibit exaggerated swings of mood back and forth from static to active, contained to aggressive, reserved to explosive. Even stronger than this oscillation in temperament, however, is the forward thrust of his growing ambition to conquer scale, first in larger-than-life works, and finally in colossal sculpture, on a par with the grandiose fountains and piazzas of Rome that he visits each summer. Unlike the artist who resents the grandeur of past art, Liberman remains the eternal pilgrim paying his respects to the masters. Since the early Seventies, the focus of his pilgrimages has been the Campidoglio in Rome, which he photographs every summer. During these sessions he has photographed the Roman statue of Marcus Aurelius at the center of Michelangelo's Renaissance piazza from every imaginable angle—and often from angles underneath the sculpture, which is thereby thrust above the spectator's head, its contours dramatically silhouetted by the harsh Roman sunlight. (280) Undoubtedly these periods of photographic study and meditation sensitized Liberman to the variety of

280. The Campidoglio in Rome,
     photographed by Liberman, c. 1975

281. The Parthenon,
     photographed by Liberman, 1965

282. Three photographs of *Adam*
     in progress with experimental cutouts, 1968

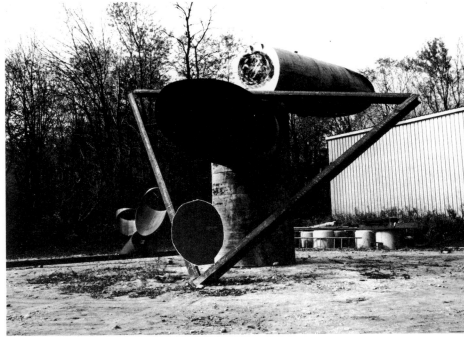

**282**

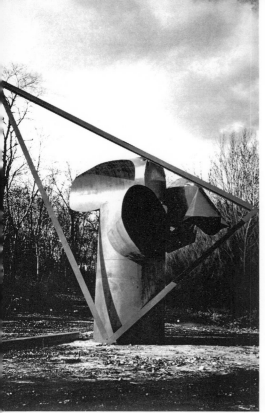

**283**

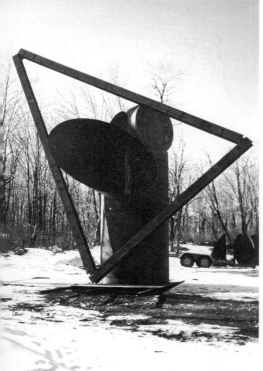

**284**

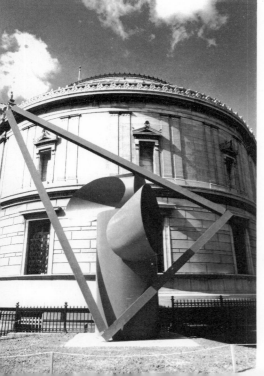

**285**

views up to and into sculptures available to the experience of public art.

The relationship of Liberman's photographs to his oeuvre is a strange one: The photographs are both the means by which he comes to know art and his definition of what art is not, for he does not consider photography an important art. His commitment to fully three-dimensional sculpture evolved in a sense as a critique of the flatness and single focus of photography. His antagonism toward photography is particularly ironic since the world considers him an important photographer. For him photography is a tool for thinking—a means not an end. The style of his photographic portraits is informal and uncomposed, close to the immediacy of a snapshot. With people, he is an action photographer—capturing the ephemeral expression and gesture. His portrait photographs are consequently more like his recent paintings—spontaneous and of the moment. His photographs of architecture and sculpture, on the other hand, beginning with the series of Greek temples and ruins of 1964-65 and continuing with the current ongoing series of the Campidoglio, are formal, static, precise, and composed. These photographs of ancient sculpture and architecture represent a continuing rumination not only on classical form, but also on the destruction of man's finest moments by nature and history. Liberman's photographs of nature itself are never ideal or pastoral landscapes. Rather are they austere and imposing, like the heroic lava rock formations on the island of Ischia. Their effect is to turn natural form into sculpture. That nature is more antique than art, both more enduring and more destructive, is the message of these photographs.

The photographic documentation of his working process thus serves as further auto-inspiration. Studying the states of *Eve* undoubtedly sharpened his perception of sculptural

283. *Adam* in progress,
    at the Warren studio, 1969

284. A later stage of *Adam*, 1969

285. *Adam* installed at the Corcoran Gallery
    of Art, Washington, D.C., 1970

286. *Adam*, 1970
    Painted, welded steel,
    28½ x 29½ x 24½ ft.
    Collection Storm King Art Center,
    Mountainville, New York;
    temporary installation,
    East Wing, National Gallery of Art,
    Washington, D.C.

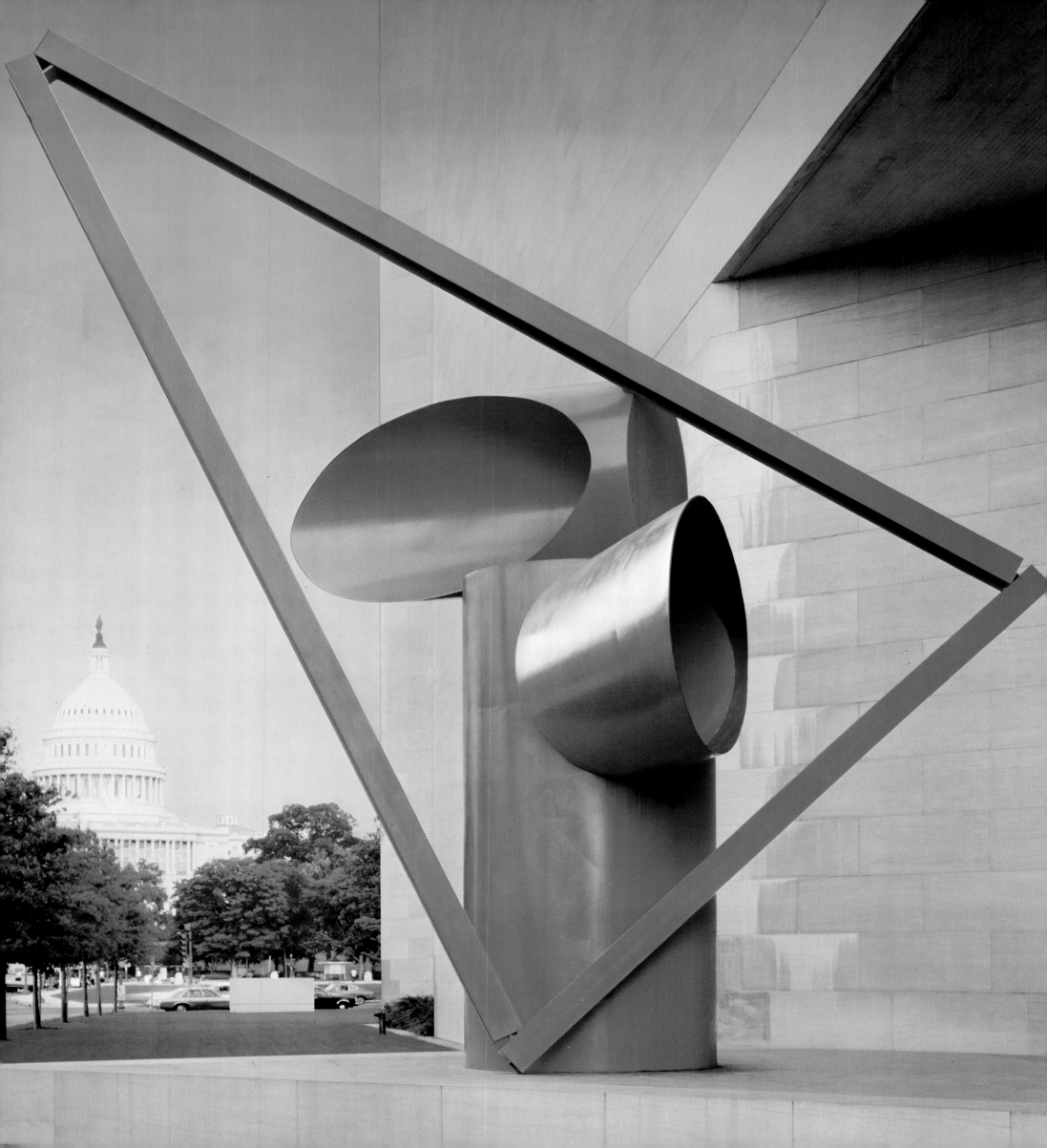

287

*Dynamiting interested me because I probably had read in some scientific magazine about experiments being made in California. I read about someone who put steel under water and put dynamite in the steel to achieve certain shapes. So I think the idea must have come to me from reading about these experiments.*

287. Preliminary studies for *Eve*,
     Warren studio, 1968

288. *Eve*, 1970
     Painted, welded steel,
     16 ft. 3 in. x 44 ft. x 24 ft. 8 in.

288

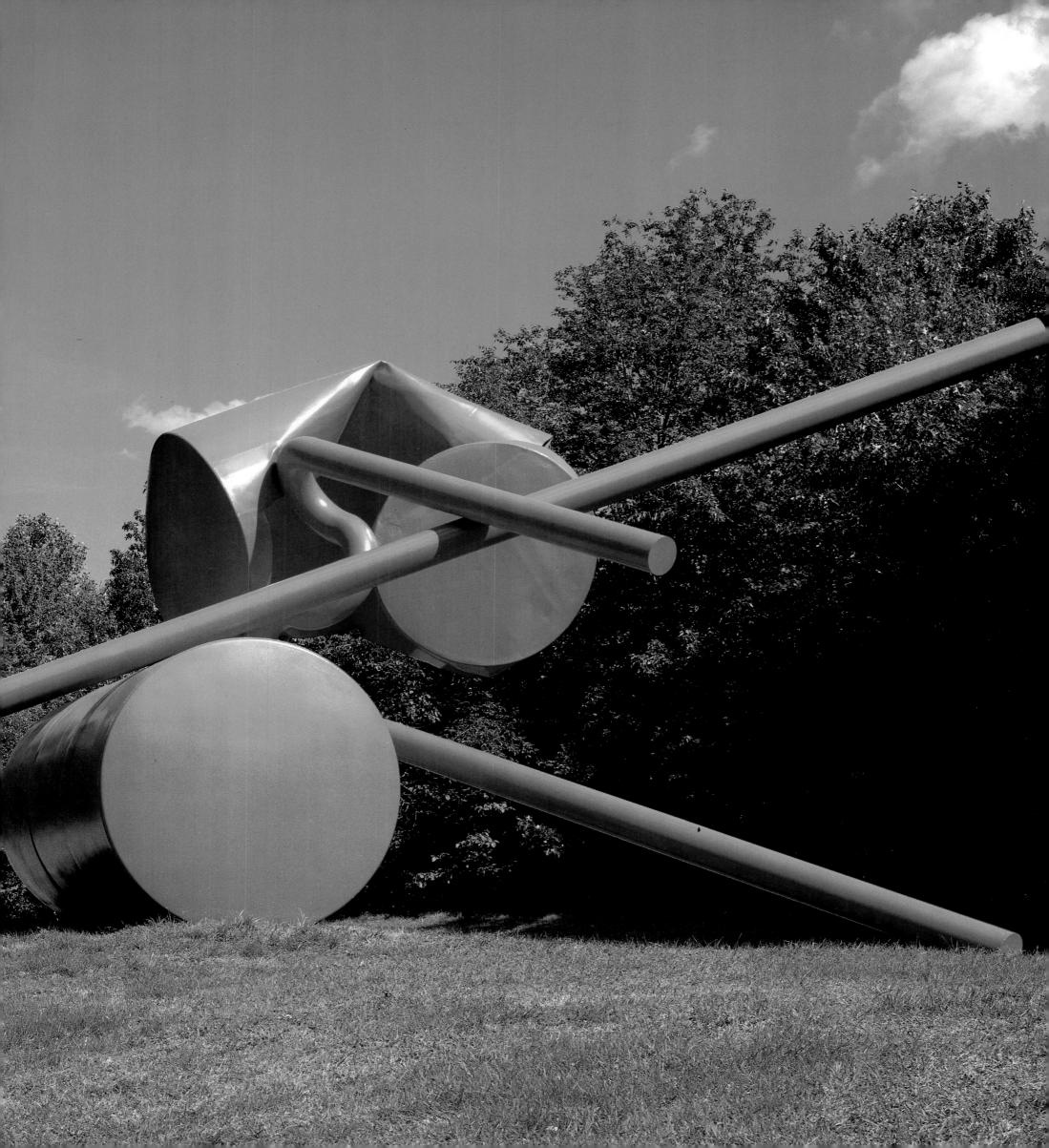

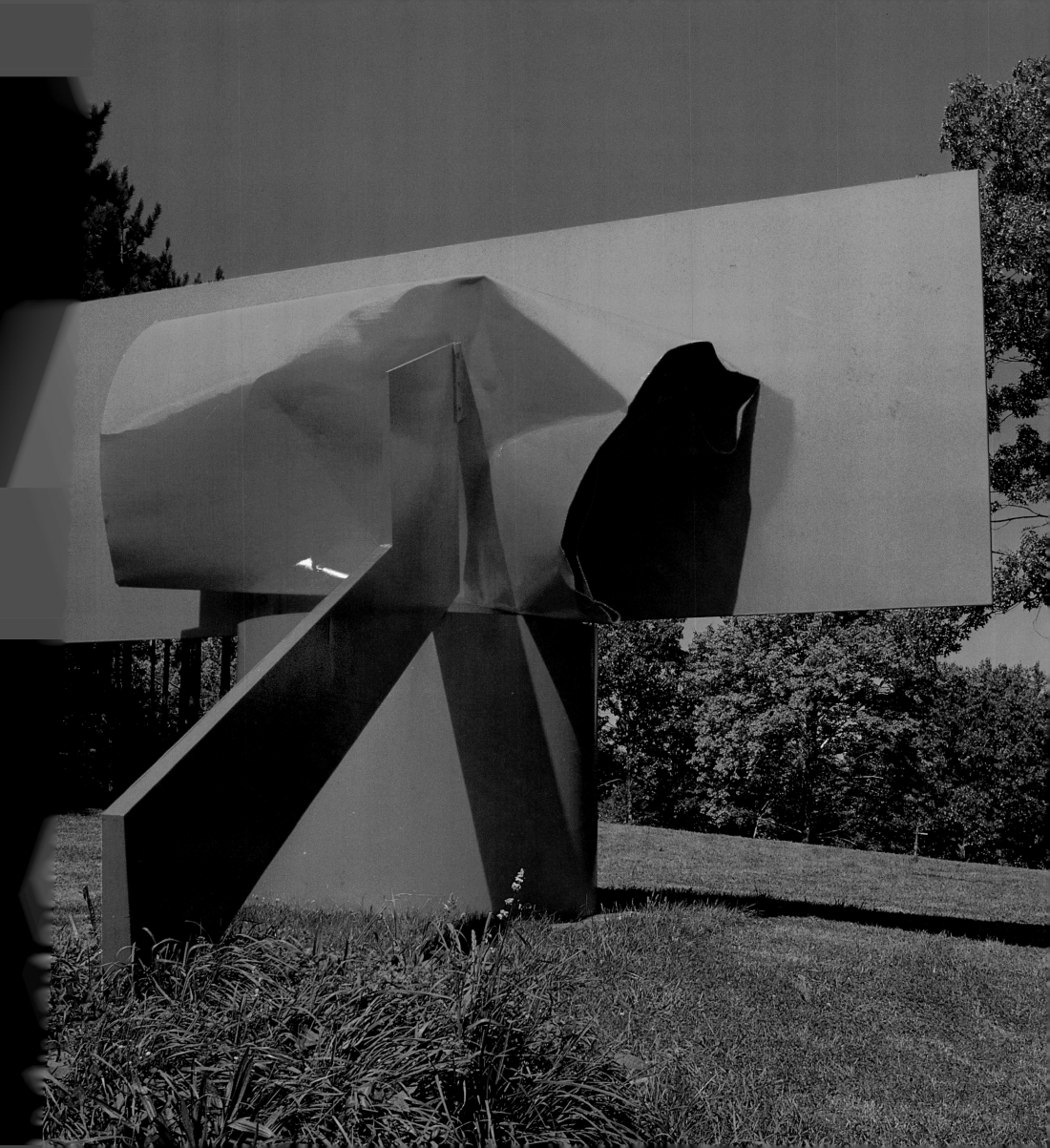

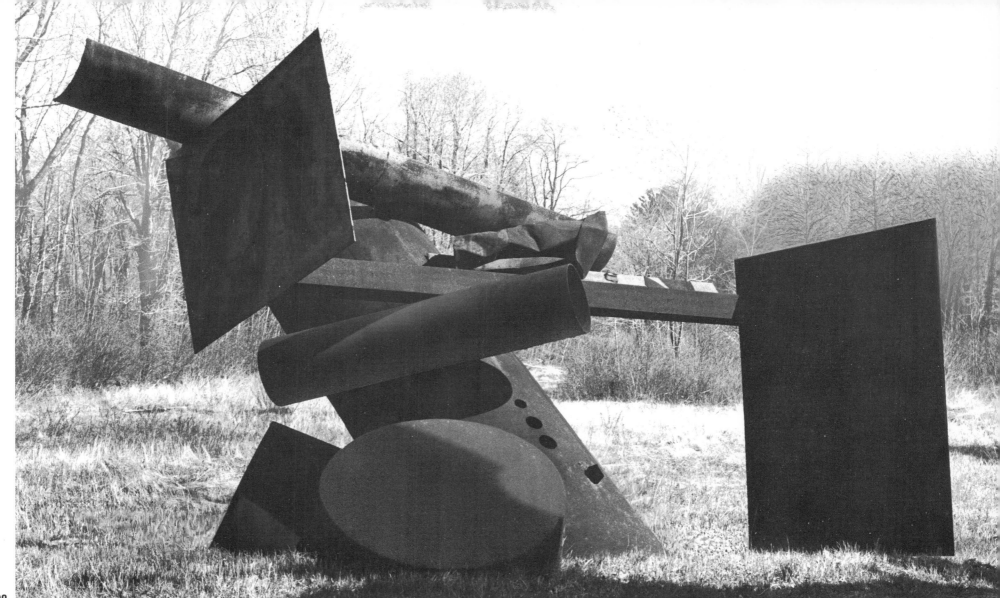

mass in space. *Eve* is a complex and poignant work in which the "body" has literally suffered by being dynamited and crushed. It is the transitional piece, between the tubular pieces of the late Sixties and the increasingly baroque sculptures of the Seventies. The crushed element, which also appears in *Ascent* and *Unfold*, is an homage to the crumpled draperies of baroque sculpture. The combination of linear rods and a "painterly" free element also recalls Nakian's *Rape of Lucrezia*, which suspends draperylike bronze fragments from a metal armature. The monumental tubular pieces of the late Sixties that lead up to *Eve*, like *Tropic* and *Arc*, were logical extensions of the linear sculptures made with exhaust pipes. In the more complex and fragile of these linear rod sculptures, such as *Trace*, thin line was balanced against a vertical plane. The odd curves in the metal piping of the pieces that succeed the sculptures made with exhaust pipes are not found forms; they were created by Liberman himself in a machine shop. *Alpha*, one of the most ambitious of these line-and-plane pieces, bridges two steel islands, which are actually platforms.

Among the last of the tubular works, *Tropic* is one of the series of works related to the theme of the shrine or taberna-

289. *Ascent*, 1970-71
Painted steel, 16 x 20 x 25 ft.
Collection Storm King Art Center,
Mountainville, New York.
Anonymous loan

290. *Logos*, 1973
Welded steel, 15 x 24 x 21 ft.

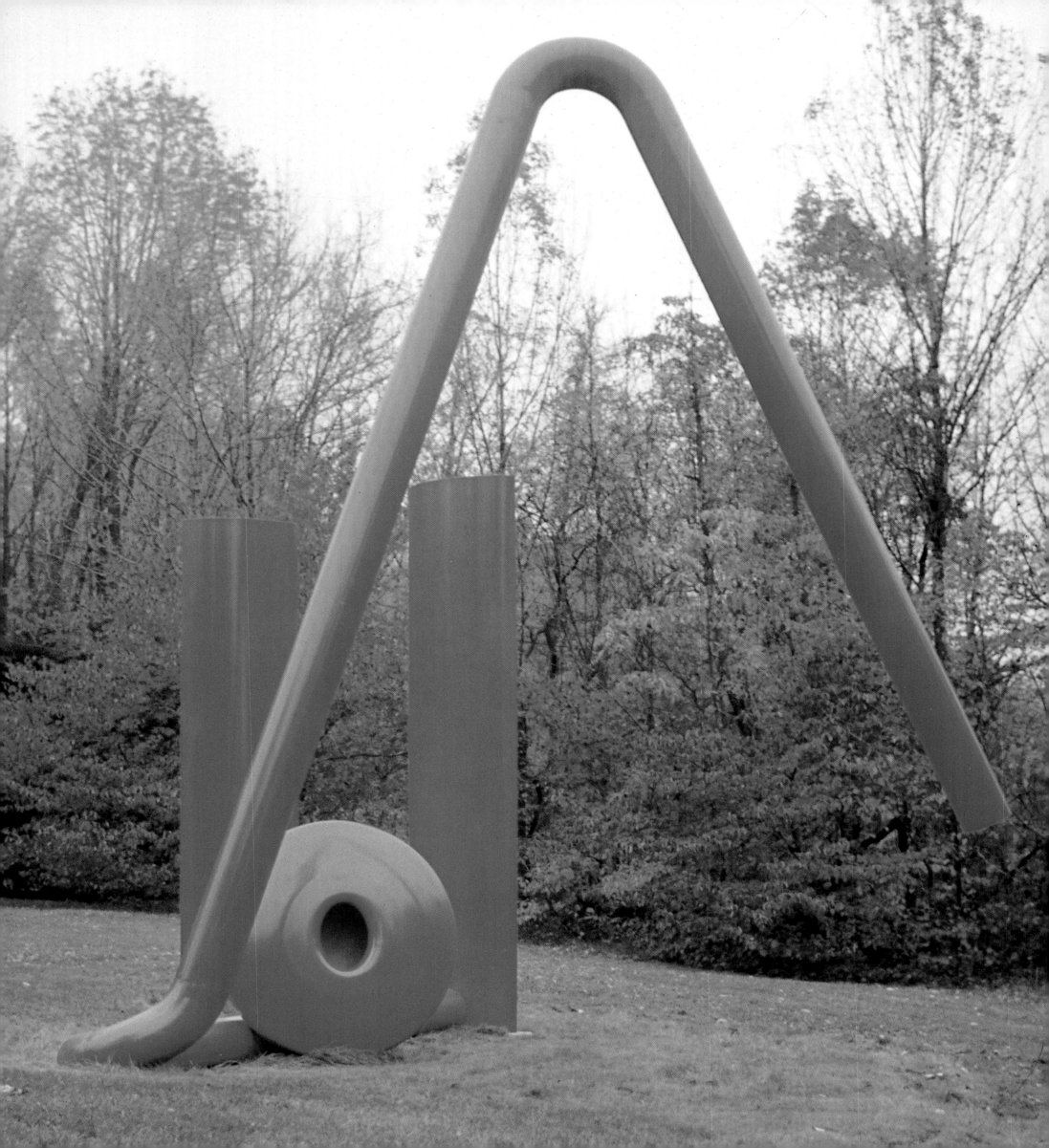

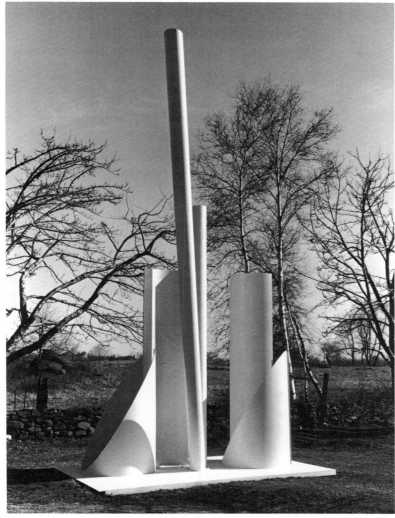

**292**

cle. A 45-degree angle of thick steel piping joins two lengths of welded pipe into a triangle. This sheltering arch encloses and embraces the circular "shrine" within. Since one side of the triangle is left incomplete, an element of imminence is introduced. *Tropic*, which is thirty feet high, is the first work by Liberman that can actually be entered. The rounded triangle here suggests the Egyptian symbol of immortality, the ankh. It is also a portal, which may enclose and shelter a viewer, as well as a shrine. Because it is a portal, *Tropic* indicated the future direction of Liberman's work, in which the theme of the propylaea or heroic gateway has become dominant.

As Liberman grew more confident as a sculptor, he drew more and more on his architectural and engineering training, using the found elements as building blocks and modules. In 1969, he began slicing cylinders on the diagonal. This introduced a new module in the form of an ellipse. By now, he was using enormous gas storage tanks rather than boilers to construct giant sculptures. Now the basic unit was twenty-four feet rather than six feet. With these huge cylindrical tanks he could truly build structures that would rival the smokestacks and pylons of the highways, the factories and girders in the drawings he had done as a teenager in Paris, when he was inspired by *l'esprit nouveau* of modern architecture. The world may not have lived up to the dreams of the Constructivists and their heirs, the urban planners, but he could build a world of his own where the ideal he was steeped in as a youth would rule. The grandiose new modules enlarged not only his scale, but changed his vocabulary of form as well. The classic circle was replaced by the more variable and ambiguous ellipse.

*Eros* was the first work based on an elliptical module. It is also the first of the cantilevered works that predominate in the Seventies. Slicing the cylinder on a diagonal to reveal its interior, *Eros*, a version of the cannon motif, is also a new interpretation of the penetration image. Previously, in works like *Torque and Circles*, *Anew*, etc., a phallic *lingam* penetrates a circular *yoni* form. The projecting diagonal ellipse of *Eros*, on the other hand, shoots forward from the plane to which it is attached and penetrates space itself. (*293*) This plane, however, impedes the penetration of vision so that we

*If you cut the tank straight, it's a circle. If you cut it at an angle, it's an ellipse. It was also very interesting to experiment with tank sections. The curved shape gives you the maximum structural strength if you want to go up high for the minimum of weight. For instance, a straight rectangle would wobble in the wind, but a curved rectangle could stand. It has a base of its own. I always wanted to build. I thought that architecture was involved with the repetition of erections. That's how I saw the colonnade.*

**291**

291. *Tropic*, 1969
Painted, welded steel,
17 ft. 10 in. x 20 ft. 9 in. x 16 ft. 8 in.
Collection Mr. and Mrs. Morton J. Hornick

292. *Odyssey*, 1970
Welded, painted steel, 24 x 14 x 8 ft.
Collection Neuberger Museum,
State University of New York College
at Purchase

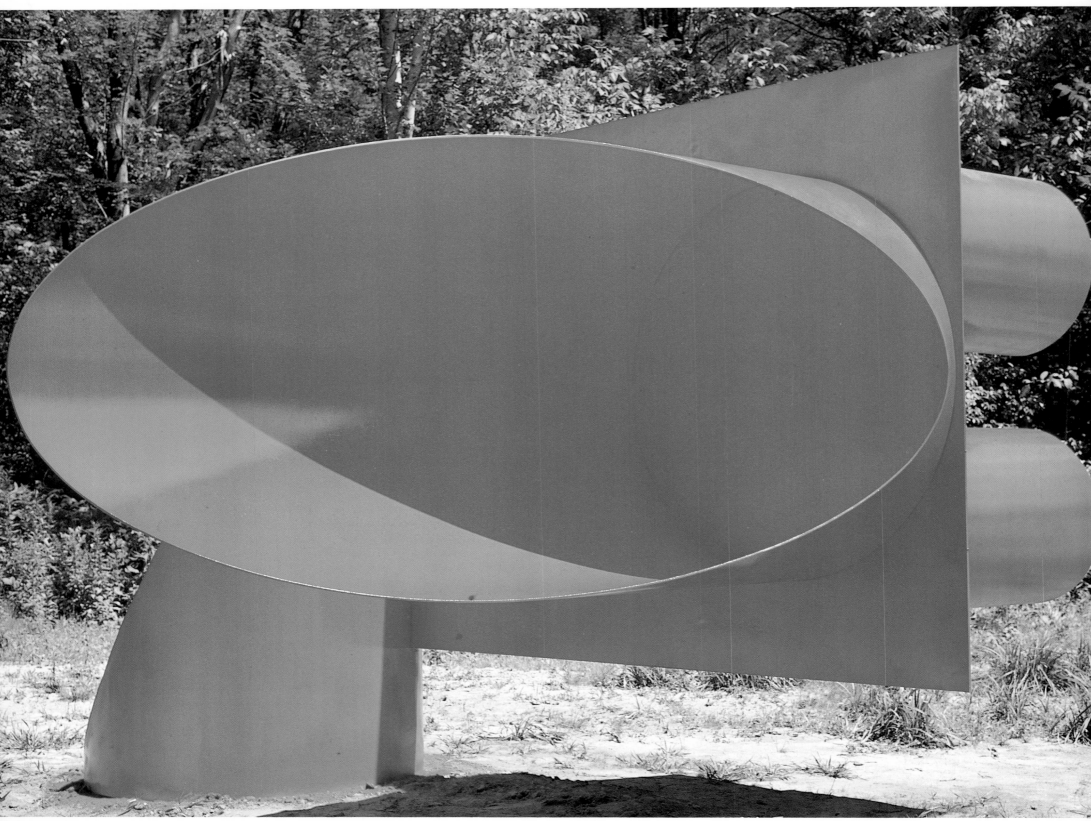

**293**

293. *Eros*, 1969
Painted, welded steel, 7 ft. 7 in. x 12 ft. x 11½ ft.
Collection Albright-Knox Art Gallery, Buffalo, New York

294. *Eros* installed at the Greater Buffalo International Airport;
present location, on loan by the Albright-Knox Art Gallery,
Buffalo, New York

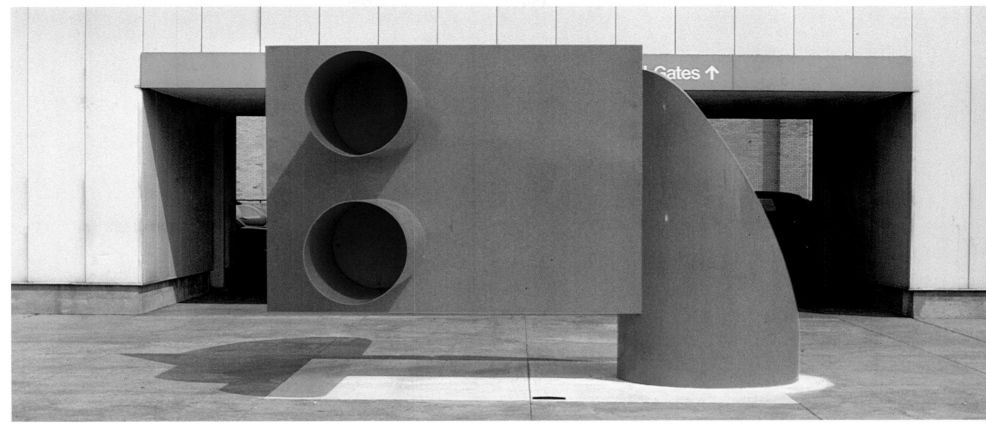

294

*I spend my time attempting the structurally impossible—I do it, and sometimes it doesn't hold up. One has to struggle then, sometimes for years, to figure out how to make the impossible possible. I want to go beyond the limit.*

have no idea what the other side of *Eros* looks like until we have circled the piece. It is entirely different, disclosing nothing of its reverse, a surprise that adds the excitement of discovery to the experience of viewing the piece. (*294*) *Eros* is a complex work that Liberman was involved with over a considerable period of time, doing eight or more versions of it until he was satisfied. It is a crucial piece in his development. By slicing the cylinder on a diagonal so that the ends were elliptical rather than circular, Liberman rendered the column transparent. The paradox of an empty volume added piquancy to the thrust of the suspended elliptical form, communicating a simultaneous sense of space contained and displaced. The extremely oblique ellipse becomes a rounded triangle, thus reintroducing Liberman's other favored geometrical form in an altered version. *Eros*

marked the beginning of a new phase in Liberman's career because the combination of cantilevering with the explicitly hollow ellipse permitted the construction of works that were daringly dramatic, massive yet transparent. In many respects, it inaugurated his career as a public sculptor.

In 1970, Linda and Harry Macklowe, who supported the cause of public sculpture by exhibiting works outside the office building they owned at Dag Hammarskjold Plaza, invited Liberman to show six of his large-scale works. Among the pieces exhibited were *Odyssey*, *Above*, and *Ascent*. (*292, 299, 289*) With very few exceptions, such as the early plexiglass and aluminum works, Liberman's sculptures were always conceived as outdoor works. However, not until the Hammarskjold Plaza exhibition had they been exhibited outside. As a result of this exhibition, the state of Hawaii com-

301

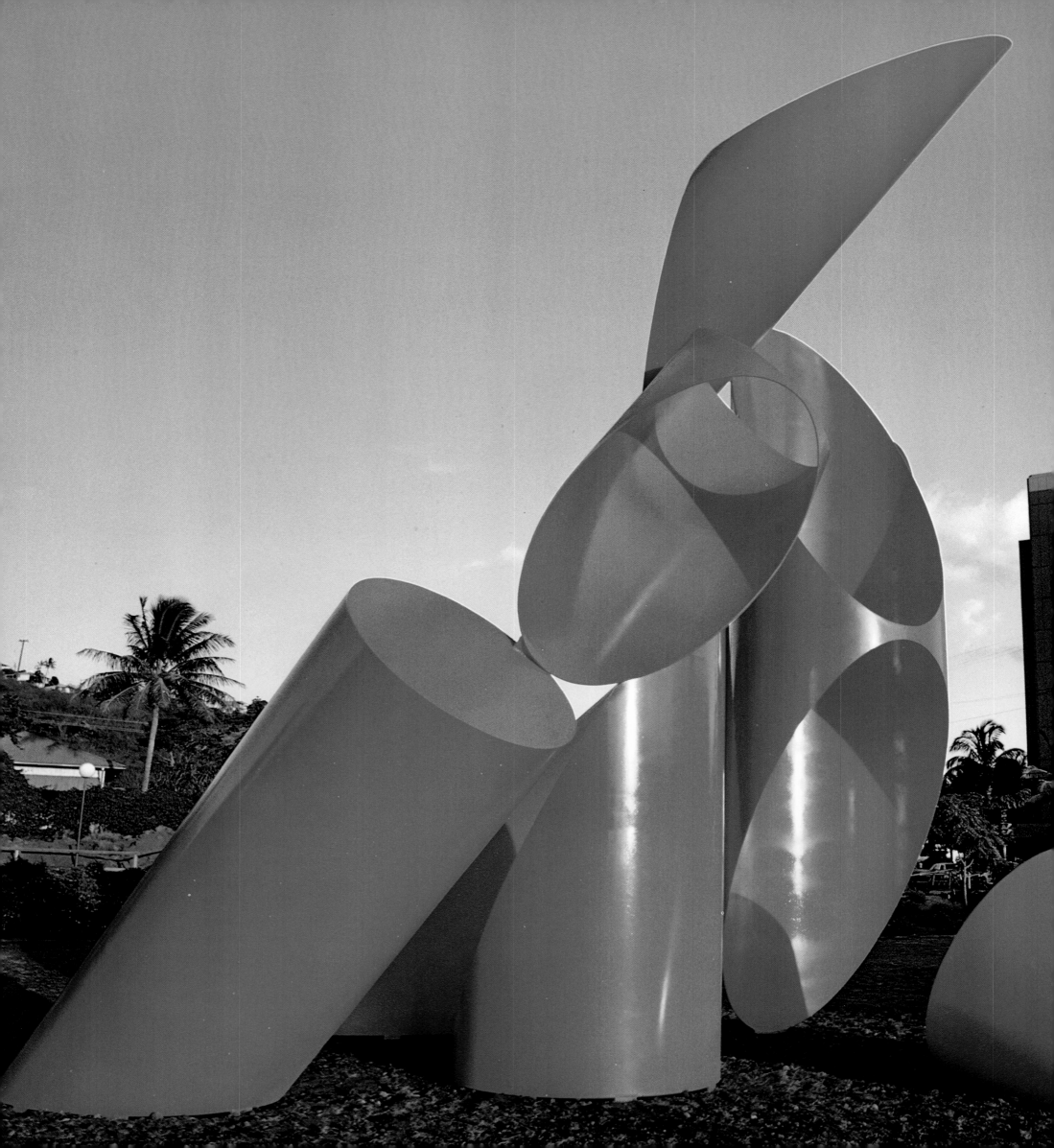

missioned a sculpture, *Gate of Hope*, for the campus of the University of Hawaii. (*295*) It was the first important public sculpture by Liberman to be installed permanently in a public place. To plan the sculpture Liberman traveled to Hawaii. The experience of discussing the maquette he brought with him changed his thoughts about public sculpture. A dialogue with the students, who wanted the massive forms opened up so that they could enter into the work—literally—altered both the work and his thinking regarding the proper forms for monumental sculpture. Deciding that the students were right —the spectator should be encouraged to engage intimately in dialogue with the work of art—he became committed to the idea of public participation with his sculpture.

Participation, in turn, suggested that the viewer was now the element of penetration in the work. We have seen that the theme of penetration was an essential leitmotif in Liberman's art throughout his career. Originally it involved the penetration of one form by another. Then it evolved into the penetration of space by solid form. Now the concept was further elaborated to mean the penetration of the work of art by the viewer, who could look up, through, and into a sculpture, which itself began to function more and more as a gateway, portal, or propylaea—a great overhead span like a bridge to be walked under.

During the Seventies, propylaea became a dominant structural idea for Liberman's public sculpture: as much in relation to interior as to exterior views. In some works like *On High*, recently installed in Federal Plaza in New Haven and *Symbol*, purchased by the citizens of Rockford, Illinois, to mark a town gathering place and serve as a symbol of their urban renewal program, tumbling ellipses span the distance between two pillars. (*323, 324, 325, 326, 327*) Even though the elements are dramatically cantilevered, the effect is not architectural because the forms are too dynamic and apparently unstable. The feeling resembles less a static building than the motion of an athletic ballet dancer's exuberant leaps. Because the form is conceived as an opening or portal rather than a solid volume, the immense scale does not become oppressive. The lightness and transparency of the cylinders, which are revealed as hollow, keep the forms

**295**

295. *Gate of Hope*, 1970-72
Painted, welded steel, approx. 35 ft. h. x 24 ft. w.
Collection University of Hawaii, Honolulu

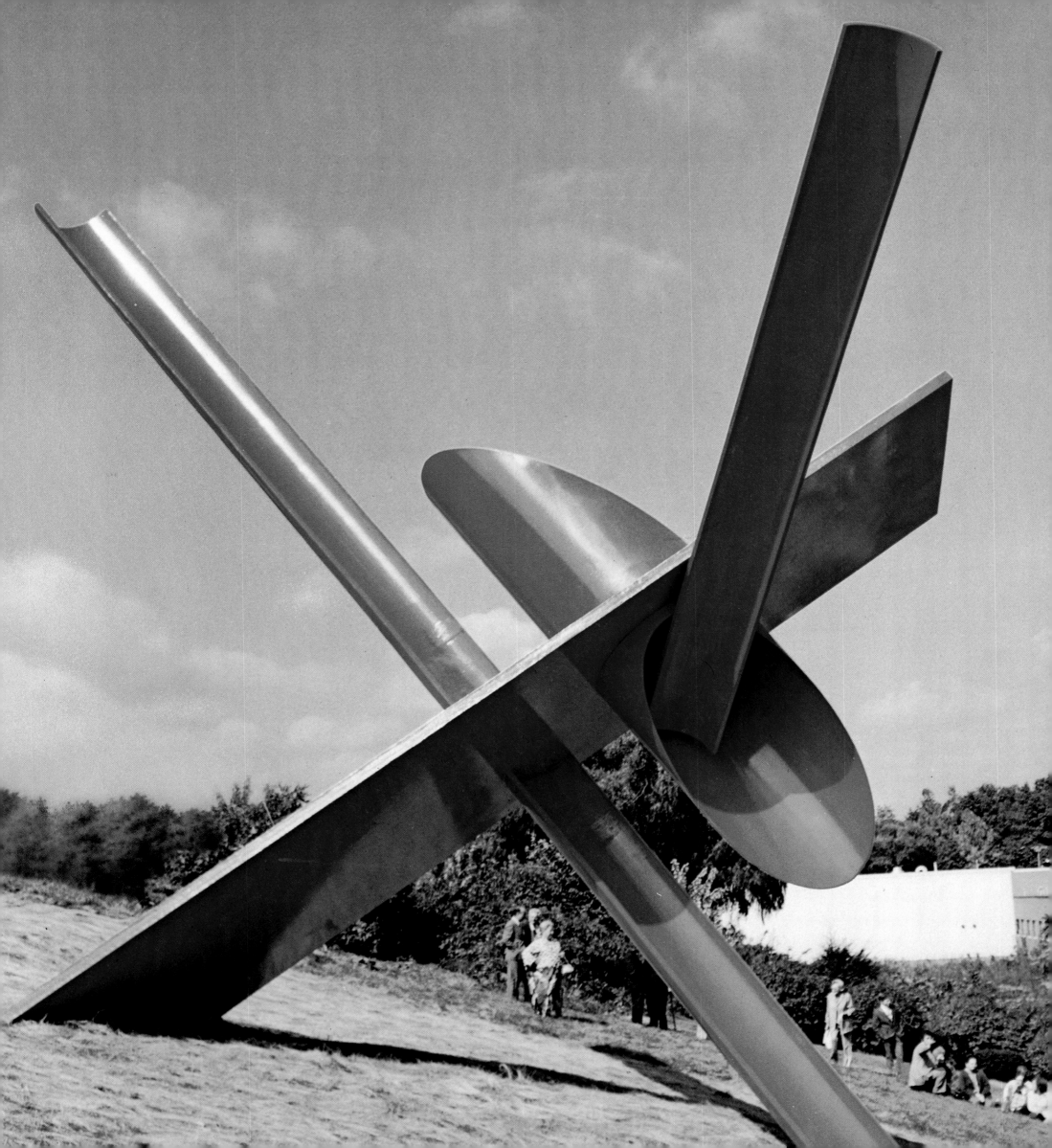

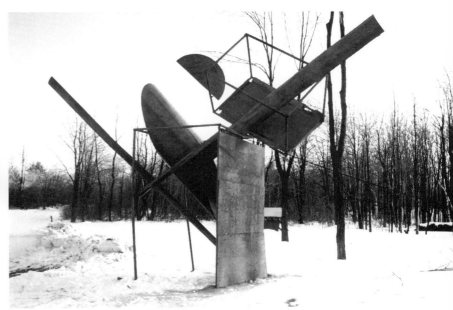

**297**

*There is a sense of thin planes drawn in space in
all three dimensions, moved at will to make contours,
to create enclosures and solid forms. The tendency
is to cut away or slice cylinders or volumes to build
into the piece sections that relate to the whole. We
are reminded of this thin, drawing-like skin of en-
closed space, rather than a contiguous solid chunk.
I think of spatial displacement rather than a solid.
Works are not like stones amassed. They are per-
ceived, felt as a spontaneous skin and line. They
displace, declare, and encompass space.*

296. *Icarus*, 1971
 Painted, welded steel, approx, 45 ft. h. x 24 ft. w.
 Collection Louis Hornick and Company

297. Earlier stages of *Icarus*, Warren studio, 1969

from becoming so massive that the spectator feels domi-
nated. As in the shrinelike sculptures, the viewer feels shel-
tered in the embrace of the work: He walks through the
forms and is not isolated from them; the overall feeling is
one of intimacy, despite the heroic scale.

The balletic somersaulting ellipses, which rise and leap
through space, are, according to Liberman, not a conscious
metaphor for dance. Though he admits that ballet was an
interest of his youth, he later rejected it. He was far more
impressed by views up into the great domes of cathedrals.
Indeed, the idea of entering a work is derived from architec-
tural space, which is penetrated by the viewer. Tony Smith's
exhibition of environmental sculpture in Bryant Park had also
impressed Liberman greatly. And he was excited by the
dynamic, changing views created by the zig-zagging levels
of highways he drove on every weekend on the way from
Manhattan to Connecticut.

In these ambitious public-scale sculptures, a diagonal el-
ement dominates. The space-activating gesture of the canti-
levered diagonal is at odds with the stable symmetry of
Liberman's early sculptures. The diagonal began to take on
importance in Liberman's sculpture in 1969-70, in works like
*Contact.* By the time he built *Icarus* in 1973, the diagonal
had become a virtual juggernaut, dramatically cantilevered
into space, defying gravity with its flying propellerlike form.

The new possibilities for permutations offered by the el-
lipse were rapidly explored by Liberman in works like *Above,
Within, Argo, Argosy, Ariel, Iliad, Above Above,* and *Ode*

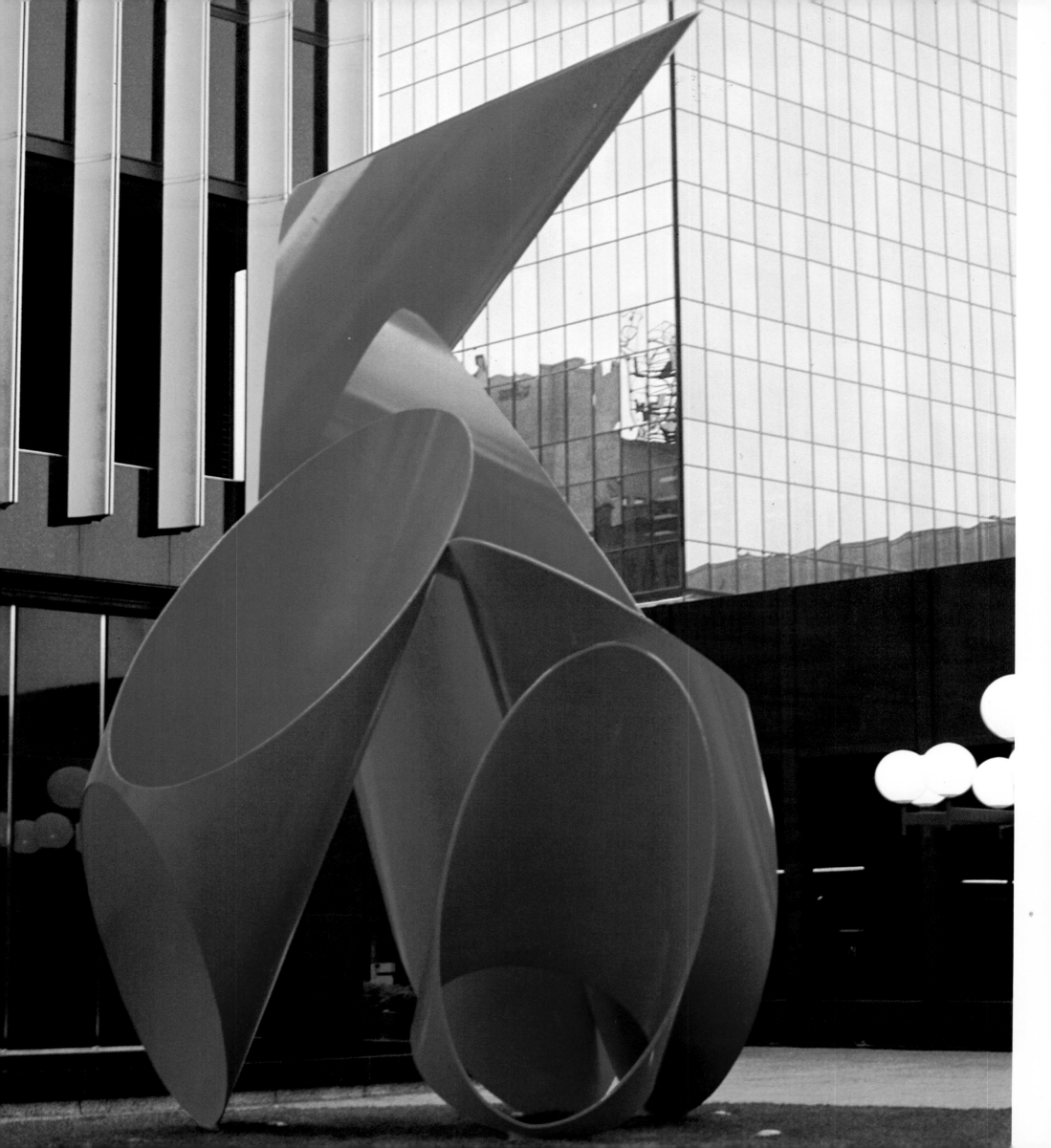

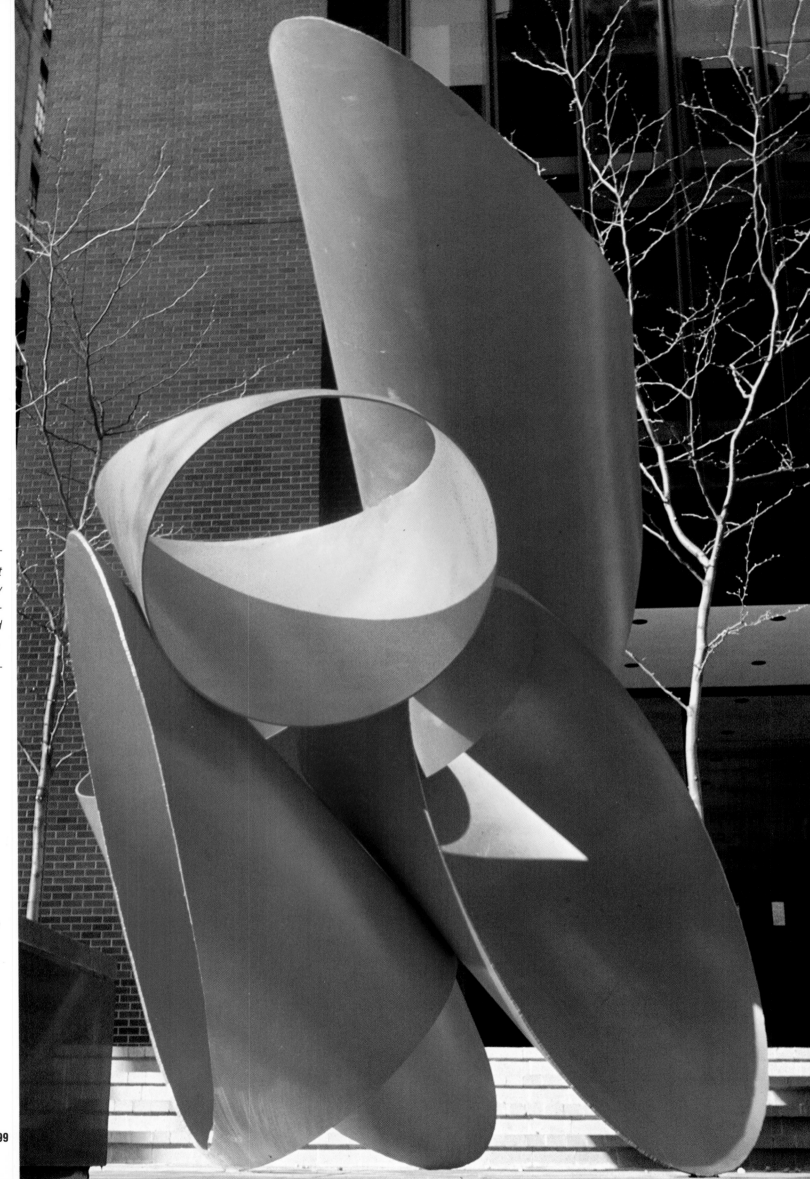

*Even the most monumental sculptures that you see are really throws of chance. Many of the cylinders that are in the air are really thrown in the air, literally assembled by me on a tentative emotional principle.*

298. *Above Above*, 1972
Painted, welded steel,
approx. 25 ft. h. x 12 ft. w.
Collection Economic Laboratory,
Osborn Building Plaza,
St. Paul, Minnesota

299. *Above*, 1970
Painted, welded steel, 14 x 12 x 8 ft.
Collection The Museum of Modern Art,
New York

FOLLOWING PAGES

300. *Ode*, 1976
Painted, welded steel,
23 x 11½ x 20 ft.
Collection Neiman-Marcus,
Northbrook, Illinois

301. *Ariel*, 1980
Painted, welded steel,
22½ x 11½ x 30 ft.
Collection Hialeah Associates,
United National Bank Building, Miami

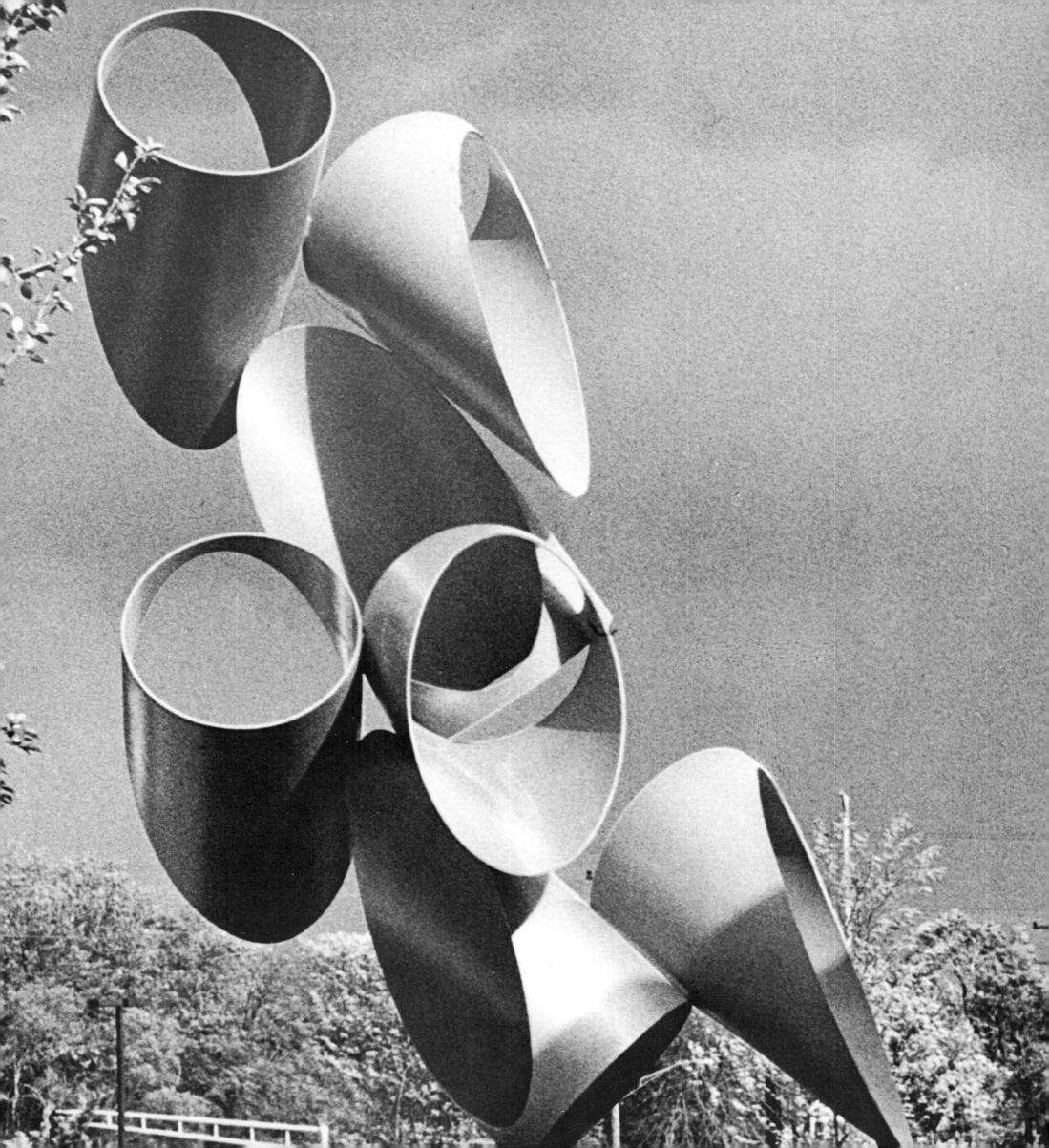

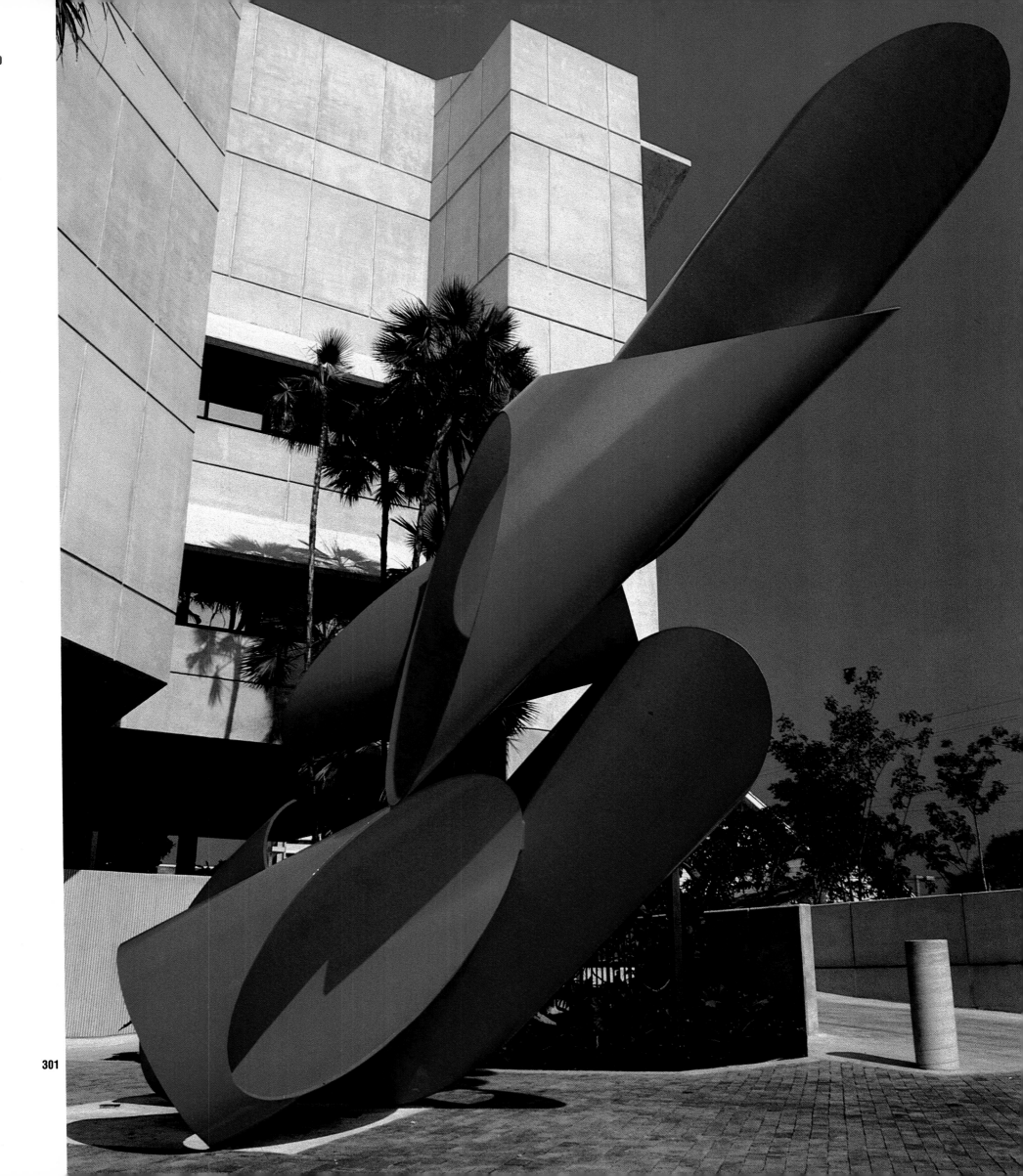

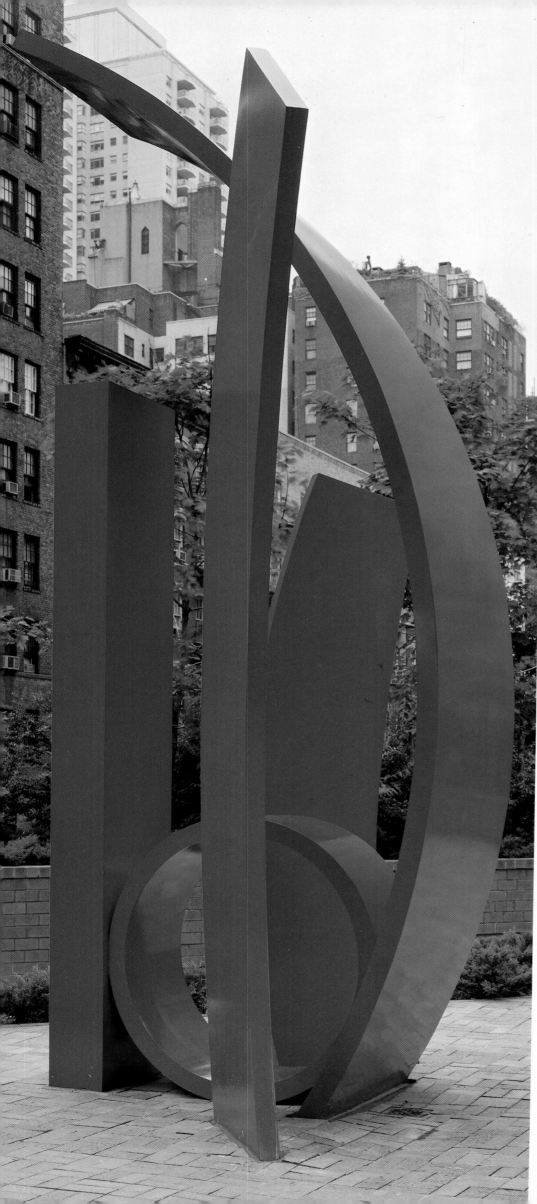

(*299*, *305*, *303*, *301*, *321*, *298*, *300*) In these the ellipse, like an element of grammar, takes on new meaning determined by its position, context, and relation to other elements. It is inverted, revolved, combined and recombined in a variety of permutations. The thinness of the metal suggests a skin or membrane: the solid-void of two-dimensional silhouetted sculpture is replaced by a more complex and sophisticated interaction between the inside and outside of form. This contrast in turn is played against twisting motion, rhythmic repetitions of similar or identical forms, to create a maximum complexity. Sometimes the effect is dizzying. Often the entire silhouette of a work cannot be perceived because the "blossoming" of ellipses takes place high over the head of the viewer, which makes it impossible to focus on silhouetted form. Liberman exposes its hollowness rather than exaggerating its volume.

However, the possibility of simultaneously perceiving exterior and interior, and the stress on the hollowness rather than on the solidity of volume was not an attempt to achieve the "truth to materials" or "truth to construction," which is the traditionally literalist interpretation of the modernist reduction. In opposition to prevailing ideals, Liberman made a conscious decision to strive for neither. Material and construction were only the means to something greater: revelation of the awe-inspiring experience that excited and amazed. In choosing drama and spectacle over truth to materials or exposure of construction—which he felt should be a miracle rather than an exposé of how a thing was made—Liberman parted company with the major direction of recent sculpture. For him, the soaring image of flight and the erotic image of penetration, the drama of asymmetry and the effect of defying gravity were uppermost. He would use any means necessary to achieve the sensation of ascension, the image of aspiration.

Liberman's attitude toward the architectural context of his sculptures opposes the current notion of the "site-specific" work, i.e., the notion of conceiving a work for a specific place. Since nearly all Liberman's sculptures are conceived and executed near his house in his own sculpture field, no more thought is given to the reality of context than to the exposure of materials or techniques. The increasingly architectural scale of Liberman's sculptures may be seen as a further

302

302. *Accord*, 1979
   Painted, welded steel,
   18½ x 11½ x 9½ ft.
   Collection 54th Street East,
   Benenson Realty, New York

303. *Argosy*, 1980
   Painted, welded steel, 30 x 18 x 16 ft.
   Collection Martin Z. Margulies,
   Grove Isle, Coconut Grove, Florida

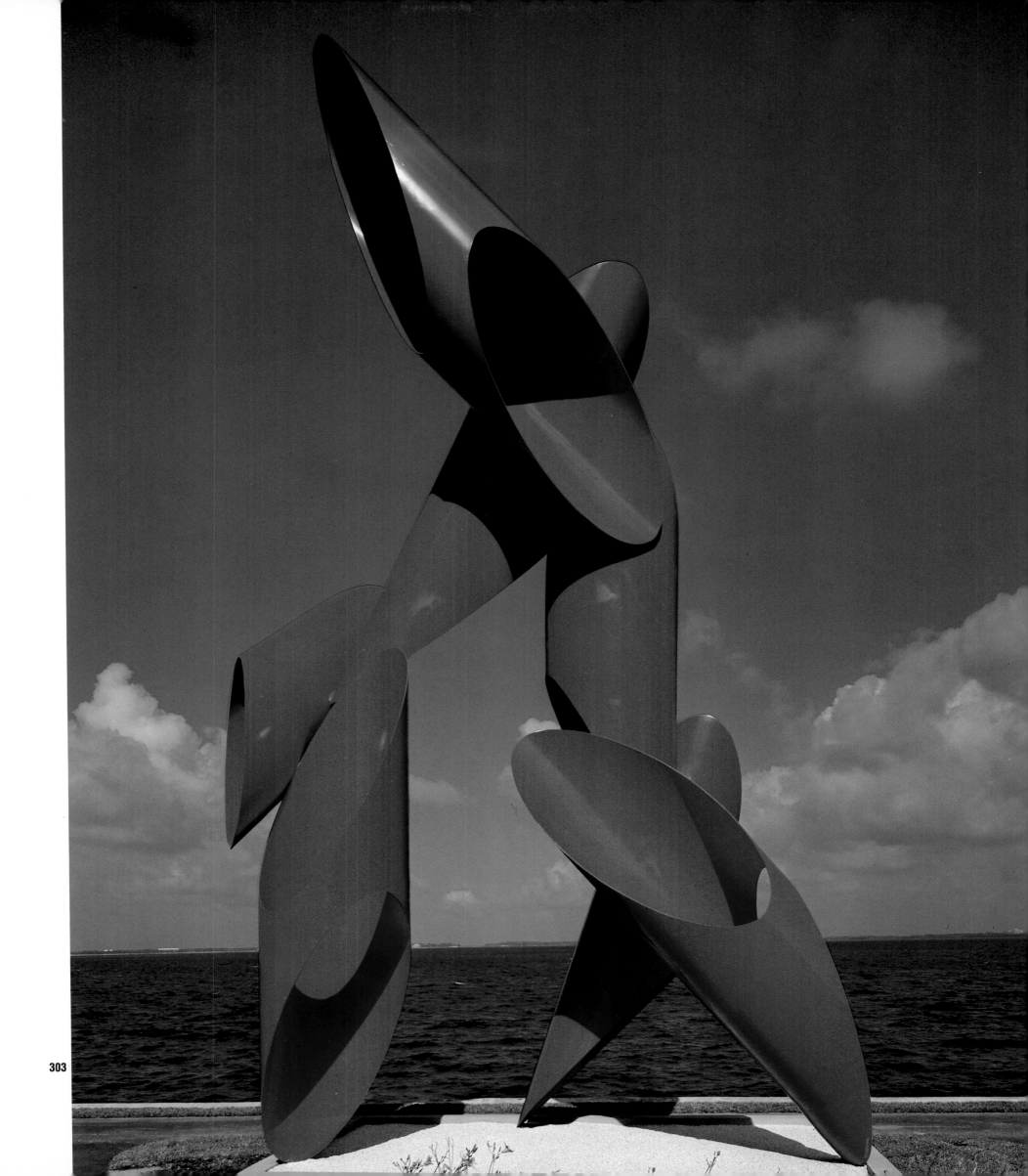

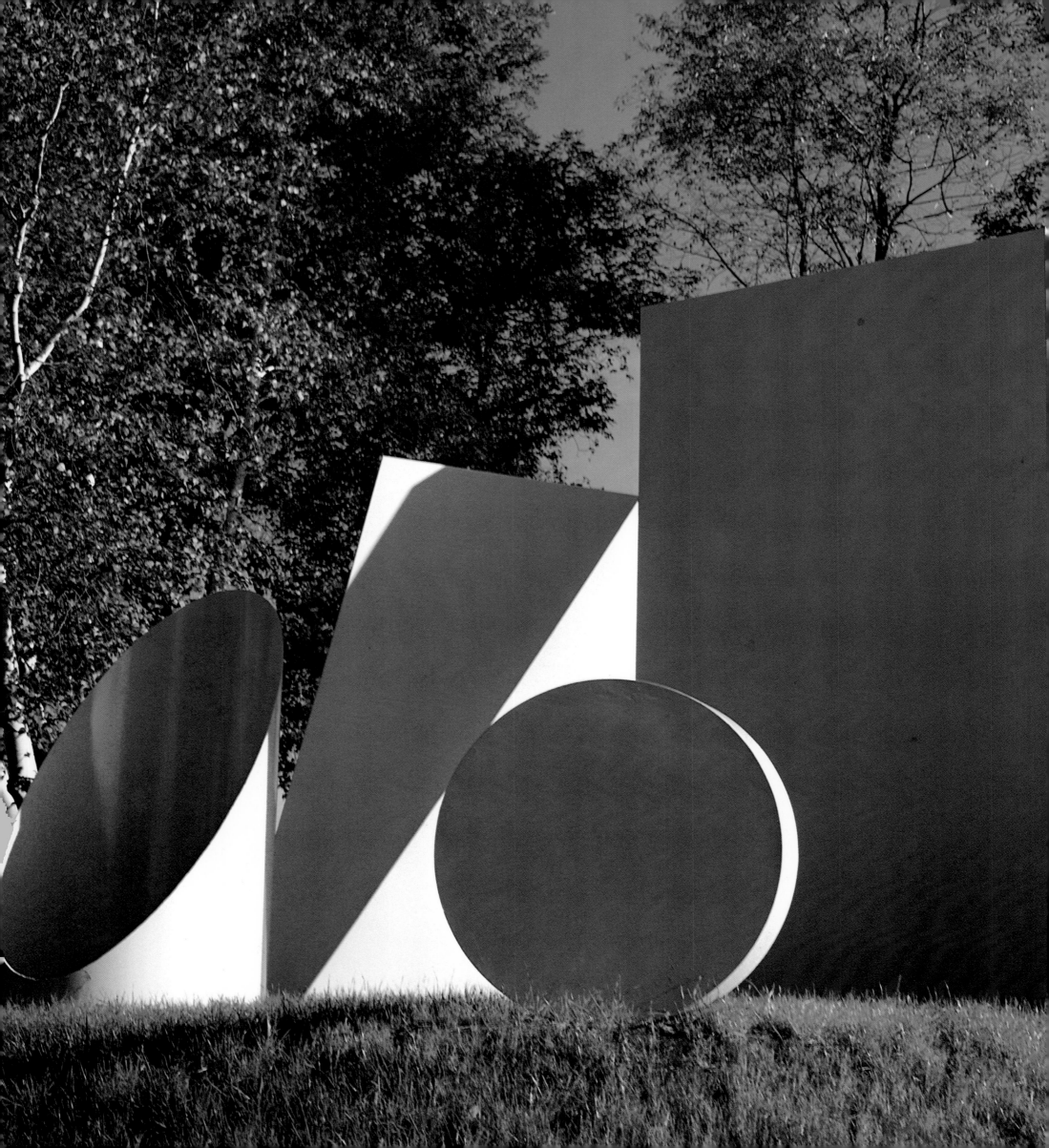

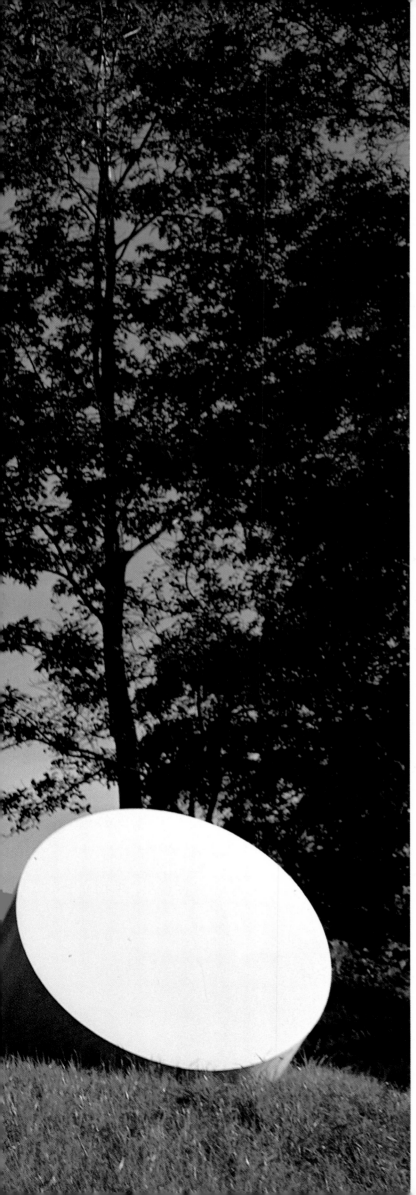

gesture on his part to ensure their autonomy from any given context. In their colossal scale, the sculptures proclaim an absolute independence; they are proud exiles from the urban landscape into which they may be thrust, just as the artist remains in many respects isolated from the various milieus in which he works.

Needless to say, the balancing and engineering of these grandiose works has become increasingly complex. To achieve the surprise of a mass of elliptical forms in the sky, bunched together like red helium balloons about to float away, Liberman had to consult engineers like Columbia professor Dr. Mario Salvadori and John Macchi who help him solve particularly difficult problems of support and balance. The diagonal element in *Ariel*, for example, was particularly difficult to cantilever because it rests daringly on three points. The thrust and weight seem to counter each other as if by magic. But in fact, three engineers worked on the piece until it was resolved. (Another had given up completely, contending it could never be done.) The idea put forth by Ouspensky that art is a form of magic had made a deep impression on Liberman. Indeed, the magical and visionary aspects of tossing heavy metal into the air and keeping it afloat comprise a major theme of his public sculptures.

Of the pieces done with ellipses, *Argosy* is the most complex. Its striding form is reminiscent of Boccioni's futurist *Unique Forms Continuing in Space.* The original cylinders were cut at nineteen different angles. Each ellipse is twisted slightly in space to achieve the maximum effect of contrapposto, leading the viewer to explore all sides of the sculpture; multiple and varying views come into focus as the work is perceived in space. When a piece like *Ariel* or *Argosy* is purchased to be permanently installed in a public site, Liberman orders new steel rolled and cut so that the element of junk sculpture is altogether lost. Yet something about the precariousness of the arrangements he creates suggests the momentary and fleeting sense of the improvised gesture with which the work was originally conceived.

The repetition of the ellipse has another function: It introduces a musical element; the ascending and descending forms of pieces like *Iliad* and *Symbol* suggest the crescendo and diminuendo of a musical passage. (*321, 325, 326*) Repetitions and inversions are analogues to fugal variations. In the case of a work like *Ode*, the tumbling ellipses suggest a glissando. (*300*)

304

304. *Behold*, 1975-78   Painted, welded steel, 12 x 23 x 17 ft.

Visionary architecture is the term given to the various styles that could be conceived but not built. In many respects, Liberman is a visionary sculptor, except that he has made his thoroughly impractical dreams into realities with the aid of modern engineering. Very early in life he became convinced that the will to art can transcend all—including physical and economic limitations. The idea that art is greater than reality led him to a style of sculpture that is profoundly antirealistic, a style that is the opposite of the exposed bolts of self-supporting constructions, and it led him to a more theatrical conception of sculpture as a visionary rather than a material experience. Liberman once suggested that he gave up architecture because it involved too much reality as well as too much compromise. Architecture, he found, was involved with pleasing clients. "The marvelous thing about art," he explains, "is that you please nobody. You please yourself. That is, you don't please yourself, but at least you do what you want to do." That greater freedom of expression was open to the artist undoubtedly persuaded Liberman to put his talent and knowledge at the service of sculpture, a more personal and individual art than architecture. However, his experience and training in that field created the possibility of creating work on an architectural scale, a scale that could compete with the massive structures of the urban landscape. Reminiscent of the colossal and imposing Roman baths and temples to the ancient gods, this scale suggested the wonders of the ancient world as well.

It has been said that the Russian mind is both mystical and childish. If this is true, it may explain why the "truth" for Liberman has remained that of the fairy tale, of the heroic adventures that defy the normal laws of logic or the practical reason of reality. Truth, for Liberman, is that which delights the child—daring, magic, spectacle, a world of giant beanstalks climbing the sky, of gay red and gleaming white pleasure domes like *Argo*, a world of theatrical delight and infinite pleasure and amazement. *(305)* It is a world of dreams-come-true, where disappointment and despair, if they exist, are acknowledged only in private.

*We live in an extraordinary age that has made things possible for the sculptor that were not possible at any other time. From an industrial point of view, from a technical point of view, the development of welding and rolling of steel, the engineering know-how opens whole new areas.*

305. *Argo*, 1973-74
 Painted, welded steel, 15 x 31 x 36 ft.
 On exhibit in "Monumenta,"
 at Newport, Rhode Island;
 now collection Milwaukee Art Institute

305

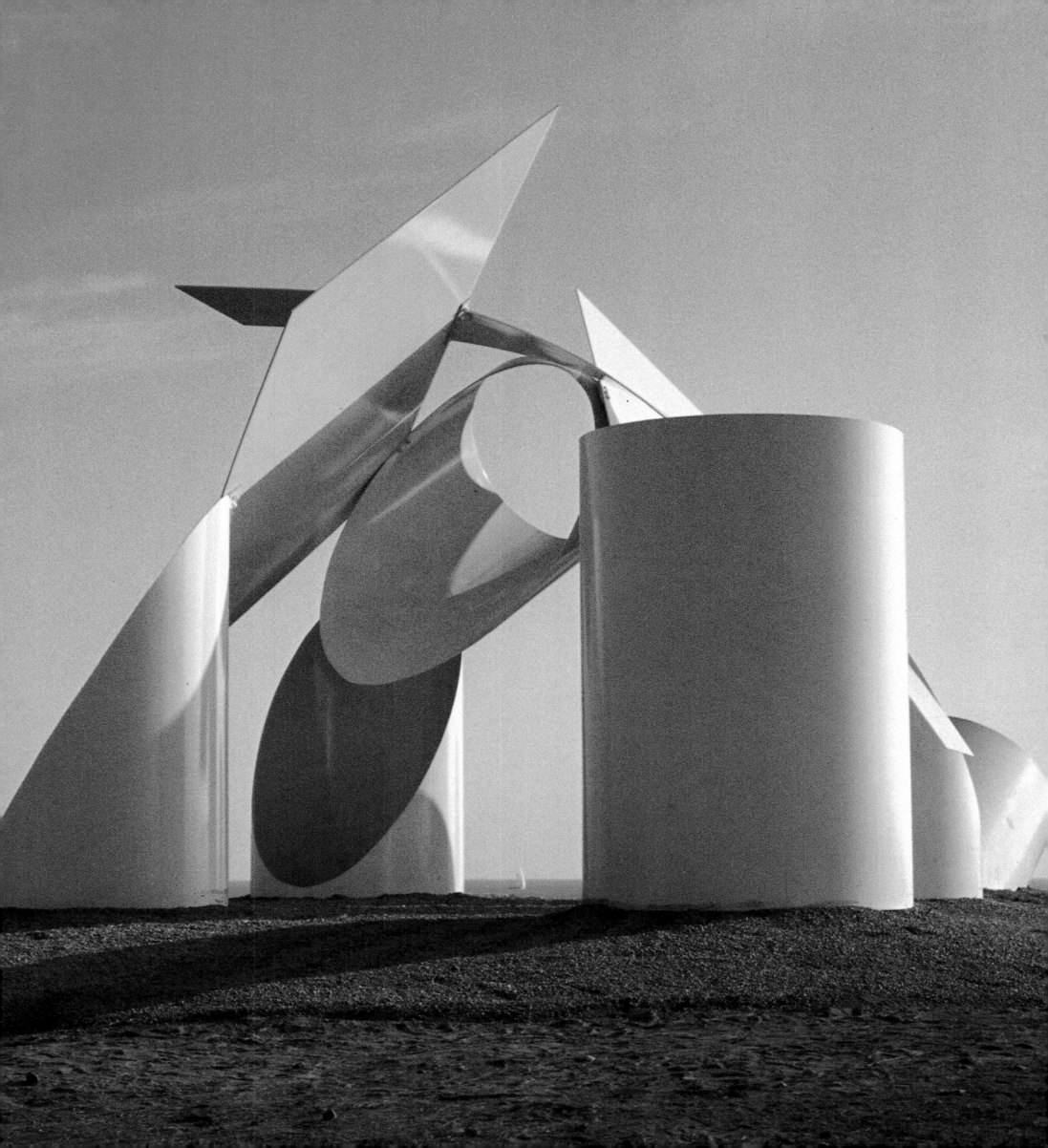

CHAPTER

# OPERA SERIA: IN THE END IS THE BEGINNING

*The American experience for me was an industrial experience, a rugged experience, a pioneering experience. I was frankly disgusted with the decadence of European civilization. After two world wars, the Russian Revolution, the Holocaust, what could these mandolins of Picasso or Braque, or the ballets of Diaghilev—all these ecstasies of aesthetics mean? All this flattery of a certain milieu when the realities were totally different! An artist like Goya at least participated in the historical reality, and Michelangelo participated in his religious drama. The modern artist turns everything into aesthetics.*

*In Henry James's description of entering into the Vatican, into St. Peter's, he describes the sense of penetration and explosion achieved when you enter through a small door. The main portal of St. Peter's is not open, it's a small door that is always cut in the big door. You enter through the smaller space, and then you walk down through the nave. You see this fantastic empty space. This feeling of explosion of space is architectural, but it is also possible in sculpture, given a certain scale. And environmental sculpture, abstract sculpture, is a wonderful means to choreograph public amazement. I think this function of sculpture in public places is very important.*

*Artists of the past were fed by literature. Today we are fed by a scientific environment. We see airplanes, we see rockets. This inspires a new scale. We see extraordinary oil refineries, incredible things for our imagination.*

*For the first time in thirty years, I'm not afraid to sign my paintings. I'm not afraid to draw a line which is my line. I make shapes in the sculpture now, too. I want to discover myself more and I'm not afraid to face myself. I was afraid of failure perhaps; it's quite possible that by using anonymous forms or found or a priori forms, I could escape myself. I am not afraid of my own hand any longer, I suppose.*

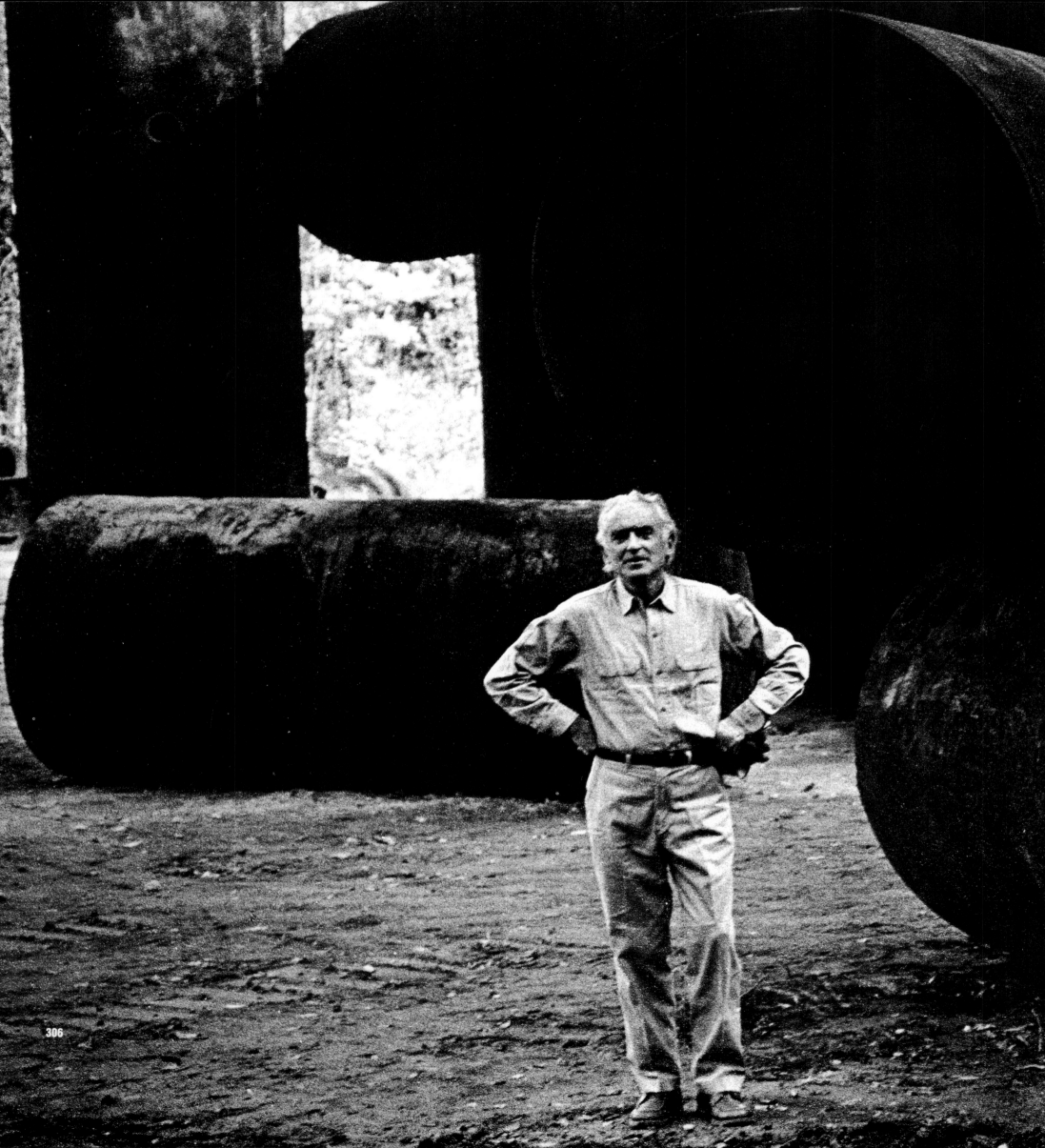

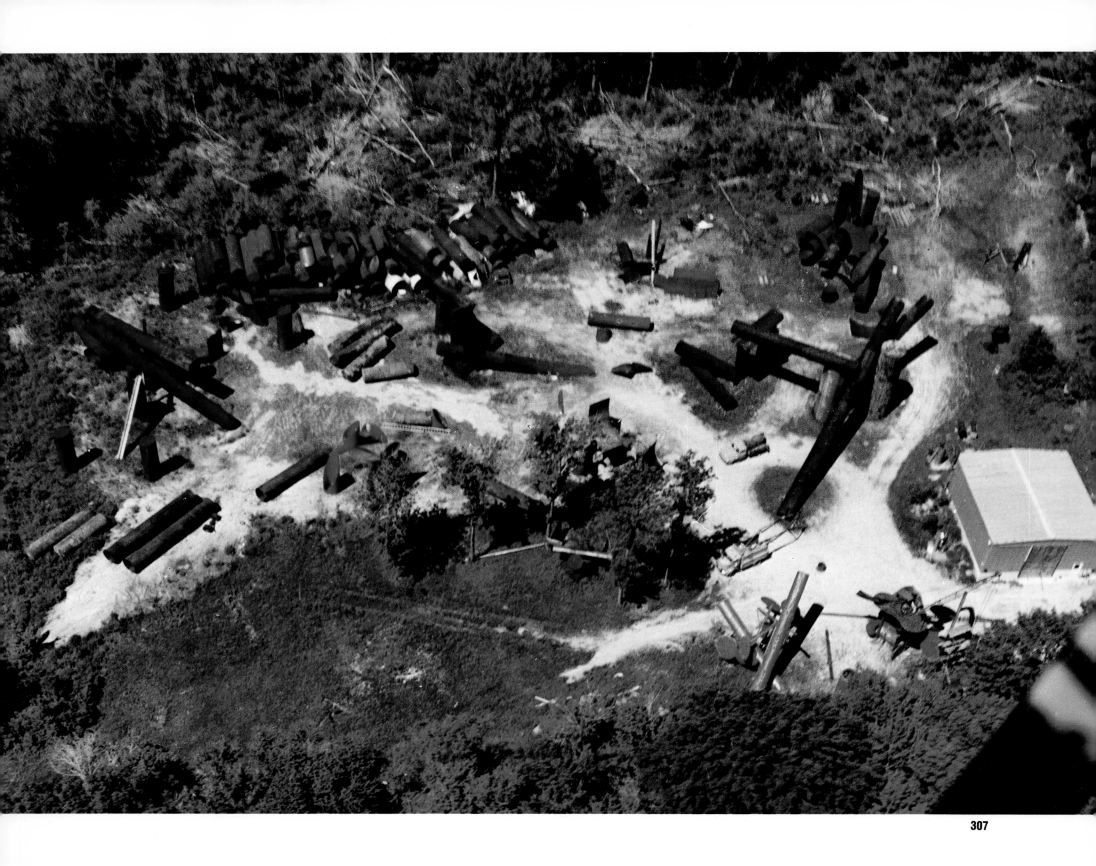

307

I remember practically every piece of metal lying around the studio and the field. They will lie sometimes for at least three years, these tanks. When I first tried to make a sculpture with them in 1968, I wasn't ready for it—I couldn't do it. The point is, you have to let things lie, and then somehow they work inside of you, and at a certain moment you're ready for them. It's mysterious what happens: You suddenly remember where a piece is, when you need it.

PREVIOUS PAGES

306. Liberman with *Adonai*, by Oliviero Toscani, 1971

307. Warren studio from the air, 1979

We Russians are living through an epoch which has few equals in epic scale . . . An artist's job, an artist's obligation is to see what is conceived, to hear that music with which "the air torn up by the wind" resounds . . .

What then is conceived?

To redo everything. To arrange things so that everything becomes new; so that the false, dirty, dull, ugly life which is ours becomes a just life, pure, gay, beautiful . . .

—ALEXANDER BLOK, *The Intelligentsia and the Revolution*, 1918

And geography blended with time equals destiny.

—JOSEPH BRODSKY, *Strophes*, 1978

IN RECENT YEARS, many sculptors, including David Smith, Anthony Caro, and Mark di Suvero, have painted metal-assembled works with a variety of colors to unify them and protect them against the weather. Alexander Liberman paints his large public sculptures when they are permanently sited outdoors. However, he uses only three colors: black, red, and white. These are the colors that the Russian Constructivists identified as appropriate for public monuments, assigning symbolic values of communication to each. The constructivist element in Liberman's work has been noted by historians of the movement such as George Rickey and Willy Rotzler, both of whom included Liberman in their surveys of constructivist art. Most artists who have worked within the constructivist tradition after World War I, however, took their geometric forms and techniques of assemblage from the lessons of the Bauhaus, where Kandinsky designed a course combining Malevich's ideas of a disembodied, transcendental spiritual art with Tatlin's call for a public art made·with industrial techniques and materials.

Unlike these second and third generation Constructivists, Liberman has a more direct and privileged relationship to the original movement. Although most children begin to draw representationally at an early age, as a child in Moscow and a youth in Paris, Liberman drew and painted in an abstract style that can only be described as constructivist. (see Chapter I and *11, 12, 13*) His brief stint as apprentice to the designer Cassandre, a Russian émigré in Paris who had adapted Rodchenko's revolutionary graphics to the needs of capitalist advertising, simply reinforced Liberman's basic formation as a Constructivist. However, because the period between the two world wars was essentially reactionary and academic, when Liberman began to pursue art seriously as a young man in Paris, he worked in highly realistic style, trying to impress his parents and the teachers with his seriousness; and to rival the old masters he studied their technique. Not until he was separated from Europe and his parents could he return to the style of his childhood.

One of the most brilliant, original, and radical art movements of the twentieth century, constructivism combined cubist aesthetics with an ideology and iconography flavored by futurist utopian thought. In its broadest sense, it joined the occult mystical art Malevich termed "suprematism" to the utilitarian offshoots such as Tatlin's "productivism." These two aspects of constructivism, the poetic and religious art of Malevich and the materialist literal art of Tatlin, seem diametrically opposed. Yet their art shares certain characteristics—characteristics which also define the unity of Liberman's art. Sometimes Liberman has expressed Malevich's spiritual sensations and transcendental aspirations and at other times Tatlin's literalism and call for a people's art. Both Malevich and Tatlin, as different as they were, were fascinated with the idea of aerial space. The novelty of airplanes and the futuristic overtones of aerial photography, which Malevich practiced, impressed them in different ways: For Malevich, the sensations of floating free of gravity implied an image of the spirit free of matter. Space, for him, was both the empyrean of transcendence as well as the means to signify pictorially the mystical concept of infinity. For Tatlin, flying had its own symbolic meaning. Forsaking sculpture during the years following the Revolution, he spent most of his time on two thoroughly impractical projects: *The Monument to the Third International* and a complicated wooden construction resembling a glider he called "Letatlin." (*Letat* in Russian means "to fly.") This bizarre item presumably could, like the machine drawn by Leonardo, turn man into a bird. When questioned regarding the relevance to the proletariat of such a contraption, Tatlin replied ambiguously, "Does not the proletariat also need gliders?" His response indicates the degree to which the Constructivists were essentially poetic dreamers, not the hard-headed realists they pretended to be.

We have seen how the theme of defying gravity, of floating forms in an infinite space, eliminating any reference to earthly horizon lines, is an essential unifying factor in Liberman's paintings. Antigravity is also expressed in his sculpture, in the creation of which transparently weightless volumes lack the density associated with mass and appear to ascend. Recent suspended works like *Shuttle* recall the airborne imagery of *Letatlin*. The other consistent feature of Liberman's painting and sculpture, once he dropped the static, iconic circle motif, is his use of the diagonal, either as a thrust across the canvas, or as a soaring and jutting form in his sculpture. The emphasis on the diagonal thrust is a distinguishing feature of *all* Russian revolutionary art, including the reactionary

socialist-realist style imposed by Stalin as soon as both the avant-garde and constructivism were banished. The diagonal connotes forward movement, dynamism—i.e., revolutionary progress—whether it is in the tilt of Tatlin's *Monument to the Third International*, the radical cantilevering of Vesnin's monument to Lenin (which is echoed in many of Liberman's public sculptures), or in the aggressive posture of peasants thrusting themselves into the future or workers with arms and clenched fists raised.

In Liberman's art, the symbolic gestures pointing upward and forward, with their revolutionary associations, are an atavistic content. Their symbolism in the context of capitalist public sculpture is necessarily as ambiguous as the meaning and purpose of Tatlin's glider in the context of the Leninist conception of proletarian needs. Whether these gestures of defiance in a contemporary context continue to carry any political significance is unknowable. However, it is certain that they are the contrary of the pessimism, demoralization, and despair that the Hungarian Marxist critic George Lukacs has described as the signs of the death of culture in late capitalism. Resisting entropy, Liberman continues to create an affirmative art. If there is something as mad as Tatlin's glider in his pursuit of the heroic in an unheroic time, it is no madder or less exemplary than Don Quixote's maintaining ideal aristocratic values after the chivalric code he had been raised to uphold was no longer practiced. The plight of the brave *hidalgo*, whose values are swept aside by the rise of a new social order, has been interpreted, as by Ortega y Gasset, as the inevitable fate of the heroic ideal in a mass age. In such a time, the hero is left to battle only the phantoms of his own imagination, the constructs of a mind too stubborn to admit that the heroic tradition is dead. In holding fast to such a tradition, Liberman displays a stubbornness that defies reality.

Among the most striking sights Liberman had experienced as a child in Moscow were the temporary monuments to the heroes and leaders of the Revolution. These huge improvised constructions were connected with the agitprop movement to inform the illiterate masses. They were colorful,

308. *To*, 1973 Welded steel, approx. 30 ft. h. x 36 ft. w.

**308**

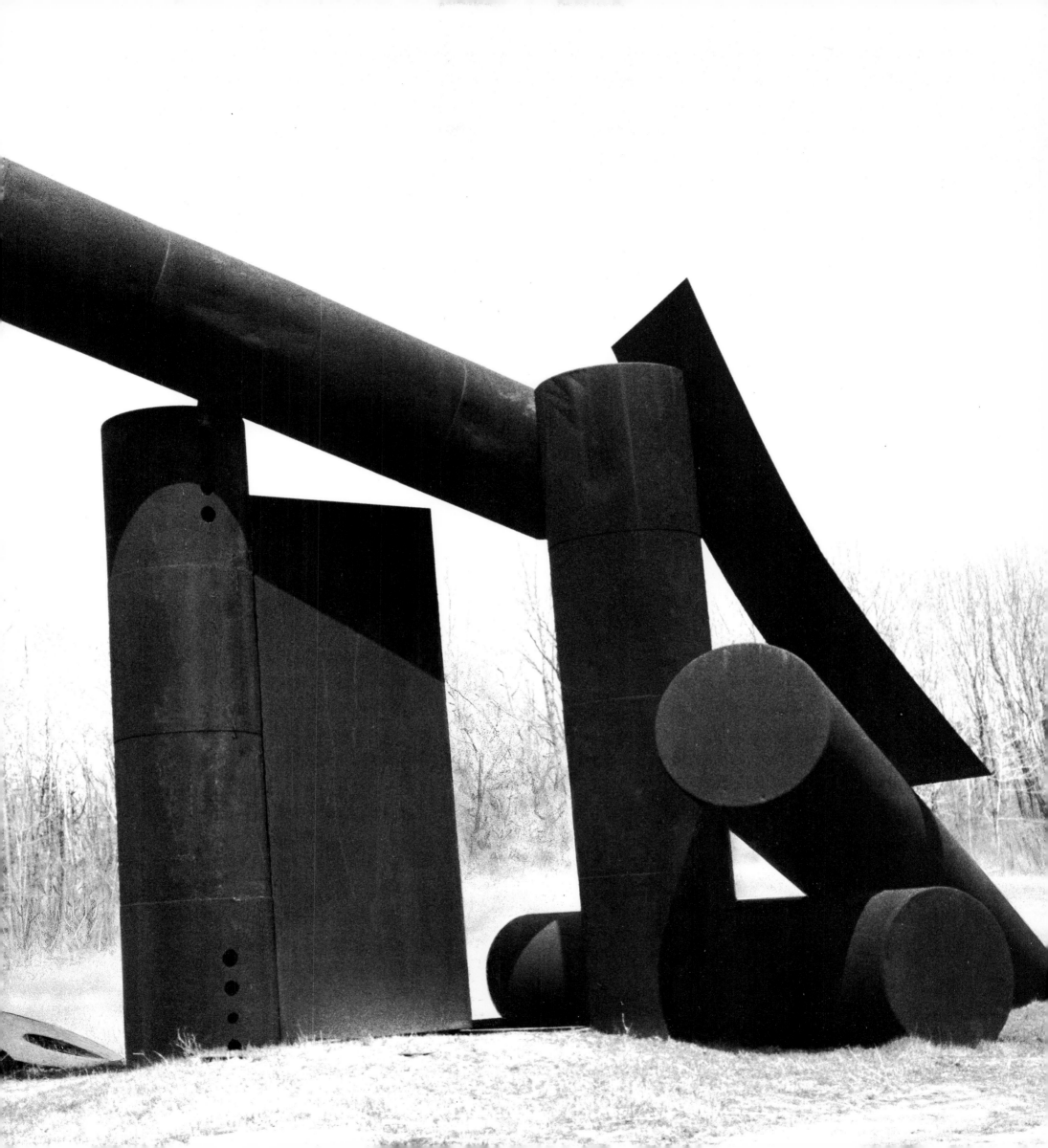

brash, three-dimensional versions of the ROSTA posters displayed in shop windows. They impressed the young Alexander with the idea that art should be spectacular, immediate, and accessible, rather than precious. An art of the streets and parks rather than of museums and palaces seemed natural to him as a result.

Although he did not consciously think of constructivist sources as he began working on a colossal scale, when he saw the Paris-Moscow exhibition of constructivism held at the Centre Pompidou (the Beaubourg Museum) in the summer of 1979, he was shocked to realize how much of the material was familiar to him, either because he had seen it on the streets of Moscow before his family went into exile, or because of the frequent trips he had made in 1925 in Paris to the Soviet pavilion of the historic Exposition des Arts Décoratifs. These trips are reflected in the drawings he made at the time. (See Chapter I and *13*, *14*, *15*) At the Soviet pavilion he clearly remembers seeing maquettes for the Utopian constructivist architecture, including the model for Tatlin's never-executed *Monument to the Third International.* The pavilion itself, designed by V. I. Melnikov, was the only genuinely constructivist building ever erected. Its soaring diagonals, directing vision upward, particularly impressed him.

E. C. Goossen has seen Liberman as quintessentially American. In his article, "Alex Liberman: American Sculptor," Goossen asked, "Why, as a late transplant, has [Liberman] been so successful in striking into the heart of what is acceptable to the peculiarities of the American tradition?" Yet despite its definitively American flavor, Liberman's art has subsumed elements of European modernism, since his aesthetic was thoroughly formed early in life. His recent paintings have strong *tachiste* and *informel* elements, reflecting his continuing admiration for Miró and the artists he influenced such as Tapies and Henri Michaux. Indeed, Liberman could well be described as the last bona fide member of the School of Paris. At the same time, there is reason to hold that he is also the youngest of the Russian Constructivists, the last living link to the original movement.

If we look at the roots of constructivism, we find that the idea of art as theater was essential to the constructivist aesthetic. Constructivism was in many respects an outgrowth of the revolutionary theater and its ideals: The first nonobjective suprematist painting, for example, was not done on canvas. It was Malevich's theater curtain depicting a white

309. *In*, 1973
  Welded steel, 40 ft. h. x 53 ft. w.
  Collection the artist;
  on loan to Storm King Art Center,
  Mountainville, New York

**309**

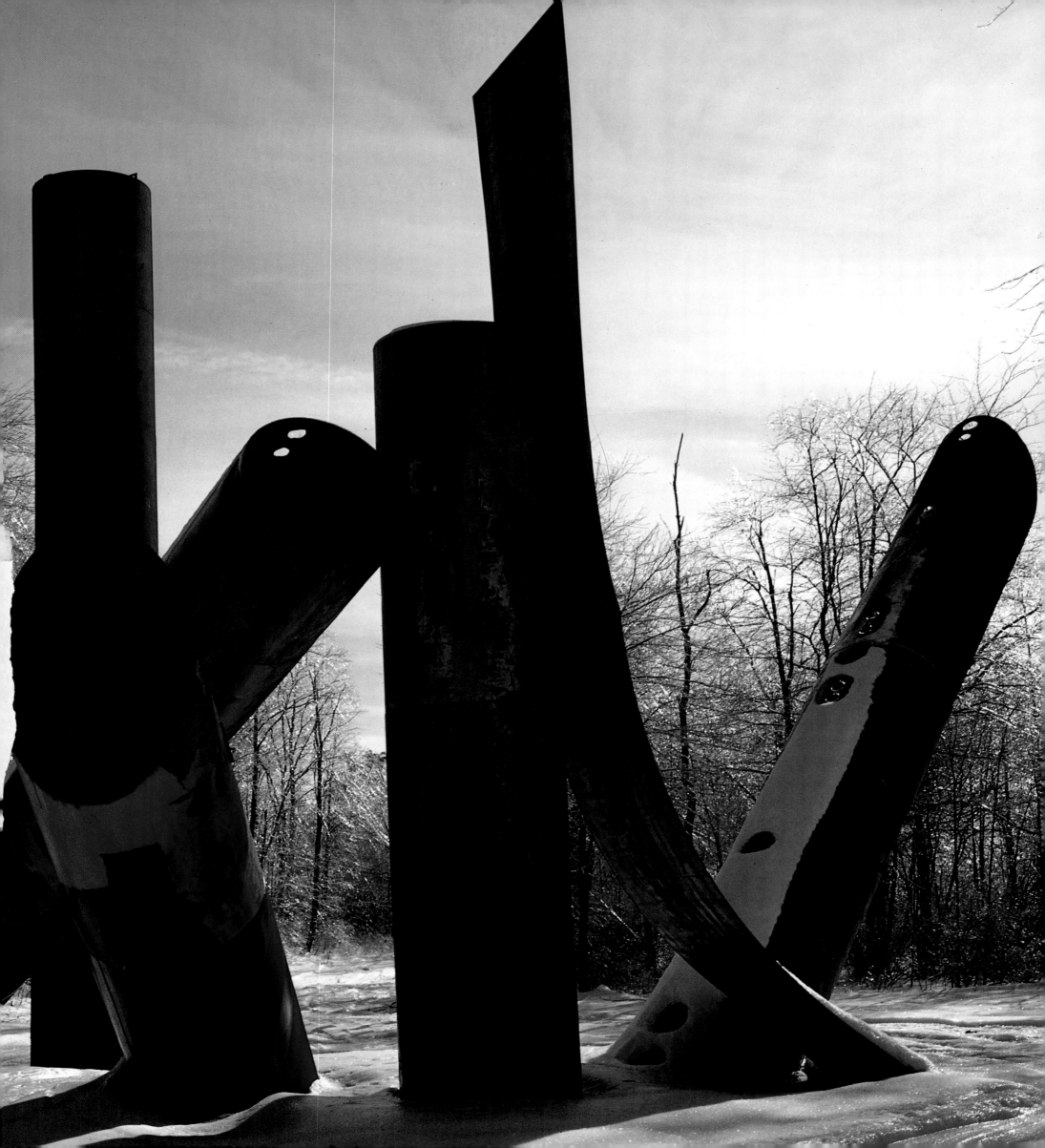

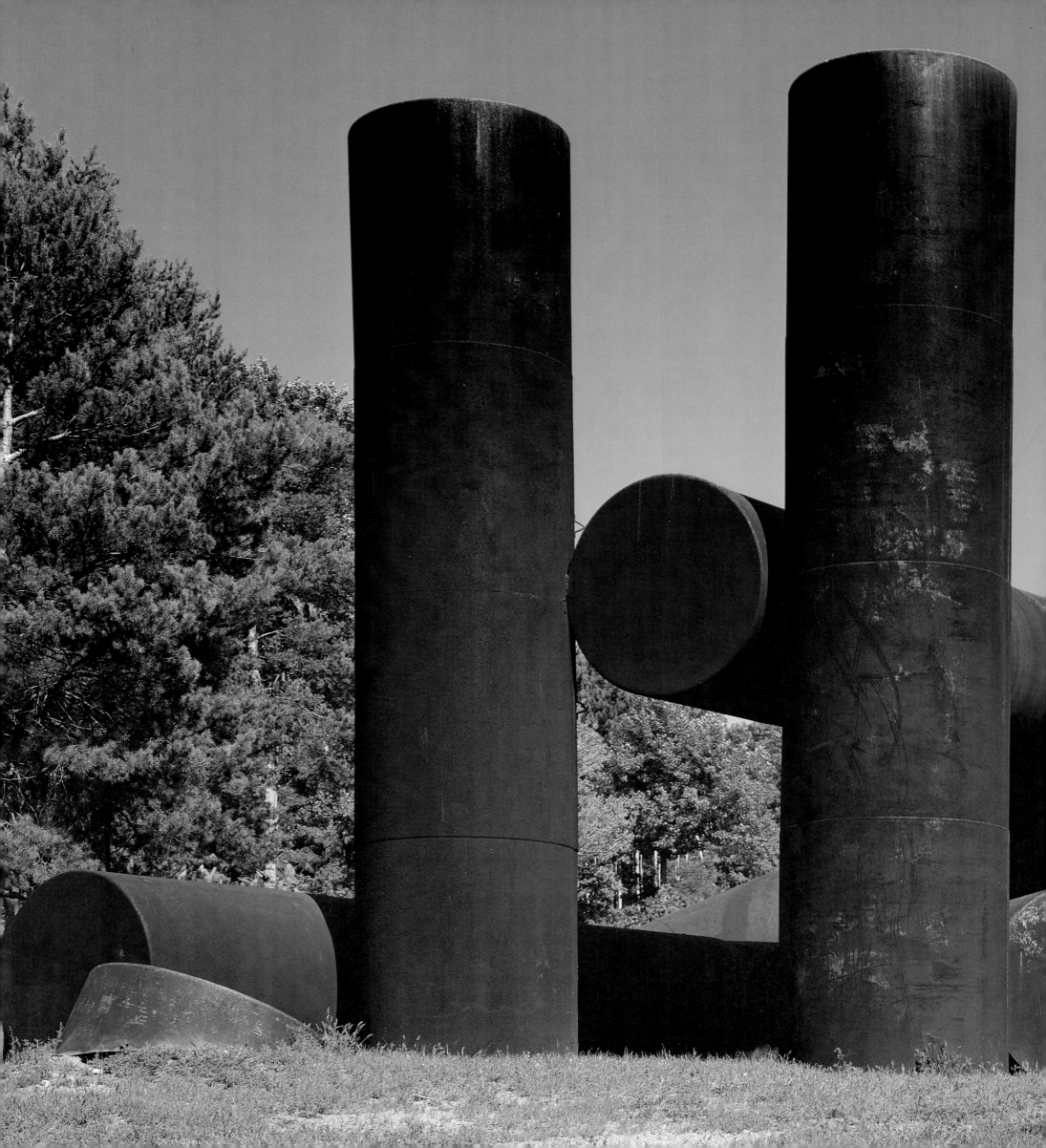

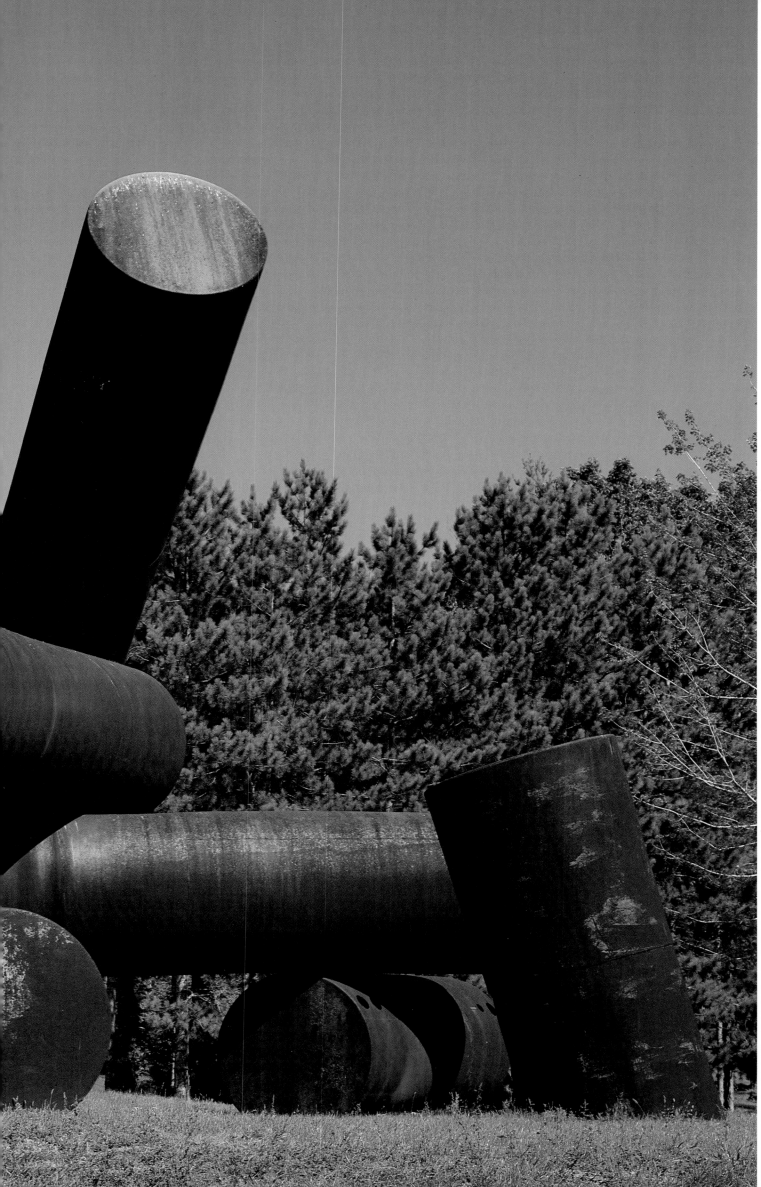

I had gone to Chartres. I was trying to analyze why cathedrals started with the basic portal. So I started with the basic portal, the two vertical cylinders of Adonai. Then there's a nave. If you look at the long horizontal cylinder of Adonai, *that's my imaginary nave. The flat circle of the cylinder, which is frontal, is held by the two uprights. You build your own imaginary cathedral. I've always admired the* Facteur Cheval, *and Simon Rodia who built the* Watts Towers, *people who performed gratuitous acts, but ones that left a tangible trace of their dreams.*

*When you load a pile of tanks, you see tanks in different positions. I mean, loading or unloading, you get a sense of scale. The tank comes alive when it's raised, say, 45 degrees. A tank that looks like 18 feet on the ground looks like nothing. But 18 feet standing up it is quite overwhelming.*

310. *Adonai*, 1970-71
Welded steel, 35 x 50 x 75 ft.
Collection Storm King Art Center,
Mountainville, New York

310

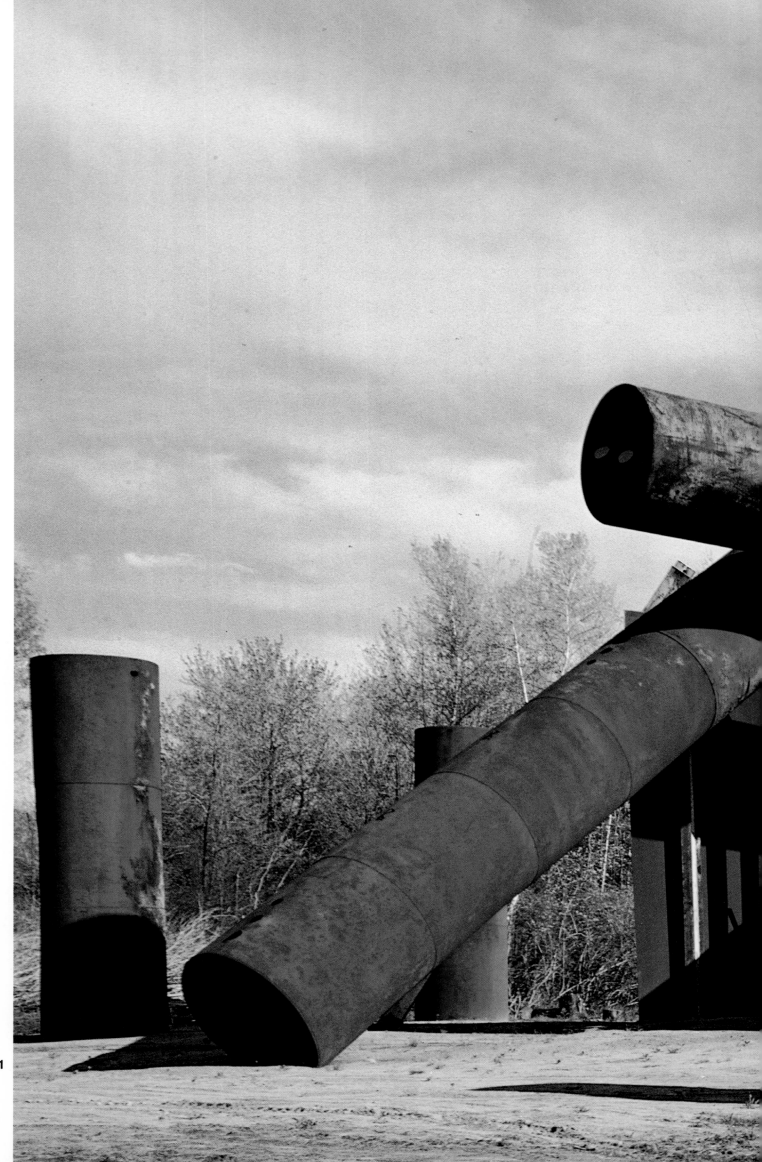

I use cheap materials for economic reasons. But also, there's a deep, maybe a romantic longing to contact the earth. I like rust. I like earth. I like rocks. The quality of a primitive forge anchors a modern mind to the earth. I think the modern mind has a tendency to fly off too easily. So I like the weight of impossibility.

I find the mercantile aspect of art appalling. In many ways I have felt happier with a job, keeping my art to myself. People come into my field and say, "Where is this sculpture going?" Nowhere. I mean why should it go somewhere? You do it because you have the necessity or the desire, or because it is in you to do that. I don't need a reason to do crazy things.

311. *Rite*, 1975
Welded steel, 45 x 102 x 87 ft.     **311**

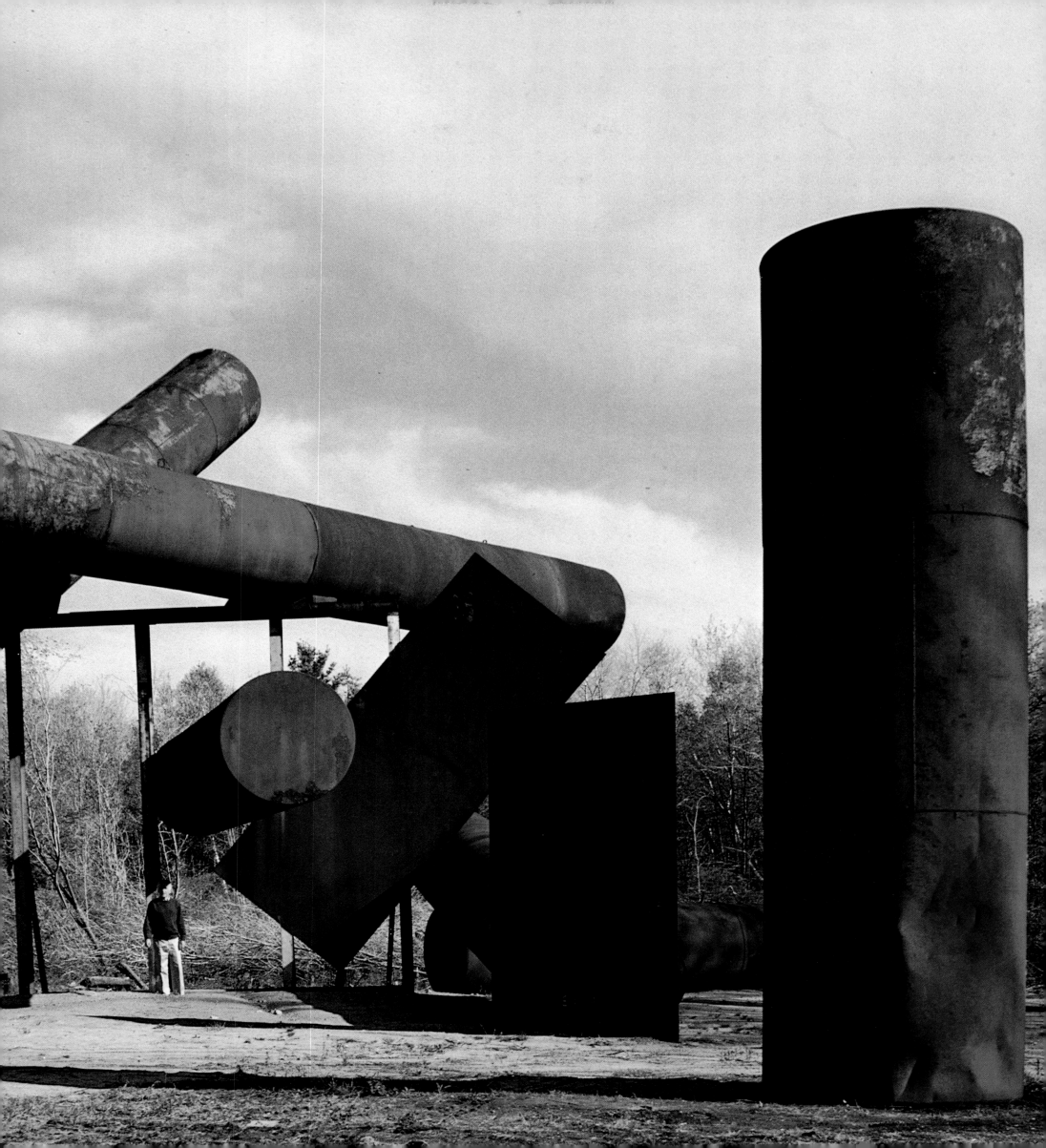

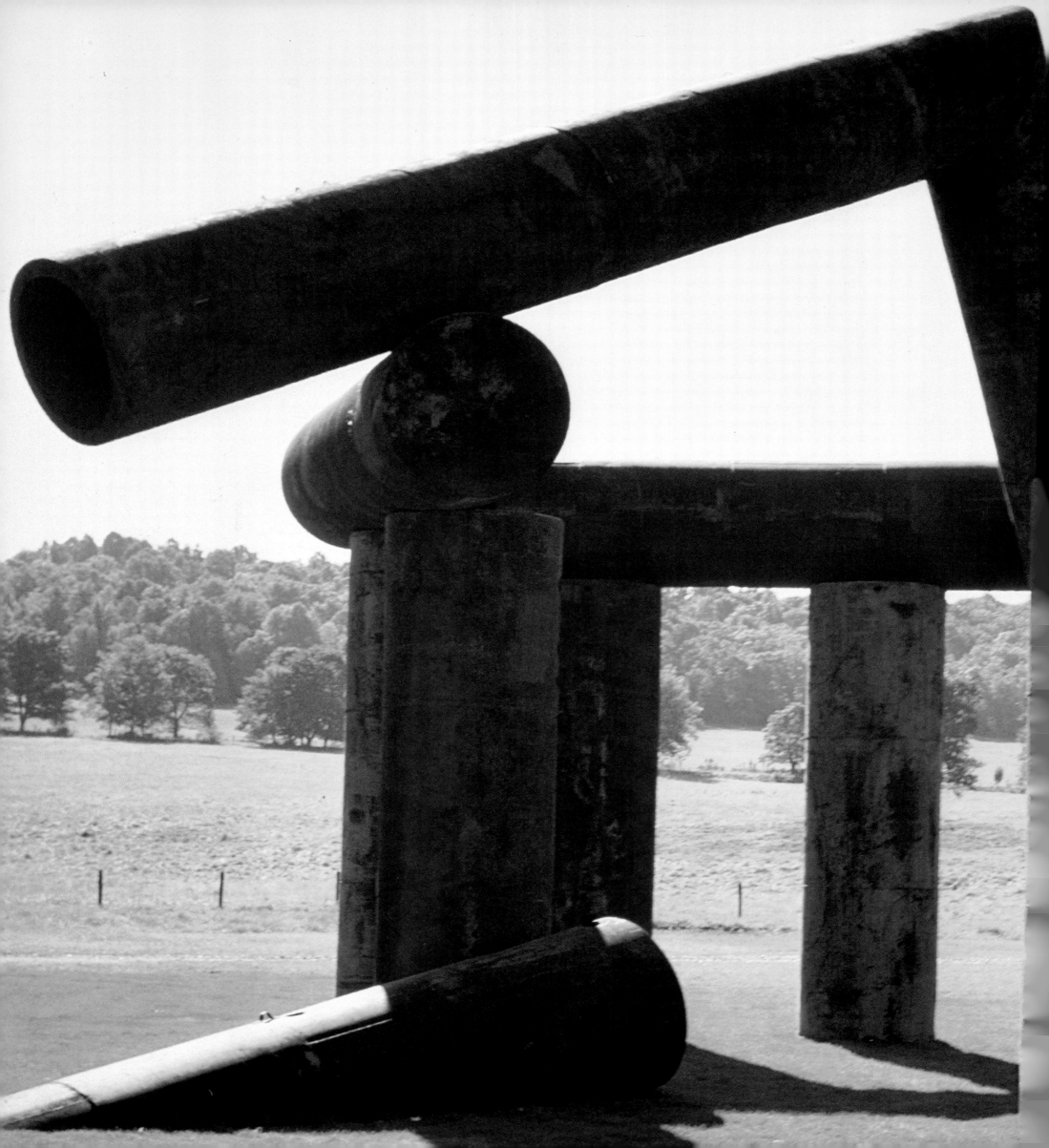

square on a black field designed for the original production of the avant-garde opera, *Victory over the Sun.* Later, El Lissitsky did sets and costumes for the same opera, which celebrates man's taming of nature through technology. This triumph of industrial progress is symbolized by the harnessing of the sun's energy—a thoroughly contemporary theme. Liberman was only a child when *Victory over the Sun* was discussed and performed. However, its central image of the sun pulled down from the heavens by man is the first theme he painted as a mature artist, and may be the origin of the circle motif.

Virtually every major Russian avant-garde artist was involved with the revolutionary theater. Many designed sets for opera and ballet as well. Exter, Gontcharova, Larionov, Chagall, Lissitsky, Malevich, Mayakovsky, and the others all worked for the theater. Even Kandinsky felt that "the creation of monumental art would be most conveniently worked out in the theater." The theater set, in other words, provided a direct use of the images. Mayakovsky considered his work in the theater his most important communication with the masses. Of his popular proletarian play *Mystery-Bouffe*, once performed in a German circus arena, he wrote: "These are but . . . theater properties. Tomorrow their poor stuff will be replaced by firm realities." Theater thus permitted a temporary glimpse of the brilliant new age that the Revolution was to make a permanent reality. In constructivist texts and manifestos, the artist was frequently described as the director or the engineer in his primary role as the shaper of public spectacles.

Theater for the Constructivists was more than entertainment and distraction for the starving masses: it was a metaphor for revolution. The world was a stage whose sets could be changed in a split-second blackout. In the theater, everything could be made new right away—clothing, architecture, furniture, city streets, etc. In the theater, and as it turned out, in theater alone, the Constructivists accomplished the total revolution of the environment they sought. Classical shapes, freed of historical connotations by the Revolution, could immediately replace the outwardly academic forms. The world, it was presumed, would follow the example of the revolutionary theater. For one unique moment in revolution-

**312**

312. *There*, 1973 Welded steel, 39 x 60 x 48 ft.

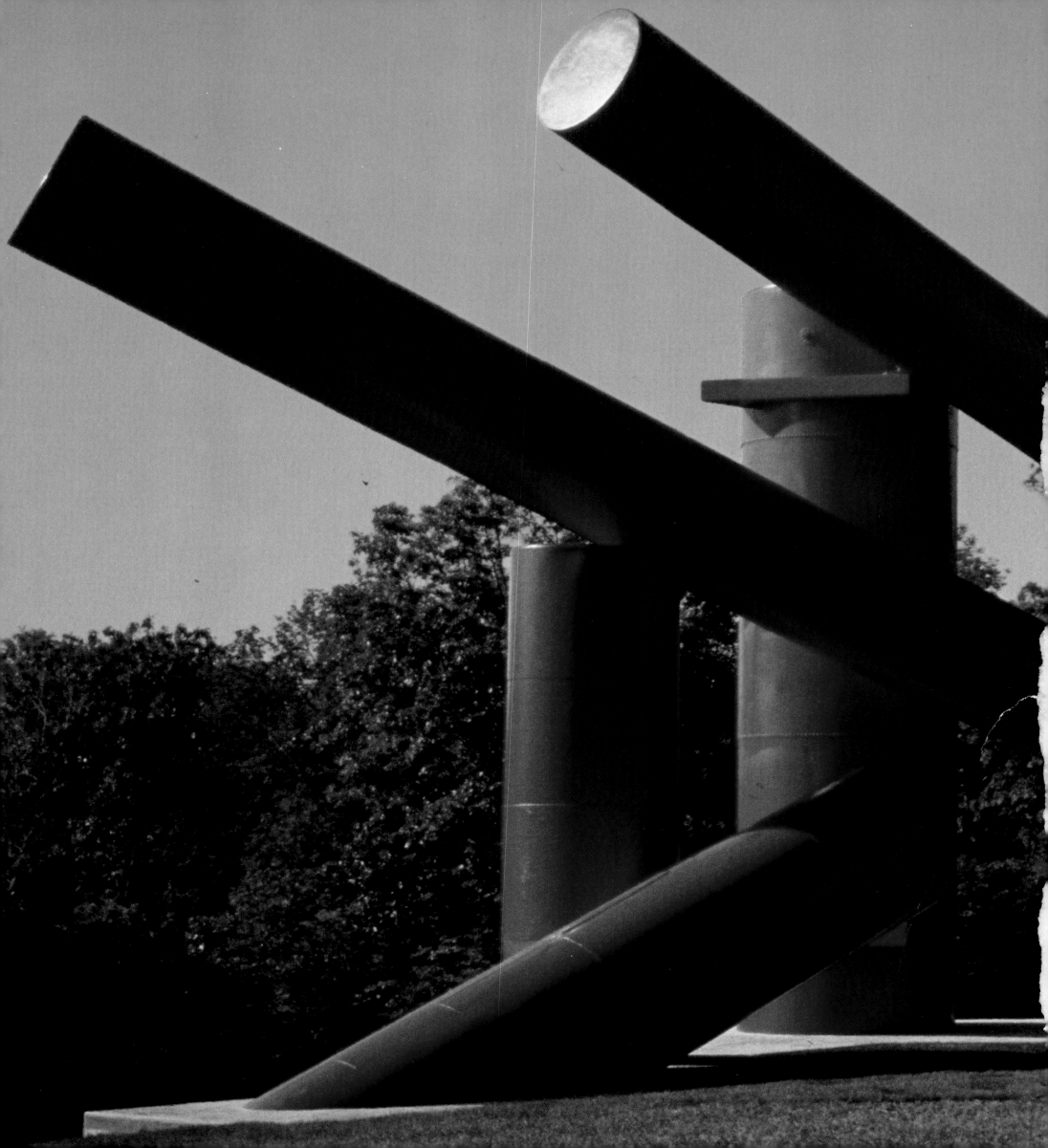

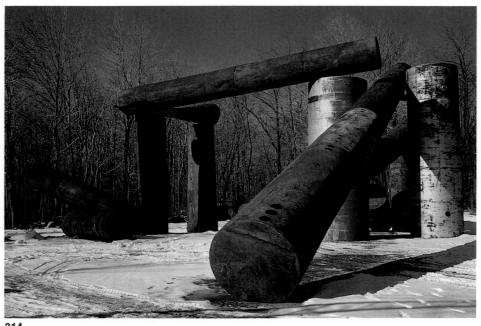

**314**

◁
313. *The Way*, 1972-80
    Painted, welded steel, 50 x 100 x 50 ft.
    Collection Laumeier International
    Sculpture Park, Sunset Hills, Missouri.
    Gift of Alvin Siteman

314. *The Way* (work in progress)

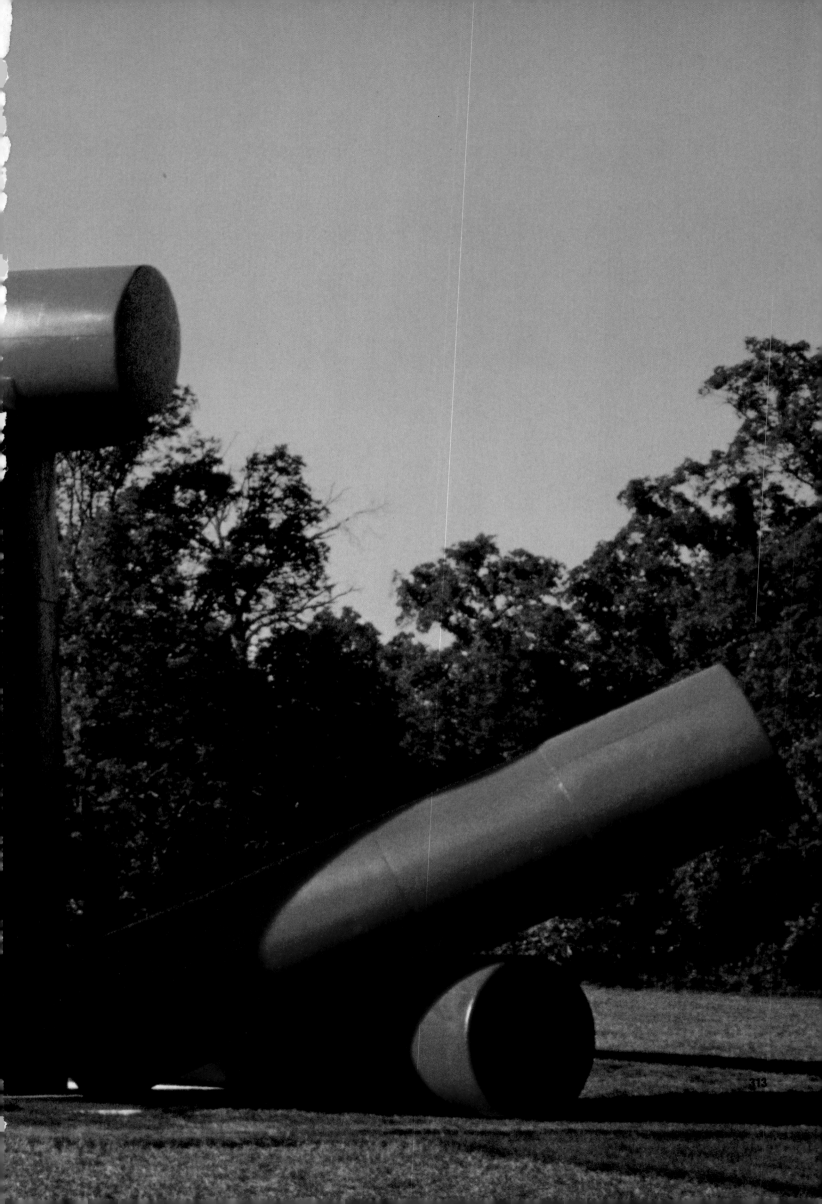

ary Russia, theater was the most advanced art, outstripping architecture and even theory itself in its radicality.

Opera and ballet, the traditional arts of imperial Russia, were subsumed under the category of theater. The performances of the Bolshoi constituted a bond of spectacle between Czarist and revolutionary Russia. Writing of the *Art of the October Revolution*, Soviet art historian Mikhail Buerman observed: "The art of this period was strikingly lavish, even to the point of excess, and it reveals a constant striving for a mass audience. . . . All this is closely linked to the brilliantly diverse theater of the period. . ." Thus, in Russia, art with theatrical overtones, indeed the most theatrical art, had positive associations. Exactly the opposite had been true in puritanical America, where the idea of theater, of masks and disguises, indeed of spectacle of any kind, had been equated by the great Puritan preachers with the essence of sin. Theater, for the American Puritans, was the tool of the Devil: the means to seduce the masses from their proper labors, filling the virtuous with thoughts of sex and diversion. This attitude persists in America, even into the twentieth century.

Because of his Russian background, Liberman could never be convinced by the American bias against the theatrical to remove the elements of spectacle and anti-realism from his work. Jonathan Edwards and American art critics influenced by him might have thought it heresy, but Liberman held fast to his belief that art should be thrilling, spectacular, and dramatic. Even his earliest sculptures, the small plexiglass panels, related to the movable panel paintings, echo Meyerhold's biomechanics: the movable panels suggesting the actors who functioned as decor as well.

The radical ideas of the Constructivists could not flourish in Russia after Lenin turned against the avant-garde; but in Germany, at the Bauhaus, the conception of "total theater," the *gesamtkunstwerk*, or total work of art, combining the various arts in a single operatic work became an important preoccupation. Through his mother's friend, Frederick Kiesler, who had designed such a total theater in Vienna (later translating the concept into the three-dimensional spatial environment for Peggy Guggenheim's Art of This Century gallery) Liberman once more came into contact with the idea of art as a theatrical environment.

Considered within the context of constructivist ideals and aspirations, Liberman's career as an editorial director and his work as an artist also seem less contradictory. For the Constructivists, the primary task of the artist was to communicate with the masses, to elevate mass taste as well as to open doors to a visionary world of the spirit, for those who labored in the material world. It is significant that Liberman always earned his living not as a businessman or entrepreneur, but as a designer and editor of illustrated mass-circulation magazines, from *Vu* to *Vogue*. In this capacity, he in-

**315**

315. "The Overthrow of the Tsarist Regime," a mass performance with participation of actors from the dramatic studio of the Red Army

316. Liubov Popova
Set for Crommelynck's farce "The Magnanimous Cockold," 1922
Collection Bakhrushin Theatre Museum, Moscow

317. Vladimir Tatlin
*Model for the Tower-Monument to the 3rd International*, 1919-20

318. Lazar (El) Lissitzky
*Lenin Tribune*, 1920
India ink, gouache, and black lead on paper
Collection The Tretyakov Gallery, Moscow

**316**

336

317

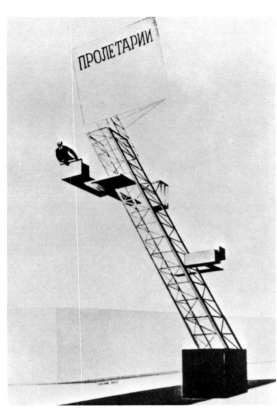

318

*The most exciting memories of my childhood are of buildings, public places—decorated, transformed by monumental-scale paintings or sculptures. Paintings, unstretched, suspended over whole facades, took over, at scales of a hundred feet by forty feet. So, from the beginning, I would think, my passion for scale started with these so-called Agitprop projects of Russian artists working to celebrate the Revolution and to transform traditional buildings into a new vision. The Revolution had to have an enormous sense of theater to capture the imagination of the spectators, and my participation with my mother's theater influenced my work on monumental projects for public places today. One must never forget that the Russian artists had to appeal to a very primitive mass, so they had to strike very directly and very hard. And this clarity of impact is perhaps one of the greatest contributions of the early Russian artists.*

troduced modern art and modern design to a mass public. Indeed, it is hard to assess how much *Vogue* changed taste in America by publishing the first extensive illustrated popular articles on Kupka, Pollock, Newman, and many others. As an artist, Liberman never wanted to be esoteric or theoretical. He has continued to hold fast to the constructivist conception of the artist as social engineer, capable of totally changing the scene in his powerful capacity as director of the great world theater.

In his recent epic sculptures, Liberman employs the techniques of advanced engineering, which the Constructivists hailed as the means to revolutionize the forms of art. Indeed, Tatlin maintained that the only source for ideas more advanced than the theater was the factory. Without creating images that ape industry, Liberman has nevertheless suggested analogies between the gigantic forms of his sculptures and the scale of the contemporary urban landscape as it has been transformed by new methods of building, transportation, and communication—practical manifestations of the material progress his father, Simon Liberman, believed in so fervently.

We have seen how Liberman's interpretation of the motif of penetration evolved into increasingly complex forms and metaphors. During the Seventies, the notion that the sculptural environment exists to be activated by the viewer's exploration of its interior has created possibilities of work on a heroic scale. The reformulation of the role of the viewer from passive spectator to active participant is an essential element of the democratizing function Liberman assigns his work—which is one more legacy of constructivism. In grandiose and flamboyant constructions like *Adonai*, *Covenant*, *Symbol*, *Iliad*, and *Ritual*, the penetration of the work by the viewer universalizes the erotic encounter, extending it from personal metaphor to public experience. (*310, 319, 325, 326, 321*) Frequently a work will be "inhabited" at a given time by more than one viewer; in this case, the act of viewing takes on the additional dimension of a communal experience. That art could and should serve such a collective social function was also drilled into Liberman very early. Because his parents were close to the inner circle of revolutionary leaders, the Moscow of his childhood, besides being a place of disruptive violence, was full of hope, optimism, and pragmatic invention. These feelings were reflected in the posters, street floats, and temporary monuments as well as the colorful public spectacles he saw as a boy. The ships, tanks, and cannon that were frequently the subjects of these floats may have found their way into the imagery of Liberman's sculptures. It is easy to see *Argo*, for example, as a proud ship conquering a rough sea. Its title refers to the Greek myths of seafaring heroes, and Liberman chose it because of his love of the sea.

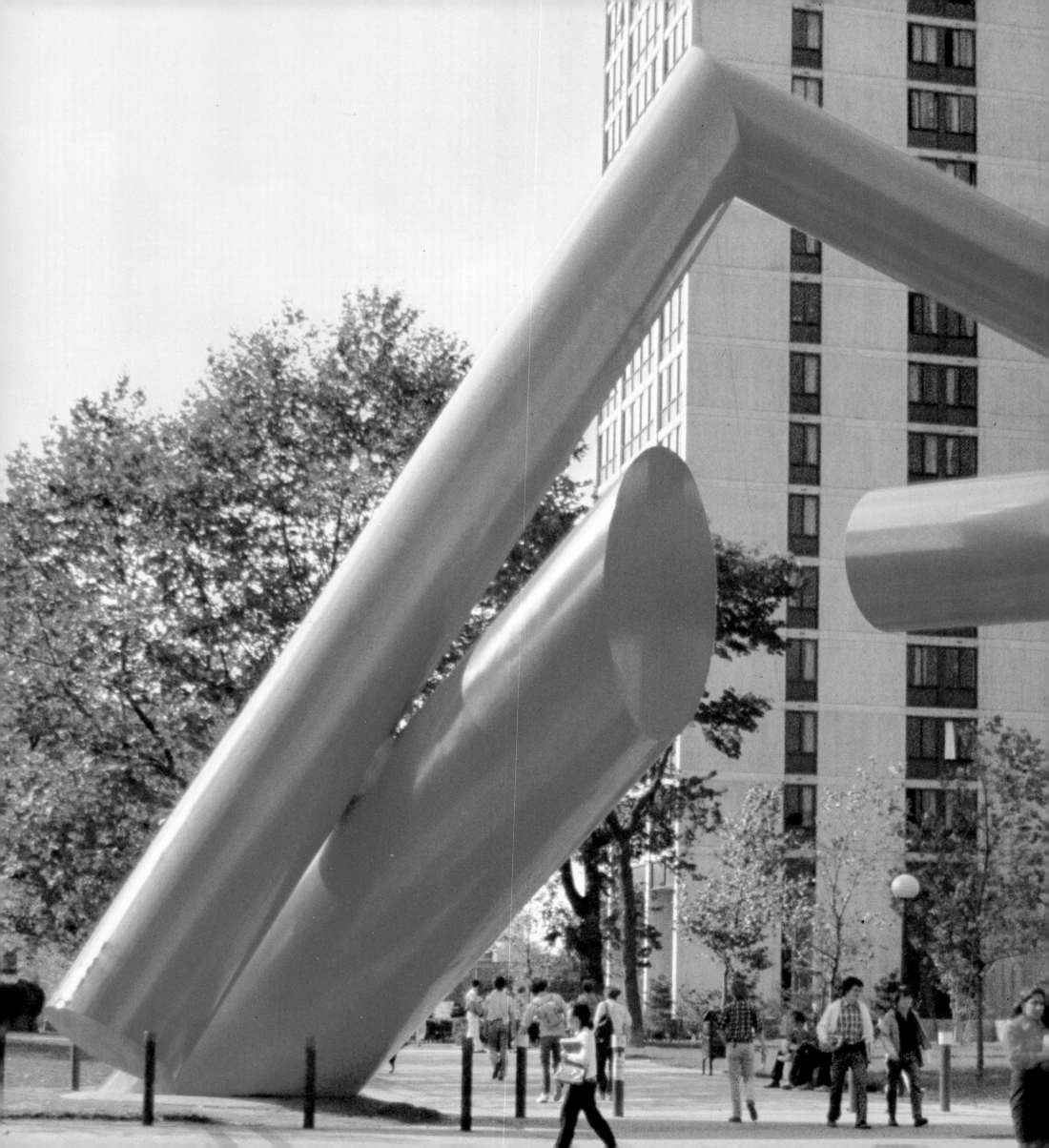

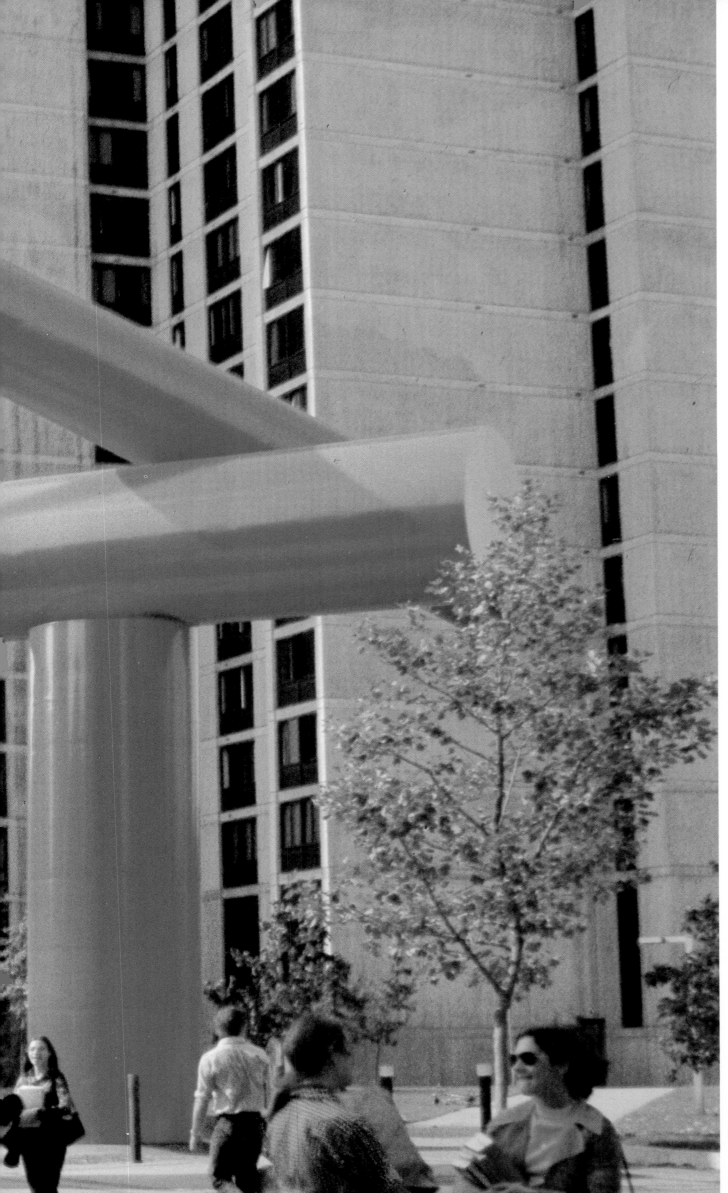

The artist must be extravagant. In order to risk, you have to gamble, in order to gamble, you have to have the means.

319. *Covenant*, 1974-75
Painted, welded steel, 48½ x 51 x 34 ft.
Collection University of Pennsylvania

FOLLOWING PAGES

320. Overhead view of *Covenant*

**319**

339

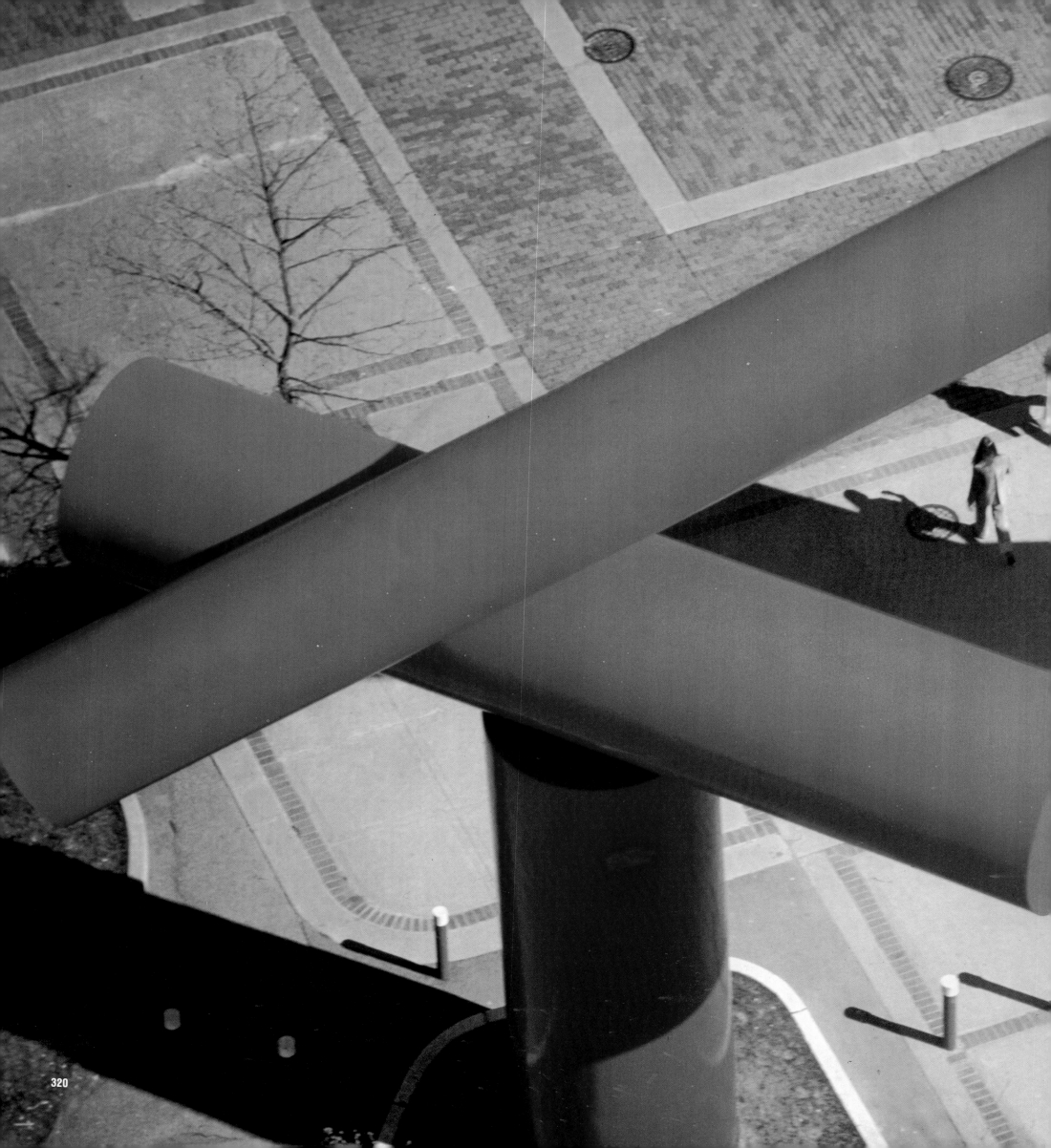

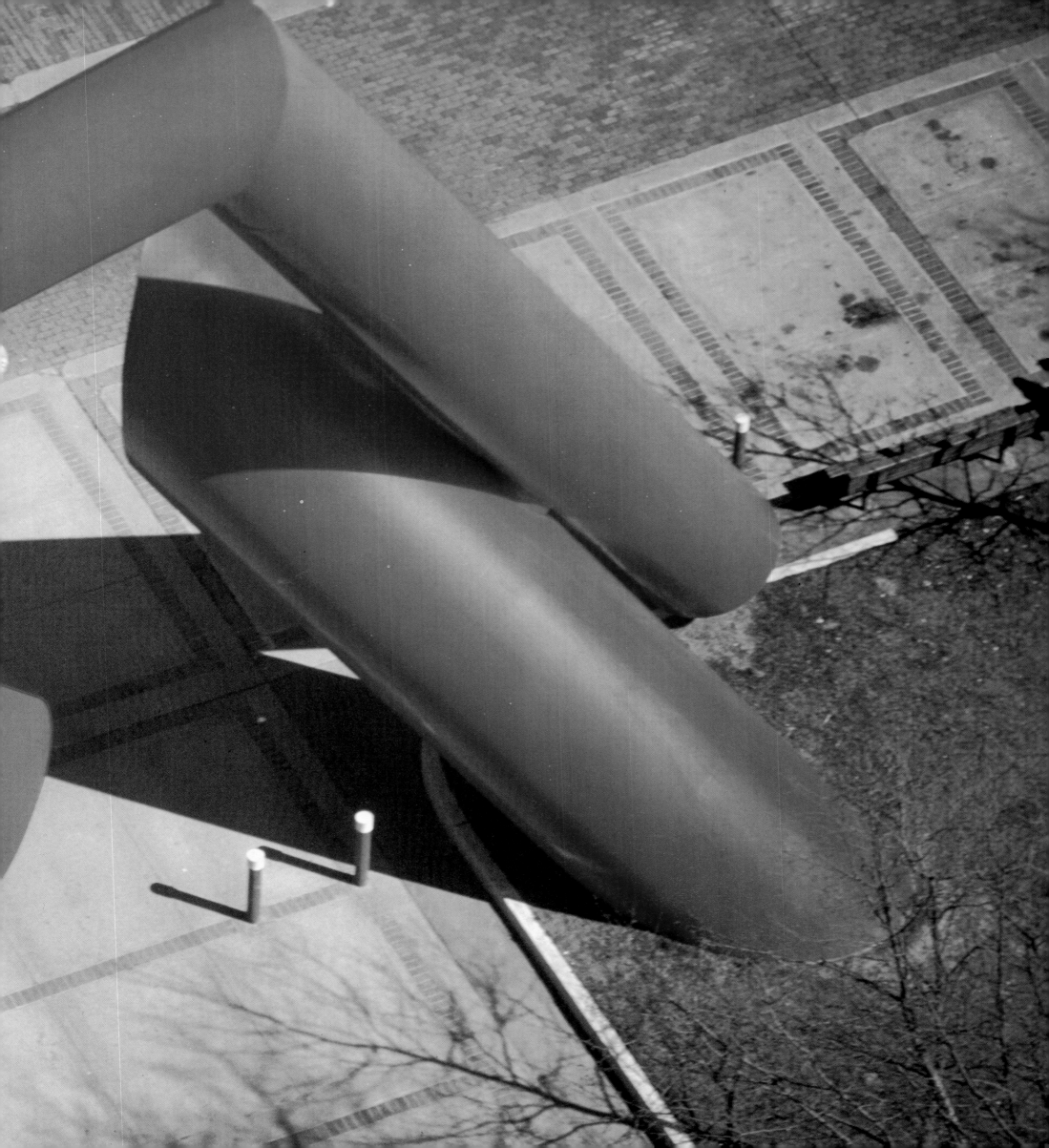

It is rare to know anything concrete of the early life of an artist, but Liberman's mother's memoir distills a concrete picture: Describing her son at play, she wrote admiringly of how he could turn a shred of paper into a costume, and improvise out of nothing just as she did. In her theater, Henriette Pascar practiced the magic of transformation; she taught her son that through the imagination tawdry reality could be made beautiful and marvelous. Her unrealistic idealism perhaps accounts for Liberman's consistent stance of defiance. For if Duchamp wished to "strain the laws of physics," Liberman has managed to strain the law of gravity. The juggled hoops and elipses tossed into air, held there magically, the forms of his mammoth constructions apparently levitating in defiance of physical laws are the images of the magician. The idea that art should be, as Ouspensky maintained, part of the search for the "miraculous" continues to play a large role in Liberman's current projects.

Among her other unusual beliefs, Henriette Pascar had curious notions regarding education as well as religion. She apparently derived them from Tolstoy's concept of the sacredness of childhood, the purity of the child's unspoiled inner life. Using her son as a guinea pig, she may have been the only person actually to put Tolstoy's theories on education into practice. Nearly every critic who has written on Liberman has commented on his unpredictability. However, he was brought up in a milieu that was changed from day to day by a mother who was both unconventional and unpredictable and who encouraged such behavior. His mother believed that educators killed fantasy, and that only poets, writers, and dramatists could speak to the imagination. Her anti-intellectual attitudes may explain why, although his work has often been conceptually advanced, Liberman avoids theoretical discussions, preferring to demonstrate rather than to explicate his intentions. This action-oriented, pragmatic, and antitheoretical bias explains why Liberman has always felt more comfortable in New York than in Paris, where theory takes precedent over practice. His willingness to work with any available material has enabled him both to produce a large body of sculpture and to work on the current superhuman scale.

321. *Iliad*, 1974-77
    Painted, welded steel, 36 ft. h.
    Collection Storm King Art Center,
    Mountainville, New York

    FOLLOWING PAGES

322. *Iliad*, 1974-77 (another view)

**321**

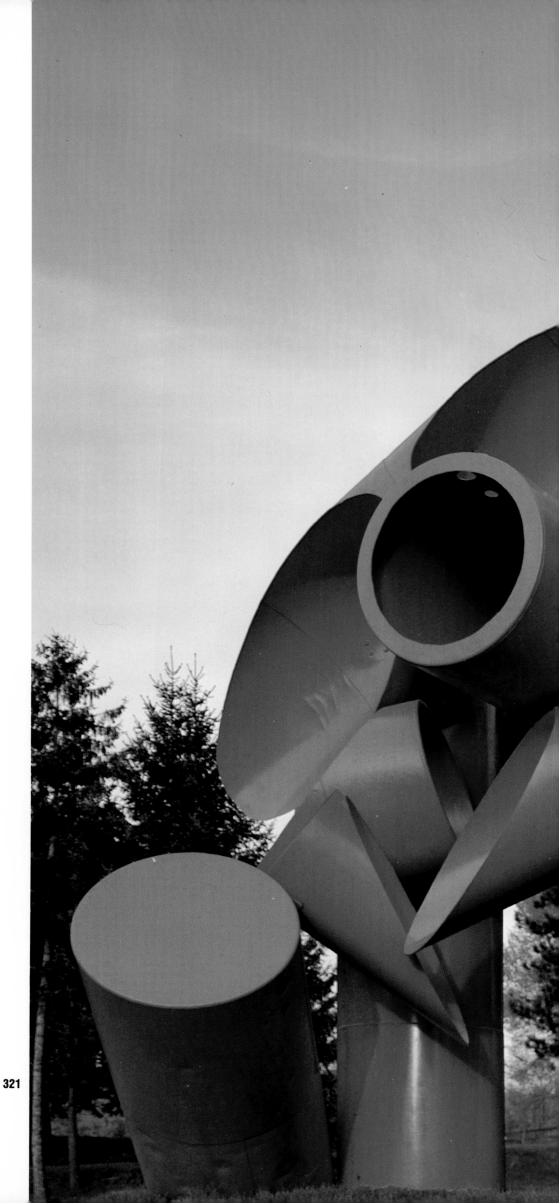

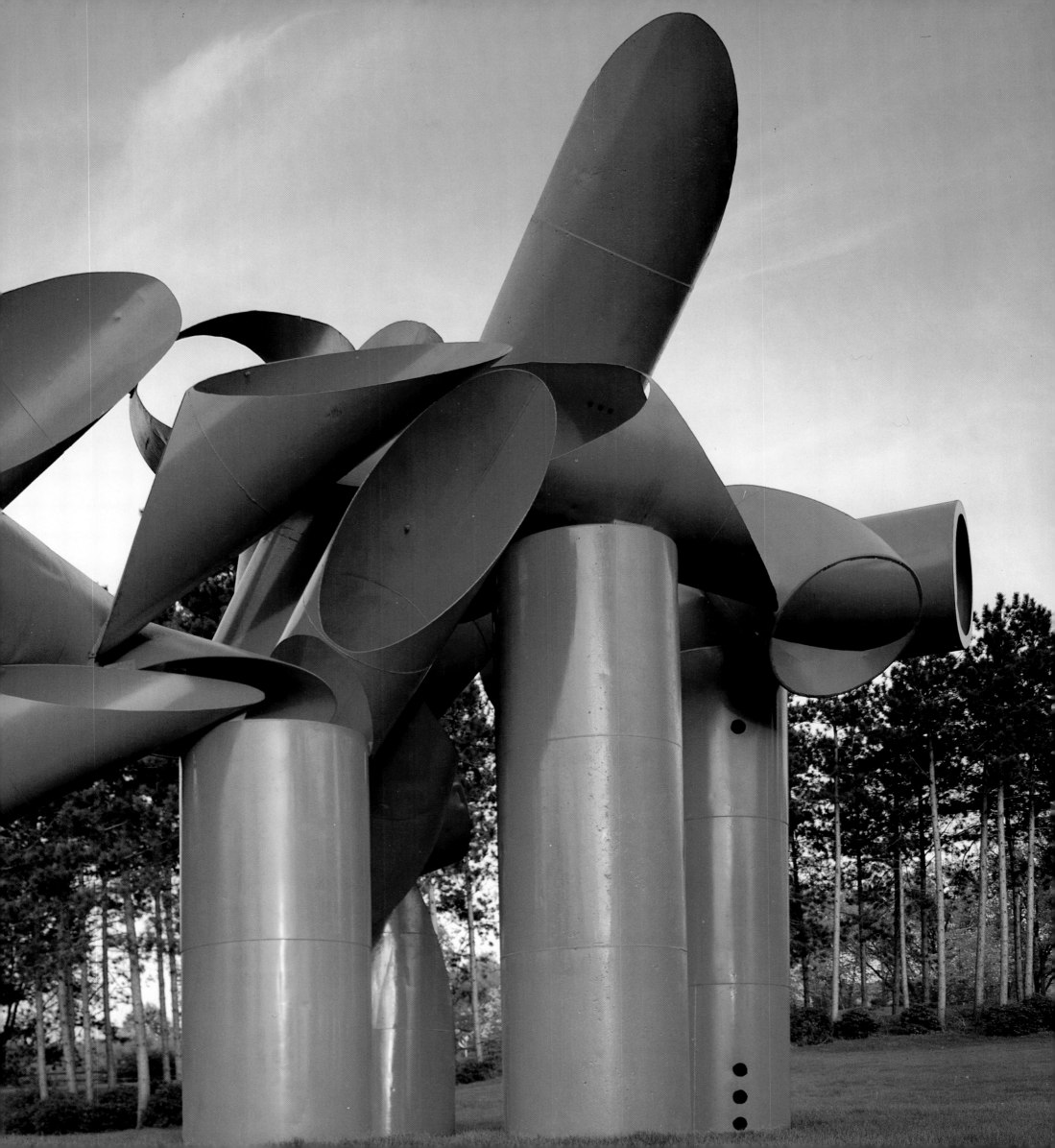

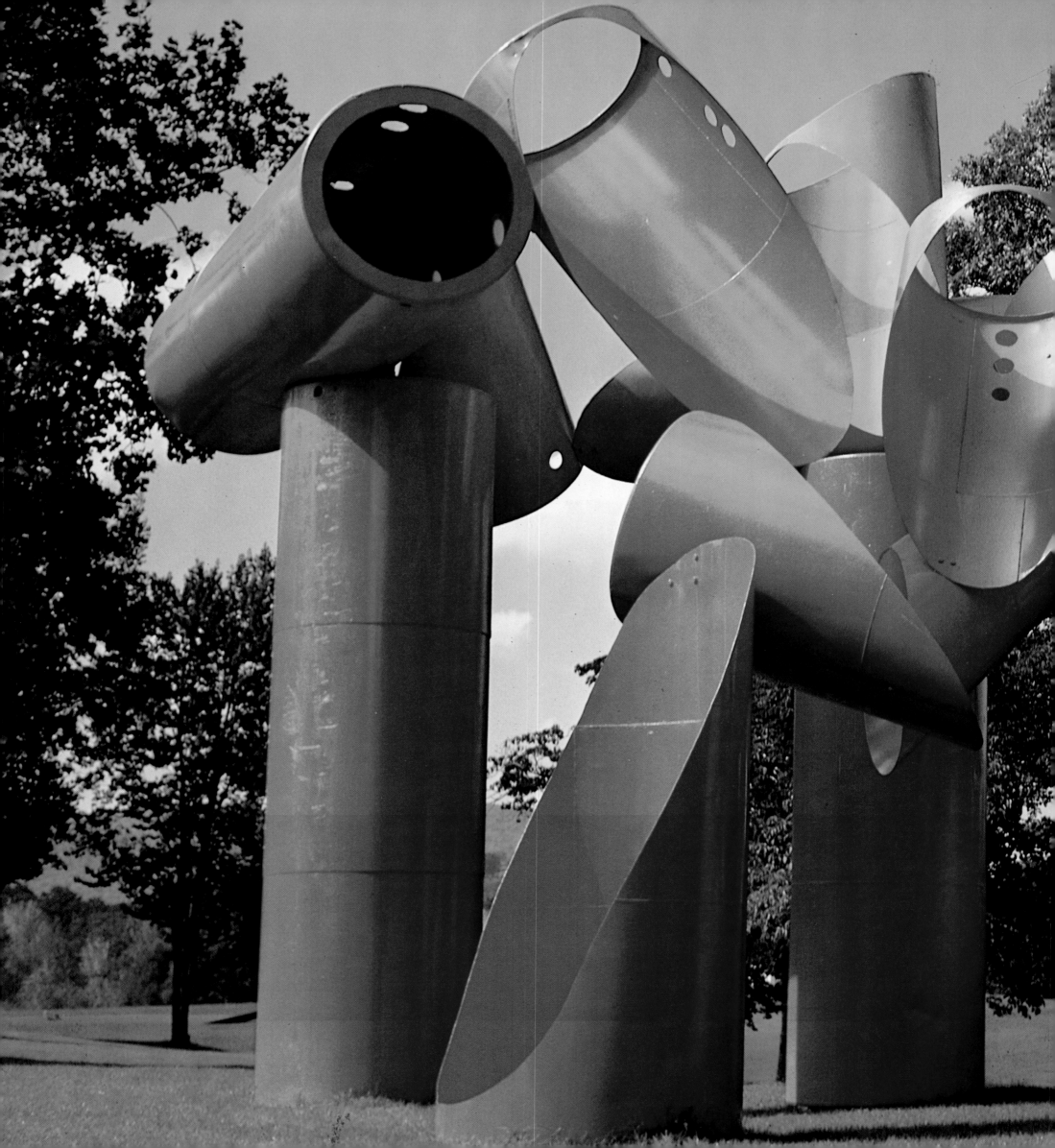

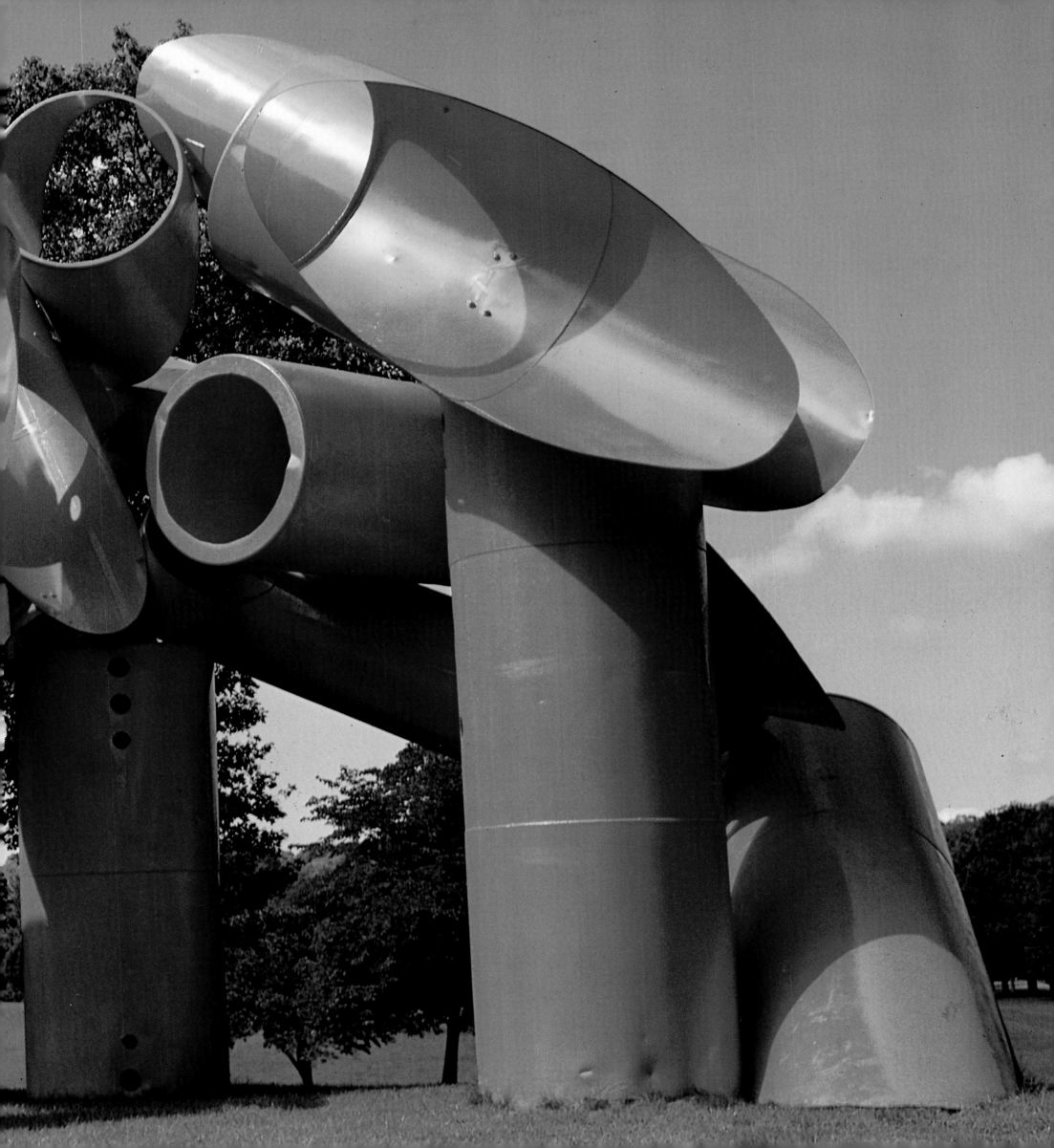

Although Liberman's parents differed on many matters, the one thing they agreed on was the importance of religion. By religion they did not mean any organized creed, either Hebrew or Christian, but rather the mystical current that permeates Russian thought and that led Kandinsky and Malevich to create, respectively, the first examples of abstract and nonobjective art. The religious ideas behind their breakthrough were close to those espoused by Simon Liberman's good friend, the theologian Nikolai Alexandrovich Berdyaev, who taught in Moscow until Simon Liberman managed to get him out of Russia in 1922. Thereafter, Liberman supported Berdyaev, and his wife remained in close contact with him in Paris. According to Berdyaev, truth is not the mirroring of objects, but the penetration of the environment by the light of the creative act, which is a message from the spirit world into the veiled world of objects. For Berdyaev, man becomes godlike in his capacity to create, and tragedy consists in the debasement of the creative impulse in the creation of objects or in the loss of creativity.

The teachings of Berdyaev are not well known outside a small circle of mystics and theologians. However, they were passed on to Liberman by both his parents, and they form the basis for his aesthetic and his idea that the creative human spirit transcends economic, political, and geographical limitations. The continuity of this spiritual tradition of the religion of art was acknowledged by Liberman in his conversations with Kupka. When Kupka died in 1957, his widow sent Liberman books from his library, including copies of Valéry's *Une Réligion d'art* and *La Culture des idées* by Remy de Gourmont, which stressed the continuity of modern culture and its origins in Mallarmé's symbolism and the idea of the religion of art. These were beliefs that Liberman shared with Kupka, and they link him to the earliest modernists as well as to the essentially religious artists of the New York School like Newman, Rothko, and Reinhardt. Like Berdyaev, Liberman does not believe the mind is the principle channel of cognition of "reality"—and this is another explanation of his horror of theory and purely conceptual art. Liberman could not be an abstract artist, inspired by forms in the world, as, for example, de Kooning has been inspired by women, because his deepest belief was that art must escape the bondage of objectivity by creating environments. The evolution of his sculpture into environments that cannot be perceived as either objects or gestalts was inevitable, given the formation of his thought in the visionary mysticism of Ouspensky and Berdyaev.

The antirational, antilogical aspects of his art as well as his belief that intellect cannot inspire revelation, which is the only true objective of art, become comprehensible in this context. For Liberman's symbolism, although it is frequently erotic, is not a Freudian opposition of sex and death; rather, he is concerned with expressing man's triumph over matter and the struggle of that particular battle. In his painting, human energy is depicted as light bursts, in his sculpture as soaring gesture. In their current epic and operatic phase, his environmental sculptures are slowly taking form on a scale abstract art has seldom if ever achieved. Today, the field outside Layman's shed is littered with the remnants of cannibalized sculptures and fragments of metal blown open or crushed to bits. (307) The shed is ringed either with the earliest standing pieces resembling armored sentries or works like *Logos* that suggest heavy artillery. (290) The colossal sculptures, such as *Iliad* and *Scan*, which span huge areas, evoke images of ruined cities with their falling and rusting columns.

In the Seventies, the motif that began as the severely classical "sacred precinct"—the geometric temple-shrine with its columnar elements, often resembling constructivist maquettes—reemerged in a more sober form in configurations that suggested destroyed temples and desolate cities. When such works as *The Way* are remade in new steel and painted to be released as public sculptures, they lose the somber quality of the sculpture in its raw form as it rusts in the field. Seeing these works in progress, before they are finished and given a gleaming coat of bright red paint that identifies them as symbols of community, is like visiting the overgrown and moldering Mayan ruins of Palenque, or the sadly disintegrating temples of Angkor Wat. In their unpainted form, they suggest neglect and decay—the de-

---

*Arresting surprise by a strange object that contrasts with the environment is a very important factor. Then through scale, the creation of—of a sense of awe. I don't think any religious experience can be had without a sense of awe, an overpowering feeling of an inexplicable invisible power that all human beings feel is above them or surrounding them. I think art should draw you upward, physically upward. Art should have sufficient complexity to create a state of meditation. This is true of the Alhambra in Granada, of all Moslem art, of the interlaces of Gothic art. The mind needs to get lost in certain complexities. I worry about oversimplification. It's not true that "less is more." I know that now.*

struction of civilization. While Liberman tours his forts and battlements, like a general deciding the strategy of the day, the great steel tanks loom in the apocalyptic grandeur of abandoned ruins. To reclaim the debris, to make it new and beautiful, shining and optimistic, becomes an ever greater challenge as he takes on larger and larger tasks, almost as if he is courting the danger of being overwhelmed by his own materials.

There is, of course, an irrational element in Liberman's determination to make sense out of the giant junk heaps he collects. Watching him work, one has the sense he believes that if his struggle to survive and to transcend material realities can continue to succeed, the complexity of the contemporary world, too, can be brought under control through the kind of will and discipline he is exerting. The mammoth sculptures become in this case a kind of moral example. There is more than a touch of ambiguity in his stand. He clings to his constructivist ideals of progress through science and industry with a stubborn tenacity, insisting that airplanes are the greatest modern sculptures, exclaiming that the gas tanks surrounding our cities are as monumental and beautiful as the pyramids. At the same time, the pillars of his grandiose temples are clearly tumbling, inclined at angles or broken like antique columns.

There is a dual metaphor involved in these recent environmental sculptures: They recall what Liberman has identified as the strongest memory of his childhood—the destruction caused by revolution—while he simultaneously attempts to create new forms from that destruction. These two apparently contradictory metaphors lend the recent works a special tension and poignancy. That they are being done by a man no longer young, but determined nevertheless to imbue his forms with the energy and optimism of youth, offers them another dimension of heroic struggle. One has the sense, watching the artist taking on increasingly more demanding and complex tasks, that Liberman is quite determined to end his life as he remembers Brancusi in old age. "I will never forget," he wrote in his essay on the Rumanian master, "the image of that small, gray, bent figure shuffling and limping through the maze of sky-reaching sculptures."

In the same essay, Liberman quotes Brancusi on the meaning of history as seen by civilizations more ancient than ours:

In India it has been proved that there were ten or eleven deluges, although we know of only one. We are living in the beginning of a new apocalypse. The deluge is coming. Nothing will be saved. If one could create as one breathes, that would be true happiness. One should arrive at that.

To face the possibility of apocalypse, yet to create as naturally as one breathes, is a goal Liberman seems to have achieved. When his friends warn him of the folly of traveling every summer in Italy where terrorism is rampant, he smiles as a witness to catastrophe who believes that life may at any point be snapped off but that the human spirit will reestablish a continuity with tradition, despite whatever discontinuities history imposes. Typically, during a recent terrorist bomb scare in Rome, Liberman took advantage of his friend Danny Berger's connections with the ruling Communist Party in Rome to get a cherry-picker—a huge crane extension with a cabin he could mount—brought to the Campidoglio so that he could photograph the statue of Marcus Aurelius from above—the one point of view missing from his sequence of 360 degrees. When the statue was removed for restoration because the Renaissance Senate building behind it was indeed bombed, Liberman congratulated himself on his foresight.

Like the project of photographing Marcus Aurelius—the stoic emperor who wrote his *Meditations* as Rome inexorably declined despite his finest efforts—the most complex and ambitious sculptures Liberman has created to date are still unfinished after several years of intensive work and revisions. *Scan* (*332, 333*) picks up the image of communication of the earphone-receptors—the discs at the ends of the pieces made with exhaust pipes—that Liberman thought of as receiving messages. Free-form elements have begun to appear in these latest works. In its giant curved screens cut out from cylinders, *Scan* makes one think of the radar

devices that are one of the wonders of modern technology. *Aria*, another work incorporating free forms with cylindrical volumes, reaches a crescendo of drama in its flying, seemingly winged peaks that reach up forty-five feet into the sky. (*330, 331*) The rhythmic rising and falling of the aria is recalled in its forms, which also suggest winged images of flight and ascension. The billowing baroque curves of *Scan*, on the other hand, suggest, like the open curved sections of *Argo*, the sails of a ship. In both of these recent works, drama continues to gain intensity as the work rises. Not just sheer height but complex overhead activity once again suggest the exaggerated intensity of operatic behavior.

The operatic baroqueness of Liberman's latest works reflects a rekindled interest in opera during recent years. On the drive from Manhattan to Connecticut, opera is always played now on the cassettes Liberman collects for these trips, maintaining that the music transports him from one world to another and helps him to shut out distracting thoughts and focus on his art. In the past, Liberman would sometimes work at his job and his art on the same day. Now, the two are kept entirely separate by the simple fact of geography. On weekends he makes the regular journey between the contemporary American skyscraper world of Manhattan and the pastoral world of Connecticut, where life goes on as it might have in Russia before the Revolution. The dramatic splitting of his life into two parts, one of which is lived as a hardworking twentieth-century man of the world and the other as a leisured nineteenth-century country gentleman, is typical of Liberman's cultural schizophrenia. These days, the rupture is even greater than it was when Liberman was in touch with the New York art world through his friendships with other artists. The process of shutting out the everyday is aided by the fact that the world that Tatiana Liberman creates is, by and large, populated by Russian émigrés, who speak Russian among themselves. Among the regular guests at the Liberman *dacha* is Gennady Smakov, the author of a biography of Mikhail Baryshnikov and currently at work on a book on Maria Callas—another reason grand opera is constantly played in the house. Sometimes other Russian émigrés who

*I experiment with balance and I say to Bill Layman, "Do you think this will stand up?" So we experiment. Sometimes it doesn't stand up. Or, at other moments, I prefer to ignore logic. You can always have anything stand up by propping things up. Then you turn to engineers and say, "Look, I know this is impossible, but what would I have to do to make it possible?" They will say you have to strengthen this, make this thicker, you have to put a support under ground. I have great trouble having a thing stand by itself, because I want the impossible. I want the extreme thrust, or the extreme overhang, because I want to achieve a certain sense of awe. For dramatic impact, you have to dominate the spectator. One of the ways of achieving this is by having great overhangs, effects that create wonder. Calders stand up by themselves and are called "stabiles." I've seldom been able to do that—first of all, I think it's impossible because of wind pressure, because of snow pressure. Most of the big cantilevered pieces have extraordinary base formations that are hidden. I never want there to be any danger to the spectator.*

323. *On High* in construction, Warren studio

324. *On High*, 1977-80
Painted, welded steel, 36 x 24 x 21 ft.
Collection Federal Building,
New Haven, Connecticut. Commissioned
by the Art-In-Architecture Program of
the U.S. General Services Administration

FOLLOWING PAGES

325-326. *Symbol* (two views), 1978
Painted, welded steel, 47 ft. h.
Collection Sculpture Committee,
Rockford Council for the Arts & Sciences,
Rockford, Illinois

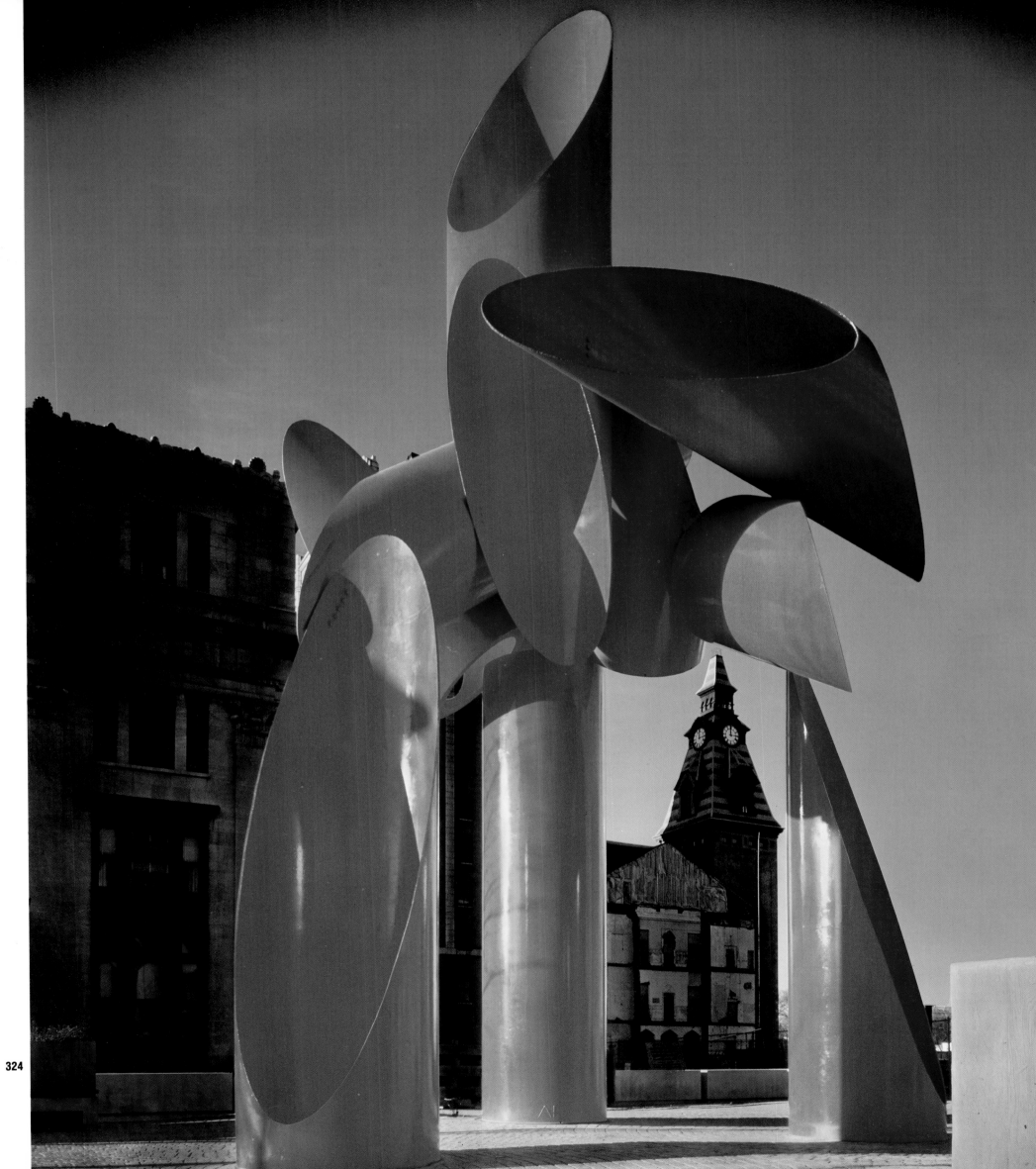

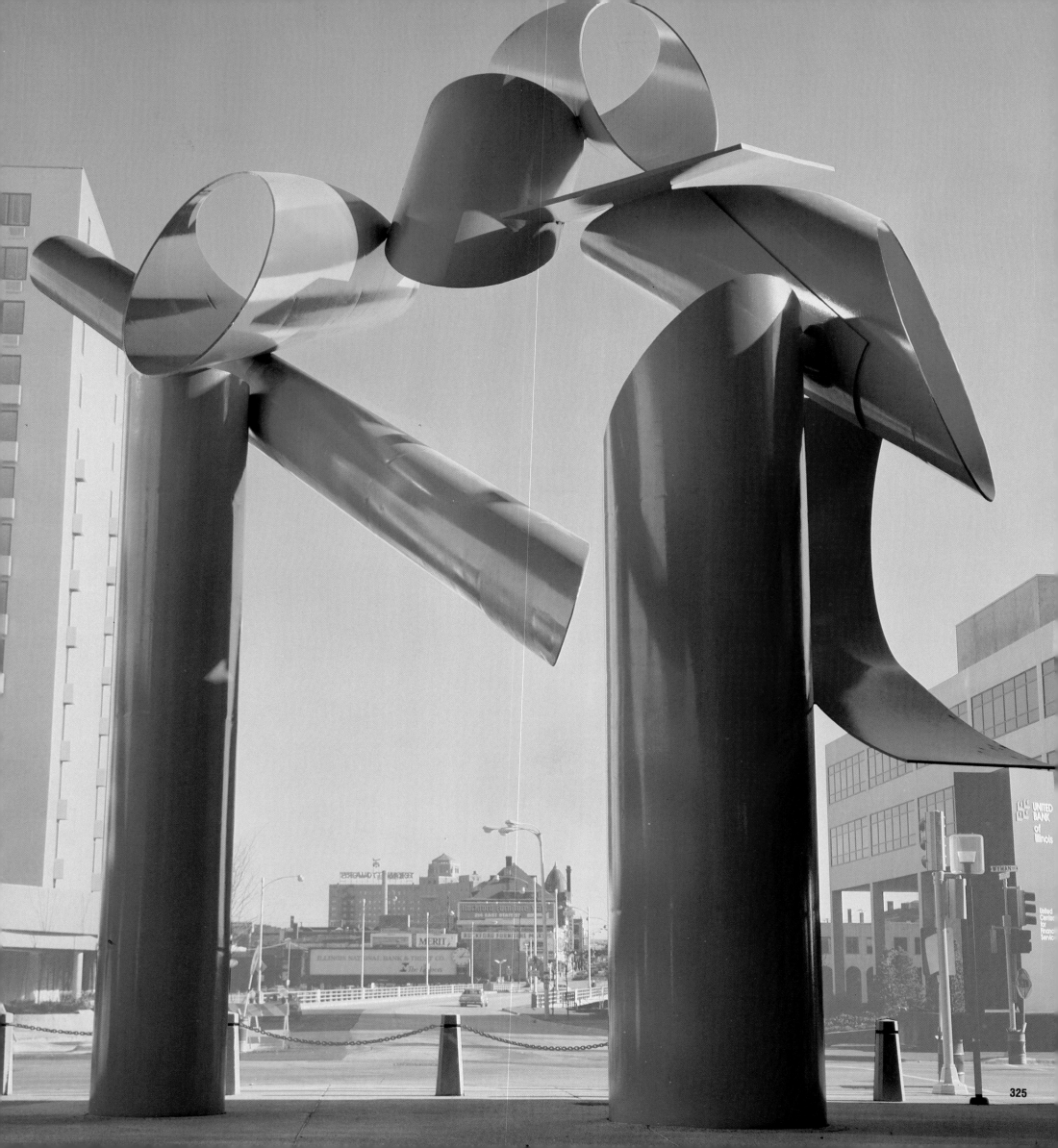

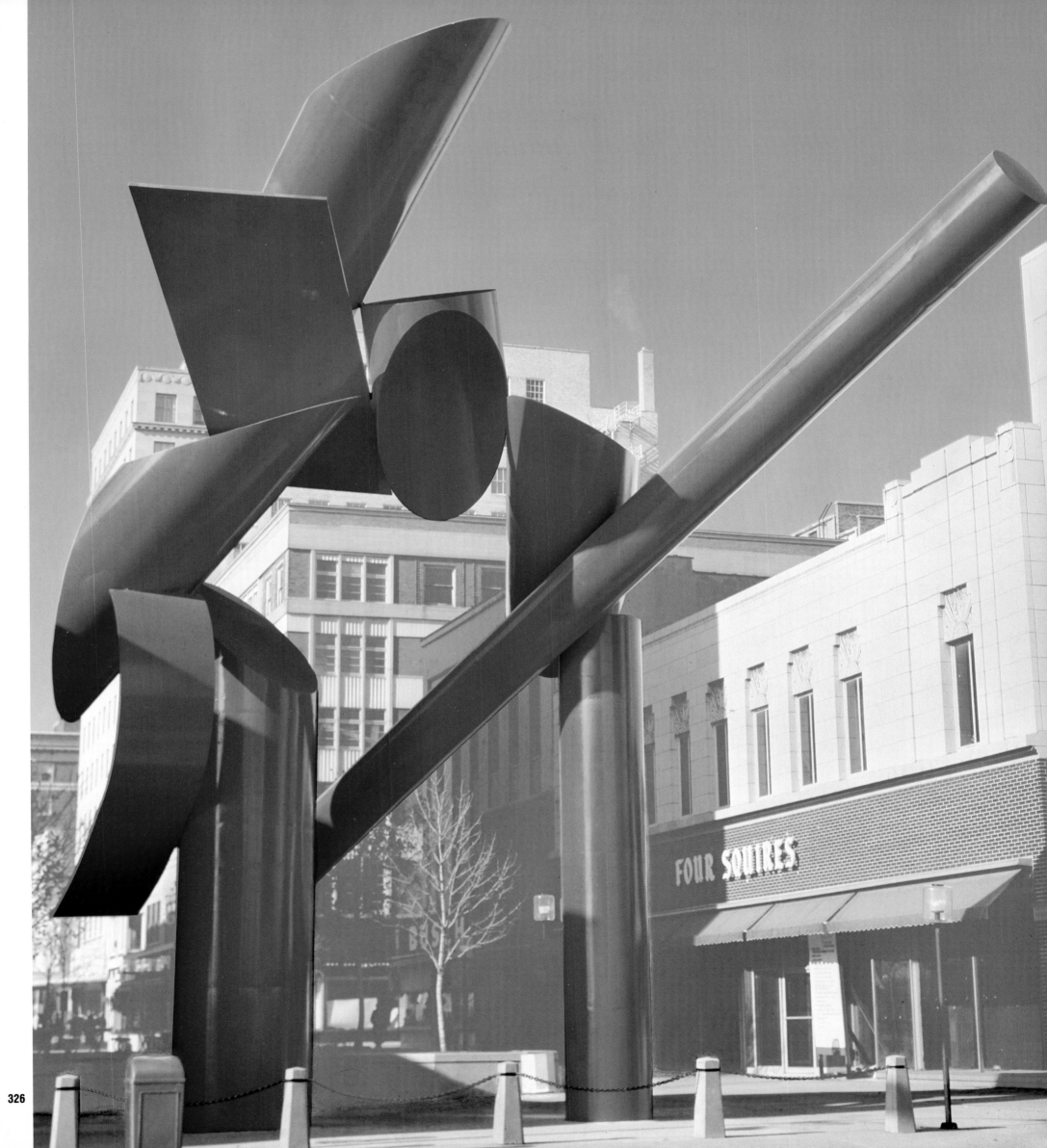

have found Connecticut congenial, like the dancer Mikhail Baryshnikov or the poet Joseph Brodsky (to be read surprisingly in the pages of *Vogue*), come for a Russian lunch cooked by Smakov, who is a considerable chef. Because of Tatiana's continuing involvement with Russian poetry, Brodsky is a particularly honored guest.

Although Brodsky is considerably younger than Liberman, and a relatively recent refugee from the Soviet Union, common cultural values unite the two. For Brodsky is also a product of the milieu Simon Liberman described as uniting the two strains of mysticism, Hebrew and Russian. In a recent review of Brodsky's poetry in the *New York Review of Books*, the Polish critic Czlaw Milosz described his peculiar mixture of hope and disappointment. According to Milosz, the reader of Brodsky's poems "enters a huge building of strange architecture (a cathedral? an IBM site?) at his own risk, since critics and literary scholars have not yet begun to compile literary guidebooks to it." This ambiguous blend of the traditional and the contemporary with its allusions to both the past, the present, and a possibly apocalyptic future is the key to Liberman's recent imagery in sculpture that, like both the airplane and the cathedral, must be entered rather than seen as an object.

Milosz also explains that Brodsky's modernism is peculiarly traditional because of the nature of the Russian language, which requires innovation within strict metrical patterns. Brodsky's art, he maintains, unites the two currents of Western cosmopolitanism and Russian modernism, which originated before the October Revolution. He describes Brodsky's notion that the poet must observe a code that requires him to be God-fearing, love his country and native tongue, rely upon his conscience, avoid alliances with evil, and be attached to a tradition. It is a description that could hold for the moral code of Alexander Liberman as well. Milosz describes the artist's responsibility "to preserve continuity in a world more and more afflicted with loss of memory"—the memory of Greece and Rome seems particularly felt by Liberman. That cosmopolitan Russians are uniquely capable of asserting the unity of European culture in America is also suggested by Milosz. According to Milosz, Brodsky's despair "is that of a poet who belongs to the end of the twentieth century, and it acquires its full significance only when juxtaposed with a code consisting of a few fundamental beliefs. This despair is held in check so that each poem becomes an exercise in stamina. . ." That endurance is the affirmation of life as well as the triumph over despair could well be the message of Liberman's art as well.

In his recent works, there is not only an operatic but an apocalyptic edge to Liberman's imagery. However, he has continued to avoid the profound pessimism of Duchamp,

*In art a very important presence is awe and terribilità. Both these elements serve to awaken us out of our existence more easily. I think sculpture can convey this terribilità and awe more easily than painting. Painting has different means, I think, of jolting. Painting sucks you in. Sculpture projects itself into you by its presence. This can convey awe. The terror of domination that sculpture can convey interests me.*

327. *Symbol*, 1978 (detail)       **327**

352

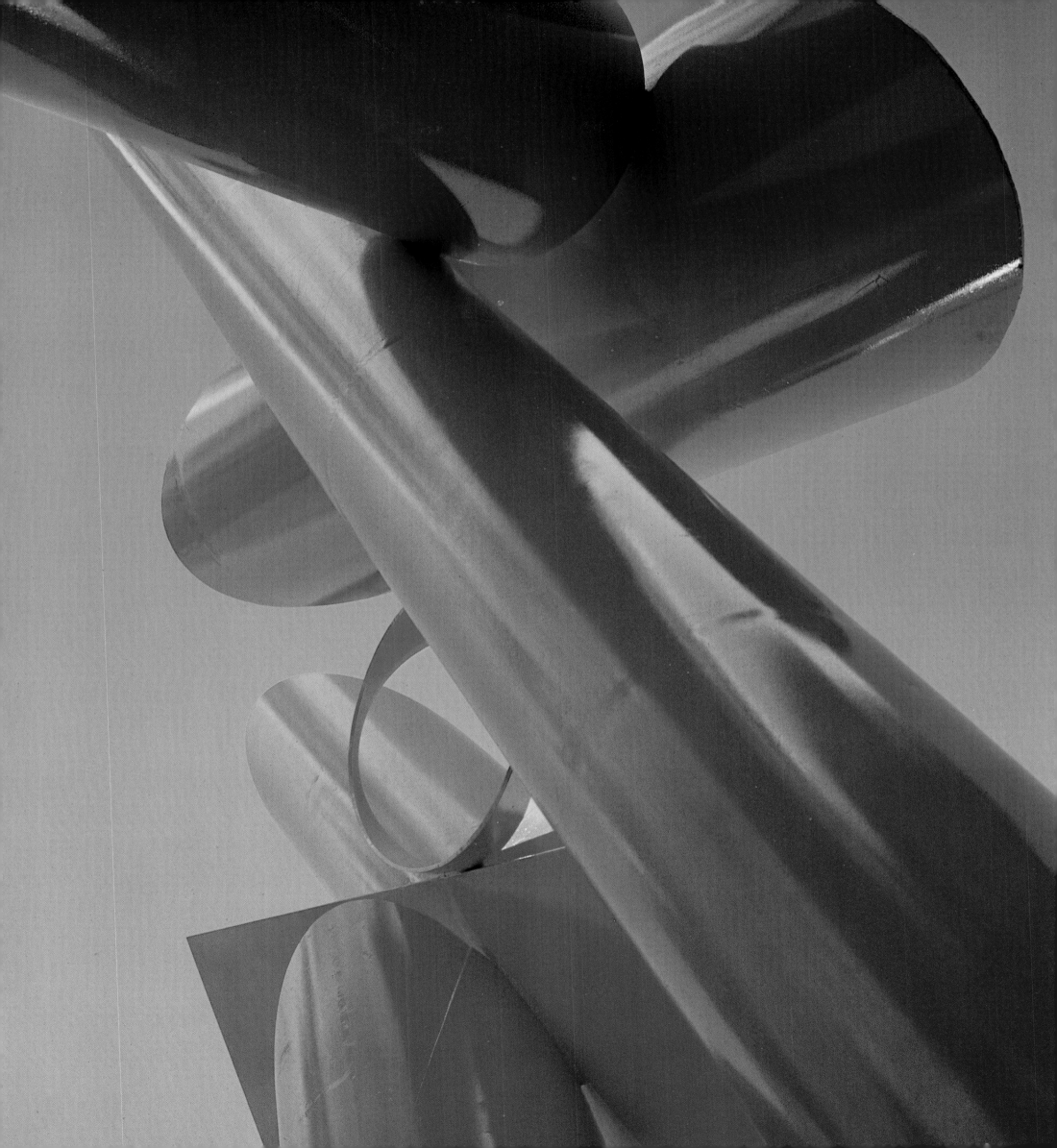

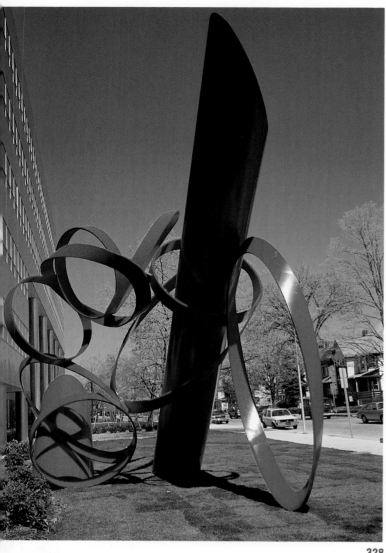

328

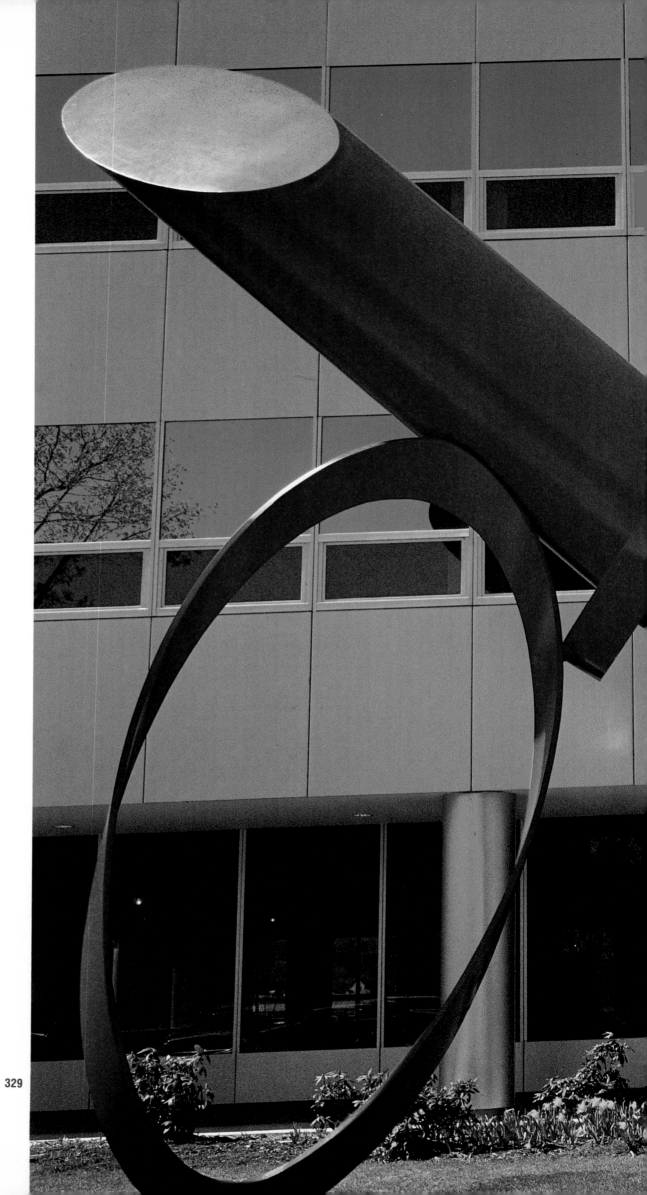

328-329. *Thrust*, 1981 (two views)
Painted, welded steel, 34 x 40 x 18 ft.
Collection Benenson Realty,
Stamford, Connecticut

329

354

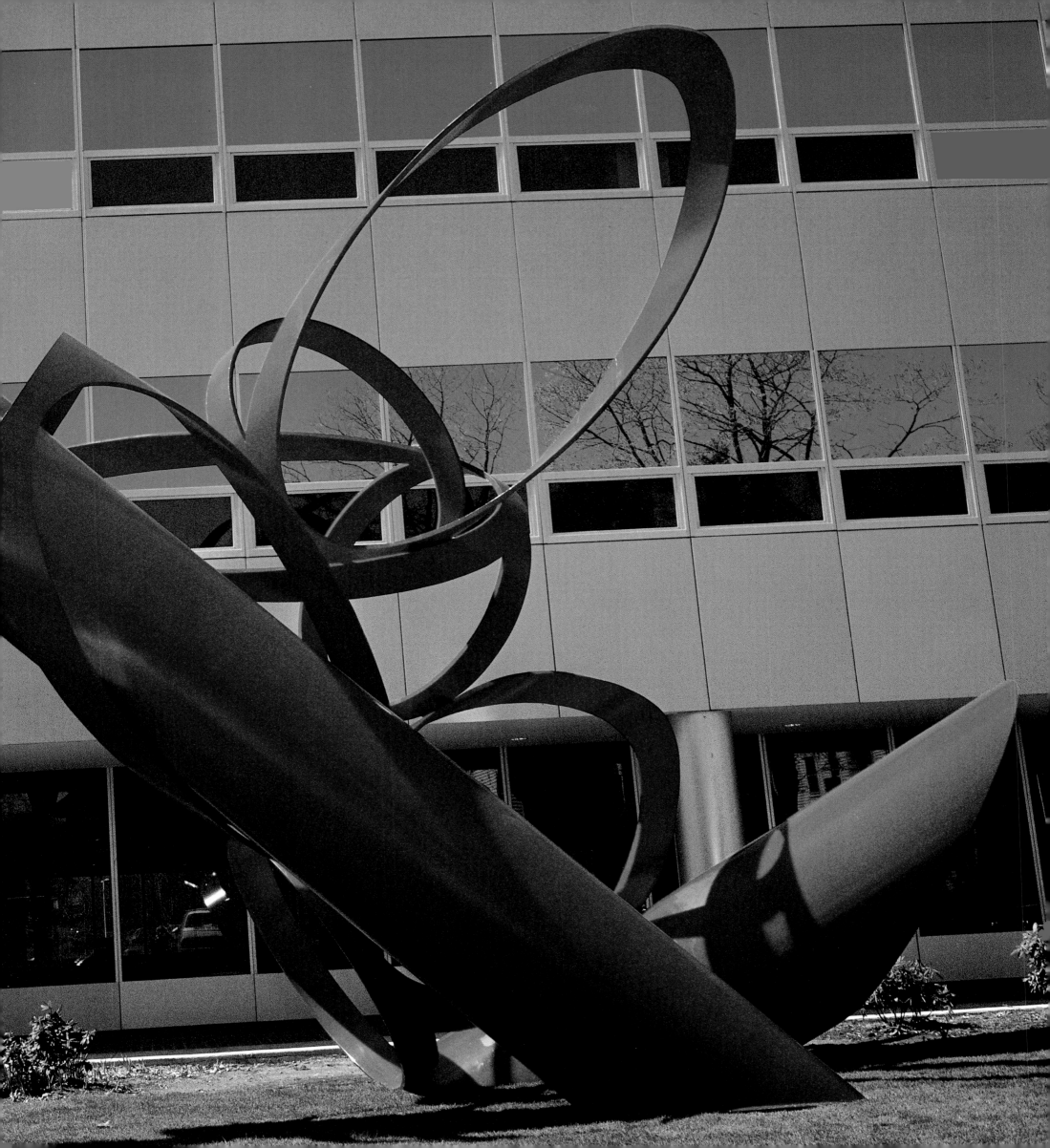

Lately I am able to cut draw cut-out forms in steel. I have never done that before. I never dared really. Perhaps I drew the circles from fear of seeing my own shape, the shape that I would draw.

Nobody has dared really to draw one's own shape. Take even Matisse: If you didn't have the human figure or if you didn't have plants or flowers or whatever, what shape has Matisse? In the cut-outs for the first time he came into a certain contact with himself and he was able to cut out some abstract shapes. Who in the history of art has really created shapes that are personal? It's an interesting problem, and it is a very difficult thing to face.

**330**

330. Study for *Aria*, 1979

331. *Aria* (work in progress), 1981
Welded steel, 42 x 43 x 33 ft.

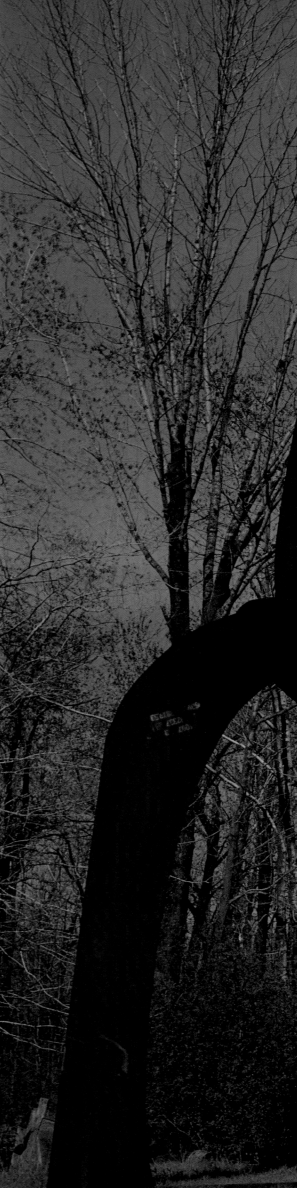

**331**

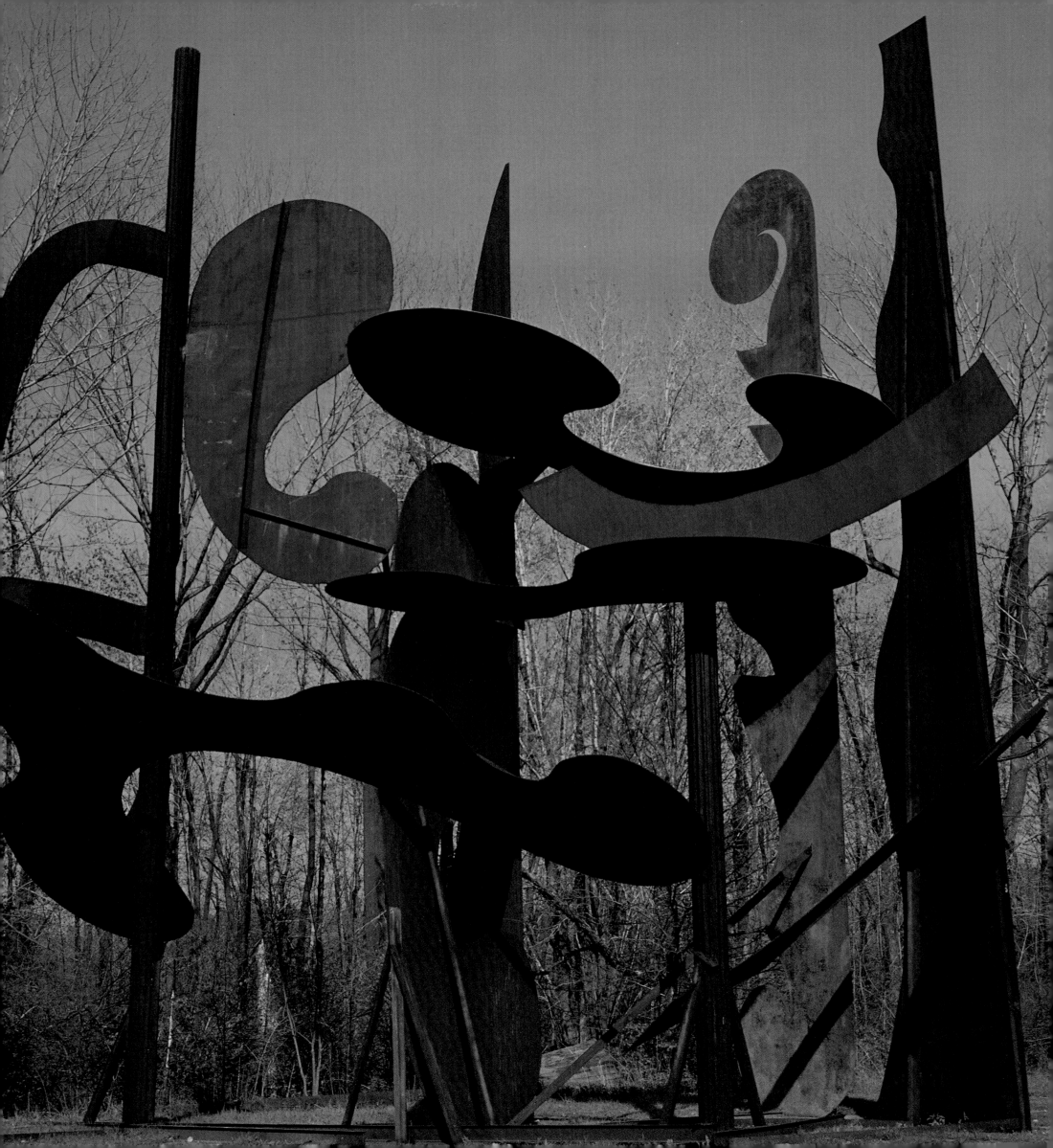

The whole ambition to create comes from looking at nature. The point is not to copy the forms, but to be inspired by the randomness and the monumentality of what surrounds us. I find extraordinary these thrown rocks of mountains in nature, the flow of rivers or waters of lakes or falls. They are a constant reminder that the definite is perhaps very superficial.

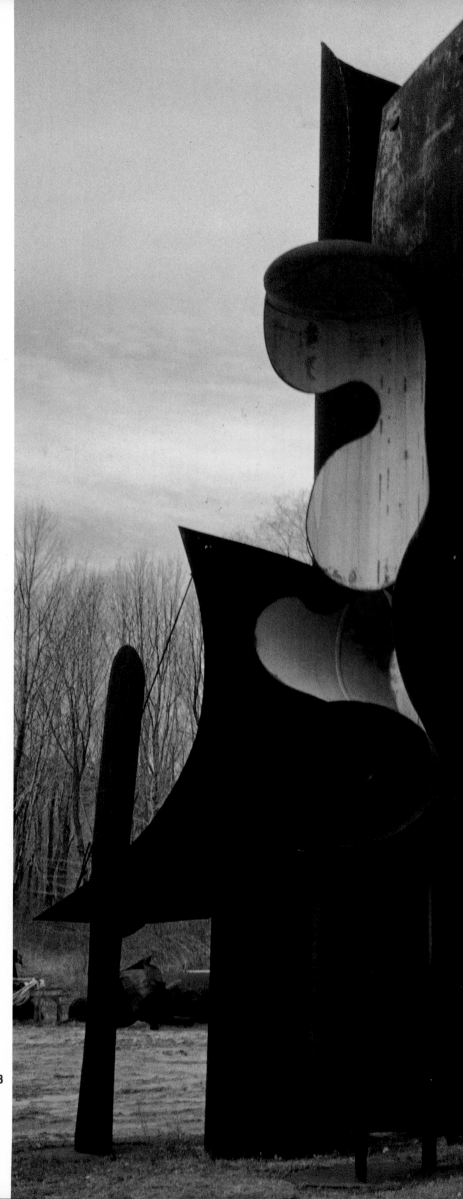

332

333. *Scan* (work in progress), 1975
Welded steel, 35 ft. h.

333

332. Study for *Scan*, c. 1977

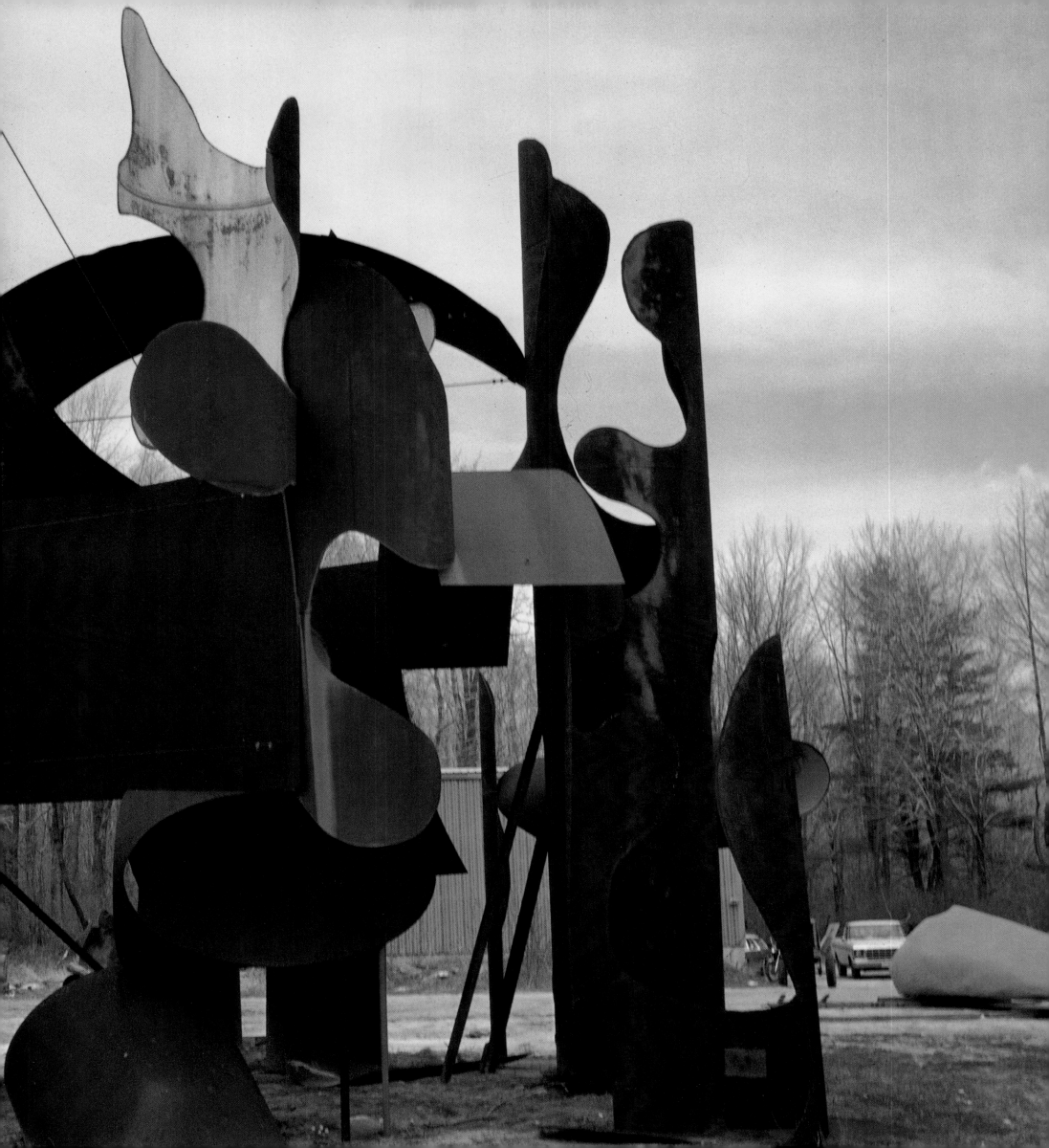

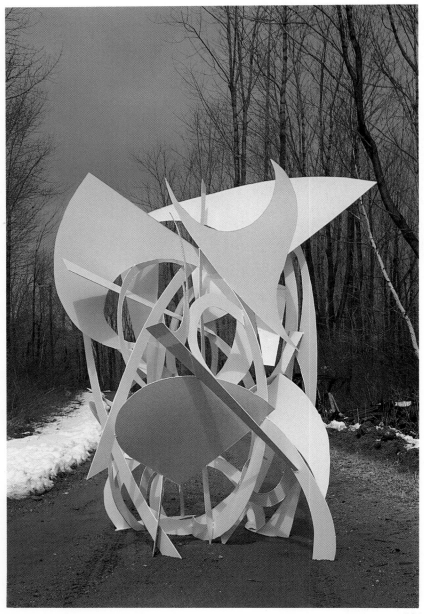

334

334-335. *Sabine Women*, 1981 (two views)
Painted, welded steel, 8 ft. 4 in. x 8 ft. x 8 ft.

335

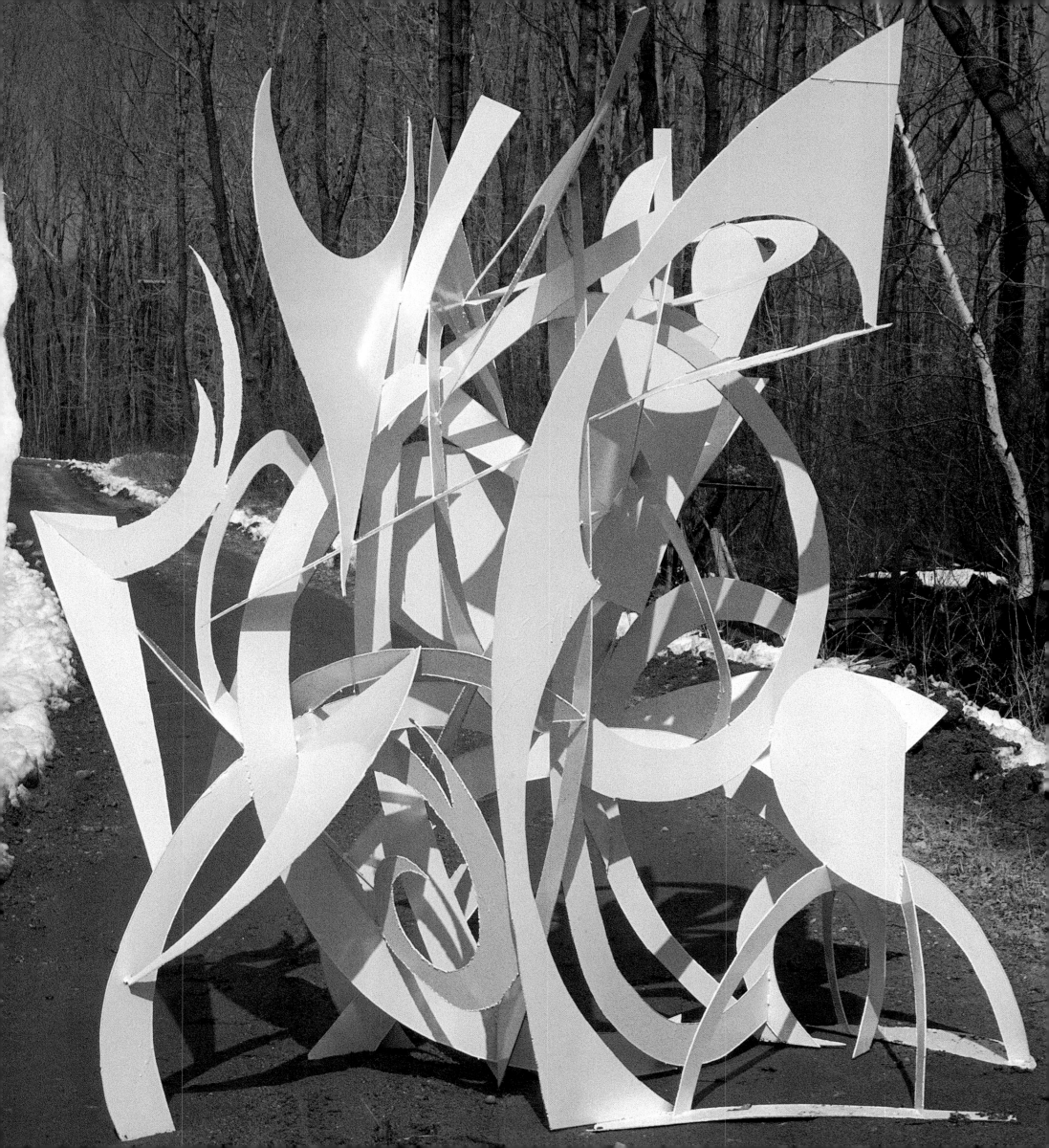

who ridiculed the idea of progress, knowing that "eau et gaz à tous les étages" was not enough to make the ignorant happy. There is an element of aristocratic snobbery in Duchamp's hermeticism. This is the antithesis of Liberman's urgent attempts to communicate messages of hope and aspiration and of the continuity of modern culture.

The Russian Constructivists dreamed of creating an abstract art for the people. Their art was not popular, perhaps because they never had time to educate the masses to appreciate form denuded of narrative and representation. Ironically, the democratic ethos of American society has provided a climate where many nontraditional forms have flourished. Today, abstract public art is taken for granted. Some of it—one thinks of Calder's kinetic works, Noguchi's fountains and rock gardens—has been widely accepted. Liberman's recent symbols of community, his giant constructions on campuses and public squares, are among the most popular abstract sculptures. Students, alumni, and citizens' groups have banded together to raise funds for some of these works. Their appeal is rooted in the element of excitement, spectacle, and breath-taking physical daring we have discussed. It is a source of great satisfaction to Liberman that his art offers an experience the public both appreciates and finds necessary. And that the general public has come to accept—indeed to want—his abstract sculptures means that Liberman has lived to see the constructivist ideal realized.

For him, not the escape from history that the anti-artist fearfully seeks but man's ability to struggle to maintain connections with the past—despite the destructive acts that rupture history—is the essential task. Liberman's is the long view of historical cycles, which is older than the Judeo-Christian tradition. Perhaps because he witnessed and survived the destruction of two great civilizations, the intimate connection between destruction and creation has become the focal point of his art at a moment when the future is once again in question. Faced with its uncertainty, Liberman refuses to embrace disillusionment and disbelief. He continues to gamble all on the possibility that art will survive history in the future as it always has in the past.

336. *Probe*, 1980-81
    Painted, welded aluminum, 26 x 58 x 44 in.

**336**

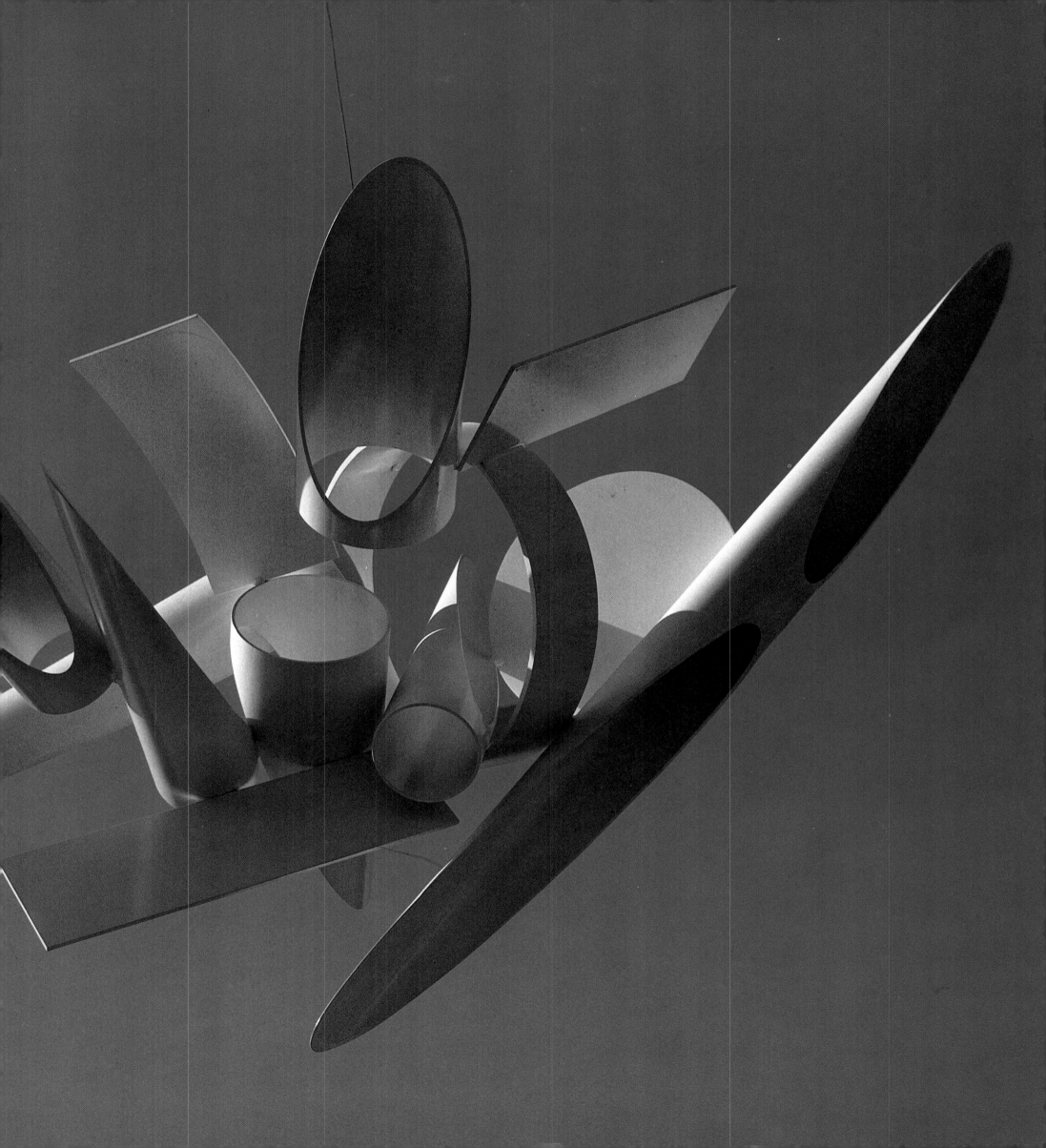

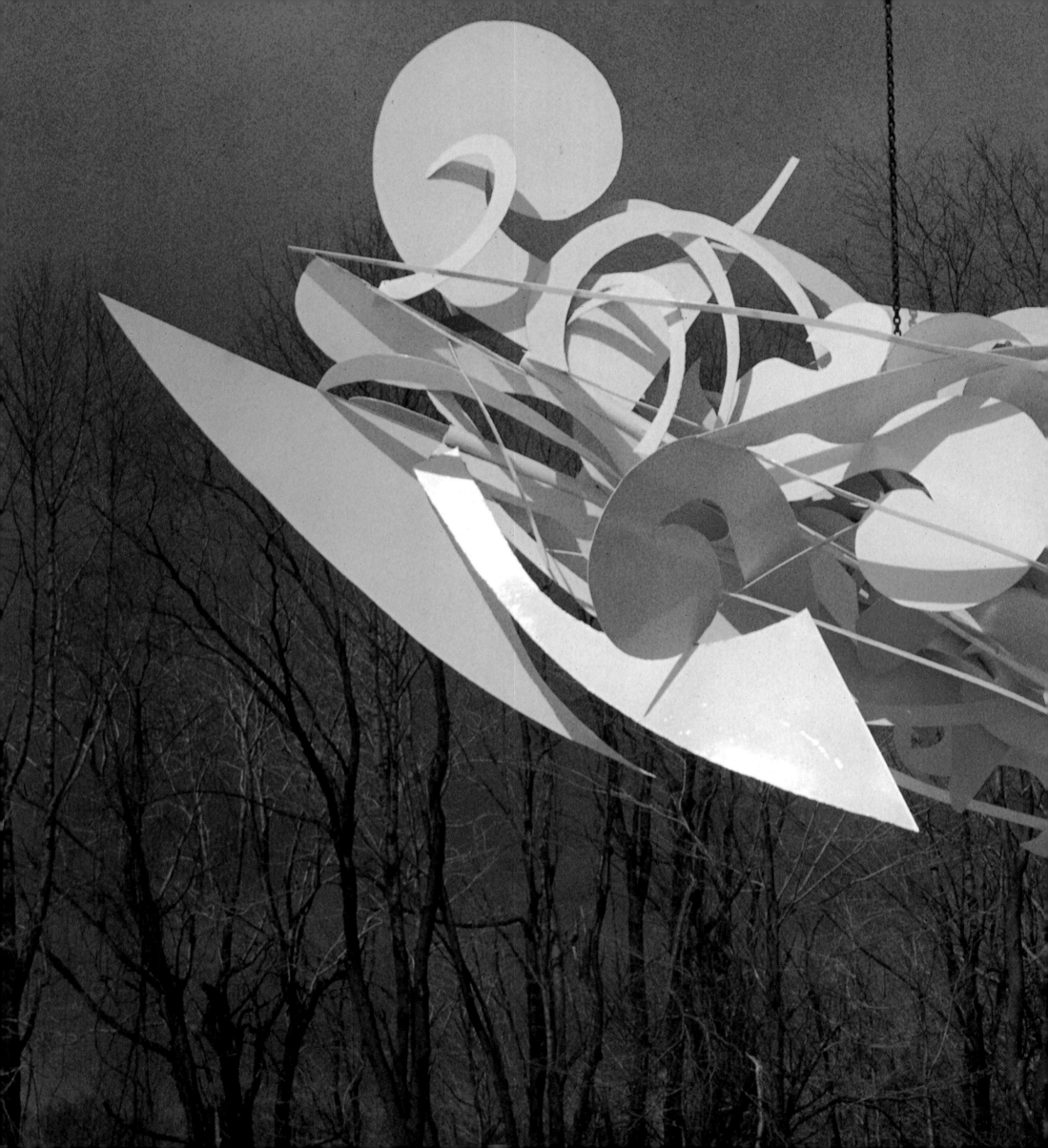

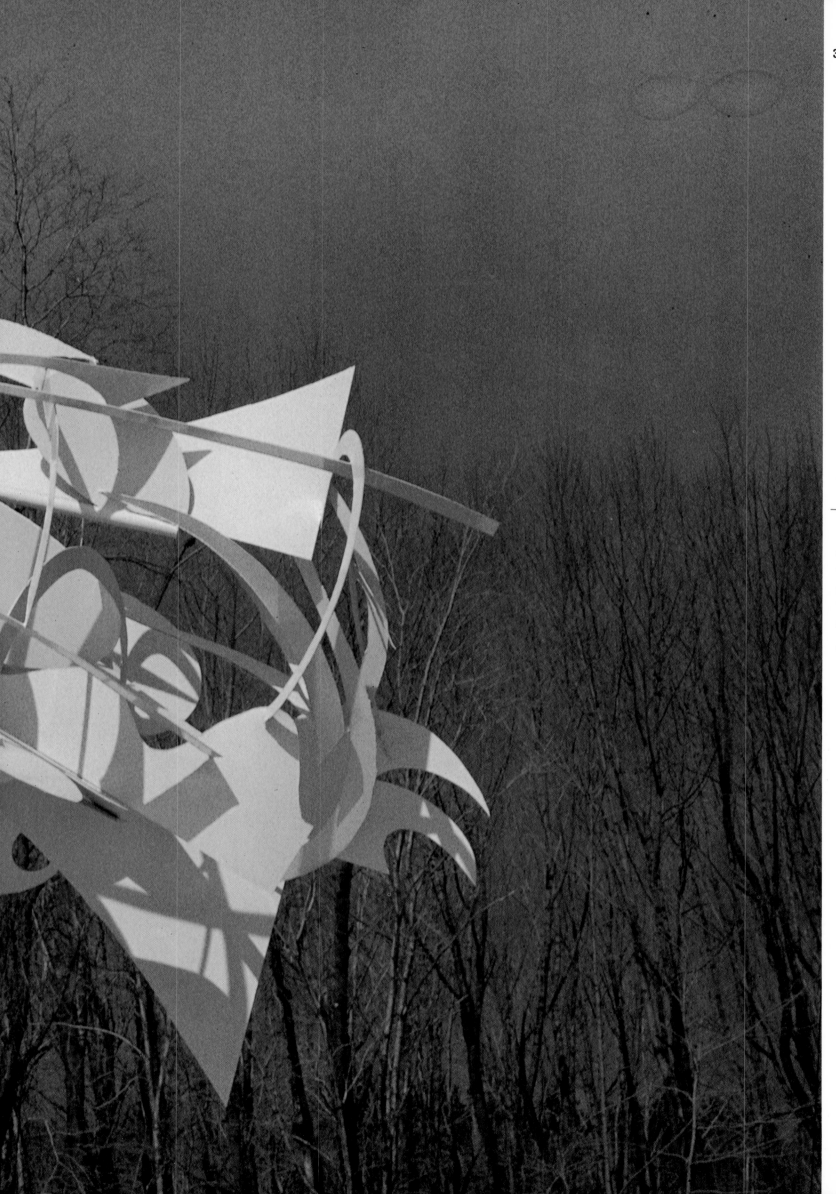

One moves and evolves and searches because it's like a Holy Grail—one never finds it. In the search lies our purpose, just as we search for love or for other things.

337. *Shuttle*, 1981
Painted, welded steel,
13½ x 21 x 11½ ft.

# CHRONOLOGY

COMPILED BY CYNTHIA GOODMAN

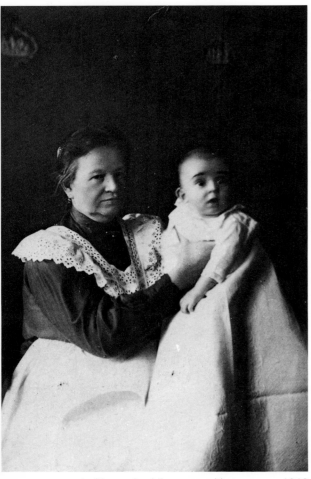

1. Alexander Liberman with nurse, c. 1913, St. Petersburg

2. Liberman, St. Petersburg, at about age four

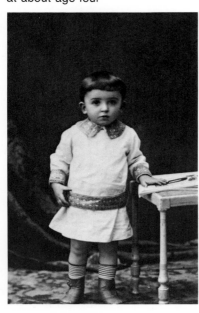

**1912** Born on September 4, in Kiev, Russia, the only child of Simon Liberman, an economist and lumber expert, and Henriette Pascar Liberman, an actress and later stage director.

**1913-** The Libermans move to St. Petersburg.
**1917** Encouraged by his mother, Liberman begins to draw at age three or four.

**1917** Moves with his family to Moscow.

**1919-** His mother establishes the first state
**1920** theater for children. Many Constructivists, including Alexandra Exter, Fedotov, and Gontcharova, create scenery and costumes for her productions. Gordon Craig and Huntley Carter visit and write about her theater. Liberman's mother's activities mark the beginning of his own involvement with theater.

Receives his first camera from his father in 1920, and photography becomes one of his life-long interests.

**1921** His father is sent to London by the Soviet government to establish a trade mission, and he brings his son out of Russia with him. In England, he attends the University School, Hastings, and St. Pirans, Maidenhead, until 1924. In addition to academic studies, he pursues carpentry and uses the school darkrooms to develop his own photographs.

**1924-** He joins his parents in Paris, where
**1928** they had settled after leaving Russia.

Attends the Ecole des Roches, where his studies include modeling, drawing, and metal-working as well as literature, history, philosophy, and mathematics.

Is first impressed by the use of collage when his mother takes him in 1924 to visit Léger, who displayed a photomontage onto which he attached a piece of red fabric, which could be raised to reveal an image underneath.

Greatly inspired by seeing the work of contemporary painters, decorators, and architects at the 1925 Exposition des Arts Décoratifs in Paris.

Does many drawings—including sketches of smokestacks, bridges, and giant gas tanks—manifesting a fascination with geometric forms, architecture, and industrial life. He also designs theatrical costumes and sets. These sketchbooks show the influence of constructivism, which he came to understand through

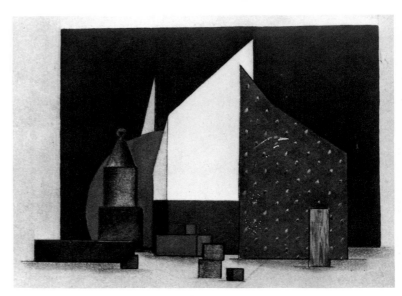

3. Fedotov's "La Dietskaja" set for Moussorgsky's "Les Enfantines," the State Children's Theater, 1920

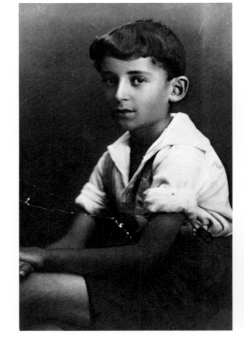

4. Liberman on vacation, 1924, at about age twelve

5. Liberman in France, summer, 1926, at age fourteen

6. Liberman, Baden-Baden, Germany, 1925

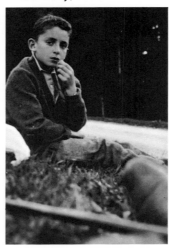

7. Engineering drawing, Ecole des Roches, c. 1927

8. Fedotov's set for Kipling's "Mowgli," State Children's Theater, c. 1920

9. *Imaginary costume*, 1924. Pencil

10. Architectural project, 1926

posters and other works that were shown in the Soviet Pavilion at the Exposition des Arts Décoratifs. The Art Deco style also influences his work.

Vacations with his mother in Baden-Baden and accompanies her on numerous museum trips to Italy.

In 1926, meets Tatiana Iacovleff, niece of the Russian painter, Alexander Iacovleff, a good friend of his mother's. Iacovleff was famous for his portraits and illustrations of the Japanese and Chinese theaters, published by Lucien Vogel. Makes his first woodcut, clay sculptures, and pastels in art class at the Ecole des Roches. Designs sets and costumes for a class performance of Mozart's *Turkish March*.

Meets many other friends of his mother's, including Exter, Chagall, Léger, Larionov, and Gontcharova.

**1929** Tatiana marries Bertrand du Plessix, a French diplomat.

**1930** Francine du Plessix is born at the French Embassy in Warsaw, Poland, where du Plessix is a commercial attaché.

Henriette Pascar Liberman performs as a dancer at a dance recital she organizes at the Comédie des Champs Elysées with sets and costumes by Marc Chagall, choreography by Bronislava Nijinska and music by Darius Milhaud. Iacovleff creates the poster for this event. Liberman also designs a poster.

His mother continues performing in masks, and writes a book, *Mon Théâtre à Moscou*.

Receives his baccalaureate from the Sorbonne in philosophy and mathematics.

Meets Tchelitchev and Eugene Berman through Waldemar George, the French art critic and friend of his mother's.

Because of his father's losses during the Crash, he begins assuming financial responsibility for his family. In order to earn a living, he designs catalogues, typography, and irons for stamping bookbindings.

**1931-1932** Enrolls in the school of cubist theoretician and painter André Lhote, considered the most important avant-garde teacher in Paris. However, he finds Lhote too dogmatic and inflexible in his approach to learning and leaves his school to study at the Ecole des Beaux-Arts, architectural section, in the atelier of the architect Defrasse.

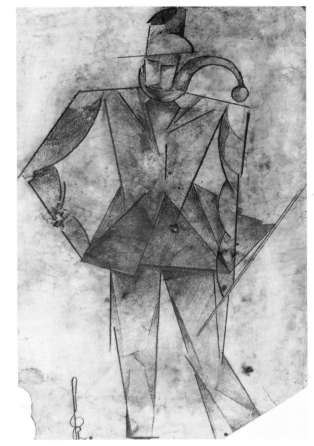

11. Drawing, 1926. Pencil

12. Alexander Iacovleff, c. 1928–29

13. Iacovleff's drawing of the artist's mother, 1930. Sanguine

14. Lucien Vogel, Paris, 1930

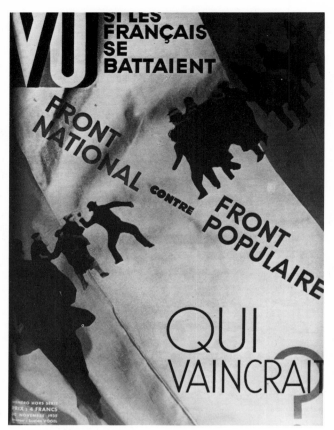

15. Liberman's photomontage for *Vu* cover, 1936

16. Liberman's photomontage for *Vu* cover, 1936

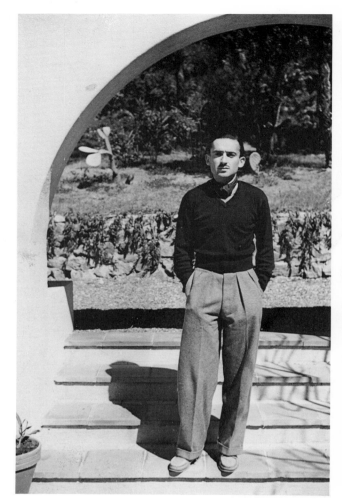

19. Liberman, south of France, 1937

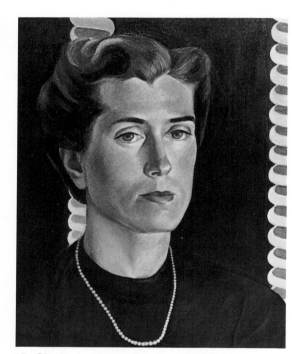

17. *Gisele de Monfreid Latham*, 1937, Paris

18. Liberman skiing, Megeve, 1938

Leaves the Ecole des Beaux-Arts and enters the Ecole Spéciale d'Architecture to study with August Perret, the pioneer in reinforced-concrete construction. Works afternoons for the French poster artist A. M. Cassandre, for approximately six months. He also works as a medical illustrator for a gastroenterologist.

In 1932, designs stage designs for a production of "L'Ours et le Pacha" by Scribe for his mother's new children's theater in Paris, the Scaramouche.

Leaves the Ecole Spéciale and works briefly with a landscape architect, making renderings of gardens. Starts working for Lucien Vogel, on the staff of *Vu*, the first magazine illustrated with photographs. Begins as an assistant in the art department, becomes art director, then managing editor. Designs numerous covers signed "Alexandre," and works extensively with layout, photomontage, and typography. While on the magazine, works with photographers Cartier-Bresson, Brassai, Blumenfeld, and Kertesz, among others.

**1934-1936** Under the nom de plume Jean Orbay, writes film reviews for *Vu*, reflecting his fascination with cinema. Is especially interested in American movies.

Briefly married to Hilda Sturm, a German skiing champion.

Leaves *Vu* because he wants to devote himself to painting, writing, and filmmaking. His father, prosperous again, buys him a small house at Ste. Maxime on the French Riviera, where he can work. Makes one of the first color films on painting, "La Femme Française dans l'Art," with the staff of the Louvre.

Completes a film on English art, not printed at the time and subsequently lost in the war.

**1937-1939** Paints many realistic portraits, landscapes, and still lifes, totally rejecting Lhote's academic cubist training.

Wins gold medal for design at the International Exhibition in Paris, for a presentation of how a magazine is created in 1937.

**1940** Mobilized by the French army at the time of the German invasion, but never in active combat: by the time he reaches his unit, the Armistice is signed.

Escapes with his mother to Ste. Maxime, in the unoccupied zone, just ahead of the German army. Bertrand du Plessix is killed and becomes one of the first heroes of the Free French army when his plane is shot down trying to reach the Free French in England. Tatiana and Francine join Liberman, their closest friend in Ste. Maxime. They escape Europe through Spain and Portugal.

**1941** They arrive in New York, where his parents had already settled. His friends from Europe, Iva S. V. Patcevitch, a

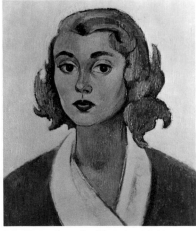

20. *Francine du Plessix*, 1941. Oil on canvas

21. *Venice Gondolier*, 1948. Oil on canvas

22. Liberman painting, New York, 1948

23. Tatiana Liberman, c. 1946, photographed by Erwin Blumenfeld

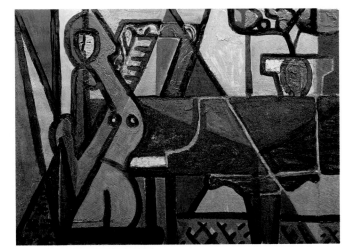

24. *The Piano*, 1947. Oil on canvas

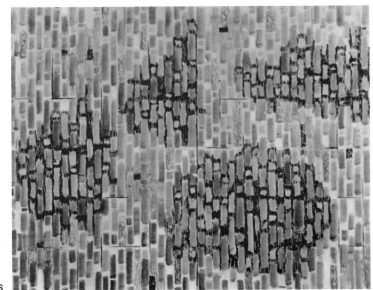

25. *Musical Notation*, 1948. Oil on canvas

close associate of Condé Nast, and Lucien Vogel, help him get a job at *Vogue*.

Beginning of contacts with the European artists living in New York; they include Duchamp, Kiesler, Léger, Chagall, and Matta.

Frequents The Museum of Modern Art, The Museum of Non-Objective Painting, and The Metropolitan Museum of Art.

Rents house at 173 East 70th Street, which he later buys and where he still lives.

**1942** Marries Tatiana Iacovleff du Plessix.

Buys his first Jackson Pollock drawing at a Knoedler auction for British War Relief.

Considers as a "great visual breakthrough" Frederick Kiesler's installation at Peggy Guggenheim's Art of This Century Gallery in New York, where Kiesler dispensed with all traditional methods of displaying art. Kiesler, a close friend of Liberman's mother, subsequently becomes a supporter of his work.

Tatiana begins designing hats at Saks Fifth Avenue, where she continues working until 1965 as "Tatiana of Saks Fifth Avenue," known for her individualistic creations.

**1943** Becomes art director of *Vogue*.

Starts commissioning such artists as Cornell, Salvador Dali, Chagall, and Duchamp to do illustrations for *Vogue*. Duchamp helps shape his idea of "chance" in art.

Visits Stanley Hayter's printing Atelier 17.

**1945** During a summer vacation at Martha's Vineyard, he starts painting again, something he could not do during the war.

**1946** Becomes a U.S. citizen.

Father dies.

Decorated Chevalier of the Legion of Honor by the French government.

Continues painting on vacation in Stony Brook, Long Island.

**1947-**
**1948** Publishes a photograph of John Cage's *Prepared Piano* by Irving Penn in *Vogue*.

Attends many concerts and becomes interested in the applicability of a musical notation system to painting when he examines an old perforated piano score.

Paints scenes of Venice on the first of his yearly trips to Europe.

His style becomes more abstract and involved with overall patterns, frequently reminiscent of Seurat and Cézanne.

Begins experimenting with blowing up mentally, as one might in a photoenlarger, sections of a pointillist painting he had done in New York. This becomes the image in his first abstract paintings.

Reads Gyorgy Kepes's *Language of Vision*, given to him by the photographer John Rawlings in 1948.

26. Liberman with Picasso on the beach at Golf Juan, 1949

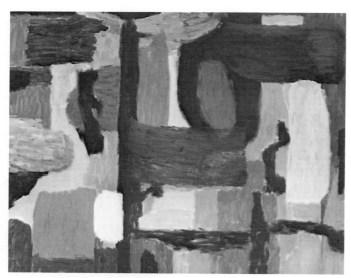

27. *Abstraction*, 1948–49

28. Detail, first welded sculpture, 1959, Ste. Maxime, France

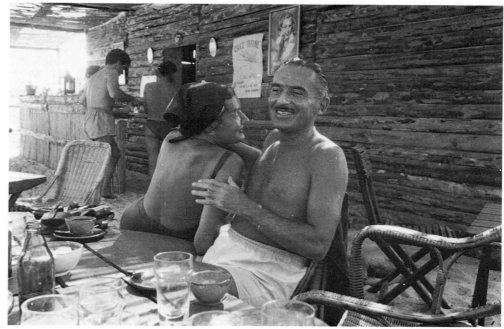

29. Liberman with Tatiana, St. Tropez, 1950

Reads Kandinsky's *Concerning the Spiritual in Art* with enormous interest.

Travels to California, accompanying Tatiana, sent there to design hats for Saks. On this trip he visits the home of Walter Arensberg who had a vast collection of works by Marcel Duchamp.

Starts on a project documenting through photography and interviews the major artists of the School of Paris.

Visit to Picasso in Vallauris on the French Riviera is the first of their several meetings.

Meets Kupka on a visit to his home and studio in Puteaux, France.

**1950** Paints a series of freehand circles on canvas in the summer of 1950. The irregularities dissatisfy him, and he begins using a compass; switches to commercial enamel paints and also to industrial panels of masonite and aluminum as supports.

Begins his exploration of primarily conceptual formulations in a series of hard-edge circle paintings. His ensuing preoccupation with the circle is partially initiated by his conviction that this form had been neglected in contemporary art. Cézanne's belief in the reducibility of all natural forms to pure geometry is also an inspiration for his use of the sphere as a compositional point of departure.

In order to determine the proportions of his compositions, he uses the Golden Section as explained in Matila Ghyka's book *The Geometry of Art and Life*.

Geometric paintings are on masonite and aluminum panels, which can be moved and placed in different positions in the manner of a Kabuki actor. He is preoccupied in these paintings with thesis and antithesis.

Develops interest in erasing individualistic characteristics in art and turns to the possibility of reproducing art objects. His goal is an "art of anonymity" that can be "repeated like music," so that a new version of a work can be made by an assistant if the original is destroyed. His stance is "anti-art, anti-painting, anti-value, the ego is hateful." For these reasons, gallery owners are often wary of showing his work. Executes a series of small white plaster sculptures.

**1951** Meets Dubuffet in New York.

Comes into contact with the Black Mountain College artists, including Robert Rauschenberg and Jasper Johns, when Francine du Plessix goes there in 1951. In the summer, photographs the Matisse Chapel in Vence, France, commissioned by Albert Skira. He is the only photographer permitted to take pictures of this building; his photographs of the chapel are published in a *Vogue* article in December.

Publishes in *Vogue* the first photograph and article to appear in America on Frank Kupka.

Buys his second drawing by Pollock and meets him at Pollock's exhibition at Betty Parsons Gallery.

Has Cecil Beaton make some fashion photographs for *Vogue* using Pollock's paintings as the background, because there was no other way to get Pollock's work reproduced in the magazine.

30. Liberman in front of Cézanne's studio, Aix-en-Provence, 1950

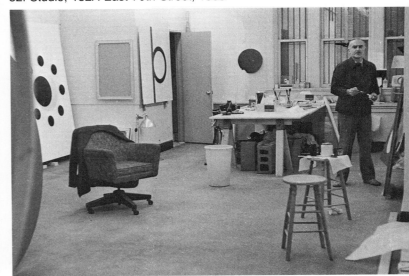

31. Donald Gratz in sculpture workshop

32. Studio, 132A East 70th Street, 1958

33-35. Enamel sculptures, 1958–59

Publishes in *Vogue* an article about Betty Parsons and the artists in her gallery, including Barnett Newman, Ad Reinhardt, Clyfford Still, and Pollock. Newman becomes a particularly close friend. Before the artists and Parsons are photographed for this article, he organizes a luncheon honoring them at the Café Chambord.

**1952** Encouraged by Irving Penn, publishes first photographs of Cézanne's studio in *Vogue*.

Visits Dubuffet in his New York studio and photographs him working on the floor on plywood panels with new plastic mediums.

**1953** Rose Fried agrees to take one of his paintings in her gallery on consignment.

Has some of his paintings executed by his friend and assistant Ed Kasper, following his instructions.

Orders a sculpture made according to his specifications over the telephone.

Commissions Robert Rauschenberg and Jasper Johns to build a set for a photographic sitting for *Vogue*.

Betty Parsons brings Clement Greenberg and Barnett Newman to his studio.

**1954** James Johnson Sweeney visits his studio at Leo Lerman's suggestion and chooses *Two Circles* to be shown in "Younger American Painters," at the Solomon R. Guggenheim Museum, his first exhibition. Bright and symmetrical, *Two Circles* is recognized by the middle of the next decade as having presaged hard-edge abstraction by almost ten years.

Profoundly moved by seeing Clyfford Still's predominantly black *Painting 1951*, when first shown at The Museum of Modern Art.

With an article on Georges Braque, starts a series of essays in *Vogue* on the modern masters with his own text and photographs.

**1955-1957** Returns to using oil paints for special effects.

Befriends Brancusi and photographs his sculpture during visits to his studio.

Visits Henri-Pierre Roché in Paris in 1955 and photographs his collection of Brancusi sculptures, including *Torso*, which was influential on Liberman's subsequent work.

Explores role of accident and chance in paintings; picks colors by throwing dice and using *I-Ching*.

In 1956, has his friend Marcel Guillaume make a rotating electric machine composed of a series of discs that project dots of colored light.

Francine du Plessix marries painter Cleve Gray and moves to Warren, Connecticut, where Liberman begins to spend weekends.

**1958** Gives Ed Kasper drawings for a group of small sculptures to be executed in plexiglass and enamel on copper.

Cleve Gray introduces him to the use of Liquitex paints.

**1959** Learns arc-welding and makes his first welded metal sculpture in Ste. Maxime, France, with help of his summer housekeeper's husband, François Coppo.

Makes a series of erasure drawings.

Pursues further the idea of chance in painting by tossing poker chips onto a canvas surface and painting in dots where the chips fall.

Thaddeus Ives Gray, his first grandson, is born. Moves studio from his home to an ex-funeral parlor at 132 East 70th Street. Begins a series of tondo paintings.

Meets Arp; admires his collaboration on sculpture with his studio assistants.

36. Edward Kasper, 1958

37. Small sculpture, 1958–59. Painted plexiglass and enamel

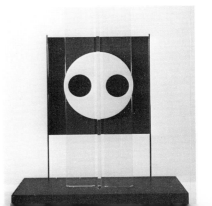

373

38. Betty Parsons, 1960

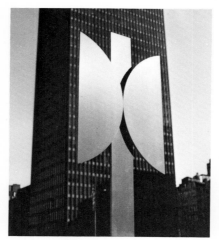

39. *The King*, 1963

40

41

40-42. Opening of first show, Betty Parsons Gallery, 1960.
Liberman shown with (40) Franz Klein and Salvador Dali,
(41) de Kooning, (42) Clement Greenberg

42

43. Liberman at the 70th Street studio, 1962

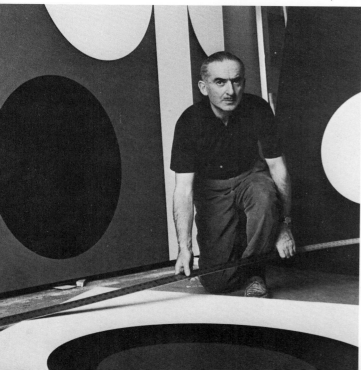

44. Liberman at Betty Parsons Gallery
with Barnett Newman installing the 1963 show

**1960**  Exhibition of his photographs, "The Artist in His Studio," organized by William Lieberman at The Museum of Modern Art.

Given his first one-man exhibition (paintings and sculpture) at the Betty Parsons Gallery because of William Lieberman's encouragement. Barnett Newman does the installation. Alfred H. Barr, Jr., buys a small sculpture, *Passage* (1959), and the painting *Continuous on Red* (1960) for The Museum of Modern Art from this show at Betty Parsons.

Profoundly influenced by the Barnett Newman exhibition at French and Company, organized by Clement Greenberg and installed by Tony Smith.

Defines his artistic credo in *On Circlism*.

Viking Press publishes his book, *The Artist in His Studio*, a collection of documentary essays and photographs on the artists of the School of Paris.

Begins to use mythological titles for paintings.

**1961**  Luke Alexander Gray, his second grandson, is born.

Mourlot prints Liberman's first lithographs when the artist sends photographs of his paintings and has them made into prints of specified dimensions.

**1962**  Begins working on the floor, straining and pouring on raw canvas, influenced by Jackson Pollock. Instead of geometric compositions, his paintings begin exploring gestural forms. Expands his palette beyond primary colors.

One-man exhibition (paintings and drawings) at the Betty Parsons Gallery. Gives drawing of a work to a fabricator, Treitel Gratz, and has him realize it as a sculpture.

Included in "Geometric Abstraction in America" exhibition, Whitney Museum of American Art.

Appointed editorial director of all Condé Nast publications.

**1963**  Makes his own first lithograph at Mourlot, where he works each year through 1966. First works on stone are instrumental in the transition to his black-and-white paintings.

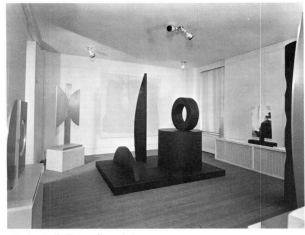

45. Installation of sculpture,
    Betty Parsons Gallery, 1963

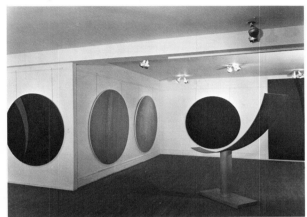

46. Installation of paintings,
    Betty Parsons Gallery, 1963

47. Liberman with grandsons
    Thaddeus and Luke Gray,
    New York, c. 1964

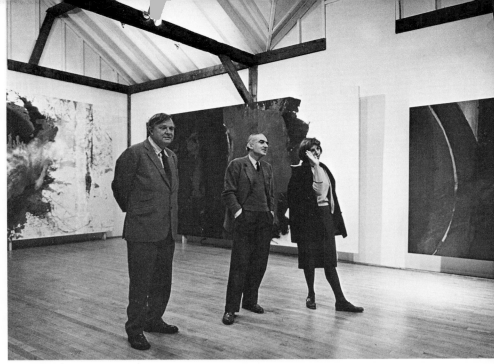

48. Liberman with Robert Motherwell and Helen Frankenthaler,
    Bennington College retrospective, 1964

49. Treasury of Atreus, Mycenae,
    photographed by Liberman, 1965

Jane Grant and William Harris give him welding equipment. Begins using junk metal, old boilers, and parts of tanks in sculptures.

Inspired by painter Adolph Gottlieb, uses a squeegee to cover large areas of canvas.

One-man exhibition (paintings and sculpture) at the Betty Parsons Gallery. Newman again installs exhibition; dialog continues between Liberman and Newman about the meaning of painting and its techniques.

William Layman, a welder and road builder, becomes his assistant in Connecticut.

Executes *Fire*, his first large sculpture commission for Ethel de Croisset in Málaga, Spain.

Included in "The Responsive Eye" exhibition at The Museum of Modern Art, organized by William Seitz.

**1964**  First bronzes cast by Alexander's Sculptural Service in New York.

Enlarges studio to include upper floor at 132 East 70th Street.

Begins a group of black paintings.

Receives a commission from Philip Johnson for his first public sculpture, *Prometheus*, for the New York State Pavilion, New York World's Fair.

One-man exhibitions: Betty Parsons Gallery, paintings and sculpture; Robert Fraser Gallery, London, paintings and sculpture; Bennington College, Vermont, paintings, arranged by Paul Feeley.

Works with clay at Bennington Potters at time of his Bennington retrospective.

Included in "Post-Painterly Abstraction" exhibition, Los Angeles County Museum of Art, organized by Clement Greenberg.

First of two consecutive summer trips to Greece to make photographs for his book *Greece, Gods, and Art*.

**1965**  Executes sculpture on an increasingly large scale, assisted by William Layman and his sons.

One-man exhibitions: Galleria dell Ariete, Milano, paintings and sculpture; Galleria d'Arte, Naples, paintings and sculpture.

Meets David Smith on visit to Bolton Landing with Helen Frankenthaler, Robert Motherwell, Tatiana, Francine, and Cleve Gray.

**1966**  Moves his sculpture studio to Layman's truck garage in order to have more interior space as well as the opportunity to use the surrounding fields.

50. Lunch at home, 1963. (Left to right) Lawrence Alloway,
    Beatrice Leval, Barnett Newman, Liberman (standing), Sylvia Sleigh
    Alloway, Robert Motherwell, Annalee Newman

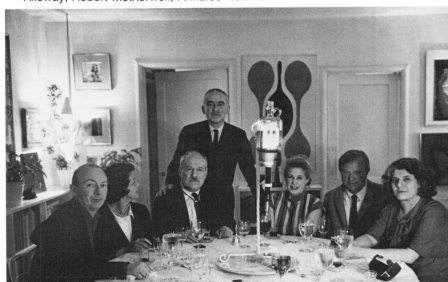

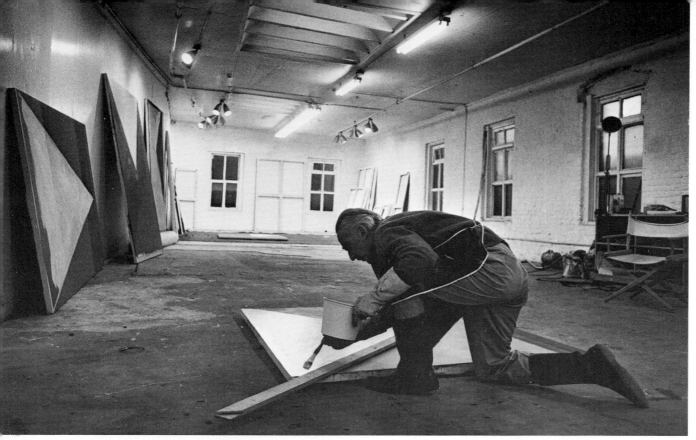

51. Studio at 414 East 75th Street, 1967

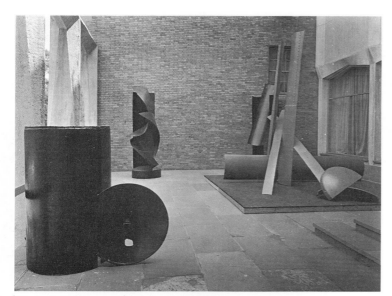

52. Installation, sculpture, Jewish Museum, 1966

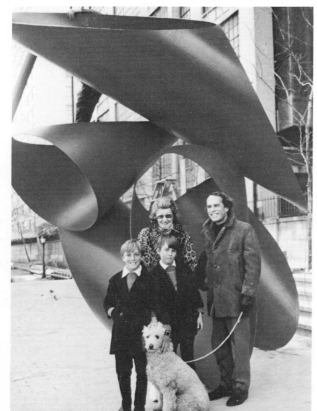

53. Liberman with Barnett Newman and William Craig Berkson

54. Tatiana, Cleve Gray, Luke, and Thaddeus in front of *Above*, Dag Hammarskjold Plaza, New York, 1970

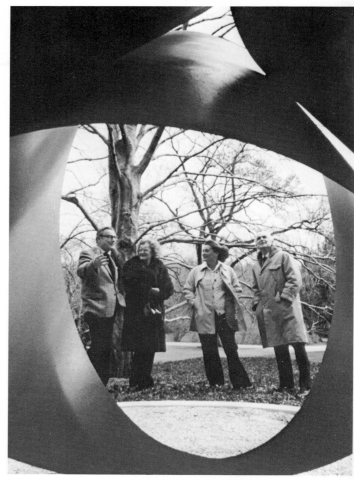

55. With Nelson and Happy Rockefeller at Pocantico at installation of *Above II*, 1972

Helen Frankenthaler brings Sam Hunter to this studio. Hunter subsequently organizes a one-man exhibition of his sculpture at the Jewish Museum.

One-man exhibition (paintings) at the Betty Parsons Gallery.

**1967** Completes series of black paintings and paintings of orbs.

Moves to new studio at 414 East 75th Street.

Triangle shape, always pointing downward, appears in his work.

One-man exhibition (paintings) at the Betty Parsons Gallery. Begins exhibiting at the André Emmerich Gallery, with two one-man exhibitions of his sculpture. Included in "American Sculpture of the Sixties" exhibition, Los Angeles County Museum of Art.

Libermans begin their yearly summer trips to Ischia, Italy.

**1968** Exhibits *Tropic* (1967) at HemisFair '68 in San Antonio, Texas.

Included in The Art of the Real exhibition at The Museum of Modern Art, organized by Eugene Goossen.

*Greece, Gods, and Art* published by Viking Press.

Buys country house called Hillside, next-door to the Grays, in Warren, Connecticut.

Starts working with a crane, making monumental sculpture possible. Takes numerous photographs of his work in progress. Often, to facilitate working in large scale, tries out his ideas for changing a sculpture by first cutting out and adjusting pieces of the composition on a photograph.

Makes first cast aluminum sculpture when commissioned by R. S. Reynolds Company for their Memorial Awards.

Included in 1968 "Annual Exhibition of Contemporary American Sculpture," Whitney Museum of American Art.

**1969** Continues exploring triangle theme in paintings. Begins machine finishing metal sculptures at Torrington Metal Works in Connecticut.

Crushed cylinders first appear in his sculpture.

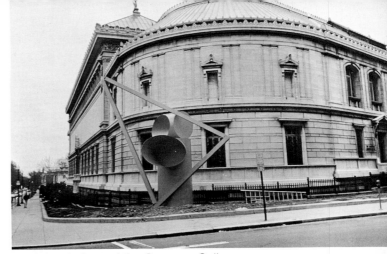

◁ The Evening Sun
(Baltimore)

56. *Adam* in front of the Corcoran Gallery, Washington, D.C., 1970

# *Work Of Art Removed After Nixon Complains*

## Nixon objects to 'Adam' sculpture

△ The Boston Globe

WASHINGTON — President Nixon, no fan of modern art, was annoyed on reaching the White House to find an abstract steel sculpture standing outside the Corcoran Art Gallery. It was a huge work named "Adam" by New York sculptor Alexander Liberman. Mr. Nixon said he didn't want the thing so close to the White House and told his aides to get rid of it. This was a delicate undertaking because the Corcoran is privately financed. The removal was finally arranged through the National Endowment for the Arts, which borrowed the sculpture and had the Park Service transport it a mile away to Hains Point under a so-called "Sculpture in the Parks" program.

Kalamazoo Gazette ▷

### Nixon Vs. 'Adam'

Presidents have a knack at getting their own way in many of the small things in life, even if they occasionally are frustrated by some of the big issues.

A recent example of presidents getting their way was reported by Charles Bartlett, a Washington correspondent.

President Nixon, it seems, is similar to many Americans who find little to warm their hearts in the form-and-design emphasis of much of modern art.

Most people who feel this way, however, can't do much about it except stay away from modern-art museums and buy copies of Norman Rockwell paintings.

The President, however, can bring a little more weight to bear.

As Bartlett tells the story, Mr. Nixon was annoyed on returning to the White House one day to find an abstract steel sculpture standing outside the nearby Corcoran Art Gallery.

It was a huge work named "Adam" by New York sculptor Alexander Liberman.

The President, Bartlett reports, said he didn't want the thing so close to the White House and told his aides to get rid of it.

That wasn't an easy order to follow, since the Corcoran is a privately financed gallery.

The removal reportedly finally was arranged through the National Endowment for the Arts, which borrowed the sculpture and had the U.S. Park Service transport it a mile away to Hains Point under a so-called "Sculpture in the Parks" program.

Such a successful mobilization of government agencies to do his bidding must gladden the heart of the President.

He must now be wondering if his aides can find a way to remove those 11 Democrats fighting for his job.

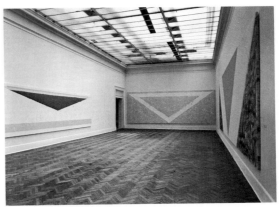

57. Installation, Corcoran Gallery, 1970

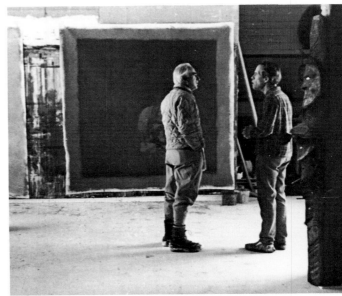

58. Liberman with Cleve Gray in Gray's studio

One-man exhibition André Emmerich Gallery, sculpture; Betty Parsons Gallery, painting.

Included in "The New American Painting and Sculpture: The First Generation" exhibition, The Museum of Modern Art; "The Pure and Clear in American Art" exhibition, Philadelphia Museum of Art.

**1970** Major retrospective exhibition organized by James Pilgrim, James Harithas, and Walter Hopps for the Corcoran Gallery of Art, Washington, D.C. His paintings and sculpture fill the entire museum. Exhibition travels to the Museum of Fine Arts, Houston, at that time directed by Philippe de Montebello.

**1971** Six of his new large sculptures are exhibited at Dag Hammerskjold Plaza, New York, in the first of a series of shows in this location, sponsored by real estate developer Harry Macklowe.

*Above* (1970) bought by The Museum of Modern Art, New York; installed in garden, 1973.

Explodes dynamite inside tanks to create random shapes for sculpture.

*Gate of Hope*, his first monumental public sculpture, is commissioned by the State Foundation on Culture and the Arts for the University of Hawaii, Honolulu.

*Echo* (1969) permanently installed at Wadsworth Atheneum.

**1972** President Nixon orders that *Adam* (1970) be removed from in front of the Corcoran Gallery, where it was installed; it is moved to Haines Point, Washington, D.C.

Nelson Rockefeller installs *Above II* (1970) on his estate Pocantico Hills, North Tarrytown, New York.

59. Installation, 1969, at The Museum of Modern Art, "New American Painting and Sculpture: The First Generation." Visible are *Six Hundred and Thirty-Nine* and *Minimum*

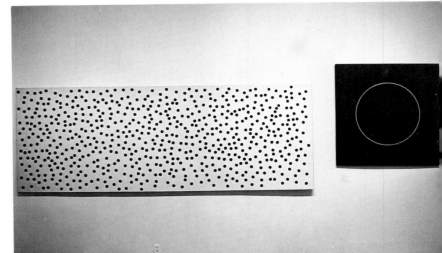

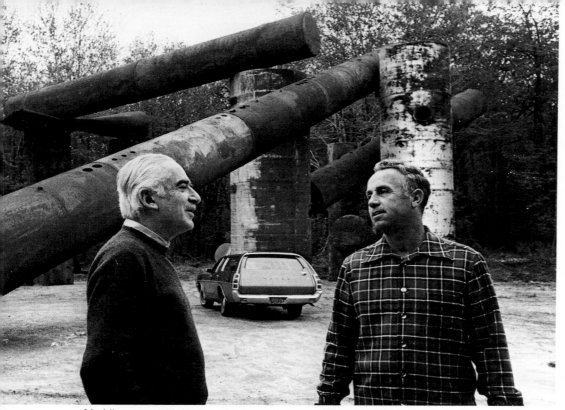

60. Liberman with William Layman, Warren studio, 1972, photographed by Marc Riboud

61. Digs at Thebes, Greece,
photographed by Liberman, 1965

62. Liberman with Thomas B. Hess at Storm King Art Center, 1977

63. With 2RC coworkers, Rome, 1973

*Above Above* is commissioned for Osborn Building Plaza Addition, St. Paul, Minnesota.

Installation of *Gate of Hope* (1970-72) at the University of Hawaii coincides with a retrospective exhibition of his paintings, sculpture, lithographs, and drawings at the Honolulu Academy of Arts.

Included in 1972 "Annual Exhibition of Contemporary American Painting," Whitney Museum of American Art.

**1973** *Adam* (1970), *Eve* (1970), *Adonai* (1971) installed at Storm King Art Center, in Mountainville, New York.

*Temple II* (1963) installed at South Mall Justice Building, Albany, New York.

Included in Whitney Biennial. One-man exhibition at André Emmerich Gallery, *Triad* paintings.

*Path* (1969-70) installed at Denison University, Granville, Ohio.

*Icarus* (1971) installed at Louis Hornick and Company, Haverstraw, New York.

*Above Above* (1972) installed at Osborn Building Plaza, St. Paul.

Included in "14 artistes américains" exhibition, Denise René Gallery, Paris.

Learns aquatinting at Walter Rossi's 2RC Studio in Rome and continues working there each year through 1977.

**1974** One-man exhibition at André Emmerich Gallery called "Sacred Precincts,"

consisting of bronzes and other small sculptures.

*Covenant*, commissioned by the University of Pennsylvania, is built by Bethlehem Steel in their Baltimore shipyard.

Two-man exhibition with Hans Hofmann at Janie C. Lee Gallery, Houston; Liberman shows bronzes.

*Argo* (1974) is included in "Monumenta," an exhibition of large-scale sculpture from the United States and Europe, at Newport, Rhode Island, organized by Sam Hunter. *Argo* singled out by Robert Hughes in his *Time* magazine review of the exhibition on September 2, 1974, as "the most successful combination of work and site in the entire show."

Included in the Düsseldorf Art Fair.

One-man exhibition at the André Emmerich Gallery entitled "Circle Paintings 1950-64."

Mother dies.

**1975** *Phoenix* (1975), commissioned by Anna Bing Arnold, is installed in the sculpture garden, Los Angeles County Museum of Art. *Covenant* (1974) is installed at the University of Pennsylvania, Philadelphia.

Included in "Sculpture: American Directions, 1945-75" exhibition, National Collection of Fine Arts, Washington, D.C. Included in "Artists by Artists," an exhibition of photographs of artists by other artists at the Zabriskie Gallery, New York. Liberman's photo-

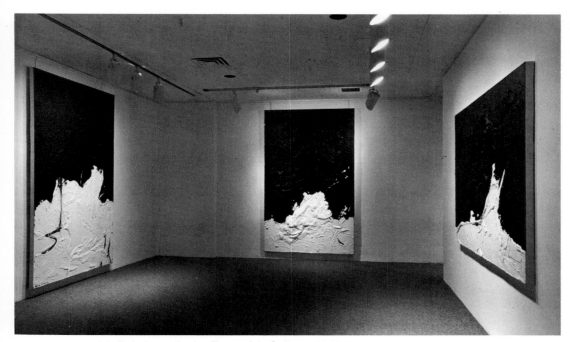

64. Paintings, André Emmerich Gallery, 1979

65. Liberman with André Emmerich, New York, 1978, photographed by Brui

graphs were of Rothko, Newman, Duchamp, and Johns.

Designs poster for Amnesty International.

*Firmament* (1970) is acquired by the Dayton Art Institute (Ohio) and installed in their outdoor garden; acquisition made possible by the National Endowment for the Arts. It is the first piece of monumental contemporary sculpture in Dayton.

**1976** *Argo* purchased for Milwaukee Art Center by Mrs. Harry Bradley.

Has painting studio built above garage of Connecticut house.

*Symbol* (1978) is commissioned by Rockford, Illinois. *Ode* (1976) installed for Neiman-Marcus, Northbrook, Illinois.

Tapestry made of painting *Number 41* produced by Gloria F. Ross Tapestries for Pace Editions.

**1977** Included in "Private Images: Photographs by Painters" exhibition, Los Angeles County Museum of Art; "Project: New Urban Monuments" exhibition, Akron Art Institute; "New York: The State of Art" exhibition, Albany, New York, organized by Thomas B. Hess.

Begins working in lithography with Tatyana Grosman at Universal Limited Art Editions (ULAE), West Islip, Long Island.

One-man exhibitions: Van Straaten Gallery, Chicago, works on paper and sculpture; André Emmerich Gallery, sculpture.

Included in an invitational portfolio of prints by thirteen artists chosen by Thomas B. Hess and Annalee Newman, published by Columbia University to endow a chair in honor of Meyer Schapiro.

Major retrospective exhibition, Storm King Art Center, Mountainville, New York, sculpture—including monumental works—paintings, graphics, and photographs. Barbaralee Diamonstein films a video interview with him on the occasion of his exhibition, aired on Channel 31 television.

Paints Unknown series.

**1978** One-man exhibitions: Harcus-Krakow Gallery, Boston, works on paper and photographs; André Emmerich Gallery, paintings; Burpee Art Museum, Rockford, Illinois, small sculpture and works on paper (in conjunction with installation of *Symbol*); Landau-Alexander Gallery, Los Angeles, paintings.

*Adam* is installed outside East Wing of National Gallery in Washington, D.C., for the inauguration of this wing.

*On High* is commissioned by the GSA for New Haven, Connecticut.

**1979** *Ariel* (1980) commissioned by Hialeah Associates. *Accord* (1979) is installed on East 54th Street

*New York Times Magazine* does article "Liberman Staying in Vogue," covering his life as an editor and artist.

Garage painting studio extension of Connecticut house is completed, doubling his working space.

66. Statue of Marcus Aurelius, Rome, photographed by Liberman, 1978

67. Installation, "The State of Art," 1977, Albany, New York. *Behold*

68. Liberman awarded Doctorate of Fine Arts at Rhode Island School of Design, 1980. With Cleve Gray and Robert Motherwell

68. Liberman awarded Doctorate of Fine Arts at Rhode Island School of Design, 1980. With Cleve Gray and Robert Motherwell

69. Triptych *Illuminations*, 1980

One-man exhibition: André Emmerich Gallery, paintings; Greenberg Gallery, St. Louis, paintings; Art Gallery, Baltimore, paintings on paper; "The Artist in His Studio" exhibition (artists photographed by Liberman), at Laumeier County Park Sculpture Gallery, St. Louis, prelude to unveiling of *The Way* (1972) in Laumeier's outdoor sculpture park.

*Eros* (1969) unveiled, on indefinite loan from the Albright-Knox Art Gallery to Greater Buffalo International Airport. *Argosy* commissioned for Grove Isle, Florida. Stephen Olswang of Yale University begins documentary film about *On High* and expands his subject matter to cover Liberman's career as sculptor.

**1980** One-man exhibition, André Emmerich Gallery, paintings on paper.

ULAE publishes *Nostalgia for the Present* by Andrei Voznesensky, illustrated by Alexander Liberman, the product of a three-year collaboration.

Receives honorary Doctorate of Fine Arts, Rhode Island School of Design.

*On High* (1977-80) is installed at Federal Plaza, New Haven, Connecticut.

*The Way* (1972-80), his largest sculpture commission, is installed in Laumeier International Sculpture Park, St. Louis, Missouri.

*Argosy* (1980) is installed at Grove Isle, Florida.

*Ariel* (1980) is installed at United National Bank Building, Miami.

*Behold* (1975-78) is installed on one-year loan to Coral Gables Sculpture Circle, Florida.

*Vortex* is commissioned by the Phoenix Art Museum, Phoenix, Arizona.

**1981** *Thrust* (1979-80) is installed at Benenson Realty, Stamford, Connecticut.

One-man exhibition, Hokin Gallery, Bay Harbor Islands, Florida, paintings and sculpture.

*Vortex* (1981) is installed at Phoenix Art Museum.

*Turn* (1973) is installed at Museo Rufino Tamayo, Mexico City.

One-man exhibition, André Emmerich Gallery, paintings and sculpture.

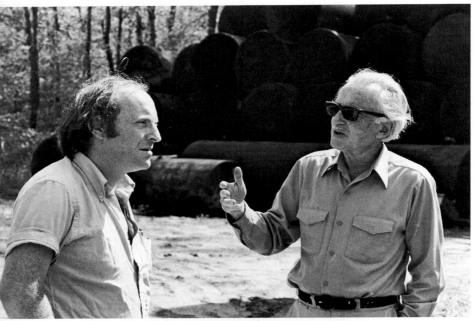

70. Liberman at Warren studio with Joseph Brodsky, c. 1978

71. Liberman with Barbara Rose in front of *Symbol*, Rockford, Illinois

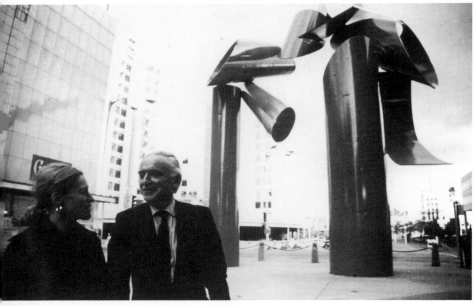

72. Installation of *The Way*, St. Louis, Missouri, 1980

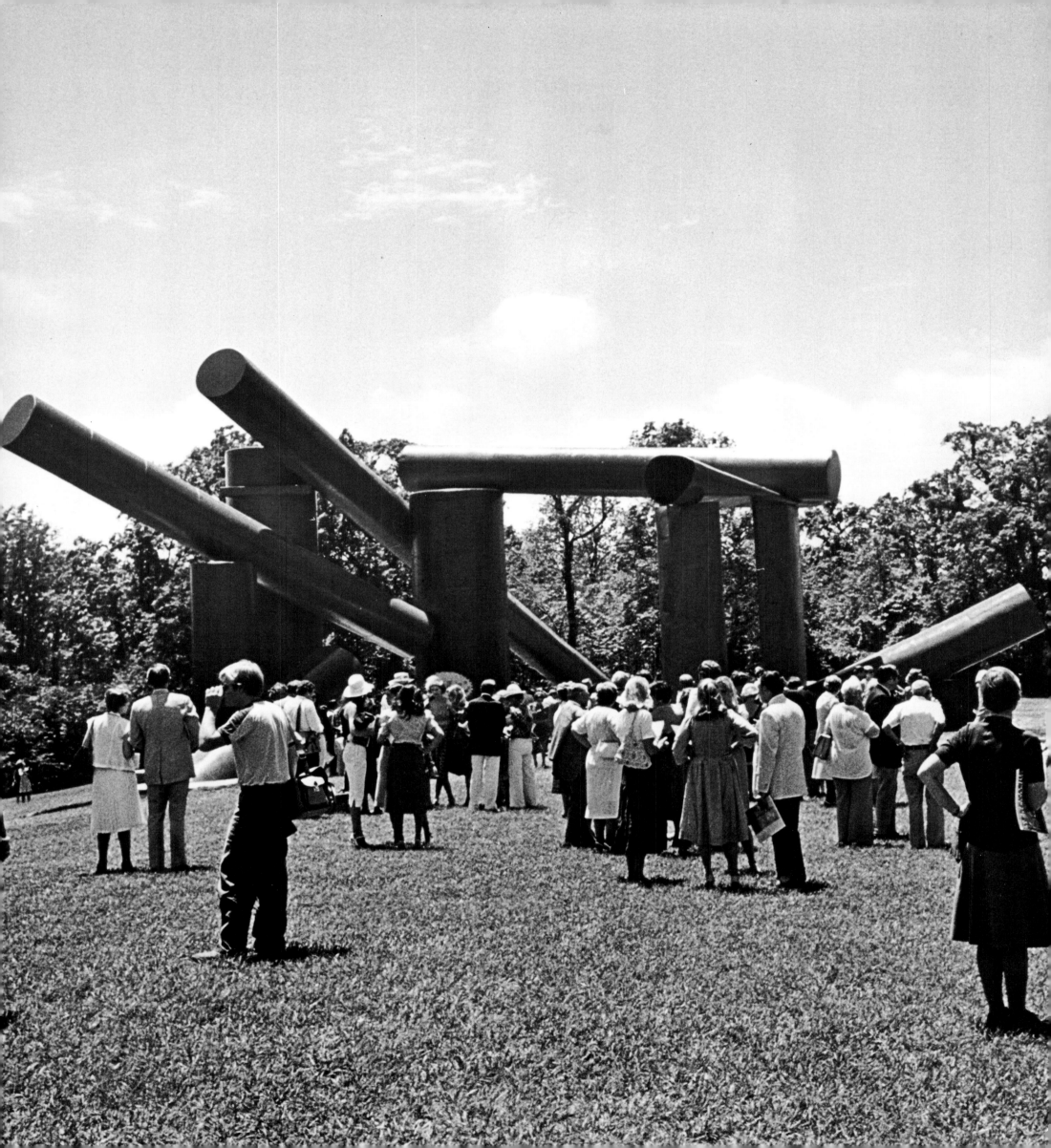

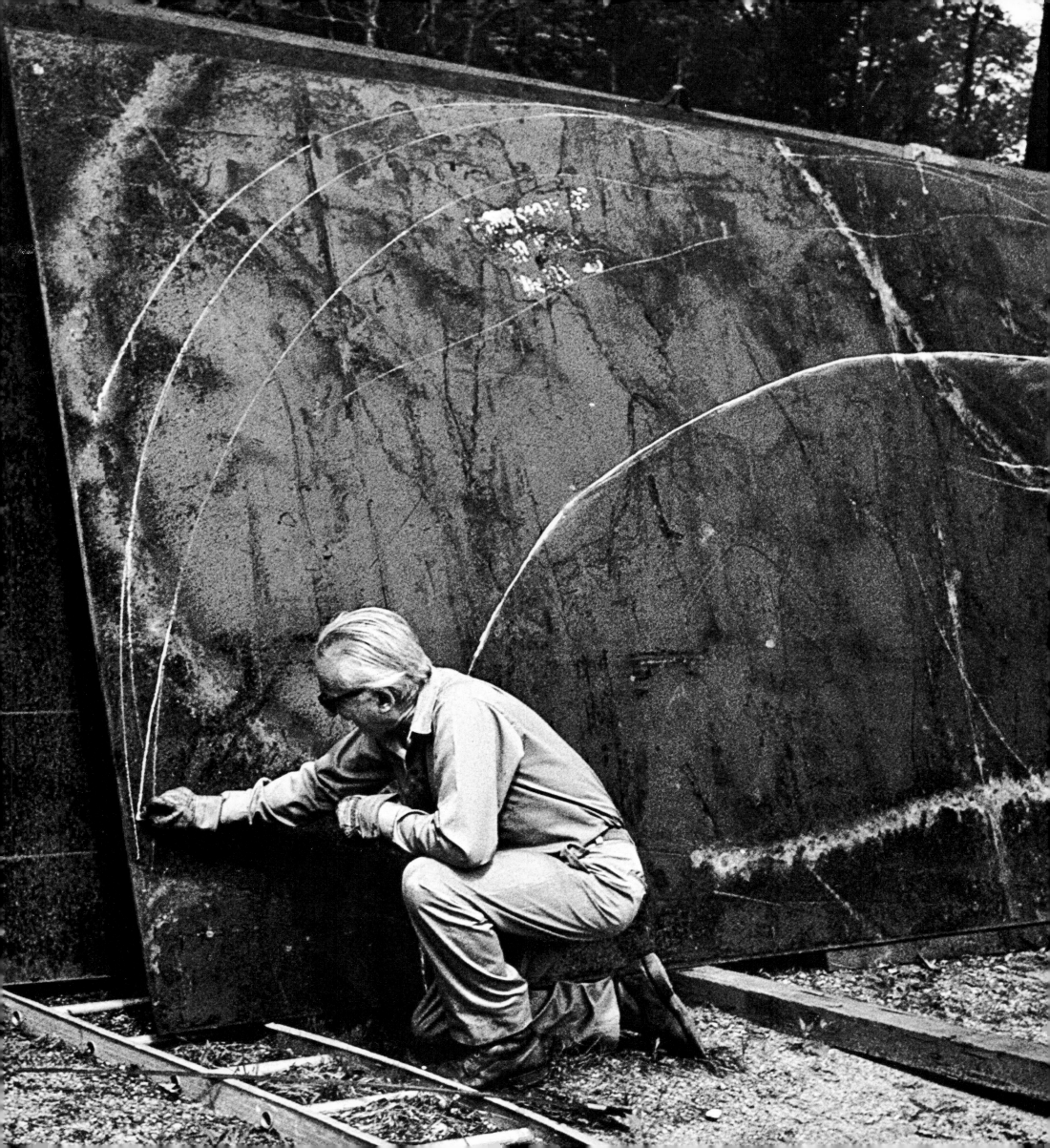

# BIBLIOGRAPHY

COMPILED BY CYNTHIA GOODMAN

## BY THE ARTIST

*The Art of Color Photography*, New York: Simon and Schuster, 1951.

*The Artist in His Studio*, New York: The Viking Press, 1960.

"Bonnard," *Vogue*, October 1, 1956, vol. 128, pp. 156–59.

"Braque," *Vogue*, October 1, 1954, vol. 124, pp. 112–19.

"Chagall," *Vogue*, April 1, 1955, vol. 125, pp. 116–21.

"Circlism," unpublished manuscript, 1960.

"Feininger," *Vogue*, April 15, 1956, vol. 127, pp. 90–93.

"Giacometti," *Vogue*, January 1, 1955, pp. 146–51.

*Greece, Gods, and Art*, New York: The Viking Press, 1968.

"Gromaire," *Vogue*, January 15, 1955, vol. 129, pp. 70–71.

"Imprint of Paris: Five Painters, 1957," *Vogue*, April 1, 1957, vol. 129, pp. 154–59.

"Kandinsky," *Vogue*, November 1, 1955, vol. 126, pp. 134–37 +.

*Moments Preserved* (Irving Penn), intro. by Alexander Liberman, New York: Simon and Schuster, 1960.

"Monet," *Vogue*, July 1955, vol. 126, pp. 64–69 +.

"Picasso," *Vogue*, November 1, 1956, vol. 128, pp. 132–37.

"Primer for Amateur Photographers," *Vogue*, August 1, 1949, vol. 114, pp. 91–93, 120.

"Rouault," *Vogue*, November 15, 1954, vol. 124, pp. 98–103.

*Steichen the Photographer* (also by Carl Sandberg), New York: The Museum of Modern Art, 1962; distributed by Doubleday and Co., Garden City.

"Steichen's Eye," *Vogue*, August 1, 1959, vol. 134, pp. 94–99 +.

"The Stones of Venice" (photographic portfolio), *Horizon Magazine*, March 1963, vol. 5, pp. 17–24.

"Thoughts on Art," unpublished manuscript, 1950, 15pp.

Untitled manuscript, unpublished, c. 1949, 7pp.

Untitled manuscript, unpublished, 1954, 1p.

"Villon," *Vogue*, February 15, 1955, vol. 125, pp. 78–83 +.

"Vlaminck," *Vogue*, May 1, 1955, pp. 124–127 +.

*Vogue Book of Fashion Photography 1919–1979* (Polly Devlin), intro. by Alexander Liberman, New York: Simon and Schuster, 1979.

## ARTICLES, EXHIBITION CATALOGUES

Alloway, Lawrence. (intro.) *Alexander Liberman*, exhibition catalogue, Betty Parsons Gallery, New York, January 29–February 17, 1962.

———. (intro.) *Alexander Liberman*, exhibition catalogue, Galleria dell'Ariete, Milano, November 1964.

———. "Farewell to Hard Edge; Interview with Alexander Liberman," *Alexander Liberman Paintings*, exhibition catalogue, Bennington College, Vermont, April 1964.

———. "Alexander Liberman's Recent Work," *Art International*, April 1964, vol. 8, no. 3, pp. 40–44.

"Artist Plans 'Symbol of the City'," and "An Interview with Alexander Liberman," *Register Star* (Rockford, Illinois), September 12, 1976.

*Art Now*. January 1969, vol. 1, no. 1.

Baro, Gene. "Alexander Liberman: Art as Involvement," *Art International*, March 20, 1967, vol. 11, no. 3, pp. 20–27.

———. "Alexander Liberman: The Art of Amplitude," *Studio International*, May 1970, vol. 179, no. 922, pp. 210–15.

Berkman, Florence. "What's That in Front of the Wadsworth? Liberman's Steel 'Echo'," *The Hartford Times* (Hartford, Connecticut).

Birch, Alison Wyrley. "Alexander Liberman of Warren Creates Sculpture By the Ton," *Waterbury Republican*, (Waterbury, Connecticut), December 4, 1977.

———. "Profile: Alexander Liberman," *The Forum*, (Kent, Connecticut), February 6, 1981, p. 3.

Blake, Peter. "Alexander Liberman: Beauty and Precision in Aluminum Sculpture," *Architectural Forum*, April 1963, vol. 118, no. 4, pp. 128–31.

Calas, Nicholas. "Liberman's Many Faces of the Cylinder," *Arts Magazine*, May 1971, vol. 45, no. 1, pp. 40–42.

Campbell, Lawrence. "Alexander Liberman in Orbit," *Art News*, April 1967, vol. 66, no. 2, pp. 40–41 +.

Daniels, Mary. "Artist and Journalist, Liberman is Leading the Full Double Life," *Chicago Tribune*, January 23, 1977.

Diamond, Adelina. "Talking with . . . Condé Nast's Alexander Liberman," *Adweek*, February, 1981, pp. 13–20.

Edwards, Owen. "Liberman's Choice," *American Photographer*, May 1980, vol. 4, no. 5.

"Embodiment of Myth." *Architectural Forum*, November 1973, vol. 140, no. 4, p. 83.

Goossen, E.C. "Alex Liberman: American Sculptor," *Art International*, October 21, 1971, vol. 15, no. 8, pp. 20–25.

Gray, Cleve. "Ceramics by Twelve Artists." *Art in America*, December 1964, vol. 52, no. 6, pp. 27–41.

Harr, Jonathan. "On High in New Haven," *New Haven Advocate*, vol. 5, no. 13, November 14, 1979.

Hernon, Peter. "There's Nothing Lightweight About This Sculpture," *St. Louis Globe Democrat*, May 23, 1980, p. 17A.

Hunter, Sam. (intro.) *Alexander Liberman—Recent Sculpture*, exhibition catalogue, The Jewish Museum, New York, June 29–September 5, 1966.

Madder, Kathleen. "Zur modephotographie: interview mit Alexander Liberman," *Du*, April 1978, pp. 58–59.

Mathis, Kenneth L. "Alexander Liberman and 'Firmament'," *Dayton Art Institute Bulletin*, October 1977, vol. 36, no. 1, pp. 12–15.

McCaslin, Walt. "Ambiguity Intrigues in Liberman Sculptures," *Journal Herald* (Dayton, Ohio), November 24, 1975.

Pilgrim, James. (intro.) *Alexander Liberman: Painting and Sculpture 1950–70*, exhibition catalogue, The Corcoran Gallery of Art, Washington, D.C., April 19–May 31, 1970.

Ratcliff, Carter. "Alexander Liberman's New Paintings," *Arts Magazine*, February 1978, vol. 52, no. 6, pp. 158–59.

———. *Alexander Liberman: New Black and White Paintings: "Unknown" Series*, exhibition catalogue, André Emmerich Gallery, New York, January 1979.

Robertson, Bryan. "Balancing Acts," *Harpers* and *Queen*, February 1980, pp. 88–91.

Salducci, Christine. "Quelques Instants avec Alexandre Liberman," *Nice-Matin*, July 20, 1966.

*Sculpture and Paintings by Alexander Liberman at the Storm King Art Center*, exhibition catalogue, May 18–August 29, 1977.

"Seeing Spots?" *Horizon*, September 1961, vol. 4, pp. 66–67.

Shelton, Patricia. "Alexander Liberman Puts Artwork in *Vogue*," *Chicago Daily News*, January 17, 1977.

Stein, Donna. "New Graphics Editions," *Print Review*, no. 10, 1979, pp. 14–17.

*The Art of Alexander Liberman*, exhibition catalogue, Honolulu Academy of Arts, September 8–October 8, 1972.

Tuten, Frederic. "Alexander Liberman's Vectors: Recent Coordinates of an Aesthetic Pattern," *Arts Magazine*, February 1969, vol. 43, no. 4, pp. 31–33.

Winn, Marie. "Liberman: Staying in Vogue," *The New York Times Magazine*, May 13, 1979.

———. "The Man Who Jazzed Up Fashion Magazines," *San Francisco Chronicle*, June 21, 1979, p. 37.

## SOLO EXHIBITIONS AND REVIEWS

### 1959

The Museum of Modern Art, New York, "The Artist in His Studio," photographs

*The Studio*, April 1960, vol. 159, no. 804, pp. 115–19.

73. Liberman drawing on steel, Warren. Photographed by Dr. William G. Cahan

383

**1960**

Betty Parsons Gallery, New York, paintings and sculpture
(B., C.) "Art Notes—Liberman's Purism," *The New York Herald Tribune*, April 9, 1960.
C(rehan), H(ubert). *Art News*, April 1960, vol. 59, no. 2, p. 46.
J(udd), D(onald). *Arts Magazine*, April 1960, vol. 34, no. 7, p. 59.
Preston, Stuart. *The New York Times*, April 9, 1960.
*The New York Journal American.* April 9, 1960.

**1962**

Betty Parsons Gallery, New York, paintings and sculpture
Adlow, Dorothy. *Christian Science Monitor*, February 10, 1962.
C(ampbell), L(awrence). *Art News*, February 1962, vol. 60, no. 10, p. 17.
Genauer, Emily. *The New York Herald Tribune*, February 4, 1962.
Levick, L.E. "Abstract or Realist? Shows Offer Variety," *The New York Journal American*, February 3, 1962.
(P., R.F., Jr.) *Pictures on Exhibit* (New York), February 1962.
Preston, Stuart. "The World Observed Without and Within," *The New York Times*, February 4, 1962.
*The New York Herald Tribune.* February 3, 1962.
T(illim), S(idney). *Arts Magazine*, March 1962, vol. 36, no. 6, p. 45.

**1963**

Betty Parsons Gallery, New York, paintings and sculpture
J(udd), D(onald). *Arts Magazine*, September 1963, vol. 37, no. 10, p. 60.
(O'D, B.) *The New York Times.* May 5, 1963.
Preston, Stuart. "A Square World," *The New York Times*, October 4, 1963.
Rose, Barbara. *Art International*, May 25, 1963, vol. 8, no. 5, pp. 54–57.
S(andler), I(rving). *Art News*, April 1963, vol. 62, no. 2, p. 12.
*The New York Herald Tribune.* April 27, 1963.

**1964**

Bennington College, Vermont, paintings
"Bennington College Opens Liberman Art Show," *Bennington Vermont Banner*, March 25, 1964.
"Liberman Show Opens Tonight at Bennington," *Berkshire Eagle* (Pittsfield, Massachusetts), March 28, 1964.
Betty Parsons Gallery, New York, paintings and sculpture
C(ampbell), L(awrence). *Art News*, October 1964, vol. 63, no. 6, pp. 62–63.
Kozloff, Max. *Arts Magazine*, January 1964, vol. 39, no. 4, p. 50.
L(evick), L.E. *The New York Journal American*, October 3, 1964.
*The New York Herald Tribune.* October 17, 1964.
Rose, Barbara. "Alexander Liberman and the Abstract Rococo," *Art International*, November 1964, vol. 8, no. 9, pp. 52–55.
T(illim), S(idney). *Arts Magazine*, November 1964, vol. 39, no. 2, p. 67.
*Time Magazine.* October 9, 1964.
Robert Fraser Gallery, London, paintings and sculpture
"Lots . . . and lots . . . of spots," *The Times* (London), February 2, 1964 (Sunday).
Maddox, Conroy. *The Arts Review* (London), March 7, 1964.
"Mr. Alexander Liberman's Abstract Works," *The Times* (London), March 31, 1964.
Russell, John. *The Times* (London), March 1, 1964 (Sunday).
Whittet, G.S. "Fresh Facets in Mature Artist's Work," *Studio International*, May 1964, vol. 167, no. 853, pp. 216–19.
Williams, Sheldon. "Art in London," *The New York Herald Tribune*, March 3, 1964.

**1965**

Galleria d'Arte, Naples, paintings and sculpture
Miele, Armando. "Alexander Liberman alla Galleria 'Il Centro'—Cronica di Napoli," *Il Tempo* (Naples), November 6, 1965.
Galleria dell'Ariete, Milan, paintings and sculpture
"Mostre a Milano," *Domus*, January 1965, no. 422, p. 48.

**1966**

Betty Parsons Gallery, New York, paintings
C(ampell), L(awrence). *Art News*, April 1966, vol. 65, no. 2, p. 17.
Glueck, Grace. "Art Notes: Always on Sundays (And Saturdays Too)," *The New York Times*, March 13, 1966 (Sunday), p. 28.
G(oldin), A(my). *Arts Magazine*, May 1966, vol. 40, no. 7, p. 62.
Levick, L.E. "Old Guard and Avant Garde," *The New York Journal American*, March 12, 1966.
*Time Magazine.* April 1, 1966.
The Jewish Museum, New York, sculpture
Fry, Edward F. *Artforum*, October 1966, vol. 5, no. 2, pp. 50–51.
W(aldman), D(iane). *Art News*, September 1966, vol. 65, no. 5, p. 15.

**1967**

André Emmerich Gallery, New York, sculpture (two exhibitions)
April:
(G., J.). *World Journal Tribune* (New York), March 31, 1967.
Kramer, Hilton. *The New York Times*, April 8, 1967.
*Time Magazine.* April 7, 1967.
December:
Kramer, Hilton. *The New York Times.* December 16, 1967.
*Time Magazine.* December 29, 1967.
Betty Parsons Gallery, New York, paintings
Kramer, Hilton. *The New York Times*, April 8, 1967.
*Kunstwerk.* April 1967, vol. 20, no. 7–8, p. 45.
Levick, L.E. "Old Masters in the Spotlight," *The New York Journal American*, April 27, 1963.
*Time Magazine.* April 7, 1967.

**1968**

André Emmerich Gallery, New York, sculpture
Mellow, James R. *Art International*, February 1968, vol. 12, no. 2, p. 74.
Perrault, John. "Painting Lives," *The Village Voice*, January 4, 1968, p. 14.
Pomeroy, Ralph. "New York Groups," *Art and Artists*, February 1968, pp. 44–45.
Tuten, Frederic. *Art News*, February 1968, vol. 66, no. 10, p. 14.
———. *Arts Magazine*, February 1968, vol. 42, no. 4, p. 60.
A(shbery), J(ohn). *Art News*, February 1968, vol. 66, no. 10, p. 14.

**1969**

André Emmerich Gallery, New York, sculpture
A(tirnomis). *Arts Magazine*, November 1969, vol. 43, no. 2, p. 58.
Campbell, Lawrence. *Art News*, November 1969, vol. 68, no. 7, p. 84.
Gruen, John. "Art in New York: Red for Danger," *New York Magazine*, May 10, 1971.
Ratcliff, Carter. *Art International*, Christmas 1969, vol. 13, no. 10, p. 72.
Betty Parsons Gallery, New York, paintings
Campbell, Lawrence. *Art News*, March 1969, vol. 68, no. 1, p. 21.
Mellow, James R. *Art International*, April 1969, vol. 13, no. 3, p. 38.

**1970**

The Corcoran Gallery of Art, Washington, D.C., and The Museum of Fine Arts, Houston, major retrospective, paintings and sculpture
Freed, Eleanor. "The Ultimate Distillation," *The Houston Post*, October 25, 1970.
Getlein, Frank. "Liberman Show at the Corcoran," *The Star* (Washington, D.C.), April 19, 1970 (Sunday).
Harithas, James. *Art in America*, March–April 1970, vol. 58, no. 2, pp. 106–107.
Holmes, Ann. "Liberman: Once a Realist, Now Abstractionist of Many Faces," *Houston Chronicle*, October 18, 1970.
Kutner, Janet. "'Forerunner' Works at Museum," *The Dallas Morning News*, November 26, 1970.
Richard, Paul. "Making a Work of Art at the Flip of a Poker Chip," *The Washington Post* (Washington, D.C.), May 10, 1970.
Tuten, Frederic. *Arts Magazine*, May 1970, vol. 44, no. 7, p. 54.

**1971**

Dag Hammarskjold Plaza, New York, sculpture
Gent, George. "Six Liberman Sculptures at Sculpture Garden," *The New York Times*, March 30, 1971.
Gruen, John. "Time Reconstructed," *New York Magazine*, May 10, 1971.
Hughes, Robert. "Spressatura in Steel," *Time Magazine*, April 26, 1971, pp. 76–77.

**1972**

Honolulu Academy of Arts, Hawaii, retrospective, paintings, sculpture, drawings, lithographs
Anderson, Web. "Liberman, Cyr Works at Academy," *Star—Bulletin and Advertiser* (Honolulu, Hawaii), September 17, 1972.

**1973**

André Emmerich Gallery, New York, paintings
Bell, Jane. *Arts Magazine*, September–October 1973, vol. 48, no. 1, pp. 67–69.
Crimp, Douglas. *Art News*, Summer 1973, vol. 72, no. 6, p. 101.
Frank, Peter. *Art in America*, September–October 1973, vol. 61, no. 5, pp. 113–115.
Mellow, James R. *The New York Times*, May 12, 1973.
Ratcliff, Carter. *Art International*, vol. 17, no. 6, p. 60.
Rose, Barbara. *New York Magazine*, May 21, 1973, p. 78.

**1974**

André Emmerich Gallery, New York
January: sculpture
*Art News*, April 1974, vol. 73, no. 4, p. 96.
Genauer, Emily. "Art and the Artist," *New York Post*, February 23, 1974.
———. *Newsday* (New York), March 1, 1974.
Tuten, Frederic. *Arts Magazine*, March 1974, vol. 48, no. 6, p. 72.
Wechsler, Jeffrey. "Two Shockingly Successful Shows in New York," *The Rutgers Daily Targum*, February 6, 1974, p. 8.
October: paintings
Alloway, Lawrence. *The Nation*, October 19, 1974, p. 382.
Bell, Jane. *Arts Magazine*, December 1974, vol. 49, no. 4, pp. 9–10.
Derfner, Phyllis. *Art International*, December 15, 1974, vol. 18, no. 1, p. 69.
Hughes, Robert. "Petronius Unbound," *Time Magazine*, October 28, 1974, p. 82.
Kaplan, Patricia. *Art News*, December, 1974, vol. 73, no. 10, p. 92.
Russell, John. "Art: Liberman Paintings Keep Their Pristine Look," *The New York Times*, October 12, 1974, p. 22.
Olson, Roberta J.M., "Alexander Liberman," *Arts Magazine*, September 1974, vol. 49, no. 1, p. 51.

**1977**

Storm King Art Center, Mountainville, New York, major retrospective, sculpture, paintings, graphics, photographs
Hess, Thomas B. "Breakthrough With Tanks," *New York Magazine*, June 6, 1977.
Russell, John. "Sculpture That's King-Size," *The New York Times*, May 27, 1977.
Ratcliff, Carter. "Alexander Liberman at Storm King," *Art in America*, November–December 1977, vol. 65, no. 6, pp. 100–101.
Tuten, Frederic. "Alexander Liberman: Aqua-

tints, Paintings, Photographs, and Sculpture,"
*Arts Magazine*, June 1977, vol. 51, no. 10, pp.
136–137.
Van Straaten Gallery, Chicago, prints, drawings,
photographs, and sculpture
*Chicago Daily News.* "Liberman Art Work To
Go On Display," January 13, 1977.

**1978**
André Emmerich Gallery, New York, paintings
Frackman, Noel. *Arts Magazine*, May 1978,
vol. 52, no. 9, pp. 28–29.
Hess, Thomas B. "Where Have All The Isms
Gone?" *New York Magazine*, February 13,
1978, pp. 69–70.
Kramer, Hilton. *The New York Times*, March
10, 1978.
Perrone, Jeff. *Artforum*, May 1978, vol. 15, no.
9, p. 58.
Schwartz, Ellen. *Art News*, May 1978, vol. 77,
no. 5, p. 186.
Burpee Art Museum, Rockford, Illinois, works on paper
and sculpture
Zimmerman, Dave. "Burpee Exhibit Shows
Varied Liberman Style," *Rockford Morning
Star*, June 9, 1978.
Landau-Alexander Gallery, Los Angeles, paintings
Muchnic, Suzanne. *Los Angeles Times*, April
20, 1979.
Harcus-Krakow, Boston, works on paper and photo-
graphs

**1979**
Arts Gallery, Baltimore, paintings on paper
André Emmerich Gallery, New York, paintings
Cavaliere, Barbara. *Arts Magazine*, March
1979, vol. 53, no. 7, p. 27.
Russell, John. *The New York Times*, January
12, 1979.
Greenberg Gallery, St. Louis, paintings on paper
Fischer, Joseph O. "Liberman Paintings
Shown at Greenberg," *St. Louis Post-Dispatch*,
February 10, 1979.
Laumeier County Park Sculpture Gallery, "The Artist
in His Studio," photographs
King, Mary. "Photographs of Artists," *St. Louis
Post-Dispatch*, August 30, 1979.
Lipkin, Joan. "'Photographs of Artists'—
Studios on Display at Laumeier Gallery,"
*Globe-Democrat* (St. Louis), September 1,
1979.
*West Co. Journal* (St. Louis). "Liberman Exhibit
Depicts Modern Artists," August 22, 1979.

**1980**
André Emmerich Gallery, New York, paintings on paper

**GROUP EXHIBITIONS**

**1954**
Guggenheim Museum, New York, "Younger American
Painters"
**1956**
Milwaukee Art Institute, "Charles Zadok Collection"
**1960**
Helmhaus, Zurich, "Konkrete Kunst"
**1961**
Art in America Exhibition, New York
Arthur Tooth Gallery, London, "American Abstract
Painters"
Chicago Art Institute, "Contemporary American
Painters"
David Herbert Gallery, New York
The New School for Social Research, New York
**1961–62**
Carnegie Institute, Pittsburgh International
**1962**
Albright-Knox Art Gallery, Buffalo
Chicago Art Institute, Annual Exhibition
The Museum of Modern Art, New York, traveling ex-
hibition of American drawings
Tokyo Biennale exhibition
Whitney Museum of American Art, New York, "Geo-
metric Abstraction in America"
Whitney Museum of American Art, New York, "Sculp-
ture and Drawing"
World's Trade Fair, Helskinki

**1963**
Allan Stone Gallery, New York, benefit for the Founda-
tion for the Contemporary Performance Arts
The Corcoran Gallery of Art Washington, D.C., "28th
Biennial Exhibition"
de Cordova Museum, Lincoln, Mass., "New Experi-
ments in Art"
Galerie Claude Bernard, Paris
Roswell Museum and Art Center, Roswell, New Mexico
Washington Gallery of Modern Art, Washington, D.C.
Whitney Museum of American Art, New York, "1963
Annual Exhibition"
**1963–64**
Washington Gallery of Modern Art, Washington, D.C.
**1964**
American Federation of Arts Gallery, New York,
"Ceramics by Twelve Artists"
Albright-Knox Art Gallery, Buffalo
Banfer Gallery, "Sculptor's Drawings"
Betty Parsons Gallery, New York, "World's Fair Artists"
Byron Gallery, New York, "100 American Drawings"
Galerie Denise René, Paris, "Hard Edge"
Guggenheim Museum, New York, "American Draw-
ings"
Los Angeles County Museum, "Post Painterly Ab-
straction," traveling exhibition
The Museum of Modern Art, New York, "Contemporary
Painters and Sculptors as Printmakers"
Smith College, Northampton, Massachusetts, "Sight/
Sound"
University of Michigan Museum of Art, Ann Arbor,
"The New Formalists"
Wadsworth Atheneum, Hartford, Connecticut, "Black,
White and Grey"
World House Galleries, New York, "World House
International '64"
**1964–65**
The Corcoran Gallery of Art, Washington, D.C., "29th
Biennial," traveling exhibition
**1965**
Detroit Institute of Arts, "Forty Key Artists of the 20th
Century"
Institute of Contemporary Art, University of Pennsyl-
vania, "Seven Sculptures"
The Museum of Modern Art, New York, "The Respon-
sive Eye," traveling exhibition
Pennsylvania Academy of the Fine Arts, Philadelphia
Richard Feigen Gallery, Chicago, "Drawings New
York"
United States Embassy, The Hague
Whitney Museum of American Art, New York, "1965
Annual Exhibition"
**1965–69**
Munson Williams Proctor Institute, "Drawings from the
Collection of Betty Parsons," traveling exhi-
bition
**1966**
Betty Parsons Gallery, New York, "Pattern Art"
Des Moines Art Center, Iowa, "Art with Optical Re-
action"
Musée Cantonal des Beaux-Arts, "2e Salon Interna-
tional de Galeries Pilotes Lausanne"
Pennsylvania State University, Hetzel Union Building
Gallery, "Selected Works from the Collection
of Nelson A. Rockefeller"
Virginia Museum of Fine Arts, "American Painting"
Whitney Museum of American Art, New York, "1966
Annual Exhibition of Sculpture and Prints"
**1966–67**
American Federation of Arts, "Inform and Interpret,"
traveling exhibition
Stedelijk Museum, Amsterdam, "New Forms and
Shapes of Color," traveling exhibition
The Museum of Modern Art, New York, "Optical Art,"
traveling exhibition
**1967**
Institute of Contemporary Art, University of Pennsyl-
vania, "Art for the City"
Los Angeles County Museum of Art and Philadephia
Museum of Art, "American Sculpture of the
Sixties"
The Museum of Modern Art, New York, "The 1960's:
Painting and Sculpture from the Museum
Collection"

New York City Office of Cultural Affairs, "Sculpture in
Environment"
University of Illinois, Urbana, "Contemporary American
Painting and Sculpture"
Washington Gallery of Modern Art organized, "Art for
Embassies"
Whitney Museum of American Art, New York, "1967
Annual Exhibition"
Wuttembergischer Kunstuerein, Stuttgart, "Formen der
Farbe"
**1967–68**
Aldrich Museum of Contemporary Art, Ridgefield,
Connecticut, "Highlights of the 1966–67 Art
Season"
Camden Arts Center and United States Embassy,
London, "Transatlantic Graphics," traveling
exhibition
**1968**
Cleveland Museum of Art, "Outdoor Garden Court
Sculpture" HemisFair '68, San Antonio, Texas
Museum of Modern Art, Belgrade, "British and Amer-
ican Graphics," traveling exhibition in Yugo-
slavia
The Museum of Modern Art, New York, "The Art of the
Real: 1948–68," traveling exhibition
R.S. Reynolds Company, Memorial Awards, "Visions
of Man" Whitney Museum of American Art,
New York, "1968 Annual Exhibition of Con-
temporary American Sculpture"
**1968–69**
Finch College, New York, "Betty Parsons Private
Collection," traveling exhibition
**1969**
The Museum of Modern Art, New York, "The New
American Painting and Sculpture: The First
Generation"
Philadelphia Museum of Art, "The Pure and Clear in
American Art"
**1971**
Boston Center for the Arts. "New England Art/Painting
and Sculpture Invitational Show"
North Jersey Cultural Council, Paramus, New Jersey,
"Sculpture in the Park"
French and Co., New York, "Contemporary American
Drawings"
**1972**
The Phillips Collection, Washington, D.C., "Contem-
porary Sculpture"
Storm King Art Center, Mountainville, New York,
"Outdoor Sculpture Indoors"
Whitney Museum of American Art, "1972 Annual
Exhibition of Contemporary American Paint-
ing"
**1973**
Denise René Gallery, Paris, "14 artistes américaines"
Whitney Museum of American Art, "Whitney Musuem
Biennial"
**1974**
Dusseldorf, Germany, "Dusseldorf Art Fair"
Janie C. Lee Gallery, Houston, "Alexander Liberman
and Hans Hofmann"
Merriwold West Gallery, Far Hills, New Jersey, "Out-
door Sculpture 1974"
North Jersey Cultural Council, Paramus, New Jersey,
"Sculpture in the Park"
Pace Gallery, New York, "American Painters of the
Fifties"
Newport, Rhode Island, "Monumenta"
**1975**
Janie C. Lee Gallery, Houston, "Monumental Sculp-
ture"
National Collection of Fine Arts, Washington, D.C.,
"Sculpture: American Directions 1945–75"
The Museum of Modern Art, International circulating
exhibition, "Color as Language," Museo de
Arte Moderno, Bosque de Chapultepec, Insti-
tut National de Bellas Artes, Mexico, D.F.
2RC Studio, Rome, "Americans in Rome"
Zabriskie Gallery, New York, "Artists by Artists"
**1976**
André Emmerich Gallery, New York, "Artists for
Amnesty"
Andrew Crispo Gallery, New York, "International
Decoration and the Arts"

**1977**

Akron Art Institute, "Project: New Urban Monuments," traveling exhibition

André Emmerich Gallery, New York, "Modernist Art of the Post-War Period"

John Weber Gallery, New York, "Drawings for Outdoor Sculpture, 1946–1977"

Los Angeles County Museum of Art, "Private Images —Photographs by Painters"

New York State Museum, Albany, New York, "New York the State of Art"

Bard College, Annandale-on-Hudson, New York, "Photographs of Artists"

Illinois Bell Lobby Gallery, Chicago, Illinois, "Contemporary International Prints"

André Emmerich Gallery, New York, "Imaginary Monuments"

Fontana Gallery, Philadelphia, Pennsylvania

Thomas Segal Gallery, Boston, "Works on Paper"

**1978**

Krannert Art Museum, University of Illinois, "American Sculpture for American Cities"

Toledo Museum of Art, "Art for Collectors V"

**1979**

Claremont Colleges, Galleries at Pomona College and Scripps College, Claremont, California, "Black and White are Colors . . . Paintings of the 1950's–1970's"

**1981**

de Cordova Museum, Lincoln, Massachusetts, "The Fine Art of Business"

Grey Art Gallery and Study Center, New York, New York, "A Tribute to Tatyana Grosman and the ULAE"

Thanks must be given to James Pilgrim who compiled the chronology and Ellen Gross who prepared the bibliography for *Alexander Liberman: Paintings and Sculpture 1950–70*, exhibition catalogue for the Corcoran Gallery of Art, Washington, D.C., 1970. Their work is a major source for bibliographical and biographical information about Alexander Liberman through 1969.

## PUBLIC COLLECTIONS

Atlantic Richfield Co., Los Angeles, California

Addison Gallery of American Art, Phillips Academy, Andover, Massachusetts

Akron Art Institute, Akron, Ohio

Albright-Knox Art Gallery, Buffalo, New York

Art Institute of Chicago, Chicago, Illinois

Brooks Memorial Art Gallery, Memphis, Tennessee

Chase Manhattan Bank, New York, New York

Civic Center Synagogue, New York, New York

Corcoran Gallery of Art, Washington, D.C.

Dayton Art Institute, Dayton, Ohio

De Cordova Museum, Lincoln, Massachusetts

Finch College, New York, New York

Housatonic Community College, Stratford, Connecticut

Laumeier International Sculpture Park, St. Louis, Missouri

Los Angeles County Museum of Art, Los Angeles, California

The Metropolitan Museum of Art, New York, New York

Museo Rufino Tamayo, Mexico City, Mexico

Museum of Art, Rhode Island School of Design, Providence, Rhode Island

Museum of Fine Arts, Houston, Texas

The Museum of Modern Art, New York, New York

Neuberger Museum, Purchase, New York

Oklahoma Art Center, Oklahoma City, Oklahoma

Phoenix Art Museum, Phoenix, Arizona

Rose Art Museum—Brandeis University, Waltham, Massachusetts

Smith College Museum of Art, Northampton, Massachusetts

Smithsonian Institution, National Collection of Fine Arts, Washington, D.C.

Solomon R. Guggenheim Museum, New York, New York

Storm King Art Center, Mountainville, New York

Tate Gallery, London, England

University of California, Berkeley, California

University of Hawaii, Honolulu, Hawaii

University of Minnesota, Minneapolis, Minnesota

Virginia Museum of Fine Arts, Richmond, Virginia

Wadsworth Atheneum, Hartford, Connecticut

Washington Gallery of Modern Art, Washington, D.C.

Whitney Museum of American Art, New York, New York

Woodward Foundation—American Embassy Program

Yale University, New Haven, Connecticut

University of Pennsylvania, Philadelphia, Pennsylvania

# LIST OF PLATES

# INDEX

## PICTURE CREDITS

*Unless otherwise indicated, plate numbers follow each credit.*

Courtesy Albright-Knox Art Gallery, 109, 294; Oliver Baker Associates, 89, 117; Beach Barrett, 324; Cecil Beaton, 150; E. Irving Blomstrann, 178, 193; William Brui, 311; Rudolph Burckhardt, 217 (courtesy Betty Parsons Gallery); William G. Cahan, M.D., 186, page 382; Gary Carlson, 325-326; Henri Cartier-Bresson, 131; Geoffrey Clements, 37, 44, 52-53, 57-65, 69, 70 (courtesy André Emmerich Gallery, Inc.), 72, 74, 76-78, 80-84, 86, 87 (courtesy Andre Emmerich Gallery, Inc.), 88, 90, 93-94, 97-100, 107, 118-119, 122 (courtesy Andre Emmerich Gallery, Inc.), 127, 129, 137-139, 142-143, 148, 152-158, 162, 175-177, 181-184, 187-189, 191-192, 194, 230-233; Courtesy Corcoran Gallery of Art, 144; Andre Emmerich, 277, 305; Courtesy André Emmerich Gallery, Inc., 243, 247-248; Feingersh, 45 (courtesy Pix, Inc.); Thomas Feist, 207 (courtesy Betty Parsons Gallery); Thaddeus Gray, 320; William Grigsby, 116, 128 (courtesy Hirshhorn Museum and Sculpture Garden, Smithsonian Institution), 130, 145, 165-166, 213, 214 (courtesy Betty Parsons Gallery); Courtesy Tatyana Grosman, 190; Martin Helfer, 300 (courtesy Neiman-Marcus, Northbrook, Illinois); Titus Hewryk, 319; Bill Johnson, 301; Vance Jones, 307; Edward Kasper, 48-51, 54-56, 67, 71, 73 (courtesy Betty Parsons Gallery), 79, 83, 91, 102, 104-105, 123, 147, 174, 195-196, 198-199, back cover; Alexander Liberman, front cover, front endpaper, 66, 80, 85, 146, 173, 180, 185, 197, 201, 203, 206, 219-221, 224-229, 235, 237-242, 244-246, 249, 252, 254-265, 267-268, 270-272, 274-276, 280-285, 287, 290-293, 296-299, 304, 308-309, 312-314, 323, 327-329, 331, 333-337; Leonid D. Lubianitsky, 269, 273, 286, 288, 289, 302, 310; Sven Martson, 321-322, 324; Robert E. Mates and Mary Donlon, 251 (courtesy The Solomon R. Guggenheim Museum); Robert E. Mates and Paul Katz, 168-172; Inge Morath, 234, 250; Ugo Mulas, 47, 218 (courtesy Betty Parsons Gallery), 222-223, 236; Courtesy The Museum of Modern Art, 68, 92, 95-96, 103, 202; Dominique Nabokov, 164; Hans Namuth, 114-115, 125, 136, 209-211, 215-216, 278, back endpaper; Helmut Newton, 295; Courtesy Betty Parsons Gallery, 205; Irving Penn, 1-6, 38-39; Eric Pollitzer, 135, 149, 151, 159-161, 167; Bill Sanders, 303; John D. Schiff, 106 (courtesy Betty Parsons Gallery), 110, 112-113, 120, 121 (courtesy Betty Parsons Gallery), 124; Oliviero Toscani, 306; Courtesy Whitney Museum of American Art, 253, 266.

## CHRONOLOGY PICTURE CREDITS

Oliver Baker, 37 (courtesy Betty Parsons Gallery); Erwin Blumenfeld, 23; William Brui, 65, 70; Robert Cato, 36; Geoffrey Clements, 27; Francine du Plessix Gray, 22; Edward Kasper, 33, 38; William Klein, 47; Alexander Liberman, 49, 61, 66; Frances McLaughlin-Gill, 43; Ugo Mulas, 51; Courtesy The Museum of Modern Art, 59; Jon Naar, 44; Hans Namuth, 48; Renate Ponsold, 68; Marc Riboud, 60; Savitry, 14; Bettina Sulzer, 64 (courtesy Andre Emmerich Gallery).